Adobe Photoshop CC for Photographers by acclaimed digital imaging professional Martin Evening has been revamped to include detailed instruction for all of the updates to Photoshop CC on Adobe's Creative Cloud, including significant new features, such as the painting tool and Pen path tool refinements, and Range Masking in Camera Raw. This guide covers all the tools and techniques photographers and professional image editors need to know when using Photoshop, from workflow guidance to core skills to advanced techniques for professional results. Using clear, succinct instruction and real world examples, this guide is the essential reference for Photoshop users. The accompanying website has been updated with new sample images, tutorial videos, and bonus chapters.

FURTHER READER RESOURCES

Martin Evening Photography, London, UK

www.martinevening.com www.facebook.com/MartinEveningPhotoshopAndPhotography

Adobe Photoshop CC for Photographers website

www.photoshopforphotographers.com

Inducted into the Photoshop Hall of Fame in 2008, **Martin Evening** is an internationally renowned photographer. Working principally on studio-based beauty photography, Martin uses Photoshop to retouch or manipulate to some degree nearly every image he produces. This regular everyday experience with the software has enabled him to gain extensive specialist knowledge of Photoshop.

Adobe Photoshop CC for Photographers

2018 Edition

A professional image editor's guide to the creative use of Photoshop for the Macintosh and PC

Martin Evening

The Westport Library Westport, Connecticut 203-291-4840

First published 2018 by Routledge 711 Third Avenue, New York, NY 10017

and by Routledge 2 Park Square, Milton Park, Abingdon, Oxon OX14 4RN

Routledge is an imprint of the Taylor & Francis Group, an informa business

© 2018 Martin Evening

The right of Martin Evening to be identified as the author of this work has been asserted by him in accordance with sections 77 and 78 of the Copyright, Designs and Patents Act 1988.

All rights reserved. No part of this book may be reprinted or reproduced or utilized in any form or by any electronic, mechanical, or other means, now known or hereafter invented, including photocopying and recording, or in any information storage or retrieval system, without permission in writing from the publishers.

Notices

Knowledge and best practice in this field are constantly changing. As new research and experience broaden our understanding, changes in research methods, professional practices, or medical treatment may become necessary.

Practitioners and researchers must always rely on their own experience and knowledge in evaluating and using any information, methods, compounds, or experiments described herein. In using such information or methods they should be mindful of their own safety and the safety of others, including parties for whom they have a professional responsibility.

Product or corporate names may be trademarks or registered trademarks, and are used only for identification and explanation without intent to infringe.

Library of Congress Cataloging-in-Publication Data

ISBN: 978-1-138-08675-3 (hbk) ISBN: 978-1-138-08676-0 (pbk) ISBN: 978-1-315-11087-5 (ebk)

Publisher's Note

This book has been prepared from camera-ready copy provided by the author.

Printed in Canada

9

THE WESTPORT PUBLIC LIBRARY 34015072385469

Contents	
Please read first	
Introduction	
Acknowledgements	

1 Photoshop fundamentals

Photoshop installation	2
The Photoshop interface	
Photoshop Welcome experience	5
In-app searches	7
Sharing images	
Creating a new document	
The legacy New Document dialog	
Tabbed document windows	
Managing document windows	12
Synchronized scroll and zoom	1/
Image document window details	15
Title bar proxy icons (Mac only)	
Info panel status information	. 10
Rulers, Grid, & Guides	18
New Guide Layout dialog	
New Guides from Shape	20
'Snap to' behavior	. 20
Pixel Grid view	. 21
The Photoshop panels	. 21
Panel arrangements and docking	
Panel positions remembered in workspaces	
Customizing the menu options	
Customizing the keyboard shortcuts	
Task-based workspaces	
Saved workspaces location	28
Working with a dual display setup	
Photoshop CC Tools panel	
Toolbar presets	32
Tool tips	
Options bar	
Tool Presets	
Selection tools	
Color Range	
A Color Range selection of a selection	
Out-of-gamut selections	
Skin tone and faces selections	
Adjustable tone ranges	
Modifier keys	40
Painting tools	
On-the-fly brush changes	
on the hy blush changes	44

On-screen brush adjustments	45
Brushes panel	46
Brush Settings panel	46
Pressure sensitive control	47
Saving Brush tool presets	48
Mixer brush	48
Bristle tip brush shapes	
Brush stroke smoothing	
Adobe Color Themes panel	
Automatically add colors to the Swatches panel	
Tools for filling	
Tools for drawing	53
Image editing tools	54
Move tool	
Layer selection using the Move tool	
Navigation and information tools	
Zoom tool	58
Zoom tool shortcuts	
Hand tool	
Bird's Eye view	
Flick panning	
Windows Multi-touch support	
Eyedropper tool	. 60
Ruler tool	
Rotate View tool	
Notes tool	
Count tool	
Screen view modes	
Working with Layers	
Preset Manager	
History	
The History panel	
History settings and memory usage	. 67
History Brush	. 69
Use of history versus undo	. 69
Art History Brush	. 69
Snapshots	. 69
Non-linear history	. 70
When files won't open	72
Save often	
Background saving	74
Using Save As to save images	75
File formats	
Photoshop native file format	76
Smart PSD	
PSDX format	
Large Document (PSB) format	
TIFF (Tagged Image File Format)	
in r (raggod inago i no r ornacjini in initiali initiali initiali initiali initiali initiali initiali initiali	

TIFF compression options	
Flattened TIFFs	
JPEG	
HEIF Support and Depth Map	
PNG	
Photoshop PDF	
Adobe Bridge CC	
Installing Bridge	
The Bridge interface	
Custom work spaces in Bridge	
Output options	
Opening files from Bridge	
Slideshows	
Camera Raw	
DNG and transparency support	
Opening photos from Bridge via Camera Raw	
Photoshop help	
Learn panel	
Splash screen	

2 Camera Raw processing

Car	mera Raw advantages	90
	The new Camera Raw workflow	
	Does the order matter?	
	Raw capture	
	It's 'raw' not 'RAW'	
	JPEG capture	
	Editing JPEGs and TIFFs in Camera Raw	
	Adobe Photoshop Lightroom	
	Alternative Raw processors	
	Camera Raw support	
	DNG compatibility	
Bas	sic Camera Raw image editing	
	Working with Bridge and Camera Raw	
	General controls for single file opening	
	Full-size window view	
	General controls for multiple file opening	101
	Preview controls	
	Checkpoints	
	Preview preferences	103
	Workflow options	
	Saving photos from Camera Raw	107
	Saving a JPEG as DNG	108
	Resolving naming conflicts	
	Color space and image sizing options	109
	Opening raw files as Smart Objects	110
	Creating Lightroom-linked Smart Objects	110

Altering the background color	114
The histogram display	115
Digital camera histograms	
Interactive histogram	115
Image browsing via Camera Raw	
Bird's Eye View	118
Modal tool refinements in Camera Raw	118
Camera Raw preferences	120
Default Image Settings	
Camera Raw cache	
DNG file handling	
JPEG and TIFF handling	
Performance: Accelerated graphics (GPU)	
Graphics card compatibility	
Scrubby zoom	
Camera Raw cropping and straightening	125
How to straighten and crop	126
Basic panel controls	
White balance	128
Using the White balance tool	128
Localized white balance measurements	130
Independent auto white balance adjustments	132
Process Versions	134
The Version 4 tone adjustment controls	
Exposure	
Contrast	
Highlights and Shadows	
Whites and Blacks	
Auto-calculated Blacks range	
Highlight clipping	
When to clip the highlights	130
How to clip the shadows	1/10
Shadow levels after a conversion	
Digital exposure The camera LCD histogram	1/12
How Camera LCD Instogram	
Basic panel image adjustment procedure	
Auto tone corrections	
Auto tone corrections Auto Whites and Blacks sliders	
Camera-specific default settings	149
Clarity	150
Negative clarity	
Correcting a high contrast image	156
Vibrance and Saturation	
Tone Curve panel	
Point Curve editor mode	
RGB Curves	
HSL/Grayscale panel	
Recovering out-of-gamut colors	. 163

Lens Corrections panel: Profile tab. 166 Accessing and creating custom lens profiles 188 Chromatic aberration 169 Lens Corrections panel: Manual tab. 171 The Defringe controls in use 172 Eyedropper tool mode 173 Localized adjustments: Defringe slider. 173 Localized adjustments: Defringe slider. 176 Transform tool and Upright corrections. 178 Synchronizing Upright settings. 184 Guided Upright adjustments. 189 Effects panel. 190 Post Crop Vignetting control. 190 Post Crop Vignette style options. 192 Highlights slider 194 Adding Grain effects. 196 Dehzze slider 200 Calibration panel. 200 Calibration panel. 200 Carera Raw legacy profiles 200 Calibration panel. 200 Carera Raw as Photoshop filter. 202 Spot Removal tool. 206 Creating circle spots. 207 Synchronized spotting with Camera Raw. 208	Adjusting the hue and saturation	. 164
Accessing and creating custom lens profiles 168 Chromatic aberration 169 Lens Corrections panel: Manual tab. 171 The Defringe controls in use 172 Eyedropper tool mode 172 How to remove axial chromatic aberration 173 Localized adjustments: Defringe slider. 176 Transform tool and Upright corrections 178 Synchronizing Upright settings 184 Guided Upright adjustments 189 Effects panel 190 Post Crop Vignetting control 190 Post Crop Vignetting control 192 Post Crop Vignetting control 194 Adding Grain effects 196 Dehaze slider 198 Calibration panel 200 Camera Raw legacy profiles 200 Camera Raw legacy profiles 201 Calibration panel 202 Calibration panel 200 Camera Raw as a Photoshop filter 202 Camera Raw as a Photoshop filter 202 Spot removal tool feathering 208 Spot removal tool feathering 209		
Chromatic aberration169Lens Corrections panel: Manual tab.171The Defringe controls in use172Eyedropper tool mode.172How to remove axial chromatic aberration173Localized adjustments: Defringe slider.176Transform tool and Upright corrections.178Synchronizing Upright settings.184Guided Upright dijustments.189Effects panel.190Post Crop Vignetting control190Post Crop Vignetting control190Post Crop Vignette style options.192Highlights slider.196Dehaze slider196Dehaze slider196Calized Dehaze adjustments198Calized Dehaze adjustments200Camera profiles200Camera profiles201Camera avalitic alibrations.201Ernedding custom profiles202Spot Removal tool208Spot removal tool208Spot removal tool209Visualize spots.210Creating circle spots207Synchronized spotting with Camera Raw.208Spot removal tool209Visualize spots.212Deleting spots.213Red Eye: Pet Eye removal214Adjustment Brush options.219Hintial Adjustments218Adjustment Brush options.219Brush settings.219Adjustment Brush options.219Adjustment Brush options.219		
Lens Corrections panel: Manual tab. 171 The Defringe controls in use 172 Eyedropper tool mode 172 How to remove axial chromatic aberration 173 Localized adjustments: Defringe slider. 176 Transform tool and Upright corrections 178 Synchronizing Upright settings 184 Guided Upright adjustments 184 Lens Vignetting controls 189 Effects panel 190 Post Crop Vignetting control 190 Post Crop Vignette style options 192 Highlights slider 194 Adding Grain effects 196 Localized Dehaze adjustments 200 Camera Profiles 200 Calibration panel 200 Calibration panel 200 Cauerar Raw legacy profiles 200 Cauera Raw legacy profiles 201 Camera Raw legacy profiles 202 Cauera Raw as a Photoshop filter. 202 Spot Removal tool 206 Creating circle spots 207 Synchronized spotting with Camera Raw 208 Spot remova		
The Defringe controls in use 172 Eyedropper tool mode 172 How to remove axial chromatic aberration 173 Localized adjustments: Defringe silder. 176 Transform tool and Upright corrections 178 Synchronizing Upright settings 184 Guided Upright adjustments 184 Lens Vignetting controls 189 Effects panel 190 Post Crop Vignetting control 190 Post Crop Vignette style options 192 Highlights silder 196 Dehaze slider 196 Localized Dehaze adjustments 200 Camera Raw legacy profiles 200 Camera Raw legacy profiles 200 Camera Raw legacy profiles 201 Camera Raw as a Photoshop filter. 202 Spot Removal tool 208 Spot removal tool 209 Visualize spots 201 Careating circle spots 207 Synchronized spotting with Camera Raw 208 Spot removal tool 209 Visualize spots 210 Creating brush spots 21	Lens Corrections panel: Manual tab	. 171
Eyedropper tool mode172How to remove axial chromatic aberration173Localized adjustments: Defringe slider176Transform tool and Upright corrections178Synchronizing Upright settings184Guided Upright adjustments189Effects panel190Post Crop Vignetting control190Post Crop Vignette style options192Highlights slider196Dehaze slider196Localized Dehaze adjustments198Calibration panel200Camera profiles200Custom camera profile calibrations201Camera Raw legacy profiles201Camera Raw as a Photoshop filter202Spot removal tool206Creating circle spots207Synchronized spoting with Camera Raw208Spot removal tool206Creating circle spots207Synchronized spoting with Camera Raw208Spot removal tool206Creating bots211Deleting spots212Deleting spots213Red Eyer Pet Eye removal214Adding a new brush effect220Resting adjustments218Adjustment Brush duplication214Ading a new brush effect220Resting adjustments218Adjustment Brush duplication214Ading a new brush effect220Resting adjustments218Ading a new brush effect220Resting adjustments221 </td <td></td> <td></td>		
How to remove axial chromatic aberration 173 Localized adjustments: Defringe slider. 176 Transform tool and Upright corrections 178 Synchronizing Upright settings 184 Guided Upright adjustments 184 Lens Vignetting controls 189 Effects panel. 190 Post Crop Vignetting control 190 Post Crop Vignette style options 192 Highlights slider 194 Adding Grain effects. 196 Dehaze slider 196 Localized Dehaze adjustments 198 Calibration panel 200 Carmera profiles 200 Carmera Raw legacy profiles 200 Carmera Raw legacy profiles 201 Camera Raw legacy profiles 201 Carmera Raw as a Photoshop filter. 202 Spot Removal tool 206 Creating circle spots 207 Synchronized spotting with Carmera Raw. 208 Spot removal tool feathering 208 Spot removal tool feathering 208 Spot removal tool feathering 216 Creat		
Localized adjustments: Defringe slider. 176 Transform tool and Upright corrections. 178 Synchronizing Upright settings 184 Guided Upright adjustments 184 Lens Vignetting controls 189 Effects panel 190 Post Crop Vignetting control 190 Post Crop Vignette style options 192 Highlights slider 194 Adding Grain effects. 196 Dehaze slider 196 Localized Dehaze adjustments 188 Calibration panel 200 Camera profiles 200 Camera profile calibrations 201 Embedding custom profiles 201 Camera Raw legacy profiles 202 Spot Removal tool 206 Creating circle spots 207 Synchronized spotting with Camera Raw 208 Spot removal tool feathering 208 Creating circle spots 207 Synchronized spotting with Camera Raw 208 Spot removal tool feathering 208 Catized adjustments 210 Creating brush spots 2	How to remove axial chromatic aberration	173
Transform tool and Upright corrections 178 Synchronizing Upright settings 184 Guided Upright adjustments 189 Effects panel 190 Post Crop Vignetting control 190 Post Crop Vignette style options 192 Highlights slider 194 Adding Grain effects 196 Dehaze slider 196 Localized Dehaze adjustments 198 Calibration panel 200 Camera profiles 200 Camera profiles 200 Camera Raw legacy profiles 201 Camera Raw legacy profiles 202 Spot Removal tool 206 Creating circle spots 207 Synchronized spotting with Camera Raw 208 Spot removal tool 208 Fine-Luning the Spot removal tool 209 Visualize spots 210 Creating brush spots 212 Deleting spots 213 Red Eye removal 216 Red Eye: Pet Eye removal 217 Localized adjustments 218 Adjustment Brush options		
Synchronizing Upright settings184Guided Upright adjustments184Lens Vignetting controls189Effects panel190Post Crop Vignetting control190Post Crop Vignette style options192Highlights slider194Adding Grain effects196Dehaze slider196Localized Dehaze adjustments188Calibration panel200Camera Profiles200Camera Profiles200Camera Raw legacy profiles201Camera Raw as a Photoshop filter202Spot Removal tool206Creating circle spots207Synchronized spotting with Camera Raw208Spot removal tool feathering208Fine-tuning the Spot removal tool208Fine-tuning the Spot removal tool208Visualize spots211Creating brush spots212Deleting spots213Red Eye removal216Red Eye: Pet Eye removal217Localized adjustments218Adjustment Brush218Initial Adjustment Brush options219Adding a new brush effect220Resetting adjustments221Adjustment Brush duplication221Adjustment Brush duplication221Adjustment Brush stoke areas223Auto masking225Range masking227		
Guided Upright adjustments184Lens Vignetting controls189Effects panel.190Post Crop Vignetting control190Post Crop Vignette style options192Highlights slider194Adding Grain effects196Dehaze slider196Localized Dehaze adjustments198Calibration panel200Camera profiles200Camera profiles200Custom camera profiles201Embedding custom profiles201Camera Raw legacy profiles201Camera Raw as a Photoshop filter202Spot Removal tool206Creating circle spots207Synchronized spotting with Camera Raw208Spot removal tool feathering208Fine-tuning the Spot removal tool209Visualize spots211Deleting spots212Deleting spots213Red Eye: Pet Eye removal216Red Eye: Pet Eye removal217Localized adjustments218Adjustment Brush options219Brush settings219Adding a new brush effect220Resetting adjustments221Ading a new brush effect220Resetting adjustments221Ading an env brush stroke areas223Auto masking225Range masking227		
Lens Vignetting controls189Effects panel.190Post Crop Vignetting control190Post Crop Vignette style options192Highlights slider194Adding Grain effects.196Dehaze slider196Localized Dehaze adjustments198Calibration panel200Camera profiles200Camera profiles200Custom camera profiles201Embedding custom profiles201Camera Raw legacy profiles201Camera Raw as a Photoshop filter202Spot Removal tool206Creating circle spots207Synchronized spotting with Camera Raw208Spot removal tool feathering208Fine-tuning the Spot removal tool209Visualize spots211Deleting spots212Deleting spots213Red Eye: Pet Eye removal216Red Eye: Pet Eye removal217Localized adjustments218Adjustment Brush options219Brush settings219Adding a new brush effect220Resetting adjustments221Adjustment Brush duplication221Editing brush adjustments223Previewing the brush stroke areas223Auto masking225Range masking227		
Effects panel190Post Crop Vignetting control190Post Crop Vignette style options192Highlights slider194Adding Grain effects196Dehaze slider196Localized Dehaze adjustments198Calibration panel200Camera profiles200Custom camera profiles200Custom camera profile calibrations201Embedding custom profiles202Spot Removal tool206Creating circle spots207Synchronized spotts207Synchronized spotts207Synchronized spotts208Fine-tuning the Spot sentos210Creating brush spots212Deleting spots213Red Eye removal216Red Eye: Pet Eye removal217Localized adjustments218Adigustment Brush218Initial Adjustment Brush options219Brush settings219Adding a new brush effect220Resetting adjustments221Adigustment Brush options219Brush settings221Adigustment Brush options221Adigustment Brush options221Editing brush stroke areas223Auto masking225Range masking227	Lens Vignetting controls	190
Post Crop Vignetting control190Post Crop Vignette style options192Highlights slider194Adding Grain effects196Dehaze slider196Localized Dehaze adjustments198Calibration panel200Camera profiles200Camera profiles200Custom camera profile calibrations201Camera Raw legacy profiles201Camera Raw a Photoshop filter202Spot Removal tool206Creating circle spots207Synchronized spotting with Camera Raw208Spot removal tool loe fathering208Fine-tuning the Spot removal tool209Visualize spots212Deleting spots213Red Eye removal216Red Eye removal217Localized adjustments218Adjustment Brush218Initial Adjustment Brush options219Brush settings219Adding a new brush effect220Resetting adjustments221Adding a new brush effect220Resetting adjustments221Adding a new brush effect220Resetting adjustments221Adding new brush effect220Resetting adjustments221Ading the brush stroke areas223Auto masking225Range masking227		
Post Crop Vignette style options192Highlights slider194Adding Grain effects196Dehaze slider196Localized Dehaze adjustments198Calibration panel200Camera profiles200Camera Raw legacy profiles200Custom camera profile calibrations201Embedding custom profiles201Camera Raw a a Photoshop filter202Spot Removal tool206Creating circle spots207Synchronized spotting with Camera Raw208Spot removal tool feathering208Spot removal tool feathering208Spot removal tool feathering209Visualize spots210Creating brush spots212Deleting spots213Red Eye removal216Red Eye: Pet Eye removal217Localized adjustments218Adjustment Brush218Initial Adjustment Brush options219Adding a new brush effect220Resetting sdjustments221Adding a new brush effect220Resetting brush duplication221Adjustment Brush duplication221Adjustment Brush duplication221Ading a new brush effect223Auto masking225Range masking225Range masking227		
Highlights slider194Adding Grain effects196Dehaze slider196Localized Dehaze adjustments198Calibration panel200Camera profiles200Camera profiles200Custom camera profile calibrations201Embedding custom profiles201Camera Raw as a Photoshop filter202Spot Removal tool206Creating circle spots207Synchronized spotting with Camera Raw208Spot removal tool feathering208Fine-tuning the Spot removal tool209Visualize spots210Creating brush spots212Deleting spots213Red Eye removal214Adjustment Brush218Initial Adjustment Brush options219Adding a new brush effect220Resetting adjustments221Adjustment Brush duplication221Editing brush stroke areas223Auto masking225Range masking227	Post Crop Vignetta atula antiona	190
Adding Grain effects.196Dehaze slider196Localized Dehaze adjustments198Calibration panel200Camera profiles200Camera Raw legacy profiles200Custom camera profile calibrations201Embedding custom profiles201Camera Raw as a Photoshop filter202Spot Removal tool206Creating circle spots207Synchronized spotting with Camera Raw208Spot removal tool feathering208Fine-tuning the Spot removal tool209Visualize spots210Creating profiles211Deleting spots212Deleting spots213Red Eye removal216Red Eye: Pet Eye removal217Localized adjustments218Initial Adjustment Brush options219Brush settings219Adding a new brush effect220Resetting adjustments221Adjustment Brush duplication221Editing brush adjustments223Auto masking225Range masking225Range masking227		
Dehaze slider196Localized Dehaze adjustments198Calibration panel200Camera profiles200Camera Raw legacy profiles200Custom camera profile calibrations201Embedding custom profiles201Camera Raw as a Photoshop filter202Spot Removal tool206Creating circle spots207Synchronized spotting with Camera Raw208Spot removal tool feathering208Fine-tuning the Spot removal tool209Visualize spots212Deleting spots213Red Eye removal216Red Eye removal217Localized adjustments218Adjustment Brush218Adjustment Brush219Adding a new brush effect220Resetting adjustments221Adjustment Brush duplication221Editing brush adjustments223Areviewing the brush stroke areas223Auto masking225Range masking227	Adding Crain affects	194
Localized Dehaze adjustments198Calibration panel200Carnera profiles200Carnera Raw legacy profiles200Custom camera profile calibrations201Embedding custom profiles201Carnera Raw as a Photoshop filter202Spot Removal tool206Creating circle spots207Synchronized spotting with Carnera Raw208Spot removal tool feathering208Fine-tuning the Spot removal tool209Visualize spots210Creating brush spots212Deleting spots213Red Eye removal216Red Eye: Pet Eye removal217Localized adjustments218Adjustment Brush218Initial Adjustment Brush options219Brush settings219Adding a new brush effect220Resetting adjustments221Adjustment Brush duplication221Editing brush adjustments223Areviewing the brush stroke areas223Auto masking225Range masking227		
Calibration panel200Carnera profiles200Carnera Raw legacy profiles201Custom carnera profile calibrations201Embedding custom profiles201Carnera Raw as a Photoshop filter202Spot Removal tool206Creating circle spots207Synchronized spotting with Carnera Raw208Spot removal tool feathering208Fine-tuning the Spot removal tool209Visualize spots210Creating brush spots212Deleting spots213Red Eye removal216Red Eye: Pet Eye removal217Localized adjustments218Initial Adjustment Brush options219Adding a new brush effect220Resetting adjustments221Adjustment Brush duplication221Editing brush adjustments223Previewing the brush stroke areas223Auto masking225Range masking227		
Camera profiles200Camera Raw legacy profiles201Embedding custom profile calibrations.201Embedding custom profiles201Camera Raw as a Photoshop filter.202Spot Removal tool.206Creating circle spots207Synchronized spotting with Camera Raw208Spot removal tool feathering208Fine-tuning the Spot removal tool.209Visualize spots210Creating brush spots212Deleting spots213Red Eye removal216Red Eye: Pet Eye removal217Localized adjustments218Initial Adjustment Brush options219Adjustment Brush effect220Resetting a new brush effect220Resting adjustments221Adjustment Brush options221Adjustment Brush options223Previewing the brush stroke areas223Auto masking225Range masking225Range masking227		
Camera Raw legacy profiles200Custom camera profile calibrations.201Embedding custom profiles201Camera Raw as a Photoshop filter.202Spot Removal tool206Creating circle spots207Synchronized spotting with Camera Raw208Spot removal tool feathering208Fine-tuning the Spot removal tool.209Visualize spots210Creating brush spots212Deleting spots213Red Eye removal.216Red Eye: Pet Eye removal217Localized adjustments218Adjustment Brush219Brush settings219Adding a new brush effect.220Resetting adjustments221Adjustment Brush duplication221Editing brush adjustments223Previewing the brush stroke areas223Auto masking225Range masking.227		
Custom camera profile calibrations.201Embedding custom profiles201Camera Raw as a Photoshop filter.202Spot Removal tool206Creating circle spots207Synchronized spotting with Camera Raw208Spot removal tool feathering208Fine-tuning the Spot removal tool209Visualize spots210Creating brush spots212Deleting spots213Red Eye removal216Red Eye: Pet Eye removal217Localized adjustments218Adjustment Brush219Brush settings219Adding a new brush effect220Resetting adjustments221Adjustment Brush duplication221Editing brush adjustments223Previewing the brush stroke areas223Auto masking225Range masking227		
Embedding custom profiles201Camera Raw as a Photoshop filter.202Spot Removal tool206Creating circle spots207Synchronized spotting with Camera Raw208Spot removal tool feathering208Fine-tuning the Spot removal tool209Visualize spots210Creating brush spots212Deleting spots213Red Eye removal216Red Eye: Pet Eye removal217Localized adjustments218Initial Adjustment Brush options219Brush settings219Adding a new brush effect220Resetting adjustments221Adjustment Brush duplication221Editing brush adjustments223Arriver Mathematics223Adjustment Brush duplication223Auto masking225Range masking227	Camera Raw legacy profiles	200
Camera Raw as a Photoshop filter.202Spot Removal tool206Creating circle spots207Synchronized spotting with Camera Raw208Spot removal tool feathering208Fine-tuning the Spot removal tool209Visualize spots210Creating brush spots212Deleting spots213Red Eye removal216Red Eye: Pet Eye removal217Localized adjustments218Initial Adjustment Brush options219Brush settings219Adding a new brush effect220Resetting adjustments221Adjustment Brush duplication221Editing brush adjustments223Arreviewing the brush stroke areas223Auto masking225Range masking227		
Spot Removal tool206Creating circle spots207Synchronized spotting with Camera Raw208Spot removal tool feathering208Fine-tuning the Spot removal tool209Visualize spots210Creating brush spots212Deleting spots213Red Eye removal216Red Eye: Pet Eye removal217Localized adjustments218Adjustment Brush218Initial Adjustment Brush options219Brush settings219Adding a new brush effect220Resetting adjustments221Adjustment Brush duplication221Editing brush adjustments223Previewing the brush stroke areas223Auto masking225Range masking227	Embedding custom profiles	201
Creating circle spots207Synchronized spotting with Camera Raw208Spot removal tool feathering208Fine-tuning the Spot removal tool209Visualize spots210Creating brush spots212Deleting spots213Red Eye removal216Red Eye: Pet Eye removal217Localized adjustments218Adjustment Brush218Initial Adjustment Brush options219Brush settings219Adding a new brush effect220Resetting adjustments221Adjustment Brush duplication221Editing brush adjustments223Previewing the brush stroke areas223Auto masking225Range masking227	Camera Raw as a Photoshop filter	202
Synchronized spotting with Camera Raw208Spot removal tool feathering208Fine-tuning the Spot removal tool209Visualize spots210Creating brush spots212Deleting spots213Red Eye removal216Red Eye: Pet Eye removal217Localized adjustments218Adjustment Brush219Brush settings219Adding a new brush effect220Resetting adjustments221Adjustment Brush duplication221Editing brush adjustments223Previewing the brush stroke areas223Auto masking225Range masking227		
Spot removal tool feathering208Fine-tuning the Spot removal tool209Visualize spots210Creating brush spots212Deleting spots213Red Eye removal216Red Eye: Pet Eye removal217Localized adjustments218Adjustment Brush218Initial Adjustment Brush options219Brush settings219Adding a new brush effect220Resetting adjustments221Adjustment Brush duplication221Editing brush adjustments223Previewing the brush stroke areas223Auto masking225Range masking227		
Fine-tuning the Spot removal tool209Visualize spots210Creating brush spots212Deleting spots213Red Eye removal216Red Eye: Pet Eye removal217Localized adjustments218Adjustment Brush218Initial Adjustment Brush options219Brush settings219Adding a new brush effect220Resetting adjustments221Adjustment Brush duplication221Editing brush adjustments223Previewing the brush stroke areas223Auto masking225Range masking227		
Visualize spots210Creating brush spots212Deleting spots213Red Eye removal216Red Eye: Pet Eye removal217Localized adjustments218Adjustment Brush218Initial Adjustment Brush options219Brush settings219Adding a new brush effect220Resetting adjustments221Adjustment Brush duplication221Editing brush adjustments223Previewing the brush stroke areas223Auto masking225Range masking227		
Creating brush spots.212Deleting spots.213Red Eye removal.216Red Eye: Pet Eye removal217Localized adjustments.218Adjustment Brush218Initial Adjustment Brush options.219Brush settings.219Adding a new brush effect.220Resetting adjustments.221Adjustment Brush duplication.221Editing brush adjustments223Previewing the brush stroke areas.223Auto masking.225Range masking.227		
Deleting spots213Red Eye removal216Red Eye: Pet Eye removal217Localized adjustments218Adjustment Brush218Initial Adjustment Brush options219Brush settings219Adding a new brush effect220Resetting adjustments221Adjustment Brush duplication221Editing brush adjustments223Previewing the brush stroke areas223Auto masking225Range masking227		
Red Eye removal216Red Eye: Pet Eye removal217Localized adjustments218Adjustment Brush218Initial Adjustment Brush options219Brush settings219Adding a new brush effect220Resetting adjustments221Adjustment Brush duplication221Editing brush adjustments223Previewing the brush stroke areas223Auto masking225Range masking227	Creating brush spots	212
Red Eye: Pet Eye removal217Localized adjustments218Adjustment Brush218Initial Adjustment Brush options219Brush settings219Adding a new brush effect220Resetting adjustments221Adjustment Brush duplication221Editing brush adjustments223Previewing the brush stroke areas223Auto masking225Range masking227		
Localized adjustments 218 Adjustment Brush 218 Initial Adjustment Brush options 219 Brush settings 219 Adding a new brush effect 220 Resetting adjustments 221 Adjustment Brush duplication 221 Editing brush adjustments 223 Previewing the brush stroke areas 223 Auto masking 225 Range masking 227	Red Eye removal	216
Adjustment Brush 218 Initial Adjustment Brush options 219 Brush settings 219 Adding a new brush effect 220 Resetting adjustments 221 Adjustment Brush duplication 221 Editing brush adjustments 223 Previewing the brush stroke areas 223 Auto masking 225 Range masking 227	Red Eye: Pet Eye removal	217
Initial Adjustment Brush options219Brush settings219Adding a new brush effect220Resetting adjustments221Adjustment Brush duplication221Editing brush adjustments223Previewing the brush stroke areas223Auto masking225Range masking227		
Brush settings219Adding a new brush effect.220Resetting adjustments221Adjustment Brush duplication221Editing brush adjustments223Previewing the brush stroke areas223Auto masking225Range masking227	Adjustment Brush	218
Adding a new brush effect. 220 Resetting adjustments 221 Adjustment Brush duplication 221 Editing brush adjustments 223 Previewing the brush stroke areas 223 Auto masking 225 Range masking 227	Initial Adjustment Brush options	219
Resetting adjustments 221 Adjustment Brush duplication 221 Editing brush adjustments 223 Previewing the brush stroke areas 223 Auto masking 225 Range masking 227	Brush settings	219
Adjustment Brush duplication 221 Editing brush adjustments 223 Previewing the brush stroke areas 223 Auto masking 225 Range masking 227	Adding a new brush effect	220
Adjustment Brush duplication 221 Editing brush adjustments 223 Previewing the brush stroke areas 223 Auto masking 225 Range masking 227	Resetting adjustments	221
Editing brush adjustments		
Previewing the brush stroke areas		
Auto masking	Previewing the brush stroke areas	223
Range masking 227		
5 5 5 C		
Color Range masking	Color Range masking	228
Luminance Range masking		

	Darkening the shadows	231
	Hand-coloring in Color mode	
	Graduated Filter tool	
	Graduated color temperature adjustment	
	Radial Filter adjustments	
	Fill to document bounds	
	Brush editing filter masks	
	Correcting edge sharpness with the Radial Filter	245
	Global sharpening only	246
	Global sharpening + radial filter adjustment	
	Camera Raw settings menu	
	Export settings to XMP	248
	Update DNG previews	248
	Load Settings Save Settings	248
	Camera Raw defaults	
	Saving and applying presets	249
	Copying and synchronizing settings	251
	Synchronizing different process versions	252
	Legacy presets	
	Synchronize Version 3 from a Version 4 master	
	Synchronize Version 4 from a Version 3 master	253
	Working with Snapshots	
DN(G file format	
	The DNG solution	256
	DNG compatibility	257
	Should you keep the original raws?	257
	Saving images as DNG	258
	Lossy DNG	
	DNG Converter	. 260
13	Sharpening and noise reduction	261
Wh	en to sharpen	. 262
	Why one-step sharpening is ineffective	
	Capture sharpening	. 262
	Capture sharpening for scanned images	. 263
	Process versions and Camera Raw sharpening	. 264
	Tailored sharpening	
	Sample sharpening image	. 265
	Detail panel	. 265
	Sharpening defaults	. 266
	The sharpening effect sliders	. 266
	Amount slider	. 267
	Radius slider	
	Detail slider	
	Interpreting the grayscale previews	
	Radius and Detail grayscale preview	
	Masking slider	
	Masking slider example	. 273
		. 210

Real world sharpening examples	4
Sharpening portrait images274	4
Sharpening landscape images	5
Sharpening a fine-detailed image 276	ô
How to save sharpening settings as presets	
Capture sharpening summary 278	8
Selective sharpening in Camera Raw	9
Negative sharpening 279	9
Extending the sharpening limits	9
Dual Smart Object sharpening layers	9
How to apply localized sharpening	C
Negative sharpening to blur an image	2
Noise removal in Camera Raw	4
Detail panel Noise Reduction sliders	ō
Color noise	ò
Removing random pixels	7
CMOS and CCD sensors	7
Noise Reduction adjustments	7
Color Smoothness slider 290	
Adding grain to improve appearance of sharpness	2
Localized noise reduction in Camera Raw	4
Localized moiré removal in Camera Raw 296	ò
No sharpening	3
Smart Sharpened	
Localized sharpening in Photoshop	3
Sharpen tool	3
Smart Sharpen filter 298	
Basic Smart Sharpen mode 298	3
Advanced Smart Sharpen mode 300	
Removing Motion Blur	
Shake Reduction filter	2
The Shake Reduction controls	3
Repeat filtering	
Smart object support 304	
Blur direction tool	
How to get the best results	
Creating a depth of field brush 308	3

4 mage enting essentials

Pixels versus vectors	
Photoshop as a vector program	
Image resolution terminology	
PPI: pixels per inch	
LPI: lines per inch	
DPI: dots per inch	
Desktop printer resolution	
Altering the image size	
Image interpolation	
Nearest Neighbor (hard edges)	

Bilinear	
Bicubic (smooth gradients)	
Bicubic Smoother (enlargement)	317
Bicubic Sharper (reduction)	317
Bicubic Automatic	317
Preserve Details (enlargement)	318
Photoshop image adjustments	320
The image histogram	. 320
The Histogram panel	. 322
Basic Levels editing and the histogram	. 323
Bit depth	. 324
8-bit versus 16-bit image editing	. 325
16-bit and color space selection	. 326
Comparing 8-bit with 16-bit editing	
The RGB edit space and color gamut	
Direct image adjustments	
Adjustment layers	
Adjustments panel controls	
Properties panel controls	. 332
Maintaining focus in the Properties panel	
Levels adjustments	
Analyzing the histogram	
Curves adjustment layers	
On-image Curves editing	
Removing curve points	
Using Curves in place of Levels	
Output levels adjustments	
Luminosity and Color blending modes	
Locking down portions of a curve	
Creating a dual contrast curve	
Shadows/Highlights	
Amount	
Tone	
Radius	
Color Correction	
Midtone Contrast	
Auto adjustments	
Match Color corrections	
Enhance Brightness and Contrast	352
Color corrections using Curves	
Hue/Saturation	
Vibrance	
Photo Filter	
Multiple adjustment layers	
Adjustment layer masks	
Properties panel mask controls	
Editing a mask using the masks controls	
Image Adjustments as Smart Filters	366

Cropping
Delete cropped pixels
Crop ratio modes
Crop measurement units
Crop tool presets
Crop overlay display
Crop tool options
Front Image cropping
Disable edge snapping
Selection-based cropping
Canvas size
Corner tracking
Content-Aware Cropping 377
Big data
Perspective crop tool
Content-Aware scaling
Protect facial features
How to remove objects from a scene
Rotating images

a) a su series consistence de la construction de la construction de la constructione de la construction de la constru de la construction de la	
Converting color to black and white	
Dumb black and white conversions	
Smarter black and white conversions	388
Black & White adjustment presets	
Split color toning using Color Balance	
Split color toning using Curves adjustments	
Split color toning using a Gradient Map	
Camera Raw black and white conversions	398
Pros and cons of the Camera Raw approach	398
Camera Calibration panel tweaks	400
HSL grayscale conversions	402
Camera Raw Split Toning panel	405
Saturation shortcut	405
Camera Raw color image split toning	406

High dynamic range imaging	
HDR essentials	
Alternative approaches	
Bracketed exposures	
Photomatix Pro	413
Capturing a complete scenic tonal range	413
HDR shooting tips	
HDR File formats	
How to fool Merge to HDR	
Basic tonal compression techniques	
Camera Raw adjustments	
Processing HDR files in Camera Raw	

The Camera Raw HDR TIFF processing	424
Creating HDR photos using Photo Merge	
Auto Tone setting	427
Steps to produce a Photo Merge DNG	427
Merge to HDR Pro	430
Response curve	430
Tone mapping HDR images	
Local Adaptation	
Removing ghosts	
How to avoid the 'HDR look'	
Disable image sharpening	435
Smooth Edges option	
HDR toning example	
How to smooth HDR toned images	

7 image retouching

43

Basic cloning methods	444
Clone Stamp tool	444
Clone Stamp brush settings	444
Healing Brush	446
Clone Source panel and clone overlays	448
Choosing an appropriate alignment mode	448
Clone and healing sample options	450
Better healing edges	451
Spot Healing Brush	
Healing blend modes	453
Spot healing in Content-Aware mode	453
Stroking a path	
Diffusion slider for the Healing tools	456
Patch tool	
The Patch tool in Content-Aware fill mode	460
Structure control	462
Content-Aware move tool	463
Content-Aware move tool in Extend mode	465
Enhanced content-aware color adaptation	468
Content-Aware move with transformations	470
Working with the Clone Source panel	472
Perspective retouching	474
Ethics of retouching in Photoshop	476
Portrait retouching	476
Beauty retouching	478
Liquify	480
Liquify filter controls	480
On-screen cursor adjustments	482
Pin edges	482
Saving and loading the mesh	483
Mask options	483
View options	484
Reconstructions	484

Face-Aware Liquify adjustments Liquify performance	
Smart Object support for Liquify	400
Targeted distortions using Liquify	
	489
Selections and channels	492
Selections	492
Recalling the last used selection	494
Quick Mask mode	494
Creating an image selection	495
Modifying selections	496
Alpha channels	496
Modifying an image selection	
Selections, alpha channels, and masks	499
Anti-aliasing	500
Feathering	500
Layers	501
Layer basics	501
Image layers	501
Vector layers	502
Text layers	502
Adjustment layers	502
Layers panel controls	503
Layer styles	
Adding layer masks	
Viewing in Mask or Rubylith mode	
Copying or removing a layer mask	
Adding an empty layer mask	
Thumbnail preview clipping	
Properties Panel in Masks mode	
Working with the Quick selection tool	
Select and Mask	
View modes	
Mask creation	
Edge detection	
Global Refinements	
Output Settings	
Select and Mask performance	
Ragged borders using Select and Mask	
Focus Area	
Color Range masking	
Layer blending modes	
Creating panoramas with Photomerge	
Blending options	537
Panorama Photo Merges in Camera Raw	
Creating Photo Merge panoramas	
The panorama projection options	
Photo Merge Boundary Warp	542

	Panorama Photo Merges and the Adaptive Wide Angle filter	542
	Editing spherical panoramas in Photoshop	544
	Depth of field blending	546
Wor	king with multiple layers	548
	Color coding layers	548
	Layer group management	
	Collapse all layers	
	Managing layers in a group	
	Clipping masks	
	How to create a clipping mask	
	Adding an adjustment layer as a clipping mask	
	Masking layers within a group	553
	Layer Comps panel	
	Layer linking	
	Multiple layer opacity adjustments	
	Selecting layers	
	Layer selection using the Move tool	
	Auto-Select shortcut	
	Layer selection using the Path selection tools	
	Layer mask linking	
	Layer locking	
	Lock Transparent Pixels	
	Lock Image Pixels	
	Lock Layer Position	
	Lock All	
	Export options	
	Metadata and Color Space sections	
	Exporting layers	
	Creative Cloud Libraries	
	Adding and linking assets	
	Sharing libraries with other users	
	Create library assets from documents	
	Smarter naming when merging layers	
	Layer filtering	
	Isolation mode layer filtering	
Tra	nsform commands	
	Repeat Transforms	
	Interpolation options	
	Numeric Transforms	
	Transforming paths and selections	
	Transforms and alignment	
	Warp transforms	
	Perspective Warp	
	Puppet Warp	
	Pin rotation	
	Pin depth	
	Multiple pin selection	
	Smart Objects	

Smart Objects	36
Smart Object workflow	
Linked Smart Objects	39
Creating linked Smart Objects58	39
Resolving bad links 59)1
Packaging linked embedded assets	
Layers panel Smart Object searches 59	12
Photoshop paths	3
Pen tool modes	4
Drawing paths with the Pen tool	
Pen path drawing example	4
Pen tool shortcuts summary	6
Pen tool options	
Path display options	
Curvature Pen tool	7
Path selection tools	
Paths panel selections	
Vector masks	
Isolating an object from the background60	1

9 Blur, optical, and rendering filters

•

Filte	er essentials	604
	Blur filters	604
	Gaussian Blur	604
	Average Blur	604
	Adding a Radial Blur to a photo	
	Surface Blur	
	Box Blur	
	Shape Blur	607
	Fade command	
	Lens Blur	
	Depth of field effects	
	Blur Gallery filters	
	Iris Blur	
	Ellipse field controls	
	Blur Tools options	
	Noise panel	
	Tilt-Shift blur	616
	Blur ring adjustments	
	Field Blur	
	Spin blur	
	Path blur	623
	Motion Blur Effects panel	
	Smart Object support	
	Blur Gallery filters on video layers	
	Smart objects and selections	
	Applying a Blur Gallery filter to a video clip	
	Blur Gallery filter with a smart object plus mask	

Smart Filters/Smart Objects	. 632
Applying a Smart Filter to an image	. 633
Lens Corrections	
Video file Lens Corrections	. 639
Custom lens corrections	. 639
Selecting the most appropriate profiles	. 642
Adobe Lens Profile Creator	. 642
Interpolating between lens profiles	643
Lens Correction profiles and Auto-Align	643
Batch lens correction processing	643
Adaptive Wide Angle filter	644
How the Adaptive Wide Angle filter works	646
Applying constraints	647
Rotating a constraint	
Saving constraints	649
Constraint line colors	649
Polygon constraints	649
Calibrating with the Adaptive Wide Angle filter	652
Editing panorama images	653
Flame filter	
Flame filter controls	658
Tree filter	659
Tree filter panel options	661
The Oil Paint filter	662
Graphics card requirements	662
Filter Gallery	664
	CC
10 Color Management	66

	000
The need for color management	
Color management objectives	667
The versatility of RGB	
Output-centric color management	668
Profiled color management	669
Color Management Modules	670
The Profile Connection Space	670
Profiling the display	672
Profiling the input	
Profiling the output	673
Color management in action	
The Color Settings	
Color management policies	
Preserve embedded profiles	676
Profile mismatches and missing profiles	676
Convert to Working space	
Color Management Off	
Profile conversions	680
Convert to Profile	
Assign Profile	682
Profile mismatches when pasting	

Saving a Color Setting
Reducing the opportunities for error
Playing detective
Conversion options
Rendering intent
Perceptual
Saturation
Relative Colorimetric
Absolute Colorimetric
Black Point Compensation
Use Dither (8-bit per channel images)
Scene-referred profiles
Advanced controls
Desaturate Monitor Colors
Blend RGB Colors using Gamma
Custom RGB and work space gamma
CMYK conversions
CMYK setup
Creating a custom CMYK setting
Ink Colors
Dot gain
Gray Component Replacement (GCR) 696
Black Generation
Undercolor Addition (UCA) 697
Undercolor Removal (UCR) 697
Choosing a suitable RGB workspace
Apple RGB 698
sRGB IEC-61966-2.1
ColorMatch RGB 699
Adobe RGB (1998)
ProPhoto RGB 699
Lab color
Measuring by the numbers700
Color management references
Keeping it simple
11 Print output 703

11 Print output	703
Desktop printing	
Print sharpening	
Judge the print, not the display	
High Pass filter edge sharpening technique	
Soft proof before printing	
Managing print expectations	710
Making a print	
Photoshop Print dialog	711
Printer selection	711
Color Management	714
Adobe Color Printer Utility	715
Rendering intent selection	716

٠

Hard Proofing	716
Proof print or aim print?	
Position and Size	
Print selected area	719
Ensuring your prints are centered (Mac)	
Printing Marks	
Functions	
Saving operating system print presets	
Print output scripting	
Configuring the Print Settings (Mac and PC)	
Creating custom print profiles	
Creating contact sheets via Bridge CC	
Printing tips	727
Colourmanagement.net	
Rod Wynne-Powell	

Please read first

The introduction of the Adobe Creative Cloud brought with it a number of changes to the way Photoshop and other programs within the Creative Cloud are delivered to Adobe customers. You can choose to subscribe to the Cloud either with a full Cloud subscription, which gives you access to all the programs in the Creative Suite, as a singleproduct subscriber, or by subscribing to the Photography Plan that includes Lightroom.

The main advantage for Cloud subscribers is the ability to access new features as program updates are released. The downside is that some of the content in this book will become out-of-date as new features are added or updated. My response has been to provide bulletin updates of all the latest changes in Photoshop that are relevant to photographers and post these to the book website: photoshopforphotographers.com. This particular book is an updated edition of the original *Adobe Photoshop CC for Photographers*, which was first published in 2013.

In revising this book I have had to cut some of the content that was in previous editions. The Configuring Photoshop, Image Management and Automate chapters have been removed and are now provided as PDF chapters on the photoshopforphotographers.com website. The main reason for this was to make way for new content, especially as the content in these chapters has mostly remained unchanged in the last few versions of the program. You will also find lots of other content available from the book website, and you can also be kept fully updated via my Facebook page: facebook.com/ MartinEveningPhotoshopAndPhotography.

Introduction

When I first started using Photoshop, it was a much simpler program to get to grips with compared with what we see today. Since then Adobe Photoshop CC has evolved to give photographers all the tools they need. My aim is to provide you with a photographer's perspective of what Photoshop CC can do and how to make the most effective use of the program.

One of the biggest problems writing a book about Photoshop is that while new features are always being added Adobe rarely removes anything from the program. Hence, Photoshop has got bigger and more complex over the 20 years I have been writing this series of books. In response to this I have concentrated mainly on the photography– related features. This edition contains all the essential information you need to know when working with Photoshop and Camera Raw.

One of the reasons why this series of Photoshop books has become so successful is because I have come from a professional photography background. Although I have had the benefit of a close involvement with the people who make the Adobe Photoshop program, I make no grandiose claims to have written the best book ever on the subject. Like you, I too have had to learn all this stuff from scratch. I write from personal experience and aim to offer a detailed book on the subject of digital photography and Photoshop. Consequently, it is one of the most thorough and established books out there; one that's especially designed for photographers.

This title was initially aimed at intermediate to advanced users, but it soon became apparent that all sorts of people were enjoying the book. Over the years I have adapted the content to satisfy the requirements of a broad readership and don't assume too much prior knowledge. I like to make sure everything is explained as clearly and simply as possible. The techniques shown here are based on the experience I have gained working alongside the Photoshop engineering team at various stages of the program's development as well as some of the greatest Photoshop experts in the industry-people such as Katrin Eismann, the late Bruce Fraser, Mac Holbert, Ian Lyons, Andrew Rodney, Seth Resnick, Jeff Schewe, and Rod Wynne-Powell, who I regard as true Photoshop masters. I have drawn on this information to provide you with the latest thinking on how to use Photoshop to its full advantage. So rather than me just tell you "this is what you should do, because that's the way I do it," you will find frequent references to how the program works and reasons why certain approaches or methods are better than others. These discussions are accompanied by diagrams and step-by-step tutorials that will help improve your understanding

Macintosh and PC keys

Throughout this book I refer to the keyboard modifier keys used on the Macintosh and PC computers. Some keys are the same on both platforms, such as the *Shift* key. And also the *all* key (although Macintosh users may still refer to it as the 'Option key' [[]]). Where the keys used are different on each system, I show the Macintosh keys first and the PC equivalents after. For example the Photoshop shortcut for opening the Levels dialog is Command + L on the Mac and Control + L on the PC. I will write this in the book as: **H**[L (Mac), *ctrl*[L (PC). of the Photoshop CC program. The techniques I describe here have evolved over a long period of time and the methods taught in this book therefore reflect the most current expert thinking about Photoshop.

This is in many ways a personal guide and one that highlights the areas of Photoshop that I find most interesting, or at least those that I feel should be of most interest. My personal approach is to find out which tools in Photoshop allow you to work as efficiently and as nondestructively as possible and preserve all of the information that was captured in the original, plus take into account recent changes that require you to use Photoshop differently. Although there are lots of ways to approach using Photoshop, you'll generally find with Photoshop that the best tools for the job are often the simplest. I have therefore structured the chapters in the book so that they follow a typical Photoshop workflow. Hopefully, the key points you will learn from this book are that Camera Raw is the ideal, initial editing environment for all raw images (and sometimes non-raw images too). Then, once an image has been optimized in Camera Raw, you can use Photoshop to carry out the fine-tuned corrections, or more complex retouching.

Figure 1.1 To access the online content, go to photoshopforphotographers.com and click on the 'Access online content' button, which will take you to the *Adobe Photoshop for Photographers Help Guide* page shown in Figure I.2.

This version has been re-edited to put most of its emphasis on the Photoshop tools that are most essential to photographers as well as all that's new in Photoshop CC. Additional content is available online via the photoshopforphotographers.com website. Go to the main page shown in Figure I.1 and click on the 'Access online content' button. Here, you will be able to access movie tutorials to accompany some of the techniques shown in the book and download many of the images to try out on your own. There is also a Tools & Panels section in the Help Guide (Figure I.2) with illustrated descriptions of all the tools and panels found in Photoshop.

Velcome Tools & Panel	is Layer Styles	Images I	Movies	PDFs
Tools and Panels				
+. □ □. ○ ··· I ○. ··· J ○. ··· ·· ··· ·· ○. ··· ··· ··· ·· ○. ··· ··· ··· ··· ○. ··· ··· ··· ··· ○. ··· ··· ··· ···· ○. ··· ··· ··· ···· ·	A Art history brush Artboard tool B Background enser Bluctool Brunt tool Burn tool Constance and tool Color states and tool Color states more tool Color states more tool Color states more tool Color tool Constance and tool Dodge tool E Fraser tool E Fraser tool F Foreground/Background colors G	R Red sive tool Rotate view tool Rotate view tool Rotate tool Screen display Selection mode/ Quick Mask mode button Sharpen tool Sharpen tool Sharpen tool Sharpen tool Scarge tool Sponge tool		Actions panel Adjuatments panel B Brush Presets panel C Character panel Character anel Character Styles panel Color panel Color panel G Glyphs panel H Histogram panel Histogramel Lucarel Laver Comps panel Laver Comps panel Laver Comps panel
0.00/2 0.8 0. 0. 0. 0. 0.	Gradient lool H Hand Iool Healing brush History brush Lasso tools M Magic eraser Magic wand Iool Marouse Jools Micro Lools Micro Lools	Soot healing brush T Typa tools Z Zoom tool * Note, the 3D, Timeline, Measurement tools and panels are not	₽5 ¥ ©	N Navigator panel Notes panel P Paragraph panel Paragraph Sivies panel Properies panel Sivies panel Sivies panel Sivies panel

Figure 1.2 The Tools and Panels section of the *Adobe Photoshop for Photographers Help Guide*, where you can access extra content such as movie tutorials and PDF documents, and download some of the images used in this book.

Contacting the publisher/author

For problems to do with the book or to contact the publisher, please email: focalpressmarketing@taylorandfrancis. com. If you would like to contact the author, please email: martin@martinevening.com. To keep updated via Facebook, go to: facebook.com/MartinEvening Photoshopandphotography.

Acknowledgements

I must first thank Andrea Bruno of Adobe Europe for initially suggesting to me that I write a book about Photoshop aimed at photographers. Also, none of this would have got started without the founding work of Adam Woolfitt and Mike Laye, who helped establish the Digital Imaging Group (DIG) forum for UK digital photographers. Thank you to everyone at Routledge: my editors, Judith Newlin and William Burch, production editorial manager, Mhairi Bennett, deputy production editorial manager, Peter Lloyd, and editorial assistant, William Burch. The production of this book was done with the help of Rod Wynne-Powell, who tech edited the final manuscript and provided me with technical advice, and Neil Dowden, who did the proofreading. I must give a special mention to fellow Photoshop expert Jeff Schewe for all his guidance and help over the years (and wife Becky), not to mention the other members of the 'pixel mafia': Katrin Eismann, Seth Resnick, Andrew Rodney and Bruce Fraser, who sadly passed away in December 2006.

Thank you also to the following clients, companies and individuals: Adobe Systems Inc., Peter Andreas, Amateur Photographer, Neil Barstow, Russell Brown, Steve Caplin, Jeff Chien, Kevin Connor, Harriet Cotterill, Eric Chan, Chris Cox, Eylure, Claire Garner, Greg Gorman, Mark Hamburg, Peter Hince, Thomas Holm, Ed Horwich, David Howe, Bryan O'Neil Hughes, Carol Johnson, Julieanne Kost, Peter Krogh, Tai Luxon, Ian Lyons, Sharad Mangalick, Bob Marchant, John Nack, Thomas Knoll, Marc Pawliger, Pixl, Herb Paynter, Eric Richmond, Russell Williams, Amateur Photographer, and X-Rite. Thank you to the models, Jasmin, Kat, Kelly, Kate, Lidia and Sundal, who featured in this book, plus my assistants Harry Dutton and Rob Cadman. And thank you too to everyone who has bought my book. I am always happy to respond to readers' emails and hear comments good or bad (see sidebar).

Lastly, thanks to all my friends and family, my wife, Camilla, who has been so supportive over the last year, and especially my late mother for all her love and encouragement.

Martin Evening, October 2017

Chapter 1

Photoshop fundamentals

Let's begin by looking at some of the essentials of working with Photoshop, such as how to install the program, the Photoshop interface, what all the different tools and panels do, as well as introducing the Camera Raw and Bridge programs. You can use this chapter as a reference, as you work through the remainder of the book.

This latest version of Photoshop is formally known as 'Photoshop CC'. Unlike Photoshop CS6 and earlier programs, this version is only available if you take out a subscription to the Creative Cloud using one of the available subscription plans. Since the first release of Photoshop CC, several updates have been released for Photoshop CC and Camera Raw. This edition of the book incorporates all the latest updates up until the 2018 release of Photoshop CC.

1

Adobe Photoshop activation limits

You can install Photoshop on any number of computers, but only a maximum of two installations can be active at any one time. To run Photoshop on more computers than this, you only need to sign out from your Creative Cloud account, rather than do a complete uninstall and reinstall.

Would you like to migrate presets from the following versions? Adobe Photoshop CSB No Yes

Figure 1.1 This shows the Migrate Settings dialog that allows you to import custom preset settings created in older versions of Photoshop. See the 'Configuring Photoshop' PDF on the book website.

Photoshop installation

Installing Photoshop (Figure 1.2) is as easy as installing any other application on your computer and more or less identical on both Mac and PC systems. Do make sure any other Adobe programs or web browsers are closed prior to running the installation setup. If you are new to using Adobe products you will be asked to register the program by entering your Adobe ID or create a new Adobe ID account. This is something that has to be done in order to activate your cloud membership and is done to limit unauthorized distribution of the program. The standard license entitles you to run your cloud subscription on up to two computers, such as a desktop plus a laptop. If installing on a machine running an older version of Photoshop, you will also be asked if you wish to migrate saved user preset settings from the older program (see Figure 1.1).

Figure 1.2 The Photoshop install dialog.

The Photoshop interface

The Photoshop CC interface shares the same design features as all the other CC creative suite programs, which makes it easier to switch from working in one CC program to another. You can work with the Photoshop program as a single application window on both the Mac (Figure 1.3) and PC platforms (Figure 1.4). You also have the ability to open and work with Photoshop image documents as tabbed windows. On first launch the 'Start' workspace is used where all Photoshop panels are hidden. If you go to the Window \Rightarrow Workspace menu (circled in red), you can select an alternative workspace such as the Photography space shown below. To switch between the classic mode and the Application Frame workspace, go to the Window menu and select or deselect the Application Frame menu item (circled in blue).

Interface scaling

Photoshop and Bridge have HighDPI/Retina support. This now includes proper Windows support for 4k and 8K displays, etc.

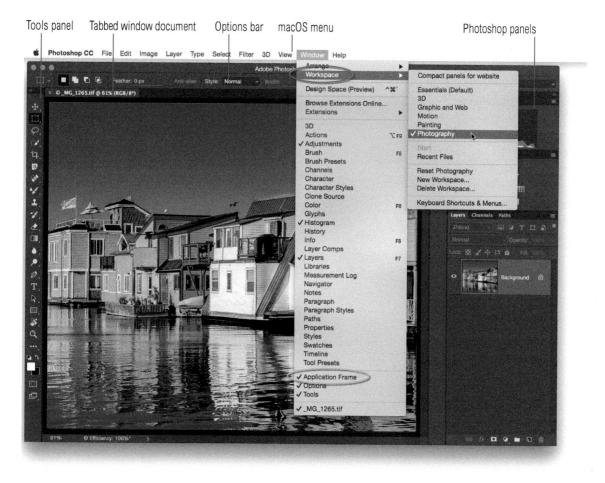

Figure 1.3 This shows the Photoshop CC Application Frame view for macOS, using the default, dark UI setting.

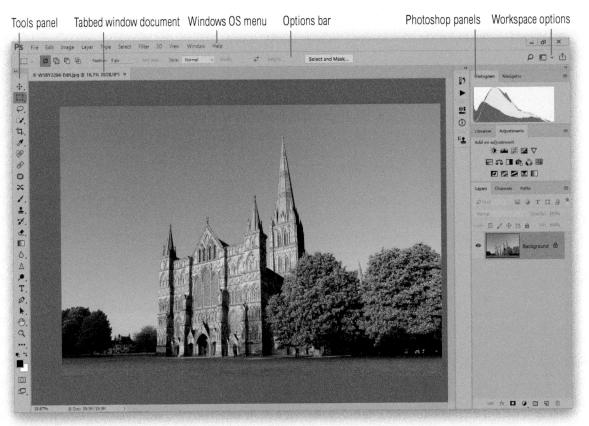

Figure 1.4 The Photoshop CC interface for the Windows OS. This has been captured using the middle light gray theme and the Photography workspace setting.

The Photoshop panels are held in placement zones with the Tools panel normally located on the left, the Options bar running across the top, and the other panels arranged on the right, where they can be docked in various ways to economize on the amount of screen space that's used yet still remain easily accessible. This default arrangement presents the panels in a docked mode, but over the following few pages we shall look at ways you can customize the Photoshop interface layout. For example, you can reduce the amount of space that's taken up by the panels by converting them to compact panel icons (see Figure 1.30).

There is application support for the Touch Bar screen in the latest MacBook Pro computers (Figure 1.5). Here you will find controls for the layer properties, brushes, and a favorites section.

esc 🖌) 🌒 🜖 Size 🕕 Hardness 🌓 Opacity () Flow 🚥 ⊃ (🔅 🗣 👯 🍚

Figure 1.5 The macOS Touch Bar showing Photoshop application brush controls.

Touch Bar settings

To manage the Touch Bar settings, open the Mac System Preferences and go to the Keyboard section. There are currently also Touch Bar options in the Enhanced Controls Preferences panel.

Photoshop Welcome experience

The first time you launch Photoshop you will see the Start workspace screen shown in Figure 1.6, but this will only appear if the Photoshop program is in Application Frame mode (which it will be by default). Here, you can view a list of documents you have opened most recently in Photoshop. These can be made to appear as thumbnails, or as a list view. The list view is best for professional photographers who need to respect client confidentiality agreements.

As soon as you open an image via the Start screen or via Bridge, the interface switches to the regular workspace configuration and the Start screen disappears. At this point I suggest you may want to switch out of the default 'Start' Workspace and select one that might be more appropriate, such as the Photography workspace shown in Figure 1.3. When you close all open files the Start screen reappears again. To prevent the Start screen from appearing, there is a 'Show "Start" Workspace when no documents are open' option in the Photoshop General Preferences you can disable.

Figure 1.6 The Start screen showing the Recent Files options.

Lightroom Classic CC

The Lightroom CC desktop program is now known as Lightroom Classic CC and all elements of Lightroom mobile, including the new computer app, are now all known as Lightroom CC. To help make this transition clearer, I sometimes refer to Lightroom CC as Lightroom CC/mobile. Just to add to the confusion, where Photoshop references LR Photos, this really means Lightroom CC.

The CC Files section in the Photoshop Start screen (Figure 1.7) lets you access files that have been uploaded to the Assets section of your Creative Cloud account to be shared with other Photoshop CC users with permitted access. The Lr Photos section (Figure 1.8) lets you access photos imported or synced to Lightroom CC/mobile. This is dependent on you also being subscribed to Lightroom CC of course. If need be, click on the Refresh button to update the LR Photos view.

To open, either double-click on a file or single-click on the photos you wish to download and click Import Selected. If opening a raw image via Camera Raw, you'll need to click Open Image to open in Photoshop. This is all dependent on full resolution data being available. Where only Smart Previews have been uploaded so far to the cloud this opens a lower resolution version instead. After editing an image you can use the Share feature (see page 8) to add the edited version to Lightroom CC/mobile.

Figure 1.7 The CC files section of the Start screen.

Figure 1.8 The LR Photos option in the Start screen.

In-app searches

To carry out a Photoshop search, choose Edit \Rightarrow Search (**HE** [Mac], **CIT** [PC]). This keyboard shortcut replaces applying the last used filter. If you wish to restore this shortcut you can do so via the Edit \Rightarrow Keyboard Shortcuts menu. Choosing Edit \Rightarrow Search opens the dialogs shown in Figure 1.9, where you can type to selectively search Photoshop, the Learning center, Adobe Stock, or all three.

In Figure 1.9 I clicked in the Search field and typed "brush tool". This revealed a number of suggestions for tools inside Photoshop, along with associated keyboard shortcuts. Clicking on a listed tool also selects that tool and dismisses the Search dialog. Figure 1.10 shows a search for "people" using an Lr Photos search.

Lightroom Photos searches

If you are subscribed to Lightroom CC you can carry out Lightroom file searches which leverage Lightroom's auto-tagging feature that is applied to your photos when you upload them via Lightroom CC, i.e any of the Lightroom CC/mobile components, or if you used Photoshop's Quick Share to add to Lightroom Photos. This allows you to search via keywords based on subject matter in your photos that you haven't tagged manually.

Figure 1.9 The Photoshop Search dialog showing search results for All (left) and Learn (Right).

Figure 1.10 The Photoshop Search dialog using Lr Photos.

Windows sharing

The ability to share to standard OS share destinations requires Windows 10 anniversary edition. And the ability to share to Lightroom CC requires Windows 10, Spring Creators release.

Sharing images

If you go to the File menu and choose Share, or click on the Share button in the Options bar (circled in Figure 1.1) this opens the Share dialog shown below. This lets you easily share content you are currently working on. For example, you can select Original size or Small (up to 1200 x 800 pixels) from the Share dialog menu and then click on one of the services listed below to share what you are currently working on with others.

The Share menu lists native sharing systems, including already authenticated services such as Facebook and Twitter. You can also add photos to Lightroom CC (assuming you have a Lightroom CC subscription). The example below shows how you can select the Mail option to email a photo from Photoshop as you work on an image. In this instance the shared photo was saved as a Generic RGB profile image.

Figure 1.11 An example of how the Share feature can be used to quickly share what you are working on in Photoshop with others.

Creating a new document

To create a new document in Photoshop with a blank canvas, go to the File menu and choose New... This opens the dialog shown in Figure 1.12 below. The New Document dialog provides extended options that include templates for different types of Photoshop work. Shown here are the Photo preset options.

In the Preset Details section you can override the preset settings by selecting the desired measurement units and then adjusting the width and height settings. You can also set the orientation to portrait or landscape. Use the Resolution section to choose between pixels per centimeter or pixels per inch. In the Color Mode section, choose between RGB, CMYK, Grayscale, etc. Next to this you can select the bit depth: 8-bit, 16-bit, or 32-bit. The Background color can be set to White, Black, or custom, clicking on the swatch next to this menu to select a color. If you expand the Advanced options you can select a color profile and pixel aspect ratio (see sidebar). Having adjusted the new document settings you can save these by clicking on the Save Preset button (circled in red) to save as a new custom preset.

Pixel Aspect Ratio

The Pixel Aspect Ratio option (available in the Advanced options) is to aid multimedia designers who work with stretched screen video formats. If a 'non-square' pixel setting is selected, Photoshop creates a scaled document which previews how a normal 'square' pixel Photoshop document will display on a stretched wide screen. The title bar adds [scaled] to the end of the file name to remind you are working in this special preview mode. The scaled preview can be switched on or off by selecting the Pixel Aspect Correction item from the View menu.

Figure 1.12 The default New Document dialog.

The new design New Document dialog used to have the disadvantage of being slow to load. It is faster now, but most photographers are mainly interested in opening existing image documents and rarely need to start with an empty new document. If you prefer you can revert to the legacy interface. To do this, go to the Photoshop General preferences and select Use Legacy 'New Document' Interface.

Concerning of the state of the	Default Photoshop Size	and the second second second second	Nicore	Anne and a state of the state o
Name: U	U.S. Paper International Paper	ОК	Name: U Default Photoshop Size	ОК
Document Type	Photo	Cancel	Document Type ✓ 16 cm X 9 cm	
and second	Web		U.S. Paper	Cancel
	Mobile App Design Film & Video	Save Preset	International Paper Photo	+ Save Prese
	Iconography	Delete Preset.	Web	Delete Presi
	Artboard		Mobile App Design Resi Film & Video	
Res	Custom		Iconography	
Color	Mode: RGB Color Y 8 bit Y		Color Artboard	· ·
Background Con	itents: White		Background Co Custom	
backyrounu con		No. 10	Advanced	Image Siz
Advanced		Image Size:	Color Profile: sRGB IEC61955-2.1	⇒ 37.1M
Color F	Profile: Working RGB: sRGB IEC61966-2.1 ×	1.54M	Pixel Aspect Ratio: Square Pixels	-
Direct Assessed	Ratio: Square Pixels			

Now, when you choose File \Rightarrow New, this opens the New document dialog shown in Figure 1.13. Here, you can start by going to the Preset menu and choose a preset setting such as: Photo, Web, or Film & Video. Depending on the choice you make here, this affects the size options available in the Size menu. When you choose a preset setting, the resolution adjusts automatically depending on whether it is a preset intended for print or one intended for computer screen type work (you can change the default resolution settings for print and screen in the Units & Rulers Photoshop preferences).

To save custom settings as a preset, click on the Save Preset... button to open the New Document preset dialog (Figure 1.14). Here you will notice there are options that allow you to select which attributes to include in a saved preset. Once you have done this the new document preset will appear listed in the main preset menu (see Figure 1.13).

Lastly, if you make a selection, such as Select All and follow this with Edit Copy, when you choose New Document it will open using the same pixel dimensions as the selection and with the same color space as the clipboard selection.

Figure 1.14 The New Document Preset dialog.

Tabbed document windows

Let's now look at the way document windows can be managed in Photoshop. The default preference setting forces all new documents to open as tabbed windows, where new image document windows appear nested in the tabbed document zone, just below the Options bar (see Figure 1.15). Here I had four image documents open. The default Photoshop behavior is for image documents to open as tabbed windows (highlighted here in yellow), docked to the area just below the Options bar. This approach to managing image documents can make it easier to locate a specific image when you have several image documents open at once. To select an open image, you simply click on the relevant tab to make it come to the front (click on the 'X' to close a document window).

If documents aren't tabbed in this way, you'll often have to click and drag on the document title bars to move the various image windows out of the way until you have located the image document you were after. On the other hand, not everyone likes the idea of tabbed document opening and if you find this annoying you can always deselect the 'Open Documents as Tabs' option in the Workspace preferences (circled in Figure 1.16). This lets you revert to the old behavior where new documents are opened as floating windows. Or, you easily convert a tabbed document to a floating window by dragging it out from the tabbed dock area (as shown in Figure 1.17). Alternatively, you can right mouse-click on a tab to access the contextual menu from where you can choose from various window command options such as 'Move to a New Window' or 'Consolidate All to Here'. The latter gathers all floating windows and converts them into tabbed documents. You can also use the N-up display options (see Figure 1.19) to manage the document windows.

Mac OS X users can mix having tabbed document windows with a classic panel layout where the Application Frame mode is disabled. You can then select 'Open Documents as Tabs' option in the Workspace preferences. Or, you can right click on a tab to open the contextual menu and select 'Consolidate All to Here' command to gather all open document windows arranged as tabbed documents. You can also select the Reveal in Finder menu item to locate saved images via the Finder.

Graphics display performance

If the video card in your computer has OpenGL and you have 'Use Graphics Processor' selected in the Photoshop Performance preferences, and in the Advanced Settings you have 'Use OpenCL' checked, you can take advantage of the OpenCL features that are supported in Photoshop. For example, when enabled you will see smoother-looking images at all zoom display levels, plus you can temporarily zoom back out to fit to screen using the Bird's Eye View (page 59), or use the Rotate view tool to rotate the on-screen image display (see page 61). 10-bit video is accessible for PC computers as well as Macintosh computers running macOS 10.11 (El Capitan) or later on the latest iMacs and Mac Pro computers.

Figure 1.15 Tabbed document windows highlighted here in yellow.

	Preferences	
General Interface Workspace Tools	Options Auto-Collapse Iconic Panels Auto-Show Hidden Panels	OK
History Log File Handling Export Performance Scratch Disks	Copen Documents as Tabs Enable Floating Document Window Docking Large Tabs	Next
Cursors Iransparency & Gamut Jnits & Rulers Guides, Grid & Slices	Condensed Enable Narrow Options Bar Changes will take effect the next time you start Photoshop.	
Plug-Ins fype 3D fechnology Previews	Restore Default Workspaces	

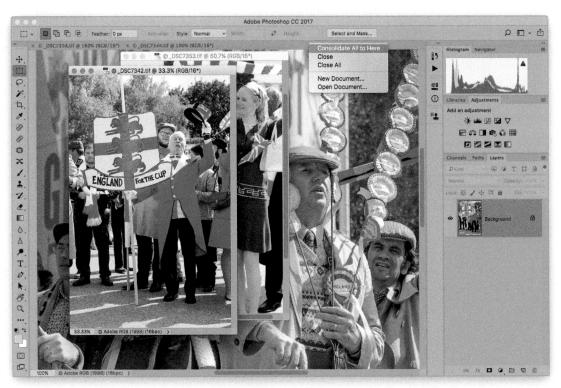

Figure 1.17 This screen shot shows the two ways you can convert a tabbed document to a floating window, either by dragging a tab out from the tabbed windows zone, or by using the contextual menu.

Managing document windows

As well as appearing in tabs upon opening, documents can also be tabbed into grouped document windows by dragging one window document across to another (see Figure 1.18). For example, Floating windows can be grouped as tabbed document windows by dragging the title bar of a document across to another until you see a blue border. You can also click on the title bar (circled in red) to drag a group of tabbed document windows to the tabbed windows zone. To drag layers between tabbed documents you need to select the Move tool and drag the image or layer (or layer from the Layers panel) from the selected document to the tab of the target document. Wait a few seconds and then (very importantly) drag down from the tab to the actual image area and release to complete the move.

You can also manage the way multiple document windows are displayed on the screen. For example, multiple window views are useful if you wish to compare different soft proof views before making a print. With floating windows you can choose Window \Rightarrow Arrange \Rightarrow Cascade to have all the document windows cascade down from the upper left corner of the screen, or choose Window \Rightarrow Arrange \Rightarrow Tile to have them appear tiled edge to edge. With document windows (tabbed or otherwise) you can use the Window \Rightarrow Arrange menu to choose any of

Figure 1.18 An example of floating windows being grouped as tabbed documents.

the 'N-up' options that are shown in Figure 1.19. This lets you choose from one of the many different document window layout options available from this menu. The **H** (Mac), *ctrl* (PC) shortcut can be used to cycle between open window documents. Use **H** *Shift* (Mac), *ctrl Shift* (PC) to cycle in reverse.

Figure 1.19 This shows the 'N-up' display options for tabbed document windows.

Synchronized scroll and zoom

In the Window \Rightarrow Arrange submenu (Figure 1.19), there are further menu controls that allow you to match the zoom, location, and rotation for all document windows, based on the current foreground image window. The Match Zoom command matches the zoom percentage based on the current selected image, while the Match Location command matches the scroll position. You can synchronize the scrolling or magnification by depressing the *Shift* key as you scroll or zoom in and out of any window view. It is possible to create a second window view of the image you are working on, where the open image is duplicated in a second window. For example, you can have one window with an image at a Fit to Screen view and the other zoomed in on a specific area. To open a second window view of a Photoshop document, choose Window \Rightarrow Arrange \Rightarrow New Window for (document name). Any edits that are applied to one document window are automatically updated in the second window preview (see Figure 1.20).

Figure 1.20 Working with a fit to view and a close-up, secondary document window.

Image document window details

The boxes in the bottom left corner of the image window contain extra information about the image (see Figure 1.21). The left-most box displays the current zoom scale percentage for the document view. Here, you can type in a new percentage for any value you like from 0.2% to 1600% up to two decimal places and set this as the new viewing resolution. The Zoom status box also has a scrubby slider option. If you hold down the **H** (Mac), **et** (PC) key as you click inside the Zoom status box you can dynamically zoom in and out as you drag left or right,

© Adobe RGB (1998) (8bpc)

Figure 1.21 The document status is shown in the bottom left corner of the document window.

Adobe Drive (formerly Version Cue)

Current Adobe Drive status.

Document Sizes

The first figure represents the file size of a flattened version of the image. The second shows the size if saved including all layers.

Document Profile

The color profile assigned to the document.

Document Dimensions

This displays the physical image dimensions, as would be shown in the Image Size dialog box.

Measurement Scale

Shows measurement scale units.

Scratch Sizes

First figure shows amount of RAM memory used. The second figure, the total RAM available to Photoshop taking into account the system and application overhead.

Efficiency

This summarizes how efficiently Photoshop is working. Basically it provides a simplified report on the amount of scratch disk usage.

Timing

Displays the time taken to accomplish a Photoshop step or the accumulated timing of a series of steps. Every time you change tools or execute a new operation, the timer resets itself.

Current Tool

This displays the name of the tool you currently have selected. This is a useful aide-mémoire for users who like to work with most of the panels hidden.

32-bit Exposure

This Exposure slider control is only available when viewing 32-bit mode images.

Save Progress

Shows the current background save status.

Smart Objects

Shows the current Smart Objects status.

Layer Count

The number of layers in a document.

at double the speed if the *Shift* key is then held down after and half speed if the *all* key is held down after. The Zoom tool Options bar offers a scrubby zoom option, which I describe later on page 58.

To the right of this is the status information box, which can be used to display information about the image. If you mouse down on the arrow to the right of this box, you will see a list of all the items you can choose to display. In the sidebar to the left here are descriptions of the items to help you choose which information is displayed.

If you mouse down in the status information box itself, this displays the width and height dimensions of the image along with the number of channels and image resolution. If you hold down the **(Mac)**, *ctrl* (PC) key as you mouse down on the status information box, this shows the image tiling information (see Figure 1.22).

(Mac only) click on any text in Title bar to reveal the path to file from the disk volume (Mac only)

Figure 1.22 The window layout of a Photoshop document as it appears on a Macintosh.

Title bar proxy icons (Mac only)

Macintosh users will see a proxy image icon in the title bar of any floating windows. The proxy icon appears dimmed when the document is in an unsaved state and is reliant on there being a preview icon saved with the image. For example, many JPEGs will not have an icon until they have been resaved. If you hold down the $(\ref{thm:self})$ key and mouse down on the proxy icon in the title bar you will see a directory path list like the one shown in Figure 1.22. You can then use this to navigate and select a folder location from the directory path and open it in the Finder.

Info panel status information

The status information box can only show a single item at a time. However, if you go to the Info panel options menu (circled in Figure 1.23) and choose Panel Options... this opens the Info Panel Options dialog. Here, you can select which Status items you would like to see displayed in the Status Information section of the Info panel. The Info panel screen shot shows all the Status Information items along with the 'Show Tool Hints' info display. When enabled, these appear at the bottom of the Info panel and will change according to any modifier keys you have held down at the time, to indicate any extra available options.

Up to ten color samplers can be displayed in the Info panel. You can change the color mode of each of these by clicking on the eyedropper icon next to each. If you hold down the *all* key as you do so, you can change the color mode for all the color sample readouts. When 'Always show composite color values' is deselected, clicking on an adjustment layer shows the color sampler value of the original followed by a color sampler value that includes the adjustment. When checked, it shows a single 'composite' color value regardless of which layer is selected.

×	Info Panel Options
Info	First Color Readout Mode: Actual Color Cancel Second Color Readout Mode: CMYK Color
+ X: 8.33 Y: 8.84 □ ₩: H:	Mouse Coordinates Ruler Units: Centimeters ~
Doc: 23.8M/23.8M ProPhoto RGB (16bpc) 14.11 cm x 21.17 cm (300 ppi) 1 pixel(s) = 1.0000 pixels Scratch: 159.5M/10.2G Efficiency: 100%* 0.3s (33%) Rectangular Marquee	Status Information Adobe Drive Document Sizes Document Profile Document Dimensions Current Tool
Click and drag to move layer or selection. Use Shift and Opt for additional options.	 Measurement Scale Smart Objects Layer Count
đ	Always show composite color values. Show Tool Hints

Figure 1.23 The Info panel and Info Panel Options dialog.

Mac proxy shortcuts

You can create a duplicate elsewhere by *all*-clicking and dragging the proxy from a Finder window to another location. Also just clicking and dragging elsewhere you can create an alias for the file somewhere else.

View menu options

The View Extras items can be selected via the View menu. To turn ruler visibility on or off, choose View ⇒ Rulers (ﷺ [Mac], off [PC]) and use the View ⇒ Show submenu to toggle the visibility of the Guides (ﷺ [Mac], off [PC]), or Grid (ﷺ [Mac], off [PC]). If a tick mark appears next to an item in the View ⇒ Show menu, it means it is switched on. Select the item in the menu again and release the mouse to switch it off.

Rulers, Grid, & Guides

Rulers can be used to check the image dimensions. If the ruler units need altering, right mouse-click on one of the rulers and select a new unit of measurement. If rulers are visible but the guides are hidden, drag out a new guide to make the other hidden guides reappear again.

The Grid overlay can be enabled by choosing View \Rightarrow Show \Rightarrow Grid (see Figure 1.24). This provides a means for aligning image elements to a horizontal and vertical axis (to alter the grid spacing, open the Photoshop preferences and select Guides & Grid).

Guides can be added at any time to an image document and flexibly positioned anywhere in the image area (see Figure 1.25). To place a new guide make sure the rulers are displayed (choose View \Rightarrow Rulers). Mouse down on the ruler bar and drag a new guide out and then release the mouse to drop the guide in place. If you hold down the Shift key as you drag, this makes the guide snap to a ruler tick mark (providing View \Rightarrow Snap is checked). If you hold down the *all* key as you drag this allows you to switch dragging a horizontal guide to dragging it as a vertical (and vice versa). Lastly, you can use 🎛 拥 (Mac), *ctrl* (PC) to toggle hiding/showing all extras items, like Guides. Once positioned, guides can be used for the precise positioning and alignment of image elements. If you are not happy with the placement of a guide, you can select the Move tool and drag the guide to the exact required position. But once positioned, it is sometimes a good idea to lock all guides (View \Rightarrow Lock Guides) to avoid accidentally moving them again. You can also place a guide choosing View \Rightarrow New Guide... and in the New Guide dialog (Figure 1.26) enter an exact position for either the horizontal or vertical axis.

Figure 1.24 The Grid view overlay.

Orienta	ition	
) Horiz	ontal	OK
O Vertic	al	Cancel
Position: 2	cm]

Figure 1.25 An image document where rulers and guides are visible.

New Guide Layout dialog

The New Guide Layout dialog (Figure 1.27) can be used to add multiple guides in one step (to access, go to the View menu and choose New Guide Layout). Here, you can specify columns, rows, gutters, and margins, and save custom layouts as presets. Figure 1.27 shows the New Guide Layout dialog with the default 8 column setting. Different column settings can be selected from the Preset menu (see Figure 1.28).

_				
Preset:	Default		~	ОК
Target:	Canvas			Cancel
Col	umns	Rows		Preview
Number	8	Number		
Width		Height		
Gutter	20 px	Gutter		
🗍 Mar	gin			
Top:	Left:	Bottom: Right:		
Center	Columns	Clear Existing Guides		

Figure 1.27 The New Guide Layout dialog.

8 Column	
12 Column	
16 Column	
24 Column	
Load Preset	altar di Testy dalamanya matu
Save Preset	
Delete Preset	

Figure 1.28 The New Guide Layout dialog Preset menu options.

New Guides from Shape

The New Guides from Shape option lets you quickly create guides according to the edges of selected layers and selected shapes within a shape layer, as shown in the steps below. Hidden layers will always be ignored.

1 This shows a layout in Photoshop made up of two background gradients, two logo layers, and an arrow shape layer.

2 In this step, I selected the Photoshop icon layer group and chose View ⇒ New Guides from Shape. This added the guides shown here.

3 Next, I selected the Arrow shape layer group and again chose View ⇒ New Guides from Shape. This added more guides based on the arrow shape outline.

'Snap to' behavior

The Snap option in the View menu allows you to toggle the 'snap to' behavior for the Guides, Grid, Slices, Document bounds, and Laver bounds. The shortcut for toggling the 'snap to' behavior is **#** *Shift* ; (Mac), *ctrl Shift* ; (PC). When the 'snap to' behavior is active and you reposition an image, type, or shape layer, or use a crop or marquee selection tool, these will snap to one or more of the above. Also, when 'snap to' is active, and new guides are added with the Shift key held down, a guide will snap to the nearest tick mark on the ruler, or if the Grid is active, to the closest grid line. Objects on layers will snap to position when placed within close proximity of a guide edge. When dragging a guide, it will snap to the edge of an object on a layer at the point where the opacity is greater than 50%. If the 'Snap to' function proves to be a problem, temporarily hold down the *ctrl* key (Mac), or right mouse (PC). This will allow a Guide to be placed close to an edge, but not snap to it. When Smart Guides are switched on in the View \Rightarrow Show menu, these can help you align layers as you drag them with the Move tool.

Pixel Grid view

The Pixel Grid view (shown in Figure 1.29) can be enabled via the View \Rightarrow Show menu. When checked, Photoshop displays the pixels in a grid whenever an image is inspected at a 500% magnification or greater on a regular display and 1200% or greater on a HiDPI display. It can only be seen if you have OpenCL enabled and the Pixel Grid option is selected in the View menu. It is useful when editing things like screen shots and aid the precise placement of the Crop tool.

Figure 1.29 The Pixel Grid view.

1 8

100%

5 圖

Figure 1.30 The different collapsed states for the Photoshop panels.

The Photoshop panels

The default workspace layout settings place the panels in a docked layout where they are grouped into column zone areas on the right of the screen. However, the panels can also be placed anywhere on the desktop and repositioned by mousing down on the panel title bar (or panel icon) and dragging them to a new location. A double-click on the panel tab (circled red in Figure 1.30) compacts the panel upwards and double-clicking on the panel tab area unfurls the panel again. A double-click on the panel header bar (circled blue in Figure 1.30) collapses the panel into the compact icon view mode, or even smaller, if you drag the panel sides inward. Double-clicking on the same panel header expands the panel again. Some panels, such as the Layers panel, can be resized horizontally and vertically by dragging the bottom right corner tab, or by hovering the cursor over the left, right or bottom edge and dragging. Others, such as the Info panel, are of a fixed height, where you can only adjust the width of the panel by dragging the side edges or the corner tab.

Panels can be organized into groups by mousing down on a panel tab or header and dragging it across to another panel (see Figure 1.31). As you do so, a blue surround appears when you are within the dropping zone. Release the mouse once it is inside the other panels. To remove a panel from a group, mouse down on the panel tab and drag it outside the panel group. When panels are grouped in this way they'll look a bit like folders in a filing cabinet. Just click on a tab to bring that panel to the front of the group, and to separate a panel from a group, mouse down on the panel tab and drag it outside the panel group again.

Figure 1.31 This shows how panels can be dragged from one panel group to another.

Panel arrangements and docking

The default workspace uses the 'Essentials' layout, but there are other workspace settings you can choose from. It is also easy to create custom workspace settings by arranging the panels to suit your own preferred way of working and save these as a new setting. Panels can be docked together by dragging a panel to the bottom or side edge of another panel. In Figure 1.32 you can see how a thick blue line appears as a panel is made to hover close to the edge of another panel. Release the mouse at this point and the panel will become docked to the side or to the bottom of the other panels.

When panels are compacted (as shown in the bottom example in Figure 1.30), you can drag on either side of the panel to adjust the panel's width. At the most compact size, only the panel's icon is displayed, but as you click and drag on the side edge to increase the width of a panel (or column of panels), the panel contents expand and you'll get to see the names of the panels appear alongside their icons (see Figure 1.33).

If you can't find a particular panel, it may well be hidden. If this happens, go to the Window menu, select the panel name from the menu and it will reappear again on the screen. It is worth remembering that the *Tab* key shortcut (also indicated as *I*) on some keyboards) can be used to toggle hiding and showing all the panels, while *Tab Shift* toggles hiding/showing all the currently visible panels except for the Tools panel and Options bar. These are really useful shortcuts to memorize. So, if you are working in Photoshop and all your panels seem to have disappeared, just press *Tab* and they'll be made visible again.

To close a panel, click on the close button in the top left corner (or choose 'Close' from the panel options fly-out menu).

Figure 1.34 shows a multi-column workspace layout. The tabbed image document fills the horizontal space between the Tools panel on the left and the three panel columns on the right. I have shown here how you can mouse down on the column edge to adjust the column width (see the double-arrow icon that's circled in red). Photoshop panels can be grouped into as many columns as you like within the application window, or positioned separately outside the application window, such as on a separate display (see 'Working with a dual display setup' on page 28). In fact, you'll see that some of the panels in Figure 1.34 are grouped in a docked, compact icon layout, outside the main application window.

Figure 1.32 This shows how to dock a panel alongside other panels.

Figure 1.33 The width of the panels can be adjusted by dragging the panel sides, circled in red above.

Figure 1.34 A multi-column workspace layout in Photoshop.

Panel positions remembered in workspaces

Photoshop is able to remember panel positions after switching workspaces. When you select a workspace and modify the layout of the panels, the new layout position is remembered when you next choose to use that particular workspace.

Customizing the menu options

As the number of features in Photoshop has grown over the years, the menu choices have become quite overwhelming and this is especially true if you are new to Photoshop. However, if you go to the Edit menu and choose Menus..., this opens the Keyboard Shortcuts and Menus dialog shown in Figure 1.35, where you can customize the menu options and decide which menu items should remain visible. This Customize menu feature is like a 'make simpler' command. You can hide those menu options you never use and apply color codings to the menu items you do use most (so they appear more prominent). The philosophy behind this feature is: "everything you do want with nothing you don't." You can easily create your own menu settings. If you set up the Menu options so that specific items are hidden from view, a 'Show All Menu Items' command will appear at the bottom of the menu list. You can select this menu item to restore the menu so that it shows the full list of menu options again.

Keyboard Shortcuts Menus				DK
Menu For: Application Menus	 Set: Photosl 	nop Defaults	Ca	incel
		ė ė 🛍		
Application Menu Command	Visibility	Color		
> File			1	
✓ Edit				
Undo/Redo	۵	None		
Step Forward	٥	None		
Step Backward	0	None		
Fade	۵	None		
Cut	٥	None		
Сору	0	None		
To temporarily see hidden mer To add color to a menu item, c	opended to the bottom to items, click on Show lick in the Color column	of a menu that contains hidden items. All Menu Items or ೫ + click on the mi , panel and uncheck Show Menu Colc	enu.	

Figure 1.35 The Keyboard Shortcuts and Menus dialog.

Creating workspace shortcuts

If you scroll down to the Window section in the Keyboard Shortcuts for Application Menus, you will see a list of all the currently saved Workspace presets. You can then assign keyboard shortcuts for your favorite workspaces. This will allow you to jump quickly from one workspace setting to another by using an assigned keyboard shortcut.

Customizing the keyboard shortcuts

While you are in the Keyboard Shortcuts and Menus dialog, you can click on the Keyboard Shortcuts tab to reveal the keyboard shortcut options shown below in Figure 1.36 (or you can go to the Edit menu and choose Keyboard Shortcuts...). In this dialog you first select which type of shortcuts you want to create, i.e., Application Menus, Panel Menus, or Tools. You can then navigate the menu list, click in the Shortcut column next to a particular menu item and hold down the combination of keys you wish to assign as a shortcut for that particular tool or menu item. Now the thing to be aware of here is that Photoshop has already used up nearly every key combination there is, so you are likely to be faced with the choice of reassigning an existing shortcut, or using multiple modifier keys such as: **H Shiff** (Mac), or **ctri all Shiff** (PC) plus a letter or Function key, when creating any new shortcuts.

•	Keyboard Shortcuts	and Menus			
Keyboard Shortcuts Menus					ОК
Shortcuts For: Application Menus	~	Set: Photo	oshop I	Defaults (modified) ~	Cance
Use Legacy Channel Shortcuts				📩 📩 🗓	
Application Menu Command	Shortcut			Accept	
				Undo	
New Window				Use Default	
Minimize	Control+ 器+M			Sec 5 shaws	
Bring All to Front					
Workspace>				Add Shortcut	
Dual Display	Opt+#+F13		8"		
Essentials (Default)				Delete Shortcut	
3D					
Graphic and Web					
Motion				Summarize	
Deintine					

Figure 1.36 The Keyboard Shortcuts and Menus dialog showing the keyboard shortcut options for the Photoshop Application Menus commands.

Task-based workspaces

The various workspace options let you access alternative panel layouts, tailored for different types of Photoshop work, such as the Painting workspace example shown in Figure 1.37. The Workspace list settings can be accessed via the Options bar menu (shown below), or via the Window ⇒ Workspace submenu. Workspace settings are automatically updated as you modify them. To reset a workspace back to the default setting, you can do so via the Workspace list menu (circled below).

You can also save a current panel arrangement as a new custom workspace via the Options bar Workspace list menu or by going to the Window menu and choosing Workspace \Rightarrow New Workspace... This opens the dialog box shown in Figure 1.38, which asks you to select the items you would like to have included as part of the workspace

Figure 1.37 The Workspace list settings in the Application bar menu.

Name: Dual Display	(Save
Capture	Cance
Panel locations will be saved in this workspace. Keyboard Shortcuts, Menus and Toolbar are optional.	Cance
Keyboard Shortcuts	
Menus	
Toolbar	

Figure 1.38 The Save Workspace dialog.

(the workspace settings can also include specific keyboard shortcuts and menu settings). The saved workspace will then appear added to the Options bar Workspace list (see Figure 1.37). Here, you can choose 'Reset Workspace', to restore the workspace settings. This can be particularly useful if you have just altered the computer display resolution, or have rearranged the panels and want to restore the original layout. To remove a workspace, choose Delete Workspace... from the menu.

The workspace settings include the panel locations and these will update as you modify the layout you are working in. This means if you select a workspace and fine-tune the panel layout or other settings, these tweaks are updated automatically. When you switch to another workspace and then go back to the original workspace, the updated settings are remembered. As you can see in Figure 1.38, saving keyboard shortcuts and menus is optional and the way things stand now, if you choose not to include these settings as part of the workspace, the menu and keyboard shortcuts used in the last selected workspace remain sticky. Let's say you save a custom workspace that excludes saving menus and shortcuts. If you switch to a workspace setting that makes use of specific menus or keyboard shortcuts and switch back again you can add these menu and shortcuts settings to the current workspace setting (until you reset).

Saved workspaces location

Custom and modified workspaces are saved to the following locations: User name/Library/Preferences/Adobe Photoshop CC 2018 Settings/ WorkSpaces (Mac), User name\AppData\Roaming\Adobe\Adobe Photoshop CC 2018 Settings\WorkSpaces (Windows).

Working with a dual display setup

If you have a second computer display, you can arrange the Photoshop interface so that all panels are placed on the second display, leaving the main screen clear to display the image document you are working on. Figure 1.39 shows a screen shot of a dual display panel layout workspace that I use with my computer setup.

In this example only the panels I use regularly were visible. The important thing to remember here is that when you save a custom panel layout like this as a workspace setting you can easily revert to it as you switch between other workspace settings.

Those users who are working with a dual display setup will notice that new documents are always opened on whichever display the current target document is on.

Figure 1.39 This shows an example of how you might like to arrange the Photoshop panels on a second display, positioned alongside the primary display.

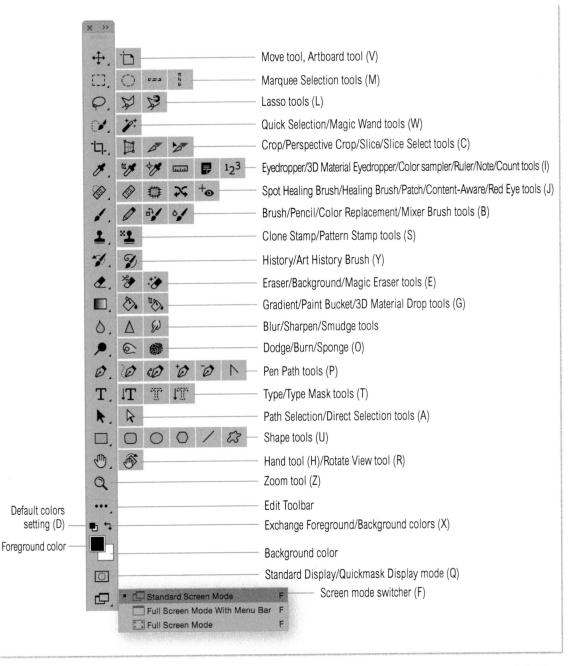

Figure 1.40 This shows the Tools panel with the keystroke shortcuts shown in brackets.

Photoshop CC Tools panel

The Tools panel (Figure 1.40) contains 67 separate tools. Doubleclicking any tool automatically displays the tool Options bar (if it is currently hidden) from where you can manage the individual tool settings (see page 34). Many of the tools in the Tools panel have a triangle in the bottom right corner of the tool icon, indicating there are extra tools nested in this tool group. You can mouse down on a featured tool, select any of the other tools in this list and make that the selected tool for the group (see Figure 1.41). On the left you can see the default single column panel view. However, you can click on the double arrow (circled) to toggle between this and the double column view shown on the right.

You will notice that the tools, or sets of tools, have single-letter keystrokes associated with them. These are displayed whenever you mouse down to reveal the nested tools or hover with the cursor to reveal the tool tip info (providing the 'Show Tool Tips' option is switched on in the Photoshop Tools preferences). You can therefore use these key shortcuts to quickly select a tool without having to go via the Tools panel. For example, pressing \bigcirc on the keyboard selects the Hand tool and pressing \bigcirc will select one of the Healing Brush group of tools (whichever is currently selected in the Tools panel). Photoshop also features spring-loaded tool selection behavior. If, instead of clicking, you hold down the key and keep it held down, you can temporarily switch to using the tool that's associated with that particular keystroke. Release the key and Photoshop reverts to working with the previously selected tool.

Where more than one tool shares the same keyboard shortcut, you can cycle through the other tools by holding down the *Shift* key as you press the keyboard shortcut. If on the other hand you prefer to restore the old behavior whereby repeated pressing of the key would cycle through the tool selection options, go to the Photoshop menu, select Preferences \Rightarrow Tools and deselect the 'Use Shift Key for Tool Switch' option. Personally, I prefer using the Shift key method. You can also *alt*-click a tool icon in the Tools panel to cycle through the grouped tools.

There are specific situations when Photoshop will not allow you to use certain tools and displays a prohibit sign (**S**). For example, you might be editing an image in 32-bit mode where only certain tools can be used when editing 32-bit images. Clicking once in the image document window will call up a dialog explaining the exact reason why you cannot access or use a particular tool.

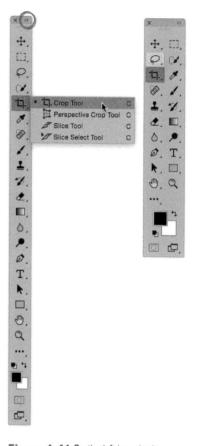

Figure 1.41 On the left is a singlecolumn Tools panel and, on the right, in double-column mode.

Workspace selection

If you select a Workspace preset, such as Painting or Photography, you will notice how this happens to apply a custom Toolbar preset as part of the workspace setting.

Toolbar presets

You can edit the Toolbar in Photoshop. To do this, go to the Edit menu and choose Toolbar... This opens the Customize Toolbar dialog shown in Figure 1.42, where you will see a list on the left of all the current Photoshop tools organized by their regular groupings. These are referred to as 'slots' and they allow you to drag and drop tools from the Toolbar section on the left to the Extra Tools section on the right.

olbar			Extra To	slot at the bottom of the toolbar.		Cancel
		1				Restore Default
+	Move Tool	۷	Þ	Artboard Tool	v	Clear Tools
[]	Rectangular Marquee Tool	м	1	Single Column Marquee Tool		Save Preset
0	Elliptical Marquee Tool	м		Single Row Marquee Tool		Load Preset
0	Lasso Tool	L	2	Magnetic Lasso Tool	. 0	
Þ	Polygonal Lasso Tool	L				
			25	Slice Select Tool		
0	Quick Selection Tool	w	5	Slice Tool	С	
1:	Magic Wand Tool	W				
			0	Pencil Tool	8	
17.	Crop Tool	с				
	Perspective Crop Tool	с	Ø	Art History Brush Tool	Y	
,	Eyedropper Tool	1		Sponge Tool	0	
**	Color Sampler Tool	1				

Figure 1.42 The Customize Toolbar interface.

S	Spot Healing Brush Tool	J
	Healing Brush Tool	J
٢	Patch Tool	J
*	Content-Aware Move Tool	
+.	Red Eye Tool	

Figure 1.43 Click and hold for a while on the left-most 15 pixels zone of a list to retain the tools in a group. You can also drag and drop to reorganize the grouping of the tools within a customized Toolbar layout. If you click on the left-most 15 pixels zone you can retain all the tools in a group when moving them (see Figure 1.43). Figure 1.44 shows a customized reconfiguration of the Toolbar in which I removed the tools I felt were surplus to normal image retouching requirements. For example, when editing photographs there is no use for the Slice and Slice Select tools (which share the **()** shortcut with the Crop and Perspective Crop tools). By moving the Slice and Slice Select tools to the Extras section I could use the **()** key to toggle just between the Crop and Perspective Crop tools, rather than have to press the **()** key four times to cycle through all four tool options that share the same shortcut. However, removing

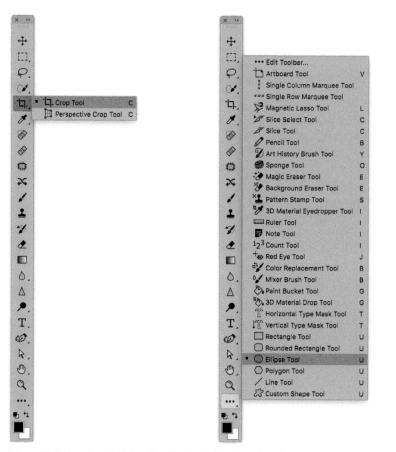

Figure 1.44 A customized Photoshop Toolbar (left) and overflow Toolbar items (right).

an item from the Toolbar also disables the shortcut. This can have unintended consequences: if you remove things like the Screen view or Quickmask options in order to remove clutter from the Toolbar, you lose the shortcut as well.

At the bottom of the Customize Toolbar dialog are options to show/ hide the non-tool widgets that appear at the bottom of the Toolbar such as Quickmask mode options, or cycle screen mode options. Just below the Zoom tool is the Edit Toolbar widget (.....), which when you click on it, displays the overflow Toolbar items as a flattened list and also provides a shortcut to open the Customize Toolbar dialog (see Figure 1.44).

Once you are happy with a configuration, you can click on the Save Preset button to save a custom Toolbar configuration and also load presets via the same dialog. Alternatively, if someone sends you a Toolbar preset you can load it by dragging and dropping it to the Photoshop application icon.

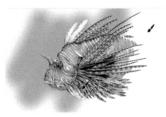

Brush tool (B) Paints custom brush strokes

Figure 1.45 An example of the new style Rich Tool tips.

Tool tips

In order to help familiarize yourself with the Photoshop tools and panel functions, a tool tip box normally appears after a few seconds whenever you leave a cursor hovering over any one of the Photoshop buttons or tool icons. This is dependent on having the 'Show Tool Tips' option selected in the Tools preferences. If the 'Use Rich Tool Tips' option is also checked, this lets new users explore Photoshop without having to leave the program (see Figure 1.45). The Rich Tool tips show animated content that helps explain the function of each selected tool.

Options bar

The Options bar (Figure 1.46) normally appears at the top of the screen, just below the Photoshop menu, and contains all the tool options associated with the currently selected tool. However, it can be removed from its standard location and placed anywhere on the screen by dragging the gripper bar on the left edge (circled in Figure 1.46).

You'll see examples of the different Options bar layouts in the rest of this chapter (a complete list of the Options bar views can be seen in the Help Guide for Photoshop tools on the book website). Quite often you will see tick () and cancel () buttons on the right-hand side of the Options bar and these are there so that you can OK or cancel a tool that is in a modal state. For example, if you are using the Crop tool to define a crop boundary, you can use these buttons to accept or cancel the crop, although you may find it easier to use the *Enter* key to OK and the *esc* key to cancel such tool operations. Remember, you can also use the *Shift Tab* shortcut to toggle hiding the panels only and keeping just the Tools panel and Options bar visible.

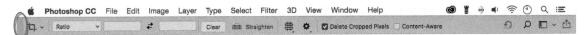

Figure 1.46 The Options bar, which is shown here docked to the main menu.

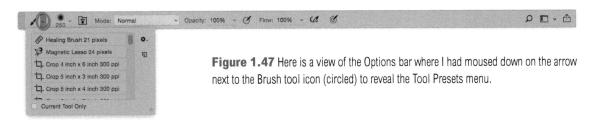

Tool Presets

Many of the Photoshop tools offer a wide range of tool options. In order to manage the tool settings effectively, the Tool Presets panel can be used to store multiple saved tool settings, which can then also be accessed via the Options bar (Figure 1.47), or the Tool Presets panel (Figure 1.48).

With Tool Presets you can access any number of tool options very quickly and this can save you the bother of having to reconfigure the Options bar settings each time you choose a new tool. For example, you might find it useful to save Crop tool presets for all the different image dimensions and pixel resolutions you typically use. Likewise, you might like to store pre-configured brush preset settings, rather than have to keep adjusting the brush shape and attributes. To save a new tool preset, click on the New Preset button at the bottom of the Tool Presets panel. To remove a preset, click on the Delete button next to it.

If you mouse down on the Tool Presets options button (circled in Figure 1.48), you can use the menu shown in Figure 1.49 to manage the various tools presets. In Figure 1.48 the Current Tool Only option was deselected which meant that all the tool presets could be accessed at once. This can be useful, because clicking on a preset simultaneously selects the tool and the preset at the same time. Most people though will find the Tool Presets panel is easier to manage when the 'Current Tool Only' option is checked.

You can use the Tool Presets panel to save or load pre-saved tool preset settings. For example, if you create a set of custom presets, you can share these with other Photoshop users by choosing Save Tool Presets... This creates a saved set of settings for a particular tool. Another thing that may not be immediately apparent is the fact that you can also use tool presets to save Type tool settings. This again can be useful, because you can save the font type, font size, type attributes, and font color settings all within a single preset. This feature can be really handy if you are working on a Web or book design project.

One important thing to bear in mind here is that any painting tool presets created in Photoshop CS5 or later will not be backward compatible with earlier versions of the program. Similarly, you won't be able to import and use any painting tool presets that were created in earlier versions of Photoshop.

Lastly, you can *cm*-click (Mac), or right mouse down on the tool icon in the Options bar and choose 'Reset Tool' or 'Reset All Tools' from the contextual menu. This will reset the Options bar to the default settings.

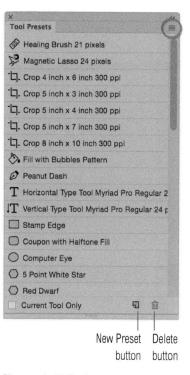

Figure 1.48 The Tool Presets panel.

New Tool Preset... ✓ Sort By Tool ✓ Show All Tool Presets Show Current Tool Presets Text Only ✓ Small List Large List Reset Tool Reset All Tools Preset Manager... Reset Tool Presets... Load Tool Presets ... Save Tool Presets... Replace Tool Presets... Art History Brushes Crop and Marquee **DP** Presets **M** Tool Presets Mixer Brush Tool Splatter Brush Tool Presets

Close Close Tab Group

Text

Figure 1.49 The Tool Presets options.

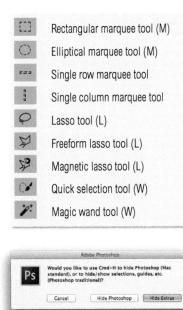

Figure 1.50 The Macintosh dialog options for choosing Hide Photoshop/Hide Extras.

Selection tools

The Photoshop selection tools are mainly used to define a specific area of the image that you wish to modify or copy. The use of the selection tools in Photoshop is therefore just like highlighting text in a word processor program in preparation to do something with the selected content. In the case of Photoshop, you might want to make a selection to define a specific area of the image, so that when you apply an image adjustment or a fill, only the selected area is modified. Alternatively, you might use a selection to define an area you wish to copy and paste, or define an area of an image that you want to copy across to another image document as a new layer. The standard Paste command pastes the copied pixels as a new layer centered in the image. The Paste Special submenu offers three options. The Paste In Place command (\# Shift V [Mac], ctrl Shift V [PC]) pastes the pixels that have been copied from a layer to create a new layer with the pixels in exactly the same location. If the pixels have been copied from a separate document, it pastes the pixels into the same relative location as they occupied in the source image. Paste Into (# 🔽 Shift V [Mac], ctrl alt Shift V [PC]) pastes the clipboard contents inside a selection with an unlinked layer mask, while Paste Outside pastes the clipboard contents outside a selection with an unlinked layer mask.

The usual editing conventions apply and mistakes can be undone using the Edit \Rightarrow Undo command (\Re [Mac], etrl [PC]), or by selecting a previous history state via the History panel. The \Re (Mac), etrl (PC) keyboard shortcut can be used to hide an active selection, but Macintosh users should be aware, the first time you use the \Re (H keyboard shortcut, this opens the dialog shown in Figure 1.50, where you will be asked to select the desired default behavior: do you want \Re (H to hide the Photoshop application, or hide all extras?

The Marquee selection tool options include the Rectangular, Elliptical, and Single row/Single column selection tools. In Figure 1.51 I show how the Elliptical marquee tool can be used to create a selection of the cup and saucer, followed by an image adjustment to make the selected area a warmer color. In Figure 1.52 I show how I used the Rectangular marquee tool to make a marquee selection of the door. In this example I applied a contrast-boosting Curves adjustment to modify the tone and color within the selection area.

The Lasso tool can be used to draw freehand selection outlines. The Polygon lasso tool can draw both straight line and freehand selections. The Magnetic lasso tool is like an automatic Freehand lasso tool that is able to auto-detect the edge you are trying to trace. The Quick selection tool is a bit like the Magic wand tool as it can be used to make selections based on pixel color values; however, the quick selection tool is a little more sophisticated than that and hence it has been made the default tool in this particular tool group. As you read through the book you'll see a couple of examples where the Quick selection tool can be used to make quite accurate selections based on

Figure 1.51 An example of a Elliptical marquee selection.

Figure 1.52 An example of a Rectangular marquee selection.

color and how these can then be modified more precisely using Select and Mask. For full descriptions of these and other tools mentioned here don't forget to check out the Help Guide on the book website.

Color Range

Color Range is a color-based selection tool. While the Quick selection and Magic wand tools create selections based on luminosity, the Color Range menu item can be used to create selections based on similar color values. To create a Color Range selection, go to the Select menu, choose Color Range... and click on the target color anywhere in the image document window, or Color Range dialog preview area (Figure 1.53) to define the initial selection. If you press the spacebar when launching the Color Range dialog the current foreground color is loaded as the sampled color. To add colors to a Color Range selection, click with the 'Add to Sample' eyedropper and keep clicking to expand the selection area. To subtract from a selection, click on the 'Subtract from Sample' eyedropper and click to select the colors you want to remove from the selection. You can then adjust the Fuzziness slider to adjust the tolerance of the selection, which increases or decreases the number of pixels that are selected based on how similar the pixels are in color to the already sampled pixels.

If the Localized Color Clusters box is checked, Color Range can process and merge data from multiple clusters of color samples. As you switch between 'sampling colors to add to a selection' and 'selecting colors to remove,' Photoshop calculates these clusters of color samples within a three-dimensional color space. As you add and subtract colors Photoshop can produce a much more accurate color range selection mask based on the color sampled data. When Localized Color Clusters is checked the Range slider lets you determine which pixels are to be included based on how far or near a color is from the sample points that are included in the selection.

The Color Range selection preview options for the document window can be set to None (the default), Grayscale, a Matte color such as the White Matte example shown in Figure 1.54, or a Quick Mask. The Color Range sub selection options include Reds, Yellows, Greens, etc. as well as an option to detect skin tones (see "Skin tone and faces selections" on page 40).

By default Color Range presets are saved to a Color Range folder in the Adobe Photoshop application Presets folder. The Color Range dialog also remembers the previously applied settings and applies these the next time the dialog is opened.

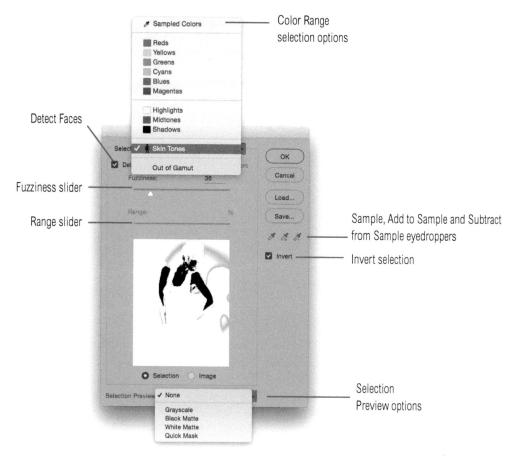

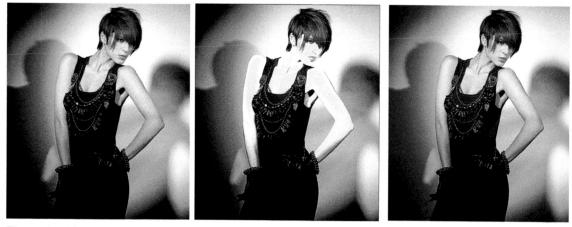

Figure 1.54 This shows a before image (left), Color Range White Matte preview (middle), and a color adjusted image (right) made using a Color Range selection.

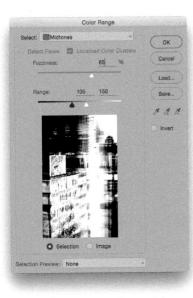

Figure 1.55 The Color Range dialog with a Midtones selection active.

A Color Range selection of a selection

A Color Range selection tool can only be used to make discontiguous selections. However, it is possible to make a selection first of the area you wish to focus on and then choose Color Range to make a Color Range selection within a selection area.

Out-of-gamut selections

Among other things, you can use the Color Range command to make a selection based on out-of-gamut colors. This means you can use Color Range to make a selection of all the 'illegal' RGB colors that fall outside the CMYK gamut and apply corrections to these pixels only. To be honest, while Color Range allows you to do this, I don't recommend using Photoshop's out-of-gamut indicators to modify colors in this way. Instead, I suggest you follow the instructions on soft proofing in the 'Print' chapter at the end of this book.

Skin tone and faces selections

The Skin Tones option in the Color Range Select menu can be used to specifically select skin tone colors in an image. There is also a separate 'Detect Faces' checkbox (which is available when the Localized Color Clusters checkbox is activated). When Detect Faces is enabled it uses a face detection algorithm to automatically look for and select faces in a photo. It appears to be effective with all different skin types. Checking the Detect Faces option in conjunction with the Skin Tones selection item can often really help narrow down a selection to select faces only. Incidentally, Photoshop CC now has an updated face-detection algorithm that recognizes faces at rotations/angles and partial faces and therefore does a better job in defining face edges.

Adjustable tone ranges

Color Range improvements in Photoshop CC offer greater control of Highlights, Midtones, and Shadows selections. Instead of being restricted to the use of 'hard-coded' value ranges, the exact range of tones and the partial selection of surrounding tones can be customized and it is possible to edit the Fuzziness and Range values for a Shadows, Midtones or Highlights selections. In the case of the Highlights and Shadows selections there is a single slider with which to adjust the extent of a highlights or shadows selection. In the case of the Midtones you have two sliders with which to fine-tune the midtone range. Figure 1.55 shows the Color Range dialog where a Midtones selection was selected and the Fuzziness and Range sliders were active below.

Modifier keys

Macintosh and Windows keyboards have slightly different key arrangements, hence the reason for me including double sets of instructions throughout the book, where the **H** key on the Macintosh is equivalent to the **ctrl** key on a Windows keyboard. You can use the right mouse button to access the contextual menus (Mac users can also use the **ctrl** key to access these menus) and, finally, the **Shift** key which is the same on both Mac and PC computers.

These keys are commonly referred to as 'modifier' keys, because they can modify tool behaviors. In Figure 1.56, you can see how if you hold down *all* when drawing an Elliptical marquee selection it centers the selection around the point where you first clicked on the image. In Figure 1.57, you can see how if you hold down the *Shift* when drawing an Elliptical marquee selection, this constrains the selection to a circle. In Figure 1.58, you can see how if you hold down *Shift* (Mac), *Shift alt* (PC) when drawing an Elliptical marquee selection, this constrains the selection to a circle and centers the selection around the point where you first clicked. The Spacebar is a modifier key too in that it allows you to reposition a selection midstream. If you make a mistake when selecting an area, rather than deselect and try again, you can simply depress the Spacebar key as you drag to realign the position of the selection.

The modifier keys mentioned above are all highlighted below in Figure 1.59. The modifier keys (shaded in orange), showing both the Macintosh and Windows equivalent key names. The other keys commonly used in Photoshop are the Tab and Tilde keys, shown here shaded in blue.

Figure 1.56 A selection made with the at key held down.

Figure 1.57 A selection made with the Shift held down.

Figure 1.58 A selection made with Shift (Mac), Shift alt (PC) keys.

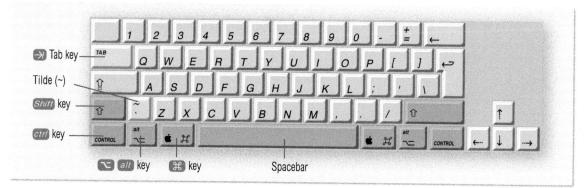

Figure 1.59 The Photoshop modifier keys on a typical computer keyboard.

Figure 1.60 An elliptical selection added to a rectangular selection by holding down the *Shift* key.

Figure 1.61 An elliptical selection subtracted from a rectangular selection by holding down the *alt* key.

Figure 1.62 An elliptical selection intersected with a rectangular selection by holding down the *Shift all* keys.

After you have created an initial selection the modifier keys will behave differently. The following figures show examples of selections (overlaid with a Quick Mask) that have been modified after the initial selection stage. In Figure 1.60, you can see how if you hold down the *Shift* key as you drag with the Marquee or Lasso tool, this adds to the selection. In Figure 1.61, you can see how if you hold down the *all* key as you drag with the marquee or Lasso tool, this subtracts from an existing selection. And lastly, in Figure 1.62, you can see how the combination of holding down the *Shift all* keys together while dragging with a selection tool creates an intersection of the two selections.

There are also equivalent selection mode options in the Options bar for the Marquee and Lasso selection tools (see Figure 1.63). The Options bar here has four modes of operation for each of the selection tools: Normal; Add to Selection; Subtract from Selection; and Intersect Selection. These are equivalent to the use of the modifier modes described above when the tool is in Normal mode.

Modifier keys can be used to modify the options that are found elsewhere in Photoshop. For example, if you hold down the *att* key as you click on, say, the Marquee tool in the Tools panel you will notice how this allows you to cycle through all the tools that are available in this group. Whenever you have a Photoshop dialog box open it is worth exploring what happens to the dialog buttons when you hold down the *att* key. You will often see the button names change to reveal more options (typically, the Cancel button will change to say 'Reset' when you hold down the *att* key).

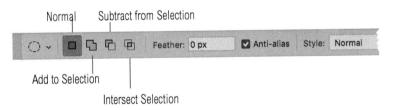

Painting tools

The next set of tools we'll focus on are the painting tools. These include: the Brush, Pencil, Mixer brush, Blur, Sharpen, Smudge, Burn, Dodge, and Sponge tools. These can be used to paint or edit the image pixels. If you want to keep your options open I find it is preferable to carry out your paint work on a separate new layer. This lets you preserve all of the original image on a base layer and you can easily undo all your paint work by turning off the visibility of the paint layer.

When you select any of the painting tools, the first thing you will want to do is to choose a brush shape, which you can do by going to the Brush Preset Picker (the second item from the left in the Options bar) and select a brush from the drop-down list shown in Figure 1.64. Here, you can choose from the many different types of brushes, including the bristle shape brushes. To display the brush preset list shown here, mouse down on the arrow next to the brush shape icon. The Size slider can be used to adjust the brush size from a single pixel to a 5000 pixel-wide brush. If a standard round brush is selected you can also use the Hardness slider to set varying degrees of hardness for the brush shape. To save as a new setting, click on the Create New Tool Preset button. Most of the painting tools offer a fairly similar range of settings and here you can see the pen tablet options, which allow you to set the pen pressure to control the opacity and/or the size of a selected painting tool.

Brush performance

There are six round brush presets. These allow you to select hard or soft brushes with either no pressure-linked controls, the brush size linked to the amount of pressure applied, or brush opacity linked to the amount of pressure applied. In this latest version of Photoshop CC you can expect improved brush performance with standard brushes. This will be particularly noticeable on large documents using large brushes.

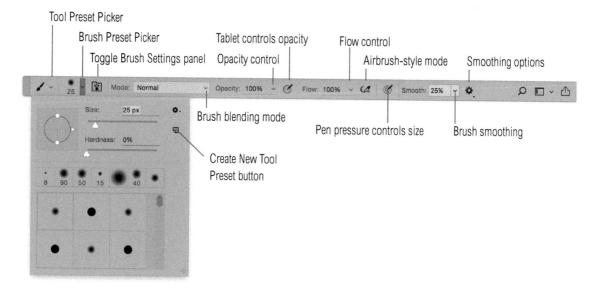

Figure 1.64 This screen shot shows you the Options bar for the Brush tool.

Figure 1.65 Adjusting the size of a brush using the square bracket keys.

Figure 1.66 Adjusting the hardness of a round brush using the *Shift* key plus square bracket keys.

On-the-fly brush changes

Instead of visiting the Brush Picker every time you need to adjust the size or hardness of a brush, you will often find it is quicker to use the square bracket keys. Figure 1.65 shows how you can use the right square bracket key 🕕 to make a brush bigger and the left square bracket key 🚺 to make it smaller. Figure 1.66 shows how you can use Shift 1 to make a round brush edge harder and use Shift 1 to make a round brush edge softer (this only applies when editing one of the round brush presets). If you *ctrl* right mouse-click on the image you are working on this opens the Brush Preset menu directly next to the cursor (Figure 1.67). Click on the brush preset you wish to select and once you start painting, the Brush Preset menu closes (or alternatively, use the esc key). If you are painting with a Wacom[™] stylus you can close this pop-up dialog by lifting the stylus off the tablet and squeezing the double-click button. If you ctrl Shift-click or right mouse plus Shift-click on the image while using a brush tool, this opens the blending mode list shown below. These blend modes are like rules that govern how the painted pixels are applied to the pixels in the image below. For example, if you paint using the Color mode, you'll only alter the color values in the pixels you are painting.

Size: 9 DX O.	Edit Brush
	Normal
Hardness: 100%	Dissolve
Hardiness, Ioox	Behind Clear
	CHORD
• • • • • •	Darken
and the second se	Multiply Color Burn
> 🖾 Basic brushes	Linear Burn
✓ ➡ Bristle brushes	Darker Color
	Lighten
	Screen
Flat Angle Right Hand Pose	Color Dodge
	Linear Dodge (Add)
Flat Angle Left Hand Pose	Lighter Color
-	Overlay
Round Curve Low Bristle Percent	Soft Light
Round Curve Low Bristle Percent	Hard Light
	Vivid Light Linear Light
Round Angle Low Stiffness	Pin Light
	Hard Mix
Round Fan Stiff Thin Bristles	Difference
	Exclusion
	Subtract
Flat Point Medium Stiff	Divide
T -	Hue
Flat Blunt Short Stiff	Saturation
	Color
A	Luminosity

Figure 1.67 The *ctrl*-click (right mouse-click) and the *ctrl Shift*-click (or right mouse + *Shift*-click) menus.

On-screen brush adjustments

Providing you have the 'Use Graphics Processor' option enabled in the Performance preferences, Photoshop provides on-screen brush adjustments. If you hold down the *cttl* set keys (Mac), or hold down the *alt* key and right-click, you can dynamically adjust the brush size and hardness of the painting tool cursors on screen. Dragging to the left makes the brush size smaller and dragging to the right, larger. Also, if you drag upwards this makes a round brush shape softer, while dragging downwards makes a round brush shape harder. You'll notice how the brush hardness is represented here with a quick mask type overlay. If you go to the Photoshop Cursors preferences you can customize the overlay color that's used for the brush preview.

If you hold down the **H C** *cttt* keys (Mac), or the *att Shift* keys and right-click (PC), this opens the Heads Up Display (HUD) Color Picker where for as long as you have the mouse held down you can move the cursor over the outer hue wheel or hue strip (depending on the HUD Color Picker setting you have selected in the Photoshop General Preferences) to select a desired hue color and then inside the brightness/saturation square to select the desired saturation and luminosity. The point where you release the mouse selects the new foreground color. When you use the key combination described here to access the HUD Color Picker, you can hold down the Spacebar to freeze the cursor position. For example, you can select a hue color from the hue wheel/strip, freeze the hue color selection, and then switch to select a brightness/saturation value. Figure 1.68 shows examples of how the paint tool cursor looks for both the on-screen brush size/hardness adjustments and the Hue Wheel HUD Color Picker displays.

Microsoft Dial support

Native support is available for Dial on Microsoft Surface Pro computers. This allows for quick access control without having to use the computer keyboard. Dial support is offered for: brush size, brush opacity, brush flow, blend modes, History states, zoom control, and text properties.

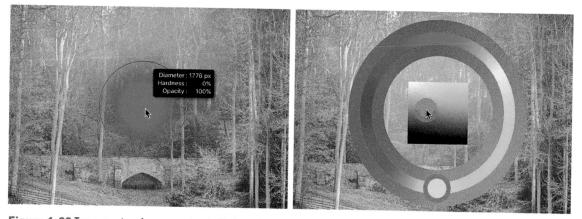

Figure 1.68 Two examples of on-screen brush displays. On the left, a brush size/ hardness overlay. And, on the right, a Heads Up Display showing the Hue Wheel HUD Color Picker display.

Adjust brush preview size

Figure 1.70 The Brushes panel.

Brushes panel

If you click on the Brushes button in the Brush Settings panel (circled red in Figure 1.69), this opens the Brushes panel from which you can select the brush shape you wish to work with (Figure 1.70). This new, updated panel allows you to create new brush groups and organize brushes into expandable folders. When Show Recent Brushes is checked (circled in Figure 1.70) the most recently used brushes will appear listed at the top of the Brushes panel. The fly-out menu can also be used to import and export selected brushes.

Brush Settings panel

The Brush Settings panel (Figure 1.69) contains all the controls you need to modify the brush characteristics (the last selected brush will be highlighted). The brush attributes on the left include things like how the opacity of the brush is applied when painting, or the smoothness of the brush. You can start by selecting an existing brush, modify it, and then click on the Create new brush button at the bottom to define this as a new custom brush preset setting. Specific brush panel settings can be locked by clicking on the Lock buttons.

Figure 1.69 The Brush Settings panel Brush Tip Shape options.

As you click on these the right-hand section changes to reveal the various options settings. The Transfer options are selected in Figure 1.71. Here, the Jitter controls introduce randomness into the brush dynamics behavior. Increasing the Opacity Jitter means that the opacity will be adjusted according to how much pen pressure is applied and there is a built-in random fluctuation to the opacity that varies more and more as the jitter value is increased. Meanwhile, the Flow Jitter setting governs the speed at which the paint is applied. To understand how the brush flow dynamics work, try selecting a brush and quickly paint a series of brush strokes at a low and then a high flow rate. When the flow rate is low, less paint is applied, but as you increase the flow setting more paint is applied. Other tools like the dodge and burn toning tools use the terms Exposure and Strength, but these essentially have the same meaning as the opacity control. The Shape Dynamics can be adjusted to introduce jitter into the size angle and roundness of the brush and the scattering controls allow you to produce broad, sweeping brush strokes with a random scatter, while the Color Dynamics let you introduce random color variation to the paint color. The Foreground/ Background color control lets you vary the paint color between the foreground and background color, according to how much pressure is applied. For example, in Figure 1.72 I selected the round point stiff brush and adjusted the Angle Jitter in the Shape Dynamics settings and the foreground/background jitter in the Color Dynamics, linking both to the angle of the pen. I then set blue as the foreground color, orange for the background and used a combination of pen pressure and pen tilt to create the doodle shown here, twisting the pen angle as I applied the brush strokes.. The Dual Brush and Texture Dynamics can introduce texture and more interactive complexity to the brush texture (it is worth experimenting with the Scale control in the Dual Brush options) and the Texture Dynamics can utilize different blending modes to produce different paint effects. The Transfer Dynamics allow you to adjust the dynamics for the build-up of the brush strokes-this relates particularly to the ability to paint using wet brush settings.

Pressure sensitive control

If you are using a pressure sensitive pen stylus, you will see additional options in the Brush panel that enable you to link the pen pressure of the stylus to how the effects are applied. You can therefore use these options to determine things like how the paint opacity and flow are controlled by the pen pressure or by the angle of tilt or rotation of the pen stylus. But the tablet pressure controls can also be controlled via the buttons in the Options bar for the various painting tools (I've highlighted these tablet button controls in Figures 1.64 and 1.74).

Figure 1.71 The Brush Settings panel showing the Shape Dynamics brush settings.

Figure 1.72 An example of a painting created using dynamic brush settings.

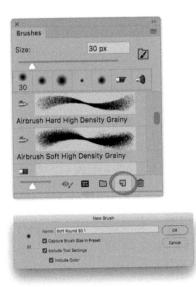

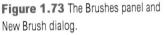

Tool preset export

Existing Tool presets can be converted to enhanced Brush presets. And indeed, you are now encouraged to do so. Go to the Tool Presets panel and uncheck Current Tool only. Go to the Tool Presets fly-out menu and choose Convert All to Brush Presets.

Saving Brush tool presets

With the brush controls split between the Brush Settings panel, the Brushes panel, the Options bar and the live brush tip preview. It's not particularly easy to pick up a brush and play with it unless you have studied all the brush options in detail and you understand how the user interface is meant to work. While the Tool Presets panel can be used to store Brush tool presets (as you can for other tools) it is now recommended you use the Brushes panel, which allows you to create new, enhanced Brush presets.

When you have finished adjusting the Brush Settings panel dynamics and other settings, you can save combinations of the brush preset shape/size, attribute settings, and brush color as a new Brushes panel preset. To do this, go to the Brushes panel and click on the Create New Brush button at the bottom (see Figure 1.73). Give the brush preset a name and click OK to add to the current list. Once you have saved a brush preset, you can access it at any time via the Brushes panel or via the Brush Preset Picker menu in the Options bar. Selecting a Brush preset when any other tool is selected will automatically switch to the Brush tool with that preset active.

Mixer brush

The Mixer brush can be used to paint more realistically in Photoshop. It lets you mix colors together as you paint, picking up color samples from the image you are painting on and set the rate at which the brush picks up paint from the canvas and the rate at which the paint dries out. The Mixer brush can be used with either the bristle tips or with the traditional Photoshop brush tips (referred to as static tips) to produce natural-looking paint strokes. The combination of the Mixer brush and bristle tip brushes provides a whole new level of sophistication to the Photoshop paint engine.

Let's take a look at the Options bar settings for the Mixer brush (Figure 1.74). The Current brush load swatch is used to set the painting color. This contains two wells: a reservoir and a pickup. The reservoir well color is defined by the current foreground color swatch in the Tools panel. You can click on the swatch to launch the Photoshop Color Picker, or and -click in the image canvas area to sample a color. The pickup well (in the center) is one that has paint flowing into it and continuously mixes the colors of where you paint with the color that's contained in the reservoir well. Selecting 'Clean Brush' from the 'Current brush load' options immediately cleans the brush and clears the current color, while selecting 'Load Brush' fills with the current foreground color again. The 'Load brush after each stroke' button

Figure 1.74 The Mixer brush options.

does what it says; it tells the Mixer brush to keep refilling the pickup well with color and therefore the pickup well becomes progressively contaminated with the colors that are sampled as you paint. The 'Clean brush after each stroke' button empties the reservoir well after each stroke and effectively allows you to paint from the pickup well only. Figure 1.75 shows an example of how the well colors can be displayed in the Options bar where the reservoir and pickup well contain different colors. Sampled fill colors are retained whenever you switch brush tips or adjust the brush tip parameters. You can also include saving the main reservoir well and pickup well colors within a Mixer brush tool preset.

The Paint wetness controls how much paint gets picked up from the image canvas. Basically, when the Wet slider is set to zero the Mixer brush behaves more like a normal brush and deposits opaque color. As the wetness is increased so is the streaking of the brush strokes. The Load slider is a dry-out control. This determines how much paint gets loaded into the main reservoir well. With low load rate settings you'll get shorter brush strokes where the paint dries out quickly and as the load rate setting is increased you get longer brush strokes.

The Mix slider determines how much of the color picked up from the canvas that goes into the pickup well is mixed with the color stored in the main reservoir well. A high Mix ratio means more ink flows from the pickup to the reservoir well, while the Flow rate control determines how fast the paint flows as you paint. With a high Flow setting, more paint is applied as you paint. If you combine this with a low Load rate setting you'll notice how at a high Flow setting the paint flows out quickly and results in shorter paint strokes. At a lower Flow rate you'll notice longer (but less opaque) brush strokes.

Typing in a number changes the Wetness value. Holding down the *alt Shift* keys while entering a number changes the Mix value. Lastly, holding down just the *Shift* key as you enter a number changes the Flow value. Type '00' to set any of the above values to zero.

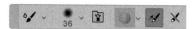

Figure 1.75 The Load swatch displays the main reservoir well color in the outer area and the pickup well color in the center.

Tablet support

Photoshop is able to exploit all of the pressure responsive built-in Wacom[™] features. You will notice that as you alter the brush dynamics settings in the Brush panel, the brush stroke preview below changes to reflect what the expected outcome would be if you had drawn a squiggly line that faded from zero to full pen pressure (likewise with the tilt and thumb wheel). This visual feedback is extremely useful as it allows you to experiment with the brush dynamics settings in the Brushes panel and learn how these affect the brush dynamics behavior.

Brushes			•	٠	•	0	10	8
Brush Tip Shape		30	30	31	30	25	25	
Shape Dynamics	ଳ	25	36	25	36	36	36	
Scattering	6		-3			2	50	
Texture	6	32	25	50 50	25	25	50 #>	
Dual Brush	6							
Color Dynamics	6	Size					25 px	
Transfer	6		(Δ)					
Brush Pose	- 6	Bri	stle Q	ualitie	95			
Noise	6		Shape	Ro	und Fa	n		~
Wet Edges	6	E	Bristles	- 🔼		traiget	13%	
Bulid-up	6	1	Length:			123%		
Smoothing	6	Thi	ckness	11 100			19%	
Protect Texture	6	St	iffness	2	-	area a	23%	
			Angle	r:	•	er bet en s	-58°	
		🖸 Sp	acing				2%	

Figure 1.76 The Brush Settings panel Bristle tip options.

Figure 1.77 The live brush preview.

Smoothing Options
Pulled String Mode
Stroke Catch-up
Catch-up on Stroke End
Adjust for Zoom

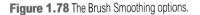

Bristle tip brush shapes

If you select one of the bristle tip brush shapes, you can click on the Brush Tip Shape option in the Brush panel (Figure 1.76) to reveal the Bristle Qualities options. These brush tips can be used in conjunction with any of the Photoshop painting tools. When a bristle tip (as opposed to a traditional 'static' Photoshop brush tip) is selected you can click the Live tip Brush preview button (circled in Figure 1.76) to display the floating Bristle preview panel shown in Figure 1.77. The Brush preview can also be turned on or off via the View/Show menu (or use $\mathfrak{H}(\mathcal{H}[Mac], \mathfrak{ctrl}(\mathcal{H}[PC])$). As you adjust the slider controls the Bristle preview provides visual feedback as to how this affects the current bristle tip behavior.

The Bristles slider determines the density of the number of bristles within the current brush size. The Length determines the length of the bristles relative to the shape and size of the selected brush. The Thickness determines the thickness of each bristle. The Stiffness controls the stiffness or resistance of the bristles. The Angle slider determines the angle of the brush position—this isn't so relevant for pen tablet users, but more so if you are using a mouse. Lastly, the Spacing slider sets the spacing between each stamp of the brush stroke.

Brush stroke smoothing

The Smooth slider control in the Options bar for the Brush, Eraser, Mixer Brush, and Pencil tools can be used to vary the amount of brush smoothing. This can help you produce smoother brush strokes when painting (even when using a mouse) and smooth out any jaggedness in your brush drawing. However, as you increase the smoothness (and therefore use a greater range of input points to smooth out the stroke) the Smoothed brush performance will lag slightly.

The Smoothing Options (Figure 1.78) are accessed via the gear wheel next to the slider. When Stroke Catch-up is checked, the paint stroke will continue to draw up to the cursor while a brush stroke is paused (see Figure 1.79). Otherwise, the brush stroke will stop when the cursor stops moving. Catch-up on Stroke End continues the brush stroke to the point where you release the mouse click or lift the stylus. This is useful for getting paint strokes to connect up to where you lift the cursor. When this is unchecked the paint drawing discontinues as soon as you release the mouse or lift the pen. When the Pulled String Mode is checked the Stroke Catch-up and Catch-up on Stroke End options are grayed out. This essentially provides some slack to the pen/mouse drawing input and can best be described as 'towing' the direction of the pen/mouse drawing. One advantage of this mode is that it enables you to combine smooth curves with sharp corners. It makes more sense if you have the Show Brush Leash option enabled in the Cursor preferences, where you will notice the length of the leash is linked to the Smoothness setting. The Adjust for Zoom option links the smoothness to the document zoom level. As the zoom level is decreased the smoothing is increased.

Keyboard shortcut

Hold down the *etc* key and type a number, such as 3 to set the smoothing to 30%, or type 35 to set to 35%.

Adobe Color Themes panel

The Adobe Color Themes panel (Figure 1.80) restores Kuler functionality to Photoshop. Kuler was removed when Photoshop CC was first released due to the removal of Flash support from Photoshop. This panel provides the same level of functionality allowing users to explore lots of different color combination themes as well as create their own custom themes.

Automatically add colors to the Swatches panel

As you sample colors with the Eyedropper tool, or via the Color Picker, this automatically adds color samples to the top row of the Swatches panel (Figure 1.81). This can be useful because it means you can make a series of color samples by clicking with the eyedropper tool and these will automatically be added to the Swatches panel ready for use in the same or another document. You don't have to explicitly save the swatches, as it semi-permanently adds them to the swatches collection.

Save

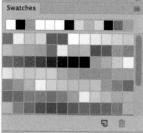

0

100 100

My Color Theme

CMYK

LAB: 54 80 69

Figure 1.81 The Swatches panel.

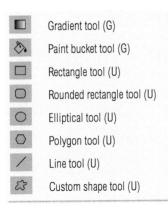

Tools for filling

The Gradient tool may certainly be of interest to photographers. For example, you can use the Adjustment layer menu to add Gradient fill layers to an image. Gradient fill layers can be applied in this way to create gradient filter type effects. You will also find that the Gradient tool comes in use when you want to edit the contents of a layer mask. For example, you can add a black to white gradient to a layer mask to apply a graduated fade to the opacity of a layer.

The Paint bucket tool is another type of fill tool and is a bit like a combination of a magic wand selection combined with an Edit \Rightarrow Fill using the foreground color.

The shape tools, including the Line tool, are mostly useful to graphic designers who wish to create things like buttons or who need to add vector shapes to a design layout. Figure 1.82 shows a Background image layer with a Gradient adjustment layer added and above that a filled, custom shape vector layer.

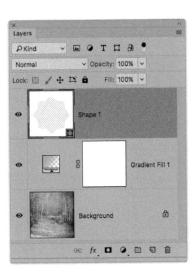

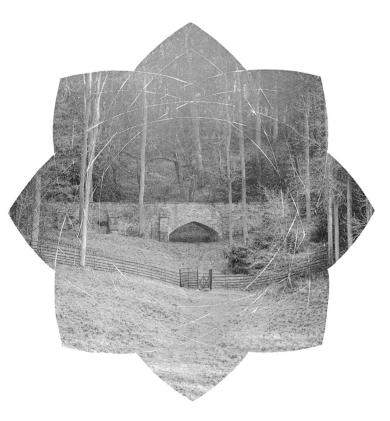

Figure 1.82 In this example I added a linear gradient using a transparency to cyan gradient. Above this I added a custom shape layer filled with white.

Tools for drawing

If you want to become a good retoucher, then at some stage you are going to have to bite the bullet and learn how to use the Pen tool. The selection tools are fine for making approximate selections, but whenever you need to create precision selections or masks, the Pen tool and associated path editing tools are essential. If you need to isolate an object and create a cut-out like the one shown in Figure 1.83, the only way to do this is by using the Pen and Pen modifier tools to draw a path outline. You see, with a photograph like this, there is very little color differentiation between the object and the background, and it would be very difficult for an auto masking tool to accurately predict the edges in this image. With experience it doesn't take too long to create a cut-out like this.

The Pen tool group includes the main Pen tool, a Freeform pen tool (which in essence is a vector version of the Lasso or Magnetic lasso tools), a Curvature pen tool plus modifier tools to add, delete, or modify the path points. There are several examples coming up in Chapter 8 where I will show how to use the pen tools to draw a path.

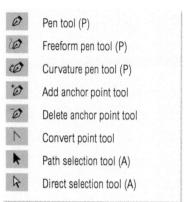

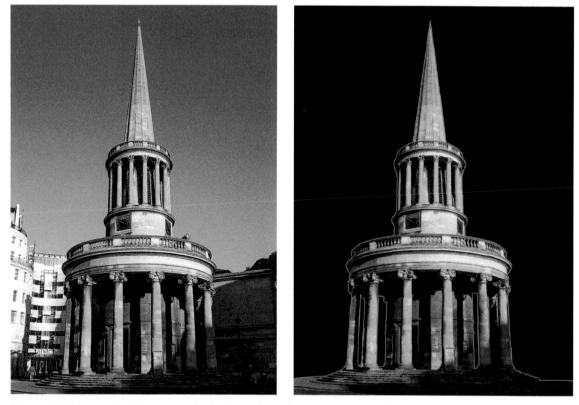

Figure 1.83 An example of how a pen path selection can be used to create a cut-out mask.

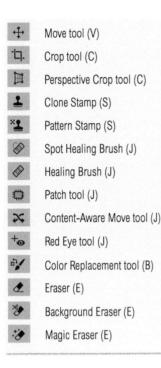

Image editing tools

The Move tool can be used to move objects, while the Crop tool can be used to trim pictures or enlarge the canvas area. The Perspective Crop tool can be used to crop and align the vertical and horizontal lines in an image.

The Clone Stamp tool has been around since the early days of Photoshop and is an essential tool for all kinds of retouching work. You can use the Clone Stamp to sample pixels from one part of the image and paint with them in another (as shown in Figure 1.84). In this example, the Clone Stamp tool was used to sample detail from different parts of the image to remove all the white spots in the original. Notice how the retouching work was applied to an empty new layer and the Sample: 'Current & Below' option selected in the Clone Stamp tool Options bar.

The Spot Healing and Healing Brush tools can be used in almost exactly the same way as the Clone Stamp, except they cleverly blend the pixels around the edges of where the Healing Brush retouching is applied to produce almost flawless results. The Spot Healing Brush is particularly clever because you don't even need to set a sample point: you simply click and paint over the blemishes you wish to see removed. This tool has an enhanced content-aware healing mode that allows you to tackle what were once really tricky subjects to retouch. The Patch tool is similar to the Healing Brush except you first use a selection to define the area to be healed and there is also a Content-Aware Move tool that can be used to either extend a selected area or move it and at the same time fill the initially selected area.

The Red Eye tool is designed to remove red eye from portrait photos. Providing you use the right flash settings on your camera it should be possible to avoid red eye from ever occurring. But for those times where the camera flash leaves your subjects looking like beasts of the night, the Red Eye tool can come to the rescue. Meanwhile, the Color Replacement brush is like a semi-smart color blend mode painting tool that analyzes the area you are painting over and replaces it with the current foreground color, using a Hue, Color, Saturation, or Luminosity blend mode. It is perhaps useful for making quick and easy color changes without needing to create a Color Range selection mask first.

The Eraser tools let you erase pixels directly, although these days it is better to use layer masks to selectively hide or show the contents of a layer. The Background Eraser and Magic Eraser tools do offer some degree of automated erasing capabilities, but I would be more inclined to use the Quick Selection tool combined with a layer mask for this kind of task.

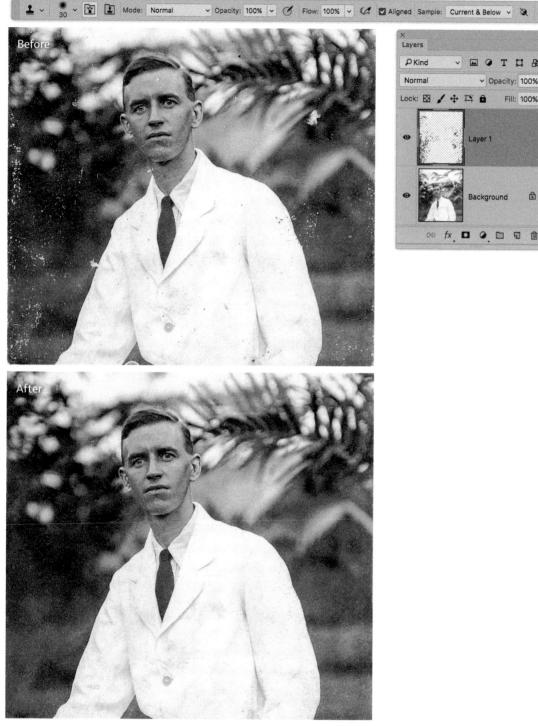

Figure 1.84 An example of the Clone Stamp being used to retouch an image.

C

Nudging layers and selections

The keyboard arrow keys can be used to nudge a layer or selection in 1 pixel increments, or with the *Shift* key held down, by 10 pixel increments. A series of nudges count as a single Photoshop step in history and can be undone with a single undo (**H** (**C** [Mac], *cttl* **C** [PC]) or a step back in history. Also, holding down the *Shift* key as you drag allows you to constrain the move direction to the horizontal, vertical or 45° angle.

Move tool

The Move tool can perform many functions. You can use it to move the contents of a layer, directly move layers from one document to another, copy layers, apply transforms, and select and align multiple layers. In this respect the Move tool might be more accurately described as a move/transform/alignment tool and you'll also see a heads-up display that indicates how much you are moving something. The Move tool can also be activated any time another tool is selected simply by holding down the 🔢 (Mac), *ctrl* (PC) key (except when the Slice tools, Hand tool, Pen, or path selection tools are selected). If you hold down the alt key while the Move tool is selected, this lets you copy a layer or selection contents. It is also useful to know that using all H (Mac), alt ctrl (PC) lets you make a copy of a layer or selection contents when any other tool is selected (apart from the ones I just listed). If the Show Transform Controls box is checked in the Move tool Options bar (Figure 1.85), a bounding box will appear around the bounds of the selected layer. When you mouse down on the bounding box handles to transform the laver, the Options bar switches modes to display the numeric transform controls.

Figure 1.85 The Move tool Options bar with the Auto-Select layer option checked. You can select Group or Layer from the pop-up menu here.

Auto layer/layer group selection

The Move tool Options panel has a menu that allows you to choose between 'Group' or 'Layer' auto-selection. When 'Layer' is selected, Photoshop only auto-selects individual layers. When 'Group' is selected, Photoshop can auto-select whole layer groups. If the Move, Marquee, Lasso, or Crop tool are selected, a **36 C**+ right mouse-click [Mac], *ctr1 att* + right mouseclick [PC] selects a target layer based on the pixels where you click. When the Move tool only is selected, **37 C** *I att* [PC] + click selects a layer group based on the pixels where you click.

Layer selection using the Move tool

When the Move tool is selected, dragging with the Move tool moves the layer or image selection contents (the cursor does not have to be centered on the object or selection, it can be anywhere in the image window). However, when the Auto-Select option is switched on (circled in Figure 1.85), the Move tool can be used to click and auto-select the uppermost layer (or layer group) containing the most opaque image data below the cursor. This can be useful when you have a large number of layers in an image. Multiple layer selection is also possible with the Move tool. When the Move tool is in Auto-Select mode you can marquee drag with the Move tool from outside the canvas area to select multiple layers, the same way as you can make a marquee selection using the mouse cursor to select multiple folders or documents in the Finder/Explorer.

In Figure 1.86 the Move tool was selected and the Auto-Select box checked. I was able to marquee drag with the Move tool from outside of the canvas area inwards to select specific multiple layers or layer groups. If the Auto-Select Layer option is deselected, you can instead hold down the **(H)** [Mac], *ctrl* [PC] key to temporarily switch the Move tool to the 'Auto-Select' mode.

Where you have many layers that overlap, there is a contextual mode for the Move tool that can help you target specific layers (use *ctrl* right mouse-click to access the contextual layer menu). Any layer with an opacity greater than 50% will show up in the contextual menu. This then allows you to select a specific layer from below the cursor.

However, the Move tool layer selection method won't select any layers that are locked. For example, if you use the Auto-Select layer mode to marquee drag across an image to make a layer selection, the background layer won't be included in the selection.

You can at any time use the **H** (Mac), *cttl* (PC) shortcut to select all layers.

Align/Distribute layers

When several layers are linked together, you can click on the Align and Distribute buttons in the Options bar as an alternative to navigating the Layer ➡ Align Linked and Distribute Linked menus.

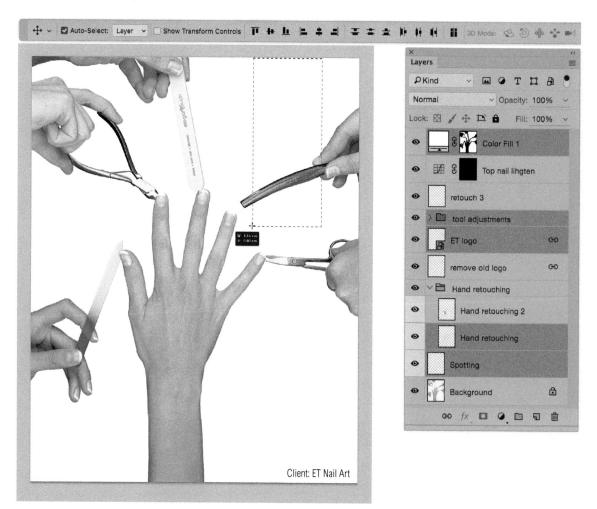

Figure 1.86 The Move tool being used to make a layer selection.

Navigation and information tools

Zoom tool

To zoom in on an image, you can either click with the Zoom tool to magnify, or drag with the zoom tool, marqueeing the area you wish to inspect in close-up. This combines a zoom and scroll function in one (a plus icon appears inside the magnifying glass icon). To zoom out, hold down the *all* key and click (you'll see a minus sign). You can also zoom in by holding down the spacebar + the *H* key (Mac) or the *cltl* key (PC). You can then click to zoom in. To zoom out, hold down the spacebar + the *all* key and click to zoom out. Double-click the zoom tool icon to magnify an image to 100%.

There are further zoom control buttons in the Zoom tool Options bar (Figure 1.87). Here, you can use the Resize Windows to Fit option to make windows resize to the selected zoom level. Zoom All Windows can be useful where you have multiple windows open. If 'Use Graphics Processor' is enabled, 'Scrubby Zoom' will be checked. This overrides the marquee zoom behavior—dragging to the right zooms in and dragging to the left zooms out. Next to this are the following zoom buttons: 100%, Fit Screen, and Fill Screen.

Zoom tool shortcuts

Photoshop uses the 3 (Mac), ctrl (PC) shortcut to zoom to 100% (or you can use 3 (Mac), ctrl alt 0 [PC]) and 3 (Mac), ctrl (PC) to zoom out to a fit to view zoom view. Another handy zoom shortcut is 3 (Mac), ctrl (PC) to zoom in and 3 (Mac), ctrl (PC) to zoom out (note the 4 key is really the key). If your mouse has a wheel and 'Zoom with mouse wheel' is selected in the preferences, you can use it with the alt key held down to zoom in or out. If 'Use Graphics Processor' is enabled you can carry out a continuous zoom by simply holding down the Zoom tool (and use alt to zoom out). Photoshop also supports two-fingered zoom gestures such as drawing two fingers together to zoom out and spreading two fingers apart to zoom in.

Hand tool

When you view an image close-up, you can select the Hand tool from the Tools panel () and drag to scroll the image. Or you can hold down the spacebar at any time to temporarily access the Hand tool (except when the type tool is selected). Double-clicking the Hand tool icon in the Tools panel will make an image fit to a screen size view.

Bird's Eye View

The Bird's Eye View feature is available whenever 'Use Graphics Processor' is enabled in the Performance preferences. If you are viewing an image in a close-up view, you can hold down the **(f)** key and, as you do this, if you click with the mouse, the image view swiftly zooms out to fit to the screen and at the same time shows an outline of the close-up view screen area (a bit like the preview in the Navigator panel). With the **(f)** key and mouse key still held down, you can drag to reposition the close-up view outline, release the mouse and the close-up view will re-center to the newly selected area in the image (see Figure 1.88).

Figure 1.88 When viewing a photo close-up you can use the Bird's Eye View method to quickly zoom out.

Figure 1.89 The Info panel.

Figure 1.90 The Eyedropper tool heads up display wheel.

Flick panning

With 'Use Graphics Processor' enabled in the Photoshop Performance preferences, you can also check the Enable Flick Panning option in the Tools preferences. When this option is activated, Photoshop will respond to a 'flick of the mouse' pan gesture by continuing to scroll the image in the direction you first scrolled, taking into account the acceleration of the flick movement. When you have located the area of interest just click again with the mouse to stop the image from scrolling any further.

Windows Multi-touch support

If you are using a Windows 7 or later operating system and have multi-touch aware hardware, Photoshop supports touch zoom in and out, touch pan/flicking as well as touch canvas rotation. This includes Windows devices such as the Microsoft Surface Pro.

Eyedropper tool

The Eyedropper tool can be used to measure pixel values directly from a Photoshop document, which are displayed in the Info panel. Figure 1.89 shows an Eyedropper tool color reading, a measurement readout, and two Color sampler readouts below. You can have up to ten color samplers in the Info panel. Photoshop also has a heads up display for the Eyedropper tool. In Figure 1.90, the outer gray circle is included to help you judge the inner circle colors more effectively. The top half shows the current selected color and the bottom half, the previous selected color. The sample ring display can be disabled via the Evedropper options. The Color sampler tool can be used to place up to four color samplers in an image to provide persistent readouts of the pixel values. This is useful for those times when you need to closely monitor the pixel values as you make image adjustments. The Eyedropper tool Options bar (Figure 1.91) provides a number of sample area size options (the sample size pop-up menu also appears when using various other eyedropper tools, such as black point and white point eyedroppers in Levels and Curves). Plus you can choose various sampling options from the Sample menu.

Figure 1.91 The Eyedropper tool Options bar.

Ruler tool

The Ruler tool can be used to measure distance and angles in an image and again, this data is displayed in the Info panel, such as in the example shown in Figure 1.89.

Rotate View tool

If 'Use Graphics Processor' is enabled in the Performance preferences, you can use the Rotate View tool to rotate the Photoshop image canvas (as shown below in Figure 1.92). Being able to quickly rotate the image view can sometimes make it easier to carry out certain types of retouching work, rather than be forced to draw or paint at an uncomfortable angle. To use the Rotate View tool, first select it from the Tools panel (or use the **Rotate Photoshop**) and click and drag in the window to rotate the image around the center axis. As you do this, you will see a compass overlay that indicates the image position relative to the default view angle (indicated in red). This can be useful when you are zoomed in close on an image. To reset the view angle to normal again, just hit the **esc** key or click on the Reset View button in the Options bar.

Non-rotating brushes

If you use the Rotate view tool to rotate the canvas, Photoshop prevents the brushes from rotating too. You can continue to paint with the same brush orientation at all canvas rotation angles.

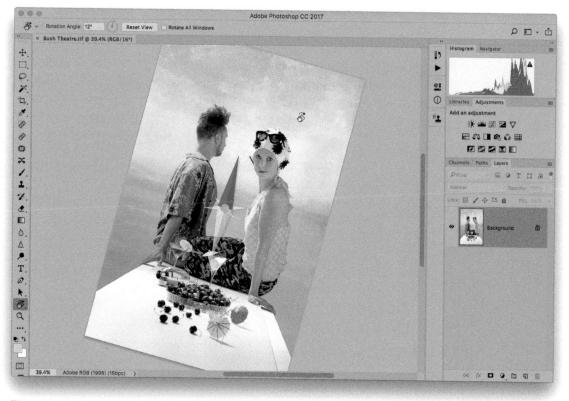

Figure 1.92 This shows the Rotate View tool in action.

Photograph: Eric Richmond

Figure 1.93 The Notes panel.

Notes tool

The Notes tool is handy for adding sticky notes to open images. You can use the Notes panel (Figure 1.93) to store the recorded note messages. This method makes the notes display and management easy to control. I have used this tool quite a lot at work, because when a client would call me to discuss a retouching job, I could open the image, click on the area that needs to be worked on, and use the Notes panel to type in the instructions for whatever further retouching needed to be done to the image. If the client you are working with is also using Photoshop, they can use the notes feature to mark up images directly, which when opened in Photoshop can be inspected as shown in Figure 1.94 below.

Count tool

The Count tool is useful to those working in areas like medical research where, for example, you can use the Count tool to count the number of cells in a microscope image.

Photograph: Eric Richmond

Screen view modes

The screen view mode options allow you to switch between the three main screen view modes. In Figure 1.95 the Standard Screen Mode view is show top and the Full Screen Mode with Menu Bar below. The Standard Screen view displays the application window the way it has been shown in all the previous screen shots and lets you view the document windows as floating windows or tabbed to the dock area. In Full Screen Mode with Menu Bar, the frontmost document fills the screen, while allowing you to see the menus and panels. Lastly, the Absolute Full Screen view mode displays a full screen view against a black canvas with the menus and panels hidden.

Full view screen mode

The Full Screen Mode with Menu Bar and Full Screen modes are usually the best view modes for concentrated retouching work. These allow full movement of the image, not limited by the edges of the document bounds. In other words, you can scroll the image to have a corner centered in the screen and edit things like path points outside the bounds of the document. The key can be used to cycle between screen modes and Shift E to cycle backwards. Mac users have the option to change the full-screen mode to use Mac OS native windowing. This allows for better Mission Control compatibility, especially when switching between apps.

Figure 1.95 Two of Photoshop's three screen view modes.

Blending modes

Layers can be made to blend with the layers below them using any of the 27 different blending modes in Photoshop. Layer effects/styles can be used to add effects such as drop shadows, gradient/pattern fills or glows to any layer, plus custom layer styles can be loaded from and saved to the Styles panel.

Layers PKind Norma + 13 Lock: 83 Shadow lave Brick laver 0 Wall image left wa 6 right wall GO œ 8 0 Background GÐ fx 🗖 🥥 俞

Working with Layers

Photoshop layers let you edit a photograph by building up the image in multiple layered sections, such as in Figure 1.96. This shows the layer contents of a typical layered Photoshop image and also how the composite image is broken down into its constituent layers. A layer can be an image element, such as a duplicated background layer, a copied selection that's been made into a layer, or content that has been copied from another image. Or, you can have text or vector shape layers. You can also add adjustment layers, which are like image adjustment instructions applied in a layered form.

Layers can be organized into layer group folders, which will make the layer organization easier to manage. You can drag and drop a file to a Photoshop document and place it as a new layer. And, you can also apply a mask to the layer content using either a pixel or vector layer mask. You will find there are plenty of examples throughout this book in which I show how to work with layers and layer masks.

Figure 1.96 The Layers panel view (left) and constituent layers (right).

Preset Manager

The Preset Manager (Edit \Rightarrow Presets \Rightarrow Preset Manager) lets you manage all your presets from within the one dialog. This allows you to keep track of: Brushes, Swatches, Gradients, Styles, Patterns, Layer effect contours, Custom shapes, and Tools (Figure 1.97 shows the Preset Manager used to manage the Tool presets). You can append or replace an existing set of presets via the Preset Manager options and the Preset Manager can also be customized to display the preset information in different ways. In the Figure 1.98 example I used a Large List to display large thumbnails of all the currently loaded Gradient presets.

If you double-click a Photoshop preset setting that is outside the Photoshop folder, this automatically loads the Photoshop program and appends the preset to the relevant section in the Preset Manager.

Preset Type: Tools	Ø. Done
Healing Brush 21 pixels	
Magnetic Lasso 24 pixels	Load
L. Crop 4 inch x 6 inch 300 ppi	Luad
다. Crop 5 inch x 3 inch 300 ppi	Save Set
니. Crop 5 inch x 4 inch 300 ppi	
니, Crop 5 inch x 7 inch 300 ppi	Rename
다. Crop 8 inch x 10 inch 300 ppi	
S Fill with Bubbles Pattern	Delete
Ø Peanut Dash	
T Horizontal Type Tool Myriad Pro Regular 24 pt	
T Vertical Type Tool Myriad Pro Regular 24 pt	
Stamp Edge	
Coupon with Haiftone Fill	
C	

Saving presets as Sets

As you create and add your own custom preset settings, you can manage these via the Preset Manager. For example, you can select a group of presets and click on the Save Set... button to save these as a new group of presets. If you rearrange the order of the tool presets, the edited order will remain sticky when you next relaunch Photoshop.

Figure 1.97 You can load and replace presets and choose how presets are displayed.

Preset Type: Gradients	Text Only
Foreground to Background	Small Thumbnail Large Thumbnail
Foreground to Transparent	Small List ✓ Large List
Black, White	Reset Gradients
Red, Green	Replace Gradients.
Violet, Orange	Color Harmonies 1 Color Harmonies 2
Blue, Red, Yellow	Metals
Blue, Yellow, Blue	Neutral Density Noise Samples
Orange, Yellow, Orange	Pastels Photographic Toning
Violet, Green, Orange	Simple Special Effects
Anno second and a second second	Spectrums

Figure 1.98 In the case of Gradients, it's helpful to see a preview alongside each gradient.

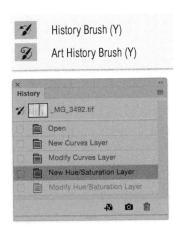

Figure 1.99 The History panel.

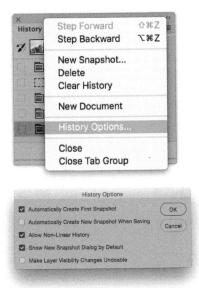

Figure 1.100 The History Options dialog.

History

The History feature allows you to carry out multiple undos during a single Photoshop editing session. History can play a really important role in the way you use Photoshop. As you work on an image, Photoshop records a history of the various image states as steps, which can be viewed in the History panel. If you want to reverse a step, you can always use the Edit \Rightarrow Undo command ($\Re \mathbb{Z}$ [Mac], *ctrl* \mathbb{Z} [PC]). This shortcut toggles between Undo and Redo. To progressively undo you can use $\Re \mathbb{A}$ (Mac), *ctrl* \mathbb{A} (PC). Or, you use the History panel instead to go back as many stages in the edit process as you have saved history steps.

The History panel

The History panel (Figure 1.99) displays the sequence of Photoshop steps that have been applied during a Photoshop session. Its main purpose is to let you manage and access the history steps that have been recorded in Photoshop. The history source column in the History panel can be used to select a history state to sample from when working with the History Brush (or filling from history). So, to revert to a previous step, just click on a specific history step. For example, in Figure 1.99 I selected the original image open state as the source. In the default configuration, you'll notice when you go back in history, the history steps after the one that is selected will appear dimmed. If you move back in history and you then make further edits to the image, the history steps after the selected history step will be deleted. Document saves can also be recorded in the History panel. This means Photoshop will automatically store a history state each time you save and gives you more options to revert to during an edit session. However, it doesn't mean history states are saved after you have closed a document.

You can look at History as a multiple undo feature in which you can reverse through up to 1000 image states. However, it is actually a far more sophisticated tool than that. For example, there is a non-linear history option for multiple history path recording. In Figure 1.100, you can see how the History Options can be accessed via the History panel fly-out menu. These allow you to configure things like the Snapshot and non-linear history settings. Non-linear history lets you shoot off in new directions and still preserve all the original history steps. I usually have Allow Non-Linear History option checked and enables me to use the History feature to its full potential (see page 70). Painting from history can therefore save you from tedious workarounds like having to create more layers than are really necessary in order to preserve fixed image states that you can sample from. With history you don't have to do this and by making sensible use of non-linear history, you can keep the number of layers that are needed to a minimum.

By default, history automatically creates an 'open' state snapshot each time you open an image and you can also choose to create additional snapshots each time an image is saved. Basically, Snapshots can be used to prevent history states from slipping off the end of the list and becoming deleted as more history steps are created (see page 68–69). 'Make Layer Visibility Changes Undoable' makes switching layer visibility on or off a recordable step in history, although this can be annoying if turning the layer visibility on or off prevents you from using an undo/redo toggle to undo the last Photoshop step.

History settings and memory usage

When the maximum number of recordable history steps has been reached, the earliest history step at the top of the list is discarded. With this in mind, the number of recorded histories can be altered via the Performance preferences (Figure 1.101). If you reduce the number of history states (or steps) that are allowed, any subsequent action will immediately cause all earlier steps beyond this new limit to be discarded.

	Preferences		
General Interface Workspace Tools History Log File Handling Export	Memory Usage Available RAM: 30620 MB Ideal Range: 16841-22046 MB Let Photoshop Use: 21434 MB (70%)	Graphics Processor Settings Detected Graphics Processor: ATI Technologies Inc. AMD Radeon R9 M296X OpenGL Engine Use Graphics Processor Advanced Settings	OK Cance Prev Next
Performance Scratch Disks Cursors Transparency & Gamut Units & Rulers Guides, Grid & Silces Plug-Ins Type 3D Enhanced Controls	History & Cache Optimize Cache Levels and Tile Size for: Web / UI Design Default / Photos Huge Pixel Dimensions	History States: 50 Cache Levels: 4 Cache Tile Size: 1024K Set Cache Levels to 2 or higher for optimum GPU performance.	
Technology Previews	Description The 'Optimize' buttons take your hardware configuration into History States: Maximum number of history states to retain in to Cache Levels: Number of cached levels of image data. Used to more Cache Levels for bigger documents with flaw layers; choor layers. Changes will take effect the next time you start Photosh cache Tile Size: Amount of data Photoshop stores or processes documents with large pixel dimensions; choose smaller tiles for layers. Changes will take effect the next time you start Photosh	te History panel. Improve screan redraw and histogram speed. Choose se fewer Cache Levels for smaller documents with many op. at once. Choose bigger tiles for faster processing of documents with small black dimensions and many	

Figure 1.101 The number of recorded history states can be set via the History & Cache section of the Performance preferences dialog.

History stages	Scratch
	disk
Open file	1360 MB
Add new layer	1360 MB
Healing Brush	1670 MB
Healing Brush	1670 MB
Marquee selection	1610 MB
Feather selection	1630 MB
Inverse selection	1660 MB
Add adjustment layer	1700 MB
Modify adjustment layer	1700 MB
Flatten image	1630 MB

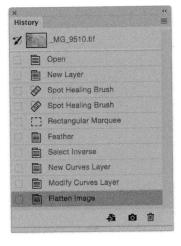

Figure 1.102 The accompanying table shows how the scratch disk usage can fluctuate during a typical Photoshop session.

Conventional wisdom would suggest that a multiple undo feature is bound to tie up vast amounts of scratch disk space to store all the previous image steps. However, this is not really the case. It is true that a series of global Photoshop steps may cause the scratch disk usage to rise, but localized changes will not. This is because the history feature makes clever use of the image cache tiling structure to limit any unnecessary drain on the memory usage. Essentially, Photoshop divides an image up into tiled sections and the size of these tiles can be set in the Performance preferences (see Figure 1.101). Because of the way Photoshop images are tiled, the History feature only needs to memorize the changes that take place in each tile. Therefore, if a brush stroke takes place across two image tiles, only the changes taking place in those tiles needs to be updated. If a global change such as a filter effect takes place, the whole of the image area is updated and the scratch disk usage rises accordingly. You can therefore customize the History feature to record a reasonable number of histories, but at the same time be aware of the need to change this setting if the history usage is likely to place too heavy a burden on the scratch disk. The history steps shown in Figure 1.102 demonstrate that successive histories need not consume an escalating amount of memory. The image I opened here was 160 MB in size and 21 GB of memory was allocated to Photoshop. The scratch disk overhead is usually quite big at the beginning of a Photoshop session, but notice how there was little proportional increase in the scratch disk usage with each successive history step. In this example, the Spot Healing Brush work only affected the tiled sections. After the first adjustment layer had been added, successive adjustment layers had little impact on the scratch disk usage (because only the screen preview was being changed). By the time I got to the 'flatten image' stage the scratch disk/memory usage had begun to bottom out.

If the image you are working with is exceptionally large, then having more than, say, ten undos can be both wasteful and unnecessary, so you should perhaps consider restricting the number of recordable history states. On the other hand, if multiple history undos are well within the scratch disk memory limits of your system, then why not make the most of them?

If excessive scratch disk usage does prove to be a problem, the Purge History command in the Edit \Rightarrow Purge menu provides a useful way to keep the scratch disk memory usage under control. Above all, remember that the History feature is more than just a mistakecorrecting tool; it has great potential for mixing composites from previous image states.

History Brush

The History Brush can be used to paint from any previous history state and allows you to selectively restore image data as desired. To do this you need to leave the current history state as it is and select a source history state for the History Brush by clicking in the box next to the history step you wish to sample from and paint with. In Figure 1.103 you can see how I had set the 'New Layer' history step as the history source (notice the small History Brush icon next to this step). This allowed me to paint with the History brush from this previous history state, painting over the areas that had been worked on with the Spot Healing Brush and use the History Brush to restore those parts of the picture back to its previous, 'New Layer' history state. You can also Fill from the selected history source. If you select Fill... from the Edit menu there is an option in the Contents Use menu to choose 'History'.

Use of history versus undo

The History feature has been carefully planned to provide the most flexible and logical approach. History is not just an "Oh I messed up. Let's go back a few stages" feature, the way some other programs work; it is a tool designed to ease the workflow and provide you with extra creative options in Photoshop. For example, there are a number of Photoshop procedures that are *only undoable* through using the Edit \Rightarrow Undo command, like intermediate changes made when setting the shadows and highlights in the Levels dialog. There are also things which can be undone using Edit \Rightarrow Undo that have nothing to do with Photoshop's history record for an image. For example, if you delete a history state, this is only recoverable by using Edit \Rightarrow Undo.

Art History Brush

The Art History Brush is something of an oddity. It is a History Brush that allows you to paint from history but does so via a brush which distorts the sampled data and can be used to create impressionist type painting effects. You can learn more about this tool from the *Photoshop for Photographers Help Guide* that's on the book website.

Snapshots

Snapshots are stored above the History panel divider and used to record the image in its current state so as to prevent this version of the image from being overwritten, and for as long as the document is open and being edited in Photoshop. The default settings for the History panel will store a snapshot of the image in its opened state and you

Figure 1.103 A previous history state can be selected as the source via the History panel.

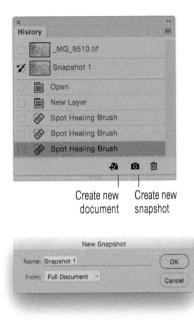

Figure 1.104 The History panel with the Create new document and Create new snapshot buttons highlighted and the New Snapshot dialog below. can create further snapshots by clicking on the Snapshot button at the bottom of the panel (see Figure 1.104).

To record a new snapshot, click on the Create New Snapshot button at the bottom of the History panel. This records a snapshot of the history at this stage. If you *all*-click the button, there are three options: Full Document, which stores all layers intact; Merged Layers, which stores a composite; and Current Layer, which stores just the currently active layer. If you have the Show New Snapshot dialog by Default turned on in the History panel options, the New Snapshot dialog appears directly, without you having to *all*-click the New Snapshot button.

The Snapshots feature is particularly useful if you have an image state that you wish to store temporarily and don't wish to lose as you make further adjustments to the image. There is no real constraint on the number of snapshots that can be added, and in the History panel options (Figure 1.100) you can choose to automatically generate a new snapshot each time you save the image (which will also be timestamped). The Create New Document button (next to the Create new snapshot button) can be used to create a duplicate image state in a new document window and saved as a separate image.

Non-linear history

The non-linear history option lets you branch off in several directions and experiment with different effects without needing to add new layers. Non-linear history is not an easy concept to grasp, so the best way to approach this is to picture a series of history steps as having more than one 'linear' progression, allowing the user to branch off in different directions in Photoshop instead of in a single chain of events. Therefore, while you are working on an image in Photoshop, you have the opportunity to take an image down several different routes and a history step from one branch can then be blended with a history step from another branch without having to save duplicate files.

In Figure 1.105, three history states were selected from the History panel: (A) the initial opened image state, (B) where I converted the photo to black and white, and (C) an alternative version where I modified the color and hue/saturation of the original.

Non-linear history requires a little more thinking on your part in order to monitor and recall image states, but ultimately makes for a more efficient use of the available scratch disk space. Overall, I find it useful to have non-linear history switched on all the time, regardless of whether I need to push this feature to its limits or not.

	Screen Shot 2016-02-12 at 15.02
PHG PHG	Screen Shot 2016-02-12 at 15.02.40 3 ME Modified: Today 15:02
Add T	ags
▶ Gen	ieral:
► Mor	re info:
▶ Nan	ne & Extension:
▶ Con	nments:
♥ Ope	en with:
-	Preview (default)
Use t one.	this application to open all documents like this
Cha	ange All
▶ Pre	view:

Figure 1.106 Here, the File Info dialog shows Preview is the default application used to open this file.

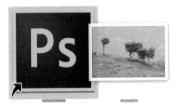

Figure 1.107 Drag the file icon on top of the Photoshop application icon, an alias to force open an image.

When files won't open

You can open an image file in Photoshop in a number of ways. You can open an image via Bridge, or you can simply double-click a file to open it. As long as the file you are about to open is in a file format that Photoshop recognizes, it will open in Photoshop and if the program is not running at the time this action should also launch Photoshop.

Every document file contains a header section, which among other things tells the computer which application should be used to open it. When files won't open up directly in Photoshop the way you expect them to, it may be because the header is telling the computer to open them up in some other program instead. Photoshop can recognize nearly all types of image documents regardless of the application they may have originated from, but sometimes you will see an image file with an icon for another specific program, like Macintosh Preview, or Internet Explorer. If you double-click these particular files, they will open in their respective programs. To get around this, you can go to the File menu and choose File \Rightarrow Get Info (see Figure 1.106) and under the 'Open with' item, change the default application to Photoshop. On a PC you can do the same thing via the File Registry. Alternatively, you can use the File \Rightarrow Open command from within Photoshop, or drag a selected file (or files) to the Photoshop program icon, a shortcut/alias of the program icon, or Apple Dock icon to force open (see Figure 1.107). In each of these cases this allows you to override the computer operating system which normally reads the file header to determine which program the file should be opened in. If you use Bridge as the main interface for opening image files in Photoshop, then you might also want to open the File Type Association preferences (see the Bridge chapter PDF on website) to check that the file format for the files you are opening are all set to open in Photoshop by default.

Yet, there are times when even these methods may fail and this points to one of two things. Maybe the file extension has been wrongly changed. It says .psd, but is it really a PSD? Is it possible that someone has accidentally renamed the file with an incorrect extension? In these situations, the only way to open it will be to rename the file using the correct file extension, or use the Photoshop File \Rightarrow Open command and navigate to locate the mis-saved image (which once successfully opened should then be resaved to register it in the correct file format). Or, you have a corrupt file, in which case the damage is most likely permanent. This can happen when images are sent as attachments. Here, it is most likely due to a break during transmission somewhere, resulting in missing data. If you are still having trouble trying to open a corrupted file, the Graphic Converter program can sometimes be quite effective at opening mildly corrupted image files.

Save often

As with all other programs, the keyboard shortcut for saving a file is: (Mac), *ctrl* (CPC). If you are editing an image that has never been saved before or the image state has changed (so that what started out as a flattened JPEG, now has layers added), this action will pop the Save As...dialog. Subsequent saves may not show the Save dialog. But if you do wish to force the Save dialog to appear and save a copy version, use: **H** (Mac), *ctrl* all (CPC).

It goes without saying that you should always remember to save often while working in Photoshop. Hopefully, you won't come across many crashes when working with the latest Macintosh and PC operating systems, and the fact that Photoshop can carry out automatic background saves is a real bonus, but there are still some pitfalls you need to be aware of.

Choosing File \Rightarrow Save always creates a safe backup of your image, but as with everything else you do on a computer, do make sure you are not overwriting the original with an inferior modified version. There is always the danger that you might make permanent changes such as a reduction in image size, accidentally hit 'Save' and overwrite the original in the process. If this happens, there is no need to worry so long as you don't close the image. You can always go back a step or two in the History panel and resave the image in the state it was in before it was modified. Incidentally, Photoshop CC allows you to save multiple documents at once, placing them in a queue.

When you save an image in Photoshop, you will normally overwrite the original. But sometimes you are forced to save a new version using the Photoshop file format. The determining factor here will be the file format the image was in when you opened it and how it has been modified in Photoshop. Over the next few pages I'll be discussing some of the different file formats you can use, but the main thing to be aware of is that some file formats do restrict you from being able to save things like layers, pen paths, or extra channels. For example, if you open a JPEG format file in Photoshop and modify it by adding a pen path, you can choose File \Rightarrow Save and overwrite the original without any problem. However, if you open the same file and add a layer or an extra alpha channel, you won't be able to save it as a JPEG any more. This is because although a JPEG file can contain pen paths, it doesn't support layers or additional channels, so it has to be saved using a file format that is capable of containing these extra items.

I won't go into lengthy detail about what can and can't be saved using each format but, basically, if you modify a file and the modifications can be saved using the same file format that the original started out in, then Photoshop will have no problem saving and

Closing unchanged files (Mac)

On the Mac S -clicking the Close button on one open image will close all the others that have remained unchanged. Where images have had changes it will stop to ask whether you want to save these or not. overwriting the original. If the modifications applied to an image mean that it can't be saved using the original file format it will default to using the PSD (Photoshop document) format and save the image as a new document via the Save As dialog (Figure 1.108). Here, you do have the option to choose an alternative file format when saving. Essentially, there are four main file formats that can be used to save everything, such as image layers, type layers, and channels, and which also support 16-bits per channel. These are: TIFF, Photoshop PDF, PSB (a large document format), and the native Photoshop (PSD) file format. In my view, the TIFF format is a good choice for saving master images since this can contain anything that's been added in Photoshop.

When you choose File \Rightarrow Close All, if any of the photos have been modified, a warning dialog alerts you and allows you to close all open images with or without saving them first. For example, if you make a series of adjustments to a bunch of images and then change your mind, with this option you can quickly close all open images if you don't need them to be saved.

Background saving

The Automatically Save Recovery Information feature can be enabled via the File Handling preferences. In case of a crash this allows you to recover data from any open files that you were working on which had been modified since opening. Note that this feature does not auto-save by overwriting the original file (which could lead to all sorts of problems). What Photoshop does is to auto-save copies of whatever you are working on in the background using the PSD format. In the event of a crash, the next time you launch Photoshop it will automatically open the most recent auto-saved copies of whatever you were working on. If you refer to the Configuring Photoshop PDF on the website you can read how to enable this option and determine how frequently you wish to update the background save files.

It is not possible to save a history of everything you did to an image. However, if you go to the Photoshop History Log preferences you can choose to save a history log information of everything that was done to the image. This can record a log of everything that was done during a Photoshop session and can be saved to a central log file or saved to the file's metadata. By referring to a log file you may be able to reconstruct the steps you applied.

Another thing you can do is go to the Actions panel and click to record an action. If you have the tool recording option enabled, you will be able to record things like brush strokes and may be able to fully record everything that was done to the image while it was edited in Photoshop.

Using Save As... to save images

If the image you are about to save has started out as, say, a flattened JPEG, but now has layers, this will force the Save As dialog shown in Figure 1.108 to appear when you save. Or, you can choose 'File \Rightarrow Save As...' (**#** Shift'S [Mac], **ctrl** Shift'S [PC]) any time you wish to save an image using a different file format, or you want to save a layered image as a flattened duplicate. In the Save As dialog you have access to various save options. In the example below, I was about to save a layered, edited image as a JPEG. In these situations, a warning triangle appears to alert you if Layers (or other non-compatible items) can't be stored when choosing the JPEG format. Incompatible features are automatically highlighted and grayed out in the Save As dialog, and the image is necessarily saved as a flattened version of the master.

	Sa	ave As: PSBook_08031	1_1021.jpg	<u>^</u>			
	Tags:						
, # Internet in the second sec		E Desktop	• •		Q Search		
avorites	Name		^	Date Modified	Size	Kind	
 Cloud Drive Applications Desktop Documents Movies Pictures Utilities Downloads Lightroom Library Piug-Ins Office docs 	Adobe F Backdro Copy file PSCC Temp fo	95		10 February 2016 08:37 7 March 2016 12:29 Yesterday 09:10 Yesterday 09:31 15 October 2015 10:32	926 KB 	Alias Folder Folder Folder Folder	
	Format:	IDEO		Pa			
	Format: Save:	JPEG ✓ As a Copy Alpha Channels	Notes Spot Colors	:			
	A	Layers					
	Color:	Use Proof Setup: W	orking CMYK				
	🗥 File mu	Embed Color Profile: st be saved as a copy wit					
New Folder					Cano	el Save	

Figure 1.108 The Save As dialog, which shows here a compatibility warning that layers can't be saved using the JPEG file format.

Maximum compatibility

Only the Photoshop PSD, PDF, PSB, and TIFF formats are capable of supporting all the Photoshop features such as vector masks and image adjustment layers.

File formats

Photoshop supports nearly all the current, well-known image file formats. For those that are not supported, you will find that certain specialized file format plug-ins are supplied as free extras for Photoshop. When these plug-ins are installed in the Plug-ins folder they allow you to extend the range of file formats that can be chosen when saving. Your choice of file format when saving images should be mainly determined by what you want to do with a particular file and how important it is to preserve all the features (such as layers and channels) that may have been added while editing the image in Photoshop. Some formats such as TIFF, PSD, and PSB are mainly intended for archiving master image files, while others such as JPEG are suited for Web use and compressing the file size. Here is a brief summary of the main file formats in common use today.

Photoshop native file format

The Photoshop file format is a universal format and seemingly a logical choice when saving and archiving your master files since the Photoshop (PSD) format will recognize and contain all known Photoshop features. The main advantage of using PSD is that when saving layered images, the native Photoshop format is generally a very efficient format because it uses a run length encoding type of compression that can make the file size more compact, but without degrading the image quality in any way. LZW compression is used to compress large areas of contiguous color such as a white background into short lengths of data instead of doggedly recording every single pixel in the image.

The PSD format has been supported in Photoshop for many years, but is poorly documented and poorly implemented outside Photoshop. This is because it arose at an early stage in Photoshop's development and remains, essentially, a proprietary file format to Adobe and Photoshop. For Photoshop (PSD) format documents to be completely compatible with other programs (such as Lightroom), you must ensure you have the 'Maximize PSD and PSB Compatibility' checked in Photoshop's File Handling preferences. The reason for this is because Lightroom is unable to read layered PSD files that don't include a saved composite within the file. If PSD images fail to be imported into Lightroom, it is most likely because they were saved with this preference switched off. Looking ahead to the future, it is difficult to say if PSD will be supported forever. What we do know though is that the TIFF file format has been around longer than PSD and is certainly a welldocumented format and integrates well with all types of image editing programs. TIFF is currently still at version 6.0 and it is rumored

it's going to be updated to v 7.0 at some point in the near future. Meanwhile, even the Adobe engineers are suggesting that PSD is close to its end, and are now recommending the use of TIFF.

Smart PSD

Adobe InDesign and Adobe Dreamweaver will let you share Photoshop format files between these separate applications so that any changes made to a Photoshop file will automatically be updated in the other program. This modular approach means that most Adobe graphics programs can integrate with each other more seamlessly.

PSDX format

PSDX is a special file format that has been developed for Photoshop Touch with tablet devices in mind and to provide better performance. Only a subset of PSD capabilities are available on tablet devices, so Photoshop Touch doesn't support things like Smart Objects, layer groups, layer styles, etc. Photoshop Touch can export your file as a PSDX. However, if you store your files in Creative Cloud, the PSDX to PSD conversion happens in the Cloud so that what you end up downloading will in fact be a PSD. You can also download the Touch Apps Plug-in for Photoshop, which then allows Photoshop to read the PSDX format.

Large Document (PSB) format

The PSD and TIFF file formats have a $30,000 \times 30,000$ pixel dimensions limit, while the PSD file format has a 2 GB file size limit and the TIFF format specification has a 4 GB file size limit. You need to bear in mind here that many applications and printer RIPs (Raster Image Processor) can't handle files that are greater than 2 GB anyway and it is mainly for this reason the above limits have been retained for all the main file formats used in Photoshop (although there are some exceptions, such as ColorByte's ImagePrint and Onyx's PosterShop, which can handle more than 2 GB of data).

The Large Document (PSB) file format is provided as a special format that can be used when saving master layered files that exceed the above limits. The PSB format has an upper limit of $300,000 \times 300,000$ pixels, plus a file size limit of 4 exabytes (that's 4 million terabytes). This format is therefore mainly useful for saving extra-long panoramic images that exceed 30,000 pixels in length, or when saving extra-large files that exceed the TIFF 4 GB limit. You do have to bear in mind that just like TIFF and PSD, only recent versions of Photoshop will offer full file format compatibility.

TIFF and bit depth

Photoshop does allow for more bit depths when saving TIFF files. For example, BIGTIFF files can now also be read in Photoshop. The BIGTIFF format is a variant of the standard TIFF format that allows you to extend beyond the 4 GB data limit. The BIGTIFF file format is designed to be backward compatible with older TIFF readers in as much as it allows such programs to read the first 4 GB of data as normal. In order to read file data that exceeds this limit, TIFF readers need to be able to read the BIGTIFF format, which Photoshop can now do. Also, prior to Photoshop CS6, Photoshop could only read TIFF files that contained an even number bit depth, such as 2, 4, 6, 8, 10, etc., but could not read TIFF files that had odd number bit depths, such as 3, 5, 7, 9. It is only really files that come from certain scientific cameras and medical systems that create such files. Anyway, Photoshop now allows these files to be read.

TIFF (Tagged Image File Format)

The main formats used for publishing are TIFF and EPS. Of the two, TIFF is the most universally recognized image format. TIFF files can readily be placed in QuarkXpress, InDesign, and other desktop publishing (DTP) programs. The TIFF format is more open and, unlike the EPS format, you can make adjustments within the DTP program as to the way a TIFF image will appear in print. It is also a well-documented format and set to remain as the industry standard format for archive work and publishing; also Camera Raw recognizes TIFF, but not PSD. Labs and output bureaux generally request that you save your output images as TIFFs, as this is the file format that can be read by most other imaging computer systems. Therefore, if you are distributing a file for output as a print or transparency, or for someone else to continue editing your master file, it is usually safest to supply the image using TIFF.

TIFFs saved using Photoshop 7.0 or later support alpha channels, paths, image transparency, and all the extras that can normally be saved using the native PSD and PDF formats. Labs or service bureaux that receive TIFF files for direct output will normally request that a TIFF file is flattened and saved with the alpha channels and other extra items removed. For example, earlier versions of Quark Xpress had a nasty habit of interpreting any path that was present in the image file as a clipping path.

The Photoshop TIFF format has traditionally saved the pixel values in an interleaved order. So if you were saving an RGB image, the pixel values would be saved as clusters of RGB values using the following sequence: RGBRGBRGB. All TIFF readers are able to interpret this pixel order. The Per Channel pixel order option saves the pixel values in channel order, where all the red pixel values are saved first, followed by the green, then the blue. So the sequence used is: RRRGGGBBB. Using the Per Channel order can therefore provide faster read/write speeds and better compression. Most third-party TIFF readers should support Per Channel pixel ordering, but there is a slim chance that some TIFF readers won't.

The byte order can be made to match the computer system platform the file is being read on, but there is usually no need to worry about this and it shouldn't cause any compatibility problems.

The Save Image Pyramid option saves a pyramid structure of scaled-down versions of the full resolution image. TIFF pyramid-savvy DTP applications (and there are none I know of yet) will then be able to display a good quality TIFF preview, but without having to load the whole file.

TIFF compression options

An uncompressed TIFF will usually be about the same megabyte size as the figure you see displayed in the Image Size dialog box, but Photoshop offers several compression options when saving a TIFF.

LZW uses lossless compression, where image data is compacted and the file size reduced, but without image detail being lost. Saving and opening takes longer when LZW is utilized so some clients may request you don't use it. ZIP is another lossless compression encoding, which like LZW is most effective where images contain large areas of a single color. JPEG image compression uses a lossy method that offers even greater levels of file compression, but again be warned that this option can cause problems when saving files for output via a printer RIP. If there are layers present in an image, separate compression options are available for these. RLE stands for Run Length Encoding and provides the same type of lossless compression as LZW, and ZIP compression is as described above. Alternatively, choose Discard Layers and Save a Copy, which saves a copy version of the master image as a flattened TIFF.

Flattened TIFFs

If an open image contains alpha channels or layers, the Save dialog (Figure 1.108) indicates this and you can keep these items checked when saving as a TIFF. If 'Ask Before Saving Layered TIFF Files' is switched on in the File Saving preferences, a further alert dialog will warn you that 'including layers will increase the file size' the first time you save an image as a layered TIFF.

JPEG

The JPEG (Joint Photographic Experts Group) format is the most effective way to compress continuous tone image files. JPEG uses what is known as a lossy compression method. For more about working with JPEG and other file formats for the Web, check out the Web Output PDF on the book website. Photoshop can open and save JPEG documents up to 65,535 pixels in width or height.

HEIF Support and Depth Map

You can now open the HEIF image file format promoted by Apple in MacOS 10.13 and iOS 11.0 in Photoshop. Photoshop can also read the depth map from HEIF files created by the iPhone 7 Plus (and later) camera into a channel, allowing users to create a depth-of-field effect using Filter \Rightarrow Blur \Rightarrow Lens Blur.

Saving 16-bit files as JPEGs

For those who prefer to edit their images in 16-bit, it always used to be frustrating when you would go to save an image as a JPEG copy, only to find that the JPEG option wasn't available in the Save dialog File Format menu. The reason for this is because 16-bit isn't supported by the JPEG format. When you choose Save As... for a 16-bit image, the JPEG file format is actually available as a save option, whereby Photoshop carries out the necessary 16-bit to 8-bit conversion as part of the JPEG save process. This allows you to guickly create JPEG copies without having to temporarily convert the image back to 8-bit. Note, however, that only the JPEG file format is supported in this way.

High Efficiency Image File format

Finalized in 2015 by the MPEG group, it is supported by Apple in macOS High Sierra and iOS 11 and is lossy, and being a container, can support image sequences and even a lower resolution JPEG.

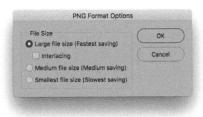

Figure 1.109 The PNG Save dialog.

PNG

The PNG file format is popular with Web designers and sometimes a useful substitute for the JPEG format. The PNG Save dialog is shown in Figure 1.109, where the file save options allow you to choose Large, Medium or Smallest file size compression settings. One of the advantages of PNG is that it is capable of storing transparency, which avoids the fudging that has to occur when using formats such as GIF. For example, it is useful for creating overlays and watermarks for Lightroom. In Photoshop CC you can save metadata and ICC profiles when saving as a PNG. There is support for PNG files up to 2 GB in size with new speed improvements when saving big files as PNG.

Photoshop PDF

The PDF (Portable Document Format) is a cross-platform file format that was initially designed to provide an electronic publishing medium for distributing documents without requiring the recipient to have a copy of the program that originated the document.

Adobe PDF has become generally accepted as a reliable and compact method of supplying page layouts to printers, due to its color management features, and its ability to embed fonts and compress images. It is now becoming the native format for Illustrator and other desktop publishing programs and is also gaining popularity for saving Photoshop files, because it can preserve everything that a Photoshop (PSD) file can. PDF files can be read using the free Adobe Reader[™] program, which will let others view documents the way they are meant to be seen, even though they may not have exactly the same fonts that were used to compile the document. The Adobe Acrobat[™] program may be required if you want to export page documents using the PDF format and edit them on your computer.

PDF documents are small in size and can be printed at high resolution. I can create a document in InDesign and export it as an Acrobat PDF using the Export command. Anyone who has installed the Adobe Reader program can then open a PDF document that's been created and see the layout just as it was intended to be seen, with the text displayed using the correct fonts. The Photoshop PDF file format can be used to save all Photoshop features such as Layers, with either JPEG or lossless ZIP compression, and is backward compatible in as much as it saves a flattened composite for viewing within programs that are unable to fully interpret the Photoshop layer information.

If you open a generic Acrobat PDF from within Photoshop choosing File ⇔ Open, you will see the Import PDF dialog shown in Figure 1.110. This allows you to select individual or multiple pages or selected images only and open these in Photoshop. You can then select individual pages or ranges of pages from a generic PDF file, rasterize them, and open them in Photoshop. Similarly, the Photoshop Parser plug-in can be used to extract text, vector graphics, or images from a PDF file. You can use File \Rightarrow Place Embedded or Place Linked to add as a Smart Object.

	Import PDF				
Select:	Page Options				
Pages O Images O 3D	Name: v-ACR.c				
	Grop To: Boundin	ng Box 👻			
	Anti-aliased				
	Image Size:				
and the second s	Width:	Pixels			
need the other of the second second	Height:	Pixels			
L PARAMAN PARAMAN	Constrain Proport	Constrain Proportions			
	Resolution:	Pixels/Inch			
	Mode: sRGB (EG61966-2,1 -				
	Bit Depth: 8 bit				
28	Suppress Warnings				
1 of 353 image(s) selected					
Thumbnail Size: Fit Page ~		Cancel OK			

PDF versatility

The PDF format in Photoshop is particularly useful for sending Photoshop images to people who don't have Photoshop, but do have the Adobe Reader[™] or Macintosh Preview programs on their computer. If they have a full version of Adobe Acrobat[™] they will even be able to conduct a limited amount of editing, such as the ability to edit the contents of a text layer. Photoshop is also able to import or append any annotations that have been added via Adobe Acrobat.

Figure 1.110 The Import PDF dialog.

Adobe Bridge CC

The Bridge program provides you with an integrated way to navigate through the folders on your computer and is compatible with all the other Creative Suite applications (see Figure 1.111). The Bridge interface lets you inspect images in a folder, make decisions about which ones you like best, rearrange them in the content panel, rate them, hide the ones you don't like, and so on.

You can use Bridge to quickly review the images in a folder and open them up in Photoshop. Advanced users can perform batch operations, share properties between files by synchronizing the metadata information, apply Camera Raw settings to a selection of images, and use the Filter panel to fine-tune image selections. It is very easy to switch back and forth between Photoshop and Bridge and one of the key benefits of having Bridge operate as a separate program is that Photoshop isn't fighting with the processor whenever you use Bridge to perform these various tasks. Bridge started as a file browser for Photoshop, but has evolved to provide advanced browser navigation for all programs in the Creative Suite.

Figure 1.111 The Bridge CC interface.

Installing Bridge

Bridge CC is provided as a separate download. Therefore, when you download and install Photoshop CC, you will need to remember to download the Bridge package separately and install afterwards.

The Bridge interface

Bridge can be accessed from Photoshop by choosing File \Rightarrow Browse in Bridge... or by using the **#** *alt* **O** (Mac), *ctrl alt* **O** (PC) keyboard shortcut. Once in Bridge you can use the same keyboard shortcut to return to Photoshop again, although to be more precise, this shortcut returns you to the last used application. So if you had just gone to Bridge via Illustrator, the **# CO** [Mac], *ctrl alt* **O** [PC] shortcut will in this instance take you from Bridge back to Illustrator again.

You can also set the Bridge preferences so that Bridge launches automatically during the system log-in and is always open and ready for use. Bridge initially opens a new window pointing to the last visited folder location. You can have multiple Bridge windows open at once and this is useful if you want to manage files better by being able to drag them from one folder to another. Having multiple windows open also saves having to navigate back and forth between different folders. If you have a dual display setup you can always have the Photoshop application window on the main display and the Bridge window (or windows) on the other.

The Bridge interface consists of three column zones used to contain the Bridge panel components. This lets you customize the Bridge layout in any number of ways. Image folders can be selected via the Folders or Favorites panels and the folder contents viewed in the content panel area as thumbnail images. When you click on a thumbnail, an enlarged view of the individually selected images can be seen in the Preview panel and images can be opened by doubleclicking on the thumbnail. The main thing to be aware of is that you can have Bridge running alongside Photoshop without compromising Photoshop's performance and it is therefore better to use Bridge in place of the Finder/Explorer as your main tool for navigating the folders on your computer system and opening documents. This can include opening photos directly into Photoshop, but of course, you can use Bridge as a browser to open up any kind of document: not just those linked to the Adobe Creative Suite programs. For example, Word documents can be made to open directly in Microsoft Word via Bridge.

In this latest version there is now a Publish panel (Figure 1.112) that can be used to publish files to Adobe Stock or Adobe Portfolio directly via Bridge.

Figure 1.112 The Publish panel.

The Bridge panels can be grouped in different ways and the panel dividers dragged, so, for example, the Preview panel can be made to fill the Bridge interface more fully and there are already a number of workspace presets which are available to use from the top bar. You can use the different workspaces to quickly switch Bridge layouts. For example, Figure 1.113 shows the Filmstrip workspace in use. This is a good workspace to start with when you are new to Bridge.

Output options

Recent improvements to the Output module mean you can use Bridge to generate PDF contact sheets. You can drag and drop images to the Output module layout view. There are now Header and Footer options as well as Watermark options when the Output module mode is selected. For more information about working with the Output workspace see the 'Print' chapter at the end of the book.

Figure 1.113 The Adobe Bridge CC Filmstrip workspace in use.

Opening files from Bridge

There are a lot of things you can do in Bridge by way of managing and filtering images and other files on your computer. For now, all that you really need to familiarize yourself with are the Favorites and Folders panels and how you can use these to navigate the folder hierarchy. The Content panel is then used to inspect the folder contents and you can use the Preview panel to see an enlarged preview of the image (or images) you are about to open. Once photos have been selected, just double-click the images within the Content panel (not the Preview panel) to open them directly in Photoshop.

Slideshows

You can also use Bridge to generate slideshows. Just go to the View menu and choose Slideshow, or use the **B**(Mac), **C**(PC) keyboard shortcut. Figure 1.114 shows an example of a slideshow. Here, you can make all your essential review and edit decisions with this easy-to-use interface (press the **F**) key to call up the Slideshow shortcuts shown below).

Figure 1.114 You can use the Bridge application View ⇒ Slideshow mode to display selected images in a slideshow presentation.

Camera Raw

Camera Raw (which is currently at version 10) offers a number of new features since the original Photoshop CC release.

Along with support for more cameras and lenses, the latest version of Photoshop includes a Range mask feature. This can be used in Color sample or Luminance modes to achieve smoother masking compared to working with Auto Mask, which itself has also been updated to provide smoother results with less blocky artifacts.

DNG and transparency support

Camera Raw is able to read transparency in files and represent transparency as a checkerboard pattern (just like in Photoshop). Camera Raw can read simple, single layer files that are saved in the TIFF and PSD file formats as well as read the transparency contained in HDR TIFF files and extract the transparency from multi-layered PSD files (this is providing the maximize compatibility option has been checked).

Opening photos from Bridge via Camera Raw

If you double-click to open a raw or DNG image via Bridge, this automatically opens the Camera Raw dialog shown in Figure 1.115, where Photoshop will host Camera Raw. Alternatively, if you choose File \Rightarrow Open in Camera Raw... via the Bridge menu, this opens the file in Camera Raw hosted by Bridge. The advantage of doing this is that it allows you to free up Photoshop to carry on working on other images. If you click on the Full Screen mode button in Camera Raw (circled blue in Figure 1.115), you can quickly switch the Camera Raw view to Full Screen mode. If you choose to open multiple raw images you will see a filmstrip of thumbnails appear down the left-hand side of the Camera Raw dialog, where you can edit one image and then sync the settings across all the other selected photos. There is also a preference setting in Bridge that allows you to open up JPEG and TIFF images via Camera Raw too.

You can even export as a Smart Object from Camera Raw, thus allowing a return to further non-destructive edits at a later point. I explain this workflow later in Chapter 2, which is devoted to looking at most of the Camera Raw controls and I would say that the main benefit of using Camera Raw is that any edits you apply in Camera Raw are non-permanent and Photoshop CC offers yet further major advances in raw image processing. If you are still a little intimidated by the Camera Raw dialog interface, you can for now just click on the Auto button (circled red in Figure 1.115). When the default settings in Camera Raw are set to Auto, Camera Raw usually does a pretty good job of optimizing the image settings for you. Once you are happy with the adjustments made to the image, you can then click on the 'Done' or 'Open Image' button without concerning yourself too much just yet with what all the Camera Raw controls do. This should give you a good image to start working with in Photoshop and the beauty of working with Camera Raw is you never risk overwriting the original master raw file. If you don't like the auto settings Camera Raw gives you, then it is relatively easy to adjust the tone and color sliders and make your own improvements upon the auto adjustment settings.

New Auto Settings

With the most recent version of Camera Raw the Auto is much improved and will auto adjust the Tone as well as Vibrance and Saturation sliders to achieve an optimum look. It is now worth always trying out the Auto option first to see if this creates an optimum look.

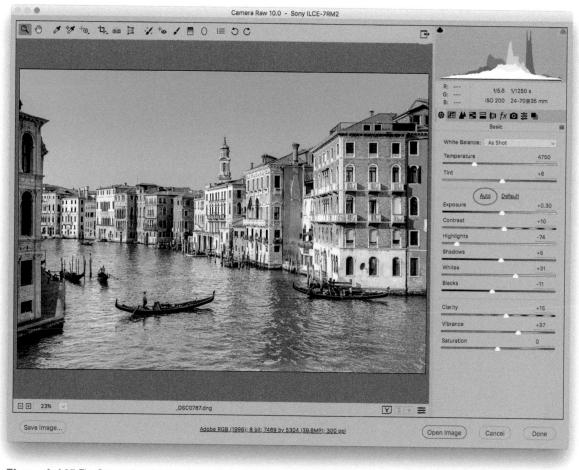

Figure 1.115 The Camera Raw interface, shown here opened via Photoshop.

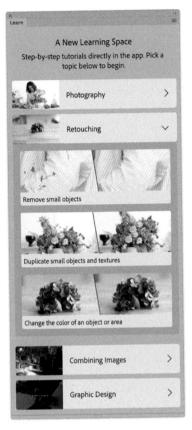

Figure 1.116 The Learn panel.

Photoshop help

Photoshop Online... is available from the Help menu and lets you access any late-breaking information along with online help and professional Photoshop tips.

Learn panel

The Learn panel (Figure 1.116) teaches you Photoshop basics without having to leave Photoshop. When opened it can be used to take you through various Photoshop tasks step by step. This includes coach marks that show you where to click next. It may also pop up when performing specific tasks. The Learn panel can also recognize when you have successfully completed a step and automatically open sample files for you to work with. All existing Photoshop CC users can access this. However, only half of those who are brand new to Photoshop CC will see the Learn panel appear by default in the Essentials workspace. If you are not in that group you can still access by choosing Window ⇒ Learn.

Splash screen

If you drag down from the system or Apple menu to select About Photoshop..., the splash screen reopens and after about 5 seconds the text starts to scroll, telling you lots of stuff about the Adobe team, who wrote the program, etc. Hold down *alt* and the text will scroll faster. Hold down the *Shift* key as well and it will scroll faster still. Last, but not least, you'll see a special mention of the most important Photoshop user of all... Now hold down **H** (Mac), *ctrl alt* (PC) and choose About Photoshop... Here, you will see the prerelease version of the splash screen (Figure 1.117).

Figure 1.117 The Photoshop CC prerelease splash screen.

Chapter 2

Camera Raw processing

In the 20 years I have been writing this series of books, the photography industry has changed out of all recognition. When I first began writing about Photoshop, most photographers were shooting with film cameras, getting their pictures scanned, and only a few professionals were shooting with high-end digital cameras. In the last decade the number of photographers who shoot digitally has grown to the point where it is the photographers who shoot film who are now in the minority. The vast majority of photographers reading this book will therefore be working with pictures that have been shot using a digital SLR or high-end digital camera that is capable of capturing files in a raw format that can be read by Adobe Camera Raw in Photoshop. This is why I have devoted a whole chapter (and more) to discussing Camera Raw image processing.

From light to digital

The CCD or CMOS chip in your camera converts the light hitting the sensor into a digital image. In order to digitize the information, the signal must be processed through an analog-to-digital converter (ADC). The ADC measures the amount of light hitting the sensor at each photosite and converts the analog signal into a binary form. At this point, the raw data simply consists of image brightness information coming from the camera sensor. The raw data must somehow be converted and it is here that the raw conversion method used can make a huge difference to the quality of the final image output. Digital cameras have an on-board microprocessor that is able to convert the raw data into a readable image file, which in most cases will be in a JPEG file format. The choice here normally boils down to raw or JPEG output. The quality of a digital image is therefore primarily dependent on the lens optics used to take the photograph, the recording capabilities of the CCD or CMOS chip, and the analog-todigital converter, but it is the raw conversion process that matters most. If you choose to process the raw data on your computer, you have much greater control compared with letting your camera automatically guess the best raw conversion settings to use.

Camera Raw advantages

Although Camera Raw started out as an image processor exclusively for raw files, it is capable of processing any RGB image that is in a JPEG or TIFF file format. This means you can use Camera Raw to process any image that has been captured by a digital camera, including raw photos up to 65,000 pixels in any dimension or up to 512 megapixels in size, or a photograph that has been scanned by a film scanner and saved as an RGB TIFF or JPEG. Camera Raw allows you to work non-destructively, so anything you do when processing the image is saved as a series of edit instructions; the pixels in the original file are never altered. In this respect, Camera Raw treats your master files like they were your negatives, allowing you to process images any way you choose without ever altering the original.

The new Camera Raw workflow

When Camera Raw first came out it was regarded as a convenient tool for processing raw format images, without having to leave Photoshop. The early versions of Camera Raw had controls for applying basic tone and color adjustments, but Camera Raw could never, on its own, match the sophistication of Photoshop. Because of this, photographers would typically follow the Camera Raw workflow steps described in Figure 2.1. They would use Camera Raw to do all the 'heavy lifting' work such as adjusting the white point, exposure, and contrast, and from there output the picture to Photoshop, where they would carry out the remaining image editing.

Camera Raw in Photoshop CC offers far more extensive image editing capabilities and it is now possible to replicate in Camera Raw some of the things which previously could only have been done in Photoshop. The net result of all this is that you can (and should) use Camera Raw first when preparing any photographic image for editing in Photoshop. Camera Raw does not replace Photoshop. It simply enhances the workflow and offers a better set of tools to work with in the early stages of an image editing workflow and is a logical place for any image to begin its journey through Photoshop. If you look at the suggested workflow listed in Figure 2.2 you will see that the current release of Camera Raw now has everything you need to optimize and enhance your photographs. It can also be argued that if you use Camera Raw to edit your photos, this replaces the need for Photoshop adjustments such as Levels, Curves, and Hue/Saturation. To some extent this is true, but as you will read later in Chapter 4, these Photoshop adjustment tools are still relevant for fine-tuning the images that have been processed in Camera Raw first, especially when you

want to edit your photos directly or apply certain kinds of image effects that require the use of adjustment layers or additional image layers.

Does the order matter?

When you edit an image in Camera Raw it does not matter which order you apply the adjustments in. For example, Figure 2.2 shows just one possible Camera Raw workflow. You could just as easily start by applying a crop first and work your way through the rest of the list backwards. However, you are best advised to start with the major adjustments first, such as setting the Exposure in the Basic panel before fine-tuning the image using the other controls.

- \Rightarrow Set the white point
- ⇒ Apply a fine-tuned camera calibration adjustment
- \Rightarrow Set the highlight and shadow clipping points
- \Rightarrow Adjust the brightness and contrast
- \Rightarrow Adjust the color saturation
- ⇒ Correct for moiré
- \Rightarrow Apply basic sharpening and noise reduction
- \Rightarrow Apply a crop
- \Rightarrow Open images in Photoshop for further image editing

Figure 2.1 Camera Raw 1 offered a limited but useful range of image adjustments.

- \Rightarrow Set the white point
- ⇒ Apply a Camera Profile camera calibration adjustment
- ⇒ Apply a Lens Profile calibration adjustment (correct for distortion, chromatic aberrations, and vignetting)
- \Rightarrow Apply a transform or perspective correction
- \Rightarrow Set the overall Exposure brightness
- \Rightarrow Enhance the highlight detail using the Highlights slider
- \Rightarrow Enhance the shadow detail using the Shadows slider
- \Rightarrow Fine-tune the highlight and shadow clipping points
- \Rightarrow Adjust the midtone contrast (Clarity)
- \Rightarrow Fine-tune the Tone Curve contrast
- \Rightarrow Fine-tune the color saturation/vibrance plus HSL color
- \Rightarrow Retouch spots using the clone or heal brush modes
- ⇒ Make localized adjustments (i.e., Radial/Graduated Filter, Adjustment Brush)
- \Rightarrow Apply capture sharpening and noise reduction
- \Rightarrow Apply a crop and/or a rotation
- \Rightarrow Open images in Photoshop for further image editing

Figure 2.2 Camera Raw 10 has now extended the list of things that can be done to an image at the Camera Raw editing stage.

Figure 2.3 The camera LCD screen histogram is based on this JPEG preview.

Raw capture

If you are shooting with a professional digital back, digital SLR, or an advanced compact digital camera, you will almost certainly have the capability to shoot using the camera's raw format mode. The advantages of shooting raw as opposed to JPEG mode are not always well understood. If you shoot using JPEG, the files are compressed by varying amounts and this file compression enables you to fit more captures on to a single card. Some photographers assume that shooting in raw mode simply provides you with uncompressed images without JPEG artifacts, but there are other, more important reasons why capturing in raw mode is better. The main benefit is the flexibility raw gives you. The raw file is a digital negative, waiting to be interpreted any way you like. It does not matter about the color space or white balance setting that was used at the time of capture, since these can all be set later in the raw processing. Capturing in raw mode is therefore like shooting with negative film. When you shoot raw you are recording a master file that contains all the color and tone information that was captured at the time of shooting. To carry the analogy further, shooting in JPEG mode is like taking your film to one of those old high street photo labs, throwing away the negatives and making scans from the prints. If you shoot in JPEG mode, the camera decides automatically at the time of shooting how to set the white balance and tonal corrections, often clipping the highlights and shadows in the process. In fact, the camera histogram you see on the camera LCD is based on the JPEG interpretation capture data regardless of whether you are shooting in raw or JPEG mode. It is therefore a poor indicator of the true exposure potential of a raw capture image (see Figure 2.3).

When shooting raw, all you need to consider is the ISO setting and camera exposure. But this advantage can also be seen to be its biggest drawback; since the Camera Raw stage adds to the overall image processing, this means more time has to be spent working on the images, plus raw captures are bigger in file size, which means longer download times. Therefore, news photographers and others may find that JPEG capture is preferable for the kind of work they do.

It's 'raw' not 'RAW'

This is a pedantic point, but raw should be written using lower-case letters instead of capitals, which would otherwise suggest that 'RAW' was an acronym, like JPEG or TIFF, which it isn't.

JPEG capture

When you shoot in JPEG mode, your options are more limited since the camera's on-board computer makes its own automated decisions about how to optimize for tone, color, noise, and sharpness. When you shoot using JPEG or TIFF, the camera is immediately discarding up to 88% of the image information that's been captured by the sensor. This is not as alarming as it sounds, because as you'll know from experience, you can get great photographs from JPEG captures. But consider the alternative of what happens if you shoot using raw mode. The raw file is saved without being altered by the camera. This allows you to work with all 100% of the image data that was captured by the sensor. If you choose to shoot in JPEG capture mode you have to make sure the camera settings are absolutely correct for things like the white balance and exposure. There is some room for maneuver when editing a JPEG, but not as much as you get when editing a raw file. In JPEG mode, your camera will be able to fit more captures onto a card, and this will depend obviously on the capture file size and compression settings used. However, it is worth noting that at the highest quality setting, JPEG capture files are often not that much smaller than those stored using the native raw format.

Editing JPEGs and TIFFs in Camera Raw

Not everyone is keen on the idea of using Camera Raw to open non-raw images. However, the Camera Raw processing tools are so powerful and intuitive to use, why shouldn't they be available to work on other types of images? The idea of applying further Camera Raw processing may seem redundant in the case of JPEGs, but despite these concerns, Camera Raw does happen to be a good JPEG image editor. So from one point of view, Camera Raw can be seen as offering the best of all worlds, but it can also be seen as a source of confusion. Is it a raw editor or what?

Perhaps the biggest problem so far has been the implementation rather than the principle of non-raw Camera Raw editing. In the Configuring Photoshop PDF (available on the book website) I make the point that opening JPEGs and TIFFs via Camera Raw is unnecessarily complex.

Compatible cameras

The list of cameras that are compatible with the latest version of Camera Raw can be found at the Adobe website by following this link: adobe.com/products/photoshop/ cameraraw.html.

Adobe Photoshop Lightroom

If you look at the Lightroom program, I think you'll find that the use of Camera Raw processing on non-raw images works very well indeed. The Adobe Photoshop Lightroom program is designed as a raw processor and image management program for photographers. It uses the same Adobe Camera Raw color engine that is used in Photoshop, which means raw files that have been adjusted in Lightroom can also be read and opened via Camera Raw in Photoshop or Bridge. Having said that, there are compatibility issues to be aware of whereby only the most recent version of Camera Raw will be able to fully interpret the image processing carried out in the most recent version of Lightroom and vice versa. Lightroom does have the advantage of offering a full range of workflow modules designed to let you edit and manage raw images all the way from the camera import stage through to Slideshow, Book, Print, or Web output.

Alternative raw processors

While I may personally take the view that Camera Raw is a powerful raw processor, there are other raw processing programs photographers can choose from. Some camera manufacturers supply their own brand of raw processing programs which either come free with the camera or you are encouraged to buy separately. Other notable programs include Capture One (phaseone.com/en/software.aspx), which is favored by a lot of photographers as their preferred raw editing program. There are those who argue Capture One is sharper and produces better color. In the comparative testing I have carried out it seems to me the default Capture One settings just happen to apply stronger sharpening and the color rendition is actually pretty close to the 'Camera Portrait' camera profile in Camera Raw. If I play around with the settings in Camera Raw to match Capture One, I find the results I get are more or less identical for color, tone, and sharpness. Other than Capture One, there is Bibble (bibblelabs.com) and DxO Optics Pro (dxo.com). If you are using one of these or some other program to process your raw images and are happy with the results you are getting then that's fine. Even so, the core message of this chapter still applies, which is to use the raw processing stage to optimize the image first so that you can rely less on using Photoshop's own adjustment tools to process the photograph afterwards. Overall it makes good sense to take advantage of the non-destructive processing in Camera Raw to freely interpret the raw capture data in ways that can't be done using Photoshop alone. Plus you can also use Camera Raw as a filter to process non-raw images within Photoshop.

Camera Raw support

Camera Raw won't 'officially' interpret the raw files from every digital camera, but over 500 different raw formats are now supported. Camera Raw has kept pace with nearly all the latest raw camera formats in the compact range and digital SLR market, but only supports a few of the higher-end cameras such as the Hasselblad, Leaf, Leica, Pentax, and Phase One cameras. Adobe is committed though to providing intermittent free Camera Raw updates. These will include any new camera file interpreters as they become available. This generally happens about once every three or four months and sometimes sooner if a significant new camera is released. It used to be the case that these updates were provided to add support for more cameras and fix a few bugs and/or improve integration with Lightroom. These days Camera Raw updates may well include new features. It is therefore always worth keeping a close check on any new Camera Raw releases to see if they contain new tools.

Camera Raw also supports the PNG file format. This was mainly done with a view to providing PNG support in Lightroom. In terms of Photoshop Camera Raw use, such PNG support remains pretty much hidden at this point. CMYK, JPEG, or TIFF files can be opened via Camera Raw, but these will be converted to RGB upon opening.

The installation update process is fairly straightforward, where standard installers for Mac and PC will automatically update Camera Raw for you. Also, whenever there is an update to Camera Raw there will also be an accompanying update for Lightroom and a new version of Adobe DNG Converter.

DNG compatibility

The DNG (digital negative) file format is an open-standard file format for raw camera files. DNG was devised by Adobe and there are already a few cameras such as Leica, Ricoh, Hasselblad, and Pentax cameras that can shoot directly to DNG; there are also now quite a few raw processor programs that can read DNG, including Camera Raw and Lightroom of course. Basically, DNG files can be read and edited just like any other proprietary raw file format and it is generally regarded as a safe file format to use for archiving your digital master files. For more about the DNG format I suggest you refer to page 256 at the end of this chapter, where I explain also how you can use the DNG Converter program to convert any supported raw camera format file to DNG. This allows you to create DNG files that can then be read by any previous version of Camera Raw.

New speed improvements

In this release, Adobe have changed much of the internal workings of the GPU implementation. These changes should improve the overall interactive image editing experience in Camera Raw, such as adjusting panel sliders, panning, and zooming.

Working with Bridge and Camera Raw

The mechanics of how Photoshop and Bridge work together are designed to be as simple as possible so that you can open single or multiple images, or batch process images quickly and efficiently. Figure 2.4 summarizes how the file opening between Bridge, Photoshop and Camera Raw works. Central to everything is the Bridge window interface where you can browse, preview, or make selections of the images you wish to process. To open images, select the desired thumbnail (or thumbnails) and open using one of the following three methods: use the File \Rightarrow Open command, use a double-click, or use the **File (Mac)**, **(PC)** shortcut. All the above methods can be used to open a selected raw image (or images) via the Camera Raw dialog hosted by Photoshop. If the image is not a raw file, it will open in Photoshop directly. Opening files in Camera Raw via Photoshop is ideal for processing individual or small numbers of images at a time.

Alternatively, you can use File \Rightarrow Open in Camera Raw... or use the **HR** (Mac), **cttl R** (PC) shortcut to open an image via the Camera Raw dialog, this time hosted by Bridge. This lets you perform batch processing operations in the background without compromising Photoshop's performance. This is better for processing large batches of images in the background. If the 'Double-click edits Camera Raw Settings in Bridge' option is deselected in the Bridge General preferences, **Shift** double-clicking allows you to open an image or multiple selections of images in Photoshop directly, bypassing the Camera Raw dialog. If you hold down the **alt** key as you double-click to open a raw image, this closes the Bridge window as you open the Camera Raw dialog hosted by Photoshop.

Opening raw images via Photoshop is quicker than opening via Bridge, but for as long as Photoshop is used to manage the Camera Raw processing this can prevent you doing other work in Photoshop. The advantage of opening via Bridge is Bridge can be used to process large numbers of raw files in Camera Raw, while freeing up Photoshop to perform other tasks. You can then toggle between the two programs.

Regarding JPEG and TIFF images, Camera Raw can be made to open these as if they were raw images, but please refer to page 122 for a fuller description as to how JPEG and TIFF files can be made to open in Camera Raw.

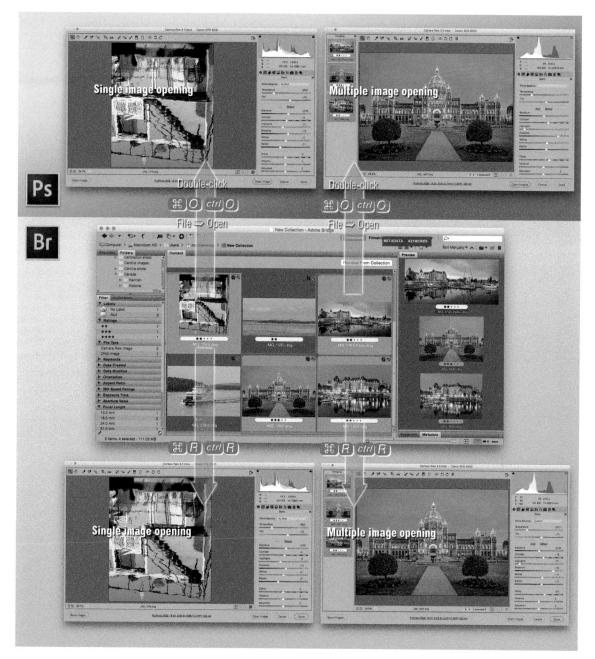

Figure 2.4 The Camera Raw opening options, showing how you can open single or multiple images in Camera Raw via Photoshop or Bridge.

Camera Raw tools

Zoom tool (Z)

This can be used to zoom in and zoom out of the preview image; double-click for 100%.

🖑 Hand tool (H)

The Hand tool can be used to scroll the magnified Preview image; double-click to Fit.

🍼 White Balance tool (I)

The White Balance tool is used to set the White Balance in the Basic panel.

🧭 Color sampler tool (S)

Allows you to place up to 9 color sampler points in the preview window (these are temporary and not stored in the XMP data).

* Target adjustment tool (T)

On-image adjustment tool.

'다. Crop tool (C)

Use to crop an image.

Straighten tool (A)

Drag along a horizontal or vertical line to apply a 'best fit', straightened crop.

Transform tool (*Shift***T)** Click to access Transform panel tools.

🖌 Spot removal (B)

Use to remove sensor dust spots and other blemishes from a photo.

+• Red Eye removal tool (E)

For removing red eye (or pet eye) from portraits shot using on-camera direct flash.

Adjustment Brush (K) Use to paint localized adjustments.

Graduated Filter (G) Use to apply linear graduated localized adjustments.

O Radial Filter (J) Apply radial graduated localized adjustments.

ACR preferences (H /ctr)-K)
 Open the Camera Raw preferences dialog.
 Rotate counterclockwise (L)

Rotates the image 90° counterclockwise.

C Rotate clockwise (R)

Rotates the image 90° clockwise.

General controls for single file opening

Figure 2.5 shows the Camera Raw dialog for opening a single image, which in this case is hosted via Bridge. You can tell if Camera Raw has been opened via Bridge, because the 'Done' button is accented. This is an 'update' button that you can click to save the current settings without opening the image. Otherwise, 'Open Image' is highlighted whenever Camera Raw is hosted by Photoshop. The status bar shows which version of Camera Raw you are using and the make and model of camera. In the top left section are the Camera Raw tools (which are listed on the left) and below that the image preview area where the zoom setting can be adjusted via the pop-up menu at the bottom.

The histogram represents the output histogram of an image and is calculated based on the RGB output space that has been selected in the Workflow options. As you carry out Basic panel adjustments, the shadow and highlight triangles in the histogram display indicate the shadow and highlight clipping. As either the shadows or highlights get clipped, the triangles will light up with the color of the channel or channels that are about to be clipped and if you click on them, display a color overlay (blue for the shadows, red for the highlights).

Below that is the panels section, where you will always see the Basic panel selected by default. The Basic panel can be used to apply basic tone and color corrections. Next to that is the Tone Curve panel, which can be used to apply a secondary, more refined set of tone adjustments using the parametric or point mode controls. The Detail panel contains controls for sharpening and noise reduction, while the HSL/Grayscale panel lets you fine-tune the hue, saturation, or luminance based on targeted colors, or convert to black and white. Then there is the Split Toning panel for adding split tone effects. The Lens Corrections panel can be used to apply profiled and manual lens corrections. The Effects panel allows you to add a post crop vignette, add grain, or a Dehaze adjustment. The Calibration panel contains the legacy calibration sliders, a list of camera looks approximating to manufacturer's offered choices of presets, and the means to apply previous Adobe Process versions.. The Presets panel can be used to save and access saved Camera Raw preset settings and, lastly, the Snapshots panel can be used to save snapshot settings.

If you click on the Workflow options (circled), this opens the Workflow Options dialog shown in Figure 2.12, where you can adjust the settings that determine the color space in which the image will open in, the bit depth, cropped image pixel dimensions plus resolution (i.e., how many pixels per inch/per cm).

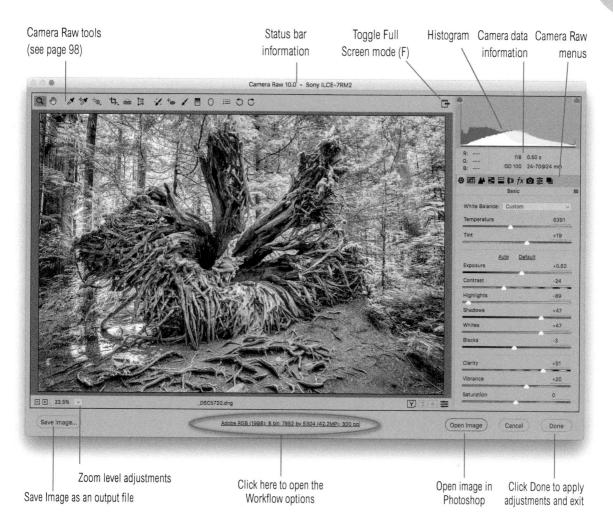

Figure 2.5 This shows the Camera Raw dialog (hosted by Bridge), showing the main controls and shortcuts for the single file opening mode.

Full-size window view

The Toggle Full screen mode button () can be used to expand the Camera Raw dialog to fill the whole screen, which can make Camera Raw editing easier providing a bigger preview area to work with. Click the button again to restore the previous Camera Raw window size view.

Filmstrip menu (the Merge items are discussed later in Chapters 6 & 8)

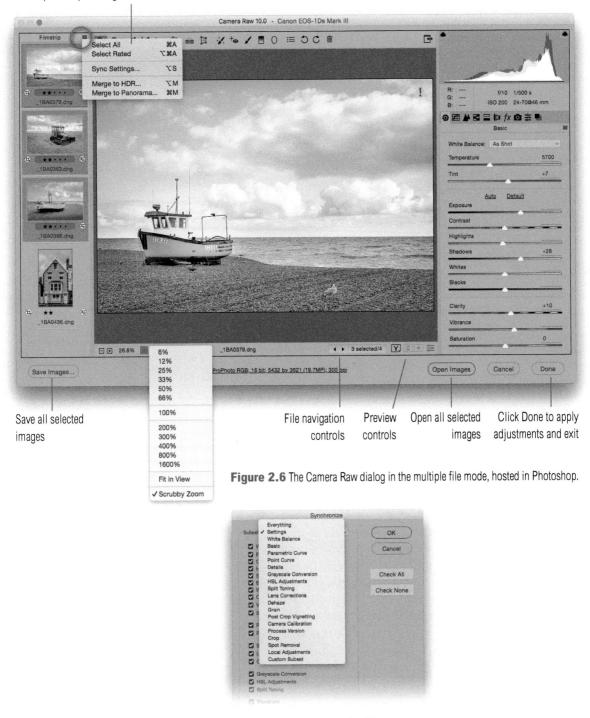

Figure 2.7 The Synchronize dialog.

General controls for multiple file opening

If you have more than one photo selected in Bridge, you can open these all at once via Camera Raw. If you refer back to Figure 2.4, you can see a summary of the file opening behavior. If you double-click (or use File \Rightarrow Open (**HO** [Mac], *etrl* **O** [PC]), this opens the multiple image Camera Raw dialog hosted via Photoshop (Figure 2.6). Choose File \Rightarrow Open in Camera Raw... or **HR** (Mac), *etrl* **R** (PC), to open multiple images in Camera Raw dialog hosted via Bridge.

The multiple image dialog contains a filmstrip of the selected images running down the left-hand side of the dialog. You can select individual images by clicking on a thumbnail, which will then be highlighted with a blue border and the 'most selected' image displayed in the preview area. The filmstrip fly-out menu is circled in Figure 2.6. Here, you can choose 'Select All' (# A [Mac], ctrl A [PC]) to select all the photos at once and use the all S shortcut to synchronize the Camera Raw settings adjustments, based on the settings for the current 'most selected' image. The Synchronize dialog (shown in Figure 2.7) then lets you choose which of the Camera Raw settings you want to synchronize. Because images may now have different process versions, if you select multiple photos that use different process versions, the Basic panel may show a message like the one shown in Figure 2.8, requiring you to update the selected photos to the process version that's applied to the most selected image. You can learn more about this and how to synchronize Camera Raw settings on page 247, as well as how to copy and paste Camera Raw settings via Bridge.

You can also make custom selections of images via the filmstrip using the *Shift* key to make continuous selections, or use the **(Mac)**, *etti* (PC) key to make discontinuous selections of images. Once you have made a thumbnail selection you can then navigate the selected photos by using the navigation buttons in the bottom right section of the Preview area to progress through them one by one and apply Camera Raw adjustments to individually selected images. If you have not yet enabled the 'Use Graphics Processor' option in the Camera Raw preferences (see page 123), you may see a yellow warning triangle, which indicates the preview has not completely refreshed yet.

Once a photo has been edited in Camera Raw you will notice a badge icon appears in the top right corner of the Bridge thumbnail (Figure 2.9). This indicates that a photo has had Camera Raw edit adjustments applied to it.

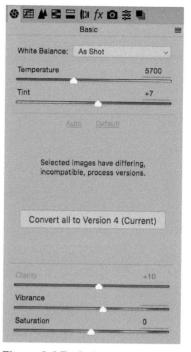

Figure 2.8 The Basic panel indicating mismatched process versions in a multiple selection of images.

Figure 2.9 The circled badge icon indicates an image has been edited in Camera Raw.

Preview controls

The preview controls can be used to quickly compare the current state of the image with a before, or checkpoint, state and repeat clicking the preview mode button lets you cycle through the five available modes. To see the list shown in Figure 2.10, click on the preview mode button () and hold the mouse down. The five options are: Single View; Before/After Left/Right (as shown in Figure 2.10); Before/ After Left/Right Split; Before/After Top/Bottom; Before/After Top/ Bottom Split. You can also use the **()** key to advance to the next preview setting.

Zooming or panning in one pane view automatically zooms or pans the other. Panning allows you to quickly compare the effects of a before and after treatment. However, as soon as you use the Crop or Straighten tool, this will take you back to the full 'After' preview mode.

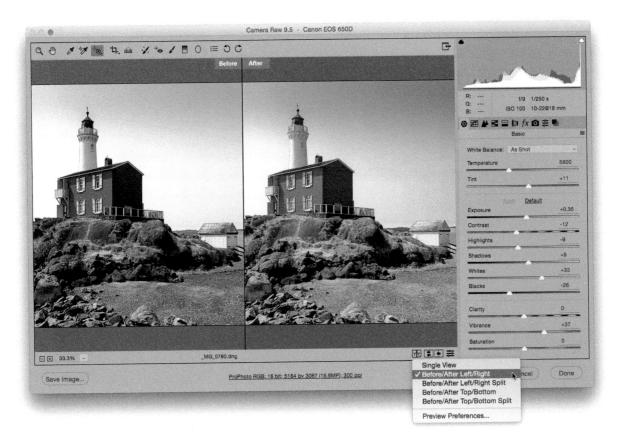

Figure 2.10 This shows the new preview controls menu that can be used to compare a preview of the current state with a before, or checkpoint, view state.

Checkpoints

Anyone who has worked with the Compare view mode in Lightroom will be familiar with these preview controls and how you are able to create checkpoints mid-session that allow you to compare an updated preview with the current version.

The Swap button (S) can be used to swap the current image settings with the before or checkpoint state settings. What happens here is, when you click this, the settings in the image for the before state are updated (like creating a new snapshot). You can then click again on the Swap button to return to the previous working state and also use the P key to swap between the two states. To update the current checkpoint using the current settings, click the Checkpoint button (C), or use the *alt* P shortcut. You can also use the Toggle between current settings and defaults for that panel, or use the *S alt* P (Mac) *ctf alt* P (PC) shortcut.

Suppose you want to compare one image state against another? Once you arrive at a setting you wish to compare with, click the Swap button to make the current After state the new Before state. You can then load a pre-saved snapshot setting and load this as a new After preview to compare with the current Before checkpoint state; you can then click on the Swap button again to swap between these two states.

Preview preferences

The Preview Preferences (Figure 2.11) can be accessed from the menu shown in Figure 2.10. This allows you to enable/disable the various Cycle Preview Modes (when clicking on the Preview button or using the 🕢 shortcut) and choose to show or hide the Draw Items listed below. The screen shots shown here were all captured with the Divider in side-by-side views and Divider in split views checked.

Cycle Preview Modes	Draw Items	
Left/Right side-by-side	Divider in side-by-side views	OK
Left/Right split view	Divider in split views	Cancel
Top/Bottom side-by-side	Pane labels	
Top/Bottom split view		

Figure 2.11 The Preview Preferences dialog.

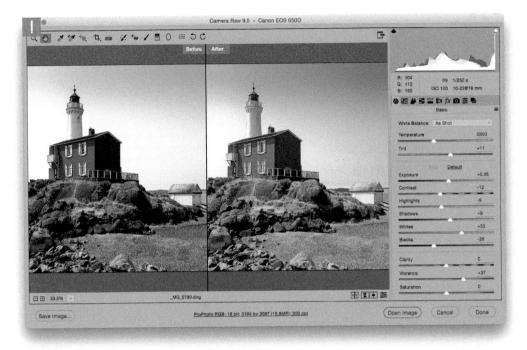

1 In this first step I selected the Before/After Left/Right Split preview. Here, you can see the image in the before state (left) and modified after state (right).

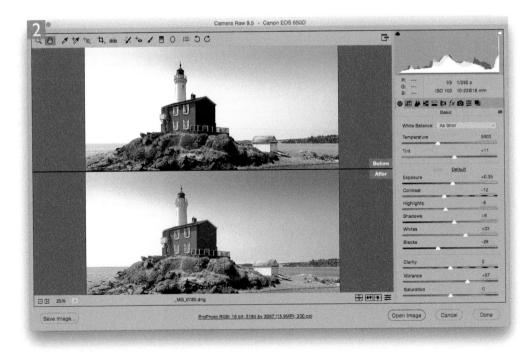

2 Here you can see the image previewed using the Before/After Top/Bottom preview.

3 And this shows the Before/After Top/Bottom Split preview.

4 In this example, I returned to the Before/After Left/Right Split preview and clicked on the Checkpoint button (to update the Before preview. I then converted the image to black and white and was now able to compare this state with the full-color edited checkpoint state.

Saving Workflow presets

The Workflow Options can be saved as presets. These let you quickly switch between different workflow options settings. They can also be accessed by right mouseclicking the Workflow options via the main Camera Raw dialog.

Workflow options

Clicking on the hyperlink text (circled in blue Figure 2.13) opens the Workflow Options dialog (Figure 2.12). This determines how files are saved or opened in Photoshop. The Color Space options allow you to choose any available profile space as the output space. This includes printer profiles, CMYK profiles, or the Lab space even. Ideally, this should match the RGB workspace setting you have established in the Photoshop color settings. Setting the bit depth to 16-bits per channel ensures the maximum number of levels are preserved when the image is opened in Photoshop.

The Image Sizing options can be used to set the pixel dimensions (or percentage) and resolution for the saved/opened images. Below that is the Output Sharpening section, where you can choose to sharpen the rendered image(s) for print or screen output. These options are relevant if you are producing a file to go directly to print or for website use. If you intend carrying out any type of further retouching then leave this disabled. Lastly, you can choose to 'Open in Photoshop as Smart Object(s)'. Alternatively, you can hold down the *Shift* key when clicking on the Open Image button to open as a Smart Object.

New Workflow Preset Delete "SWOP Med GCR default" Rename "SWOP Med GCR default"			
set ✓ SWOP Med GCR default			ОК
Color Space			Cancel
Space: SWOP 2006 #3 Med GCR	~	Depth: 16 Bits/Channel v	
Intent: Relative	~	Simulate Paper & Ink	
Image Sizing			
Resize to Fit: Default (21.0 MP)		V Don't Ewarge	
W: 5876 H: 3744	pixels	~	
Resolution: 300 pixels/inch			
Output Sharpening			
Sharpen For: Screen		Amount. Standard x	
Photoshop			
Open in Photoshop as Smart Objects			

Saving photos from Camera Raw

When you click on the Save Image... button this opens the Save Options dialog. Here, you have the option of choosing a folder destination to save the images to and a File Naming section for customized file naming. In the Format section you can choose which file format to use when rendering a pixel version from the raw master.

ation: Save in New Location Lect Folder /Users/martinevening/Desktop/ ming ple: JBA0424.TIF ment Name	Custom		~		
lect Folder /Users/martinevening/Desktop/ ming ple: 18A0424.TIF ment Name + + + * * * * * * * * * * * * *				Save	
Iming pie: _IBA0424.TIF Imment Name	tination: Save in New Location 🔶			Cancel	
ple: 1BA0424.TIF ment Name	Select Folder /Users/martinevening/Desktop/				
Imment Name	Naming				
Windbarrage e Extension: TIF e TIFF etadata: All Remove Location info ression: None pace pace pace pace startage v: ProPhoto RGB Depth: 16 Bits/Channel String size to Fit: Width & Height Don't Enlarge V: 2500 H: 2500 pixels 2500 by 1436 (3.6MP) tesolution: 300 pixels/inch Sharpening	ample: _1BA0424.TIF				
Numbering: e Extension: TIF • etadata: Al • etadata: Al • etadata: Al • etadata: Al • etadata: None • ression: None •	ocument Name v +		v +		
e Extension: TIF	•				
r TIFF etadata: All					
etadata: All Remove Location Info ression: None ression: None ression: ProPhoto RGB ProPhoto RGB Depth: 16 Bits/Channel Sizing	File Extension: TIF				
	nat: TIFF v				
Remove Location Info ression: None ression: None ression: Non	Metadata: All		~		
ipace ProPhoto RGB	Remove Location Info				
size constant of the second se	mpression: None		v		
r ProPhoto RGB					
r ProPhoto RGB					
Sizing size to Fit: Width & Height Obn't Enlarge W: 2500 H: 2500 pixels V 2500 by 1436 (3.6MP) tesolution: 300 pixels/inch V Sharpening	or Space				
Sizing size to Fit: Width & Height Obn't Enlarge W: 2500 H: 2500 pixels V 2500 by 1436 (3.6MP) tesolution: 300 pixels/inch V Sharpening	ace: ProPhoto RGB	Depth: 16 Bits/Channel			
Sizing size to Fit: Width & Height Onn't Enlarge W: 2500 H: 2500 pixels 2500 by 1436 (3.6MP) tesolution: 300 pixels/inch					
size to Fit: Width & Height On't Enlarge W: 2500 H: 2500 pixels V 2500 by 1436 (3.6MP) tesolution: 300 pixels/inch V Sharpening					
W: 2500 H: 2500 pixels V 2500 by 1436 (3.6MP) tesolution: 300 pixels/inch V Sharpening	je Sizing				
tesolution: 300 pixels/inch	Resize to Fit: Width & Height	 Don't Enlarge 			
Sharpening	W: 2500 H: 2500 pixels	~ 2500 by 1436 (3.6MP)			
	Resolution: 300 pixels/inch				
arpan For: Strandges	but Sharpening				
	Sharpen For: Sorsen				
		and the second second second second	The water in the second		
pe C ³ <u>1 remaining</u> SWOP Med GCR default (edited); 10.2 by 15.3 cm (2.2MP) Open Object	hage C3 1 remaining SWOP Med GCR (default (edited): 10.2 by 15.3 cm	(2.2MP)	Open Object	Cancel

Figure 2.13 The Save Options dialog and Save status indicator (below).

These options include: PSD, TIFF, JPEG, or DNG. If you have used the crop tool to crop an image in Camera Raw, the PSD options let you preserve the cropped pixels by saving the image with a nonbackground layer (in Photoshop you can then use Image \Rightarrow Reveal All should you wish to revert to an uncropped state). The JPEG and TIFF format save options provide the usual compression options and if you save using DNG you can convert any raw, or non-raw original as a DNG file. The file save processing is then carried out in the background, allowing you to carry on working in Bridge or Photoshop (depending on which program is hosting Camera Raw at the time) and you'll see a progress indicator (circled in red in Figure 2.13) showing how many photos there are left to save.

If you hold down the *all* key as you click on the Save... button, this bypasses the Save dialog box and saves the image (or images) using the last used Save Options settings. This is handy if you want to add file saves to a queue and continue making more edit changes in the Camera Raw dialog.

Saving a JPEG as DNG

Although it is possible to save a JPEG or TIFF original as a DNG via Camera Raw it is important to realize that this step doesn't actually convert a JPEG or TIFF file to a raw image. Once an image has been rendered as a JPEG or TIFF it cannot be converted back into a raw format. Saving to DNG does though allow you to use DNG as a container format for JPEG or TIFF originals. This means you can store a Camera Raw rendered preview alongside the JPEG or TIFF data, which will be portable when sharing such files with other (non Camera Raw aware) programs. For example, if you choose to convert your JPEG files to DNG, the Camera Raw-applied settings will travel with the master image and allow another Camera Raw/ Lightroom user access to the settings applied to the JPEG. At the same time, saving as a DNG file saves a Camera Raw-adjusted preview, so when it's viewed in any third-party, DNG-aware program, the correct preview is seen, even if it doesn't have the same edit controls as Camera Raw.

Resolving naming conflicts

A save operation from Camera Raw will auto-resolve any naming conflicts so as to avoid overwriting any existing files in the same save destination. This is done by adding an incremental number at the end of the filename when saving. This is important if you wish to save multiple versions of the same image as separate files and avoid overwriting the originals.

Color space and image sizing options

The Color Space section lets you save a document using a profiled color space (see Figure 2.14).

When saving as a TIFF, PSD, or JPEG, you can choose an Image Sizing setting that is independent of what has been set in the Workflow Options dialog. You can also choose to apply output sharpening when saving. Once configured you can save the combined Save settings as a preset (as shown below).

Matching the profile space

When saving files to a CMYK profile space you may want to also make the Workflow settings use the same CMYK space so you can preview the image in CMYK as you apply the Camera Raw adjustments.

New Save Options Pres Delete "SWOP GCR A4 Rename "SWOP GCR A	Portrait"		
eset 🗸 SWOP GCR A4 Portrait			Save
Destination: Save in New Los	cation		Cancel
Select Folder /Users	martinevening/Desktop/		
File Naming			
Example: IMG_6657.TIF			
Document Name	× +	✓ +	
	 ✓ + 		
Begin Numbering:			
File Extension: .TIF			
Format: TIFF	······································		
Metadata: All		· · · · ·	
Remove L	ocation Info		
Compression: None			
Color Space			
Space: SWOP 2006 #3 Med	GCR v Depth: 8 Bits/Cl	hannel v	
Intent: Relative			
Image Sizing			
Resize to Fit: Width & He	ight 🔗 🗋 Don't Enl	arge	
W: 21	H: 29.7 cm v 19.8 by 29.7	(8.2MP)	
Resolution: 300	pixels/inch ~		
Output Sharpening			
Sharpen For: Screen	v Ameunt Standard		

Figure 2.14 The Camera Raw Save dialog.

2

Camera Raw as a filter

It is also possible to apply Camera Raw adjustments as a filter in Photoshop. This isn't the same as placing a raw image as a Camera Raw Smart Object, but does give you the option to apply Camera Raw style edits to already rendered RGB images in Photoshop (see page 202).

Opening raw files as Smart Objects

While working in Camera Raw you can open a raw image in Photoshop and have the Camera Raw settings remain editable. Essentially, if you open a photo from Camera Raw as a Smart object, it is placed as a Smart Object layer in a new Photoshop document. There are two ways you can go about this. You can click on the Workflow options link to open the Workflow Options dialog and check the 'Open in Photoshop as Smart Objects' option (see Figure 2.15). When this is done all Camera Raw processed images will open as Smart Object layers in Photoshop. The other method is to simply hold down the Shift key which makes the Camera Raw 'Open Image' button change to say: 'Open Object'. In the example on the next page I opened two raw images as Smart Object layers and was able to merge them in a composite image in Photoshop. In Step 6 you will notice I duplicated a Smart Object layer. This duplicate shared the same Camera Raw settings as the original. To create an independent duplicate Smart Object, right mouse-click and choose 'New Smart Object' via Copy.

Creating Lightroom-linked Smart Objects

Working with Lightroom, it is possible to create a linked Smart Object. To do this, *alt*-drag a file from the Lightroom Library module Grid view to a Photoshop document. You will then find that updates made to the source file in Lightroom are reflected in the Photoshop document Smart Object.

Color Space			Coursel .
	~	Depth: 16 Bits/Channel V	(Cancel
Space: ProPhoto RGB			
		D Simulate Paper & Ins	
Image Sizing			
Resize to Fit: Default (14.0 MP)		 Don't Unlarge 	
W: 00.000 H: 05.100 cm			
Resolution: 300 pixels/inch		•	
Output Sharpening			
Sharpen For: Classy Paper			
Photoshop			
Open in Photoshop as Smart Objects			

Figure 2.15 If you click on the Workflow options link this opens the Workflow Options dialog, where you can check the 'Open in Photoshop as Smart Objects' option.

1 In this first step, I opened a raw image of house boats and held down the *Shift* key as I clicked on the 'Open Image' button, to open it as a Smart Object layer in Photoshop.

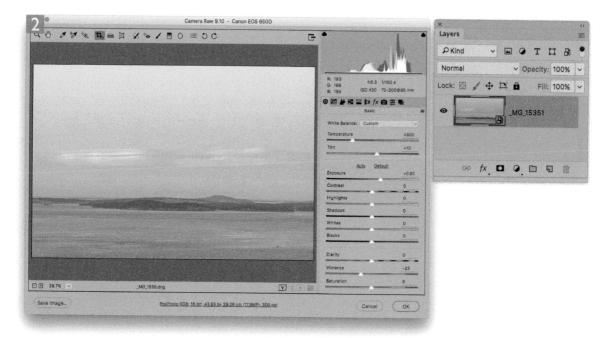

2 In this next step I selected a new image, this time a photo of a sky, and again held the *Shift* key as I clicked on the 'Open Image' button, to open this too as a Smart Object layer.

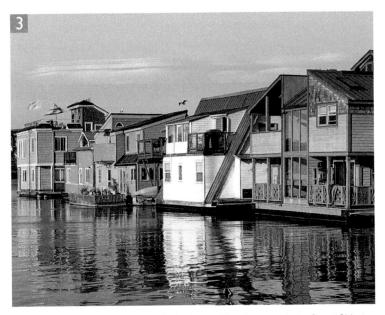

3 In Photoshop I dragged the Smart Object layer of the sky across to the Smart Object layer image of the building to add it as a new layer. I then made a selection of the outline of the house boats and converted this to a layer mask to create the merged photo shown here.

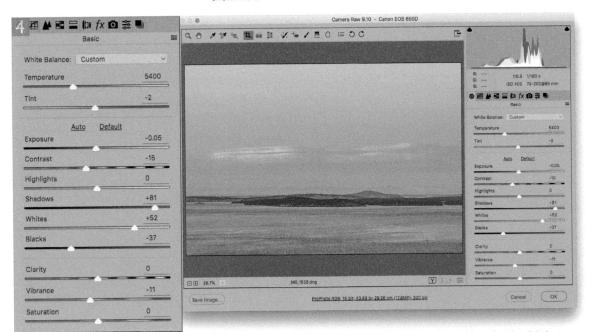

4 Because both layers were raw image Smart Objects, I was able to double-click the top layer thumbnail (circled in red in Step 3 above) to open the Camera Raw dialog and edit the settings. In this step I chose to give the sky more of a rich sunset color balance.

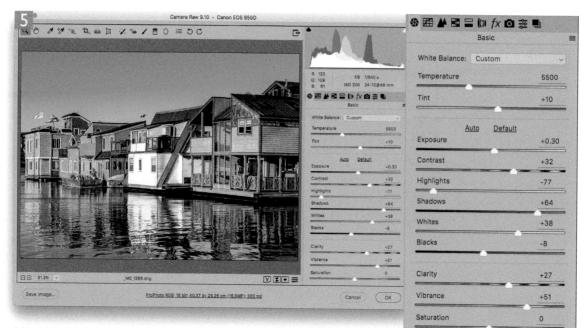

5 Next, I double-clicked the lower layer. This also opened the raw image Smart Object layer via Camera Raw, where I added more contrast to the buildings.

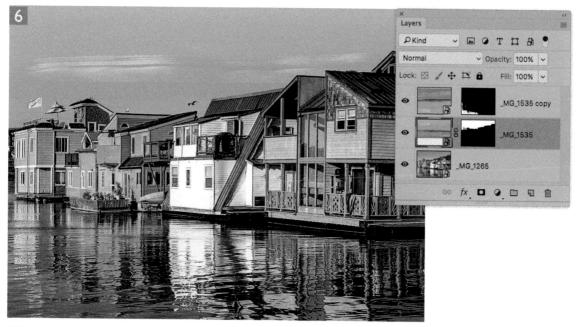

6 Here is the image with the updated Smart Object layers. What I also did here was to duplicate the _IMG 1535 layer (by dragging it to the New Layer button in the layers panel). I applied a vertical Flip transform and then edited the layer mask to replace the blue sky reflections at the bottom with a reflection of the _IMG 1535 sky layer.

Altering the background color

You can set the background color of the work area and toggle the Draw Image Frame option to toggle visibility. Right mouse-click outside the image in the work area to select the desired options from the contextual pop-up menu (see Figure 2.16). In the top screen shot a Medium Gray background was used and White was chosen in the lower screen shot.

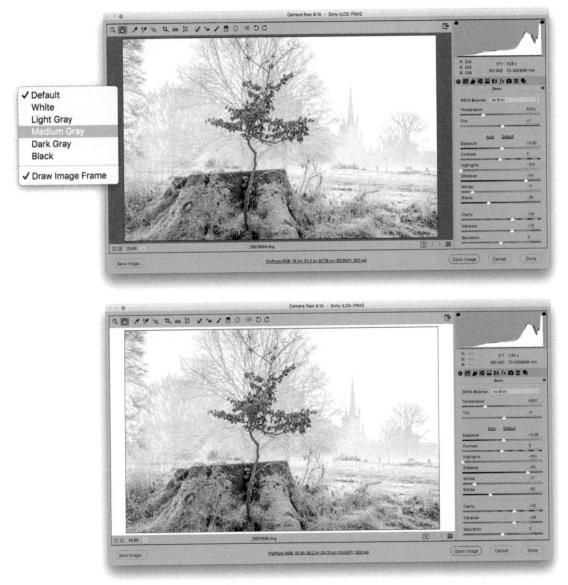

Figure 2.16 In these screen shots you can see examples of the Camera Raw interface using alternative background colors.

The histogram display

The Camera Raw Histogram provides a preview of how the Camera Raw output image histogram will look after the image data has been processed and output as a pixel image. The histogram appearance adjusts to reflect the tone and color settings you apply in Camera Raw. More importantly, it is also influenced by the RGB space selected in the Workflow options. It can therefore be interesting to compare the effect of different output spaces when editing a raw capture image. For example, if you edit a photo using the ProPhoto RGB or Adobe RGB space and then switch to sRGB, you may see some color channel clipping in the sRGB histogram. Such clipping can then be addressed by readjusting the Camera Raw settings to suit the smaller gamut RGB space. This exercise clearly demonstrates why it is better to output your Camera Raw processed images using either the ProPhoto or Adobe RGB color spaces.

Digital camera histograms

Some digital cameras provide a histogram display that enables you to check the quality of what you have just shot. This too can be used as an indication of the levels captured in a scene. However, the histogram you see displayed is usually based on a JPEG capture image. If you prefer to shoot using raw mode, the histogram you see on the back of the camera will not provide an accurate guide to the true potential of the image you have captured.

Interactive histogram

The histogram is interactive, meaning that you can click on the histogram directly to apply basic tone adjustments. It allows you to click and drag to adjust the Blacks, Shadows, Exposure, Highlights, and Whites settings (Figure 2.17). It has to be said that the zones referenced in the histogram are not actually an accurate representation of the tones that are being manipulated. I think in the end that it is just as easy to click and drag on the sliders in the Basic panel. Where this is advantageous is if you are working in one of the other panels, say the Tone Curve panel. It means you can access these Basic panel tone controls without having to switch panel views.

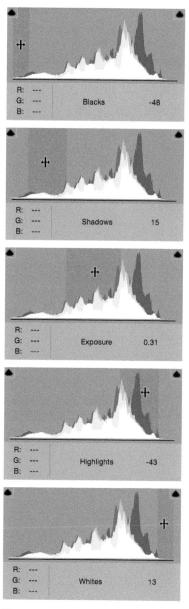

Figure 2.17 The interactive histogram.

Image browsing via Camera Raw

In the multiple image mode, the Camera Raw dialog can be used as an image browser. You can match the magnification and location across all the selected images to check and compare details, inspect them in a sequence and apply ratings to the selected photos.

Selecting and deleting

You can use all **H** A (Mac), all of A (PC) to select the rated images only. This means you can use star ratings to mark the images you are interested in during a 'first pass' edit and then use the above shortcut to make a quick selection of just the rated images. The **Delete** key can be used to mark images that are to be sent to the trash. This places a red X in the thumbnail. To undo, select the image and hit **Delete** again. 1 If you have a large folder of images to review, the Camera Raw dialog can be used to provide a synchronized, magnified view of the selected pictures. The dialog is shown here in a normal window view, but you can click on the Full Screen mode button (circled) to expand the dialog to a Full screen view mode. In this first step I went to the Filmstrip menu and chose 'Select All'.

2 Next, I used the zoom tool to magnify the preview. This action synchronized the zoom view for all the selected images in the Camera Raw dialog; I was also able to use the hand tool to synchronize the scroll location for the selected photos.

3 Once this was done I could deselect the thumbnail selection and start inspecting the photos. This could be done by clicking on the file navigation controls (circled in the Step 3 image), or by using the ⊕ e keyboard arrow keys to progress through the images one by one. I could then mark my favorite pictures using (Mac), *ctrl* ≥ (PC) to progressively increase the star rating for a selected image and (Mac), (Mac), *ctrl* ≤ (PC) to progressively decrease the star rating.

Bird's Eye View

The Bird's Eye View feature provides an easy way to zoom in and out of photographs that are open in Camera Raw and works similarly to the Bird's Eye View feature in Photoshop. It basically provides a fast, alternative way to navigate an image. To use the Bird's Eye View you must have 'Use Graphics Processor' enabled in the Performance section of the Camera Raw preferences. While zoomed in on an image, hold down the 🕼 key while clicking in the zoomed-in image and you will be temporarily taken back to a filled screen view with the outline boundary of your zoomed-in magnification; you can now position this elsewhere in the image and, when you release the 闭 key, be at the same zoom level as before. The previously zoomed-in area will be represented by a zoom rectangle outline (see Figure 2.18). For example, if you started at a 200% zoomed-in view, after releasing the mouse you'll be back at a 200% view again. You have to be careful when selecting the I key to click and hold down the key to initiate a Bird's Eye View, as a short click will simply select the Hand tool instead. You must click and hold down the 🖪 key so when you release, the previously selected tool remains unchanged.

Modal tool refinements in Camera Raw

With earlier versions of Camera Raw, when you selected the Spot Removal tool, Red Eye tool, Graduated Filter, Radial Filter, or Adjustment Brush and applied an edit, if you were to click the *esc* or *Return* key this would apply the adjustment and dismiss the Camera Raw dialog. If you pressed the *esc* key this would just close the Camera Raw dialog, while pressing the *Return* key would dismiss and open a rendered image.

Now, in Camera Raw, when any of the above tools are active, entering *esc* or *Return* prevents the dismissal of the Camera Raw dialog and dismisses the tool instead. In the case of the Graduated Filter, Radial Filter, or Adjustment Brush, entering *esc* or *Return* exits working with the current pin adjustment and selects the 'New' radio button. A subsequent click will add a new localized adjustment. This means you no longer need to move the cursor over to the panel in order to create a new adjustment. In the case of the Spot Removal and Red Eye tools, clicking *esc* or *Return* will deselect the spot or red eye correction that is currently active without dismissing the Camera Raw dialog. If there is no active correction, the Zoom tool becomes selected (this matches the behavior of the Crop tool in Camera Raw).

Blacks -13 Clarity +8 Vibrance +39 Saturat 0 E 🛨 31.9% 1BA0594.dng 11 Save Image ... ProPhoto RGB: 16 bit: 47.55 by 31.7 cm (21.0MP): 300 ppi Open Image Cance Done

Figure 2.18 This shows the Camera Raw Bird'S Eye View in action.

Photograph: Newtown Garage, Chesham.

XMP sidecar files

Camera Raw edit settings are written as XMP metadata. This data is stored in the central Camera Raw database on the computer and can also be written to the files directly. In the case of JPEG, TIFF, and DNG files, these file formats allow the XMP metadata to be written to the XMP space in the file header. However, in the case of proprietary raw file formats such as CR2 and NEF, it would be unsafe to write XMP metadata to an undocumented file format. To get around this, Camera Raw writes the XMP metadata to XMP sidecar files that accompany the image in the same folder and stay with the file when you move it from one location to another via Bridge.

Camera Raw preferences

Let's look at the General section first. From the 'Save Image Settings' menu I suggest you choose 'Sidecar ".xmp" files'. You see, TIFF, JPEG, and DNG files can store the XMP data in the header, but with raw files the XMP data can't be stored internally. Selecting this option forces the image settings to be stored locally in XMP sidecar files that accompany the image files (see also page 248).

Should you wish to preview adjustments with the sharpening turned on, but without actually sharpening the output, the 'Apply sharpening to' option can be set to 'Preview images only'. This is

General	OK
Save image settings in: Sidecar ".xmp" files	Cancel
Apply sharpening to: All images 🗢	Cancer
Default Image Settings	
Apply auto tone adjustments	
Apply auto grayscale mix when converting to grayscale	
Make defaults specific to camera serial number	
Make defaults specific to camera ISO setting	
Camera Raw Cache	
Maximum Size: 20.0 GB Purge Cache	
Select Location /Users/martinevening/Library/Caches/Adobe Camera Raw/	
DNG File Handling	
Ignore sidecar ".xmp" files	
Update embedded JPEG previews: Full Size ~	
JPEG and TIFF Handling	
JPEG: Automatically open JPEGs with settings	
TIFF: Automatically open TIFFs with settings	2
Performance	
Use Graphics Processor	
AMD Radeon R9 M295X OpenGL Engine	

Figure 2.19 Camera Raw preferences dialog.

because you might want to use a third-party sharpening program in preference to Camera Raw. However, with the advent of Camera Raw's improved sharpening, you will most likely want to leave this set to 'All images' to make full use of Camera Raw sharpening.

Default Image Settings

In the Default Image Settings section, you can select 'Apply auto tone adjustments' as a Camera Raw default. When this is switched on, Camera Raw automatically applies an auto tone adjustment to new images it encounters that have not yet been processed in Camera Raw, while any images you have edited previously via Camera Raw will remain as they are.

The 'Apply auto grayscale mix when converting to grayscale' option refers to the HSL/Grayscale controls, where Camera Raw can apply an auto slider grayscale mix adjustment when converting a color image to black and white. The next two options can be used to decide, when setting the camera default settings, if these should be camera body and/or ISO specific (see page 149 for more information).

Camera Raw cache

When photos are rendered using the Camera Raw engine, they go through an early stage initial rendering and Camera Raw builds full, high quality previews direct from the master image data. In the case of raw files, the early stage processing includes the decoding and decompression of the raw data as well as the linearization and demosaic processing. All this has to take place first before getting to the stage that allows the user to adjust things like the Basic panel adjustments. The Camera Raw cache is therefore used to store the unchanging, early stage raw processing data that is used to generate the Camera Raw previews so that this step can be skipped the next time you view that image and renders the photo quicker in the Camera Raw dialog. The 1 GB default setting is rather conservative. If you have enough free hard disk space available, you may want to increase the size limit for the cache, plus you can choose a new location to store the central preview cache data. If you increase the Camera Raw cache size, more image data can be held in the cache. This in turn results in swifter Camera Raw preview generation when you reopen these photos. The Camera Raw cache can also be utilized by Lightroom as the cache data is shared between both programs. Because the Camera Raw cache files are compressed, this means you can cache a lot more files within the limit you set in the Camera Raw preferences.

DNG file handling

Camera Raw and Lightroom both embed the XMP metadata in the XMP header space of a DNG file. There should therefore be no need to use sidecar files to read and write XMP metadata when sharing files between these two programs. However, some third-party programs may create sidecar files for DNG files. If 'Ignore sidecar "xmp" files' is checked, Camera Raw will not be sidetracked by sidecar files that might accompany a DNG file and cause a metadata conflict.

However, there are times where it may be useful to read the XMP metadata from DNG sidecar files. For example, when I work from a rental studio I'll have a computer in the studio with all the captured files (kept as standard raws) and a backup/shuttle disk to take back to the office at my house from which I can copy everything to the main computer there. If I make any further ratings edits on this main machine, the XMP metadata is automatically updated as I do so. It then only takes a few seconds to copy just the updated XMP files across to the backup disk, replacing the old ones. Back at the studio I can again copy the most recently modified XMP files back to the main computer (overwriting the old XMP files). The photos in Bridge will then appear updated. So, if in the meantime the files on the studio computer happen to have been converted to DNG, it's important that the 'Ignore sidecar "xmp" files' option is now left unchecked, otherwise the imported xmp files will simply be ignored.

DNG files have embedded previews that represent how the image looks with the current applied Camera Raw settings. When 'Update embedded JPEG previews' is checked, this forces the previews in all DNG files to be continually updated based on the current Camera Raw settings, overriding previously embedded previews. While DNG is a safe format for the archiving of raw data, other DNG compatible programs that are not made by Adobe, or that use an earlier version of Camera Raw, will not always be able to read the Camera Raw settings that have been applied using the latest version of Camera Raw or Lightroom. Embedding updated previews allows you to share DNG files with other programs and have the photo previews appear correctly even though they won't be able to edit the photos unless they are using Adobe software.

JPEG and TIFF handling

If 'Disable JPEG (or TIFF) support' is selected, all JPEG (or TIFF) files will always open in Photoshop directly. If 'Automatically open all supported JPEGs (or TIFFs)' is selected, this causes all supported JPEGs and TIFFs to always open via Camera Raw. However, if 'Automatically open JPEGs (or TIFFs) with settings' is selected,

Photoshop will only open a JPEG or TIFF via Camera Raw if it has previously been edited via Camera Raw. When this option is selected you have the option in Bridge to use a double-click to open a JPEG directly into Photoshop, or use **H (**Mac), *ctrl* **(**Mc) to force JPEGs to open via Camera Raw. But when you edit the Camera Raw settings for that JPEG, the next time you use a double-click to open, it will default to opening via Camera Raw.

Performance: Accelerated graphics (GPU)

The Performance section has a 'Use Graphics Processor' option. When checked it allows Camera Raw to use the Graphics Processing Unit (GPU) to speed up its interactive image editing when editing images. This option will be particularly helpful if you are using a high-resolution display, such as a 4K or 5K display (where the benefits will be most noticeable). The 'Use Graphics Processor' option is normally on by default (providing your installed video card meets requirements), but you may need to visit this section of the Camera Raw preferences and check this is the case (the GPU options in Photoshop's Performance Preferences have no effect on Camera Raw).

When you compare performance with the 'Use Graphics Processor' option enabled, the first thing you will notice is how the panning and zooming are both much faster. If you open a large image and choose to zoom in to a 100% view or higher, you'll soon notice how quickly you can scroll from one corner of the image to another. Without GPU support the Camera Raw preview performance will be identical to earlier versions of Camera Raw and you'll notice by comparison how the scrolling tends to be slow and jerky. But when 'Use Graphics Processor' is enabled the scrolling should be noticeably smoother. If you look at what is happening more closely you will notice how the on-screen image initially loads a standard preview resolution image before rendering a full resolution preview. Also, when you are viewing an image close-up, Camera Raw pre-emptively loads and renders parts of the image that are just outside the current visible area. By doing so, Camera Raw is able to provide a smoother scrolling experience. You will also notice that as you adjust the sliders the preview response will appear a lot less jerky.

There is though a trade-off when implementing the GPU path. The main benefit is that it makes the interactive image editing faster, although at the same time there is more setup overhead required to accomplish this. Therefore, even though you may have GPU processing enabled, there may still be a slight delay when skimming through a bunch of raw images in Camera Raw. You'll also see more of a performance boost with some types of Camera Raw edits than others.

Graphics card compatibility

It is important to realize that the GPU performance boost will only be available for certain types of video cards (OpenGL 3.3 upwards). If the card you are using is compatible, the video card name will appear in the Performance section of the Camera Raw preferences. If it's not, Camera Raw shows an error message. You'll also need to make sure your video drivers are up to date. On the Mac system, video drivers are updated whenever you carry out an operating system update, but on Windows the operating system is not always as accurate and may tell you that the outdated drivers you have installed are just fine. So in these instances, PC users who are experiencing problems, may need to go to the manufacturer's website to download a dedicated video driver update utility.

Camera Raw can currently use only a single GPU. So if your computer has more than one video card this won't offer any improvement (although the performance boost from using just one should be significant). For best results the main requirement is that you have a compatible graphics card manufactured from 2010 onwards. You don't necessarily have to have the fastest card to get optimum performance, as a solid, mid-range card can be just as effective as a high-end one. Basically, to process large images, a video card with 2 GB memory should be suitable for Camera Raw processing, especially if you are working with a 4K or 5K display.

It should also be noted that the GPU acceleration described here only applies to processing carried out on the main display. Those users with multiple displays should be aware that performance on secondary displays will be unchanged regardless of whether they have the 'Use Graphics Processor' option checked or not.

Scrubby Zoom

When 'Use Graphics Processor' is enabled you can also make use of a Scrubby Zoom option. To access, select the Zoom tool in the Camera Raw dialog, click on the Zoom menu (bottom left of the image preview) and select 'Scrubby Zoom' from the bottom of the menu (this allows you to toggle scrubby zoom behavior on/off). This option is actually enabled by default when 'Use Graphics Processor' is selected. Once enabled, click-dragging on an image with the zoom tool will allow you to zoom smoothly in and out.

Q 🖑 & *# to.	
	✓ Normal
	1 to 1
	2 to 3
	3 to 4
	4 to 5
	5 to 7
	9 to 16
	Custom
	Constrain to Image
	Show Overlay
	Clear Crop Set to Original Crop

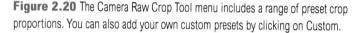

Camera Raw cropping and straightening

The Crop tool is accessed via the Toolbar in Camera Raw. When cropping an image for the first time you have to click and drag to define the crop area. A quick tip is to press the \bigotimes key twice to force the Crop tool to define the bounds of the image. Cropping is limited to the bounds of the image area only. If you press down the spacebar after dragging with the Crop tool, this lets you reposition the marquee selection. Release the spacebar to continue to modify the marquee area. The crop you apply in Camera Raw will be applied when the image is opened in Photoshop. However, if you save a file out of Camera Raw using the Photoshop format, there is an option in the Save dialog to preserve the cropped pixels so you can recover the hidden pixels later.

You can use the Custom Crop menu option highlighted in Figure 2.20 to create a custom crop ratio and save this as a custom setting. In Figure 2.21 I created a custom crop ratio with A4 metric proportions. This then appeared added to the Crop menu. To remove a crop, open the image in the Camera Raw dialog again, select the crop tool and choose 'Clear Crop' from the Crop menu. Alternatively, you can hit *Delete* or simply click outside the crop in the gray canvas area.

The Camera Raw Straighten tool (which is next to the Crop tool) can be used to measure a vertical or horizontal angle and at the same time apply a minimum crop to the image, which you can then resize accordingly. You can automatically straighten a picture in the following ways. You can simply double-click on the Straighten tool button icon in the Toolbar to auto-straighten an image. Or, with the Straighten tool selected, you can double-click anywhere within the preview image.

		(OK
29.7 to 21		
		Cance

Figure 2.21 This shows the Custom Crop settings that can be accessed via the Crop Tool menu (Figure 2.20).

Straighten tool shortcuts

If the Crop tool is selected, you can hold down the **#** key (Mac), or *cttd* key (PC) to temporarily switch to the Straighten tool, and then double-click anywhere within the preview image. Also, when using the Crop tool or Straighten tool you can press **X** to flip the crop aspect ratio.

How to straighten and crop

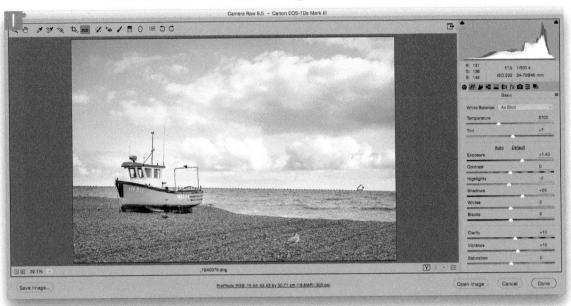

1 To straighten this photograph, I selected the Straighten tool from the Camera Raw tools and dragged with the tool to straighten the horizon.

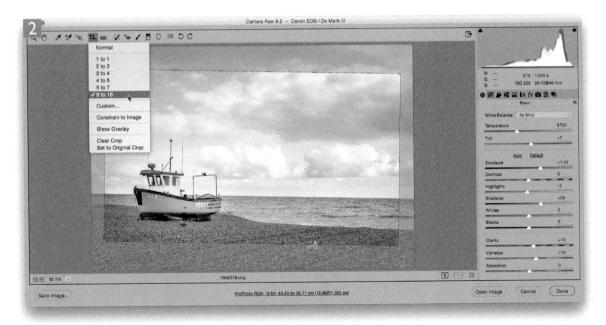

2 This action straightened the image. I then clicked on the Crop tool to access the Crop Tool menu and chose a 9 to 16 crop ratio preset.

3 After selecting the 9 to 16 crop ratio setting, I dragged one of the corner handles to resize the crop bounding box as desired.

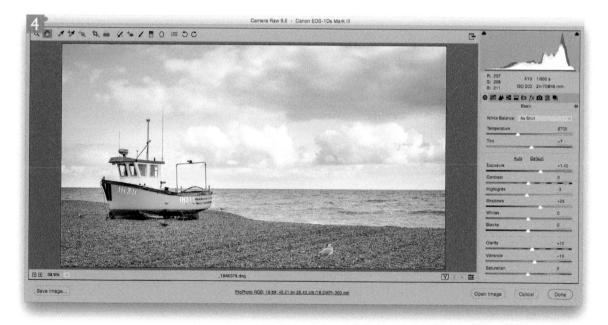

4 Finally, I deselected the Crop tool by clicking on one of the other tools (such as the hand tool). This reset the preview to show a fully cropped and straightened image.

Figure 2.22 The Camera Raw Basic panel controls.

Basic panel controls

The Basic panel (Figure 2.22) can be used to carry out the main color and tone edits. Most photos can be improved by making just a few Basic panel edits.

White balance

Let's start with the White Balance controls. The Temperature slider refers to the color temperature of the lighting conditions at the time a photo was taken Color temperature is a term that refers to the appearance of a black body object at specific temperatures, measured in Kelvin, or degrees Kelvin. Think of a piece of metal being heated in a furnace. At first it will glow red but as it gets hotter, it emits a yellow and then a white glow. Indoor tungsten lighting has a low color temperature (a more orange color), while sunlight has a higher color temperature and emits a bluer light. For example, quartz-halogen lighting has a warmer color and a low color temperature value of around 3,400 K, while daylight has a bluer color (and a higher color temperature value of around 6,500 K). If you choose to shoot in raw mode it does not matter how you set the white point setting on the camera because you can always decide later which is the best white balance setting to use. Camera Raw White Balance adjustments are all about getting the White Balance setting to match the color temperature of the scene when the photograph was taken.

The default white balance setting uses 'As Shot'. This is based on the white balance setting that was embedded in the raw file metadata at the time the image was taken. This might be a fixed white balance setting that you had selected on your camera, or it could be an auto white balance that was calculated at the time the photo was shot. If this is not correct you can try mousing down on the White Balance pop-up menu and select a preset setting that correctly describes which white balance setting should be used. Alternatively, you can simply adjust the Temperature slider to make the image appear warmer or cooler and adjust the Tint slider to adjust the white balance green/magenta tint bias.

Using the White Balance tool

The easiest way to set the white balance manually is to select the White Balance tool and click on an area that is meant to be a light gray color (see Figure 2.23). Don't select an area of pure white as this may contain some channel clipping, which could produce a skewed result. You will also notice that as you move the White Balance tool

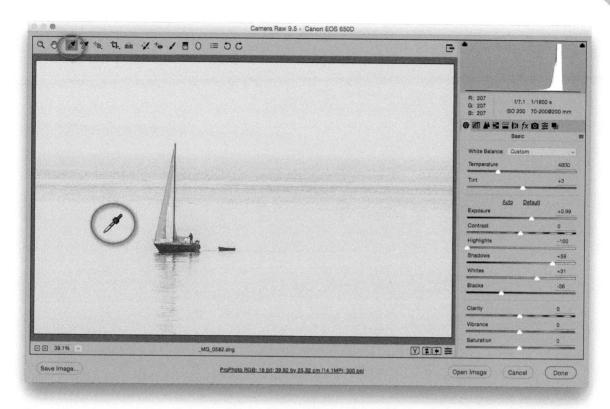

Figure 2.23 To manually set the White Balance, select the White Balance tool (circled), locate what should be a neutral area, and click to update the white balance.

across the image, the sampled RGB values are displayed just below the histogram, and after you click to set the white balance, these numbers should appear even.

There are also calibration charts such as the X-Rite ColorChecker chart, which can be used in carrying out a custom calibration, although the light gray patch on this chart is regarded as being a little on the warm side. For this reason, you may like to consider using a WhiBal[™] card (Figure 2.24). These cards have been specially designed for obtaining accurate white point readings under varying lighting conditions.

Figure 2.24 WhiBal™ cards come in different sizes and are available from RawWorkflow.com.

Localized white balance measurements

The White Balance tool can be applied selectively when white balancing an image. Just click-and-drag with the White Balance tool to define a rectangular pixel area. As you release the mouse, Camera Raw uses all the pixels within the marked rectangle to set the global white balance. The single-click behavior of the White Balance tool remains unchanged.

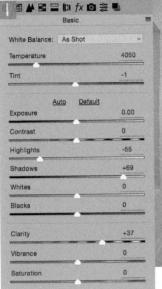

1 I opened this image in Camera Raw, which currently shows the 'As Shot' white balance setting. I selected the White Balance tool and marquee dragged to sample the pixels within the area shown here to set the white balance.

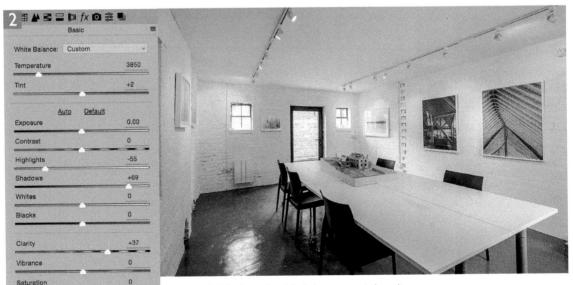

2 This shows the white balance corrected result.

The White Balance tool also takes localized adjustments into account. For example, if you use a Graduated Filter to apply a cool white balance, when you click with the White Balance tool it takes the localized Temperature or Tint adjustments into account to ensure the pixels where you click are always neutralized.

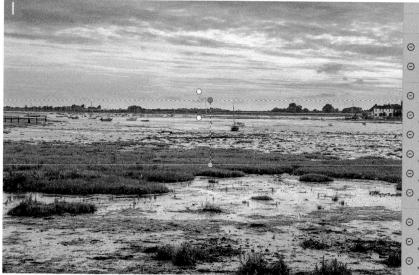

1 In this example, a cooling Temperature Graduated Filter was applied to the lower half of the image.

2 When I selected the White Balance tool and clicked on the bottom half of the image it calculated a new white balance adjustment that took into account the locally applied white balance adjustment.

	Graduated	Filter	
	New O E	dit 💮 Brush	
Θ	Temperature	-19	•
Θ	Tint	0	€
Θ	Exposure	0.00	€
Θ	Contrast	0	€
Θ	Highlights	0	€
Θ	Shadows	0	€
Θ	Whites	0	€
Θ	Blacks	0	Ð
Θ	Clarity	0	•
Θ	Dehaze	0	Ð
Θ	Saturation	0	€
	Overlay Mask	Clear A	1

Basic	
White Balance: Custom	1 v
Temperature	5700
Tint	+5
Auto De	efault
Exposure	+0.66
Contrast	+17
Highlights	0
Shadows	+64
Whites	-11
Blacks	+5
Clarity	0
Vibrance	0
Saturation	0

Independent auto white balance adjustments

You can set the Temperature and Tint sliders independently. It used to be the case that when you selected 'Auto' from the White Balance menu, this auto set both the Temperature and Tint sliders. In Camera Raw, you can use Shift + double-click on the Temperature and Tint sliders to set these independently of each other.

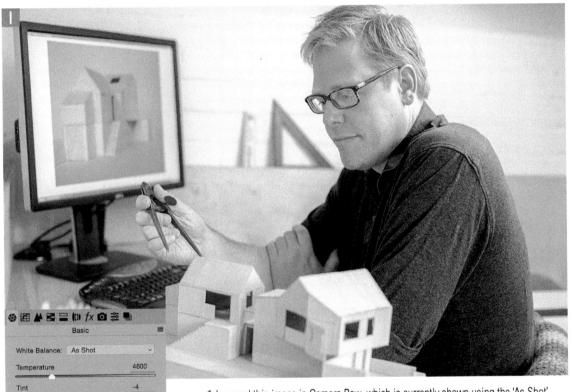

1 I opened this image in Camera Raw, which is currently shown using the 'As Shot' white balance setting.

Auto

Exposure

Contrast

Highlights

Shadows

Whites

Blacks

Clarity

Vibrance

Saturation

Default

-0.60

0

-100

+30

+16

-34

0

0

0

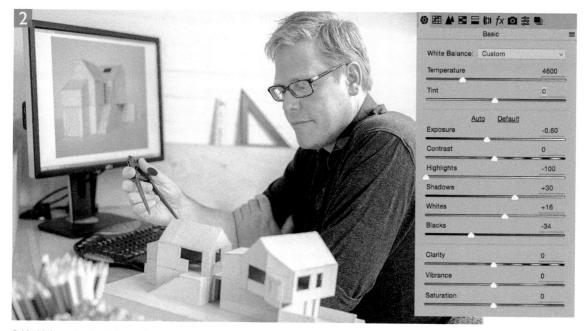

2 I held down the *Shift* key and double-clicked on the Tint slider. This auto-set the Tint slider only to the Auto calculated white balance setting.

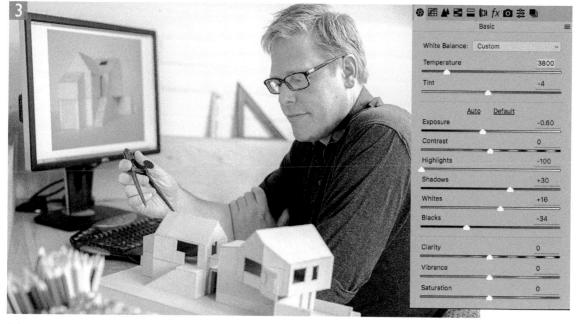

3 I reset the Tint slider. I then held down the *Shift* key again and double-clicked on the Temperature slider. This set the Temperature slider only to an Auto calculated setting.

Figure 2.25 This shows the Process Version update warning triangle.

	📓 🚍 🕼 fx 🖸 葦	
	Camera Calibration	
rocess:	✓ Version 4 (Current)	
	Version 3 (2012)	
	Version 2 (2010)	
	Version 1 (2003)	
ame:	Adobe Standard	
	Shadows	
Tint		0
Hue	Red Primary	0
Saturati	on	0
	Green Primary	
Hue		0
Saturati	on	0
	Blue Primary	
		0
Hue		

Figure 2.26 The Process Version setting can be accessed via the Camera Calibration panel.

E	Auto	
Exposure		0.00
Contrast		0
Highlights		0
Shadows		0
Whites		0
Blacks		0

Figure 2.27 The Version 4 tone adjustment controls.

Process Versions

In the lifetime of Camera Raw there have been several updates to the core Camera Raw processing that have been distinguished as new process versions. Previously known as Process 2003, Process 2010 and Process 2012, these are now known as Version 1, Version 2, and Version 3. The most current is now Version 4. With Version 3 and Version 4 the default settings are identical for both raw and non-raw files alike. This makes it possible to share and synchronize settings between raw and non-raw images more effectively. Also, the tone controls have been revised with an eye to the future and the ability to handle high dynamic range (HDR) images. For example, you can use Camera Raw to edit 32-bit HDR files, or Photomerge HDR DNGs as if they were raw originals. As camera manufacturers focus on better ways to capture high dynamic range scenes, these can now be processed more effectively.

Version 3 and Version 4 processing are more or less identical. The only difference is the ability to apply Range Masking in Version 4. All new imported images now use Version 4 and whenever you adjust any Version 3 image it will silently update to Version 4, *except* where Auto Mask has been applied. In such instances (and to avoid confusion) the image remains as Version 3. Essentially, the new Version 4 update makes a distinction between the use of Range Masking to edit localized adjustments. The lack of compatibility with existing Version 3 images has therefore necessitated a new version update. For example, if you add a localized adjustment to a Version 4 image, apply a Luminance or Color Range Mask edit and then convert back to Version 3 you'll see a change in the image's appearance as the 'Version 4 only' Range Mask will be ignored.

Whenever you edit a photo that's previously been edited in an earlier process version of Camera Raw, an exclamation mark button will appear in the bottom right corner of the preview (Figure 2.25) to indicate this is an older Process Version image. Clicking on the button will pop a dialog asking if you wish to update the file to Version 4 (Current). Or, you can *all*-click to bypass this warning dialog. Updating to Version 4 allows you to take advantage of the latest image processing features in Camera Raw. Or, you can go to the Camera Calibration panel and select the desired Process Version from the Process menu shown in Figure 2.26. Camera Raw will attempt to match the legacy settings as closely as possible when updating to Version 4. Should you wish to do so you can revert to a previous Version 1, 2, or 3 setting.

The Version 4 tone adjustment controls

Let's now look at the Basic panel tone adjustment controls in more detail (Figure 2.27). You can adjust the sliders manually, or you can click on the Auto button to auto-set the slider settings. In this edition of the book I only discuss the Version 4 controls. Should you need to know how to master the Version 1/Version 2 controls there is a PDF guide you can download from the book website.

Exposure

With Version 4, there is just one main control for adjusting the overall brightness and that is the Exposure slider, which is essentially a blend of the old Version 1/Version 2 Exposure and Brightness sliders. The Exposure slider is primarily an 'exposure brightness' adjustment. It is possible to hold down the *alt* key as you drag to see a threshold preview that indicates any highlight clipping, but such feedback can prevent you from using the Exposure slider effectively. If you try to preserve the highlight clipping using the Exposure slider alone you'll quite possibly end up with an over-dark image. What you therefore want to do is to concentrate on using the Exposure to adjust the brightness for the midtones rather than for the highlights and mainly use the Contrast, Highlights and Whites sliders to control the highlight clipping. For regular raw and non-raw images the Exposure slider has a range of -4.00 to +4.00, but when editing 32-bit TIFFs or HDR DNGs the range will extend from -10.00 to +10.00.

The Exposure slider's behavior is also dependent on the image content. With Version 4, as you increase exposure there is a 'soft clipping' of the highlights as the highlight clipping threshold point is reached. As the exposure is increased the highlights will roll off smoothly instead of being clipped. As you further increase exposure you will of course see more and more pixels mapping to pure white, but overall, such exposure adjustments should result in smooth highlights and reduced color shifts.

Contrast

Normally when you increase the contrast the dark tones get darker and the light tones get lighter, and as you reduce contrast the opposite happens. Meanwhile, the midpoint tones remain anchored. With Version 4 the midpoint is able to vary slightly according to the content of the image. With low-key images the midpoint shifts slightly more to the left and with high-key images, it shifts more to the right. Consequently, the Contrast slider behavior adapts according to the image content and should allow you to better differentiate the tones in the tone areas that predominate.

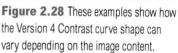

Highlight recovery

Camera Raw's Highlights slider can recover luminance and color data in the highlight regions whenever one or more of the red, green and blue channels are partially clipped, but not all three channels are affected. Initially, Camera Raw looks for luminance detail in the non-missing channel or channels and uses this to build luminance detail in the clipped channel or channels. It preserves the partial color relationships as well as the luminance texture in the highlights and there is less tendency for color detail to quickly fade to neutral gray. This may be enough to recover the missing detail in the highlights. After that Camera Raw applies a darkening curve to the highlight region only, and in doing so brings out more detail in the highlight areas. This works best for raw files only, although JPEG images can sometimes benefit too.

In Figure 2.28 the top curve shows the range of contrast options offered by the Contrast slider when using Version 2, where the midpoint always remains anchored. When you edit using Version 4 the Contrast slider curve shape response can vary depending on the image content. With images that have an even distribution of tones the contrast response will be locked to the middle point. The middle example shows how for low-key images the midpoint shifts slightly to the left, while the bottom example shows how for low-key images the midpoint shifts slightly to the right.

Basically, you need to think of the Exposure slider as a control for establishing the midtone brightness and the Contrast slider as a control for setting the amount of contrast around that midpoint. By working with these two sliders you can fairly quickly get to a point where you have an image with more or less the right brightness and contrast. Everything you do from there on is about fine-tuning these initial adjustments.

One of the things that tends to confuse some people is the fact that as well as having the Contrast adjustment in the Basic panel there is also a separate Tone Curve panel that can be used to adjust contrast. Basically, The Tone Curve panel sliders are useful for fine-tuning the image contrast after you have adjusted the main Contrast slider.

As you increase the contrast in Camera Raw you should not see any unusual color shifts (as you sometimes see in Photoshop when applying a Curves adjustment). This is because the Camera Raw processing is designed to prevent hue shifts from occurring as you pump up the contrast.

Highlights and Shadows

The Highlights and Shadows sliders can be regarded as 'second-level' tone adjustment controls that are to be applied after you have adjusted the Exposure and Contrast. The important thing to know here, is they work at opposite ends of the tonal scale and are symmetrical in behavior. A Highlights adjustment won't affect the darker areas and, similarly, a Shadows adjustment won't affect the lighter areas. So, by using these two sliders it is easier to work on the shadow and highlight regions independently without affecting the overall image brightness. Therefore, the midtones will mostly remain unchanged (where they can be better governed by an Exposure slider adjustment). I say 'mostly', because the range of both the Highlights and Shadows sliders do extend slightly beyond the midtone region.

You can hold down the *all* key as you drag the Highlights or Shadows sliders to see a threshold preview. This will indicate any

highlight or shadow clipping. I would say that a threshold preview analysis at this stage is more 'helpful' rather than essential. As you play around with the Version 4 controls you'll notice that the Highlights and Shadows adjustments have the potential to apply quite strong corrections when bringing out detail in the shadow or highlight areas. If you prefer a more natural look then you are advised to keep your adjustments within the -50 to +50 range. As you go beyond this, Camera Raw uses a soft-edge tone mapping method to compress the tonal range. This technique is similar to that used when converting high dynamic range images to low dynamic range versions, such as when using the HDR Toning adjustment in Photoshop or the Photomatix program. As you increase the amount that's applied using the Highlights or Shadows sliders you will start to see something that looks like an 'HDR effect' look, though this will be nothing like as noticeable as the obvious halo effects typically associated with overprocessed HDR images.

It is also possible to apply negative Shadows adjustments to darken the shadows—this can be useful where you wish to darken just the shadows to add more contrast. Similarly, you can apply positive Highlights adjustments in order to lighten the whites in images where the highlight tones need extra lightening. The Highlights and Shadows controls also inform the Whites and Blacks how much tonal compression or expansion has been applied and, as a result, the Whites and Blacks controls will automatically adjust their ranges to take this into account.

Whites and Blacks

The Whites and Blacks sliders can be used to fine-tune the highlight and shadow clipping. In most instances it should be possible to achieve the look you are after using just the main Basic panel tone sliders, i.e. the Exposure, Contrast, Highlights, and Shadows controls. Should you find it necessary to further tweak the highlight and shadows, you can use the Whites and Blacks sliders to precisely determine how much the shadows and highlights should be clipped, while preserving the overall tonal relationships in the rest of the image. These controls do have less range compared to the other four. This is because they are primarily intended for fine-tuning the endpoints after the initial tones have been adjusted. As with the Highlights and Shadows sliders, you can hold down the all key as you drag a slider to see a threshold preview and this will indicate any highlight or shadow clipping. At this stage a threshold preview analysis can be particularly useful, as you can rely on the highlight clipping indicator (discussed on page 139) to tell you where the highlights are about to be clipped.

Localized Whites and Blacks

Whites and Blacks controls are available for all the local adjustment tools. Such adjustments are useful for fine-tuning the very lightest and darkest tone areas to reduce or add more contrast. It is recommended that you apply such adjustments *after* having applied the main tone adjustments and watch out in particular for any signs of clipping.

Order of Basic panel adjustments

It isn't mandatory that you adjust the Basic panel sliders in a particular set order, although it is generally best to work on the sliders in the order they are presented from top to bottom. The first step should be to set the Exposure to get the overall image brightness looking right. After that you may want to use the Contrast slider to set the contrast. You can judge this visually by looking at the image preview, or you can let the Histogram be your guide to see what type of Contrast adjustment would be appropriate. After that, you can use the Highlights and Shadows sliders to lighten or darken the highlight and shadow regions. By this stage you should be almost there, but if the highlights and shadows are in need of any further adjustment you can adjust the Whites and Blacks sliders. I would suggest applying in this order to start with, but as you become more familiar with the controls there is no reason why you can't adjust these controls in any order you like.

By working with the Whites and Blacks sliders you can correct for extreme highlights and shadows and adjust them to reveal more detail. You can also push them the other way to reduce the shadow or highlight detail. For example, you might want to apply a positive Whites adjustment to deliberately blow out some of the highlights. You might also want to use a negative Blacks adjustment in order to make a dark background go completely to black. See also the section on localized adjustments (page 231) and how it can be useful to apply such corrections via the Adjustment Brush, or as a Filter adjustment.

With images that have previously been processed using Version 1/ Version 2, and where the Blacks slider was set quite high, the blacks will most likely appear somewhat different after being converted to Version 4. This is because the Version 4 Blacks slider tends to back off quite a bit.

Auto-calculated Blacks range

The Blacks range is auto-calculated based on the content of the image. This means that when editing a low contrast image, such as a hazy landscape, the Blacks range adapts so you should always be able to crush the darkest tones in the image. Also, the Blacks adjustment will become increasingly aggressive as you get closer to a -100 value. This means that you gain more range when processing such images, but at the expense of some loss in precision.

Highlight clipping

As you apply Basic adjustments in Camera Raw, you will want to make the brightest parts of the photo go to white so the highlights are not too dull. At the same time though, you will want to ensure that important highlight detail is always preserved. This means taking care not to clip the highlights too much, since this might otherwise result in important highlight detail being lost when you come to make a print. You therefore need to bear in mind the following guidelines when deciding how the highlights should be clipped.

Where you should set the highlight clipping point is really dependent on the nature of the image. In most cases you can adjust the Highlights followed by the Whites slider so that the highlights just begin to clip and not worry too much about losing important highlight detail. If the picture you are editing contains a lot of delicate highlight information then you will want to be careful when setting the highlight point so that the brightest whites in the photo are not too close to the point where the highlights start to become clipped. The reason for this is all down to what happens when you

ultimately send a photo to a desktop printer or convert an image to CMYK and send it to the press to be printed. Most photo inkjet printers are quite good at reproducing highlight detail at the top end of the print scale, but at some point you will find that the highest pixel values do not equate to a printable tone on paper. Basically, the printer may not be able to produce a dot that is light enough to print successfully. Some inkjet printers use light colored inks such as a light gray, light magenta, and light cyan to complement the regular black. gray, cyan, magenta, yellow ink set and these printers are better at reproducing faint highlight detail. CMYK press printing is a whole other matter. Printing presses will vary of course, but there is a similar problem where a halftone dot may be too small for any ink to adhere to the paper. In all the above cases there is an upper threshold limit where the highlight values won't print. So, when you are adjusting the Highlights and Whites sliders, it is important to examine the image and ask yourself if the highlight detail matters or not.

However, some pictures may contain subtle highlight detail (such as in Figure 2.29), where it is essential to make sure the important highlight tones don't get clipped.

When to clip the highlights

You therefore have to be careful when judging where to set the highlight point. If you clip too much you risk losing important highlight detail. But what if the image contains bright specular highlights, such as highlight reflections on shiny metal objects? Figure 2.30 shows an image that has specular highlights containing no detail. There was no point in trying to preserve detail in the shiny areas as this would needlessly limit the contrast. It was therefore safe to clip these highlights, because if I were to clip them too conservatively I would end up with dull highlights in the print. The aim here was for the shiny reflections to print to paper white. The color sampler over the shiny reflection measured a highlight value of 255,255,255. If the highlight clipping warning is checked in the Camera Raw histogram, a red colored overlay indicates where there is highlight clipping. With images like this it is OK to let the highlights burn out. When adjusting the Highlights and Whites slider for subjects like this, you would use the Exposure slider to visually decide how bright to make the photo and not be afraid to let the specular highlights blow out to white when adjusting the Highlights and Whites sliders.

Essentially, most images contain at least a few specular highlights, where it is OK to clip. It is only where you have a photo like the one shown in Figure 2.29 that you need to pay particular attention to ensure the brightest highlights aren't totally clipped.

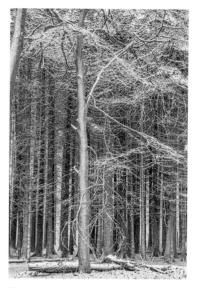

Figure 2.29 Here, I wanted to ensure the brightest highlights did not become clipped when setting the white point.

Figure 2.30 An example of an image that has specular highlights that one can allow to clip to white.

Hiding shadow noise

Raising the threshold point to where the shadows start to clip is one way to add depth and contrast to your photos. It can also help improve the appearance of an image that has noisy shadow areas.

How to clip the shadows

Setting the black clipping point is, by comparison, much easier. Put aside any concerns you might have about matching the black clipping point to a printing device; Blacks slider adjustments are simply about deciding where you want the shadows to clip. With some images, where the initial clipping appears too severe, you may want to ease the clipping off by dragging the Blacks slider more to the right, but it is inadvisable to lighten the Blacks too much. Some photos, such as the one shown below in Figure 2.31, can actually benefit from a heavy black clipping so that the black background areas print to a solid black. In this example the Blacks were well and truly clipped. This is because I deliberately wanted to force the shadow detail in the shadows to a solid black. As you can see, the color sampler over the backdrop in this picture (circled) showed an RGB reading of 0,0,0.

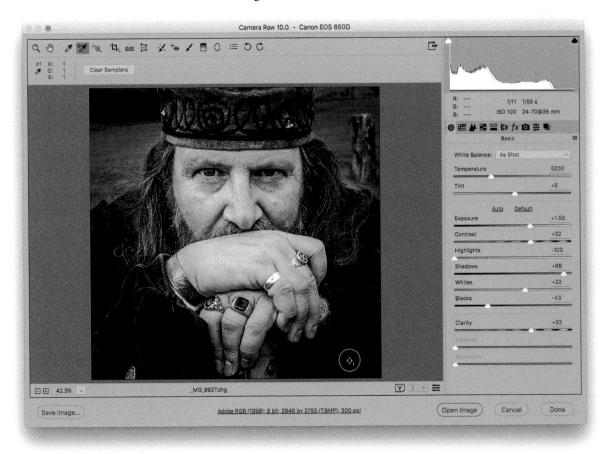

Figure 2.31 With this photograph the blacks were deliberately clipped to solid black.

Shadow levels after a conversion

Setting the shadows is fairly easy. All you need to do is to decide if you want to clip the blacks a little, or a lot and let Photoshop's color management engine take care of the rest when making a print or converting an image to CMYK.

Because of factors such as dot gain, it has always been necessary to make the blacks in a digital image slightly lighter than the blackest black (0,0,0,) before outputting an image to print. Photoshop's automated color management system is designed to take care of the black clipping at the output stage. When you open a Camera Raw processed photo in Photoshop and send the image data to a printer, or convert to CMYK, Photoshop automatically calculates the precise amount of black clipping adjustment required for each and every print/ paper combination. In the Figure 2.32 example you can see how the black clipping point automatically compensates when converting the image data to different profiled print spaces. The Histogram panel views show (left) the original histogram for a ProPhoto RGB image. The middle histogram shows a comparison of the image histogram after converting the RGB data to an Innova Fibraprint glossy paper print profile space. The print output histogram is overlaid here in green and you can see how the black levels clipping point has been automatically indented. The example on the right shows a standard CMYK conversion to the US Web coated SWOP profile, which is also colored green so you can compare it more easily with the before histogram. Again, you can see how the black clipping point is moved inwards to avoid clogging up the shadow detail. These histograms were all captured using the Luminosity mode, which more accurately portrays the composite luminance levels in each version of the image.

Evaluating the Histogram panel

It is easy to prove this for yourself. Open an image, set the Channel display in the Histogram panel to Luminosity, and refresh the histogram to show the most up-to-date histogram view (click on the yellow warning triangle in the top right corner). Once you have done that go to the Edit menu, choose Convert to Profile and select a CMYK or RGB print space. You'll need to refresh the histogram display again, but once you have done so you can compare the before and after histograms and check what happens to the black clipping point.

Original histogram - ProPhoto RGB

different output spaces.

× e Histogram Channel: Luminosity € Source Entire Image Mean: 138.02 Level: Std Dev: 57.32 Count: Median: 140 Percentile: Pixels: 1506271 Cache Level: 1

Innova Fibraprint glossy paper

Figure 2.32 A comparison of the output histogram when converting an image to

US Web coated SWOP CMYK

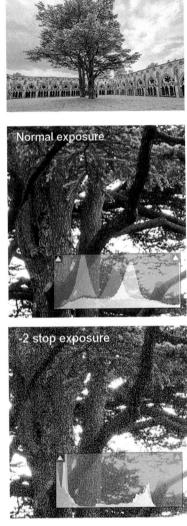

Figure 2.33 A comparison of the shadow detail between shooting at an optimum normal exposure and underexposure.

Digital exposure

Compared to film, shooting with a digital camera requires a whole new approach when determining what the optimum exposure should be. With film you need to underexpose slightly for chrome emulsions (because you don't want to risk blowing out the highlights). With negative emulsion film it is considered safer to overexpose as this ensures you capture more shadow detail and thereby record a greater subject tonal range.

When capturing raw images on a digital camera it is best to overexpose as much as it is safe to do so before you start to clip the highlights. Most digital cameras are capable of capturing at least 12 bits of data, which is equivalent to 4096 recordable levels per color channel. As you halve the amount of light that falls on the chip sensor, you potentially halve the number of levels that are available to record an exposure. Let us suppose that the optimum exposure for a particular photograph at a given shutter speed is f8. Let's say this exposure makes full use of the chip sensor's dynamic range and consequently there is the potential to record up to 4096 levels of information. If one were then to halve the exposure to f11, you would only have the ability to record up to 2048 levels per channel. It would still be possible to lighten the image in Camera Raw or Photoshop to create an image that appeared to have similar contrast and brightness. But that one stop exposure difference will mean you immediately lose half the number of levels that could potentially be captured using a one stop brighter exposure. The image is now effectively using only 11 bits of data per channel instead of 12. Perhaps you may have already observed how difficult it can be to rescue detail from the very darkest shadows, and how these can end up looking posterized. Also, have you ever noticed how much easier it is to rescue highlight detail compared with shadow detail when using the Shadows/Highlights adjustment? This is because far fewer levels are available to define the information recorded in the darkest areas of the picture and these levels are easily stretched further apart as you try to lighten them. This is also why posterization and noise is always most noticeable in the shadows. It also explains why it is important to target your digital exposures as carefully as possible so that you capture the brightest exposures possible, but without the risk of blowing out the highlight detail.

Figure 2.33 shows the difference the exposure can make in retaining shadow information. The close-up views compare the outcome when lightening an underexposed image to match the correctly exposed version.

The camera LCD histogram

The histogram that appears on a compact camera or digital SLR screen is unreliable for anything other than JPEG capture. This is because the histogram you see there is based on the camera-processed JPEG and is not representative of the true raw capture. The only way to check the histogram for a raw capture file is to open the image via Camera Raw.

How Camera Raw interprets the raw data

Camera sensors have a linear response to light and unprocessed raw files therefore exist in a linear gamma space. If you could preview a raw capture image in its native, linear gamma state, it would look something like the image shown on the left in Figure 2.34, where the picture appears very dark.

Human vision on the other hand interprets light in a non-linear fashion, so one of the main thing a raw conversion has to do is apply a gamma correction to the original image data to make the correctly exposed, raw image look the way our eyes expect such a scene to look (i.e., the view on the right). The adjustments you apply in Camera Raw are therefore applied directly to the raw linear data and displayed on the screen (and ultimately rendered) as a gamma corrected image.

As a consequence of this, the more brightly exposed areas preserve the most tonal information and the shadow areas will end up with fewer levels because these are stretched further apart in the gamma correction process. This illustrates one aspect of the subtle but important differences between the tone edits applied in Camera Raw to raw files and those applied in Photoshop to images that are already gamma corrected.

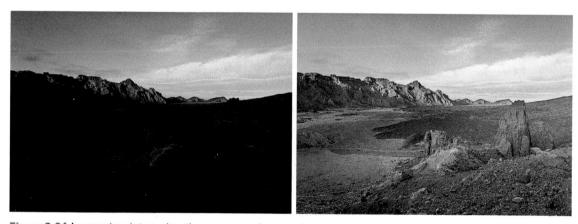

Figure 2.34 A comparison between how the camera records a scene in raw mode (left) and how the data is previewed in Camera Raw and finally rendered (right).

Basic panel image adjustment procedure

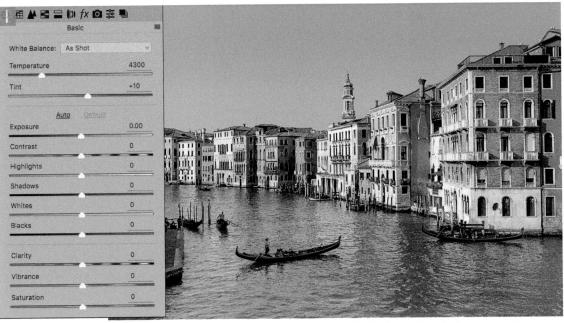

1 Here you can see the starting point for this image where the Basic panel settings were all set to the default values.

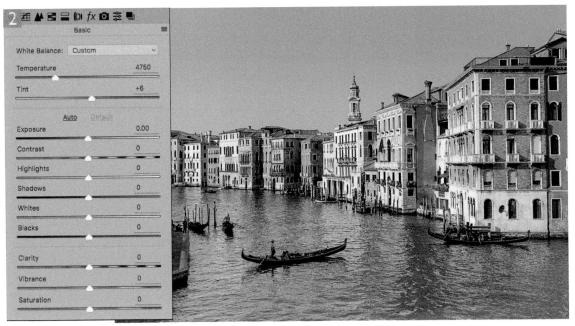

2 To begin with I manually adjusted the Temperature slider to make the image appear slightly warmer in color.

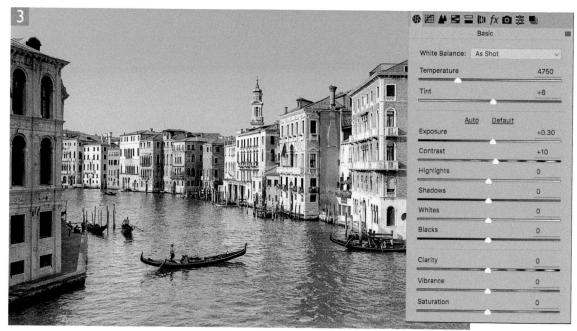

3 Next, I adjusted the Exposure and Contrast sliders to lighten the image and also to increase the contrast slightly.

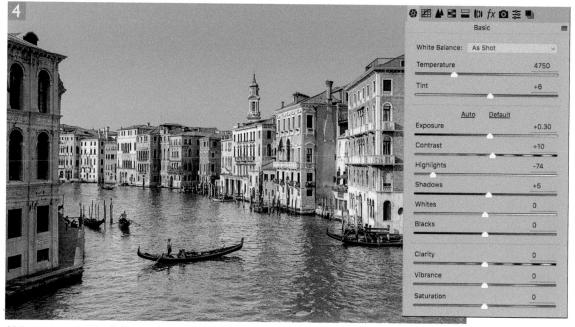

4 I then reduced the Highlights to restore more detail in the highlight areas and at the same time increased the Shadows to lighten the darker areas.

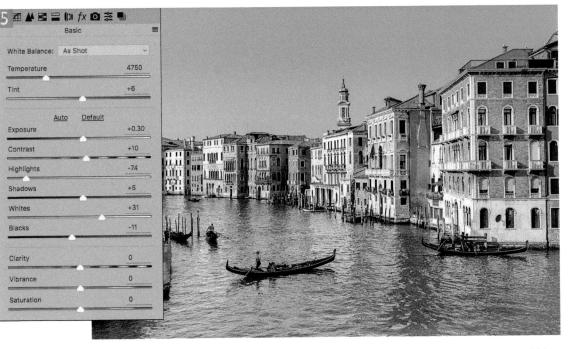

5 In this step I fine-tuned the white and black clipping points applying a positive Whites adjustment and a negative Blacks adjustment.

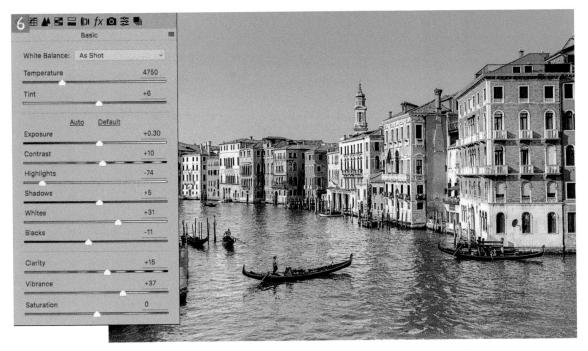

6 Finally, I added a positive Clarity and a positive Vibrance adjustment.

Auto tone corrections

To carry out an auto tone correction in Camera Raw, just click on 'Auto' (**H**) [Mac], *cttf* (**D**) [PC]) in the Camera Raw dialog (circled in Figure 2.35). An auto tone adjustment will affect the Exposure, Contrast, Highlights, Shadows, Whites, and Blacks, and is to some extent affected by the white balance setting. Auto tone adjustments can work really well on images such as outdoor scenes and naturally lit portraits, but work less well on photographs that have been shot in the studio under controlled lighting conditions.

The Auto adjustment has also been improved in successive releases of Camera Raw, making it now more consistent from image to image, as well as being more consistent across different image sizes that have been set in the Workflow options. For the most part Auto results will appear to produce the same results as before, but with overbright images the auto setting will produce noticeably tamer results. Personally, I find the Auto adjustment to be too hit and miss to choose this as a default Develop setting. It is generally more successful at processing general scenic shots. However, I do find when adjusting individual images the Auto tone may get you close to provide a suitable starting point from which one can fine-tune the sliders to personal taste. Having said that, there are new developments in Lightroom CC, which is now the new name for the Lightroom mobile ecosystem. Here, you will find options for a new Auto Tone method that uses machine learning and artificial intelligence to produce more reliable auto tone results. The goal here has been to greatly increase the utility of the current Auto feature in Adobe imaging products and let you get even closer to the results you envision. So far this is 'mobile only'.

Auto Whites and Blacks sliders

You can also use a *Shift* + double-click on any of the tone sliders to auto-set individual slider adjustments. For example, when *Shift* + double-clicking the Whites or Blacks sliders, Camera Raw analyzes the image and computes the Whites or Blacks value needed to just begin to clip. This isn't quite the same as applying a standard auto tone adjustment, as the auto adjustment is recalculated based on all other adjustment settings that have been applied and takes into account things like the cropping and Lens Corrections. It also excludes from the auto calculation any pixels that are not currently visible. Therefore, if there are some bright highlights in your image, but these have been cropped, then you'll find these highlight areas will be ignored when you double-click the Whites slider to make an auto calculation (see the example shown on the following page).

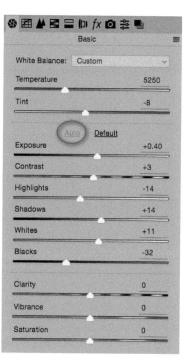

Figure 2.35 Clicking on the Auto button applies an auto adjustment to the Basic panel settings in Camera Raw.

Machine learning and Auto

In the latest version of Camera Raw clicking the Auto button auto-adjusts the tone plus Vibrance and Saturation sliders. Such auto adjustments are the result of extensive research using artificial intelligence and machine learning. Generally I find the new auto results to be a big improvement. Be aware that the auto is crop-aware. Therefore, if auto-adjusting a scene with say, a lot of black surrounding areas you may want to temporarily crop the image to center on the subject, click Auto and afterwards cancel the crop.

Basic	
White Balance: As Shot	~
Temperature	4150
Tint	+8
Auto Default	
Exposure	+0.60
Contrast	-25
Highlights	0
Shadows	0
Whites	-7
Blacks	-38
Clarity	0
Vibrance	0
Saturation	0

1 This shows a full-frame view of a photograph in which I *Shift* + double-clicked on the Whites and Blacks sliders to auto-set the Whites and Blacks adjustments.

	2 4
White Balance: As Shot	
Temperature	4150
Tint	+8
Auto Default	
Exposure	+0.60
Contrast	-25
Highlights	0
Shadows	0
Whites	+17
Blacks	-43
Clarity	0
Vibrance	0
Saturation	0

2 I then cropped the image to focus on the young woman's face. This excluded the lighter areas at the edges. When I **Source** + double-clicked on the Whites and Blacks sliders again, a different value was computed for each slider.

Camera-specific default settings

The Default Image Settings section of the Camera Raw preferences allows you to make any default settings camera-specific. If you go to the Camera Raw fly-out menu options shown in Figure 2.36, there is an option where you can 'Save New Camera Raw Defaults' as the new default setting to be used every time Bridge or Camera Raw encounters a new image. This menu item lets you create a default setting based on the current Camera Raw settings. It saves all the current Camera Raw settings as a default setting according to how the preferences are set in Figure 2.19 (see page 120) and applies this to all subsequent photos (except where you have already overridden the default settings). If the 'Make defaults specific to the camera serial number' option is selected in the Camera Raw preferences, selecting 'Save New Camera Raw Defaults' only applies this setting as a default to files that match the same camera serial number. Similarly, if the 'Make defaults specific to camera ISO setting' option is checked, this allows you to save default settings for specific ISO values.

Basic White Balance: As Shot	(Image Settings Camera Raw Defaults
Temperature	6000	Previous Conversion ✓ Custom Settings
Tint	0	Preset Settings
1		Apply Preset
<u>Auto Defeut</u> Exposure	0.00	Apply Snapshot
Contrast	0	Clear Imported Settings
		Export Settings to XMP
dighlights	0	Update DNG Previews
Shadows	0	Load Settings
Vhites	0	Save Settings
Blacks	0	Save New Camera Raw Defaults Reset Camera Raw Defaults
Clarity	0	
librance	0	
aturation	0	
Image Cancel	Done	1

Figure 2.36 You can use the Camera Raw menu option circled here to choose the 'Save New Camera Raw Defaults'.

Camera Raw Defaults tip

When establishing the Camera Raw settings to save as a new Camera Raw default it is important to ensure the Basic panel settings have all been set to their defaults first.

When both this and the previous option are checked, you can effectively have multiple default settings in Camera Raw that take into account the combination of the camera model and ISO setting. You do have to be careful how you go about using the 'Save New Camera Defaults' option. When used correctly you can cleverly set up Camera Raw to apply appropriate default settings for any camera and ISO setting. However, it is all too easy to make a mistake, or worse still, select the 'Reset Camera Defaults' option and undo all your hard work. The main thing to watch out for is that you don't include too many Camera Raw adjustments (such as the HSL/Grayscale panel settings) as part of a default setting. The best thing is to open a previously untouched image, apply a Camera Calibration panel adjustment plus, say, enable the Camera Profile and Lens Profile correction settings and save this as a camera-specific default. You might find it useful to adjust the Detail panel noise reduction settings for an image shot at a specific ISO setting and save this as a 'Make defaults specific to camera ISO setting'. Or, you might like to check using both Camera Raw preference options and setup defaults for different ISO settings with specific cameras.

Clarity

Adding Clarity to a photo adds localized, midtone contrast. In other words, the Clarity slider can be used to build up the contrast in the midtone areas by effectively applying a soft, wide radius unsharp mask type of filter. Consequently, when you add a positive Clarity adjustment, you will notice improved tonal separation and better texture definition in the midtones. By applying a small positive Clarity adjustment you can therefore increase the local contrast across narrow areas of detail and a bigger positive Clarity adjustment increases the localized contrast over broader regions of the photo. Positive Clarity adjustments utilize the same tone mapping logic that is employed for the Highlights and Shadows sliders. As a result of this, halos either side of a high contrast boundary edge should appear reduced compared to earlier versions of Camera Raw.

All photos can benefit from adding a small amount of Clarity. I would say, a +10 value works well for most pictures. However, you can safely add a maximum Clarity adjustment if you think a picture needs it. In the Figure 2.37 example the left half of the Camera Raw preview shows how the photo looked before Clarity was added and the right half of the preview shows the same image with +100 Clarity.

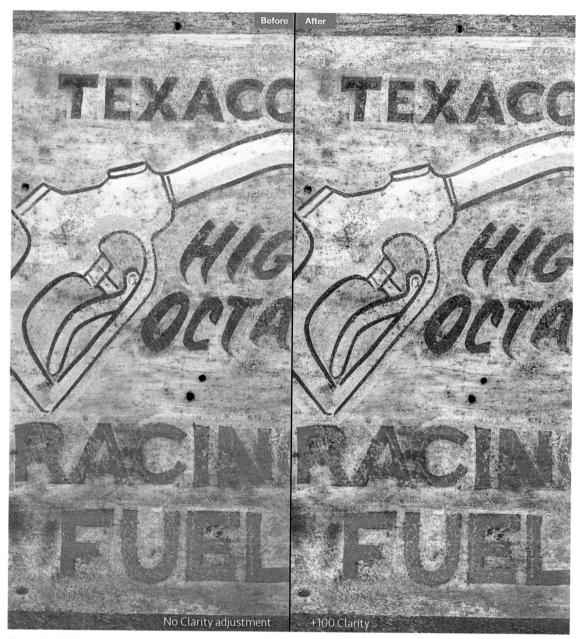

Figure 2.37 This screen shot shows a before and after example of a Clarity adjustment.

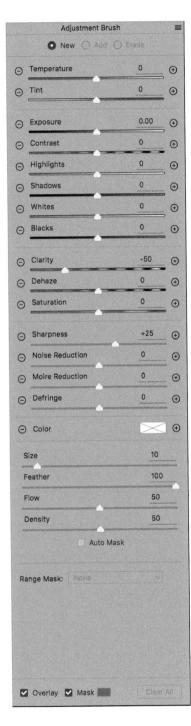

Negative clarity

Just as you can use a positive clarity adjustment to boost the midtone contrast, you can also apply a negative clarity adjustment to soften the midtones. There are two uses that come to mind here. A negative clarity adjustment could be useful for softening skin tones in portrait and beauty shots. In Figure 2.38 I selected the Adjustment Brush and used a combination of a -50 Clarity effect with a +25 Sharpness effect to produce the skin softening look achieved here. I applied this effect a little stronger than I would do normally in order to really emphasize the skin softening effect.. This works great if you use the Adjustment Brush tool (discussed on pages 218-234) to apply this combination of settings. The other thing you can do is use negative clarity to simulate a diffusion printing technique that used to be popular with a lot of traditional darkroom printers. In Figure 2.39 you can see examples of a before and after image where I used a maximum negative clarity to soften the midtone contrast to produce a kind of soft focus look. You will find that this technique works particularly well with black and white photos.

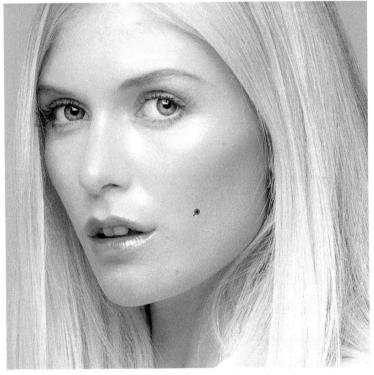

Figure 2.38 This shows the results of an Adjustment Brush skin softening effect.

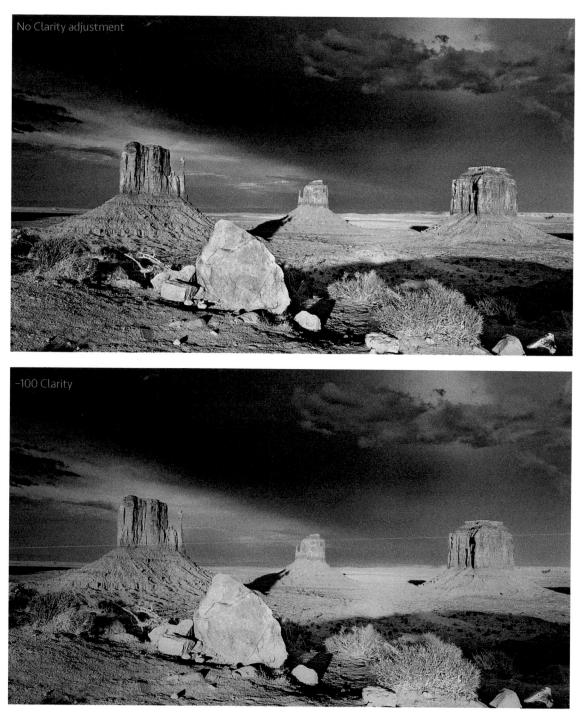

Figure 2.39 This shows a before version (top) and an after version (below), where I applied a -100 Clarity adjustment.

White Balance: As Shot		
Temperature	4650	
Tint	+1	
Auto		
Exposure	0.00	
Contrast	0	
Highlights	0	
Shadows	0	
Whites	0	
Blacks	0	
Clarity	0	
Vibrance	0	
Saturation	0	

White Balance: As Shot	,
Temperature	4650
Tint	+1
Auto Defau	<u>ult</u>
Exposure	+2.60
Contrast	0
Highlights	0
Shadows	0
Whites	0
Blacks	0
Clarity	0
Vibrance	0
Saturation	0

Correcting a high contrast image

1 This photograph has a very wide subject brightness range, and is shown here opened in Camera Raw using the default Version 4 settings.

2 I began by adjusting the Exposure slider to brighten the image.

3 I next adjusted the Shadows slider, setting this to +55 to reveal more of the interior.

4 Lastly, I adjusted the Highlights slider to reveal more detail in the view outside the window. I also fine-tuned the Whites and Blacks sliders and added more Clarity to boost the midtone contrast.

White Balance: As Shot	~
Temperature	4650
Tint	+1
Auto Default	
Exposure	+2.60
Contrast	0
Highlights	0
Shadows	+55
Whites	0
Blacks	0
Clarity	0
Vibrance	0
Saturation	0

● 2日 ▲ 20 二 (D) fx 回 き ■ Basic	
White Balance: As Shot	~
Temperature	4650
Tint	+1
Auto Default	
Exposure	+2.60
Contrast	0
Highlights	-75
Shadows	+55
Whites	+2
Blacks	-12
Clarity	+30
Vibrance	0
Saturation	0

The Saturation slider can be used to boost color saturation, but extreme saturation adjustments will soon cause the brighter colors to clip. However, the Vibrance slider can be used to apply what is described as a non-linear color saturation adjustment, which means colors that are already brightly saturated in color remain relatively protected as you boost the Vibrance, whereas the colors that are not so saturated receive a greater saturation boost. The net result is a saturation control that lets you make an image look more colorful, but without the attendant risk of clipping those colors that are saturated enough already. Try opening a photograph of some brightly colored flowers and compare the difference between a Vibrance and a Saturation adjustment to see what I mean.

Not all of us want to turn our photographs into super-colored versions of reality. So it is worth remembering that you can use the Vibrance and Saturation sliders to apply negative adjustments too to produce interesting pastel-colored effects. The other thing that is rather neat about the Vibrance control is that it has a built-in skin tone protection filter which does rather a good job of not letting the skin tones increase so much in saturation as you move the slider to the right. In Figure 2.40, I set the Vibrance to +55, which boosted the colors in the clothes, but without giving the model too 'vibrant' a suntan.

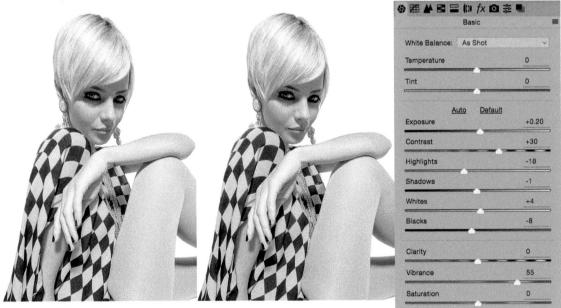

Model: Lucy @ MOT

Figure 2.40 Boosting the colors using the Vibrance control in the Basic panel.

1 In this example you can see what happens if you choose to boost the saturation in a photo using the Saturation slider to enrich the colors. If you look at the histogram you can see how the blue channel is clipped. This is what we should expect, because the Saturation slider in Camera Raw applies a linear adjustment that pushes the already saturated blues off the histogram scale.

) 🗷 🖌 🖻 🚍 🕼 fx 🖸 📚	
Basic	
White Balance: As Shot	~
Temperature	7250
Tint	+45
Auto Default	
Exposure	+0.85
Contrast	+47
Highlights	0
Shadows	0
Whites	-14
Blacks	-84
Clarity	+45
Vibrance	0
Saturation	+100

2 Compare what happens when you instead use the Vibrance slider to boost the saturation. In this example you will notice how the blue channel isn't clipped. This is because the Vibrance slider boosts the saturation of the least saturated colors most, tapering off to a no saturation boost for the already saturated colors. Hence, there is no clipping in the histogram.

Basic	
White Balance: As Shot	
Temperature	7250
Tint	+45
<u>Auto Defa</u>	ult
Exposure	+0.85
Contrast	+47
Highlights	0
Shadows	0
Vhites	-14
Blacks	-84
Diarity	+45
librance	+100
Saturation	0

Tone Curve panel

The Tone Curve panel provides a fine-tuning contrast control that can be applied in addition to the tone and contrast adjustments made in the Basic panel. There are two modes of operation available here: parametric and point. We'll look at the parametric controls first. The starting point is a linear curve. When editing a Tone Curve in parametric mode you use the Tone Curve panel slider controls to modify the curve shape. This is essentially a more intuitive way to work, plus you can also use the target adjustment tool (**1**) in conjunction with the parametric sliders to adjust the tones in an image. Note that you can use the **1** shortcut as a toggle action to access and use the Tone Curve target adjustment tool while editing in the Basic panel. Here then is an example of how to edit the Tone Curve in the parametric editor mode.

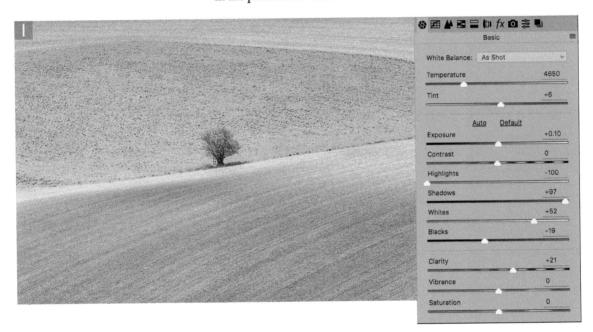

1 The image shown here was corrected using the Basic panel controls to produce an optimized range of tones that were ready to be enhanced further. I could have used the Contrast slider to boost the contrast more, but the Tone Curve panel provides a simple yet effective interface for manipulating the image contrast.

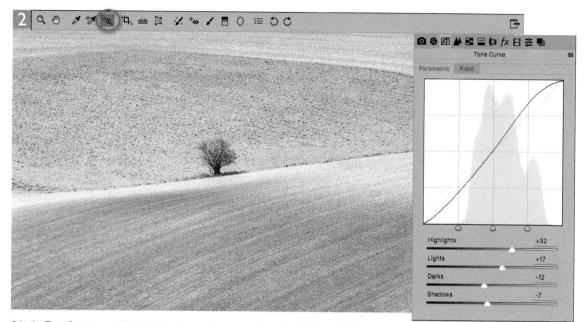

2 In the Tone Curve panel I selected the Parametric curve option. By adjusting the four main sliders I was able to apply a strong tone contrast to the photo. You can also apply these adjustments by selecting the target adjustment tool (circled) and then clicking and dragging up or down on target areas of the image.

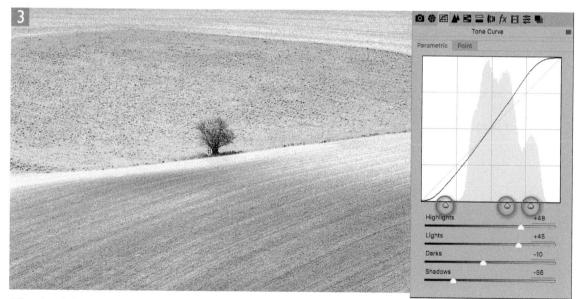

3 Here, I made further adjustments to the Highlights, Lights, and Darks sliders. In addition, I fine-tuned the scope of adjustment for the Tone Curve sliders by adjusting the positions of the three tone range split points (circled).

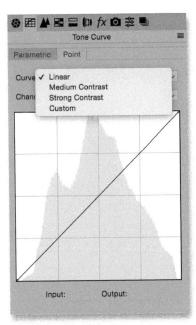

Figure 2.41 The Tone Curve panel, shown here in Point Curve editor mode with the default Linear tone curve setting.

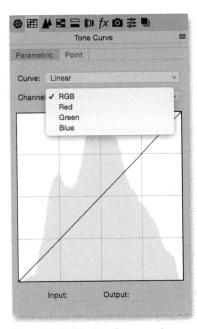

Figure 2.42 The Tone Curve panel, shown here with the RGB channel selected.

Point Curve editor mode

In the Point Curve editor mode, you can manipulate the shape of the Tone Curve as you would with the Curves adjustment in Photoshop. The default curve shape in Version 4 is 'Linear', which is actually the same as the old Medium Contrast curve. If you want, you can use the Point Tone Curve panel mode to apply a stronger contrast base curve setting. Regardless of any adjustments you have already made in the parametric mode, the curve shape th at's shown here uses as a starting point the Curve setting selected in the Curve menu (see Figure 2.41). I suppose you could say that the way the Tone Curve panel represents curves in Camera Raw is similar to having two Curves adjustment layers one on top of the other in Photoshop. In fact, if you also take into account the effect of the Contrast slider in the Basic panel, you effectively have three curves adjustments to play with. To edit the point tone curve, just click on the curve line to add points and drag to adjust the overall curve shape. You can edit the curve points just like in Photoshop. When a point is selected, use the keyboard arrow keys to move the point around. As you nudge using the arrow keys this restricts the anchor point movement within the allowable curve range only. To select a new existing point, use *ctrl Tab* to select the next point up and use *ctrl Shift Tab* to select the next point down. You can delete a selected anchor point by 🎛 (Mac), *ctrl* (PC) + clicking it, hit the Delete key, or drag the point off to the side of the curve graph. Also, if you hold down the 🔀 (Mac), *ctrl* (PC) key while hovering the cursor over the image preview, you can see exactly where a tone will fall on the curve, and you can 🛞 (Mac), *ctrl* (PC)-click in the preview to place a point on the curve. Lastly, use the Shift key to select multiple points on the curve.

RGB Curves

The Channel menu lets you choose to edit either the RGB or individual red, green, or blue channels (Figure 2.42). This allows you to apply fine-tuned color corrections. To some extent this does duplicate functionality available elsewhere in Camera Raw. Even so, RGB curves do let you apply unique kinds of adjustments, such as the color curve looks shown in Figure 2.43, where in the middle example I cooled the highlights and added warmth to the shadows. In the version on the right, I deliberately applied a strong red/yellow cast. In Figure 2.44 I desaturated the image, taking the Saturation slider in the Basic panel to –100. I then applied the point tone curve adjustments shown here to add a multi-color split tone effect.

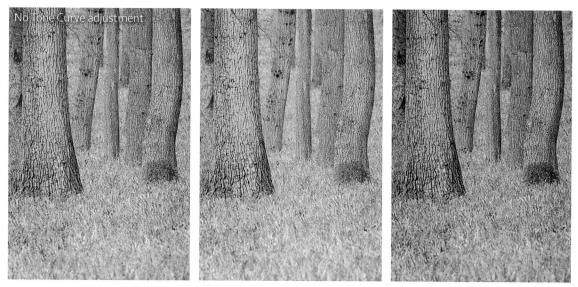

Figure 2.43 This shows two different RGB point tone curve adjustments.

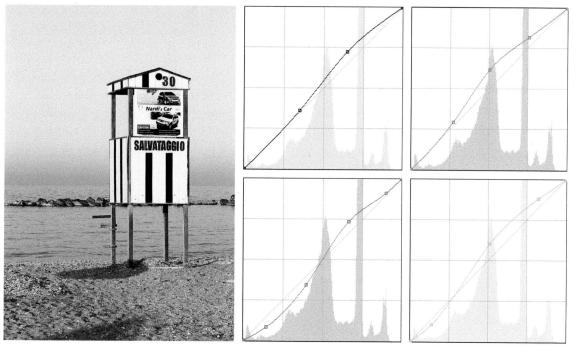

Figure 2.44 Using a point curve Tone Curve adjustment to produce a multi-color split tone effect.

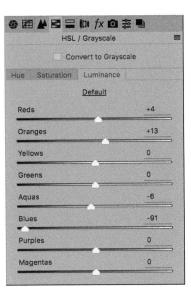

HSL/Grayscale panel

The HSL controls has eight color sliders with which to control the Hue, Saturation, and Luminance. These work in a similar way to the Hue/Saturation adjustment in Photoshop, but are in many ways better and the response when using these sliders is more predictable. In Figure 2.45 I used the Luminance controls to darken the blue sky. Try doing this using Hue/Saturation in Photoshop and you will find that the blue colors tend to lose saturation as you darken the luminosity. You will also notice that instead of using the traditional additive and subtractive primary colors of red, green, blue, plus cyan, magenta, and yellow, the color slider controls in the HSL panel are based on colors that are of more actual relevance when editing photographic images. For example, the Oranges slider is useful for adjusting skin tones and Aquas allows you to target the color of the sea, but without affecting the color of the sky.

Figure 2.45 In this example, the Luminance sliders in the HSL/Grayscale panel were used to darken the sky and lighten the red and orange colors on the totem pole.

Recovering out-of-gamut colors

Figure 2.46 highlights the problem of how the camera you are shooting with is almost certainly capable of capturing a greater range of colors than can be displayed on the display or seen in print. Just because you can't see them doesn't mean they're not there! Although a typical monitor can't give a true indication of how colors will print, it is all you have to rely on when assessing the colors in a photo. The HSL Luminance and Saturation sliders can therefore be used to reveal hidden color detail. In Figure 2.47 the 'Before' version the red flowers appeared flat. To produce the improved 'After' version I adjusted the Luminance sliders to darken the red and magenta colors. The images shown here were saved as fully processed ProPhoto RGB images. You can judge the effectiveness of this adjustment by how well the lower one reproduces in print.

Figure 2.46 This diagram shows a plot of the color gamut of an LCD monitor (the solid shape in the center) compared to the actual color gamut of a digital camera (the wireframe that surrounds it). Assuming you are using a wide gamut RGB space such as Adobe RGB or ProPhoto RGB, the colors you are able to edit will certainly extend beyond what can be seen on the display.

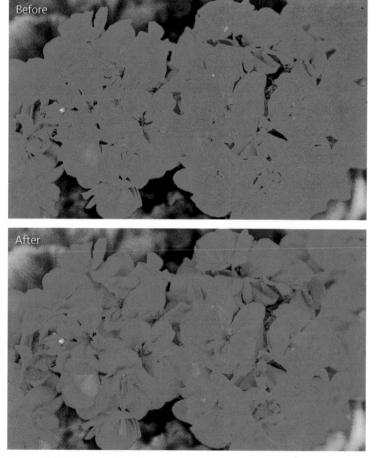

Figure 2.47 Using the HSL sliders to recover out-of-gamut colors.

▶ 🖽 🖌 🖻 🚍 (1)) fx HSL / Grayso	
Convert to	Grayscale
lue Saturation Lumin	ance
Defaul	t
Reds	-65
Oranges	0
Yellows	0
Greens	0
Aquas	0
Blues	0
Purples	0
Magentas	-5

Emulating Hue/Saturation behavior

In Photoshop's Hue/Saturation dialog, there is a Hue slider that can be used to apply global hue shifts. This can be useful if you are interested in shifting all of the hue values in one go. With Camera Raw you can create preset HSL settings where all the Hue sliders are shifted equally in each direction. Using such presets you can quickly shift all the hues in positive or negative steps, without having to drag each slider in turn.

Adjusting the hue and saturation

The Hue sliders in the HSL/Grayscale panel can be used to finetune the hue color bias using each of the eight color sliders. In the Figure 2.48 example, I adjusted the Reds hue slider to make the reds look less magenta and more orange. Photographs shot using a basic digital camera can often benefit from hue tweaks such as this to make the skin tones appear more natural.

The Saturation sliders allow you to decrease or increase the saturation of specific colors. In Figure 2.49 I have shown a before version (top) and a modified version (below), where I used the HSL/ Grayscale panel Saturation sliders to selectively desaturate the green and brown colors. The HSL Saturation sliders offer a quick method for selectively editing the colors in this way. As with the Tone Curve, you can also use the Target adjustment tool to pinpoint the colors and tones you wish to target and adjust.

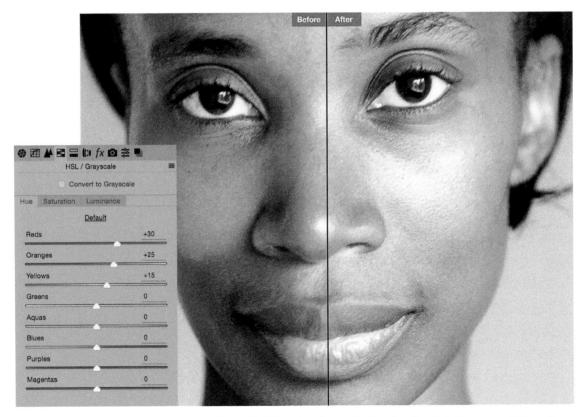

Figure 2.48 Here, I used a combination of positive Reds, Oranges, and Yellows Hue adjustments to make the skin tones look less reddish.

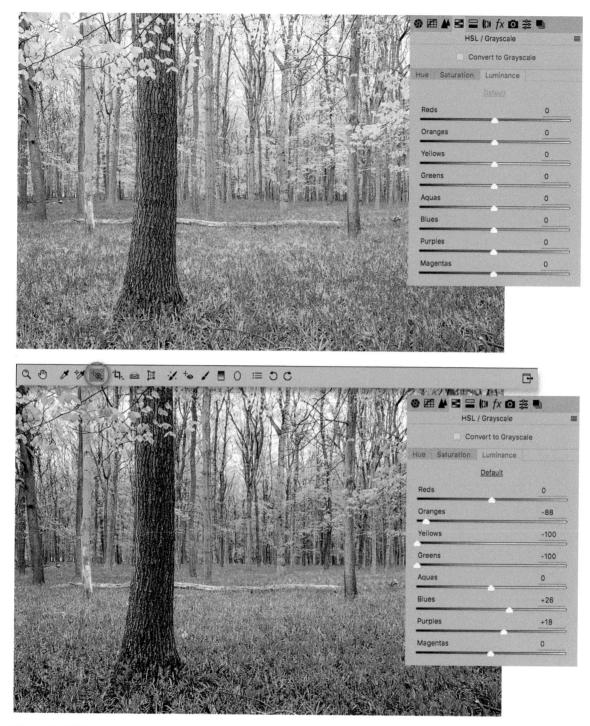

Figure 2.49 This example shows how the Saturation sliders can be adjusted to selectively desaturate specific colors in an image.

Photograph: © Angelica Evening

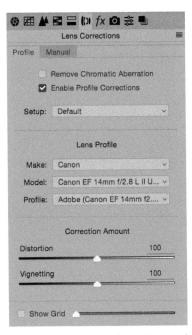

Figure 2.50 The Lens Corrections panel Profile tab controls.

Lens Corrections panel: Profile tab

The Lens Corrections panel controls can be used to help correct some of the optical problems that are associated with digital capture.

The Lens Corrections panel Profile tab is shown in Figure 2.50. Here, you can check 'Enable lens Profile Corrections' to apply an auto lens correction adjustment. This will work for any image where there is a matching lens profile in the Photoshop and Camera Raw lens profile database. If there is no profile available for the lens you are using, you will need to use a custom lens profile. I'll come on to this shortly, but where lens profiles are available for the lenses you are shooting with, it is a simple matter of checking the 'Enable Lens Profile Corrections' box. When you do this you should see the 'Make' of the lens manufacturer, the specific lens 'Model' and lens 'Profile' (which will most likely be the installed 'Adobe' profile) appear in the boxes below. If these don't show up, you may need to first select the lens manufacturer brand from the 'Make' menu, then the specific lens 'Model' and, lastly, the desired lens profile from the 'Profile' menu.

It is important to appreciate here that full-frame digital SLRs have a full-frame sensor, while compact SLR range cameras have smaller-sized sensors that make use of a smaller portion of the lens's total coverage area. The Adobe lens profiles have mostly been built using cameras that have full-frame sensors. Therefore, from a single lens profile it is possible to calculate the appropriate lens correction adjustments to make for all other types of cameras in that manufacturer's range where the sensor size is smaller than a fullframe. When processing raw images, Camera Raw will prefer to use lens profiles that have been generated from raw capture files. This is because the vignette estimation and removal has to be measured directly from the raw linear sensor data rather than from a gammacorrected JPEG or TIFF image.

An auto lens correction consists of two main components: a 'Distortion' correction to correct for barrel or pincushion geometric distortion and a 'Vignetting' correction to correct for light falloff toward the corners of the frame. The Amount sliders allow you to fine-tune an auto lens correction. So, for example, if you wanted to have a lens profile correction correct for the lens vignetting, but not correct for, say, a fisheye lens distortion, you could drag the Distortion slider all the way to the left. On the other hand, if you believe an auto lens correction to be too strong or not strong enough, you can compensate the correction amount by dragging either of these sliders left or right.

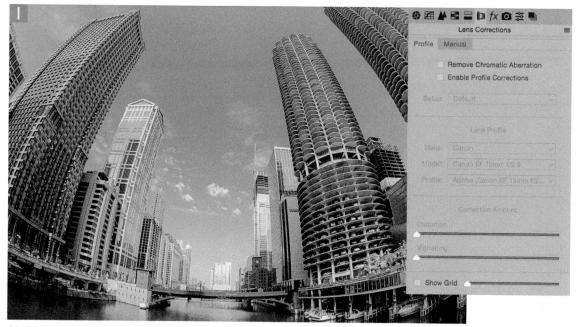

1 In this initial step you can see an example of a photograph that was shot using a 15 mm fisheye lens, where there is a noticeable curvature in the image.

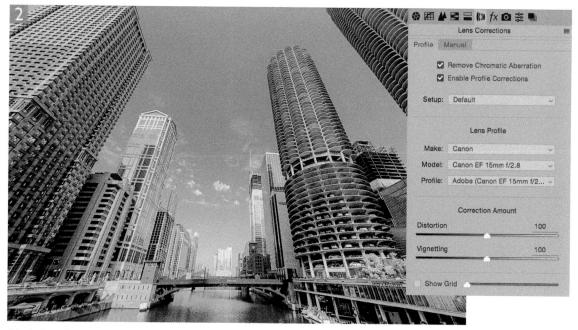

2 In the Lens Corrections panel I simply checked the Enable Lens Profile Corrections box to apply an auto lens correction to the photograph. In this instance I left the two Correction Amount sliders at their default 100% settings.

Where lens profiles are kept

Custom lens profiles created via Adobe Lens Profile Creator 1.04 should be saved to the following locations:

Username/Library/Application Support/ Adobe/Camera Raw/Lens Profiles/1.0 (Mac), C: User name\Program Data\Adobe\ CameraRaw\LensProfiles\1.0 (PC). The default option in the Setup menu will say 'Default'. This instructs Camera Raw to automatically work out what is the correct lens profile to use based on the available EXIF metadata contained in the image file, or use whatever might have been assigned as a 'default' lens correction to use with a particular lens (see below). The 'Custom' option will only appear if you choose to override the auto-selected default setting, or you have to manually apply the appropriate lens profile.

As you apply automatic lens profile corrections to specific images you will also have the option to customize the Lens Corrections settings and use the Setup menu to select the 'Save new Defaults...' option. This allows you to set new Lens Correction settings as the default to use when an image with this particular EXIF lens data setting is selected. After you do this the Setup menu will in future show 'Default' as the selected option in the Setup menu.

Accessing and creating custom lens profiles

If you don't see any lens profiles listed for a particular lens, you have two choices. You can either make one yourself using the Adobe Lens Profile Creator program, or locate a custom profile that somebody else has made. The Adobe Lens Profile Creator program is available free via the Adobe website (tinyurl.com/kg538r7). The download includes full documentation that explains how to photograph one of the supplied Adobe Lens Calibration charts and generate custom lens profiles. It isn't too difficult to do yourself once you have mastered the basic principles. If you are familiar with the Lens Correction filter in Photoshop (see page 638) you will know how easy it is to access shared custom lens profiles that have been created by other Photoshop customers (using the Adobe Lens Profile Creator program). Unfortunately, the Lens Corrections panel in Camera Raw doesn't provide a shared user lens profile option, so whether you are creating lens profiles for yourself or wishing to install supplied lens profiles, you will need to reference the directory path lists shown in the 'Where lens profiles are kept' sidebar. Once you have added a new lens profile to the Lens Profiles folder, you will need to quit Photoshop and restart before a newly added lens profile will appear listed in the Automatic Lens Corrections panel profile list.

Images that are missing their EXIF metadata cannot be processed directly using lens profile corrections. However, if you save an appropriate lens profile correction setting as a Camera Raw preset, it is kind of possible to apply such adjustments to any images that are missing the EXIF metadata by applying as a Camera Raw preset. Some cameras have built-in lenses that apply lens profile corrections automatically and Adobe are obliged to respect these. Camera Raw reads the camera manufacturer's own embedded lens correction metadata and applies a lens profile correction by default (an example of this is the Fuji X-E2 camera). In these instances, checking the Enable Lens Profile Corrections box will make no difference. If the lens used is one that applies a profile correction automatically, you will see an alert message like the one shown in Figure 2.51. Some compact cameras rely on software to correct for geometric distortion and chromatic aberration. In fact, it has always been conditional that Adobe read and apply these behind the scenes when reading the raw data. If you could see a raw image without the correction you would notice quite a difference. But because these are applied automatically there is no need to apply a profile correction, hence the message.

Chromatic aberration

If you inspect an image closely towards the edge of the frame area, you may notice some color fringing where the different color wavelengths are not all focused at the same point. The effect is particularly noticeable in digital images because the camera sensor records three discrete color channels of information. This is known as latitudinal chromatic aberration. It will be most apparent around areas of high contrast and is particularly noticeable when shooting with wide-angle lenses at a wide aperture. It's a problem that can occur with even the best lenses. To correct for latitudinal chromatic aberration check the 'Remove Chromatic Aberration' box in the Profile tab section. The correction essentially scales the size of the individual color channels that make up the composite color image so that the color misregistration that occurs towards the edges of the frame is corrected.

When using Version 4, the chromatic aberration correction data contained in a lens profile is ignored and Camera Raw carries out an auto correction based on an analysis of the image. As you can see in the Figure 2.52 example, this approach to removing chromatic aberration can work well. One of the added advantages is that you can process images where a non-centrally aligned lens has been used. For example, a photograph that's been shot using a tilt/shift lens where the central axis has been tilted can be corrected.

Lens Profile Make: None
Make: None
Model: None .
Profiis: Nono .
Correction Amount
istortion
Tanélting

Figure 2.51 The Lens Corrections Profile tab section where the photograph already has an embedded lens profile.

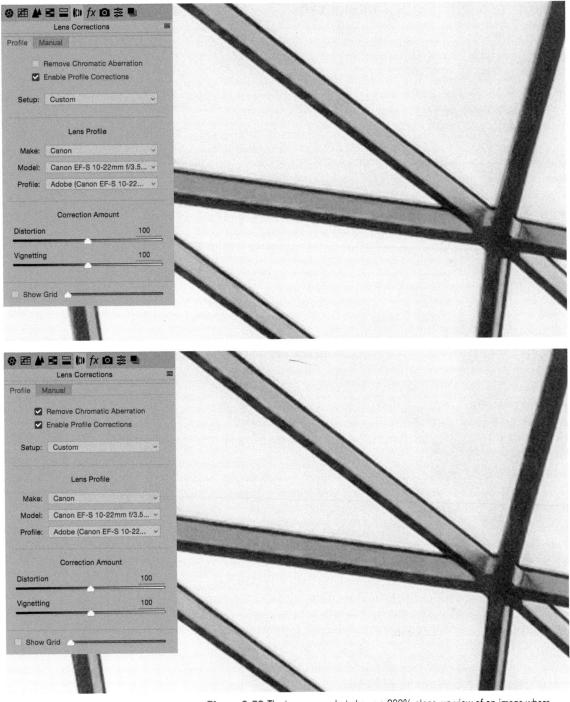

Figure 2.52 The top screen shot shows a 200% close-up view of an image where you can see strong color fringing around the high contrast edges. In the lower version I enabled the 'Remove Chromatic Aberration' option to remove the color fringes.

Lens Corrections panel: Manual tab

The Manual tab (Figure 2.53) contains a Distortion slider that can be used to apply a geometric distortion adjustment that is independent of a distortion correction applied using a lens profile correction. The other controls are mainly for fixing axial (longitudinal) chromatic aberrations, which can be caused by ghosting, lens flare, or charge leakage (this can affect some CCD sensors).

Unlike lateral chromatic aberration, which only occurs towards the edges of the frame, axial chromatic aberrations can appear anywhere in the image. It is something that can particularly affect fast, wide aperture lenses and is most noticeable when shooting at the widest lens apertures. They will typically appear purple/magenta when they're in front of the plane of focus, and green when they're behind the plane of focus. But even at the exact point of focus you may sometimes see purple fringes (especially along high contrast or backlit edges). As you stop down the lens these types of aberrations should become less noticeable.

The Defringe section consists of four sliders. There are Purple Amount and Green Amount sliders for controlling the degree of correction and below each of these are Purple Hue and Green Hue sliders, which have split slider controls. If we look at the two Purple sliders, the Purple Amount slider has a range of 0-20 and is used to determine the strength of the purple fringing removal. The Purple Hue slider can then be used to fine-tune the range of purple colors that are to be affected. What you need to be aware of here is that a higher Purple Amount setting will apply a stronger correction, but the downside is that at higher settings this may cause purple colors in the image that are not the result of fringing to also become affected. To moderate this undesired effect you can tweak the Purple Hue slider split points to narrow or realign the purple range of colors to be targeted. You can drag on either of the knobs one at a time, or you can click and drag on the central bar to align the Hue selection to a different purple portion of the color spectrum. If you need to reset these sliders then just double-click on each individual knob. Likewise, double-click the central bar to reset this to its default position. The minimum distance that may be set between the two sliders is 10 units.

The Green Amount and Green Hue sliders work in exactly the same fashion as the Purple sliders, except these two sliders allow you to control the green fringes. However, the default range for the Green Hue slider is set at 40 to 60 instead of 30 to 70. This is to help protect common green and yellow colors such as foliage colors.

Figure 2.53 The Lens Corrections dialog showing the Manual tab controls.

Figure 2.54 This shows the Lens Corrections panel where the **H** (Mac), *ctrl* (PC) key was held down.

The Defringe controls in use

The recommended approach is to carry out all your major tone and color edits first using the Basic panel controls. Then make sure that you have checked the Enable lens Profile Corrections box to correct for geometric distortion and vignetting and also checked 'Remove Chromatic Aberration'. Once you have done that go to the Manual tab, where you can start adjusting the Defringe sliders to remove any axial chromatic aberrations. Be aware that the global controls can have an adverse effect on the rest of the image. Should this prove to be a problem you can reduce the Purple/Green Amount sliders and use a localized adjustment with the Defringe slider set to a positive value to apply a Defringe as a localized adjustment. As with the Detail panel controls, the Lens Correction Defringe controls are best used when viewing an image at 100% or higher.

You can use the *alt* key as a visualization aid. This lets you see emphasized overlays that give a clearer indication as to what effect the sliders are having and can help you apply the most suitable adjustments. For example, you can use the all key to drag on the Purple Amount slider to visualize purple fringe removal. This will cause the preview to reveal the affected areas of the image only and all other areas will be shown as white. This lets you concentrate on the affected areas and help verify that the purple fringe color is being removed. You can then use the alt key to drag on either of the Purple Hue slider knobs to visualize the range of hues that are to be defringed. As you do this, the preview will show the affected hue range as being blacked out. As you drag on a slider you will need to pay close attention to the borders of the blacked out area to check if there are any residual purple colors showing still. The same principles apply when adjusting the Green Amount and Green Hue sliders with the alt key held down.

Eyedropper tool mode

When working with the Defringe sliders you can hold down the (Mac), *ctrl* (PC) key as you roll the cursor over the preview window to reveal an Eyedropper tool. This tool can be used to help auto set the Purple/Green Amount and Hue slider knobs. If the Caps Lock key is enabled, the Eyedropper cursor will be shown as a cross hair. This can help you to pick the fringe pixels more accurately.

To use this tool it helps to be zoomed in extra close, such as at 200%, or even 400%. This will make the color picking more accurate and you will notice a little white bar appear on one or other color ramp as you hover the cursor over different parts of the image. Figure 2.54 shows the Lens Corrections panel where the 🔀 (Mac), *ctrl* (PC) key was held down. Here, you can see a white bar on the Purple Hue color ramp indicating where on the color ramp the sampled color lies. As you click in the preview this allows Camera Raw to analyze the pixels in the local area around where you click, which can result in one of three outcomes. Camera Raw detects that you clicked on a purple fringe and adjusts the Purple Amount and Purple Hue sliders to suit. Alternatively, Camera Raw detects that you clicked on a green fringe and will adjust the Green Amount and Green Hue sliders. Or, Camera Raw determines that the area you clicked on was too neutral, or was a color that falls outside the supported color range. In which case you will see the alert dialog shown in Figure 2.55, where the alert message points out that the sampled color is too neutral.

Figure 2.55 This shows the error message you might see when working with the Eyedropper tool.

			Lens Corrections	
	F	Profile N	Manual	
			Remove Chromatic Al	perration
			Enable Profile Correct	ions
	U. p. de	Setup:	Custom	~
A A A A A A A A A A A A A A A A A A A			Lens Profile	
		Make:	Canon	~
		Model:	Canon EF 100mm f/	2 USM ~
A A A A A A A A A A A A A A A A A A A	E	Profile:	Adobe (Canon EF 1)	00mm f/ ×
			Correction Amoun	
	Contraction and	Distortion		100
		Vignetting		100
	Charles and the	Show G	arid	
	The second second			

1 The first step was to apply all the main color and tone adjustments and to enable the lens profile corrections and remove chromatic aberration in the Lens Corrections panel.

2 # # 8 = (I fx O	*		
Lens Co	orrections			
Profile Manual				
Di	stortion			
Amount		0		囲
				Ħ
D	efringe			
Purple Amount			12	
Purple Hue			30/	70
8		2		
Green Amount			0	
Green Hue			40 /	60
5	2			
V	ignetting			
Amount			0	_
Midpoint				
	even is en even mente van en	130 Y TA		ale provinsi
Show Grid				

2 Here, I clicked on the Manual tab to view the Defringe controls. I then held down the att key and moused down on the Purple Amount slide to get a visualization of the extent of the purple fringed area, with everything else displayed as white. It helps to use a close-up view beyond 100% when judging the effectiveness of such an adjustment.

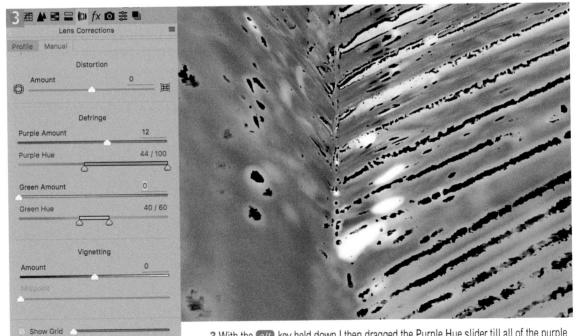

3 With the *multicle constant of the purple of the purple of the purple fringing appeared to have been removed.*

③ 甜 ▲ B 〓 ()) fx 回 毫 Lens Corrections Profile Manual Distortion Amount 0 用 Defringe Purple Amount 12 Purple Hue 44 / 100 Green Amount 0 Green Hue 40/60 3 6 Vignetting Amount 0 Show Grid

4 Next, I wanted to concentrate on the Green fringing. Here, you can see the extent of the green fringes in the areas that were behind the plane of focus.

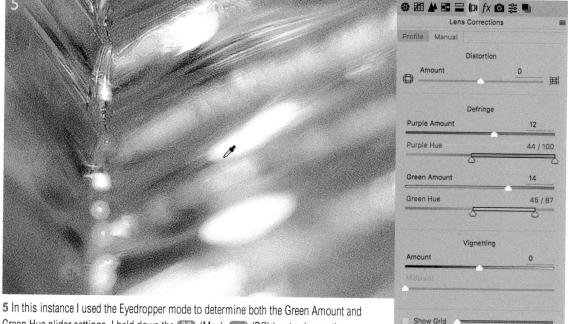

5 In this instance I used the Eyedropper mode to determine both the Green Amount and Green Hue slider settings. I held down the **(Hac)**, **(PC)** key to change the cursor to an Eyedropper and clicked on the green fringe area. This single step auto-set the Green Amount and Green Hue sliders.

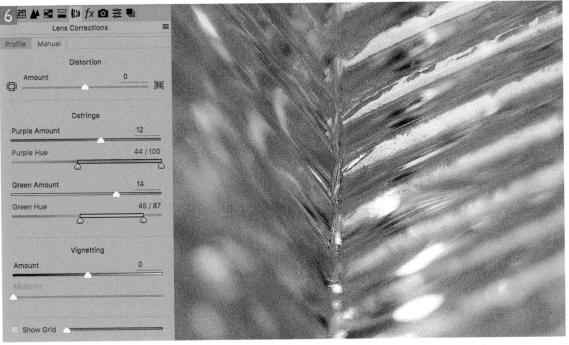

6 This shows the final version with the chromatic aberration removed.

Localized adjustments: Defringe slider

The global Defringe controls should be all you need to remove troublesome fringing. However, there may be times where it won't be possible to remove all visible fringing using the global Defringe sliders on their own. Or, it may be the case that when applying a strong global correction the adjustment you apply has an adverse effect on other areas. In situations like this it may be useful to apply a global adjustment combined with a localized defringe correction using either the Adjustment Brush, Graduated Filter or Radial Filter. But note that localized Defringe adjustments will remove fringes for all colors (not just purple and green) and therefore works independently from the global Purple Hue and Green Hue settings set in the lens Corrections panel.

The global lens corrections are available for all process versions, but in order to apply a localized adjustment the image you are processing must be updated to the latest Version 4. The standard range goes from -100 to +100. A positive Defringe adjustment can be used to apply extra defringing where required, such as when working on specific problem areas in a picture. It may even be the case that with some images a localized defringe adjustment is all that you need to apply. A negative, -100 defringe adjustment will of course completely remove any global defringing and can be used where you wish to protect an area of the photo. One example of how you might want to use this would be to imagine a picture where, say, a strong purple defringe had been applied globally, which resulted in the edges of purple areas becoming desaturated. In a situation like this you could paint over the affected areas with the Defringe slider set to -100. This would allow you to restore some of the original color to these areas.

The localized defringe control is not as powerful as the global defringe controls. This is why it is usually best to use the global Lens Corrections panel controls first and then use a localized adjustment to fine-tune as necessary. Also, be aware that there is no benefit to be gained in applying multiple localized Defringe adjustments to improve upon what a single application can achieve.

The Defringe slider is also only available as a localized adjustment when using Version 4. If a defringe adjustment has been applied to a Version 4 image and you convert the image back to an earlier process version this will cause the defringe effect to be zeroed. The pin you added will still be present, but there will be no defringe adjustment. However, if you then convert the image back to Version 4 the adjustment mask will be preserved and you can restore the defringe effect by adjusting the Defringe slider setting.

1 This shows a close-up view of an image with noticeable fringes.

2 I selected the Adjustment Brush, set the Defringe slider to +100 and painted over the affected areas to reduce the colored fringing. Using the Adjustment Brush in this way I was able to get rid of nearly all the visible fringing and target the Defringe adjustment precisely, where it was needed most.

Transform tool and Upright corrections

To apply an Upright correction, you need to select the Transform tool (*Shift*) from the Camera Raw Toolbar (Figure 2.56). This then reveals the Transform options in the panel view area (Figure 2.57).

The five main Upright corrections are: Auto, Level, Vertical, Full, and Guided. These can be used to auto-calculate an Upright adjustment based on an analysis of the image, applying an instant auto transform correction in place of using the manual transform Vertical, Horizontal or Rotate sliders. To apply an Upright adjustment first check 'Enable Lens Profile Corrections' option in the Lens Corrections panel and make sure you haven't already applied a rotate crop or a manual transform adjustment. This should help you achieve the best results since letting Upright work with a geometrically corrected image

Q 🖑 🌶	** *0.	口. 🖮 🔟	1. +0 1	/	0 ≔	00
-------	--------	--------	---------	---	-----	----

Figure 2.56 This shows the Transform tool in the Camera Raw Toolbar.

can make the line detection work better. If the image you intend to process cannot be corrected after clicking one of the Upright buttons, you'll see here a warning message saying 'No upright correction found.' For example, Upright corrections can only work for images with lines or geometric shape content.

The Auto setting applies a balanced correction to the image, which, rather than auto-selecting an Upright setting, uses a balanced combination of the options listed below. Essentially, it aims to level the image and, at the same time, fixes converging vertical and horizontal lines in an image. The ultimate goal here is to apply a suitable transform adjustment that avoids applying too strong a perspective correction. When selecting an Auto setting it mostly crops the image to hide the outside areas (when applied to an uncropped photo).

A Level adjustment applies a levelling adjustment only—this behaves like an auto straighten tool. The Vertical setting applies a level plus converging vertical lines adjustment, while a Full Upright adjustment applies a full level plus converging vertical and horizontal lines adjustment, applying a strong perspective correction.

It may be that an Upright correction can end up looking too perfect. With architectural shots it is generally a good idea to allow the verticals to converge slightly. You might therefore want to combine an Upright correction with a manual Vertical slider adjustment. You might even consider saving an Upright auto correction plus a Vertical adjustment as a preset.

The Off/Disable button () can be used to turn off an Upright correction. You can also use *ctrl Tab* to cycle through the correction options and *ctrl Shift Tab* to reverse cycle.

If an Upright adjustment ends up being quite strong some outside areas may become visible as transparent pixels. Because Camera Raw includes transparency support, this means such outer areas are displayed using the same default checkerboard pattern as in Photoshop and preserved as such whenever you export from Camera Raw using the PSD and TIFF formats (Camera Raw is also able to read transparency in DNG and TIFF files). However, if you export as a JPEG, the transparent areas will be rendered solid white.

F

Figure 2.57 The Transform panel controls.

It is important to understand here that the underlying math behind Upright adjustments is doing more than just auto-set the Vertical, Horizontal, and Rotate sliders in the Transform section. Behind the scenes there are angle of view and center of projection adjustments taking place and the vertical and horizontal adjustments involved in the Upright process are actually rather sophisticated. It's all to do with how the interaction of one rotation movement can affect another. Think what it's like when you adjust the tilt and yaw on a camera tripod head and you may get some idea of the problem. However, there may be times when an Upright adjustment can't make an appreciable improvement to the perspective and you may wish to adjust the manual Transform sliders instead. Other times you may find it helps to use the manual sliders to finetune an Upright correction.

The Vertical slider can be used to make keystone corrections and the Horizontal slider can similarly be used to correct for horizontal shifts in perspective, such as when a photo has been captured from a viewpoint that is not completely 'front on' to the camera. It can be useful to see the grid overlay when adjusting the Vertical and Horizontal sliders. You can check the Grid box (Shift) (G) to toggle showing/hiding the grid overlay. This can help you evaluate the effectiveness of an Upright correction. Next to this is a slider that allows you to adjust the fineness/coarseness of the grid scale. The Grid on/off setting and Grid slider settings always remain sticky between sessions.

The Rotate slider lets you adjust the rotation of a transform adjustment. Not all Upright adjustments will result in perfectly level images, so fine-tuning may sometimes be required using this slider.

Upright adjustments may cause the image to appear stretched vertically or horizontally. The Aspect slider can be used to compensate for such distortions and thereby keep the adjusted image looking more natural. If you find an Upright setting that you like, but an important part of the image is cropped, you can correct using the Scale and Offset sliders. The X and Y Offset sliders can be used to adjust the placement of an Upright adjusted image. Alternatively, you can hold down the **H** *all* (Mac) or *ctrl alt* (PC) keys and then click-drag on the image. This key combination is like having temporary access to a Move tool in Camera Raw.

As you adjust any of the above sliders you may again end up with transparent areas around the edges of a transformed image. You have the option of using the 'Constrain to image' option from the Crop tool menu (see Figure 2.58) to constrain to the non-transparent pixel area, or you can use Photoshop to fill in these areas.

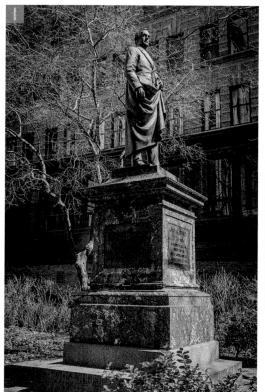

ofile M	Janual	
	Remove Chromatic Al	berration
	Enable Profile Correct	tions
Setup:	Default	×
	Lens Profile	
Make:	Canon	~
Model:	Canon EF 24-70mm	f/2.8 L ~
Profile:	Adobe (Canon EF 24	4-70mm ~
	Correction Amoun	ıt
Distortion	1	100
Vignetting	3	100

1 Here is an image opened in Camera Raw where so far I had applied a lens profile correction via the Profile tab section of the Lens Corrections panel.

2 On the left is an Auto adjustment in which Camera Raw applied an adjustment that combined a Level, Horizontal, and Vertical adjustment. On the right is a 'Level' adjustment, which aimed to straighten the horizon only.

#

0

0.0

0

100

0.0

0.0

P

C

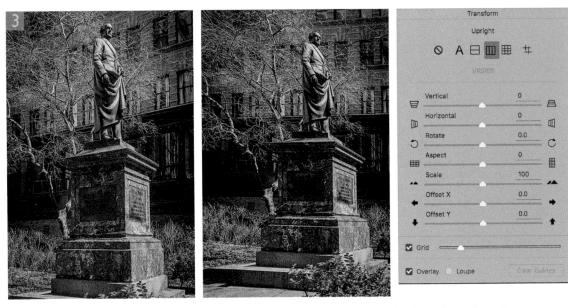

3 On the left is a Vertical adjustment, which aimed to straighten the verticals. On the right is a 'Full' Upright adjustment which applied a full perspective plus levelling correction regardless of how strong the perspective adjustment would be.

4 I thought the Vertical option was the most natural-looking. I checked the Grid box at the bottom of the Lens Corrections panel to enable the Grid overlay. I was also able to adjust the slider to fine-tune the Grid overlay scale.

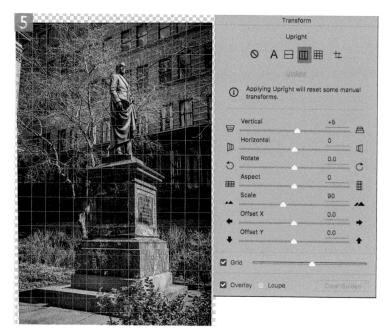

5 In the sliders section I adjusted the Vertical slider to converge the verticals slightly and reduced the Scale to 90%.

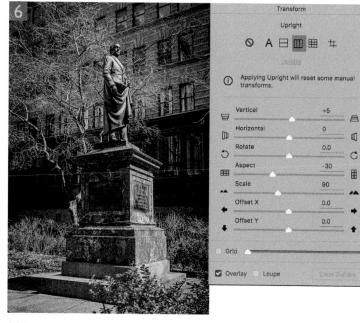

Figure 2.58 The 'Constrain to Image' item in the Crop menu.

6 I then adjusted the Aspect slider to stretch the image horizontally. Where you end up with transparency in an image you can select the 'Constrain to image' option from the crop tool menu (see Figure 2.58). This trims the transparent areas.

Figure 2.59 The Synchronize Settings menu options for synchronizing Camera Raw settings.

Synchronizing Upright settings

If you want to synchronize an Upright adjustment across multiple images, select Synchronize Settings and check the Transform option. This will apply a matching Upright adjustment to all the selected photos. Figure 2.59 shows the Synchronize Settings menu options for synchronizing Camera Raw settings. When the Transform option is selected this allows auto synchronization of Upright settings. For example, if you want to prepare a group of bracketed exposure images to create an HDR master and wish to apply an Upright perspective correction, this will match the Upright adjustment precisely. Synchronizing the Transform setting also force synchronizes any crop setting that is in force.

Guided Upright adjustments

In addition to the Auto, Level, Vertical, and Full Upright options there is a Guided button. This Upright correction method requires user input to apply an Upright adjustment. Essentially, Guided Upright adjustments can be used to force straight lines to align to vertical or horizontal, where none of the other Upright adjustments are able to do so. To help you judge where to click, you can check the Loupe option at the bottom of the panel. This reveals an enlarged loupe preview that can help you position the guides more accurately. Or, as you adjust a guide you can hold down the *all* key to access the loupe preview.

To apply, click and drag on the image preview to add a guide that defines either a horizontal or a vertical angle and then click and drag to apply a second guide. You won't see any adjustment take place until you have applied a second horizontal or vertical line. In the Figure 2.60 example I first applied a horizontal guide to match the angle of the electric cable at the top and then applied a second line along the bottom of the wall. I needed to apply these two guides to achieve a guided horizontal transformation. Having done that I added a vertical guide to the left, followed by a vertical guide to the right. The addition of these two guides applied a guided vertical transformation to complete the Guided Upright transformation. You will notice in the accompanying screen shot of the Transform panel controls I also adjusted the Aspect and Scale sliders to fit the transformed image to the same cropped area as the before version.

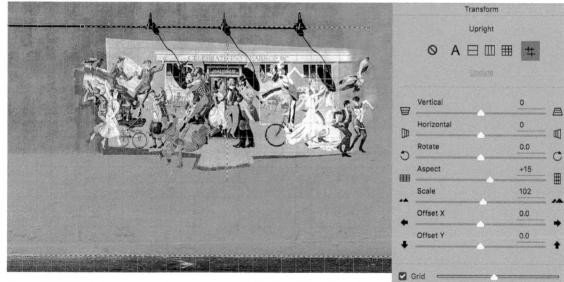

Figure 2.60 The before version is shown above and a Guided Upright transformed version is shown below.

🖸 Overlay 🔄 Loupe

Clear Guides

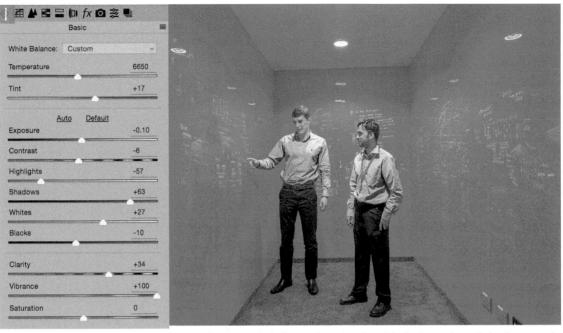

1 This shows the before version, where I used the Basic panel to optimize the tone and colors. However, the angles in this photo were not perfectly straight.

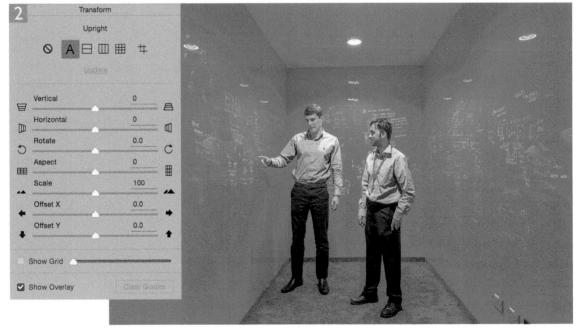

2 In this step I selected the Transform tool and in the Transform options clicked on the Auto button to apply an Auto Upright adjustment. This made the rear wall appear straighter, although not perfectly straight.

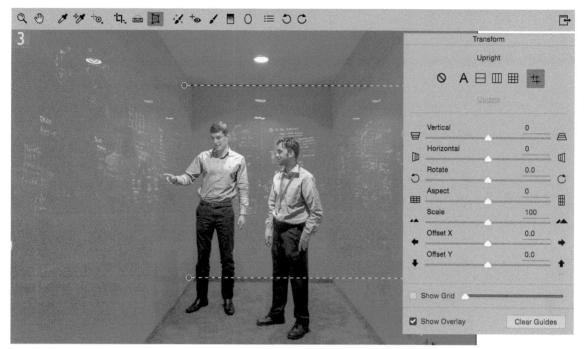

3 Instead, I clicked on the Guided Upright button and added two horizontal guides to apply a horizontal Guided Upright correction.

4 For the final version shown here I also added two vertical guides to apply a full Guided Upright correction. I held down the *mu* key while adjusting one of the guides to reveal the loupe seen here.

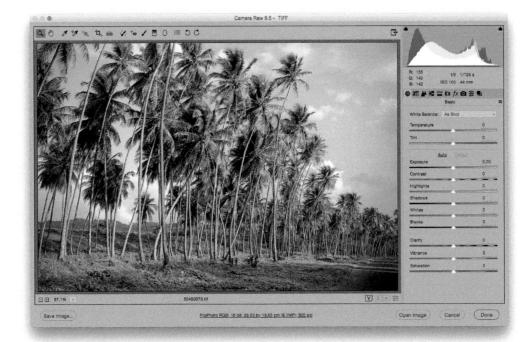

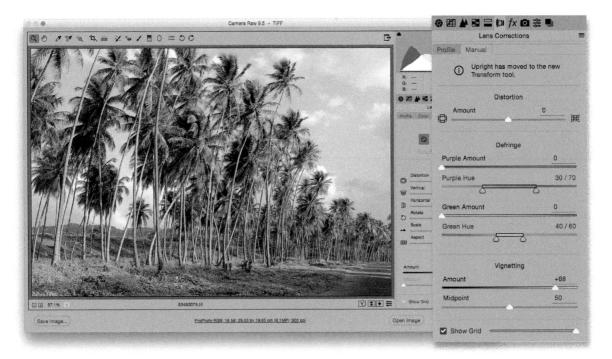

Figure 2.61 In this example, I took a rendered TIFF image that had signs of lens vignetting. Here, I used the Lens Corrections panel Manual Lens Vignetting Amount slider to compensate for this.

Lens Vignetting controls

If you wish to correct for the lens vignetting inherent in an image, it is always best to enable a lens profile correction and fine-tune the correction using the Vignetting slider. This assumes a lens profile is available though. Where there is none, or you are processing a scanned image, you can use the Manual tab Lens Vignetting controls. The Amount slider can be used to compensate for the corner edge darkening relative to the center of the photograph (see Figure 2.61) and the Midpoint slider can be used to offset the rate of fall-off. As you increase the Midpoint value, the exposure compensation will be accentuated more towards the outer edges.

Vignetting is not always a problem caused by the lens. In the studio I sometimes shoot with extreme wide-angle lenses and the problem here is that it's often difficult to get the backdrop evenly lit in all four corners. In these kinds of situations it can help to use the Lens Vignetting slider to compensate for the fall-off in light towards the corners of the frame by lightening the edges (see Figure 2.62).

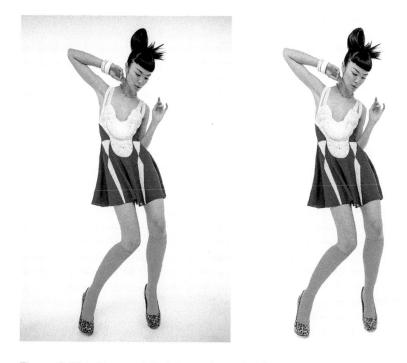

Figure 2.62 In this example the before version on the left has a noticeable vignette as a result of uneven studio lighting. The version on the right was improved by applying a positive Vignetting Amount setting.

Effects panel

Post Crop Vignetting control

The Lens Vignetting controls can be used as a creative tool for darkening or lightening the corners of their pictures. The problem here though is that a Vignetting slider adjustment can only be applied to the whole of the image frame area. However, the Post Crop Vignetting sliders in the Effects panel can be used to apply a vignette relative to the cropped image area. This means you can use the Post Crop Vignette sliders as a creative tool for those times when you deliberately wish to lighten or darken the edges of a photo. The Post Crop Vignetting Amount and Midpoint sliders work identically to the Lens Corrections lens Vignetting controls, except you also have the option to adjust the Roundness and the Feathering of a vignette adjustment.

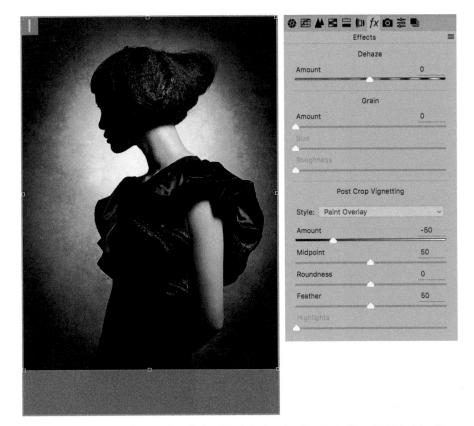

1 In this first step I applied a -70, darkening vignette offset with a +45 Midpoint setting. This adjustment was not too different from a normal Lens Vignetting adjustment, except it was applied to the cropped area of an image.

0
0
0
0
-50
50
+100
Contraction of the second

2 To create this version, I adjusted the Roundness slider to make the vignette shape less elliptical and adjusted the Feather slider to make the vignette edge harder.

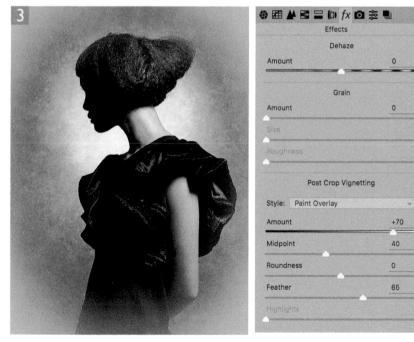

3 For this final version, I applied a +70 vignette Amount to lighten the corners of the cropped image, combined with a low Midpoint and a soft Feather setting.

Client: Andrew Collinge Hair & Beauty. Hair by Andrew Collinge artistic team, Make-up: Liz Collinge.

So far I have just shown you the options for the Paint Overlay vignette style option, which was the only option when this feature was first introduced. In the Figure 2.63 photograph of frost-covered trees, the before version shows no adjustment, and below that one, where I applied a standard Paint Overlay effect with a negative setting. You can see for yourself how this applies a semi-opaque, hazy kind of effect. The Paint Overlay mode kind of blends either a black or white color into the edges of the frame depending on which direction you drag the Amount slider.

Figure 2.63 This shows the before version (top) and a negative Paint Overlay style effect (below).

Dehaze	
Mount	0
Grain	
Amount	0
Size	
loughtness	
Post Crop Vign	etting
Style: Paint Overlay	~
Amount	-50
Midpoint	50
Roundness	0
Feather	50

The Color Priority and Highlight Priority modes produce an effect that is more similar to a Lens Correction vignetting adjustment since the darkening or lightening is created by varying the exposure at the edges. Of the two, the Color Priority mode (Figure 2.64) is usually gentler as this applies the Post Crop Vignette after the Basic panel Exposure adjustments, but before the tone adjustment stage. This minimizes color shifts in the darkened areas, but it can't perform any highlight recovery when you darken the edges.

The Highlight Priority mode (see Figure 2.65) tends to produce more dramatic results. This is because it applies the Post Crop Vignette prior to the Exposure adjustment. It has the benefit of allowing better highlight recovery, but this can lead to color shifts in the darkened areas.

Whichever method you use, the suggested workflow is to use the Lens Correction panel to apply a profiled lens correction, to apply a profiled vignette correction and use the Post Crop Vignetting sliders in the Effects panel to add a vignetting effect.

Figure 2.64 This shows an example of a darkening post-crop vignette adjustment in which the Color Priority style was used.

Effects	
Dehaze	
Amount	0
Grain	
Amount	0
Size	
Roughness	
Post Crop Vignett Style: Color Priority	ing
Style: Color Priority	
Post Crop Vigneti Style: Color Priority Amount Midpoint	~
Style: Color Priority Amount Midpoint	-50
Style: Color Priority Amount	-50

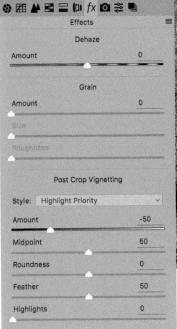

Figure 2.65 This shows an example of a darkening Post Crop Vignette adjustment in which the Highlight Priority style was used.

Highlights slider

There is also a 'Highlights' slider, which can be used to further modify the effect. In Paint Overlay mode, the Highlights slider is disabled, while in the Color Priority and Highlight Priority modes the Highlights slider is only active when applying a negative Amount setting. As soon as you increase the Amount to apply a lightening vignette, the Highlights slider will be disabled. In the Figure 2.66 example I applied a Highlight Priority Post Crop Vignette style and added a 100% Highlights adjustment to the vignette effect. In this instance, the Highlights slider adjustment made a fairly subtle change to the appearance of this Post Crop Vignette effect. In Figure 2.67 I applied a Color Priority Post Crop Vignette style and added a 100% Highlights adjustment to the vignette effect. If you compare this with the Figure 2.66 example, you can see how a Highlights slider adjustment can have a more substantial effect on the Post Crop Vignette adjustment when using the Color Priority mode.

Increasing the Highlights amount allows you to boost the highlight contrast in the vignetted areas, but the effect is only really noticeable in subjects that have bright highlights. Here it had the effect of lightening the frost-covered branches in the corners of the image, taking them back more to their original exposure value. The difference can be quite subtle, but overall I find that the Highlights slider usually has the greatest impact when editing a Color Priority Post Crop Vignette.

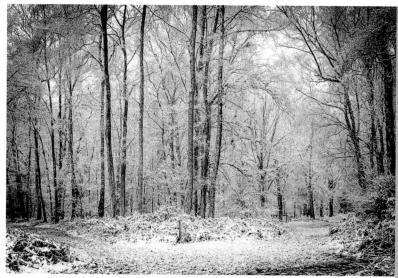

Figure 2.66 In this example I applied a Highlight Priority Post Crop Vignette style and also added a 100% Highlights adjustment.

Effects		
Dehaze		
Amount	0	
Grain		
Amount	0	
Size		
	No. of the second second	
Roughness		
Post Crop Vignett Style: Highlight Priority		
Style: Highlight Priority		
Style: Highlight Priority Amount Vidpoint	-50	
Style: Highlight Priority	-50	

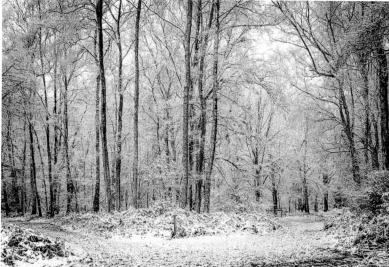

Figure 2.67 In this example I applied a Color Priority Post Crop Vignette style and also added a 100% Highlights adjustment.

Effect:	
Deha	ize
Amount	0
Gra	in
Amount	0
Size	
Roughness	
Michaeline in a carine bear and a surray water	
Post Crop V	ignetting
	lignetting
Post Crop V Style: Color Priority Amount	lignetting -50
Style: Color Priority	
Style: Color Priority Amount	-50
Style: Color Priority Amount Midpoint	-50

Dehaz	ze
Amount	0
Grair	1
Amount	25
Size	25
Roughness	50
Post Crop V	ignetting
	0
Amount	
Amount Midpoint	
Mideoint	

Figure 2.68 The Effects panel showing the Dehaze and Grain sliders.

Adding Grain effects

The Effects panel also contains Grain controls (Figure 2.68). The Amount slider determines how much grain is added, while the Size slider controls the size of the grain particles. The default setting is 25 and dragging to the left or right allows you to decrease or increase the grain particle size. If the Size slider is set any higher than 25, then a small amount of blur is applied to the underlying image. This is done to help make the image blend better with the grain effect. The exact amount of blur is also linked to the Amount setting; the higher the Amount, the more blur you'll see applied. The Roughness slider controls the regularity of the grain. The Default value is 50. Dragging to the left will make the grain pattern more uniform, while dragging to the right can make the grain appear more irregular. Basically, the Size and Roughness sliders are intended to be used in conjunction with the Amount slider to determine the overall grain effect.

Dehaze slider

The Dehaze slider in the Effects panel can be used to compensate for atmospheric haze in photographs, as well as mist, fog, or anything that contributes to the softening of detail contrast in a scene. You can drag this slider to the right to apply a positive value and remove haze from a scene. Alternatively, you can drag the slider to the left to add haze to an image. The results you get are in some ways similar to adjustments made using the Clarity slider, but a Dehaze effect is overall a lot stronger than can be achieved using the Clarity slider on its own. As well as removing haze from daylight scenes you can also use the Dehaze slider contrast to improve the contrast in photographs taken of the night sky to reduce the effects of light pollution.

It is recommended that you set the white balance first prior to applying a Dehaze adjustment. I have also noticed that when you apply a Dehaze adjustment to remove haze, it can also emphasize the lens vignetting in an image. It is therefore best to make sure you apply a lens profile correction (or a manual vignetting correction) first in order to remove any lens vignetting before you apply a Dehaze slider adjustment.

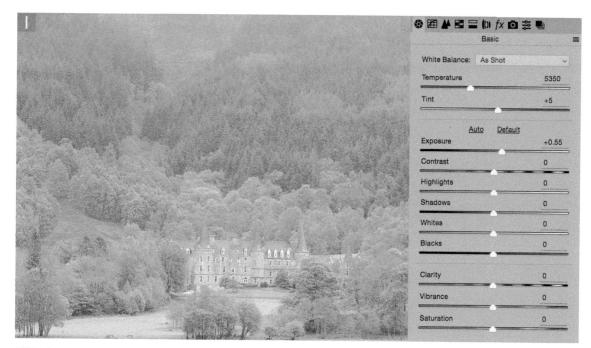

1 This shows a scene where the castle in the photograph was some distance away from the camera and the weather conditions were quite hazy.

2	● 甜 ▲ B 〓 ()) fx 回 菜 ■		
		Effects	
		Dehaze	
The work of the second s	Amount		+55
V. C. Start Charles and the start of the		Grain	
and the second	Amount		0
	Size		
	Roughness		
	Po	st Crop Vignetting	
	Amount		0
	Midpoint		
	Roundness		
AND STREET STREET	Feather		
	Highlights		

2 In this step, I went to the Effects panel and adjusted the Dehaze slider, setting it to +55, to cut through the haze to add more contrast and reveal more detail.

Localized Dehaze adjustments

Dehaze is also available as a localized adjustment when using the Graduated Filter, Radial Filter, or Adjustment Brush. As with the Dehaze slider in the Effects panel you can drag the slider to the right to apply a positive value to remove haze from a scene. Or, you can drag the slider to the left to add haze to an image. What I like about using Dehaze as a localized adjustment is the way you can selectively apply Dehaze adjustments to the sky only in a landscape. This is best done using the Graduated Filter tool. I have also found it helpful to apply localized Dehaze adjustments using the Radial Filter or Adjustment Brush to remove lens flare.

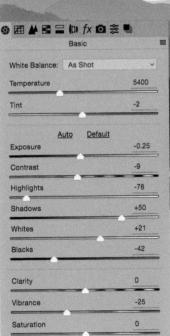

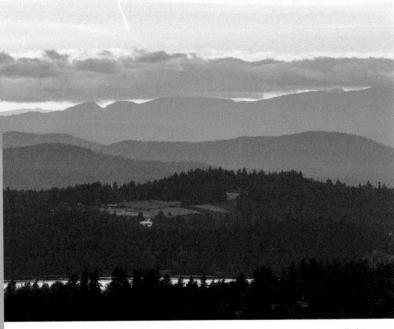

1 Here is an image shot of a sunset with a few Basic panel adjustments applied to optimize the tones in the foreground of this landscape.

2	St. 1	Graduated Filter 📰		
	Θ	Temperature	0	Œ
	Θ	Tint	0	•
And and a second se	Θ	Exposure	+1.00	•
	Θ	Contrast	0	•
	Θ	Highlights	0	Œ
An one	Θ	Shadows	0	•
	Θ	Whites	0	⊙
The second s	Θ	Blacks	0	. 🕣
and the second	Θ	Clarity	0	
	Θ	Dehaze	0	•
	Θ	Saturation	0	Ð
the survey and the second second second	Θ	Sharpness	0	€
and a second state and an and a second s	Θ	Noise Reduction	0	€
	Θ	Moire Reduction	0	⊙
2 In this step I added a darkening Graduated Filter adjustment to the bottom of the photo.	Θ	Defringe	0	Œ

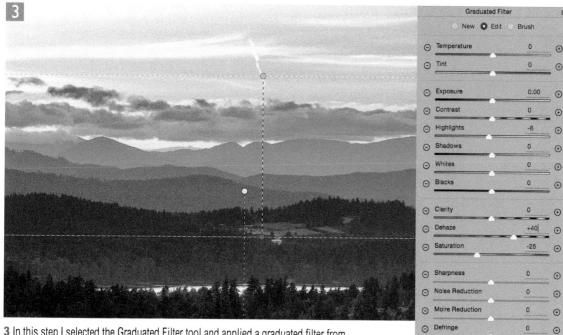

3 In this step I selected the Graduated Filter tool and applied a graduated filter from the middle of the sky downwards. Here, I applied a +40 Dehaze and -25 Saturation adjustment to bring out more detail in the sky, clouds, and mountain range.

€

•

0

 \odot

 \odot

€

Figure 2.69 The Calibration panel.

Calibration panel

The Calibration panel (Figure 2.69) can be used to select specific process versions. This is handy should you wish for some reason to revert to an older process version. The Camera Profile menu can be used to select a profile as a starting point for image processing in Camera Raw. The manual Calibration sliders are now mostly redundant, but these are still useful if you wish to apply manual calibration adjustments or artificial color treatments.

Camera profiles

Nearly all digital SLRs will have an Adobe Standard profile option. Canon and Nikon users can access the following profiles: Camera Faithful, Camera Landscape, Camera Neutral, Camera Portrait, and Camera Standard. Nikon users may also see a Camera Vivid as well as Mode 1, Mode 2, Mode 3 options. Olympus cameras include a Camera Muted profile, while Fuji X-Trans cameras offer a unique set of profiles that match different Fuji film looks including black and white profile options. Sony Alpha cameras have Camera Clear, Camera Deep, Camera Light, and Camera Vivid profile options.

As I just mentioned, the Adobe Standard should be the most color accurate profile option. This is because the profile is made by building a two-part profile of the camera sensor's spectral response under standardized tungsten and daylight balanced lighting conditions. From this, Camera Raw is able to calculate a pretty good color interpretation under these specific lighting conditions, and extrapolate beyond these across a full range of color temperatures. By choosing the Camera Standard profile you can get the Camera Raw interpretation to closely match the default camera manufacturer rendering and also match the default camera JPEG renderings.

Photographers have often complained that Camera Raw in Bridge and Lightroom changes the look of their photos soon after downloading. They find they liked the initial JPEG previews only to see them quickly replaced by a Camera Raw rendering. If you select the Camera Standard profile and set this as the new default you won't see such jumps in color as the Camera Raw processing kicks in.

Camera Raw legacy profiles

The Camera Profile menu may also include earlier, legacy Camera Raw profiles. These are color profiles that were built for the digital cameras that Camera Raw supported up until version 5.0. These may appear listed as ACR 3.6 or ACR 4.3, etc. What's happened is that with new releases of Camera Raw the profiles for some of these cameras got updated based on more extensive camera testing and hence appeared as ACR profile updates. The Adobe Standard profile now supersedes all these earlier profiles. The reason for preserving the older profiles is to maintain backward compatibility for images that were processed using one of these older profiles and therefore preserve the color profile that was applied. After all, it wouldn't do to find that all your existing Camera Raw processed images suddenly looked different because the profile had been updated to Adobe Standard. Therefore, Adobe give you the choice to decide which profile is best to use. If you are happy to trust the 'Adobe Standard' profile, then I suggest you leave this as the default starting point for all your raw conversions.

Custom camera profile calibrations

While the Adobe Standard profiles are better than the original profiles, they have still been achieved through testing a limited number of cameras. You can, however, create custom standard camera profiles for individual camera bodies. Creating a custom camera calibration profile does require a little extra effort to set up, but it is worth doing if you want to fine-tune the color calibration for each individual camera you shoot with. To do this you will need an X-Rite ColorChecker chart (Figure 2.70). This can be bought as a mini chart or the full-size chart shown here. You then need to photograph the chart with your camera in raw mode, save the raw file as a DNG and process it using the Adobe DNG profile Editor program. It is important the chart is evenly lit and is exposed correctly. It does not matter what other camera settings you use. I recommend you shoot at a low ISO rating and remember to bracket the exposures.

Embedding custom profiles

If you create a custom camera profile for your camera and apply this to an image, the custom profile can only be read if the same camera profile exists on the computer reading it. If you share a raw file on another computer it will look to see if the same camera profile is in the 'CameraProfiles' folder. If it isn't, it defaults to using the Adobe Standard profile. However, if you convert your raw files to DNG. The current DNG spec allows for camera profiles to be embedded within the file and thereby removes the dependency on the host computer having a copy of the custom camera profile that's been applied.

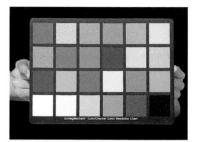

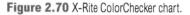

Filtering individual channels

You can apply the Camera Raw filter to individual channels, such as the luminosity channel while working in Lab mode. However, when used this way certain features such as per-channel curves and split tone controls will be disabled.

Camera Raw as a Photoshop filter

Camera Raw adjustments can be applied as a filter effect. You can do this directly, or ideally non-destructively by first converting to a Smart Object (Smart Filter) layer. This lets you re-edit the Camera Raw settings just as you would when editing a raw image. In the case of layered images you must decide whether you intend to filter only a specific layer or all current visible layers. So, before creating a smart object do make sure you have the layer or layers you wish to process correctly selected. Some might argue that Camera Raw editing is already available for non-raw images, but this is limited to flattened files saved in the TIFF or JPEG format.

The Camera Raw filter can be applied to RGB or grayscale images that don't exceed 65,000 pixels in either dimension. This may benefit certain workflows. For example, when working with scanned images you can use the Camera Raw filter to apply the capture sharpening. Or, maybe you'll feel more comfortable using the Camera Raw Basic panel tone controls instead of Levels or Curves to tone edit an image? There's also the benefit of being able to apply other Camera Raw specific adjustments such as Clarity to adjust the midtone contrast, or Camera Raw style black and white conversions.

You will notice the workflow options (the hyperlink beneath the preview) is missing when using Camera Raw as a filter. This is because the workflow output settings are not relevant when processing an image directly in Photoshop—it will already have been rendered to a specific RGB space and bit depth and the histogram RGB values use the document color space. The Camera Raw Filter displays the histogram and the RGB color readouts refer to the assigned color space of the corresponding Photoshop document.

There are limitations when using this filter. For example, you can't expect to achieve the same range of adjustment control on a non-raw image when adjusting say the Highlights slider to rescue extreme highlight detail. Not all Camera Raw tools are made available when using the Camera Raw filter. You can't save snapshots, because there is nowhere to save them and the lens profile correction options are not available because you already have the Lens Corrections filter in Photoshop. There is also the overhead that comes from having to create a Smart Object, which inevitably leads to bigger saved file sizes. Above all, if you care about optimum image quality, you shouldn't skip carrying out the Camera Raw processing at the raw image stage. Camera Raw is most effective when it's used to edit raw images. The Camera Raw filter is basically a convenience when working in Photoshop as it can save you having to export an image or layer to apply the Camera Raw processing separately.

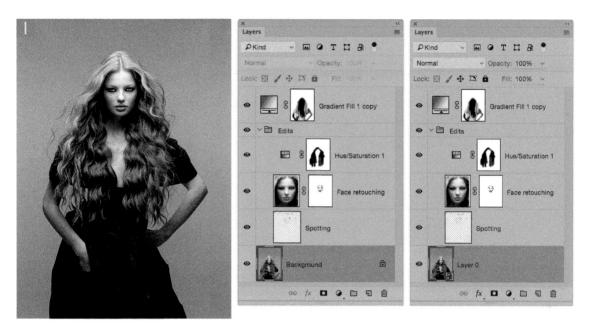

1 Here is a photograph that had been edited in Photoshop. In this first step the Background layer only was selected. I then went to the Filter menu and chose 'Convert for Smart Filters.' This converted the Background layer to a smart object.

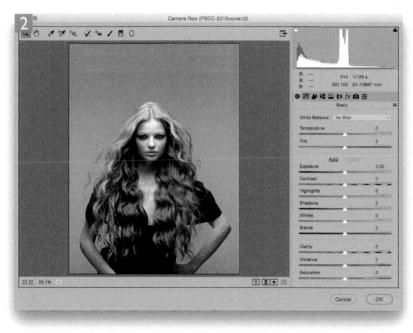

2 I went to the Filter menu and chose the Camera Raw Filter. As you can see, the filter was applied to the Background layer contents only as that was what had been selected in step 1.

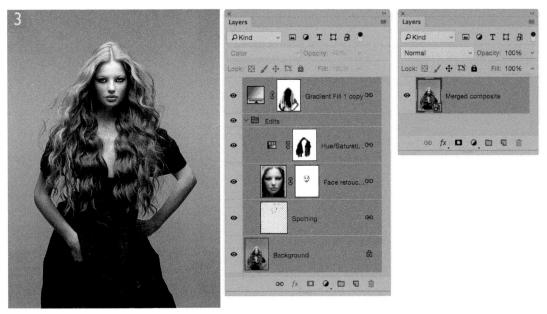

3 I clicked the Cancel button to return to the original, layered image in Photoshop. This time I ensured all the visible layers were selected and chose 'Convert for Smart Filters' again. This created a smart object that contained all the layers.

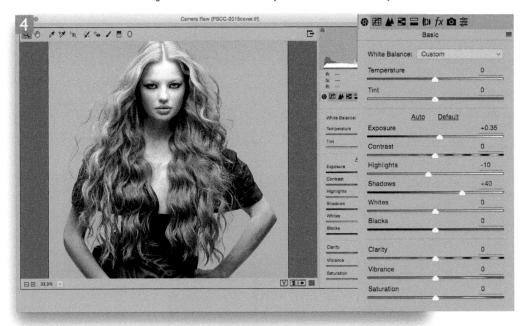

4 I renamed the smart object layer 'Merged composite' and chose the Camera Raw Filter, which would now be applied to a composite of all the layers contained within the smart object. In the Effects panel I added a post-crop vignette adjustment to darken the corners and in the Basic panel I adjusted the Highlights and Shadows.

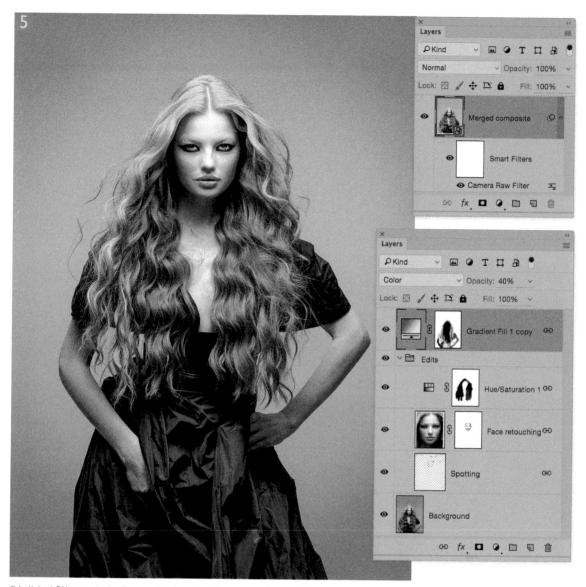

5 I clicked OK to apply the Camera Raw filter. The Layers panel shows the smart object layer with the Camera Raw filter applied. If I were to double-click the smart object thumbnail in the Layers panel this would open the expanded layers view, which is the same as the one seen at step 1. As with all smart object editing, you can open a smart object to reveal the contents and continue editing the document. In this instance, if I were to change the Gradient Fill overlay layer and resave, this would update the smart object and the Camera Raw filter adjustments would also update accordingly.

You can use the Spot removal tool (**B**) to retouch spots and blemishes. Whenever the spot removal tool is active you will see the Spot Removal options appear in the panel section (Figure 2.71). From here you can choose between Heal and Clone type retouching. In Clone mode, the tool behaves like the Clone Stamp tool in Photoshop. It allows you to sample from a source area that will replace the destination area, without blending. In Heal mode, the tool behaves like the Healing or Spot Healing Brush in Photoshop, blending the sampled pixels with the surrounding pixels outside the destination area. The performance has been much improved since Photoshop CC 2015.2, as has the image quality resulting in improved Heal mode blending with the surroundings. This applies to all newly created spots using this new method. However, adding multiple spots (and especially brush spots) may still slow down the overall Camera Raw performance.

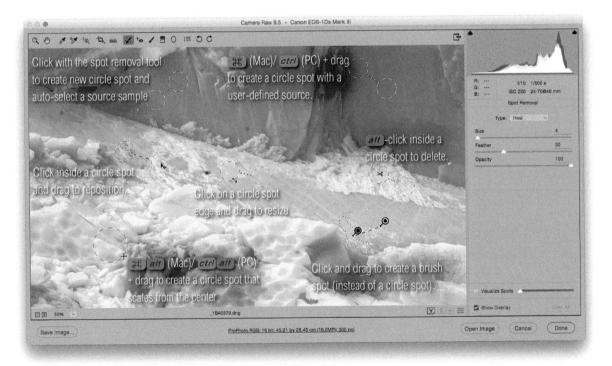

Figure 2.71 This screen shot shows the Spot removal tool in action, with explanations of how to apply and modify the retouch circle spots. Brush spots are covered in more detail later on page 212.

Creating circle spots

Ideally you should carry out the spotting work at a 100% zoom setting. Whenever you click with the Spot removal tool, this creates a new circle spot and auto-selects the most suitable area to clone from. This is a little like using the Spot Healing Brush in Photoshop, except it works using either the Clone or Heal modes. If you don't like the auto-selection made you can use the 💋 key to recalculate a new source area to sample from. This can be useful where the initial auto-sample selection wasn't successful. Rather than manually override the source selection you can ask Camera Raw to take another guess, which may just work out better. The auto find source aspect of the Spot removal tool is now able to cope better with textured areas such as rocks, tree bark, and foliage. It also takes into account the applied crop. This means that if a crop is active the Spot removal tool gives preference to sourcing areas within the cropped area rather than outside it. Basically, if an image is cropped, Camera Raw carries out two searches for a most suitable area to clone from: one within the cropped area and one outside. Preference is given to the search inside the cropped area when computing the optimum auto find area. If somewhere outside the cropped area yields a significantly better result, then that will be used instead.

If you hold down the Ralt (Mac), or ctrl alt (PC) key + click and drag, this creates a circle spot that scales from the center. To manually set the source area to sample from you need to hold down the 🎛 (Mac), 🎛 (PC) key + click and drag to define the source area. If you click to select an existing circle spot you can adjust both the destination or source point circles, repositioning them and changing the type from Clone to Heal or vice versa. You also have the option to adjust the radius of the Spot removal tool as well as the opacity (the Opacity slider allows you to edit the opacity of your spotting work on a spot by spot basis). You can always use the [] keys to adjust the Radius, but it is usually simpler to drag with the cursor instead. You can click on the 'Show Overlay' box or use the W key to toggle showing and hiding the circles and use the Toggle Preview button (# alt P [Mac], or ctrl alt P [PC]) to toggle showing/hiding the spot removal retouching. 🚮 toggles between the Spot Healing Brush and the last used panel.

Synchronized spotting with Camera Raw

You can synchronize the spot removal tool across multiple photos. Make a selection of images in Bridge and open them up via Camera Raw (as shown in Figure 2.72). Next, go to the Filmstrip menu and choose 'Select All' to select all the photos. Now, if you work with the Spot removal tool, you can retouch the most selected photo (the one shown in the main preview), and the spotting work will automatically be updated to all the other selected images.

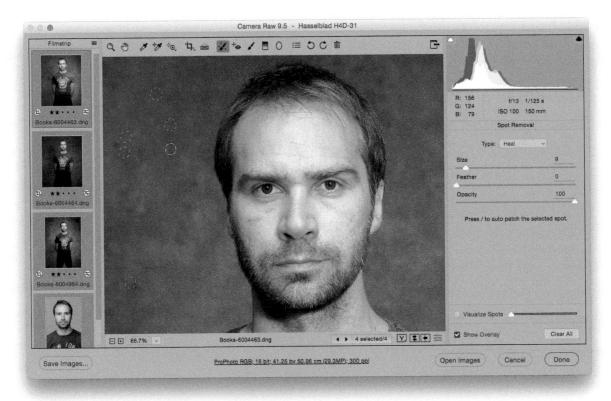

Figure 2.72 An example of the Camera Raw dialog being used to carry out synchronized spotting.

Spot removal tool feathering

The Spot removal tool has a Feather slider (Figure 2.73). This allows you to modify the brush hardness when working with the Spot removal tool in the Clone or Heal modes, applying either a circle spot or brush spot. This is interesting because while it has always been possible to adjust the brush hardness in Photoshop when working with the Clone Stamp tool, there has never been a similar hardness,

or feathering option for the Healing Brush. This is because the Healing Brush and Spot Healing Brush have always had an internal feathering mechanism built in, so additional feathering has never been needed. Looking at what has been done here in Camera Raw the Feather slider control works well and is useful for both modes of operation. There is also another reason. With Lightroom 5 and Camera Raw 8, Adobe switched to using a faster healing algorithm in order to make the brush spots retouching work speedier. However, as a result of this the blending wasn't always as smooth as the previous algorithm. This was one motivation for adding a Feather slider. At the same time, the Feather slider does appear to offer more control over the Spot removal tool blending and can help overcome the edge contamination sometimes evident when using the Spot removal tool in Heal mode, but with a hard feather edge. The feathering is applied to the destination circle spot or brush spot and the Feather amount is proportional to the size of the spot, so bigger spots will use a bigger feather. Also, the Feather setting that's applied remains sticky across Camera Raw sessions.

You can hold down the *Shift* key as you use the square bracket keys to control the feather setting. Use *Shift* + 1 to increase the feathering and *Shift* + 1 to decrease. You can also hold down the *Shift* key as you right mouse-click and drag left or right to dynamically adjust the Feather amount.

Fine-tuning the Spot removal tool

You can nudge both the destination and source circle/brush spots using the keyboard arrow keys. Use the # key (Mac), or *ctrl* key (PC) + arrow to nudge a destination circle or brush spot more coarsely and use # *att* (Mac), or *ctrl att* (PC) + arrow to nudge more finely. Use the # *Shift* keys (Mac), or *ctrl Shift* keys (PC) + arrow to nudge a source circle or brush spot more coarsely and use # *Shift att* (Mac), or *ctrl Shift att* (PC) + arrow to nudge more finely.

Finally, when you hold down the **#** *alt* (Mac), or *ctrl alt* keys (PC) and click in the preview and drag to adjust the cursor size, the size value is now reflected by the Size slider.

Spot Remo	oval
Type: Heal	~
Size	9
Feather	75
Opacity	100
Visualize Spots	

Figure 2.73 The panel controls for the Spot removal tool.

Visualize Spots

The Visualize Spots feature can be used to help detect dust spots and other anomalies. This consists of a Visualize Spots checkbox and slider. When enabled, you can drag the slider to adjust the threshold for the preview and this can sometimes make it easier for you to highlight the spots in an image that need to be removed. You can also use the comma and period keys (or think of them as the \leq and \geq keys) to make the slider value increase or decrease, and use the *Shift* key to jump more. Obviously, it helps to view the image close-up as you do this. When adjusting the slider the slider value remains sticky until you turn on Visualize Spots to treat another image.

The Spot removal tool visualization will only be active for as long as the Spot removal tool is selected. As soon as you select another tool the preview reverts to normal.

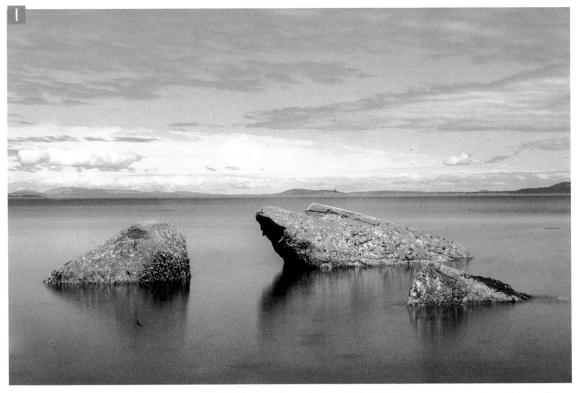

1 This shows an image that was shot with dirty camera sensor marks, which wasn't helped much by shooting a high-key subject using a small lens aperture.

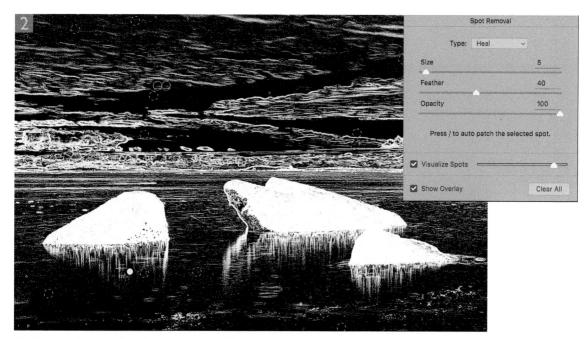

2 I checked the Visualize Spots box at the bottom of the Spot Removal panel options and adjusted the slider to obtain a suitable preview, one that picked out the spots more clearly. I then clicked with the spot removal tool to remove the spots that had been identified using this method.

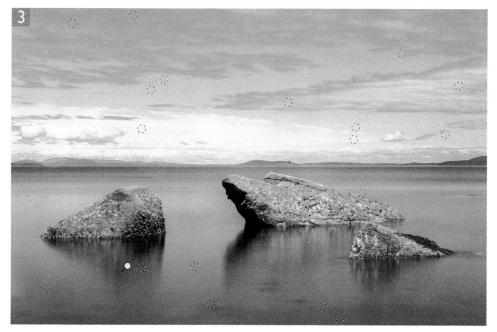

3 Here you can see the final retouched image with the brush spot overlays visible.

Figure 2.74 You can click and drag with the spot removal tool to precisely define the area you wish to remove.

Creating brush spots

By clicking and dragging with the Spot removal tool you can precisely define the areas you wish to remove (see Figure 2.75). As you drag with the Spot removal tool a red dotted outline defines the area you are removing and a green dotted outline define the area you are sampling from (see Figure 2.74). As with circle spots, the brush spot method auto-selects the best area to sample from and you can use the \bigcirc key to force Camera Raw to recalculate a new sample area.

If you click and drag with the *Shift* key held down this constrains the line to a horizontal or vertical direction. But if you click and click again with the *Shift* key held down this lets you create a 'connect the dots' selection. Also, using a regular right mouse-click you can drag left or right to reduce or increase the cursor size.

With brush spots (where you click and drag), these are indicated by a pin marker. As you hover over the pin you will see a white outline of the brush spot shape. When you click to make a pin active the outline of the destination brush spot will appear red and the corresponding source outline green. With brush spots it is not possible to manually

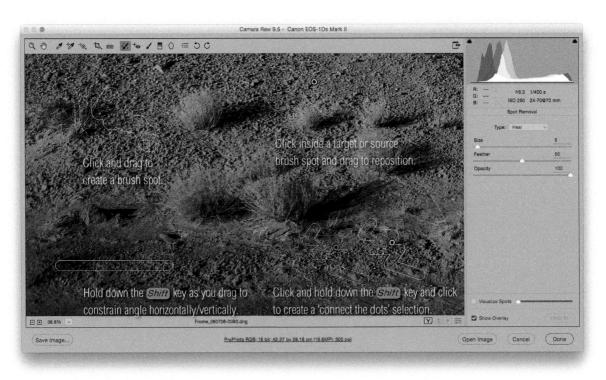

Figure 2.75 This screen shot shows the Spot removal tool in action, with explanations of how to apply and modify brush spots.

resize the brush outline, but you can click on either pin marker or drag anywhere inside either brush stroke outline to reposition a destination or source brush spot.

Deleting spots

To delete a circle or brush spot, you simply select it and press the *Delete* key. Alternatively, you can hold down the *all* key and click on an individual spot (as you do so the cursor changes to a scissor). Or, you can hold down the *all* key and marquee drag within the preview area to select any spots you wish to delete. This will delete the spots as soon as the mouse is released. If you simultaneously hold down the spacebar after doing so, this allows you to reposition the marquee area. As soon as you release the mouse the deletion is applied.

Substitute zoom shortcut

You can use **#** *all Shift* (Mac) *ctrl all Shift* (PC) as a substitute zoom tool in Camera Raw when working with Spot removal tool.

1 With this image I was interested in using the Spot removal tool to remove the hose pipe from the foreground.

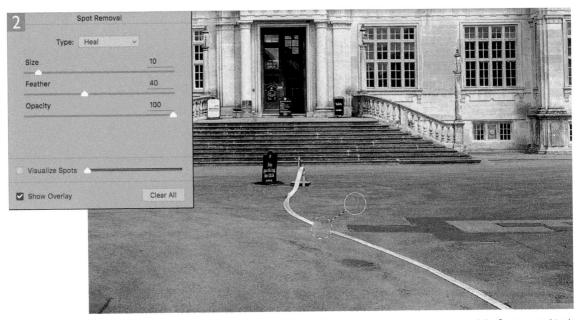

2 In this step you can see I had zoomed in on the image, selected the Spot removal tool and clicked on the hose pipe. This applied a standard circle spot that auto-selected a source circle area.

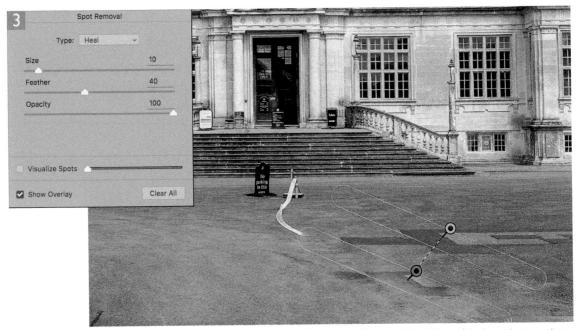

3 I then held down the *Shift* key and clicked at the bottom of the hose pipe to apply a straight line brush spot. In this screen shot the destination area is outlined in red and the auto-selected source area is outlined in green.

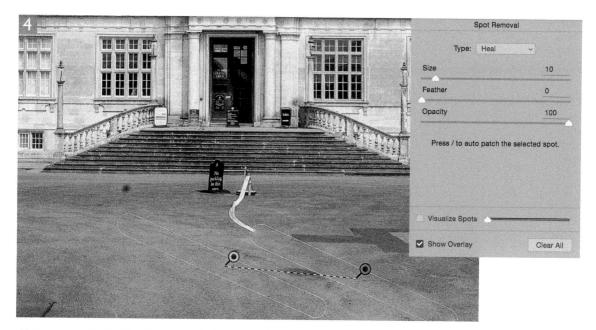

4 I obviously needed to adjust the source selection area, so I clicked on the green pin and moved this until I had found a nice match inside the red selected destination area.

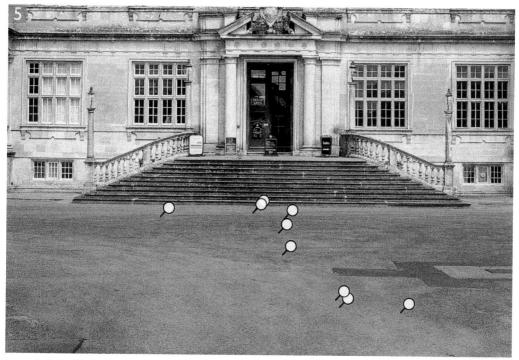

5 I carried on using the Spot removal tool in this way to remove the hose pipe and sign.

Hiding the red eye rectangles

As with the Spot removal tool, you can click on the 'Show Overlay' box to toggle showing and hiding the rectangle overlays (or use the *W* key).

Red Eye removal

The Red Eye removal tool is useful for correcting photos that have been taken of people where the direct camera flash has caused the pupils to appear bright red. To apply a red eye correction, select the Red Eye removal tool and drag the cursor over the eyes that need to be adjusted. In the Figure 2.76 example I dragged with the mouse to roughly select one of the eyes. As I did this, Camera Raw was able to detect the area that needed to be corrected and automatically adjusted the marquee size to fit. When dragging with the Red Eye removal tool you can press down the spacebar to reposition the marquee selection. Release the spacebar to continue to modify the marquee area.

The Pupil Size and Darken sliders can then be used to fine-tune the Pupil Size area that you want to correct as well as the amount you want to darken the pupil by. You can also revise the Red Eye removal settings by clicking on a rectangle to reactivate it, or use the *Delete* key to remove individual red eye corrections. If you don't like the results you are getting, you can always click on the 'Clear All' button to delete the Red Eye removal retouching and start over again.

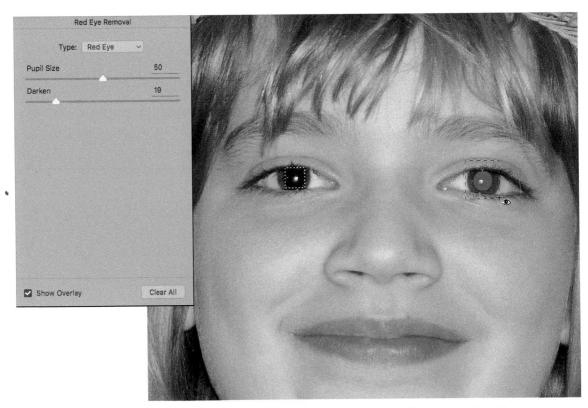

Figure 2.76 Here is an example of the Red Eye removal tool in action.

Red Eye: Pet Eye removal

There is also a Pet Eye mode for the Red Eye removal tool. This is available as a menu option when the Red Eye tool is selected. This has been added because the red eye effect you see when using flash to photograph animals isn't always so easy to remove using the standard Red Eye removal tool. Corrected pupils can be made darker to give you a more natural look. The Pet Eye controls allow you to adjust each pupil independently by adjusting the Pupil Size slider. You can also check the Add Catchlight box to add a catchlight highlight, which you can then click and drag into position over each eye. In Figure 2.77 I used the Red Eye removal tool in Pet Eye mode to marquee drag over the right eye of the dog in this photograph. Having selected the eye I adjusted the Pupil Size slider to match the area that needed to be darkened.

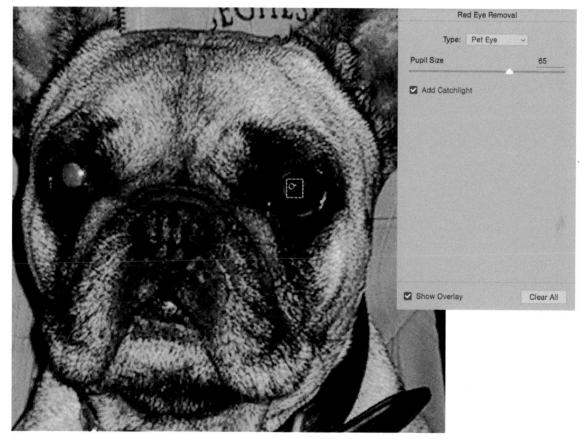

Figure 2.77 The Red Eye tool in Pet Eye mode.

Localized adjustments

The Adjustment Brush and Graduated/Radial Filter tools can be used to apply localized edits in Camera Raw. As with the Spot removal and Red Eye removal tools, you can revise these edits as often as you like. But these are more than just dodge and burn tools—there's a total of 16 effects to choose from, as well as an Auto Mask option.

Adjustment Brush

The Adjustment Brush tool (\mathcal{K}) options are shown in Figure 2.78 with the 'New' button selected. Use the \mathcal{K} or \mathcal{H} key to toggle between the Adjustment Brush panel and the main Camera Raw panel controls).

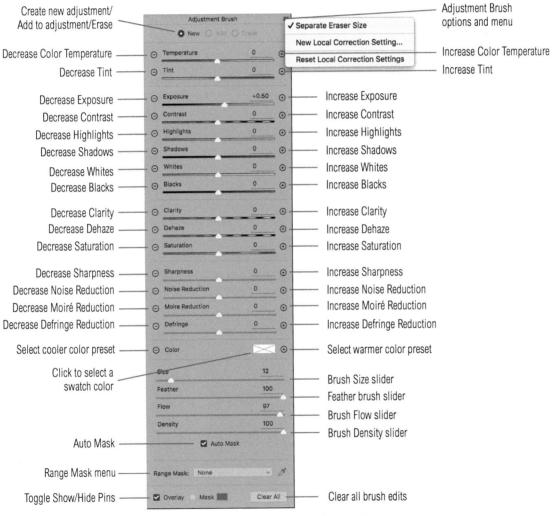

Initial Adjustment Brush options

To apply a brush adjustment, click on the New brush button at the top of the panel and select the effect options you wish to apply by using either the plus or minus buttons or the sliders. For example, clicking on the Exposure plus button sets the Exposure setting to +0.50 and clicking on the negative button sets it to -0.50 (these are your basic dodge and burn settings). The effect buttons therefore make it fairly easy for you to quickly create the kind of effect you are after. However, using these buttons you can only select one effect setting at a time and all the other settings are zeroed. Using the slider controls you can fine-tune the Adjustment Brush effect settings and combine multiple effects in a single setting.

Brush settings

Below this are the brush settings. The Size slider adjusts the brush radius (you can use the **ID** keys to make the brush smaller or larger). It is also possible to resize a brush on screen. If you hold down the *ctrl* key (Mac), or use a right mouse-click (Mac and PC), you can drag to resize the cursor before you start using it to retouch the image. The Feather slider adjusts the softness of the brush and you can also use the *Shift* weys to make the brush edge softer and Shift 1 to make the brush harder (you can also hold down the *Shift* key combined with a right mouse drag to adjust the feathering). These settings are reflected in the cursor shape shown in Figure 2.79, where the outer edge of the Adjustment Brush cursor represents the overall size of the brush, while the inner circle represents the softness (feathering) of the brush relative to the overall brush size. The Flow slider is a bit like an airbrush control. If you select a low Flow setting, you can apply a series of brush strokes that successively build to create a stronger effect. As you brush back and forth with the brush, you will notice how the paint effect gains opacity, and if you are using a pressure-sensitive tablet such as a Wacom™, the Flow of the brush strokes is automatically linked to the pen pressure you apply. The Density slider determines the maximum opacity for the brush. This means that if you have the brush set to 100% Density, the flow of the brush strokes can build to a maximum density of 100%. If on the other hand you reduce the Density, this limits the maximum brush opacity to a lower opacity value. For example, if you lower the Density and paint over an area that was previously painted at a Density of 100%, you can paint with the Adjustment Brush to reduce the opacity in these areas. If you reduce the Density to 0%, the Adjustment Brush acts like an Eraser tool.

Hiding and showing brush edits

If you refer back to page 102 you will see an example of how you can compare the current image state with a previous checkpoint state. When carrying out localized adjustments it can help to click on the Swap button () to toggle the localized adjustments on or off, or use the **36** *att* **P** (Mac) *ctrt att* **P** (PC) shortcut.

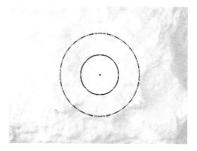

Figure 2.79 The Adjustment Brush cursor.

Localized adjustment strength

Localized adjustments have the same effective strength as their global adjustment counterparts. All the effects have linear incremental, cumulative behavior except for the Temp, Tint, Highlights, Shadows, and Clarity adjustments. These have non-linear incremental behavior, which means they only increase in strength by 75% relative to the previous localized adjustment each time you add a new pin group.

Adding a new brush effect

Now let's look at how to apply a brush effect. When you click on the preview, a pin marker is added and the Adjustment brush panel shows that it is now in 'Add' mode. As you start adding successive brush strokes, these are collectively associated with this marker and will continue to be so until you click on the 'New' button and click to create a new pin marker with a new set of brush strokes. Doubleclicking a slider arrow pointer resets it to zero, or to its default value. The pin markers therefore provide a tag for identifying groups of brush strokes. You just click on a pin marker whenever you want to add or remove brush strokes, or need to re-edit the brush settings that were applied previously.

In Figure 2.80 I added a pin marker to the bottom right corner of the building. This represented a group of brush strokes. Here, I added an Adjustment Brush edit to lighten the dark areas at the bottom of the photo with a positive Exposure setting. If you want to hide the markers you can do so by clicking on the Overlay box to toggle showing/hiding the pins, or use the *W* key shortcut.

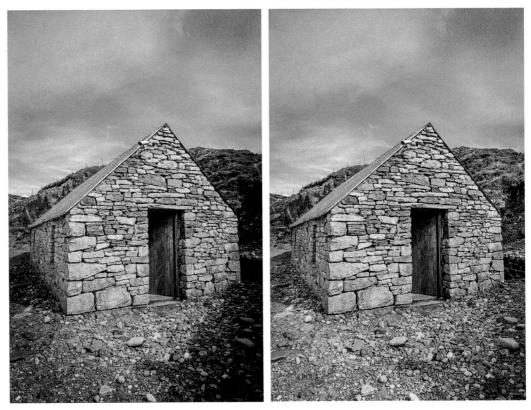

Figure 2.80 In this example I used the Adjustment Brush to edit a photograph.

Resetting adjustments

To reset a localized adjustment, right-click on an adjustment pin and choose 'Reset Local Correction Settings' from the context menu (see Figure 2.81).

Adjustment Brush duplication

When you add a brush adjustment you can click on the pin and drag to relocate the applied adjustment. There is a contextual menu for the brush pins (right-click on a pin to reveal), which allows you to duplicate a selected adjustment or delete (see Figure 2.81). There is also a shortcut you can use to clone an Adjustment Brush pin. Click on a brush pin with the **figure** (Mac), *ctrl alt* (PC) held down and drag.

1 In this example, I applied an Adjustment Brush effect to the eye on the left in this picture to make it slightly darker and add more contrast.

Figure 2.81 The Adjustment Brush contextual menu.

Adjustment Brush				
	🔿 New 🔘 Add 🔾	Erase		
Θ	Temperature	0	Ð	
Θ	Tint	0	Ð	
Θ	Exposure	+0.13	•	
Θ	Contrast	+100	€	
Θ	Highlights	+44	€	
Θ	Shadows	-57	€	
Θ	Whites	0	Ð	
Θ	Blacks	0	€	
Θ	Clarity	+85	€	
Θ	Dehaze	0	€	
Θ	Saturation	0	Ŧ	
Θ	Sharpness	0	€	
Θ	Noise Reduction	0	€	
Θ	Moire Reduction	0	€	
Θ	Defringe	0	•	
Θ	Color		€	
Si	ze	12		
Fe	ather	100		
Fl	w	97		
De	ensity	100		
Auto Mask				
Ran	ge Mask: None	× (4	
	Overlay Mask	Clear All		

2 In this step I used a right mouse click on the brush pin to reveal the contextual menu, where I selected the Duplicate option.

3 I was then able to click and drag on the duplicated pin to reposition it on the image. In this case I dragged to place it over the eye on the right.

Editing brush adjustments

To edit a series of brush strokes, just click on an existing pin marker to select it (a black dot appears in the center of the pin). This takes you into the 'Add' mode, where you can add more brush strokes or edit the current brush settings. For example, in Step 2 (over the page), in 'Add' mode I could readjust the Exposure setting, or add more areas to this brush adjustment. To erase portions of a brush group click on the Erase button at the top of the Adjustment Brush panel, where you can independently edit the brush settings for the eraser mode (except for the Density slider which is locked at zero). Alternatively, you can hold down the *att* key to temporarily access the Adjustment Brush in eraser mode. To add a new brush adjustment, click on the image to add a new pin marker and a new set of brush strokes. Use *(Mac)*, *(PC)* to undo brush strokes.

Previewing the brush stroke areas

If you click on the 'Mask' option, you'll see a temporary overlay view of the painted regions. The color overlay represents the areas that have been painted and can also be seen as you roll the cursor over a pin marker. In Figure 2.82 the 'Mask' option was checked and you can see an overlay mask for the selected brush group. If you wish to choose a different color for the overlay display you can click on the swatch next to it.

Figure 2.82 The Adjustment Brush mask preview and mask Color Picker (right).

Previewing the mask more clearly

Sometimes it is useful to initially adjust the settings to apply a stronger effect than is desired. This lets you judge the effectiveness of your masking more clearly. You can then reduce the effect settings to reach the desired strength for the brush strokes.

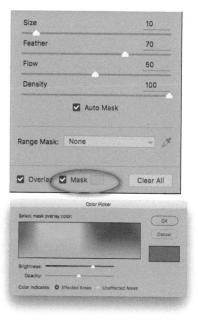

1 Here is a photograph where I had adjusted the Basic panel settings to optimize the image tones.

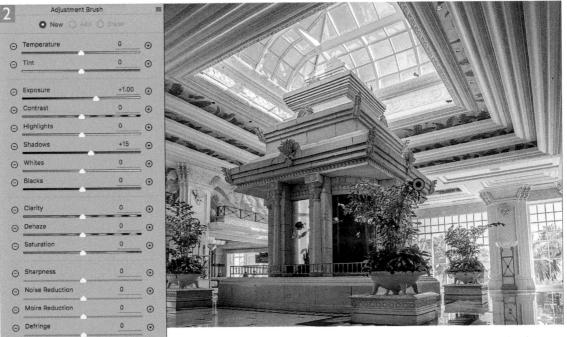

2 I then added a new brush group to lighten the shadows in the plant stands using a positive Exposure setting.

⊖ Color

<u>></u> ⊙

Auto masking

At the bottom of the Adjustment Brush panel is the Auto Mask option. When this is switched on it masks the image at the same time as you paint. It does this by analyzing the colors in the image where you first click and then proceeds to apply the effect only to those areas with the same matching tone and color (Figure 2.83). It does this on a contiguous selection basis. For example, in the following steps I dragged on the eggplant with the Adjustment Brush in Auto Mask mode to darken and boost the color saturation. While the Auto Mask can do a great job at auto selecting the areas you want to paint, at extremes it can lead to pixelated edges. However, with Version 4 Auto Mask edges are now noticeable smoother. The other thing to watch out for is a slow-down in brush performance. As you add extra brush stroke groups, the Camera Raw processing takes a big knock, but it gets worse when you apply a lot of Auto Mask brushing. It is therefore a good idea to restrict the number of adjustment groups to a minimum.

1 This shows a still life subject with no tone corrections and just the 'As Shot' white balance applied.

Figure 2.83 The Adjustment Brush using Auto Mask mode to select and adjust areas that share the same tone and color.

● 翻 ▲ B 〓 (D) fx 回 豪 ៕ Basic ■			
White Balance: As Shot	~		
Temperature	4700		
Tint	+5		
Auto Det	quit		
Exposure	0.00		
Contrast	0		
Highlights	0		
Shadows	0		
Whites	0		
Blacks	0		
Clarity	0		
Vibrance	0		
Saturation	0		

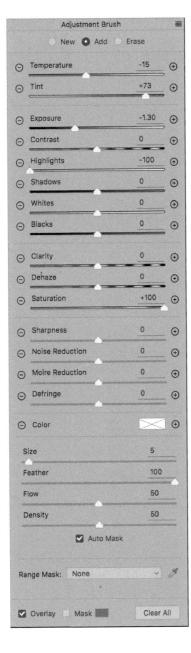

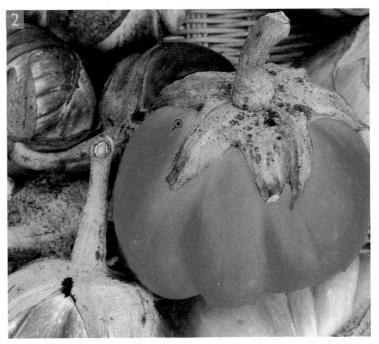

2 I selected the Adjustment Brush and used the setting shown here (with the Auto Mask option checked) to apply the desired adjustment to the pale eggplant only.

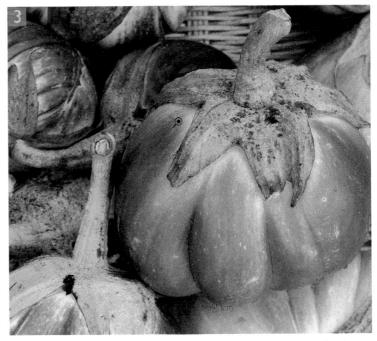

3 I then adjusted the settings to adjust the Temperature and Tint settings, darken the Exposure and Highlights, and boost the Saturation.

Range masking

In addition to auto masking, Camera Raw now offers Color and Luminance Range Mask controls. The Range Mask options are at the bottom of the Adjustment Brush, Graduated Filter, and Radial Filter panels. For example, if you apply a localized adjustment and select the Color Range Mask option (Figure 2.84), you can mask an adjustment based on a sampled color. To do this select the Eyedropper tool and use a single click to define the color you wish to mask, such as a blue sky. The Color Range slider can then be used to adjust the depth of the color range selection. Dragging the slider to the left narrows the range. Dragging to the right widens, but you'll notice how the Color Range Mask selection becomes smoother and more diffuse. Therefore, lower settings are required for more precise masking. The localized adjustment is restricted to the color range selection area and to preview the range mask you can hold down the *all* key as you drag the Color Range slider to see a temporary black and white mask preview.

To refine a color range selection you can click again to sample a new color, or you can marquee drag to make a broader color range selection. To add more sample points, click or drag again with the *Shift* key held down. You can sample up to five color points in this way. As you exceed that number the oldest sample points are removed. To exit the Eyedropper mode, click the tool button again, or press the *esc* key.

Alternatively you can use the Luminance Range Mask mode (Figure 2.85). Using the Luminance Range slider you can drag the shadow and highlight handles to control the range of luminance tones that are selected based on the sampled area. Meanwhile, the Smoothness slider can be used to refine the selection. You can also hold down the *all* key as you drag the Luminance Range and Smoothness sliders to see a temporary black and white mask preview.

The Color Range and Luminance Range mask controls make Camera Raw masking that much simpler to create and adjust. The smoothness of this masking method is a big improvement upon the Auto Mask method whereby the mask edge can sometimes end up being quite blocky and you see edge artifacts. With these new masking controls you can achieve much smoother edge blends. In extreme cases you are still likely to see some edge artifacts, but this can be mitigated by fine-tuning the slider settings.

It is also possible to combine a Range Mask with the new, improved Auto Mask, although this does add more complexity. If working with the Adjustment Brush, you should set the Develop settings and paint broadly over the subject with Auto Mask switched off and without aiming for a perfect outline. For example, you can select the Color Range Mask mode, select the Eyedropper tool and

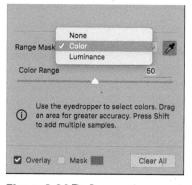

Figure 2.84 The Range mask menu and Color Range mask slider.

Range Mask: Luminance	~
Luminance Range	20 / 75
0	_2
Smoothness	35
Overlay Mask	Clear All

Figure 2.85 The Luminance Range Mask slider controls.

Range Mask tip

If you apply a Graduated Filter adjustment by dragging outside the image area you can first apply a global adjustment. You can then follow this by using either a Color or Luminance Range Mask to refine the extent of the global adjustment you just made.

Mask options tip

Figure 2.82 shows the Mask Color Picker options. It is worth noting that you can choose for the mask to represent either the affected, or the unaffected areas.

Graduated Filter			
	🔿 New 🗿 Edit 🔘	Brush	
Θ	Temperature	-9	€
Θ	Tint	+8	€
		1.25	
Θ	Exposure	-1.35	•
Θ	Contrast	+30	÷
Θ	Highlights	+18	÷
Θ	Shadows	0	•
Θ	Whites	0	€
Θ	Blacks	0	€
Θ	Clarity	+25	Ŧ
Θ	Dehaze	+20	•
Θ	Saturation	0	•
Θ	Sharpness	0	Ð
Θ	Noise Reduction	0	Ð
Θ	Moire Reduction	0	€
Θ	Defringe	0	Ð
Θ	Color		€
Rai	ige Mask: None	~	
	Overlay Mask	Clear /	All

click to sample the colors you want the adjustment to affect. Having done that adjust the Color Range Mask Amount slider to fine-tune the adjustment. Having done that, you can revert to working with the Adjustment Brush in Add or Subtract modes with Auto Mask on or off to refine the original adjustment selection.

If editing a Graduated Filter or Radial Filter adjustment, the best approach is to add a Filter effect, adjust the Develop sliders and select Color or Luminance from the Range Mask menu. Refine the mask as usual by sampling colors/adjusting the luminance range values and smoothing. Lastly, switch to the Brush Edit mode working in the Add or Erase mode. Adding reveals (dependent on the Filter Mask and Range Mask selection), while erasing hides the adjustment completely. You can do this with Auto Mask on or off.

Color Range masking

1 In this step I added a Graduated Filter adjustment that darkened the sky, where the Range Mask was set to None.

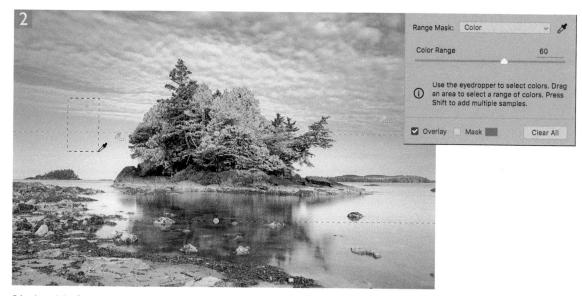

2 I selected the Color Range Mask mode and with the Eyedropper tool selected marqueed the sky to sample the sky colors. I then held down the *Shift* key to add further color samples. Finally, I adjusted the Color Range slider to soften the mask slightly.

Luminance Range masking

1 With this photo of a Harley Davidson motorbike, there are a few distracting hot spots. The aim here was to add a number of Radial Filter adjustments to darken specific areas and use also Luminance Range Masks to selectively darken the highlights.

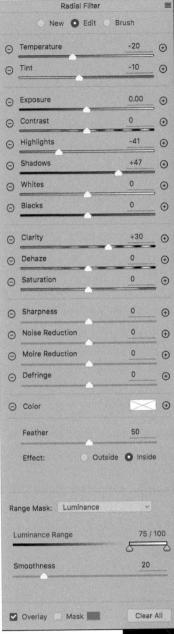

Radial Filter

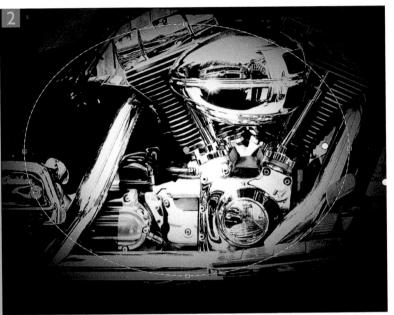

2 In this step I added a Radial Filter to the center of the image, added a blue tint and darkened the Highlights. I then selected the Luminance Range Mask option and adjusted the Luminance Range and Smoothness sliders. Shown here is a mask preview captured with the all key held down.

3 This shows the final outcome, where I also added further darkening Radial Filter adjustments to darken the saddle and other local areas.

Darkening the shadows

When making localized adjustments you have a lot of tone and color controls at your disposal. I want to focus here though on the Shadows slider. As you raise the Shadows amount you can selectively lighten the shadow to midtone areas. However, The Shadows slider can also be used to apply a negative amount to darken the shadows. I see this as being particularly useful in situations like the one shown here, where you can make a dark backdrop darker and clip to black.

Likewise, with the Highlights slider you can use negative amounts to apply localized adjustments to selectively darken the highlight areas and you can use positive amounts to deliberately force highlight areas to clip to white and deliberately blow out the highlights in an image.

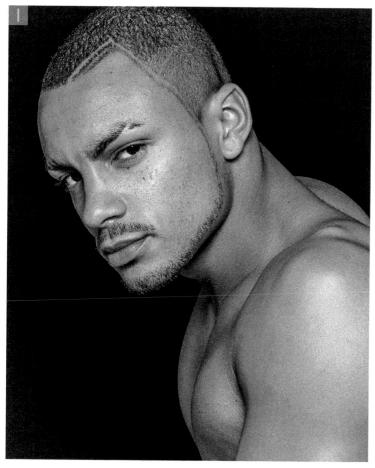

1 For this portrait I photographed the subject against a dark backdrop, which I wanted to appear black in the final image. However, after carrying out preliminary Basic panel adjustments, there was still some detail showing in the backdrop.

Basic	
White Balance: As Shot	
Temperature	4600
Tint	0
Auto Default	
Exposure	-0.45
Contrast	+40
Highlights	-65
Shadows	+82
Whites	+43
Blacks	-6
Clarity	+20
/ibrance	-12
Saturation	0

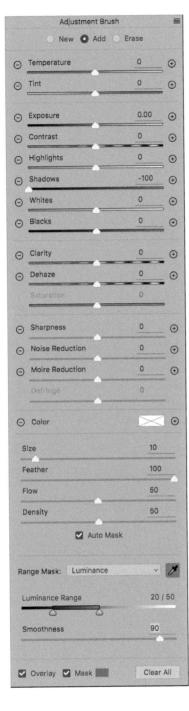

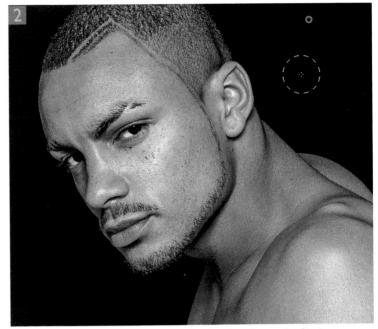

2 To correct this, I selected the Adjustment Brush and used a negative Shadows adjustment (with the help of a Luminance Range Mask) to selectively darken the backdrop area only.

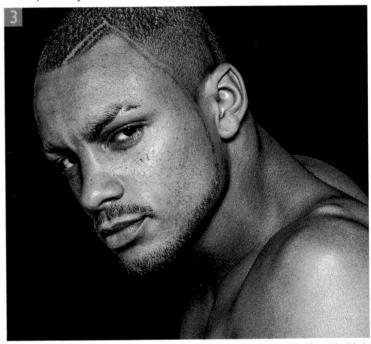

3 Here is the final version, in which I converted the photo to black and white and added a split tone effect.

Hand-coloring in Color mode

The Adjustment Brush tool can also be used to tint black and white images and this is a technique that will work well with any raw, JPEG or TIFF image that is in color. This is because the Auto Mask feature can be used to help guide the adjustment brush to colorize regional areas that share the same tone and color. In other words, if the underlying image is in color, the Auto Mask has more information to work with. To convert the image to black and white, you can do what I did here and take the Saturation slider in the Basic panel all the way to the left. Alternatively, you can go to the HSL panel and set all the Saturation sliders to -100. The advantage of doing this is that you then have the option of using the HSL panel Luminance sliders to vary the black and white mix (see Chapter 5). After desaturating the image you simply select the Adjustment Brush and click on the color swatch to open the Color Picker dialog and choose a color to paint with.

The fact that you can apply non-destructive localized adjustments to a raw image is a clever innovation, but this type of editing can never be as fast as editing a pixel image in Photoshop. This example demonstrates how it is possible to get quite creative with the Adjustment Brush tool. In reality though it can be quite slow to carry out such complex retouching with the adjustment brush, even on a fast computer.

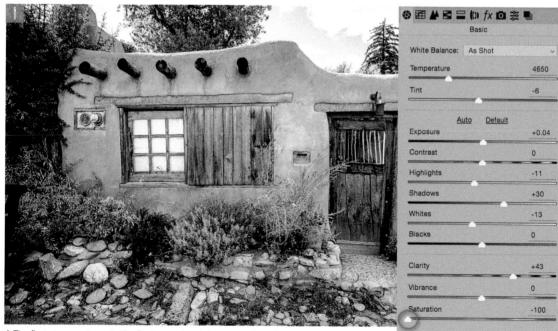

1 The first step was to go to the Basic panel and desaturate the colors in the image by dragging the Saturation slider all the way to the left.

01	Adjustment Bru	Jsh		
2	🔿 New 🔘 Add	C Erase		日本が
Θ	Temperature	0	Ð	の時代
Θ	Tint	0	•	-Ser
Θ	Exposure	0.00	Ð	24
Θ	Contrast	0	•	10 A.
Θ	Highlights	0	Ð	
Θ	Shadows	0	•	いいない
Θ	Whites	0	€	
Θ	Blacks	0	•	
Θ	Clarity	0	⊕	
Θ	Dehaze	0	Ð	1 - 192
Θ	Saturation	0		No.
Θ	Sharpness	0	Ð	Sault Bar
Θ	Noise Reduction	0	•	States in
Θ	Moire Reduction	0	•	1 TEL
Θ	Defringe	0	•	aporterverueu
Θ	Color		•	000mm24/20000000000000000000000000000000
			TAR STOR	1

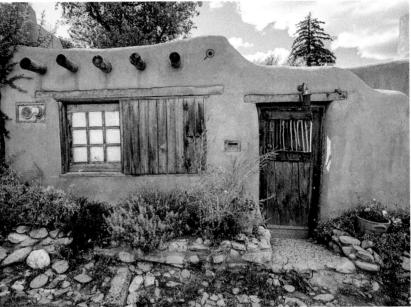

2 Once I had done this I selected the Adjustment Brush and edited the brush settings. In this instance I clicked on the color swatch to choose an orange color and with Auto Mask selected, started coloring the building.

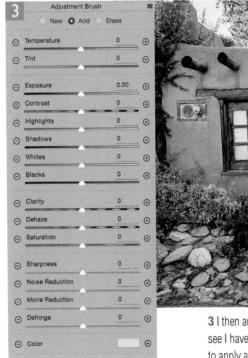

3 I then added several more brush groups to color the photo. In this example, you can see I have the pin marker on the front path selected, where I adjusted the brush settings to apply a green color to the bushes.

Graduated Filter tool

Everything that has been described so far with regards to working with the Adjustment Brush more or less applies to working with the Graduated Filter (\bigcirc) (Figure 2.86). This lets you add linear graduated adjustments. To use, click in the photo to set the start point (the point with the maximum effect strength), drag the mouse to define the spread of the Graduated Filter, and release to set the minimum effect strength point. Use \bigotimes to invert a Graduated Filter selection.

Graduated Filter effects are indicated by green and red pin markers. The green dashed line represents the point of maximum effect strength and the red dashed line represents the point of minimum effect strength. The dashed line between the two points indicates the spread of the filter and you can change the width by dragging the outer pins further apart and move the position of the gradient by clicking and dragging the central line.

Angled gradients

As you drag with the Graduated Filter you can do so at any angle you like and edit the angle afterwards. Just hover the cursor over the red or green line and click and drag. If you hold down the *Shift* key you can constrain the angle of rotation to 45° increments.

		Graduated Fi	lter	-	
		New O Edit	Brush		Create New gradient/Edit gradient/Brush
Decrease Color Temperature —	Te	mperature	0	•	— Increase Color Temperature
Decrease Tint —		nt	0	· 🕀 –	— Increase Tint
Decrease Exposure	Ex	posure	0.00	•	Increase Exposure
Decrease Contrast —	Co	ontrast	0	⊕	Increase Contrast
Decrease Highlights		ghlights	0	⊕	Increase Highlights
Decrease Shadows —		adows	-100	⊕	Increase Shadows
Decrease Whites		hites	0	•	Increase Whites
Decrease Blacks	- O Bi	acks	0	•	— Increase Blacks
Decrease Clarity	- O _ CI	arity	0	•	 Increase Clarity
	⊖ De	haze	0	•	— Increase Dehaze
Decrease Saturation —	Sa	turation	0	⊕	 Increase Saturation
Decrease Sharpness —		arpness	0	·	— Increase Sharpness
Decrease Noise Reduction —		ise Reduction	0	•	 Increase Noise Reduction
Decrease Moiré Reduction		pire Reduction	0	•	 Increase Moiré Reduction
Decrease Defringe Reduction	(De	fringe	0		Increase Defringe Reduction
Select cooler color preset	Co	lor		⊙	 Select warmer color preset
				_	 Click to select a swatch color
Range Mask menu —	Range	Mask: None	¥ .	.*	Click to clear all gradient edits
Toggle show/hide overlay —	- 🖸 Ove	riay Mask 🗾 ·	Clear Al		 Mask option

Figure 2.86 The Graduated Filter tool options.

Temperature 6200 Tint -1 Exposure 40.45 Contrast 0 Highlights 0 Shadows 0 Whites 0 Blacks -2	Basic	
Tint -1 Auto Default Exposure +0.45 Contrast 0 Highlights 0 Shadows 0 Whites 0 Blacks -2 Clarity 0 Vibrance 0	White Balance: Custom	×
Auto Default Exposure +0.45 Contrast 0 Highlights 0 Shadows 0 Whites 0 Blacks -2 Clarity 0 Vibrance 0	Temperature	6200
Exposure +0.45 Contrast 0 Highlights 0 Shadows 0 Whites 0 Blacks -2 Clarity 0 Vibrance 0	Tint	-1
Contrast 0 Highlights 0 Shadows 0 Whites 0 Blacks -2 Clarity 0 Vibrance 0	Auto Default	
Highlights 0 Shadows 0 Whites 0 Blacks -2 Clarity 0 Vibrance 0	Exposure	+0.45
Shadows 0 Whites 0 Blacks -2 Clarity 0 Vibrance 0	Contrast	0
Whites 0 Blacks -2 Clarity 0 Vibrance 0	Highlights	0
Blacks -2 Clarity 0 Vibrance 0	Shadows	0
Clarity 0 Vibrance 0	Whites	0
Vibrance 0	Blacks	-2
	Clarity	0
Saturation 0	Vibrance	0
	Saturation	0

1 In this screen shot you see an image where all I had done initially was to optimize the Exposure.

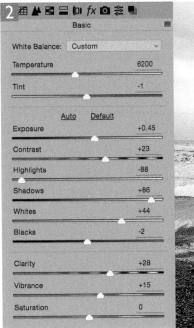

2 In this step I adjusted the Highlights and Shadows sliders to reveal more detail in the sky and the rock in the foreground.

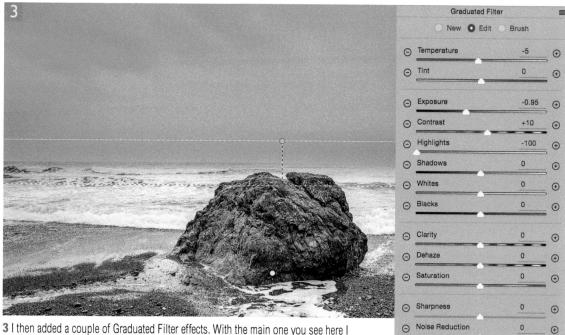

3 I then added a couple of Graduated Filter effects. With the main one you see here I decreased the Exposure and Highlights and added a little more Contrast to the sky.

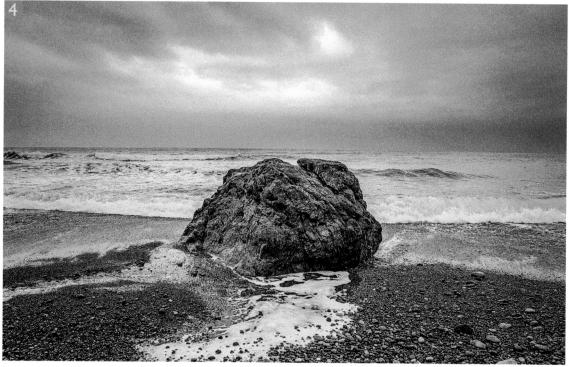

4 This shows the final Camera Raw processed version.

Graduated color temperature adjustment

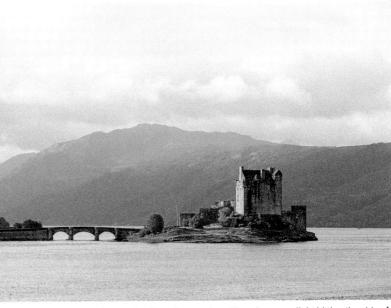

1 This photograph was taken just after sunrise with a nice warm light hitting the side of the castle.

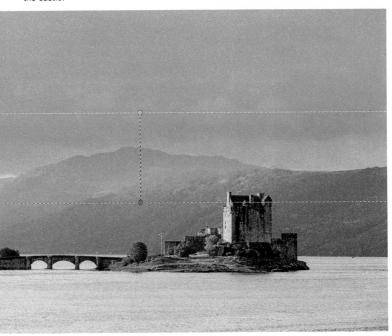

2 Here, I wanted to add more color contrast to the sky and bring our more detail in the clouds. I selected the Graduated Filter tool and applied the settings shown here to the sky.

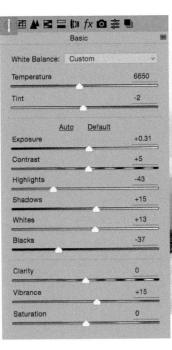

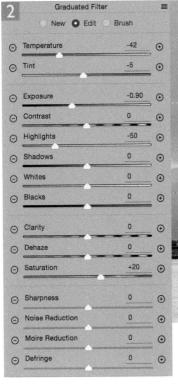

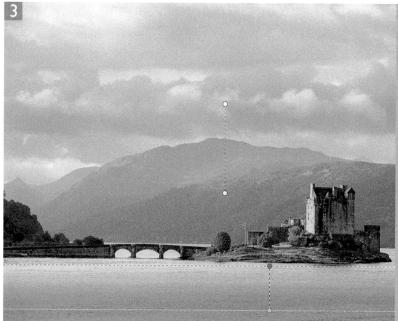

3 I also added a further Graduated Filter to the bottom of the image. Here, I wanted to
darken the bottom and add more contrast.

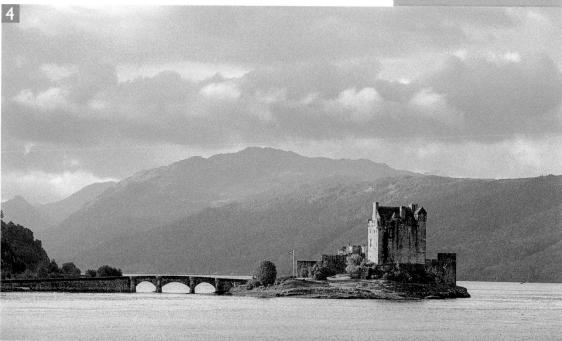

4 This shows the final version where I also boosted the Vibrance slightly.

Graduated Filter					
	O New	O Edit O Brush			
Θ	Temperature	-34	Ð		
Θ	Tint	-5	•		
Θ	Exposure	-0.90	Ð		
Θ	Contrast	0	€		
Θ	Highlights	0	Ð		
Θ	Shadows	0	⊕		
Θ	Whites	0	Ð		
Θ	Blacks	0	•		
Θ	Clarity	0	•		
Θ	Dehaze	0	Ð		
Θ	Saturation	0	•		
Θ	Sharpness	0	•		
Θ	Noise Reduction	n <u>0</u>	Ð		
Θ	Moire Reduction	n <u>0</u>	Ð		
Θ	Defringe	0	Ð		

Figure 2.87 The Radial Filter options.

Radial Filter adjustments

Camera Raw has a Radial Filter () to complement the linear Graduated Filter. Essentially, the Radial Filter adjustment options (Figure 2.87) are exactly the same and you can use this tool to apply selective adjustments to the inner or outer area of a pre-defined ellipse shape. By default, the full effect adjustment is applied using the 'Inside' option where the effect starts at the center of the ellipse, and the zero effect is at the boundary and outside the ellipse. The strength of the effect tapers off smoothly between the center and the boundary edge. You can invert the adjustment effect by clicking the 'Outside' button, or use the X key shortcut to quickly toggle between the two. The Radial Filter has a Feather slider control, with which to adjust the hardness of the edge and the *Caps Lock* key lets you visualize the extent of feathering applied to the Radial Filter adjustment.

To apply a Radial Filter adjustment you click and drag to define the initial ellipse area (you can press the spacebar as you do so to reposition). Once you have done this, use the handles to adjust the ellipse shape and drag the central pin to reposition the filter and narrow or widen the ellipse shape (holding down the *alt* key as you drag a perimeter handle adjusts only that side of the filter). To center a new Radial Filter adjustment hold down the *alt* key as you click and drag. If you want to preserve the roundness of the radial ellipse shape hold down the *Shift* key as you drag.

Use the \mathfrak{K} (Mac), or \mathfrak{ctrl} (PC) key + double-click to auto-center the ellipse shape within the current (cropped) image frame area and use \mathfrak{K} (Mac), or \mathfrak{ctrl} (PC) + double-click to expand an existing Radial Filter to fill the cropped image area. To clone an existing Radial Filter, hold down the \mathfrak{K} *alt* (Mac), or \mathfrak{ctrl} *alt* (PC) keys as you click and drag on a Radial Filter pin.

There are many creative uses for this tool. You can use it to apply more controllable vignette adjustments to darken or lighten the corners. For example, instead of simply lightening or darkening using the Exposure slider, you can use the Highlights or Shadows sliders to achieve more subtle types of adjustments.

As with the Graduated Filter, you can add multiple Radial Filter adjustments to an image. Once added, a Radial Filter adjustment is represented by a pin marker. As you roll over unselected pins the adjustment area will be revealed as a dashed outline.

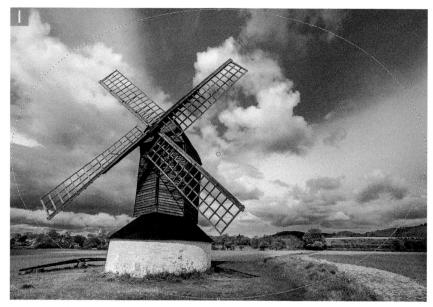

1 Here, I opened an image in Camera Raw and selected the Radial Filter tool. I **(Mac)**, or **(PC)** + double-clicked inside the preview area to add a new adjustment that filled the current frame area. I then set the Exposure slider to -0.75. By default, the adjustment was applied from the (green) center pin outwards.

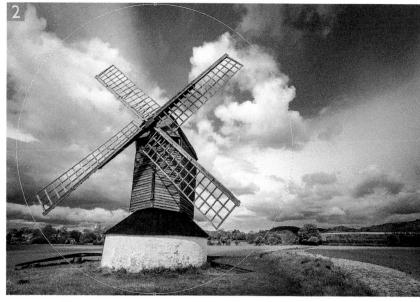

2 I used the XX key to invert the effect, set the Exposure to a positive value of +0.40. I then clicked on the side handles and adjusted these so that the effect was centered on the windmill.

	Radial Fil	ter	
	New O Ed	t 🔘 Brush	
Θ	Temperature	0	•
Θ	Tint	0	•
Θ	Exposure	-0.75	Ð
Θ	Contrast	0	•
Θ	Highlights	0	⊙
Θ	Shadows	0	
Θ	Whites	0	•
Θ	Blacks	0	•
Θ	Clarity	0	⊙
Θ	Dehaze	0	⊕
Θ	Saturation	0	€
Θ	Sharpness	0	€
Θ	Noise Reduction	0	Ð
Θ	Moire Reduction	0	⊙
Θ	Defringe	0	⊙
Θ	Color		⊙
	Feather	40	
	Effect: 0 0	utside O Inside	

	Radial Filter		
	New O Edit	Brush	
Θ	Temperature	0	•
Θ	Tint	0	€
Θ	Exposure	-D.40	•
Θ	Contrast	0	⊙
Θ	Highlights	0	
Θ	Shadows	0	•
Θ	Whites	0	€
Θ	Blacks	0	€
Θ	Clarity	0	€
Θ	Dehaze	0	€
Θ	Saturation	0	€
Θ	Sharpness	0	€
Θ	Noise Reduction	0	€
Θ	Moire Reduction	0	•
Θ	Defringe	0	•
Θ	Color		⊙
	Feather	75	
	Effect: O Outsid	te inside	

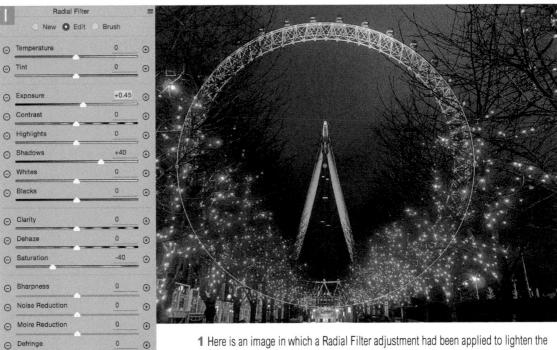

1 Here is an image in which a Radial Filter adjustment had been applied to lighten the outer area of this nighttime scene.

2 I used a right mouse-click to access the contextual menu and selected Fill Image to expand the Radial Filter size to fit the bounds of the image.

Fill to document bounds

The contextual menu for the Radial Filter includes an option that allows you to expand a Radial Filter adjustment to fill the image bounds (see opposite). Just right mouse-click on a Radial Filter pin and select 'Fill Image.' You can achieve the same result by doubleclicking inside the ellipse overlay for a Radial Filter adjustment.

Brush editing filter masks

It is also possible to brush edit Graduated Filter and Radial Filter masks. To start with you will notice that there is a Mask option at the bottom of the Graduated Filter and Radial Filter panels (see Figure 2.88). This can be used to reveal a colored overlay indicating the unmasked areas. Next to this is a color swatch, which you can click to choose any mask color you want.

After you have applied a Graduated Filter, or Radial Filter adjustment you can click on the Brush button at the top (Shift + K) to reveal the brush editing options. These let you modify the mask for the filter adjustment. You can click on the Brush + (I) and Brush - (I)buttons to add to or erase from the selected mask. There is an Auto Mask option to help limit the brush editing based on the pixel color where you first clicked and if you want to undo the mask editing you can click on the Clear button to undo your edits.

The ease with which you can now apply a Color Range mask means you may not always need the brush edit controls. But a key advantage is that the original filter mask and brush edit mask remain independent of each other.

1 This photograph was processed to optimize for tone and color.

Si	Ze	10	
-maintain An an	eather	100	
FI	ow	100	ten C
	Auto Mask	Cle	ear
Θ	Temperature	+40	Œ
Θ	Tint	0	
Θ	Exposure	+0.65	Œ
Θ	Contrast	0	- . €
Θ	Highlights	-49	•
Θ	Shadows	0	_ . €
Θ	Whites	0	œ
Θ	Blacks	0	, €
Θ	Clarity	-5	Œ
Θ	Dehaze	0	Œ
Θ	Saturation	0	œ
Θ	Sharpness	0	Œ
Θ	Noise Reduction	0	Œ
Θ	Moire Reduction	0	Œ
Θ	Defringe	0	Œ
Θ	Color	\sim	Ŧ
	Feather	35	
	Effect: O Outside) Inside	
Ran	ge Mask: None	· · · ·	ø

Figure 2.88 The Brush edit controls for the Graduated Filter options.

2 In this step I added a Radial Filter effect to add more warmth and color to the buildings next to the lighthouse.

Θ Dehaze

⊖ Saturation

+25

0

0

-14

0

0

0

+23

+63

0

+0.50

 \odot

•

 \odot

•

 \odot

•

 \odot

 \odot

€

€

3 I then clicked on the Brush button to edit the Radial Filter mask. By switching between the subtract and add brush options I was able to edit the Radial Filter so it had less effect on the sky and the lighthouse.

2

Correcting edge sharpness with the Radial Filter

Another thing the Radial Filter can be useful for is adding sharpness to the corner edges of a picture. If you own good quality lenses then this should not always be a problem as you would expect these to have good overall sharpness. However, I do have a couple of lenses where the quality isn't always so great. For example I often photograph using a Sony RX-100 compact camera. I like the fact that this camera has a nice wide lens aperture and you can shoot in raw mode, but the edge sharpness is an issue compared to when shooting with prime lenses on a digital SLR camera. To help resolve this I have found you can use the Radial Filter to apply a Sharpness adjustment that gains in strength from the center outwards. Now it has to be said that the falloff in sharpness towards the edges is more tangential in nature and a standard/radial sharpening boost isn't the optimum way to sharpen the corner edges. For example, DxO Optics Pro features a special edge sharpness correction that is built in to its auto lens corrections. Even so, the following example shows how you can make improvements using this feature in Camera Raw.

Edge sharpening presets

If you find this tip useful you might want to save a Radial Filter adjustment as a preset and then simply apply the preset setting to other images shot using the same lens and at the same aperture range.

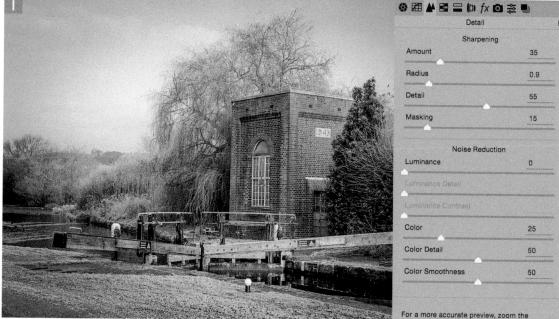

1 Here is a photograph that I shot using a Sony RX-100 compact camera. The image quality is good, though there is a noticeable fall-off in sharpness towards the edges of the frame. I went to the Detail panel and applied the sharpening settings shown here.

For a more accurate preview, zoom the preview size to 100% or larger when adjusting the controls in this panel.

Dedial Elite 2 New O Edit Brush 0 Temperature Đ () Tint 0 • 0.00 Exposure • ⊖ Contrast • Highlights \odot O Shadows 0 Đ Whites • Θ 0 € G Blacks G Clarity 0 € 0 • Dehaze Saturation 0 (+) +66 Sharpness \odot Noise Reduction 0 € Moire Reduction 0 \odot Defringe 0 • (-) Color € 70 Feather Effect O Outside Inside Range Mask Clear All 🖸 Overlay Mask

2 Having applied a global sharpening adjustment I then selected the Radial Filter tool and double-clicked inside the preview area to auto-center the ellipse shape so that the adjustment effect I was about to apply would taper from the center to the outer edges. I also needed to press the 💓 key to toggle the adjustment so that the effect was strongest at the outer edges. I then adjusted the Sharpness slider, to apply a +66 adjustment.

3 Here you can see a comparison of one of the corners of the image where the version on the left shows how the image looked before with the global sharpening only and on the right, how it looked with additional edge sharpening using the Radial Filter adjustment.

Camera Raw settings menu

If you mouse down on the Camera Raw menu (circled in Figure 2.89) this reveals a number of Camera Raw settings options. 'Image Settings' is whatever the Camera Raw settings are for the current image you are viewing. This might be a default setting or it might be a custom setting you created when you last edited the image in Camera Raw. 'Camera Raw Defaults' resets the default settings in all the panels and applies whatever the white balance setting was applied at the time the picture was captured. 'Previous Conversion' applies the Camera Raw settings that were applied to the previously saved image.

If you proceed to make any custom changes while the Camera Raw dialog is open, you'll also see a 'Custom Settings' option. Whichever setting is currently in use will be shown with a check mark next to it. Below that is the 'Apply Preset' submenu. This lets you access the Camera profiles available for the selected image.

Basic	(7
White Balance: Custom	~	 Image Settings Camera Raw Defaults 	
Temperature	2750	Previous Conversion Custom Settings	
Tint	-8	Apply Preset	Adobe Standard
<u>Auto Default</u>		Apply Snapshot	Camera Clear Camera Deep
Exposure	+0.95	Clear Imported Settings	Camera Landscape Camera Light
Contrast Highlights	+23	Export Settings to XMP Update DNG Previews	Camera Neutral
	-32		Camera Portrait Camera Standard
Shadows	+100	Load Settings	Camera Vivid
Whites	+1	Save Settings	Sony ILCE-7RM2 Teamwork3NDstopp
Blacks	-18	Save New Camera Raw Defaults Reset Camera Raw Defaults	
Clarity	0		
Vibrance	+59		
Saturation	0		

Figure 2.89 The Camera Raw menu options can be accessed via any of the main panels by clicking on the menu icon that's circled here.

The Camera Raw database

The Camera Raw preferences have the option to save the XMP metadata to the Camera Raw database or to the XMP sidecar files (or the XMP space in the file header). If you choose to save to the Camera Raw database, all the Camera Raw adjustments you make will be saved to this central location only. An advantage of this approach is that it makes it easier to back up the image settings. All you have to do is ensure that the database file is backed up, rather than the entire image collection.

On a Mac, the Adobe Camera Raw Database file is stored in: Users/username/ Library/ Preferences. On Windows it is stored in: Settings\Username\Application Data\Adobe\CameraRaw. However, if you are working with Bridge and Lightroom, Lightroom will not be able to pick up any changes made to an image using Camera Raw via Photoshop or Bridge. You have two options. You either have to remember to select the photos first in Camera Raw and choose 'Export Settings to XMP,' or forget about saving image settings to the Camera Raw database and ensure that the 'Save image settings to XMP sidecar files' option is selected in the Camera Raw preferences.

mbedded JPEC Previews 🗸 Medium Size	ОК
Full Size	Cancel

Figure 2.90 The Update DNG Previews dialog.

Export settings to XMP

If you refer to the Camera Raw preferences shown in Figure 2.19, there is an option to save the image settings either as 'sidecar ".xmp" files,' or save them to the 'Camera Raw database.' If the 'sidecar ".xmp" files' option is selected, the image settings information is automatically written to the XMP space in the file header. This is what happens for most file formats, including DNG. In the case of proprietary raw files such as CR2s or NEFs, it would be unsafe for Camera Raw to edit the header information of an undocumented file format. To get around this the settings information is stored using XMP sidecar files, which share the same base file name and accompany the image whenever you use Bridge or Lightroom to move a raw file from one location to another. Storing the image settings in the XMP space is a convenient way of keeping the image settings data stored locally to the individual files instead of it being stored only in the central Camera Raw database. If 'Save image settings in Camera Raw database' is selected in the Camera Raw preferences you can always use the 'Export Settings to XMP' option from the Camera Raw options menu (Figure 2.91) to manually export the XMP data to the selected images. For example, if you are editing a filmstrip selection of images and want to save out the XMP data for some images, but not all, you could use the 'Export Settings to XMP' menu command to do this (see also the sidebar).

Update DNG previews

DNG files can store a JPEG preview of how the processed image should look based on the last saved Camera Raw settings. If you refer again to the Camera Raw preferences, there is an option to 'Update embedded JPEG previews.' When this is checked, the DNG JPEG previews are automatically updated, but if this option is disabled in the Camera Raw preferences you can manually update the JPEG previews by selecting 'Update DNG Previews...' from the Camera Raw options menu (Figure 2.91). This opens the Update DNG Previews dialog shown in Figure 2.90, where you can force update the JPEG previews in a DNG file, choosing either a Medium Size or Full Size preview. You can also choose to 'Embed Fast Load Data.'

Load Settings... Save Settings...

These Camera Raw menu options allow you to load and save precreated XMP settings. Overall, I find it preferable to click on the New Preset button in the Preset panel (discussed opposite) when you wish to save a new Camera Raw preset.

Camera Raw defaults

The 'Save New Camera Raw Defaults' Camera Raw menu option creates a new default setting based on the current selected image. These defaults are also affected by the 'Default Image Settings' that have been selected in the Camera Raw preferences (see 'Cameraspecific default settings' on page 149).

Saving and applying presets

Custom Camera Raw settings can be saved as presets via the Presets panel. To save a preset, you can go to the Camera Raw fly-out menu and choose Save Settings... Or, you can click on the Add Preset button in the Presets panel (circled below) to create a new Camera Raw preset. In Figure 2.91 I saved a High ISO preset using the New Preset settings shown in Figure 2.92. You can also use the Load Settings... and Save Settings... menu options to load and save new presets. A preset can be defined by selecting all the Camera Raw settings, or made up of a subset of settings (as shown in Figure 2.92).

New Camera Raw defaults

The Save New Camera Raw Defaults option will make the current Camera Raw settings sticky every time from now on when Camera Raw encounters a new file. This includes images processed by Bridge. For example, if you are working in the studio and have achieved a perfect Camera Raw setting for the day's shoot, you can make this the new Camera Raw default setting. All subsequent imported images will use this setting by default. At the end of the day you can always select 'Reset Camera Raw defaults' from the Camera Raw options menu to restore the default Camera Raw settings.

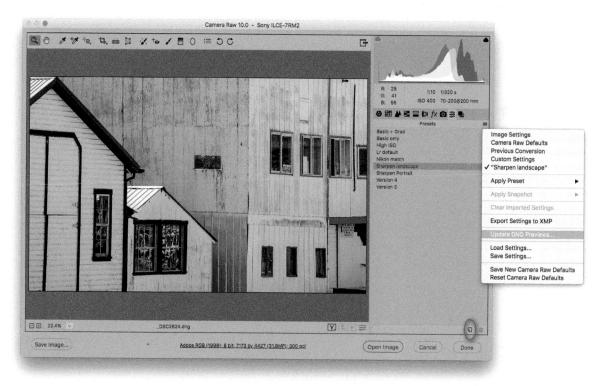

Figure 2.91 The Presets panel and fly-out menu options.

Camera Raw preset wisdom

Before you save a Camera Raw preset, it is important to think carefully about which items you need to include in a preset. When saving presets it is best to save just the bare minimum number of options. In other words, if you are saving a grayscale conversion preset, you should save the Grayscale Conversion option only. If you are saving a camera body and ISO-specific camera default, you might want to save just the Camera Calibration and Enable lens profile correction settings. The problem with saving too many attributes is that although the global settings may have worked well for one image, there is no knowing if they will work as effectively on other images. It is therefore a good idea to break your saved presets down into smaller chunks.

Camera Raw dialogs

An all-click shortcut has been added to the Synchronize, New Preset, Save Settings, and Copy/Paste (Bridge) dialogs. What happens now is when you all-click a checkbox item in one of these dialogs, it checks that box exclusively. Just all-click again to toggle back to the previous checkbox state. Here, you can choose to save All Settings to record all the current Camera Raw settings as a preset. You can select a sub setting selection such as: Basic, or HSL Adjustments, or you can manually check the items that you want to include in the subset selection that will make up a saved Camera Raw preset. Just click on a setting to apply it to an image. To remove a preset setting, go to the Presets panel, select it and click the Delete button at the bottom—the trash can next to the Add new preset button (see Figure 2.91).

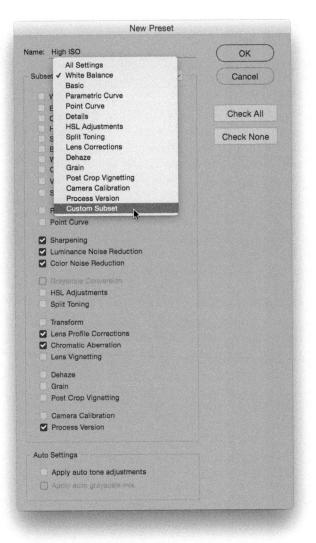

Figure 2.92 The New Preset dialog can be accessed by clicking on the New Preset button (circled in Figure 2.91).

Copying and synchronizing settings

If you have a multiple selection of photos in the Camera Raw dialog you can apply synchronized Camera Raw adjustments to all the selected images at once. For example, you can (H) (Mac), Ctrl (PC)click or Shift-click to make an image selection via the Filmstrip, or click on the Select All button to select all images. Once you have done this any adjustments you make to the most selected photo are simultaneously updated to all the other photos too. Alternatively, if you make adjustments to a single image, then include other images in the Filmstrip selection and choose 'Sync Settings...' from the Filmstrip menu (Figure 2.94), this pops the Synchronize dialog shown in Figure 2.93. Here you can select a preset range of settings, or make your own custom selection of settings and click OK to synchronize the currently selected images. The Camera Raw settings will then synchronize to the currently selected image. You can also copy and paste the Camera Raw settings via Bridge. Select an image and choose Edit \Rightarrow Develop Settings \Rightarrow Copy Camera Raw Settings ($\Re \mathbb{C}$) [Mac], *ctrl all C* [PC]). Then select the image or images you wish to paste the settings to and choose Edit \Rightarrow Develop Settings \Rightarrow Paste Camera Raw Settings (# V [Mac], ctrl alt V [PC]).

Figure 2.93 The Synchronize options dialog box.

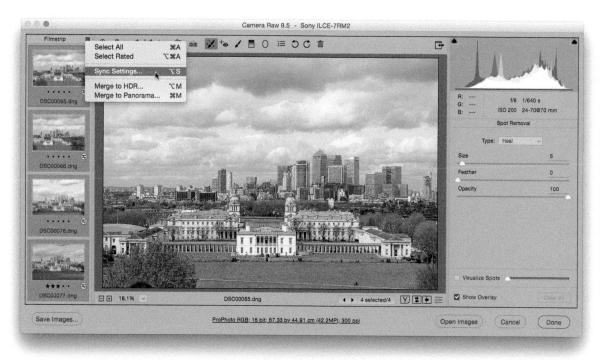

Figure 2.94 In this example, I made a selection of images via the Filmstrip, chose 'Select All,' followed by 'Sync Settings,' which opened the dialog shown in Figure 2.93.

Figure 2.95 The Basic panel view when selecting multiple images with a Process Version mismatch.

Synchronizing different process versions

The Synchronize command will work as described, providing the photos you are synchronizing all share the same process version. If the selected images have a mixture of process versions applied to them, the Basic panel will display the message shown in Figure 2.95, highlighting the fact that the selected images have differing, incompatible process versions and gives you the option to convert all the selected files to the process version that's applied to the most selected image. What happens next when you synchronize depends on whether you have the Process Versions box checked or not (see Figure 2.96). If checked, it synchronizes the selected photos converting them to the process version of the most selected photo and updates them accordingly. If unchecked, it synchronizes just those settings that are common to the process versions that are applied to the selected images and ignores all the others. Be aware that such synchronizations can lead to unpredictable results. If there is a process version mismatch when synchronizing settings, the Process Version box determines what will happen. If checked, those photos with differing process versions will be updated to match the process version of the most selected image. If you attempt to synchronize Version 2 images that reference a Version 4 master, the adjustments that are new in Version 4: Exposure, Contrast, Highlights, Shadows, Blacks, Whites, Clarity, and Tone Curve will be applied by default, which is why the boxes next to the above settings are all checked and dimmed (meaning you can't edit them). Similarly, if you attempt to synchronize Version 4 images referencing a Version 2 master, the Exposure, Recovery, Fill Light, Blacks, Brightness, Contrast, Clarity, and Tone Curve adjustments will be checked by default.

Whenever you copy Camera Raw settings, Camera Raw utilizes the Basic panel settings associated with the process version of the selected image, and automatically includes the process version of the image in the copy settings.

Legacy presets

If the Process Version box is checked when you save a preset (see Figure 2.92), the process version is included when applying the preset to other images. If the photos you then apply this preset to don't share the same process version they'll be converted. If the Process Version box isn't checked when you create a preset, things again become more complicated. In this situation no process version is referenced when applying the preset. Therefore, if you apply a Version 2 preset (without checking the process version box) to a Version 4 image,

Synchronize Version 4 from a Version 3 master

Synchronize Version 3 from a Version 4 master

Synchronize	•	Synchroniz	e
Subset: Everything	× (ок)	Subset: Everything	v — Ок
White Balance	Cancel	White Balance	
Exposure	Cancel	Exposure	Cancel
🖾 Contrest		Recovery	
🖾 Highlights	and the second	Fill Light	
Shadowa	Check All	Blacks	Check All
🖸 Blocks		🔛 Brightricas	
Whites	Check None	Contraist	Check None
💟 Clarity		Clarity	ONOCK NOTE
Vibrance		Vibrance	
Saturation		Saturation	
🙄 Parametric Curva		Parametric Corve	
Point Curve		Point Curve	
Sharpening		Sharpening	
Luminance Noise Reduction		Luminance Noise Reduction	
Color Noise Reduction		Color Noise Reduction	
Grayscale Conversion		Grayscale Conversion	
HSL Adjustments		HSL Adjustments	
Split Toning		Split Toning	
Transform		Transform	
Lens Profile Corrections		Lens Profile Corrections	
Chromatic Aberration		Chromatic Aberration	
Lens Vignetting		Lens Vignetting	8
C2 Denare		Dehaza	
Grain		Grain	
Post Crop Vignetting			
		Post Crop Vignetting	
Camera Calibration		Camera Calibration	
Process Version		Process Version	
Crop		Crop	
Spot Removal		Spot Removal	
Local Adjustments		Local Adjustments	

Figure 2.96 This shows the Synchronize Settings dialog when there is a Process Version mismatch between the selected images.

settings such as Recovery or Fill Light won't be translated. Similarly, if you apply a Version 4 preset (without checking the process version box) to a Version 2 photo, settings like Highlights and Shadows won't be recognized either. Older presets that don't contain Basic or Tone Curve panel adjustments (other than White Balance, Vibrance and Saturation) will still work OK when applied to Version 4 images. Where legacy presets do contain Basic or Tone Curve panel settings, they'll only continue to work effectively on images that share the same process version. Therefore, when creating new presets it is important to check the Process Version box. When you do this, if the image you apply the preset to has the same process version, the preset is applied as normal. If it has a different process version a conversion is carried out. Also, when working with third-party presets this is something to be aware of.

Lightroom snapshots

Snapshots can also be created in Lightroom. If you save and update the metadata to the file in Lightroom, the snapshots will be readable in Camera Raw. Similarly, snapshots applied in Camera Raw can also be read in Lightroom.

Working with Snapshots

As you work in Camera Raw you can save favorite Camera Raw settings as snapshots via the Snapshots panel. The ability to save snapshots means you are not limited to applying only one type of Camera Raw rendering to an image. By using snapshots you can store multiple settings or looks within the image file's metadata and with minimal overhead, since Camera Raw snapshots only occupy a small amount of file space. I find snapshots are extremely useful whenever I need to experiment with different types of processed looks on individual images, or wish to save in-between states.

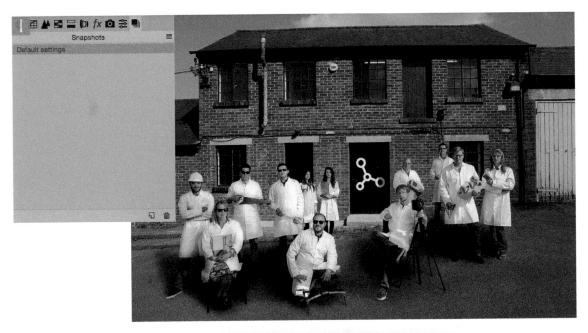

Name:	Default settings	ОК
		Cancel

1 The Snapshots panel can be used to store multiple versions of Camera Raw settings. You can make adjustments to the photo using the Camera Raw controls and use this panel to create new saved snapshots. To begin with I clicked on the Add New Snapshot button (circled) to save this setting as a snapshot called 'Default settings.'

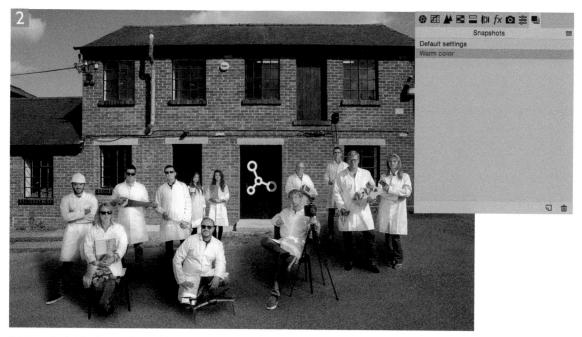

2 I then adjusted the Camera Raw settings to create an optimized adjustment and saved this as an 'Optimized edit' snapshot.

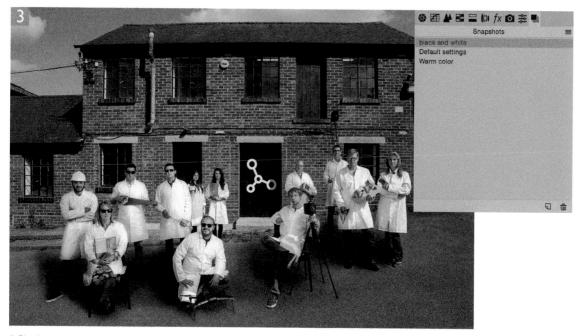

3 Finally, I created a black and white version and saved this too as a snapshot.

Raw compatibility and DNG adoption

Many years ago, Adam Woolfitt and I conducted a test report on a range of professional and semi-professional digital cameras. Wherever possible, we shot using raw mode. I still have a CD that contains the master files and if I want to access those images today I will, in some cases, have to track down a computer capable of running Mac OS 8.6, in order to load the camera manufacturer software that will be required to read the data! If that is a problem now, what will the situation be like in another 18 years' time? Over the last few years DNG has been adopted by many of the mainstream software programs such as Phase One Media Pro 1, Capture One, Portfolio, and Photo Mechanic. At this time of writing, there are Hasselblad, Leica, Pentax, Ricoh, Casio, and Samsung cameras that support DNG as a raw capture format option.

DNG file format

In the slipstream of every new technology there follows the inevitable chaos of lots of different new standards competing for supremacy. Nowhere is this more evident than in the world of digital imaging. In the last 20 years or so, we have seen many hundreds of digital cameras come and go along with other computer technologies such as Syquest disks and SCSI cables. In that time I have probably encountered well over a hundred different raw format specifications. It would not be so bad if each camera manufacturer were to adopt a raw format specification that could be applied to all the cameras they produced. Instead we've seen raw formats evolve and change with each new camera model that has been released and those changes have not always been for the better.

The biggest problem is that with so many types of raw formats being developed, how reliable can any one raw format be for archiving your images? It is the proprietary nature of these formats that is the central issue here. At the moment, all the camera manufacturers appear to want to devise their own brand of raw format. As a result of this if you need to access the data from a raw file, you are forced to use their brand of software in order to do so. Now, while the camera manufacturers may have excelled in designing great hardware, the proprietary raw processing software they have supplied with those cameras has mostly been quite basic. Just because a company builds great digital cameras, it does not follow they are going to be good at designing the software that's needed to read and process the raw image data.

The DNG solution

Fortunately there are third-party companies who have devised ways to process some of these raw formats, which means you are not always limited to using the software that comes with the camera. Adobe is the most obvious example. Capture One Pro is another.

The DNG (digital negative) file format specification came about partly as a way to make Adobe's life easier for the future development of Camera Raw and make Adobe Photoshop compatible with as many cameras as possible. DNG is a raw file format designed to accommodate the many different requirements of the proprietary raw data files in use today. DNG is flexible enough to adapt to future technologies. Because DNG is an open standard, the specification is freely available for anyone to develop and to incorporate it into their software or camera system. It is therefore hoped that camera manufacturers will continue to adopt the DNG file format and that it will more and more be offered as an alternative file format choice. DNG brings several advantages. Since it is a well-documented open-standard file format, there is less risk of your raw image files becoming obsolete. There is the potential for ongoing support for DNG despite whatever computer program, computer operating system, or platform changes may take place in the future. This is less likely to be the case with proprietary raw files. Can you imagine in, say, 25 years' time there will be guaranteed support for the CR2 or NEF files shot with today's cameras?

DNG compatibility

When raw files are converted to DNG the conversion process aims to take all the proprietary MakerNote information that is sitting alongside the raw image data in the raw original and place it into the DNG. Any external DNG-compatible software should have no problem reading the raw data that is rewritten as a DNG. However, there are known instances where manufacturers have placed some of the MakerNote data in odd places, such as alongside the embedded JPEG preview, which at one point this was discarded during the Adobe DNG conversion process. Basically, the DNG format is designed to allow full compatibility with Camera Raw (in fact, images opened in Camera Raw are automatically converted to DNG as part of the internal Camera Raw file processing process). At the same time, full DNG compatibility is in turn dependent on proper implementation of the DNG spec by third parties.

Converting JPEGs to DNG won't allow you to magically turn them into raw files, but with the advent of lossy DNG, there are better reasons to now consider doing so. Where a JPEG has been edited using Camera Raw or Lightroom, when you save using the DNG format a Camera Raw generated preview is saved with the file. The advantage of this is that Camera Raw/Lightroom adjustments can be seen when previewing such images in other (non-Camera Raw aware) programs.

Should you keep the original raws?

Whether you preserve the original raw files after conversion all depends if you feel comfortable discarding the originals and keeping just the DNGs. Some proprietary software such as Canon DPP is able to recognize and process dust spots from the sensor using a proprietary method that relies on reading private XMP metadata information. Since DPP does not support DNG, if you delete the original CR2 files you won't be able to process the DNG versions in DPP. The only solution here is to either not convert to DNG or choose to embed the original raw file data when you convert to DNG. This

Dual pixel support and DNG

The Canon EOS 5D MkIV camera can capture dual pixel raw data. When converting to DNG, Camera Raw preserves both parts of the dual pixel raw data in a single DNG, but at this point only actually processes one part of the DPR raw data. means you retain the option to extract the CR2 raw originals any time you need to process them through the DPP software. The downside is you end up with bloated DNG files that will be about double in size.

Saving images as DNG

To convert images to DNG, you can either do so at the time you import photos from the camera, or when you click on the Save Image button in the Camera Raw dialog. This opens the dialog shown in Figure 2.97, where you can see the options available when saving an image using the DNG format.

Lossy DNG

It is possible to save DNG files using lossy compression while preserving most of the raw DNG aspects of the image, such as the tone and color controls. To do this you need to check the 'Use Lossy Compression' option. When this option is enabled you can also reduce the pixel dimensions of a raw image by selecting one of the resize options shown in Figure 2.97. Whenever you resize a DNG in this way the image data has to be demosaiced, but is still kept in a linear RGB space. This means that while the demosaic processing becomes baked into the image, most of the other Develop controls such as those for tone and color remain active and function in the same way as for a normal raw/DNG image. Things like Lens Correction adjustments for vignetting and geometric distortion will be scaled down to the DNG output size. The same is true for sharpening, where the slider adjustments for things like Radius are scaled down to the new downsampled size.

You do want to be careful about where and when you use lossy compression when converting to DNG. 'Baking in' the demosaic processing is a one-way street. Once done, you'll never be able to demosaic the raw data differently. So you need to consider here whether Adobe (or someone else) might one day come up with a better way to demosaic a raw image. Overall, I would say if you don't need to compress your DNG files, then don't—aim to preserve your raw files in as flexible a state as possible. On the other hand, I do foresee some uses. For example, to create a time-lapse video you need to shoot a lot of photos to create each short clip. Here I reckon it might be a good idea to archive the raw stills for such projects as lossy DNGs. After all, even if the end output is 4K video, that is still fewer pixels than is captured on most still digital SLRs. Another benefit of lossy DNG is that I am now able to provide more images from this chapter as downsized DNGs for readers to experiment with.

	ocation v	~	Save
Destination: Save in New L	acation		(
Only of Fallen			Cancel
Select Folder /User	rs/martinevening/Desktop/		
File Naming			
Example: _1BA1487-2.DNG			
Document Name	× +	∨ +	
	→ +	~	
Begin Numbering:			
File Extension: .DNG	·		
Format: Digital Negative	~		
Compatibility: Camera Re	aw 7.1 and later		
JPEG Preview: Medium Si	ize 🗸		
Embed Fast Load Data			
Use Lossy Compression	✓ Preserve Pixel Count		
	Limit Size to 600 pixels/side		
Embed Original Raw File	Limit Size to 800 pixels/side		
	Limit Size to 1024 pixels/side	the second s	
Coin: Space	Limit Size to 1440 pixels/side		
ENVIOR ENVIOLE	Limit Size to 1680 pixels/side		
Space:	Limit Size to 2048 pixels/side		
	Limit Size to 2560 pixels/side	The second se	
Intent	Limit Pixel Count to 1.0MP		
and the second s	Limit Pixel Count to 1.5MP		
and the second	Limit Pixel Count to 2.0MP	for the second second second second	
Image Sizing	Limit Pixel Count to 3.0MP		
	Limit Pixel Count to 4.0MP		
Resize to Fit.	Limit Pixel Count to 6.0MP	10	
	Limit Pixel Count to 8.0MP		
	Limit Pixel Count to 10MP		
	Limit Pixel Count to 15MP		
Resolution:	Limit Pixel Count to 20MP		
Output Sharpening			
C Sharpen For:	Amount:	~	

Figure 2.97 The Camera Raw Save Options dialog, showing the Lossy Compression DNG options, including the pixel size menu choices.

Maintaining Camera Raw compatibility

If you refer back to page 95, you can read how it is possible to use the DNG Converter program to convert new camera files to DNG and thereby maintain Camera Raw support with older versions of Photoshop and Camera Raw.

DNG Converter

The Adobe DNG Converter program (Figure 2.98) is available as a free download from Adobe's website: adobe.com/products/dng/main.html. Adobe DNG Converter is regularly updated at the same time as each new release of Camera Raw and is able to convert raw files from any camera that is currently supported by Camera Raw. This provides a mechanism for those users limited to working with earlier versions of Camera Raw for you to convert the very latest raw file formats to DNG, which can then be read by earlier versions of Camera Raw. The user interface includes options to rename files during conversion, embed fast load data, choose lossy compression, and whether to embed the original raw data. The DNG conversion process also carries out a health check on the files and alerts you if corrupt raw files are found.

C A	dobe Digital Negative Converter	Adobe
) Selec	t the images to convert	
0	Select Folder /Volumes/Library-HD/Personal Photos/Canary Islands/	
0	Include images contained within subfolders	
	Skip source image if destination image already exists	
2 Selec	t location to save converted images	
6	Save in New Location	
U	Select Folder /Users/martinevening/Desktop/	
	Preserve subfolders	
Color	t name for converted images	
O Gelec	Name example: MyDocument.dng	
	Document Name v + v	+
	v +	
	Begin numbering:	
	File extension: .dng ~	
Prefei	rences	
	Compatibility: Camera Raw 7.1 and later JPEG Preview: Medium Size Change Preferences	
	Don't embed fast load data	
	Don't use lossy compression	
	Preserve Pixel Count Don't embed original	
		-
Abo	ut DNG Converter Extract Quit Conve	ort)

Figure 2.98 The DNG Converter program.

on 8.5.1990 sea Kooli Dhan a Bury I a Bury I racea a Bury I racea I a Bury I racea I a Bury I a Company Marrill Marr

Adobe^{*}DNG Converter

Ul rights reserved. Adobe and the vadee logo are either registered rademarks or trademarks of Adobe systems incorporated in the United Nates and/or other countries. Ado

Chapter 3

Sharpening and noise reduction

This chapter is all about how to pre-sharpen your photographs in Photoshop and reduce image noise. Here, I will be discussing which types of images need pre-sharpening, which don't, and what are the best methods to use for camera captured or scanned image files.

In earlier editions of this book I found it necessary to go into a lot of detail about how to use the Unsharp Mask filter and the Photoshop refinement techniques that could be used to improve the effectiveness of this filter. Now that the sharpening and noise reduction controls in Camera Raw have been much improved, I strongly believe that it is best to carry out the capture sharpening and noise reduction for both raw and scanned TIFF images in Camera Raw first, before you take them into Photoshop. Therefore, the first part of this chapter is devoted entirely to Camera Raw sharpening and noise reduction.

Print sharpening

I should also mention here that this chapter focuses solely on the capture and creative sharpening techniques for raw and non-raw images. I placed this chapter near the beginning of the book quite deliberately, since capture sharpening should ideally be done first (at the Camera Raw stage) before going on to retouch an image. The output sharpening, such as the print sharpening, should be done last. For more about print output sharpening, please refer to the 'Print' chapter at the end of this book.

When to sharpen

All digital images will require sharpening at one or more stages in the digital capture and image editing process. Even with the best camera sensors and lenses, it is inevitable that some image sharpness will get lost along the way from capture through to print. At the capture end, image sharpness can be lost due to the quality of the optics and the image resolving ability of the camera sensor, which in turn can also be affected by the anti-aliasing filter that covers the sensor (and blurs the camera focused image very slightly). With scanned images you have a similar problem, where the resolving power of the scanner sensor and the scanner lens optics can lead to scans slightly lacking in sharpness. These main factors can all lead to capture images that are less sharp than they should be.

When it comes to making a print, this too results in a loss of sharpness, which is why it is always necessary to add some extra sharpening before you send the photograph to the printer. Also, between the capture and print stages you may find that some photographs can do with a little localized sharpening to make certain areas of the picture appear that extra bit sharper. This briefly summarizes what we call a multi-pass sharpening workflow: capture sharpening followed by an optional creative sharpen, followed by a final sharpening for print.

Why one-step sharpening is ineffective

It may seem like a neat idea to use a single step sharpening that takes care of the capture sharpening and print sharpening in one go, but it's just not possible to arrive at a formula that will work for all source images and all output devices. There are too many variables that have to be taken into account and it actually makes things a lot simpler to split the sharpening into two stages. The image capture sharpening should be applied at the beginning and be dependent on the source image characteristics. An appropriate amount of output sharpening should be applied at the end and this should be dependent on the type of print you are making and the print output size.

Capture sharpening

The majority of this chapter focuses on the capture sharpening stage, which is also referred to as pre-sharpening. It is critical that you get this part right because capture sharpening is one of the first things you do to an image before you start to do any retouching work. The question then is, which images need sharpening and of those that do need sharpening, how much sharpening should you apply? Let's deal with JPEG capture images first. If you shoot using the JPEG mode, your camera will already have sharpened and perhaps also reduced the noise in the capture data, so no further pre-sharpening or noise reduction should be necessary. Since JPEG captures are already pre-sharpened there is no way to undo what has already been fixed in the image. I suppose you could argue there are some cameras that allow you to disable the sharpening in JPEG mode and you could do this separately in Camera Raw, but I think this runs counter to the very reason why some photographers prefer to shoot JPEG in the first place. They do so because they want their pictures to be fully processed and ready to proceed to the retouching stage. So, if you are shooting exclusively in JPEG mode, capture sharpening isn't something you really need to worry about and you can skip the first section of this chapter.

If you shoot in raw mode it won't matter what sharpen settings you have set on your camera; these will have no effect on the raw file. Any capture sharpening must be done either at the raw processing stage or afterwards in Photoshop. It now makes sense to carry out the capture sharpening at the Camera Raw image processing stage before you open your images in Photoshop.

Capture sharpening for scanned images

Scanned images may have already been pre-sharpened by the scanning software and some scanners will do this automatically without you even realizing it. If you prefer to take control of the capture sharpening yourself you should be able to do so by disabling the scanner sharpening and use whatever other method you prefer. For example, you could use a third-party plug-in like PhotoKit[™] Sharpener, or follow the Unsharp Mask filter techniques I describe in the Image Sharpening PDF on the website. So long as you export your scanned images using the TIFF or JPEG format, you can also use the Detail panel controls in Camera Raw to sharpen them.

So what about all those techniques that rely on Lab mode sharpening or luminosity fades? Well, if you analyze the way Camera Raw applies its sharpening, these controls have almost completely replaced the need for the Unsharp Mask filter. In fact, I would say that the Unsharp Mask filter has for some time now been a fairly blunt instrument for sharpening images, plus I don't think it is advisable to convert from RGB to Lab mode and back again unless it's necessary to do so. Compare the old ways of sharpening with the Camera Raw method and I think you'll find that this is now the most effective, if not the only way to capture sharpen your photos.

PhotoKit[™] Sharpener

Bruce Fraser devised the Pixel Genius PhotoKit Sharpener plug-in, which can be used to apply capture, creative, and output sharpening via Photoshop. The work Bruce did on PhotoKit capture sharpening inspired the improvements made to the Sharpening controls in Camera Raw. It can therefore be argued that if you use Camera Raw you won't need to use PhotoKit Sharpener capture sharpening routines. Adobe also worked closely with Pixel Genius to bring the PhotoKit Sharpener output routines to the Lightroom Print module. If you are using Lightroom 2.0 or later, you can take advantage of this. However, if you have Photoshop and Lightroom, PhotoKit Sharpener can still be useful for the creative sharpening and halftone sharpening routines it provides.

Real World Image sharpening

If you want to learn more about image sharpening in Camera Raw, Lightroom, and Photoshop then I can recommend *Real World Image Sharpening with Adobe Photoshop, Camera Raw, and Lightroom* (2nd Edition), which is available from Peachpit Press. ISBN: 0321637550. The first edition was authored by Bruce Fraser. This new version is an update of Bruce's original book, now co-authored by Jeff Schewe.

Process versions and Camera Raw sharpening

As I mentioned in Chapter 2, Process Versions updates for Camera Raw have seen new changes to the way raw images are handled. Since Camera Raw 6 and the introduction of Version 2, there have been refinements to capture sharpening in Camera Raw. As a result of this, legacy photos processed via Camera Raw 5 or earlier and photos processed via Lightroom 2 or earlier are classified as using Version 1. All photos that have been edited subsequently, in Camera Raw 6 or later, can be edited using Version 2, 3 or Version 4.

Sharpening is achieved by adding halos to the edges in an image. It does this by adding a light halo on one side of an edge and a dark halo on the other. To quote Camera Raw engineer Eric Chan (who worked on the new Camera Raw sharpening), "good sharpening consists of halos that everybody sees, but nobody notices." To this end, the halo edges in Camera Raw are kept subtle and balanced such that the darker edges are just dark enough dark and the brighter edges just bright enough to create a halo effect. They are still there of course but you are less likely to actually 'see' them as visible halos in an image. You should only notice them in the way they create the illusion of sharpness. When you select a Sharpen Radius that's within the 0.5–1.0 range the halos are sufficiently narrowed to allow fine detailed subjects to be sharpened more effectively. You'll also read later how the Detail panel Sharpen settings are linked to the Sharpen mode of the Adjustment tools. This means you can use the Adjustment Brush, Graduated Filter, or Radial Filter as creative sharpening tools to 'dial in' more (or less) sharpness. Lastly, we have the improved noise reduction controls which, compared to Version 1, offer more options than before for removing the luminance and color noise from a photograph. During the Version 4 demosaic process not every trace of noise gets removed from the image. This is deliberate so that when the image is viewed close-up it doesn't end up looking plastic and over-smooth in appearance.

Tailored sharpening

Different cameras require different amounts of base level sharpening. The Default 25 Amount setting is standard for all raw images. However, the actual amount of sharpening applied varies from camera to camera, with some requiring less sharpening and others more depending on the sensor. The aim is for all cameras to achieve a similar level of sharpness at the default 25 Amount setting.

Sample sharpening image

To help explain how the Camera Raw sharpening tools work, I have prepared a sample test image that you can access from the book website. The Figure 3.1 image has been especially designed to highlight the way the various slider controls work when viewed at 100%. Although this is a TIFF image, it's one where the image has been left unsharpened and the lessons you learn here can equally be applied to sharpening raw photos.

Figure 3.1 This demo image can be downloaded from the book's website.

Detail panel

To sharpen an image in Camera Raw, I suggest you start off by going to Bridge, browse to select a photo, and choose File \Rightarrow Open in Camera Raw, or use the **H** (Mac) **ctr** (PC) keyboard shortcut. The Sharpening controls are all located in the Detail panel (Figure 3.2). The Luminance Detail, Luminance Contrast, Color Detail, and Color Smoothness sliders will all appear active so long as the image has been updated to Version 4. If the photo won't open via Camera Raw, check you have enabled TIFF images to open via Camera Raw in the Camera Raw preferences (see page 120).

) 23 ¥ 8 = (□ fx 0 ≈ •	
Detail	
Sharpening	9
Amount	25
Radius	1.0
Detail	25
Masking	10
Noise Reduct	ion
Luminance	10
Luminance Detail	50
Luminance Contrast	0
Color	25
Color Detail	10
Color Smoothness	50

Figure 3.2 The Camera Raw Detail panel.

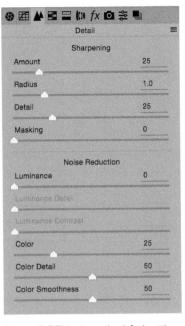

Figure 3.3 This shows the default settings for the Detail panel in Camera Raw when processing a raw image.

Sharpening defaults

The Detail panel controls consist of four Sharpening slider controls: Amount, Radius, Detail, and Masking. When you open a raw image via Camera Raw, you will see the default settings shown in Figure 3.3. But if you open up a non-raw image via Camera Raw, such as a JPEG or TIFF, the Amount setting defaults to 0%. This is because if you open a JPEG or TIFF image via Camera Raw it is usually correct to assume the image has already been pre-sharpened, so the default amount of sharpening for non-raw files is always set to zero. You should only apply sharpening to JPEGs or TIFF images if you know for sure that the image has not already been sharpened. When you download and open the TIFF image that's used in the following steps it should open with zero sharpening and noise reduction settings. The Noise Reduction sliders can be used to remove image noise and we'll come onto these later, but for now I just want to guide you through what the sharpening sliders do.

The sharpening effect sliders

Let's start by looking at the two main sharpening effect controls: Amount and Radius. These control how much sharpening is applied and how the sharpening gets distributed.

If you are viewing a photo at a fit to view preview size you will see a warning message that says 'For a more accurate preview, zoom the preview size to 100% or larger when adjusting the controls in this panel,' which means you should follow the advice given here and set the image view magnification in the Camera Raw dialog to a 100% view or higher. The test image I created is actually quite small and will probably display at a 100% preview size anyway. If you are using a high pixel density display, then set the preview to 200%. The main thing to remember is that when you are sharpening images, the preview display should always be set to a 100% view or higher for you to judge the sharpening accurately. In addition to this I should also point out that the screen shots over the next few pages were all captured as grayscale sharpening previews, where I held down the all key as I dragged the sliders.

Amount slider

1 The Amount slider is like a volume control. As you increase the Amount the overall sharpening is increased. A default setting of 25% is applied to all raw or raw DNG images, but if you open a TIFF or JPEG image, Camera Raw assumes the image has already been pre-sharpened and applies a 0% Amount setting. If you are editing the downloaded image you will need to set this to 25% to simulate the default shown here.

2 As you increase the Amount setting to 100% you will notice how the image becomes sharper. 100% is plenty strong enough, but you can take the Amount even higher. Camera Raw allows this extra headroom because it can sometimes be necessary when you start dampening the sharpening effect using the Detail and Masking sliders.

Detail	
Sharpening	g
Amount	
Radius	1.0
Detail	25
Masking	0
Luminance	0
Noise Reduct	ion
Luminance Detail	
Luminance Contrast	
Color	0
Color Detail	
Color Smoothness	

Detail	
Sharpening	
Amount	100
Radius	1.0
Detail	25
Masking	0
Noise Reductio	on 0
Luminance Detail	
Luminance Contrast	
Color	0
Color Detail	
Color Smoothness	

Sharpening	
Amount	25
Radius	0.5
Detail	25
Masking	0
Noise Reduction Luminance	0
Luminance Detail	
Luminance Contrast	
Color	0
Color Cetal	
Color Smoothness	

Sharpening	25
ladius	3.0
Detail	25
Masking	0
Noise Reduction	0
ummance Datall	
uminance Contrast	
Color	0
Color Detail	

Radius slider

1 The Radius slider is similar to the one found in the Unsharp Mask filter. The Radius determines the width of the halos that are generated around the edges in a photo. A small radius setting can be used to pick out fine detail in a picture, but will have a minimal effect on the soft, wider edges in a picture.

2 A high radius setting will over-emphasize the fine edges, but do more to enhance the soft edges such as the facial features in a portrait. I have shown here the two extremes that can be used, but for most sharpening adjustments you will want to stick close to a 1.0 Radius and make small adjustments around this setting.

Detail slider

The Amount and Radius sliders control the sharpening effect. The next two sliders act as 'suppression' controls. These constrain the sharpening and target the sharpening effect where it is most needed and you can use the Detail slider to fine-tune the Amount and Radius effects.

Increasing the Detail beyond the 25 default setting makes it act as a high frequency concentrator' and effectively increases the Amount sharpening but without generating too noticeable halo edges in the image. Essentially, it biases the amount of sharpening, applying more to areas of high frequency and less to areas of low frequency. Detail slider settings above 50 are more likely to exaggerate any areas that contain fine-textured detail (such as noise). As a result you may want to avoid setting the Detail too high when processing high ISO images. One way to resolve this is to increase the Masking setting. With low ISO images it is certainly safer to use a high Detail setting. In fact, Eric Chan, who worked on the Camera Raw sharpening, points out he often uses a +100 Detail setting when shooting low ISO landscape images.

There has always been a certain amount of halo suppression built into the Camera Raw sharpening, but as you take the Detail slider below the default 25 value it acts as a halo suppressor that further suppresses the amount of contrast in the halos.

1 In this first example the Detail slider was set at the default setting of 25 and captured here with the *att* key held down. This displays an isolated grayscale preview of the sharpening effect. At this setting the Detail slider gently suppresses the halo effects to produce a strong image sharpening effect but without over-emphasizing the fine detail or noisy areas of the image.

● 2 ▲ ▲ ■ □ ↓	:
Sharpening	
Amount	25
Radius	1.3
Detail	25
Masking	0
Noise Reduction	
Luminance	0
Luminance Detail	
Luminence Contrast	
Color	0
Color Detail	
Color Smoothnesa	
The second s	

Detail	
Sharpening	
Amount	25
Radius	1.3
Detail	100
Masking	0
Noise Reduction	0
Luminance	0
Luminance Botal	enterita contra de chemican
Luminance Contrast	
Color	0
Colar Datail	
Color Smoothness	

Sharpening	1
Amount	25
Radius	1.3
Detail	0
Masking	0
Noise Reduct	tion
Luminance	0
.uminance Detail	
Luminance Contrast	
Color	0
Calor Detail	
Color Smoothnesa	

2 If you take the Detail slider all the way up to 100, the capture sharpening will look similar to a standard unsharp mask filter effect applied in Photoshop at a zero Threshold setting.

3 If, on the other hand, you take the Detail slider down to zero you can see how the image looks with maximum halo suppression. What we learn from this is how to set the Detail slider between these two extremes. For portraits and other subjects that have soft edges, I would recommend a lowish Detail setting of around 20–30 so that you prevent the flat tone areas from becoming too noisy. For images that have lots of fine detail I would mostly suggest using a higher value, because you don't want to suppress the halo edges quite so much. With these types of photos you probably will want to add more emphasis to the fine edges.

Interpreting the grayscale previews

In the screen shots you have seen so far, I captured these with the att key held down as I dragged on the sliders. Adjusting the Amount slider with the att held down allows you to preview the effect this adjustment has by displaying a grayscale image which shows the sharpening effect as applied to the luminance information only. With Camera Raw the sharpening is always applied to the luminance of the image, which is why you shouldn't see any unwanted color artifacts generated whenever you apply a sharpening effect. The Amount slider is therefore designed to show you exactly how the sharpening is applied to the luminance of the photo, hiding the color information so you can judge the sharpening effect more easily.

Radius and Detail grayscale preview

With the Radius and Detail sliders you see a slightly different kind of preview when you hold down the *all* key as you adjust these sliders. The grayscale preview you see here displays the sharpening effect in isolation as if it were a sharpening effect applied on a separate layer. For those of you who are acquainted with Photoshop layering techniques, imagine a layer in Photoshop that is filled with 50% gray and where the blend mode is set to 'Overlay.' Such a layer will have no effect on the layers beneath it until you start darkening or lightening parts of that layer. In Figure 3.4, you can see a mock-up of what the Detail grayscale preview is actually showing you. This is a Photoshop simulation of what the grayscale Radius and Detail previews in Camera Raw are displaying. Imagine the sharpening effect being carried out on a separate layer above the background layer with the blend mode set to Overlay. It effectively displays the sharpening effect in isolation as light and dark areas against a neutral, midtone gray. If you consider a Camera Raw Detail panel grayscale preview in this context you will understand how the low contrast preview image represents an isolated preview of the sharpening effect.

Figure 3.4 This is a Photoshop simulation of what the grayscale Radius and Detail previews in Camera Raw are showing you.

Figure 3.5 Here is another simulation of what the Camera Raw Masking slider grayscale preview is showing you.

Masking slider

The Masking slider can be used to effectively add a filter mask based on the edge details of an image. Essentially, this allows you to target the Camera Raw sharpening so that the sharpening adjustments are more targeted to the edges in the image rather than sharpening everything globally. As you adjust the Masking slider a mask is generated based on the image content, so that areas of the image where there are high contrast edges remain white (the sharpening effect is unmasked) and in the flatter areas of the image where there is smoother tone detail the mask is made black (the sharpening effect is masked). If you take the Masking slider all the way down to zero, no mask is generated and the sharpening effect is applied without any masking. As you increase the Masking, more areas become protected.

The effect the Masking slider has on the Camera Raw sharpening is like a layer mask that masks the layer applying the sharpening effect. Figure 3.5 shows another Photoshop simulation of what the Camera Raw Masking slider grayscale preview is showing you. As you hold down the *alt* key and drag the Masking slider you are effectively previewing a layer mask that masks the sharpening layer effect. In other words, the Masking slider preview shown opposite is kind of showing you a pixel layer mask preview of the masking effect. The calculations required to generate the mask are quite intensive, but on a modern, fast computer you should hardly notice any slow-down.

The Masking slider was inspired by a Photoshop edge masking technique that was originally devised by Bruce Fraser. You can read all about Bruce's Photoshop techniques for Input and Output sharpening in an updated version of his book, which is now co-authored with Jeff Schewe: *Real World Image Sharpening with Adobe Photoshop, Camera Raw and Lightroom* (2nd Edition). This book includes instructions on how to create the edge masking technique referred to in Figure 3.5.

Masking slider example

1 When the Masking slider is set to the default zero setting, no masking is applied. If you hold down the *alt* key as you drag the Masking slider, you can see a grayscale preview of the mask that is being generated. At the 50% setting shown here, the mask is just starting to protect the areas of flat tone from being sharpened.

2 This screen shot shows a preview where the Masking slider was taken to the maximum 100% setting. In this example the masking is a lot stronger and protects all the flat tone areas leaving only the strongest edges unmasked. The sharpening effect is now only applied to the remaining white areas.

>	:
Sharpening	
Amount	40
Radius	1.2
Detail	20
Masking	50
Noise Reduction	0
Luminance Detail	
Cuminarios Contrast	
Color	0
Color Detail	
Color Smoothness	

Detail	
Sharpenir	ıg
Amount	40
Radius	1.2
Detail	20
Masking	100
Noise Reduc Luminance	otion 0
Luminance Betall	
Luminance Contrast	
Color	0
Color Detail	
Color Smoothness	

Real world sharpening examples

Now that I have given you a rundown on what the individual Sharpening sliders do, let's look at how you would use them in practice to sharpen an image.

Sharpening portrait images

Figure 3.6 shows a 1:1 close-up view of a portrait shot where I used the following settings: *Amount: 35, Radius: 1.2, Detail: 20, Masking 70.* This combination of Sharpening slider settings is most appropriate for use with portrait photographs, where you wish to sharpen the important areas of detail such as the eyes and lips, but protect the smooth areas (like the skin) from being sharpened.

Figure 3.6 Here is an example of the sharpening settings used to sharpen a portrait.

Detail	
Sharpening	
Amount	35
Radius	1.2
Detail	20
Masking	70
Noise Reduction	
Luminance	5
Luminance Detail	50
Luminance Contrast	0
Color	25
Color Detail	50
Color Smoothness	50

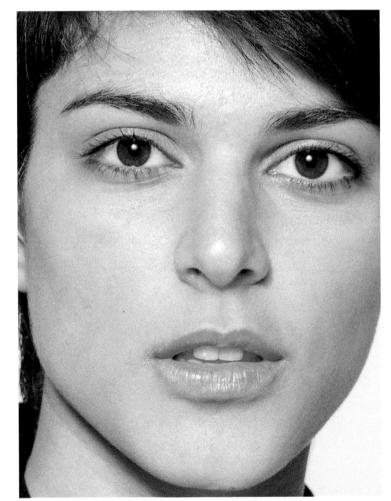

Sharpening landscape images

Figure 3.7 shows the settings that could be used to sharpen a landscape image. The settings used here were: *Amount: 40, Radius: 0.8, Detail: 50, Masking: 10.* These settings can suit a wide range of subject types. Basically, you might want to use this particular combination of slider settings whenever you needed to sharpen photographs that contain a lot of narrow edge detail. Version 4 generates extra narrow halo edges whenever the Radius slider is applied in the 0.5–1.0 range. This means you can apply lower Radius settings to fine-detailed images that need a low radius, but without generating such noticeable halos.

Detail	
Sharpening	
Amount	40
Radius	0.8
Detail	50
Masking	10
Noise Reducti	on
Luminance	5
Luminance Detail	50
Luminance Contrast	0
Color	25
Color Detail	50
Color Smoothness	50

Sharpening a fine-detailed image

Figure 3.8 shows an example of a photograph that contains a lot of fine-edge detail. In order to sharpen the fine edges in this picture I set the Radius to 0.7. I also wanted to emphasize the detail and therefore ended up setting the Detail slider to +90. This is a lot higher than one would choose to use normally, but I have included this particular image in order to show an example of a photograph that required a unique treatment. As with the previous example, I only needed to apply a very small amount of Masking since there were few areas in the photograph where I needed to hide the sharpening.

Figure 3.8 This shows an example of the Detail panel sharpening settings that were used to pre-sharpen a fine-detailed subject.

Detail	
Sharpening	9
mount	45
ladius	0.7
Detail	90
Aasking	15
Noise Reduct	tion
uminance	5
uminance Detail	50
uminance Contrast	0
Color	25
Color Detail	50
Color Smoothness	50

How to save sharpening settings as presets

You can save the sharpening settings as Camera Raw presets and then, depending on what type of photo you are editing, load them as required. You could try using the settings in Figure 3.6, 3.7, or 3.8 to create sharpening presets that can be applied to other photographs.

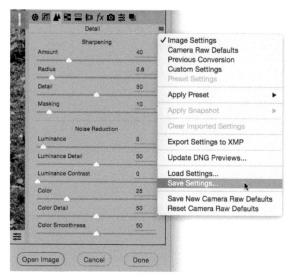

Default sharpening settings

The standard default sharpening setting for raw images uses the settings shown earlier in Figure 3.3. This isn't a bad starting point, but based on what you have learned in the last few examples, you might like to modify this and set a new default. For example, if most of the work you shoot is portraiture, you might like to use the settings shown in Figure 3.6 and set these as a default and make this setting specific to your camera (see page 149).

1 After configuring the Detail panel settings, go to the fly-out menu and choose 'Save Settings...'

Save	Settings	
Subset: Details	· · · · ·	Save
White Balance		(<u>.</u>
Exposure		Cancel
Contrast		
Highlights		
Shadows		Check All
Blacks		
Whites		Check None
Clarity		
Vibrance		
Saturation		
Parametric Curve		
Point Curve		
Sharpening		
Z Luminance Noise Reduction		
Color Noise Reduction		
HSL Adjustments		
Split Toning		
Transform		
Lens Profile Corrections		
Chromatic Aberration		
Lens Vignetting		
Dehaze		

2 This opens the Save Settings dialog. Check the Sharpening, Luminance Noise Reduction and Color Noise Reduction sliders and click the Save... button.

Settings folder location

On a Mac, the Camera Raw Settings folder location is: username/Library/Application Support/Adobe/Camera Raw/Settings. On a PC, look for: C:\Documents and Settings\username\Application Data\Adobe\ CameraRaw\Settings.

Save As:	Sharpen landscape		~
Tags:			
Where:	Settings	6	
		Cancel	Save

3 Now name the setting and save to the default Settings folder (don't change the directory location).

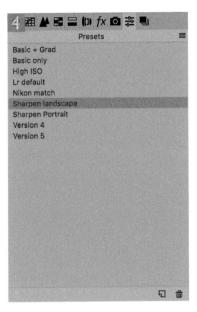

4 Whenever you need to access a saved setting, go to the Presets panel in Camera Raw and click on a saved setting to apply it to the image. Since the setting selected here saved the Sharpening adjustments only, when selected this preset only adjusts the Sharpening sliders when it's applied to another image.

Capture sharpening summary

Hopefully this section has given you the confidence to carry out all your capture sharpening in Camera Raw. You should use the Camera Raw Sharpening controls to tailor the capture sharpening adjustment to suit the image content. Soft-edged subjects such as portraits will suit a higher than 1.0 Radius setting combined with a low Detail and high Masking setting. Fine-detailed subjects such as those shown in the Figure 3.7 and 3.8 examples will suit using a low Radius, high Detail, and low Masking setting. The aim always is to apply enough sharpening to make the subject look visually sharp on the screen, but without over-sharpening to the point where you see any edge artifacts or halos appear in the image. If you overdo the capture sharpening you are storing up trouble for later when you come to retouch the photograph.

Selective sharpening in Camera Raw

With some images it can be tricky to find the optimum settings that will work best across the whole of the image. This is where it can be useful to use the localized adjustment tools to selectively modify the sharpness of an image. Basically, whenever you use the Adjustment Brush, Graduated Filter, or Radial Filter tools in Camera Raw you can use the Sharpness slider to add more or less sharpness. In particular, as you increase the Sharpness, the sharpness applied using a brush or filter increases the sharpness amount based on the settings set in the Detail panel Sharpening section.

Negative sharpening

Negative sharpening settings in the zero to -50 range can be used to fade out existing sharpening. Therefore, if you apply -50 sharpness as a localized adjustment you can use the local adjustment tools to disable the capture sharpening. As you apply a negative sharpness in the -50 to -100 range, you start to apply anti-sharpening, which produces something like a gentle lens blur effect.

Extending the sharpening limits

You can also go beyond the +100/-100 limit set by the Sharpness slider by applying multiple sharpness adjustments. To do this you need to create a new brush group using a new Sharpness setting and paint on top of an existing brush group.

Dual Smart Object sharpening layers

An alternative approach is to use the 'Open raw files as Smart Objects' technique described on page 110 to open an image twice. You can then apply one set of Detail panel settings to one Camera Raw Smart Object layer and a different type of sharpening effect to the other Camera Raw Smart Object layer. You can then use a layer mask to blend these two layers so that you are able to combine two different methods of sharpening in the one image.

How to	apply	localized	sharpening
--------	-------	-----------	------------

Basic	
White Balance: As Shot	v
Temperature	5200
Tint	-2
<u>Auto D</u>	efault
Exposure	0.00
Contrast	0
Highlights	-48
Shadows	+60
Whites	0
Blacks	0
Clarity	+33
Vibrance	+45
Saturation	

	•
Detail	
Sharpening	
Amount	50
Radius	1.0
Detail	50
Masking	0
Noise Reductio	n
Luminance	10
Luminance Detail	50
Luminance Contrast	0
Color	25
Color Detail	50
Color Smoothness	50

1 In this photograph I had the camera switched to auto focus mode. Although the driver's right arm was sharp, the helmet and steering wheel were not.

2 To start with I clicked to select the Detail panel and adjusted the Sharpening sliders to obtain the optimum sharpness for the driver's arm.

3 Here, I selected the Adjustment Brush tool and used the brush to paint over the helmet, shoulder, and steering wheel. I then adjusted the settings to add +15 Clarity, +100 Sharpness, and +35 Noise Reduction.

4 This combination of settings applied the optimum additional sharpening to the areas of the photograph that needed the most added sharpening. Here you can see the final version with the Mask overlay disabled.

	Adjustment Brush		J
Θ	Temperature	0	•
Θ	Tint	0	; ⊕
Θ			•
Θ	Exposure	0.00	. ⊙
Θ	Contrast	0	Ð
Θ	Highlights	0	. ⊕
Θ	Shadows	0	•
Θ	Whites	0	, ⊕
Θ	Blacks	0	•
Θ	Clarity	+15	•
Θ	Dehaze	0	•
Θ	Saturation	0	€
Θ	Sharpness	+100	÷
Θ	Noise Reduction	+35	€
Θ	Moire Reduction	0	Ð
Θ	Defringe	0	€
Θ	Color		€
Si	ze	4	
Fe	ather	70	and an a
Flow		50	
Density		100	
	Auto Mask		
🖸 Overlay 💟 Mask 📰 Clear All			

Negative sharpening to blur an image

Here is an example of how to use a negative Sharpness amount to deliberately blur an image. Again, it is possible to apply multiple passes of negative sharpening, but the effect will eventually max out and beyond a certain point won't add any extra blurring. You can't yet apply what you might call a true lens blur effect in Camera Raw. Having said that it's still possible to be used effectively as a creative tool and there is one use where I think this technique would be particularly useful and that is when shooting a sequence of images to be incorporated into a time-lapse video. Rather than having to render every frame as a TIFF or JPEG and process each of these in Photoshop using a blur filter, doing this in Camera Raw can still be quite effective and offers the ultimate in flexibility.

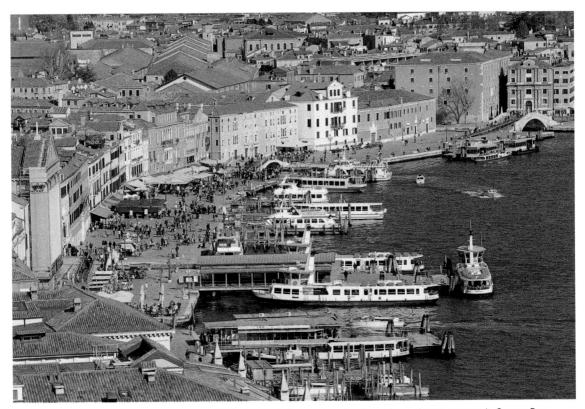

1 This shows a before version of an image I was about to process in Camera Raw, where the aim was to apply a combination of negative sharpening effects and eventually synchronize the settings applied here to every frame in a sequence of photographs.

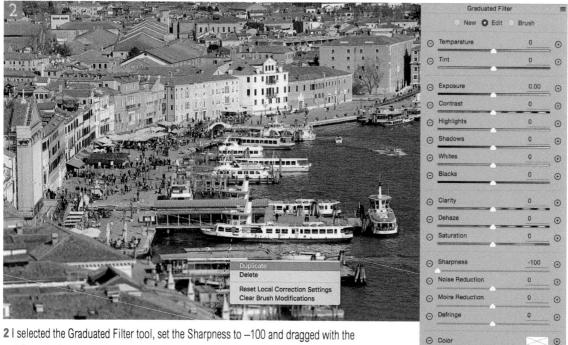

2 I selected the Graduated Filter tool, set the Sharpness to -100 and dragged with the tool from the bottom to apply a negative sharpness, blurring adjustment. I then right clicked the adjustment and selected Duplicate to build the blurring effect

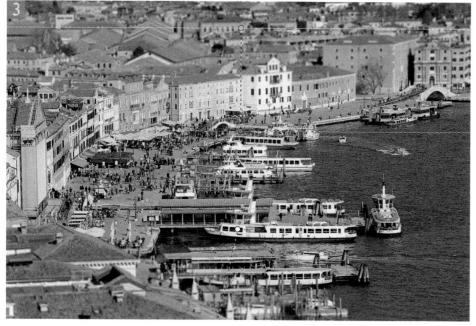

3 Finally, I added three further negative sharpness Graduated Filter adjustments that added more blurring to the top of the image.

Overlay

Mask

Clear All

Noise removal in Camera Raw

All images will contain some degree of noise and is caused by a number of factors. For example, noise can be the result of too few photons reaching the sensor. This is known as 'shot noise', where a low number of photons will result in sensor signal errors. You can see this for yourself when using a camera in live view mode under low light conditions. The screen image will be very noisy. Yet, when you capture an image using a correct exposure value at a low ISO setting, the image can appear noise-free. This is because at a longer exposure more photons reach the sensor to produce a cleaner image.

All camera sensors have a base level of noise even at the optimum, lowest ISO setting. As the ISO is increased the underlying noise becomes amplified. It is like turning up the volume of an audio tape that was recorded at a low volume and hearing lots of hiss. You have to bear in mind here that the camera sensor is an analog device and the digital file is created via the camera's analog to digital converter. An amplified input signal will therefore inevitably contain more noise after it has been digitized. Another factor is exposure. On page 142 I showed how deliberately underexposing a digital photo can lead to shadow noise problems as you compensate by increasing the Exposure slider setting. To determine how successful your camera is as at handling image noise, you should check how the shadows look.

The underlying Version 4 demosaic process aims to filter the noise so as to reduce the luminance pattern noise and color noise component which we generally find obtrusive, but retain the random grain-like noise that we don't find distracting. The aim here is to filter out the good noise from the bad and provide, as a starting point, an image where the Camera Raw demosaic process preserves as much detail as possible. As the ISO setting is increased beyond whatever is the optimal ISO setting you then have the means to remove noise by adjusting the Noise Reduction sliders from their default settings. Extra help will still be required to further suppress the unwanted image noise which can be characterized in two ways: as luminance and color noise.

The Noise Reduction sliders in Camera Raw should be able to meet all your noise reduction requirements and therefore less need to rely on Photoshop or third-party products to carry out the noise reduction. Bear in mind that JPEG capture images will have already been processed in-camera to remove any noise. So, to take full advantage of Camera Raw noise reduction, you'll need to work with raw capture images. The other thing to bear in mind here is that the noise reduction and sharpening processes are essentially counteractive. As you attempt to reduce the noise in an image you'll inevitably end up softening image detail. The Camera Raw controls have therefore been designed to make the noise reduction as targeted as possible, curing the problems of noise with minimal softening of the image. In some instances you will still need to consider revising the sharpening settings to restore sharpness.

Detail panel Noise Reduction sliders

The Noise Reduction controls are shown in Figure 3.9. The Luminance slider is used to smooth out the speckled noise that is always present to some degree, but is more noticeable in high ISO captures. The default setting is zero, but even with low ISO captures I think you'll find it beneficial to apply just a little Luminance noise reduction; in fact my colleague Jeff Schewe likes to describe this as the fifth sharpening slider and suggests you always add at least a little Luminance noise reduction as part of a normal sharpening process. Since Luminance noise reduction inevitably smooths the image, it is all about finding the right balance between how much you set the Luminance slider to suppress the inherent noise and how much you sharpen to emphasize the edges (but without enhancing the noise).

Excessive Luminance slider adjustments can lead to a softening of edge detail. To counter this, the Luminance Detail slider acts like a threshold control for the main Luminance slider. The default setting is 50 and the Luminance Detail slider sets the noise threshold of what the noise reduction algorithm determines to be noise. When this slider is dragged to the left you will see increased noise smoothing. However, be warned that some detail areas may be inappropriately detected as noise and important image detail may also become smoothed. Dragging the slider to the right reduces the amount of smoothing used and preserves more detail. This allows you to dial back in any missing edge sharpness, but it may also cause noisy areas of the image to be inappropriately detected as detail and therefore not get smoothed.

Luminance noise tends to have a flattening effect at the macro level where the underlying texture of the noise grain appears so smoothed out that in close-up the image has something of a plastic look to it. The Luminance Contrast slider therefore can be used to restore more contrast, but does so at the expense of making preserved noise blobs more noticeable. The smoothest results are achieved by leaving the Luminance Contrast slider at the default zero setting. However, doing so can sometimes leave the noise reduction looking unnatural where the details may appear too smoothed out. Dragging the slider to the right allows you to preserve more of the contrast and texture in the image, but at the same time this can lead to increased mottling in some high ISO images. It is also worth pointing out that the Luminance

Oha	
Sharpening	
Amount	50
Radius	0.8
Detail	60
Masking	10
Noise Reductio	n
Luminance	10
Luminance Detail	50
Luminance Contrast	0
Color	25
Color Detail	50
Color Smoothness	50

Figure 3.9 The Detail panel showing the Noise Reduction sliders.

Contrast slider has the greatest effect when the Luminance Detail slider is set to a low value. As you increase the Luminance Detail the Luminance Contrast slider has less effect on the overall Luminance noise reduction.

The noise reduction in Camera Raw is also adaptive to different camera models and their respective ISO settings. The effective amount of noise reduction for the Luminance noise and Color noise amount settings therefore varies when processing files from different cameras as the noise reduction is based on a noise profile for each individual camera. The end result is that the noise reduction behavior feels roughly the same each time you adjust the noise reduction controls although the "under the hood" values applied are actually different.

Color noise

Color noise occurs due to the inability of the sensor in low light levels to differentiate color (because the luminance is so low). As a result of this we see errors in the way color is recorded and hence the appearance of color artifacts in the demosaiced image. The Color slider smooths out the color noise artifacts such as the magenta/ green speckles you commonly see in noisy high ISO captures. In fact, since Camera Raw 7, the quality of the color noise reduction has been improved at extreme color temperatures such as 3200K or lower in order to reduce the effects of color splotchiness.

For the most part you can safely crank the Color noise reduction slider up towards the maximum setting. However, increasing the Color noise slider can also result in color bleeding, which results in the fine color details in an image becoming desaturated. This kind of problem is one that you are only likely to see with really noisy images that contain fine color edge detail, so it's not something you need to worry about most of the time. Where this does appear to be an issue, the Color Detail slider can be used to preserve color detail in such images. As you increase the Color Detail slider beyond the default 50 setting you'll notice how it preserves more detail in the color edges. Take care when you use this slider, because as you increase the amount that is applied this can lead to some color speckles reappearing along the preserved edges. And in areas that have a strong color contrast you can see an over-sharpening of the color boundary edges. To understand more clearly the effect these sliders are having, you may want to zoom in to look at a 400% view. With really noisy images you might also want to adjust the Blacks slider in the Basic panel to crush the blacks more. This can help disguise noise that's still present.

Removing random pixels

Camera Raw noise reduction is also able to remove outlying pixels, those additional, random light or dark pixels that are generated when an image is captured at a high ISO setting. Camera Raw can also detect any dead pixels and smooth these out too. You won't normally notice the effect of dead pixels, but they do tend to show up more when carrying out long time exposures. Even then you may only see them appear very briefly on the screen as Camera Raw quickly generates a new preview image.

CMOS and CCD sensors

In recent years we have seen digital SLR and mirrorless cameras such as Nikon, Canon, and Sony, where the latest sensors are now able to capture images at high ISO settings without producing too much obtrusive noise. At the highest ISO settings it is mostly only the luminance noise that you have to remove. Meanwhile, medium format cameras that use CCD type sensors don't perform well at anything but the lowest ISO settings. These sensors are very good in terms of color performance and sharpness, but do not tend to respond well when the signal is amplified. However, Sony recently created a 50 megapixel CMOS sensor for medium format cameras. I have tested this with the Hasselblad H5D-50C and Pentax 645Z camera systems, and the sensor performance is exceptionally good, even at the very highest ISO settings.

Although you may still see noise after applying noise reduction if you zoom in close, will such noise will be noticeable in print? The more important consideration here is the effect of ISO on the dynamic range. This is because the sensor is less able to discern as many levels of shadow detail as the ISO is increased the dynamic range is reduced.

Noise Reduction adjustments

The following steps show how the Noise Reduction sliders can be best used to remove both luminance and color noise from a high ISO capture image.

Basic	
White Balance: As Shot	
Temperature	2900
Tint	+5
Auto Default	
Exposure	+0.80
Contrast	0
Highlights	-54
Shadows	+53
Whites	-15
Blacks	-39
Clarity	+10
Vibrance	+30
Saturation	0

● 2 ▲ ● □ □ (1) fx 回 章 □ Detail Sharpening

Noise Reduction

25

1.0

25 0

0

0

Amount

Radius

Detail

Masking

Luminance

Color

1 Here is a photograph that was shot at 3200 ISO and is a good example with which to demo color noise reduction, and is shown here with the default Detail panel settings.

2 I began by setting the Color slider to zero. As you can see, there were a lot of visible color noise artifacts in this image.

3 In this step, I applied a Color noise reduction of 50. This cured most of the color noise problem, but the color edges were noticeably diffuse.

	© ‡ ¶ =
Sharpenir	ıg
Amount	50
Radius	1.0
Detail	15
Masking	10
Noise Reduc	tion
Luminance	0
Luminance Detail	
Luminance Contrast	
Color	50
Color Detail	0
Color Smoothness	50

4 The Color Detail slider can do a good job resolving the problem of color edge bleed, commonly associated with color noise reductions. Here, I applied a Color Detail setting of 100. I then applied a Luminance noise reduction of 55 with a Luminance Detail setting of 70 and a Luminance Contrast setting of 80.

Detail	
Sharpening	
Amount	50
Radius	1.0
Detail	15
Masking	10
Noise Reducti	on
Luminance	55
Luminance Detail	70
Luminance Contrast	80
Color	50
Color Detail	100
Color Smoothness	35

Color Smoothness slider

The Detail panel Noise Reduction section includes a Color Smoothness slider. This can be used to help deal with color mottling artifacts (or large colorful noise blobs). These are usually caused by low frequency color noise and can be present in low as well as high ISO images, especially in the shadow regions. The default setting is 50. Dragging to the right can help make these disappear, though this will, at the same time, cause the image to appear smoother.

The example shown here was shot using a Canon EOS 1Ds MkIII camera at 100 ISO. I deliberately lightened the shadows to reveal the problem highlighted here. It is mainly some Canon cameras that seem to benefit most from this feature, although the most recent Canon models appear to have much improved noise handling across the board as well as at higher ISO settings.

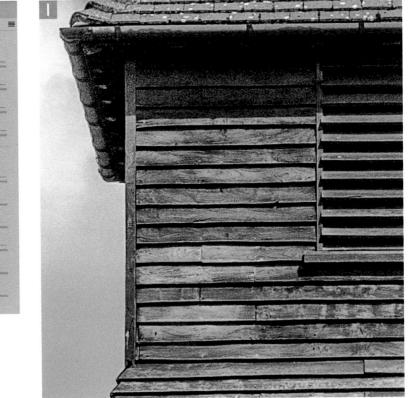

1 This shows a 200% close-up view of an image that was shot at ISO 100, but where there were clearly signs of color mottling in the shadow areas.

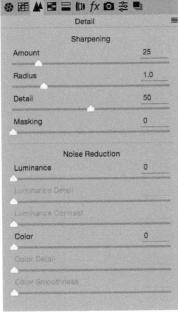

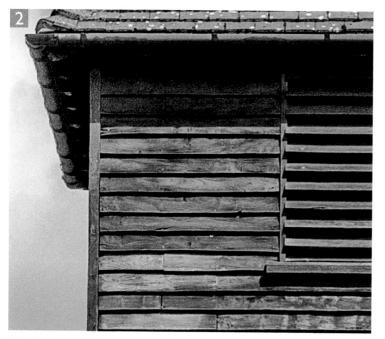

0	
Sharpening Amount	25
Radius	1.0
Detail	50
Aasking	0
Noise Reducti	on
uminance	10
uminance Detail	50
uminance Contrast	0
Color	25
Color Detail	50
color Smoothness	50

2 In this step I set the Luminance noise reduction to 10 and the Color slider to 25. This got rid of some of the color noise, but not all.

3	and and a stand of the grade open the	a The second
Contract of		
		~
		is ja si
		1.000
		in the second se

3 Setting the Color Smoothness slider to 100 smoothed out the mottling effect. This meant I didn't have to otherwise further increase the Color amount setting.

Detail	
Sharpening	
Amount	25
Radius	1.0
Detail	50
Masking	0
Noise Reduction	
Luminance	10
uminance Detail	50
uminance Contrast	0
Color	25
Color Detail	50
Color Smoothness	100

Adding grain to improve appearance of sharpness

The Grain slider can sometimes actually be useful when you are editing high ISO images and need to get rid of obtrusive noise artifacts. In the example shown here you can see how adding a small amount of noise can be used to compensate for some of the oversmoothing produced by the noise reduction process.

Detail	
Sharpening	
Amount	40
Radius	1.0
Detail	30
Masking	10
Noise Reductio	n
Luminance	60
Luminance Detail	10
Luminance Contrast	20
Color	40
Color Detail	20
Color Smoothness	50

2 As a result of the noise reduction adjustment applied in Step 1, some of the image detail ended up becoming over-smooth. To counteract this I added a small amount of grain using the Grain slider in the Effects panel.

3 Finally, I returned to the Detail panel and readjusted the Sharpening sliders to restore more sharpness.

Deha	ze
Amount	0
Grai	n
Amount	45
Size	5
Roughness	50
Post Crop V	ignetting
Amount	0
Midpoint	
Roundress	
Feather	
processing and the second state of the second state of the second states	Moon the Contract States in the Contract of Contract o

Detail	
Sharpening	
Amount	80
Radius	1.0
Detail	30
Masking	10
Noise Reducti	on
Luminance	70
Luminance Detail	55
Luminance Contrast	75
Color	40
Color Detail	20
Color Smoothness	50

Camera Raw features a Noise slider in the Adjustment Brush, Graduated Filter and Radial Filter settings. As you increase the slider setting you can apply a localized adjustment that strengthens the noise reduction that's applied to the selected area. As with other localized sharpening adjustments, this strengthening of the noise reduction effectively increases the amount setting for the Luminance and Color sliders, proportionally. Basically, you can use this slider adjustment to apply additional noise reduction where it is needed most, such as the shadow areas. I see this tool being useful where you have used a Camera Raw localized adjustment to deliberately lighten the shadows in a scene. Instead of bumping up the overall noise reduction it makes sense now to do so locally by increasing the Noise slider amount. You can also apply negative amounts of noise reduction using a localized adjustment. For example, you might have an image where it is easier to apply a global adjustment that is heavy on the noise reduction and use a negative localized noise reduction adjustment to selectively remove the noise reduction effect.

1 Here is a photograph that required localized lightening in the shadow areas. As you can see, I had already adjusted the Detail panel sliders to remove most of the image noise.

Detail	
Sharpening	
Amount	56
Radius	1.0
Detail	36
Masking	39
Noise Reductio	on
Luminance	15
Luminance Detail	10
Luminance Contrast	31
Color	25
Color Detail	50
Color Smoothness	50

2 In this step I used the Adjustment Brush to apply a lightening adjustment to the background area. However, this made the noise problem here worse.

3 To fix this, I kept the Adjustment Brush pin active and simply increased the Noise slider so that this simultaneously applied additional noise reduction (based on the Detail panel settings in Step 1). This helped make the noise less noticeable.

Adjustment Brush			
	🔿 New 🔘 Add	I 🔘 Erase	
Θ	Temperature	0	•
Θ	Tint	0	•
Θ	Exposure	+0.80	•
Θ	Contrast	O	€
Θ	Highlights	0	•
Θ	Shadows	0	•
Θ	Whites	0	. ⊕
Θ	Blacks	0	€
Θ	Clarity	0	Ð
Θ	Dehaze	0	€
Θ	Saturation	0	Ð
Θ	Sharpness	0	€
Θ	Noise Reduction	0	•
Θ	Moire Reduction	0	•
Θ	Defringe	0	•

	Adjustment B	rush	1
	New O Add	🕓 Erase	
⊖ Temp	perature	0	. 🕀
⊖		0	•
⊖ Expo	sure	+0.80	•
G Cont	rast	0	•
High	lights	0	⊕
Shad	ows	0	•
White	98	0	€
Black	(S	0	, 🕀
Clarit	у	0	Ð
Deha	ze	0	•
Satur	ation	0	•
Sharp	oness	0	€
	Reduction	+100	€
Moire	Reduction	0	€
Defrir	ige	0	•

Removing moiré at the shoot stage

One way to avoid the effects of moiré is to reshoot the subject from a slightly further distance and crop the image accordingly. Usually a small change in shooting distance is all that is required. The effects of moiré are much less of a problem now compared with the early days of digital camera technology.

Localized moiré removal in Camera Raw

The term 'moiré' is used to describe image detail problems that are related to artifacts generated as a result of light interference. This can be due to the way light reflected from a fine pattern subject, such as a shiny fabric, causes interference patterns to appear in the final capture. What actually happens here is the frequency of the fabric pattern and the frequency of the photosites on the sensor clash and this causes an amplified moiré pattern to appear in the captured image-this is just a limitation of the sensor. These days digital SLR cameras mostly all have a high pass, anti-aliasing filter attached to the surface of the sensor, which is designed to mitigate some of the effects of moiré. However, there are some cameras where the sensors don't have high pass filters (such as the Nikon D8100 and Canon 5DS R) and as a result you can end up seeing moiré-type effects when viewing an image close-up. Basically, if the camera lens is imaging fine-detail lines which correspond to less than one pixel width, this can cause a problem in the demosaic process. Therefore, it is really only certain types of subject matter photographed on the larger, medium format backs and above mentioned digital SLR cameras where the need to reduce moiré becomes necessary.

In the Camera Raw localized adjustments menus is a Moiré slider. As with the Noise slider, increasing the amount helps reduce the effects of moiré. Increasing the Moiré Reduction setting lets you apply a stronger effect and you can, if necessary, consider applying a double dose of moiré reduction to a local area. However, as you increase the effect you are likely to see color bleeding occur. Moiré removal is more effective removing luminance artifacts on raw images than JPEGs. This is because Camera Raw can take advantage of the higher resolution green channel (before color processing) to perform a fix. This is not possible with JPEGs as the green channel has already been fixed (color processed) and therefore 'polluted' the other two channels.

In the accompanying example there was a moiré pattern in the brickwork. When I used a Moiré Reduction Adjustment brush to remove the moiré, the brush referenced a broad area of pixels near where I was brushing in order to calculate what the true color should be. When retouching an image such as this it was important to use a hard-edged brush to constrain the brush work and avoid the green colors of the foliage spilling over. Selecting the Auto Mask option can certainly help here. Also, when fixing different areas (such as the moiré on the air-conditioning grilles) you should consider creating a new brush pin to work on these areas separately. You also have the ability to apply negative amounts of Moiré Reduction. This lets you apply a Moiré Reduction adjustment and subsequent negative adjustments can be used to reduce the Moiré Reduction effect.

1 Here you can see there is a big problem with moiré on the side of the building. To fix this I selected the Adjustment Brush tool and set the Moiré Reduction slider to +100%.

2 I painted with the Adjustment Brush using the Auto Mask mode to carefully target the brickwork and used the Eraser mode to erase any areas that spilled over into adjacent areas. It can sometimes be necessary to increase the Saturation slightly as the Moiré Reduction process may cause the painted areas to become slightly desaturated.

	Adjustment Br	rush	H
	New O Add	🔿 Erase	
Θ	Temperature	0	. 🖸
Θ	Tint	0	•
Θ	Exposure	0.00	•
Θ	Contrast	0	. •
Θ	Highlights	0	•
Θ	Shadows	0	_ •
Θ	Whites	0	•
Θ	Blacks	0	•
Θ	Clarity	0	•
Θ	Dehaze	0	•
Θ	Saturation	0	•
Θ	Sharpness	0	•
Θ	Noise Reduction	0	•
Θ	Moire Reduction	+100	•
Θ	Defringe	0	Ð
Θ	Color	\sim	•

	Adjustment Brus	ih	
	New O Add	Erase	
Θ	Temperature	0	. •
Θ	Tint	0	•
Θ	Exposure	0.00	•
Θ	Contrast	0	•
Θ	Highlights	0	•
Θ	Shadows	0	•
Θ	Whites	0	€
Θ	Blacks	0	•
Θ	Clarity	0	Ð
Θ	Dehaze	0	€
Θ	Saturation	+30	•
Θ	Sharpness	0	€
Θ	Noise Reduction	0	€
Θ	Moire Reduction	+100	Ð
Θ	Defringe	0	Ð
Θ	Color	\sim	€

Λ~

Figure 3.10 This shows the Sharpen tool options, including the Protect Detail mode.

Localized sharpening in Photoshop

Sharpen tool

The Sharpen tool (Figure 3.10) has a Protect Detail mode. This minimizes any pixelation when the Sharpen tool is used to emphasize image details. The Protect Detail mode can therefore faithfully enhance high frequency image details without introducing noticeable artifacts, though I recommend using this tool set to the Luminosity mode in order to help reduce the risk of generating color artifacts.

Smart Sharpen filter

So far we have seen how to apply localized sharpening in Camera Raw. Let me now show you a few ways this can be done directly in Photoshop. One method is to use the Smart Sharpen filter. Don't be too taken in by the fact that it's called a 'smart' filter. Some people figure this is a kind of 'super Unsharp Mask' filter to be used for general sharpening. When applied correctly, it can be used to sharpen areas where there is a distinct lack of sharpness, but if used badly may introduce noticeable artifacts (see Figure 3.11). However, there is a Reduce Noise slider in the Advanced options, which can play a key role in suppressing such artifacts. The Smart Sharpen filter also runs very slowly compared with the Unsharp Mask filter and Camera Raw sharpening. Therefore, I generally consider Smart Sharpen to be more useful as a tool for 'corrective' rather than general sharpening.

Basic Smart Sharpen mode

The Smart Sharpen filter has three blur removal modes: the Gaussian Blur mode makes it work more or less the same as the Unsharp Mask filter. The Lens Blur mode can be used to counteract optical lens blurring. Lastly, there is the Motion Blur removal mode, which can sometimes be effective at removing small amounts of motion blur from an image. After you have selected a blur removal method, you can use the Amount and Radius slider controls to adjust the sharpening effect.

In the example shown on the page opposite I converted the Background layer to a Smart Object layer. This allowed me to apply the Smart Sharpen filter as a smart filter, where I could edit the filter effect coverage by painting directly on the layer mask.

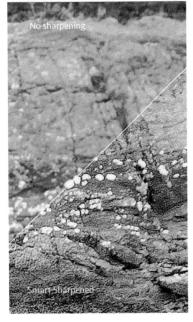

Figure 3.11 A close-up view of an image before and after applying the Smart Sharpen filter.

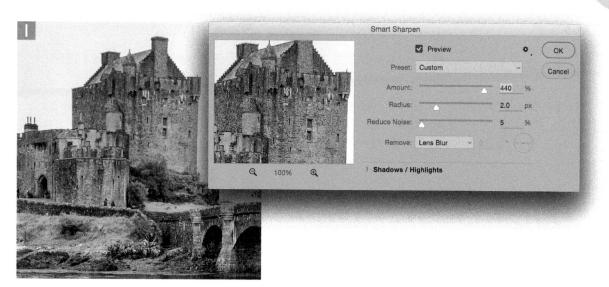

1 This shows a close-up view of a photograph where the main subject was slightly out of focus. I converted the Background image layer to a Smart Object and applied the Smart Sharpen filter in 'Lens Blur' mode using the settings shown here. The Reduce Noise slider can help hide unwanted artifacts.

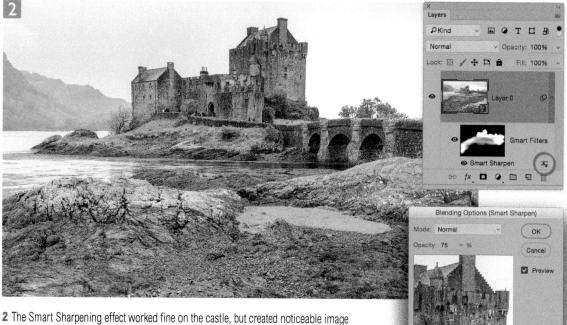

2 The Smart Sharpening effect worked fine on the castle, but created noticeable image artifacts in the background, so I clicked on the Smart Object mask layer, filled with black, and painted on this layer with white so that the smart filtering was applied selectively. I then double-clicked the Smart Object layer options (circled) to open the Blending Options dialog and reduced the filter effect opacity to 75%.

Q 1009

Saving the Smart Sharpen settings

You can save Smart Sharpen settings as you work by clicking on Presets menu circled below in Figure 3.12, and choose 'Save Preset...'

Advanced Smart Sharpen mode

Just below the Advanced mode section are two additional expandable sections: Shadows and Highlights. These controls act like dampeners on the main smart sharpening effect. The Fade Amount slider selectively reduces the amount of sharpening in either the shadows or highlights. This main control will have the most initial impact in reducing the amount of artifacting that may occur in the shadow or highlight areas. Below that is the Tonal Width slider and this operates in the same way as the one you find in the Shadows/Highlights image adjustment: you can use this to determine the tonal range width that the fade is applied to. These two main sliders can be used to subtly control the smart sharpening effect. The Radius also works in a similar way to the Radius slider found in the Shadows/Highlights adjustment and is used to control the width area of the smart sharpening.

In Figure 3.12 I set the Smart Sharpen filter to Advanced mode and applied an Amount of 400% at a Radius of 4.5 using the 'Lens Blur' mode. Once I had selected suitable settings for the main Smart Sharpen, I clicked on the Shadow and Highlight tabs and used the sliders in these sections to decide how to limit the main sharpening effect. A high Fade Amount setting faded the sharpening more, while the Tonal Width determined the range of tones that were to be faded. Lastly, there was the Radius slider, where I could enter a Radius value to determine the scale size for the corrections.

		Preview		۰.	ОК
	Preset:	Custom		·D	Cancel
	Amount:	<u></u>	400	%	
	Radius:		4.5	рх	
	Reduce Noise:	-	10	%	
	Remove:	Lens Blur ~	,) ø (9	
	✓ Shadows				
	Fade Amount:	-	19	%	
	Tonal Width:		15	%	
345 m 10 1 1	Radius:		9	рх	
	Highlights				
	Fade Amount:	•	15	%	
	Tonal Width:		10	%	
MARCE BARRAN TO PRIME	Radius:	-	5	рх	
and a second sec					
Q 100% Q					

Figure 3.12 The Advanced Smart Sharpen controls.

Removing Motion Blur

The Motion Blur method of smart sharpening can be reasonably good at improving sharpness where there is just a slight amount of camera shake or subject movement. With the Remove Motion Blur mode, the trick is to get the angle in the dialog to match the angle of the Motion Blur in the picture and adjust the Radius and Amount settings to optimize the Motion Blur correction.

In Figure 3.13 I initially set the Amount, Radius, and Angle to achieve the most effective sharpening and in Advanced mode I went to the Shadow tab to adjust the Fade Amount and Tonal Width settings so as to dampen the sharpening effect in the shadows. This helped achieve a smoother-looking result.

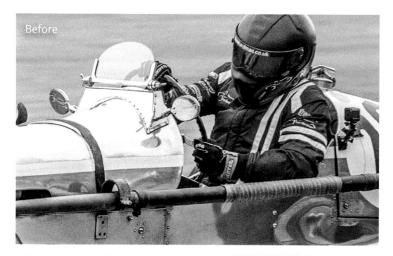

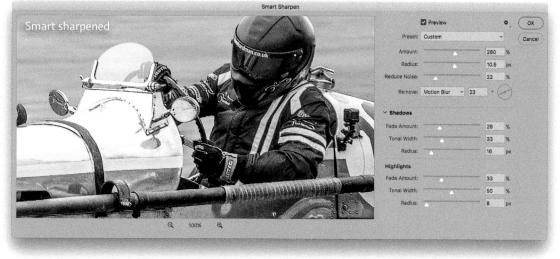

Figure 3.13 The Smart Sharpen Motion Blur mode.

Figure 3.14 The Shake Reduction filter tools.

Shake Reduction filter

The Shake Reduction filter can also be used to correct for motion blur. What it does is to correct the camera shake in a captured photo rather than work out how to refocus an out-of-focus image. The way it does this is by interpreting the image and looking for signs of camera shake. In particular, clues to the path that a camera moved during an exposure. For example, this will be most apparent in sharp pinpoint areas such as catch lights in the eyes. From this, the Shake Reduction filter is able to calculate a camera shake signature for the image and use this to work out how to reconstruct the scene without camera shake. It's like a software version of the image stabilizing control found on some lenses and cameras.

This can't be expected to work perfectly in every case as there is a lot of guesswork going on here that is being computed by the filter. It works best where the source image is essentially in focus, but was

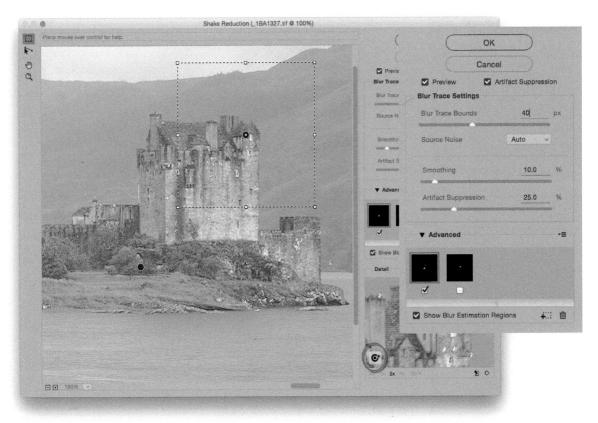

Figure 3.15 The Shake Reduction filter dialog. In this example, there is one blur trace active with an active blur trace region plus filled pin and one that's inactive (with a hollow pin).

shot at a slow shutter speed and where camera shake is the only issue. In other words, without additional subject movement. This means the filter works best when processing static subjects, because if you shoot anything that's moving at a slow shutter speed you'll have the combined issue of camera shake plus subject movement to contend with. It will also work best if the source image is captured with a decent lens and camera sensor.

The Shake Reduction controls

The Shake Reduction filter controls are quite complex. Fortunately, when you open the filter it automatically analyzes the image and applies auto-calculated settings for you, including the auto-placement of a blur estimation region, represented by a marquee area with a central pin. If you like the result this gives, then click OK to apply. If not, you can override this auto-calculated starting point and refine the settings. These are shown in Figure 3.15. The Detail view at the bottom shows you a close-up view of the current blur estimation region and as you adjust the controls you can preview the results of that adjustment. If you want to relocate the blur estimation region, then simply click in the main preview window. This re-centers the loupe. As you do this though, you will see a refresh icon appear in the bottom left corner of the loupe view (circled in Figure 3.15). Click on this to refresh the preview.

In the Blur Trace Settings section there is a Blur Trace Bounds slider. This is initially set automatically, but you can adjust the amount here to increase or decrease the size of the blur trace area. The Source Noise menu is used to specify the noise content of the original image and defaults to Auto, but you can override this to choose Low, Medium, or High. It is usually best to leave it set to 'Auto' though. The Smoothing slider can be used to control the sharpening-induced noise. In Figure 3.16 you can see an example of no Smoothing and with Smoothing. Below this is the Artifact Suppression slider, which can be used to suppress large artifacts. There is also a checkbox at the top of the panel controls that allows you to disable the Artifact Suppression and hides the Artifact Suppression slider. In Figure 3.17 'ringing' artifacts can clearly be seen in the 'Without' version. When the Artifact Suppression is applied using the correct amount, these can mostly be removed.

In the Advanced section there is an option to show or hide the Blur Estimation Regions in the preview area. This simply allows you to see the blur region outlines or not. Below that are the trace blur previews and here you can choose to turn individual blur regions on or off.

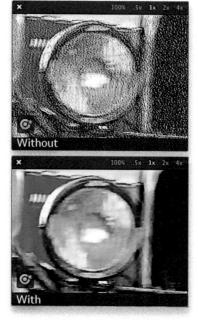

Figure 3.16 This shows the before and after effects of controlling the Smoothing

Figure 3.17 This shows the before and after effects of controlling the Artifact Suppression.

Figure 3.18 The Advanced controls and Advanced menu options.

Figure 3.19 The 'Region Too Small' warning.

Figure 3.20 An enlarged blur trace view.

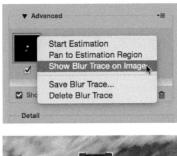

Figure 3.21 This shows the contextual blur trace menu with 'Show Blur Trace on Image' and a blur trace overlaying the preview.

Figure 3.18 shows a normal blur trace produced as a result of using the Blur estimation tool (see Figure 3.14). Figure 3.22 shows a manual blur trace, produced using the blur direction tool to manually define the camera shake blur. In the Figure 3.15 only one blur estimation blur trace was currently active. The Blur Trace settings can be applied individually to each blur trace. If the blur estimation made is too small, then you will see the warning shown in Figure 3.19, which points out the blur estimation region is not big enough to calculate a blur trace from.

In Figure 3.18, you can see the Advanced section menu options. This shows the Advanced controls, with the Advanced menu options and enlarge blur trace icon Here, you can save and load workspaces or blur traces. A workspace is the combination of the blur estimation regions plus their associated blur reduction settings. To save a blur trace, select one from the Advanced panel section and choose 'Save Blur Trace...' This will save the selected blur trace as a 16-bits per channel PNG format grayscale image (which you can then edit in Photoshop if you wish). Also, if you hover the mouse over a blur trace you can click on the enlarge blur trace icon (circled in Figure 3.18) to see a magnified blur trace view (see Figure 3.20). If you make a right mouse-click on a blur trace icon, you'll see a pop-up menu, from where you can choose 'Show Blur Trace on Image' (Figure 3.21). This overlays the Blur Trace on the image and allows you to adjust the Blur Trace Bounds slider to see how it grows or shrinks.

Repeat filtering

If you apply the Shake Reduction filter using an automatic settings adjustment, a repeat application of the Shake Reduction filter will also apply an automatic adjustment. If custom settings were used to override the auto-calculated settings, a repeat use of the filter will use these same user-defined settings. However, if the filter is repeated on an image with different dimensions, the image will be reanalyzed and auto-corrected.

Smart object support

You can also apply Shake Reduction as a Smart Filter and make use of the masking to apply the filter effect selectively.

Blur direction tool

The Blur direction tool can be used to manually specify the direction and length of a straight blur trace, but is only available when the Advanced options are expanded. It is purposely designed to let you apply a more aggressive style shake reduction to a specified area or areas. It's a tool you should therefore use in moderation and in conjunction with blur estimation region calculations to treat particularly tricky sections of an image (although you can use it on its own should you wish). A blur direction blur trace is represented using a lock icon (see Figure 3.22). Here you can see the Blur Trace Settings for when a Manual blur direction is in force.

You can edit a manual blur trace in a number of ways. You can click inside the bounds of the blur trace that overlays the preview and drag to reposition it. If you click on either of the two handles you can manually drag to change the length or angle of the blur trace. In Figure 3.23 the top view shows the blur direction tool being applied to an image, where I dragged with the tool to follow the direction and length of the blur. The bottom view shows how you can edit a manually defined blur trace. But just be aware that small changes made to the blur trace can have a significant effect on the result of the Shake Reduction adjustment. If you want to apply small, incremental adjustments you can use the bracket keys. Use **(1)** to reduce the blur trace length and use **(1)** to increase it. Also, you can use the **(Hac)**, **etrl ()** (PC) shortcut to twist the angle anti-clockwise and use the **(Hac)**, **etrl ()** (PC) shortcut to twist the angle clockwise.

How to get the best results

These detailed instructions are admittedly very complex. However, what I tend to find is that if the Shake Reduction filter is going to be of any use it will mostly apply an optimum correction using the default auto settings. To help improve the success of the filter, it is best to apply noise reduction first in Camera Raw (especially for the Color noise), avoid use of Clarity and Contrast and disable capture sharpening.

I imagine the majority of candidate images for this filter will have been shot using a camera phone or cheap compact camera, as it is these types of cameras that will suffer most from camera shake. At the same time, the camera settings in low light conditions will mean the camera is capturing an image at a high ISO setting and at full aperture. Therefore, the plug-in is having to contend with processing an image that's not optimally in focus and there will also be issues to do with sensor noise. That said, every bit helps of course. If you are aware of these limitations you should be pleased with its ability to at least make most pictures appear to look somewhat sharper than they did before, even if the results you get won't always be as dramatic as those shown in the demos.

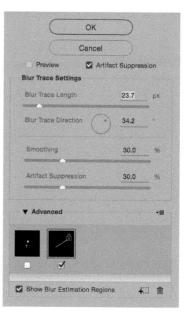

Figure 3.22 The Blur Trace Settings.

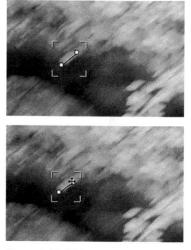

Figure 3.23 Editing a blur trace.

1 Here you can see the image I wished to improve. This was shot using a long focal length lens and there is noticeable camera shake in this picture.

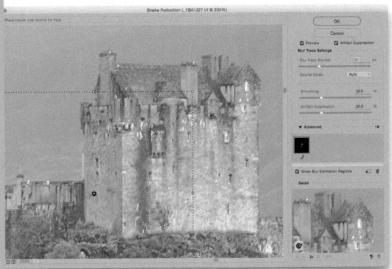

2 I went to the Filter menu and chose Sharpen ⇒ Shake Reduction. When this filter is opened it first auto-estimates the required blur size. It follows this by auto-estimating the required noise reduction (using the Auto setting). The Auto noise is a value calculated by the Shake Reduction algorithm (when set to 'None' it means it won't take noise into consideration). It will then auto-choose a blur trace estimate for the blur trace. The default Blur Trace size is determined by the image size and some image analysis, so it can be different from one image to another. After that, it will render a coarse preview followed by a fine preview. In many cases the result you see here should not need any further alteration to achieve a sharper result.

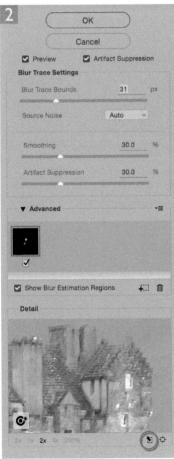

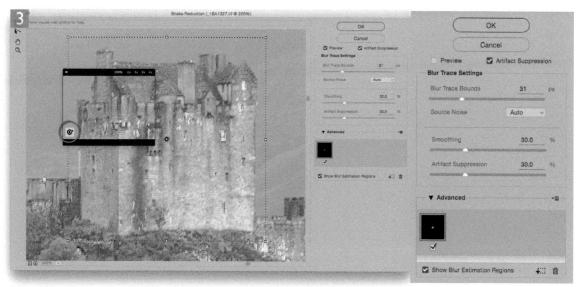

3 In the Detail section you can click on the Undock Detail button circled in Step 2 (or use the 🕢 toggle shortcut) to undock the Detail loupe. This will snap to the preview area and allow you to drag and reposition on an area of interest. As you adjust the Blur Trace Bounds you will see a fast update within the Detail loupe view. When repositioning the Detail loupe, click the refresh button (circled) to recalculate.

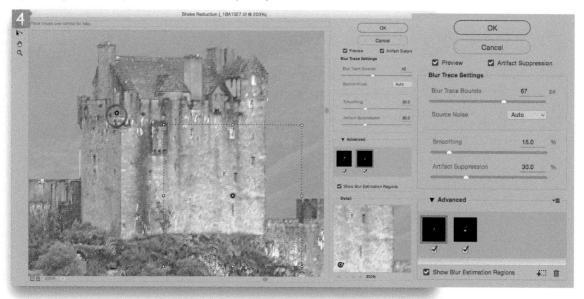

4 When the Advanced options are expanded, you can use the Blur estimation tool (E) to define additional blur trace regions, which will then be added to the Blur Estimation Regions gallery. When two or more of these are defined (and made active), the overall blur estimations are blended together between these points. In this step I had two regions defined (the first here is circled).

Creating a depth of field brush

On page 298 I described how you could use the Smart Sharpen filter to remove the blurriness from parts of an image and selectively apply the filter effect through a layer mask. There is also another way you can reduce blur in a photograph and this technique is closely based on a technique first described by Bruce Fraser, in the *Real World Image Sharpening with Adobe Photoshop, Camera Raw and Lightroom* (2nd Edition) book. The only thing I have done here is to change some of the suggested settings, in order to produce a narrower edge sharpening brush. Basically, you can adapt these settings to produce a sharpness layer that is suitable for different types of focus correction.

This technique can be used to help make the blurred image detail appear to look sharper by adding a blended mixture of sharp and soft halos, which create the illusion of apparent sharpness. You will notice that Step 2 involved editing the Blend If sliders. To create the split slider adjustment shown here, I held down the all key and clicked on one half of the slider arrow and drag to split it into two. I also changed the blend mode of the duplicate background layer to Overlay. This initially made the image appear more contrasty, but you will notice that once I had applied the Unsharp Mask followed by the High Pass filter, it was only the image edges that were enhanced. In Step 3 you will notice I applied the Unsharp Mask filter at a maximum strength of 500%, with a Radius of 1.0 pixel and the Threshold set to zero. The purpose of this step was to aggressively build narrow halos around all the edge detail areas, and in particular the soft edges, while the High Pass filter step was designed to add wider, overlapping, soft-edged halos that increase the midtone contrast.

When these two filters are combined you end up with a layer that improves the apparent sharpness in the areas that were out of focus, but the downside is that the previously sharp areas will now be degraded. By adding a layer mask filled with black, you can use the Brush tool to paint with white on the layer mask to selectively apply the adjustment to those areas where the sharpening effect is needed most. The Unsharp Mask and High Pass filter settings used here were designed to add sharpness to areas that contained a lot of narrow edge detail (such as the edges in a landscape). You will want to vary these settings when treating other types of photographs where you perhaps have wider edges that need sharpening.

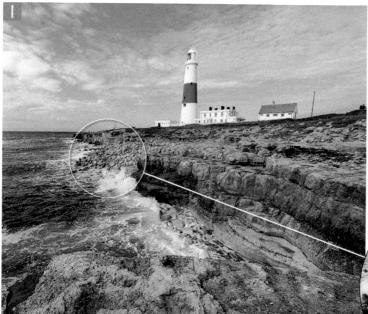

1 This shows the before version of a photograph in which the foreground was perfectly sharp, but there was a fall-off in focus towards the middle distance. The first step was to make a duplicate of the Background layer.

Styles		Blending Options General Blending O	ĸ
Blending Options		Blend Mode: Overlay	
Bevel & Emboss		Opacity: 50 % Car	icel
Contour		Advanced Biending New S	tyle
() Texture		Fill Opacity: 100 %	ulaw
C Stroke	+	Channels: 🖸 R 🖸 G 🖸 B	VIEW
Inner Shadow	Ŧ	Knockout: None V	
Inner Glow		Blend Interior Effects as Group	
Satin		Transparency Shapes Layer	
Color Overlay	Ŧ	Layer Mask Hides Effects	
Gradient Overlay	+	Vector Mask Hides Effects	
Pattern Overlay		Blend If: Gray 🗸	
Outer Glow		This Layer: 0 225 / 255	
Drop Shadow	Ŧ	Underlying Layer: 0 / 30 225 / 255	
fx 🔹 🖶	8		

2 I then double-clicked the Background layer to open the Layer Style options. The blend mode was set to Overlay and the layer Opacity reduced to 50%. The layer 'Blend If' sliders were adjusted as shown here so the sharpening effect would be limited to the midtone areas only and the extreme shadows and highlights were protected.

High Pass Unsharp Mask OK OK Cance Cancel Preview Preview 0 100% • Radius: 20 Pixels Amount: 500 % Radius: 1.0 Pixels Threshold: 0 levels

3 I clicked OK to the Layer Style changes and applied an Unsharp Mask filter to the Background copy layer, using an amount of 500% and a Radius of 1.0 pixel. This was followed by a High Pass filter (Filter \Rightarrow Other \Rightarrow High Pass) using a Radius of 20 pixels.

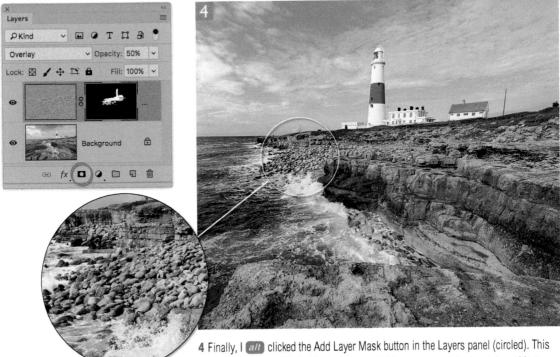

4 Finally, I <u>all</u> clicked the Add Layer Mask button in the Layers panel (circled). This added a layer mask filled with black, which hid the layer contents. I was then able to select a normal brush and paint on the layer mask with white to reveal the depth of field sharpening layer and in doing so, add more apparent sharpness to the middle distance.

Chapter 4

Image editing essentials

So far I have shown just how much can be done to improve an image when editing it in Camera Raw, before you bring it into Photoshop. Some of the techniques described in this chapter may appear to overlap with Camera Raw editing, but image adjustments such as Levels and Curves still play an important role in everyday Photoshop work. This chapter also explains how to work with photos that have never been near Camera Raw, such as images that have originated as TIFFs or JPEGs. I'll start off by outlining a few of the fundamental principles of pixel image editing such as bit depth and the relationship between image resolution and image size. After that we'll look at the main image editing adjustments and how they can be used to fine-tune the tones and colors in a photograph.

Pixels versus vectors

Digital photographic images are constructed of a mosaic of pixels and as such are resolution-dependent. If you enlarge such an image beyond the size at which it is meant to be printed, the pixel structure will soon become apparent. Therefore, the ultimate size at which a pixel image can be printed is limited by the number of pixels an image has.

By contrast, vector objects, created in programs like Adobe Illustrator (as well as Photoshop), are defined mathematically. If you draw a vector shape, the proportions of the shape edges, the relative placement on the page, and fill color can all be described using a mathematical description. An object defined using vectors is therefore resolution-independent and it does not matter if the image is reproduced on a computer display, a postage stamp or as a huge poster, it will always be rendered with the same amount of detail. In Figure 4.1, the image on the left shows an enlarged (website resolution) pixel image of the front cover design and the screen shot on the right shows the vector paths that were used to create the neon sign effect. As you can see, the pixel image version starts to break up as soon as it is magnified, whereas the outlines in the vector image can reproduce smoothly at any size.

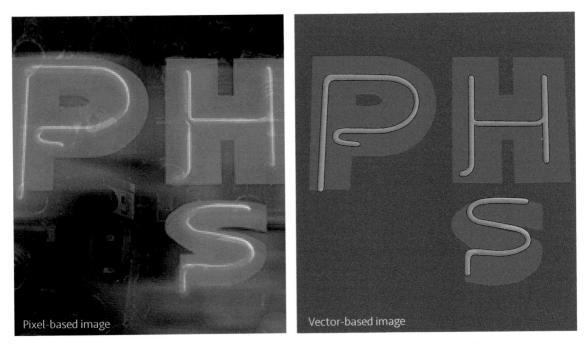

Figure 4.1 A comparison between a pixel- and vector-based image.

Photoshop as a vector program

Photoshop is both a pixel and vector editing program. This is because Photoshop contains a number of vector-based features that can be used to generate things such as custom shapes and layer clipping paths. This raises some interesting possibilities, because you can create various graphical elements like type, shape layers, and layer clipping paths in Photoshop, which are all resolution-independent. These vector elements can be scaled in size in Photoshop without any loss of detail, just as they can when placed as an Illustrator graphic.

Image resolution terminology

Before I proceed any further let me help explain a few of the terms that are used when describing image resolution and clarify their correct usage.

PPI: pixels per inch

The term 'pixels per inch' (PPI) should be used to describe the pixel resolution of an image. However, the term 'dots per inch' (DPI) is sometimes used instead. This is wrong because digital devices like scanners and cameras work with pixels and it's only printers that produce dots. Even so, it's become commonplace for scanner manufacturers and other software programs to use the term 'DPI' when what they really mean is 'PPI.' Unfortunately this has only added to the confusion, because you often hear people describing the resolution of an image as having so many 'DPI,' but if you look carefully, Photoshop and the accompanying user guide always refer to the input resolution as being in 'pixels per inch.' So if you have an image that has been captured on a digital camera, scanned from a photograph, or displayed in Photoshop, it is always made up of pixels and the pixel resolution (PPI) is the number of pixels per inch in the input digital image. Obviously, those using metric measurements can refer to the number of 'pixels per centimeter.'

LPI: lines per inch

LPI refers to the number of halftone lines or 'cells' in an inch (also described as the screen ruling). The origins of this term go back way before the days of digital desktop publishing. To produce a halftone plate, the film exposure was made through a finely etched criss-cross screen of evenly spaced lines on a glass plate. When a continuous tone photographic image was exposed this way, dark areas formed heavy halftone dots and the light areas formed smaller dots, which when

Figure 4.2 A halftone dot shown here within a 16 ×16 dot matrix.

viewed from a normal distance gave the impression of a continuous tone image on the page. The line screen resolution (LPI) therefore refers to the frequency of halftone dots or cells per inch.

DPI: dots per inch

This should refer to the resolution of an output device. For example, each halftone dot is rendered by a PostScript RIP from the pixel data and output to a device called an 'imagesetter.' The halftone dot, such as the one illustrated in Figure 4.2 is plotted using a 16×16 dot matrix. This matrix can therefore reproduce a total of 256 shades of gray and it is the variation in halftone cell size (constructed of smaller dots) which gives the impression of tonal shading when viewed from a distance.

The DPI resolution of the imagesetter, divided by 16, will equal the line screen resolution. Therefore, if the resolution of the imagesetter is 2400 DPI, if this is divided by 16 you get a 150 LPI screen resolution.

You may hear people refer to the halftone output as 'DPI' instead of 'LPI,' as in the number of 'halftone' dots per inch, and the imagesetter resolution referred to as having so many 'SPI,' or 'spots per inch.' Whatever the terminology I think we can all logically agree on the correct use of the term 'pixels per inch,' but I am afraid there is no clear definitive answer to the mixed use of the terms 'DPI', 'LPI,' and 'SPI.' It is an example of how the two separate disciplines of traditional repro and those who developed the digital technology chose to apply different meanings to these same terms.

Desktop printer resolution

In the case of desktop inkjet printers the term 'DPI' can (correctly) be used to describe the resolution of the printer head. The DPI output of a typical inkjet can range from 360 to 2880 DPI. Inkjet printers lay down a scattered pattern of tiny dots of ink that accumulate to give the impression of different shades of tone, depending on either the number of dots, the varied size of the dots, or both. While a correlation can be made between the pixel size of an image and the 'DPI' setting for the printer, it is important to realize that the number of pixels per inch is not the same as the number of dots per inch created by the printer. When you send a Photoshop image to an inkjet printer, the pixel image data is processed by the print driver and converted into data that the printer uses to map the individual ink dots that make the printed image. The 'DPI' used by the printer simply refers to the fineness of the dots. Therefore a print resolution of 360 DPI can be used for speedy, low-quality printing, while a DPI resolution of 2880 can be used to produce high-quality print outputs.

Altering the image size

The image size dimensions and resolution can be altered using the Image Size dialog (Figure 4.3). The user interface is straight forward and makes it easy to understand what you are doing when you modify the Width, Height, and Resolution settings. The image preview window shows you what the resized image will look like and can be made larger by resizing the Image Size dialog box. You can also click inside the preview and drag to pan the preview image; the dialog settings are also sticky.

If you go to the 'Fit To' menu and select Auto... this opens the Auto Resolution dialog shown below. This can help you pick the ideal pixel resolution for repro work based on the destination line screen resolution. The Resample menu lists all the available pixel resampling options (see the sidebar for the keyboard shortcut options). These can make it easy to toggle and compare different interpolation methods. When the Resample box is checked (as shown in Figure 4.3) you can

Resample method shortcuts

While the Image Size dialog is active you can use the following keyboard shortcuts to quickly access a desired resample method.

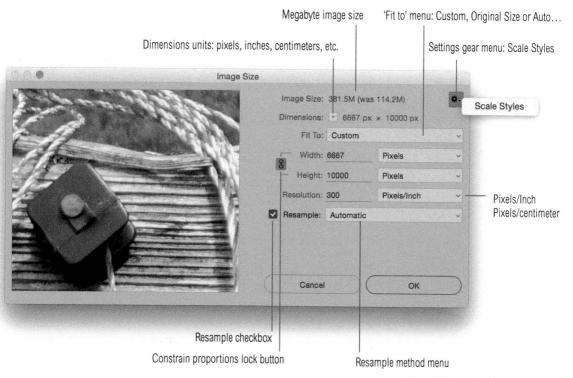

Figure 4.3 The Image Size dialog.

0000	+	OK
		Cance
it		
	t	t

resize an image by adjusting the values for the Width and Height fields, or by adjusting the Resolution. If you uncheck the Resample checkbox the Resolution field becomes linked to the Width and Height fields and you can resize an image to make it print bigger or smaller by altering the Width/Height dimensions, or the file resolution (but not the actual image document size). Therefore, any adjustment made to the Width, Height, or resolution settings will not alter the total pixel dimensions and only affect the relationship between the measurement units and the resolution. The formula is really simple: the number of pixels = physical dimension \times (PPI) resolution. You can put that to the test here and use the Image Size dialog as a training tool to better understand the relationship between the number of pixels, the physical image dimensions and resolution. For example, if you have an image that is 3000 pixels x 2400 pixels you can output it at 10 inches x 8 inches @ 300 pixels per inch. Or, you can output the same image at 15 inches x 12 inches @ 200 pixels per inch.

The constrain proportions lock button links the horizontal and vertical dimensions, so that any adjustment is automatically scaled to both axes. Only uncheck this if you wish to squash or stretch the image when altering the image size.

Image interpolation

Image resampling is also referred to as interpolation and there are seven methods to choose from when resizing an image. The interpolation options are all located in the Resample menu (see Figure 4.3) as well as appearing in the Options bar when transforming a layer (except for the Edge-Preserving Upscale option).

In theory the larger a picture is printed, the further away it is meant to be viewed. Because of this you can easily get away with a lower pixel resolution such as 180 or 200 pixels per inch when creating a poster print output. There are limits, though, below which the quality will suffer and the image won't contain enough detail at normal viewing distance (except at the smallest of print sizes). As my late colleague Bruce Fraser used to say, "in the case of photographers, the ideal viewing distance is limited only by the length of the photographer's nose."

I generally consider it better to 'interpolate up' an image in Photoshop rather than rely on a third-party program. Digital camera files are extremely clean and because there is no grain present, it is usually easier to magnify a digitally captured image than a scanned image of equivalent size. Here is a guide to how each of the interpolation methods work and which are the best ones to use and when.

Nearest Neighbor (hard edges)

This is the simplest interpolation method of all, in which the pixels are interpolated exactly using the nearest neighbor information. I actually use this method a lot to enlarge dialog box screen grabs by 200% for use in the book. This is because I don't want the interpolation to cause the sharp edges of the dialog boxes to appear fuzzy. Interpolating at 200% makes each single pixel become four identical pixels.

Bilinear

This calculates new pixels by reading the horizontal and vertical neighboring pixels. It is a fast method of interpolation, which was perhaps an important consideration in the early days of Photoshop, but there is not much reason to use it now.

Bicubic (smooth gradients)

This provides better image quality when resampling continuous tone images. Photoshop reads the values of neighboring pixels vertically, horizontally, and diagonally, to calculate a weighted approximation of each new pixel value. Photoshop intelligently guesses new pixel values, by referencing the surrounding pixels.

Bicubic Smoother (enlargement)

This is the ideal choice whenever you want to make a picture bigger, as it will result in smoother, interpolated enlargements.

Bicubic Sharper (reduction)

This method should be used whenever you need to reduce the image size more accurately. If you use Bicubic Sharper to dramatically reduce a master image in size, this can help avoid the stair-step aliasing that can sometimes occur when using other interpolation methods.

Bicubic Automatic

In the Photoshop preferences you'll notice how Bicubic Automatic is the default option. This automatically chooses the most suitable interpolation method to use when resizing an image. If you make a small size increase/decrease, it applies the Bicubic interpolation method. If upsampling to a greater degree, it uses Bicubic Smoother and if downsampling to a greater degree, it selects the Bicubic Sharper option. The same logic is also applied if you select the Bicubic Automatic option when transforming a layer.

Planning ahead

Once an image has been scanned at a particular resolution and manipulated, there is no going back. A digital file prepared for advertising usage may never be used to produce anything bigger than an A4 size. 35 MB CMYK separation, but you never know. It is therefore safer to err on the side of caution and better to sample down than have to interpolate up. It also depends on how much manipulation you intend doing. Some styles of retouching work are best done at a magnified size and then reduced afterwards. Suppose you wanted to blend a small element into a detailed scene. To do such work convincingly, you need to have enough pixels to work with to be able to see what you are doing. Another advantage of working with large file sizes is you can always guarantee being able to meet clients' constantly changing demands, even though the actual resolution required to illustrate a glossy magazine double-page full-bleed spread is probably only around 40-60 MB RGB or 55-80 MB CMYK. Some advertising posters may even require smaller files than this, because the print screen on a billboard poster is that much coarser.

When you are trying to calculate the optimum resolution you cannot rely on being provided with the right advice from every printer.

Deep Upscaling

If you check Enable Preserve Details 2.0 Upscale in the Technology Previews preferences, the Preserve Details resampling method utilizes an artificial intelligence trained resampling model (known as Deep Upscaling). This uses a deep learning neural network model that detects and preserves the most important details and textures in images when resizing, without introducing over-sharpening of prominent edges or smoothing out lower contrast details. It better preserves localized areas of texture and critical edges that can otherwise appear smoothed out in traditional resampling methods. The downside is that upsizing using this new method does take longer than usual to process.

Preserve Details (enlargement)

These days most digital cameras are capable of shooting files large enough for most output requirements. However, if an image ends up being heavily cropped, or you are perhaps working with older images shot with a camera that had a low number of megapixels, you may need to enlarge an image in order to meet some output requirements. The Preserve Details option works by upscaling the image in multiple steps of x1.5 magnification. At each step the image is divided into 7x7 pixel segments and the output step segments are compared with the source. This algorithm makes use of the high frequency information in the source to make the patches in the output appear as sharp as the source and so on at each stage. The calculation is also carried out in a color space similar to Lab in order to reduce color contamination and to gain speed.

Since the Preserve Details upscaling process has a tendency to generate noise artifacts you can use the Reduce Noise slider to produce a smooth-looking result. As with all noise reduction, there will be a trade-off between edge sharpness and noise removal, so if you set the Noise slider too high you may end up with an over-soft result. You can check the Image Size dialog preview to judge just how much noise reduction should be added.

•	nage Size			
NIX	and the second se	215.2M (was		¢.
VOIT	Fit To:	Custom		~
1 A man a	Width:	500	Percent	~
	Height:	500	Percent	~
	Resolution:	300	Pixels/Inch	~
	Resample:	e: Bicubic Smoother (enlargen		•
0× 1º	Canc	:el	ОК	\supset

1 This shows a close-up section of a photograph, where I used the Image Size dialog to enlarge by 500%. I selected the Bicubic Smoother option to enlarge the image.

2	Image Size				
XXX			215.2M (was 8		٥.
V V /	FI	it To:	Custom		~
	w w	idth: 5	00	Percent .	~
	He	ight: 5	00	Percent	~
	Resolu	tion: 3	00	Pixels/Inch	~
	Resam	iple:	Preserve Det	ails (enlargement)	~
	Reduce No	oise: 🋆		0	%
ox 1		Cancel	\Box	ОК	\supset
A CONTRACTOR OF THE OWNER		Contraction of			

2 In this step I selected the Preserve Details option (utilizing the new Deep Upscaling method). If you compare this with the preview in Step 1, the detail in the lettering is slightly crisper.

3	Image Size			
XX		215.2M (was 8		¢.
LY Y	Fit To:	Custom		~
	Width:	500	Percent	~
	Height:	500	Percent	~
	Resolution:	300	Pixels/Inch	~
	Resample:	e: Preserve Details (enlargement)		~
	Reduce Noise:		50	%
ox 19	Cance	a) (ОК	

3 Although the Preserve Details option helped keep the details looking sharp, it did so at the expense of adding more noise to the image. A Reduce Noise slider appears when this option is selected. By increasing the Reduce Noise setting it was possible to reduce some of the noise that resulted from this Preserve Details (enlargement) choice.

Photoshop image adjustments

In Chapter 2 we explored the use of Basic panel adjustments in Camera Raw to optimize a photo before it is opened in Photoshop as a rendered pixel image. The following section is all about the main image adjustment controls in Photoshop and how you can use these to fine-tune your images, or use them as an alternative to working in Camera Raw, such as when editing camera shot JPEGs or scanned TIFFs directly in Photoshop.

If you intend bringing your images in via Camera Raw, it can be argued that Photoshop image adjustments are unnecessary, since Camera Raw provides you with everything you need to produce perfectly optimized photos. Even so, you will still find the information in this chapter important, as these are the techniques every Photoshop user needs to be aware of and use when applying things like localized corrections. The techniques discussed here should be regarded as essential foundation skills for Photoshop image editing. However you bring your images into Photoshop, you will at some point need to know how to work with the basic image editing tools such as Levels and Curves. So, for now, let's look at some basic pixel image editing principles and techniques.

The image histogram

The histogram graphically represents the relative distribution of the various tones (referred to as Levels) that make up a digital photograph. While we can use our eyes to make subjective judgments about how the picture looks, we can also use the numeric information to provide useful and usable feedback. The Histogram panel is an excellent reference tool with which to interpret an image. For example, an 8-bit per channel grayscale image has a single channel and uses 256 shades of gray to describe the levels of tone from black to white. Black has a levels value of 0 (zero), while white has a levels value of 255 and all the numbers in between represent the different shades of gray going from black to white. The histogram is therefore like a bar graph with 256 increments, each representing how frequently a particular levels number (a specific gray value) occurs in the image. Figure 4.4 shows a typical histogram such as you'll see in the Histogram, Levels, and Curves panels. This diagram also shows how the appearance of the graph relates to the tonal structure of a photographic image.

Now let's look at what that information can actually tell you. It shows the position of the shadow and highlight points and the distribution of the levels information between those two points. For example, with a low-key photograph (such as the one shown

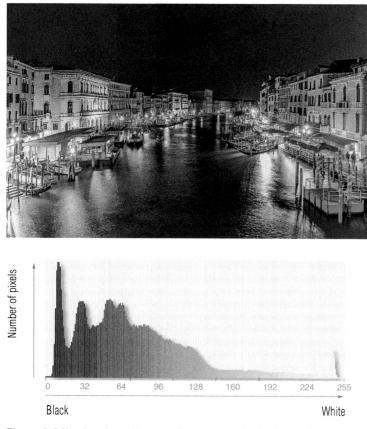

in Figure 4.4) the levels are predominantly located to the left end of the histogram. The height of each bar in the histogram indicates how frequently each levels value is represented in the image based on a 0–255 scale. When you apply a tonal correction using Levels or Curves, the histogram provides visual clues that help you judge where the brightest highlights and deepest shadows should be. The histogram also tells you something about the condition of the image you are editing. If there are peaks jammed up at one or other end of the histogram, this suggests that either the highlights or the shadows have become clipped. In other words, when the original photograph was captured or scanned it was effectively under- or overexposed. Unfortunately, once the levels are clipped you can't restore the detail that's been lost here. Also, if there are gaps in the histogram, this most likely indicates a poor quality original capture or scan, or that the image had previously been heavily manipulated.

Figure 4.5 The Histogram panel.

The Histogram panel

A histogram will be shown whenever you work in Levels and Curves, plus there is a separate Histogram panel (Figure 4.5) to provide feedback when working in Photoshop. With the Histogram panel, you can continuously observe the effect your image editing has on the image levels and you can check the histogram while making any type of image adjustment. The Histogram panel initially provides an approximate representation of the image levels. To obtain more accurate feedback, click on the Refresh button in the top right corner (circled in Figure 4.5). This forces Photoshop to update the Histogram view.

Throughout this book I like to guide readers to work as nondestructively as possible. So be aware, anything you do to adjust the levels to make the image look better will result in some data loss. This is normal and an inevitable consequence of the image editing process. The steps on the page opposite illustrate what happens to the histogram when you edit a photograph. You will notice that as you adjust the input levels and adjust the Gamma (middle) input slider, you end up stretching some of the levels further apart and gaps may start to appear in the histogram. More importantly, stretching the levels further apart can result in less well-defined tonal separation and therefore less detail in these regions. This can particularly be a problem with shadow detail because there are always fewer levels of usable tone information in the shadows compared with the highlights (see Digital exposure on page 142). While moving the Gamma slider causes the tones on one side to stretch, it causes the tones on the other side to compress and these can appear as spikes in the histogram. This too can mean data loss, resulting in flatter tone separation.

The histogram can therefore be used to provide visual feedback on the levels information in an image and indicate whether there is clipping at either end of the scale. However, does it really matter whether you obtain a perfectly smooth histogram or not? If you are preparing a photograph to go to a print press, you would be lucky to detect more than 50 levels of tonal separation from any single ink plate. Therefore, the loss of a few levels at the completed edit stage does not necessarily imply you have too little digital tonal information from which to reproduce a full-tonal range image in print. Having said that if you begin with a bad-looking histogram, the image is only going to be in a worse state after it has been retouched. For this reason it is best to start out with the best quality scan or capture you can get.

Basic Levels editing and the histogram

The image editing example below was carried out on an 8-bit RGB image, so it should come as no surprise that the histogram broke down as soon as I applied a simple Levels adjustment (the following section highlights the advantages of editing in 16-bits per channel mode).

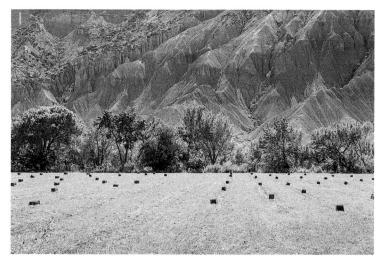

1 This image contained an evenly distributed range of tones, as can be seen in the accompanying Histogram panel view.

2 I applied a Levels image adjustment and dragged the middle (gamma) input slider to the left. This lightened the image and the Histogram panel on the right shows the histogram display as this adjustment had been applied. Notice how the levels in the section to the left of the gamma slider became stretched (there are gaps) and the levels to the right of the gamma slider became compressed (they are more spiky).

de

Why is 16-bits really 15-bits?

You may have noticed that Photoshop's 16-bits per channel mode is actually 15-bit as it uses only 32,768 levels out of a possible 65,536 levels when describing a 16-bit mode image. This is because having a tonal range that goes from 0 to 32,767 is more than adequate to describe the data coming off any digital device. Also, from an engineering point of view, 15-bit math calculations give you an exact midpoint value, which can be important for precise layer blending operations.

Bit depth

The bit depth refers to the maximum number of levels per channel that can be contained in a photograph. The bit depth is a mathematical description of the maximum levels of tone that are possible, expressed as a power of 2. An 8-bit grayscale image contains 2 to the power of 8 (2^8) and up to 256 levels of tonal information. An 8-bit RGB color image is made up of three 8-bit image channels, which results in a 24-bit color image with 16.7 million colors (see Figure 4.6). A 16-bit per channel image can contain up to 32,768 data points per color channel, because, in truth, Photoshop's 16-bit depth is actually 15-bit +1 (see sidebar).

JPEG images are always limited to 8-bits, but TIFF and PSD files can be in 8-bits or 16-bits per channel. Photoshop lets you edit in 8-bit or 16-bits per channel modes using standard integer channels. Any source image with more than 8-bits per channel has to be processed as a 16-bits per channel mode image. Since most scanners are capable of capturing at least 12-bits per channel data, this means such images should ideally be edited as 16-bits per channel images in order to preserve all of the 12-bits per channel data.

You can check the bit depth of an image quite easily by looking at the document window title bar, where it will indicate the bit depth as being 8, 16 or 32-bit. With the 32-bit mode, Photoshop uses floating point math instead of integer values to calculate the levels.

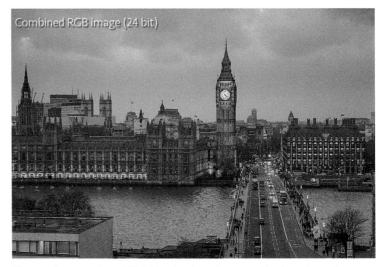

Figure 4.6 When three RGB 8-bit color channels are combined together to form a composite color image, the result is a 24-bit color image that can contain up to 16.7 million shades of color (2⁸ x 3).

In the case of raw files, a raw image contains all the original levels of capture image data, which will usually have been captured at a bit depth of 12-bits, or 14-bits per channel. Camera Raw image adjustments are mostly calculated using 16-bits per channel, so once again, all the levels information that is in the original can only be preserved when you save a Camera Raw processed raw image using 16-bits per channel mode.

8-bit versus 16-bit image editing

A higher bit depth doesn't add more pixels to an image. Instead, it offers a greater level of precision to the way tone information is recorded by the camera or scanner sensor. One way to think about bit depth is to consider the difference between making measurements with a ruler that is accurate to the nearest millimeter, compared with one that's only accurate to the nearest centimeter. Which would you find most useful?

There are those who have suggested 16-bit editing is a futile exercise because no one can tell the difference between an image that has been edited in 16-bit and one that has been edited in 8-bit. Well, if a scanner or camera is capable of capturing more than 8-bits per channel, then why not make full use of the extra tonal information? If a scanner say, is capable of scanning to a greater bit-depth than 8-bits per channel, you might as well save the freshly scanned images using the 16-bits per channel mode and apply the initial Photoshop edits using Levels or Curves in 16-bit. If you preserve all the levels in the original through these early stages of the edit process, you'll have more headroom to work with and avoid dropping useful image data. Overall, it may only take a second or two longer to edit an image in 16-bits per channel compared with when it is in 8-bit, but even if you only carry out the initial edits in 16-bit and then convert to 8-bit, you'll retain significantly more image detail. Similarly with raw camera files, all the levels are preserved as you edit in Camera Raw. You might as well continue to make use of that levels data when you switch to editing in Photoshop.

My second point is that you never know what the future holds in store for us. On pages 346–349 we shall be looking at Shadows/ Highlights adjustments. This type of adjustment can be used to emphasize image detail that might otherwise have remained hidden in the shadows or highlight areas. It exploits the fact that a deep-bit image can contain lots of levels of data that can be further manipulated to reveal more detail. A Shadows/Highlights adjustment can still work just fine with 8-bit images, but you'll get better results if you open your raw processed images as 16-bit photos or scan in 16-bit per channel mode first. Photoshop also offers extensive support for 16-bit editing. When a 16-bit grayscale, RGB, CMYK or Lab color mode image is opened in Photoshop you can crop, rotate, apply all the usual image adjustments, use any of the Photoshop tools and work with layered files. The main restriction is that not all filters can work in 16-bits per channel mode. You may not feel the need to use 16-bits per channel all the time, but it is a good idea to at least make all your preliminary edits in 16-bits per channel mode. It should go without saying of course, but there is no point editing an image in 16-bit unless it started out as a deep-bit image to begin with. There is nothing to be gained by converting to 16-bit an image that is already in 8-bit.

If you use Camera Raw to process a raw camera file or a 16-bit TIFF, the Camera Raw edits will all be carried out in 16-bits. If you are able to produce a perfectly optimized image in Camera Raw it can be argued there is less harm in converting such a file to an 8-bits per channel mode image in Photoshop. However, you never know when you might be required to edit an image further. If you keep a photo in 16-bits this gives you peace of mind, knowing that you've preserved as many levels as possible that were in the original capture or scan.

In the steps shown opposite, I started with an image that was in 16-bits mode and created a duplicate version that was converted to 8-bits. I then proceeded to compress the levels and expand them again in order to demonstrate how keeping an image in 16-bits per channel mode provides a more robust image mode for making major tone and color edits. Admittedly, this is an extreme example, but preserving an image in 16-bits offers a significant extra margin of safety when making everyday image adjustments.

16-bit and color space selection

Photoshop allows you to edit extensively in 16-bits per channel mode. One of the advantages this brings is you are not limited to editing in relatively small gamut RGB workspaces. If you edit using 16-bit, it is perfectly safe to use a large gamut space such as ProPhoto RGB because you'll have that many more data points in each color channel to work with (see the following section on RGB edit spaces).

Comparing 8-bit with 16-bit editing

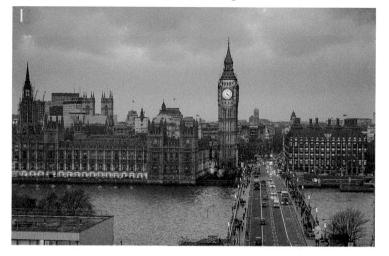

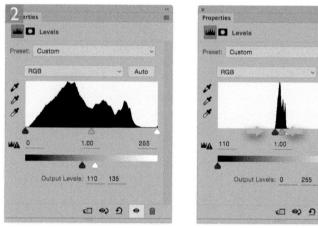

1 Here, I started out with a full color image that was in 16-bits per channel mode and created a duplicate that was converted to 8-bits per channel mode.

2 With each version I applied two sequential Levels adjustment layers. The first (shown here on the left) compressed the output levels to an output range of 110-135. I then applied a second Levels adjustment layer in which I expanded these levels to 0-255 again.

3 The outcome of these two sequential Levels adjustments can clearly be seen when examining the individual color channels. On the left you can see the image histogram for the 8-bit file green channel after these two adjustments had been applied and on the right you can see the histogram of the 16-bit file green channel after making the same adjustments. As you can see, with the 8-bit version there is noticeable banding in the sky and gaps in the histogram. Meanwhile, the 16-bit version exhibits no banding and retains a smooth histogram.

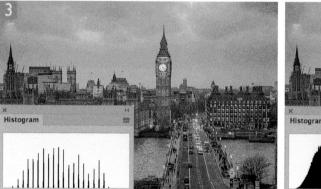

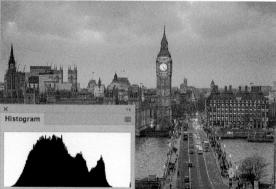

~ Auto

135

•

255

Settings: Euro pres	stess oustom	
Working Spaces		C
RGB:	ProPhoto RGB	Eng
CMYK:	Coated FOGRA39 (ISO 12647-2:2004) ~	Int
Gray:	Dot Gain 15%	
Spot:	Dot Gain 15%	
Color Managemen	t Policies	
RGB:	Preserve Embedded Profiles ~	A
OMYK:	Preserve Embedded Profiles ~	
Gray:	Preserve Embedded Profiles	
Profile Mismatches:	Ask When Opening Ask When Pasting	۵
Missing Profiles:	Ask When Opening	-
Description		
Euro prepress custom		

Figure 4.7 The Color Settings dialog.

The RGB edit space and color gamut

One of the first things you need to do when you configure Photoshop is to open the Edit \Rightarrow Color Settings dialog (Figure 4.7) and choose an appropriate RGB edit space from the RGB Working Spaces menu.

For photo editing work, the choice really boils down to Adobe RGB or ProPhoto RGB. The best way to illustrate the differences between these two RGB color spaces is to consider how colors captured by a camera or scanner are best preserved when they are converted to print. Figure 4.8 shows (on the left) top and side views of a 3D plot for the color gamut of a digital camera, seen relative to a wire frame of the Adobe RGB working space. Next to this you can see top and side views of a glossy inkjet print space plotted as a solid shape within a wire frame of the same Adobe RGB space. You will notice here how the Adobe RGB edit space clips both the input and output color spaces. This can be considered disadvantageous because all these potential colors are clipped as soon as you convert the capture data to Adobe RGB. Meanwhile, Figure 4.9 offers a direct comparison showing what happens when you select the ProPhoto RGB space. This shows on the left a top and side view of the gamut of a digital

Figure 4.8 A comparison between the size of a digital camera capture and the Adobe RGB space and an inkjet print output and the Adobe RGB space.

camera source space plotted as a solid shape within a wire frame shape representing the color gamut of the ProPhoto RGB edit space. On the right is a top and side view of the gamut of a glossy inkjet printer color space plotted as a solid shape within a wire frame of the same ProPhoto RGB space. The ProPhoto RGB color gamut is so large it barely clips the input color space at all and is certainly big enough to preserve all the other colors through to the print output stage. In my view, ProPhoto RGB is the best space to use if you really want to preserve all the color detail that was captured in the original photo and see those colors preserved through to print.

Another choice offered in the Color Settings is the sRGB color space, but this is only really suited for Web output work (or when sending pictures to clients via email).

There have been concerns that the ProPhoto RGB space is so huge that the large gaps between one level's data point and the next could lead to posterization. This might be a valid argument where images are mainly edited in 8-bits per channel throughout. In practice, you can edit a ProPhoto RGB image in 16-bits or 8-bits per channel mode, but 16-bits is safer. Also, these days you can use Camera Raw to optimize an image prior to outputting as a ProPhoto RGB pixel image.

Figure 4.9 A comparison between the size of a digital camera capture and the ProPhoto RGB space and an inkjet print output and the ProPhoto RGB space.

Figure 4.10 This shows the classic workflow for applying a levels adjustment.

Direct image adjustments

Most Photoshop image adjustments can be applied in one of two ways. There is the traditional, direct adjustment method where image adjustments can be accessed via the Image \Rightarrow Adjustments menu and applied to the whole image (or an image layer) directly. Figure 4.10 shows the classic way to apply a basic Levels adjustment. Here, I had an image open with a Background layer, I went to the Image Adjustments menu and selected 'Levels...' (**H** [Mac], *ettl* [PC]). This opened the Levels dialog and I was able to apply a permanent Levels adjustment to the tones in this photograph.

Direct image adjustments are appropriate for those times where you don't need the editability that adjustment layers can offer. They are also the only way to edit an alpha channel or layer mask.

Adjustment layers

With adjustment layers, an image adjustment can be applied in the form of an editable layer adjustment. These can be added to an image in several ways. You can go to the Layer \Rightarrow New Adjustment layer submenu, or click on the Add new adjustment layer button in the Layers panel to select an adjustment type. Or, you can also use the Adjustments panel to add an adjustment layer. The Properties panel (in adjustment controls mode) displays the adjustment controls.

In the Figure 4.11 example I again started out with an image with a Background layer. I went to the Adjustments panel and clicked on the Levels adjustment button (circled in red). This added a new Levels adjustment layer above the Background layer and the Properties panel shows the Levels adjustment controls for this new adjustment layer. You can also mouse down on the Add Adjustment layer button in the Layers panel (circled in blue) to add a new adjustment layer.

There are several advantages to the adjustment layer approach. First of all, adjustment layers are not permanent. If you decide to undo an adjustment or readjust the settings, you can do so at any time. Adjustment layers offer the ability to apply multiple image adjustments and/or fills to an image and for the adjustments to remain 'dynamic.' In other words, an adjustment layer is an image adjustment that can be revised at any time and allows the image adjustment processing to be deferred until the time when an image is flattened. The adjustments you apply can also be masked when you edit the associated layer mask and this mask can also be refined using the Properties panel (in Masks mode). With the Properties panel you have the ability to quickly access the adjustment layer settings any time you need to. This also means you can easily switch between tasks. So, if you click on an adjustment layer to select it, you can paint on the layer mask, adjust the layer opacity and blending options, and have full access to the adjustment layer controls via the Properties panel.

The great thing about adjustment layers is they add very little to the overall file size and are much more efficient than applying an adjustment to a duplicate layer. Images that contain adjustment layers are savable in the native Photoshop (PSD), TIFF, and PDF formats.

Adjustments panel controls

Figure 4.12 shows the default Adjustments panel view, where you can click on any of the buttons to add a new image adjustment. The button icons may take a little getting used to at first, but you can refer to the summary list to help identify them and read a brief summary of what each one does. If you have the 'Show Tool Tips' option selected in the Photoshop Interface preferences, the tool tips feature displays the names of the adjustments as you roll the cursor over the button icons.

Brightness/Contrast Basic brightness and contrast adjustment. Levels To set clipping points and adjust gamma. Curves Used for more accurate tone adjustments. **Exposure** Primarily for adjusting 32-bit images.

Vibrance A tamer saturation adjustment control.

📰 Hue/Saturation A color adjustment for editing hue color, saturation and lightness.

55 Color Balance

Basic color adjustments.

Black & White

For simple black and white conversions.

Adjustments panel buttons

> Photo Filter Adds a coloring filter adjustment. Channel Mixer For adjusting individual color channels. E Color Lookup Adds a color lookup adjustment. Invert Converts an image to a negative. Posterize Used to reduce the number of levels in an image. Threshold

Reduces the number of levels to 2 and allows you to set the midpoint threshold.

Selective Color Apply CMYK selective color adjustments.

🔲 Gradient Map Use gradients to map the output colors.

Figure 4.12 The Adjustments panel showing the adjustment buttons.

Figure 4.11 This shows the adjustment layer workflow for adding a Levels adjustment layer.

x (0) 1

1.2

Output Levels: 0

255

255

0 俞

Properties panel controls

Once you are in the Properties panel there are two modes of operation. The 'mask controls' mode I describe later on page 362. But by default, the Properties panel displays the 'adjustment controls' mode when an adjustment layer is first created (Figure 4.13).

As you click on any other adjustment layers in the Layers panel to select them, the Properties panel will update to show all the controls and settings for that particular adjustment layer. Doubleclicking an adjustment layer opens up the Properties panel if it is currently hidden.

Figure 4.13 This shows the Properties panel with a Levels adjustment selected.

You can click on the Preset pop-up menu to quickly access one of the pre-supplied adjustment settings. Here, you might want to select each in turn, to see what each effect does, but without adding a new adjustment layer. Once you have configured a particular adjustment you can go to the Properties panel menu and choose Save Preset... to save as a custom adjustment setting. This will then appear appended to the Preset list as a custom setting.

The middle section contains the main adjustment controls for whatever adjustment you are currently working on.

At the bottom you have, on the far left, the adjustment layer clipping control button, which lets you choose whether a new adjustment is applied to all the layers that appear below the current adjustment layer, or are clipped to just the layer immediately below it. Next to this is a button for changing the preview image between the current edited state and the previous state. If you click on the button and hold the mouse down (or hold down the key), you can see what the image looked like before the last series of image adjustments had been applied to it. Next to this is a reset button for canceling the most recent adjustments. You can also use the \mathfrak{A} all \mathfrak{Z} (Mac), ctrl all \mathfrak{Z} (PC) shortcut to progressively undo a series of adjustment panel edits and use the $\mathfrak{R} \mathfrak{Z}$ (Mac), ctrl \mathfrak{Z} (PC) shortcut to toggle between an undo and redo. Next to this is an eyeball icon for turning the adjustment layer visibility on or off and lastly a Delete button.

Maintaining focus in the Properties panel

The Photoshop adjustment layers behavior has evolved such that adjustment layer editing is not modal. This is mostly a good thing, but losing the modality means that you must first use the *Shift Return* keyboard command in order to enter a 'Properties panel edit mode' where, for example, pressing the *Tab* key allows you to jump from one field to the next. Simply press the *esc* key to exit the Properties panel edit mode.

Figure 4.14 This histogram shows an image that contains a full range of tones.

Figure 4.15 A histogram of an image that has been heavily manipulated or an insufficient number of levels were captured.

Levels adjustments

If you use the Camera Raw Basic panel controls to optimize the tones, there shouldn't be so much need to use Levels to make further tone adjustments. However, it is still important and useful to understand the basic principles of how to apply Levels adjustments as there are still times when it is more convenient to apply a quick Levels adjustment to an image, rather than use Camera Raw.

Analyzing the histogram

Levels adjustments can have a big effect on the appearance of the histogram, so it is important to keep a close eye on the histogram shown in the Levels dialog/Properties panel as well as the one in the Histogram panel itself. Figure 4.14 shows a nice, smooth histogram where the image was first optimized in Camera Raw before being opened in Photoshop. It contains a full range of tones, without any shadow or highlight clipping and no gaps between the levels. A histogram with a comb-like appearance (as in Figure 4.15) indicates that either the image has already been heavily manipulated or an insufficient number of levels were captured in the original image.

The main Levels controls are shown in Figure 4.16. The Input sliders are just below the histogram display and you use these to adjust the input whites and blacks clipping points and the Gamma (the relative image brightness between the whites and blacks points). The Auto button sets the clipping points automatically. *att*-click the Auto button to open the Auto Options dialog (the Auto settings are covered

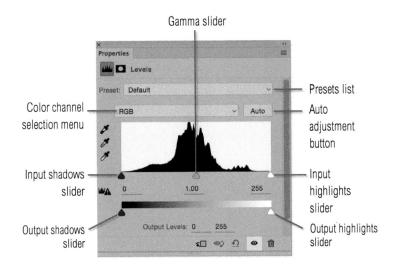

Figure 4.16 This shows a view of the Properties panel when adding a Levels adjustment.

later in this chapter). Below this are the Output sliders that can be used to set the output clipping point values. It is best not to adjust the Output sliders unless you are retouching a prepress file in grayscale or CMYK, or deliberately wish to reduce the output contrast.

Figure 4.17 shows a low-key image where the blacks are quite heavily clipped and most of the levels are bunched up to the left, while in Figure 4.18 the highlights are clearly clipped in this high-key image. However, it isn't necessarily a bad thing to sometimes clip the shadows or highlights in this way.

perties C Levels et: Default RGB Auto 1.00 255 Output Leveis: 0 (CO []2

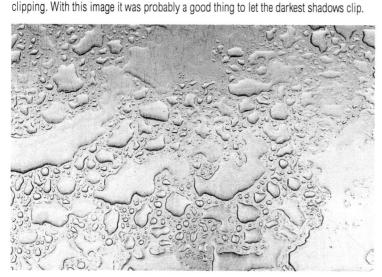

Figure 4.18 If the levels are bunched up towards the right, the highlights may be clipped. In this example it was desirable to let some of the highlights go to white.

Better negative number support

When applying a Curves adjustment and editing an image in Lab color mode, it is possible to enter triple digit negative numbers directly into the fields in the Curves dialog. This provides extra precision when making Lab color mode adjustments.

Curves adjustment layers

Any image adjustment that can be carried out using Levels can also be done using Curves, except Curves allows you to accurately control the tonal balance and contrast of the master composite image as well as the individual color channels. The Curves dialog represents the relationship between the input and output levels plotted as a graph. You can target specific points on the Tone Curve and remap the pixel values to make them lighter or darker and adjust the contrast in specific tonal areas.

As with all the other image adjustments, there are two ways you can work with Curves. There is the direct route (using the Image \Rightarrow Adjustments menu) and the adjustments layer method described here. I believe this approach is more useful for general image editing.

Figure 4.19 shows the Properties panel displaying the Curves controls, where the default RGB units are measured in brightness levels from 0 to 255 and the curve line represents the output tonal range plotted against the input tonal range. The vertical axis represents the output and the horizontal axis the input values (and the numbers correspond to the levels scale for an 8-bit per channel image). When you edit a CMYK image, the input and output axis is reversed and the units are measured in ink percentages instead of levels. The Curves grid normally uses 25% increments for RGB images and 10% increments for CMYK images, but you can toggle the Curves grid display mode by *all*-clicking anywhere in the grid. In Figure 4.19, the shadow end of the curve was dragged inwards (just as you would in Levels) to set the optimum shadow clipping point. You can control both the lightness and the contrast of the image by clicking on the curve line to add curve points and adjust the shape of the curve.

In the Curves controls section you have a channel selection menu. This defaults to the composite RGB or CMYK mode, where all channels are affected equally by the adjustments you make. You can, however, use this menu to select individual color channels (Figure 4.20). This can be useful when carrying out color corrections using Curves. The Auto button in Curves is the same as the one found in Levels. When you click on this, it applies an auto adjustment based on how the Auto Color Correction settings are configured (see Auto image adjustments on page 351).

If you double-click the eyedroppers, you can edit the desired black point, gray point, and white point colors and then use these eyedroppers to click in the image to set appropriate black, gray, and

Figure 4.19 The Curves adjustment Properties panel.

white point values. There was a time in the early days of Photoshop where the eyedropper controls were important, but this is less the case now—mainly because you can set the black and white clipping points in Camera Raw (as described on pages 139–141). However, the gray eyedropper can still prove useful for auto color balancing a photo.

The Input levels sliders work the same way as those in Levels and you can drag these with the *alt* key held down to access a threshold view mode (RGB and Grayscale Curves adjustments only). The Input and Output boxes provide numeric feedback for the current selected curve point so that you can adjust the curve points more precisely. You may sometimes see a histogram warning appear. This tells you the histogram displayed in the grid area is not an accurate reflection of what the true histogram should be. If you click on this, it forces an update of the histogram view. The Curves dialog uses the Point curve editor mode by default, but there is also a pencil button for switching to a draw curve mode, which lets you draw a curve shape directly. While in 'draw curve' mode the 'Smooth curve shape' button is made active and clicking on this allows you to smooth a drawn curve shape. Overall, you are unlikely to need to use the draw curve mode when editing photographic images.

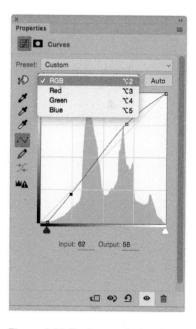

Figure 4.20 The Curves adjustment Properties panel showing the Channel menu options.

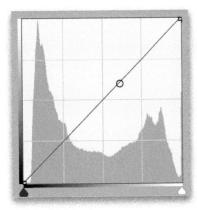

Figure 4.21 When the cursor is dragged over the image, a hollow circle indicates where the tone value is on the curve.

On-image Curves editing

If you click on the Target adjustment tool button to activate it and move the cursor over the document window, a hollow circle will hover along the curve line (Figure 4.21). This shows you where the tones in any part of the image appear on the curve. If you then click on the image a new curve point is added to the curve. However, if you click to add a curve point and at the same time drag the mouse up or down, this also moves the curve up and down where you just added the curve point. Therefore, when the Target adjustment tool mode is active, you can click and drag directly on the image to make specific tone areas lighter or darker (see the step-by-step example shown opposite). There is also an 'Auto-Select Targeted Adjustment Tool' Properties panel menu option that automatically selects the Target adjustment tool whenever a Curves adjustment layer is made active.

With both the Eyedropper and the Target adjustment tool methods, the pixel sampling behavior is determined by the sample options set in the Options bar. Figure 4.22 shows a view of the Options bar while the Target adjustment tool is active. If a small sample size is used, the curve point placement can be quite tricky, because the hollow circle will dance up and down the curve as you move the cursor over the image. If you select a large sample size this averages out the readings and makes the cursor placement and on-image editing a much smoother experience.

Figure 4.22 The Target adjustment tool options bar showing the Sample Size options. For on-image selections it can be useful to choose a large sample size.

Removing curve points

To remove a curve point select it and drag from the grid. Or, as you hover the cursor over an existing curve point on the curve line you can (Mac), *cttl* (PC)-click to delete it.

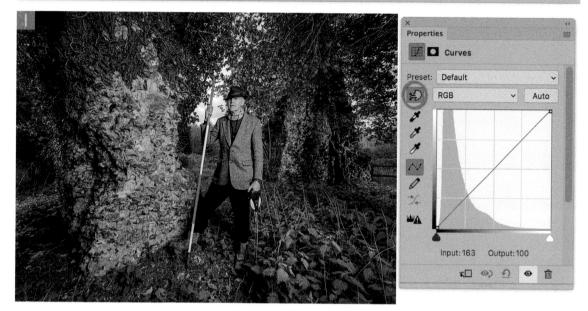

1 In this step I added a new Curves adjustment layer. I clicked on the Target adjustment tool button (circled) and made sure that I had set a large sample size in the Target adjustment tool options.

~

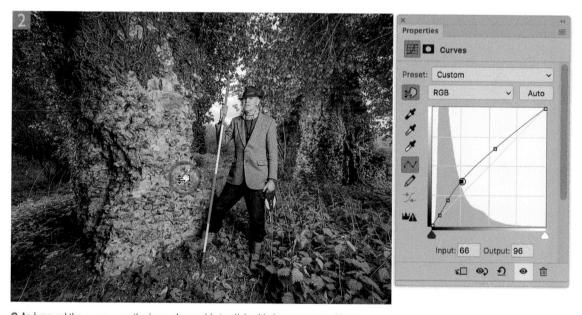

2 As I moved the cursor over the image I was able to click with the mouse to add new points to the curve. As I dragged the cursor upwards, this raised the curve upward and lightened the tones beneath where I had clicked.

Threshold mode preview

The Curves input sliders work exactly like the ones found in Levels. You can preview the shadow and highlight clipping by holding down the *all* key as you drag on the shadow and highlight sliders circled in the Properties panel views shown in Figures 4.23 and 4.24.

Using Curves in place of Levels

You can adjust the shadow and highlight levels in Curves in exactly the same way as you would using Levels. In Figure 4.23 I moved the Levels Properties panel shadows and highlight Input levels sliders inwards. The Curves properties panel has an identical pair of sliders with which you can map the shadow and highlight input levels. With a Levels adjustment you can alter the relative brightness of the image by adjusting the Gamma slider. With a Curves adjustment you can add a single curve point midway along the curve and move it left to lighten or right to darken.

Output levels adjustments

To adjust the output levels you move the curves point up or down. The Levels and Curves settings shown in Figure 4.24 will also apply identical adjustments. In the Levels adjustment I adjusted the output levels to produce an image where the optimized levels were mapped to a levels range of 20–210. In the Curves dialog you can see how I was similarly able to adjust the shadow and highlight output values to match the Levels adjustment settings.

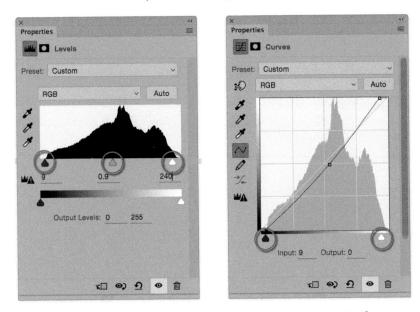

Figure 4.23 This shows how you can match Levels adjustments using the Curves adjustment controls.

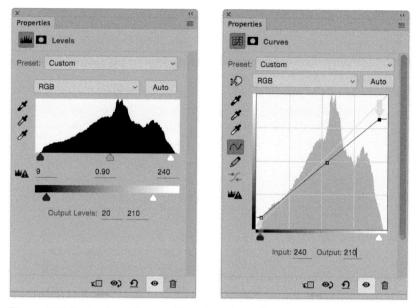

Figure 4.24 The Levels and Curves settings shown here will also apply identical Output Levels adjustments.

Setting the output levels to something other than zero isn't something you would normally want to do, except for those times where you specifically want to dull down the tonal range of an image. In the Figure 4.25 example, the left section shows the standard optimized levels, the middle section shows the same image with reduced highlight output levels and the right section shows the image with reduced shadow output levels.

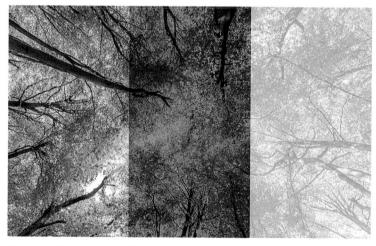

Figure 4.25 Examples of different Output Levels adjustments.

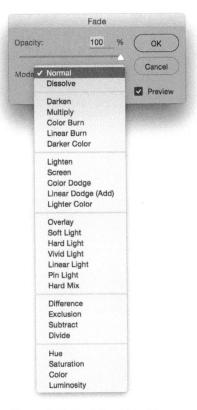

Figure 4.26 The Edit ⇒ Fade dialog.

Luminosity and Color blending modes

One of the problems you may encounter when applying Normal blend mode tone adjustments is that as you use Levels or Curves to adjust the tonal balance of a picture, the adjustments you make may also affect the color saturation. In some instances this might be a desirable outcome. For example, whenever you start off with a flat image that requires a major Levels or Curves adjustment, the process of optimizing the shadows and highlights will produce a picture with increased contrast and more saturated color. This can be considered a good thing, but if you are carrying out a careful tone adjustment and wish to manipulate the contrast or brightness, *but without* affecting the saturation, changing the blend mode to Luminosity can isolate the adjustment so that it targets the luminosity values only.

This is where working with adjustment layers can be useful, because you can easily switch the blend modes for any adjustment layer. In the example shown opposite, a Curves adjustment was used to add more contrast to the photograph. When this adjustment was applied in the Normal mode (as shown in Step 1), the color saturation was increased. However, when this Curves adjustment was applied using the Luminosity blend mode, there was an increase in the contrast but without there also being an increase in color saturation. Incidentally, I quite often use the Luminosity blend mode whenever I add a Levels or Curves adjustment layer to an image, especially if it has already been optimized for color. This is because whenever I add localized corrections I usually don't want these adjustments to further affect the saturation of the image. Similarly, if you are applying an image adjustment (such as Curves) to alter the colors in a photo, you may want the adjustment to target the colors only and leave the luminance values as they are. So whenever you make a color correction using, say, Levels, Curves, Hue/Saturation, or any other method, it is often a good idea to change the adjustment layer blend mode to Color.

If you happen to prefer the direct adjustment method, you can always go to the Edit menu after applying a Curves and choose Fade Curves... (**H** Shift **F** [Mac], **ctr** Shift **F** [PC]). This opens the Fade dialog shown in Figure 4.26, where you can change the blend mode of any adjustment as well as fade the opacity. One of the main benefits of the adjustment layers approach is that you can switch easily between editing the adjustment controls in the Properties panel and adjusting the layer opacity and blend mode settings.

1 When you increase the contrast in an image using a Curves adjustment, you will also end up increasing the color saturation. Sometimes this will produce a desirable result because often photographs will look better when you boost the saturation.

2 In this example I applied the same Curves adjustment as was applied in Step 1, but I changed the layer blend mode to Luminosity. This effectively allowed me to increase the contrast in the original scene, but without increasing the color saturation.

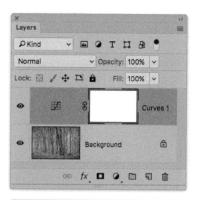

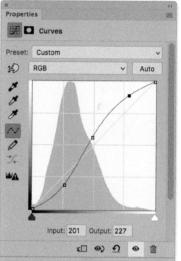

Locking down portions of a curve

As you add more than one or two points to a curve, you need to be careful to keep the curve shape under control. Once you start adding further points, adjusting a point on one part of the curve may cause the curve shape to move, pivoting around the adjacent points. The solution is to lay down 'locking' points on the curve. In Figure 4.27 I wanted to make the midtones and highlights lighter, but without affecting the dark tones so much. Here, I placed one curve point on the lower portion of the curve to anchor it. I then added two other curve points higher up and dragged upwards to lighten. Because I had added the shadow curve point first, adjusting the other curve points had little effect on the lower portion of the curve.

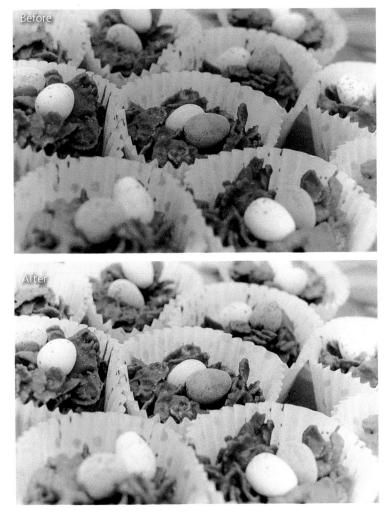

Figure 4.27 Adding multiple points to better control the Curve shape.

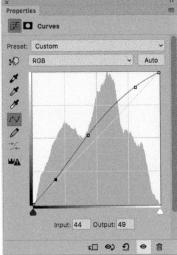

Creating a dual contrast curve

Now let's look at adding even more curve points. There are times where you may want to manipulate the contrast in two sections of the curve at once. For this you may need to place three or more points on the curve such as in the Figure 4.28 example, where I wanted to boost the contrast in the shadows and the highlights separately. To do this, I applied the curve shape shown here where you will see that by using six curve points I was able to independently steepen the shadow/ midtone and highlight portions of the curve. This is where you need to be really careful, because it is all too easy for the tones to appear solarized, or you may end up flattening them. Either way you may risk losing tonal detail.

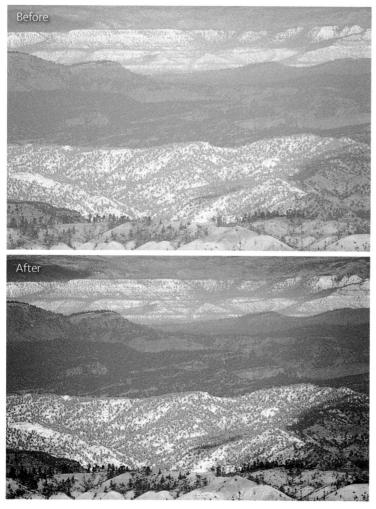

Figure 4.28 A dual contrast Curve to add contrast in the shadows and highlights.

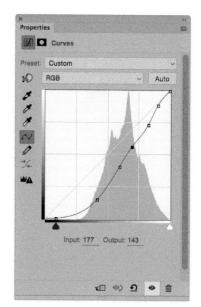

Shadows	-		ОК
Amount:	35	_ %	1
Highlights			Cancel
Amount:	<u> </u>	96	Losd
Show More Options			Save

Figure 4.29 The Shadows/Highlights adjustment dialog, shown here in basic mode.

Shadows			ОК
Amount:	35	. %	\leq
Tone:	50	%	Cancel
Radius:		рх	Load
Highlights			Save
Amount:	<u> </u>	_%	Preview
Tone:	50	%	
Radius:	<u>30</u>	px	
Adjustments			
Color:	+20		
Midtone:	<u> </u>		
Black Clip:	0.01	_%	
White Clip:	0.01	- %	
Save Defaults			

Figure 4.30 In the Advanced mode, the Shadows/Highlights dialog contains a comprehensive range of controls.

Shadows/Highlights

The Shadows/Highlights image adjustment can be used to reveal more detail in either the shadow or highlight areas of a picture. It is a great image adjustment tool to use whenever you need to expand compressed image tones in an image, but it can be used to perform wonders on most photos and not just those where you desperately need to recover shadow or highlight detail.

In the basic mode (Figure 4.29), a Shadows/Highlights adjustment makes adaptive adjustments to an image, and works in much the same way as our eyes do when they automatically compensate and adjust to the amount of light illuminating a subject. Essentially, a Shadows/ Highlights adjustment works by looking at the neighboring pixels in an image and makes a compensating adjustment based on the average pixel values within a given radius.

Checking the Show More Options box reveals the advanced mode dialog shown in Figure 4.30. I recommend you always leave the 'Show More Options' box checked and have this as the default mode. Here, the Shadows/Highlights dialog has additional controls with which to make the following fine-tuning adjustments.

Amount

The default Amount setting applies a 35% amount to the Shadows. You can increase or decrease this to achieve the desired amount of highlight or shadow correction. I find the default setting does tend to be rather annoying, so I usually try setting the slider to a lower amount (or zero even) and click on the 'Save As Defaults' button to set this as the new default setting each time I open Shadows/Highlights.

Tone

The Tone slider determines the tonal range of pixel values that will be affected by the Amount setting. A low Tone setting narrows the adjustment to the darkest or lightest pixels only. As the Tone setting is increased, the adjustment spreads to affect more of the midtone pixels as well (see the example shown in Figure 4.31). For example, if the Shadows Tone slider is set to 40, only the pixels which fall within the darkest range from level 0 to level 40 will be adjusted (such as the deep shadows in this photograph).

Radius

The Radius setting governs the pixel width of the area that is analyzed when making an adaptive correction. To explain this, let's analyze what happens when adjusting the shadows. If the Shadow Radius is set to zero, the result will be a very flat-looking image. You can increase the

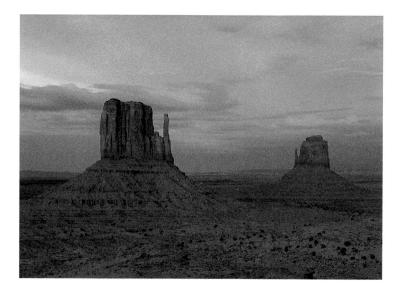

Amount to lighten the shadows and restrict the Tonal Width, but if the Radius is low or set to zero Photoshop has very little neighbor pixel information to work with when calculating the average luminance of the neighboring pixels. So, if the Radius is set too small, the midtones will also become lightened. If the Radius setting is set too high this has the effect of averaging a larger selection of pixels in the image and likewise the lightening effect will be distributed such that most of the pixels get the lightening treatment, not just the dark pixels. The optimum setting is always dependent on the image content and the pixel area size of the dark or light regions in the image. The optimum pixel Radius width should therefore be about half that amount or less. In practice you don't have to measure the pixel width of the light and dark areas in an image to work this out. Just be aware that after you have established the Amount and Tonal Width settings you should adjust the Radius setting and make it larger or smaller according to how large the dark or light areas are. There will be a 'sweet spot' where the Shadows/Highlights Radius correction is just right.

As you adjust the Radius you will sometimes notice a soft halo appearing around sharp areas of contrast between the dark and light areas. This is a natural consequence of the Radius function and is most noticeable when you apply large Amount adjustments. Aim for a Radius setting where the halo is least noticeable or apply a Fade... adjustment after applying the Shadows/Highlights adjustment. If I am really concerned about halos, I sometimes use the History Brush to selectively paint in a Shadows/Highlights adjustment.

The following example shows how one might typically use a Shadows/Highlights adjustment to tone correct an image.

Channel:	RGB	~		Ø
		4		
Source:	Entire Ima	ga		_
Source: Mean:		ga Level:	224	
Mean:	97.43			
Source: Mean: Std Dev: Median:	97.43 56.64	Level:	361	

Figure 4.31 The Tone slider determines the range of levels the Shadows/Highlights adjustment is applied to.

HDR Toning adjustment

There is also an HDR Toning adjustment in the Image ⇒ Adjustments menu. This is described on page 416 and provides an alternative approach to applying Shadows/ Highlights type image adjustments.

1 This photograph was significantly underexposed. Using the Shadows/Highlights adjustment it was possible to bring out more information in the shadow detail of the car, but without degrading the overall contrast.

2	Shado	ws/Highlights		
	Shadows Amount:	40	%	ОК
	Tone:	50	%	Cancel
	Radius:	0	рх	Load
	Highlights			Save
	Amount:	0	%	Preview
, Charles	Tone:	50	%	
	Radius:	30	рх	
	Adjustments			
	Color:	+20		
	Midtone:	0		
	Black Clip:	0.01	%	
	White Clip:	0.01	%	
	Save Defaults			
	Show More Options			

2 I went to the Image menu and chose Adjustments \Rightarrow Shadows/Highlights. I set the Shadows adjustment Amount to 40% and set the Tone slider to 50%. The Radius adjustment was now crucial because this determined the distribution width of the Shadows/Highlights adjustment. As you can see in this step, the image appeared rather flat when the Radius was set to zero.

30	adows/Highlights		
Shadows			ОК
Amount:	40	%	<u> </u>
Tone:	50	%	Cancel
Radius:	120	px	Load
Highlights			Save
Amount:	outpainteresting and	%	Preview
Tone:	50	%	FIEVIEW
Radius:	30	рх	
Adjustments			
Color:	+20		
Midtone:	+25		
Black Clip:	0.01	%	
White Clip:	0.01	%	
Save Defaults			
Show More Options			

3 Setting the Radius too high can also diminish the Shadows/Highlights adjustment effect. It is important to remember that the optimum Radius setting is 'area size' related and falls somewhere midway between these two extremes. In the end, I went for a Radius setting of 120 pixels for the Shadows. This was because I was correcting large shadow areas and this setting appeared to provide the optimum correction for this particular photo. I also increased the Midtone Contrast to +25. This final tweak compensated for some loss of contrast in the midtone areas.

Color Correction

As you correct the highlights and the shadows, the color saturation may change unexpectedly. This can be a consequence of using Shadows/Highlights to apply extreme adjustments. The Color slider lets you compensate for any undesired color shifts.

Midtone Contrast

The midtone areas may sometimes suffer as a result of a Shadows/ Highlights adjustment. Even though you may have paid careful attention to getting all the above settings perfectly optimized so that you successfully target the shadows and highlights, the photograph can appear to be lacking in contrast. The Midtone slider control lets you restore or add more contrast to the midtone areas.

Adobe Camera Raw adjustments

Shadows/Highlights adjustments can work great on a lot of images, but now that Camera Raw can be applied as a filter, you may like to explore using the Highlights and Shadows adjustments described on page 136. In many cases Highlights and Shadows adjustments in Camera Raw will work better than using the Photoshop Shadows/Highlights adjustment.

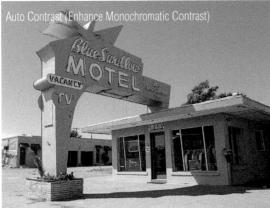

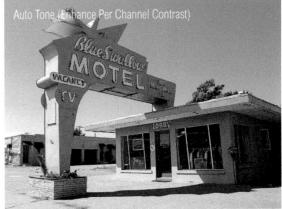

Auto Color (Find Dark & Light Colors + Snap Neutral Midtones)

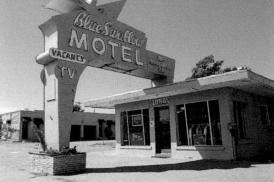

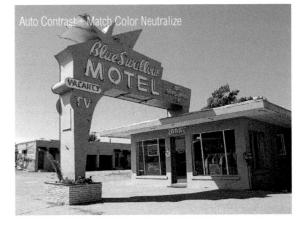

Figure 4.32 This compares the three Image menu auto adjustment methods, alongside an Auto Contrast adjustment followed by a Match Color Neutralize adjustment.

Auto adjustments

The Image menu contains three auto image adjustment options: Auto Tone, Auto Contrast, and Auto Color. Examples of these are shown in Figure 4.32.

The Auto Tone adjustment (**H** Shift [[Mac], Ctr) Shift [[PC]) works by expanding the levels in each of the color channels individually. This per-channel levels contrast expansion method will always result in an image that has fuller tonal contrast, but may also change the color balance. The Auto Tone adjustment can produce improved results, but not always. If you want to improve the tonal contrast, but without affecting the color balance of the photograph, then try using the Auto Contrast adjustment instead (**H** Shift [[Mac], Ctr) alt Shift [[PC]). This carries out a similar type of auto image adjustment as Auto Tone, except it optimizes the contrast by applying an identical Levels adjustment to each of the color channels, so that it does not alter the color balance.

Lastly, there is the Auto Color adjustment (**B** *Shift* **B** [Mac], *ctrl Shift* **B** [PC]). This applies a combination of Auto Contrast to enhance the tonal contrast, combined with an auto color correction that maps the darkest colors to black and the lightest colors to white and also aims to neutralize the midtones. However, if the swatch colors shown in Figure 4.33 have been altered, you may see a different result.

If you an -click the Auto button (circled) in the Properties panel, this opens the Auto Color Correction Options shown in Figure 4.33. The options listed here match the auto adjustments found in the Image menu. Enhance Per Channel Contrast is the same as Auto Tone. Enhance Monochromatic Contrast is equivalent to Auto Contrast, and Find Dark & Light Colors is the same as Auto Color. However, there is also a Snap Neutral Midtones option available. When this is checked, a Gamma adjustment is applied in each of the color channels which aims to color-correct the neutral midtones as well as the light and dark colors. A clipping value can be set for the highlights and shadows and this determines by what percentage the endpoints are automatically clipped. The Enhance Brightness and Contrast auto adjustment is discussed on the following page.

The Target Colors & Clipping section can be used to customize the clipping values to determine how much the highlights and shadow tones are clipped by the image adjustment.

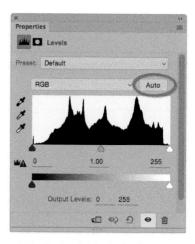

	Color Correction	options	
Algorithms Enhance Mor	nochromatic Contr	ast C	ж
C Enhance Per	Channel Contrast	Ca	ncel
O Find Dark & I	Light Colors		
Enhance Brig	htness and Contra	ast	
Target Colors &			
Shadows:	Clip: 0.10	%	
Shadows: Midtones:	Clip: 0.10	_%	

Figure 4.33 The Auto image adjustments options in the Auto Color Correction options dialog.

Match Color corrections

The Figure 4.33 example includes a Match Color correction. This is a powerful yet rather hidden feature. If you go to the Image \Rightarrow Adjustments menu you will see an item called Match Color... In the dialog shown in Figure 4.34 you just need to check the Neutralize box to apply a Match Color neutralize adjustment. This adjustment is remarkably good at removing most color casts.

		Match C	Color		
Destina	tion Image				- Car
Target:	W1BY0269.tif (Backs	ground, RC	GB/16)		ОК
	Ignore Selection	when Appl	ying Adju	stment	Cancel
Image	e Options				
	Luminance		100		Preview
		a a construction de la construction de la construcción de la construcción de la construction de la construction Construcción de la construction de la construcción de la construcción de la construction de la construction de la	The process of the second		
	Color Intensity		100		
	Fade		0		
	_		*****		
	Neutralize				
Image	Statistics				
	Use Selection in	Source to	Calculate	Colors	
	Use Selection in	T	Salaudada.	Adjustment	
	Use Selection in	larget to t	alculate	najasineni	
Source:	None	*		-	
Layer:	Background		1	A AN	
	Load Statistics		REA	INAL	
	Save Statistics		1		

Figure 4.34 The Match Color dialog with the Neutralize box checked.

Enhance Brightness and Contrast

The 'Enhance Brightness and Contrast' auto option (Figure 4.35) is a bit more advanced than the other auto options and is in fact the default option whenever you click the Auto button in Levels or Curves.

When you hit the Auto button (or *all*-click the Auto button and select Enhance Brightness and Contrast), Photoshop analyzes the histogram and references a database of Levels and Curves adjustments to decide which would be the most appropriate adjustment to select. In the case of Levels (and Brightness/Contrast adjustments),

Photoshop aims to clip the black and white points as necessary and applies an appropriate Gamma adjustment. In the case of Curves, it selects an appropriate curve shape to apply, based on an analysis of the histogram levels distribution.

This feature is quite effective and can produce some pleasing results, although I think it's more likely most photographers will want to use Camera Raw to auto process their raw capture images. But the one thing that has to be said when you apply this auto adjustment (as well as any kind of auto adjustment) is you do have the ability to edit the applied Levels or Curves settings before clicking OK to confirm the adjustment. Figure 4.36 shows a before and after example of an Enhance Brightness and Contrast auto Curves adjustment and how it added points to the curve.

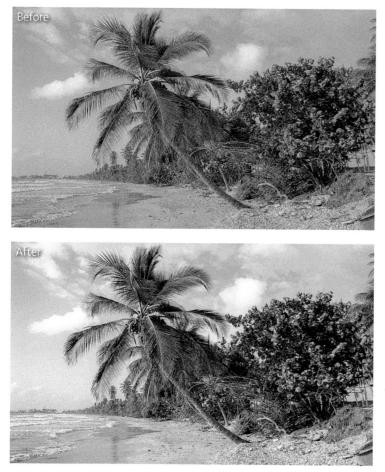

Figure 4.36 This shows a before and after example of an Enhance Brightness and Contrast Auto Curves adjustment and the curve shape applied to this particular image.

Enhance Per	phochromatic Contra r Channel Contrast Light Colors ghtness and Contra	Cancel
Snap Neutra	l Midtones	
Target Colors 8	Clipping	
Shadows:	Olip: 0.10	%
Midtones;		
	Clip: 0.10	%

Figure 4.35 The Enhance Brightness and Contrast option in the Auto Color Correction Options Curves dialog.

Channel selection shortcuts

The channel selection shortcuts are as follows. You need to use att 2 to select the composite curve channel, use att 3 to select the red channel, and so on. Likewise, you can use **H** att 2 (Mac), ctt att 2 (PC) to load the composite (luminosity) channel as a selection, **H** att 3 (Mac), ctt att 3 (PC) to load the red channel as a selection, etc.

Color corrections using Curves

Of all the Photoshop color correction methods described so far, Auto Color probably provides the best automatic one-step tone and color correction method. However, if you prefer to carry out your color corrections manually, I would suggest you explore using Levels or Curves color channel adjustments instead. Earlier I mentioned how you can set the highlight and shadow points in Levels and how to use a Gamma adjustment to lighten or darken the image. Let's now take things one stage further and use this technique to optimize the individual color channels in an RGB color image.

This section shows how you can use the threshold mode analysis technique to discover where the shadow and highlight endpoints are in each of the three color channels and use this feedback information to set the endpoints. This is a really good way to locate the shadows and highlights and set the endpoints at the same time, because once you have corrected the highlight and shadow color values in each of the color channels independently, the other colors usually fall into place and the photograph won't require much further color correction.

1 This JPEG capture was taken with a basic digital camera and has an overall blue cast. The first step was to go to the Adjustments panel and click on the Curves button (circled) to add a new Curves adjustment layer.

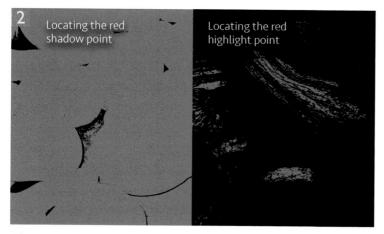

2 I went to the Channel menu, selected the red channel, and adjusted the Shadow and Highlight input sliders until the red shadow and red highlight points just started to clip. If you hold down the *att* key as you do this you will see the threshold display mode (shown here) which can help you locate the shadow and highlight points more easily. I then repeated these steps with the green and blue channels until I had individually adjusted the shadow and highlight points in all three color channels.

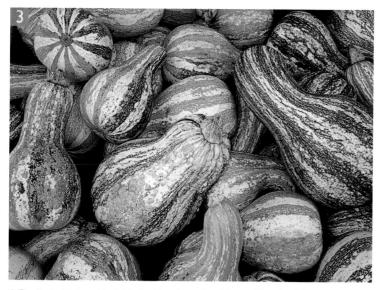

3 Finally, I added a midpoint in the blue channel and dragged it to the right to add more yellow. This technique of adjusting the color channels one by one can help you remove color casts from the shadows and highlights with greater precision. The trick is to use the threshold display mode as a reference tool to indicate where the levels start to clip in each channel and consider backing off slightly so that you leave some headroom in the composite/master channel. This then allows you to make general refinements to the Curves adjustment, ensuring the highlights do not blow out.

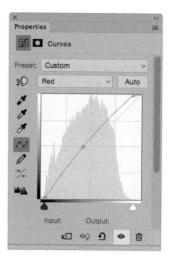

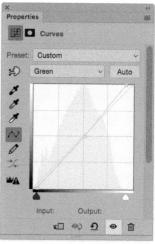

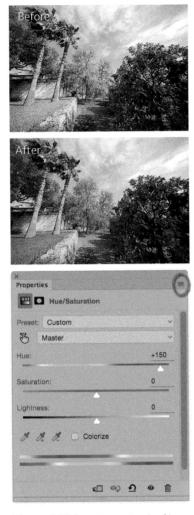

Figure 4.37 An extreme example of how a Hue/Saturation adjustment can radically alter the appearance of a photograph.

Hue/Saturation

The Hue/Saturation dialog controls are based on hue, saturation, and Brightness, which is basically an intuitive form of the Lab Color model. When you apply a Hue/Saturation image adjustment you can adjust the image colors globally, or you can selectively apply an adjustment to a narrower range of colors. The two color spectrum ramps at the bottom of the Hue/Saturation dialog box provide a visual clue as to how the colors are being mapped from one color to another. These hue values are based on a 360 degree spectrum, where red is positioned mid-slider at 0 degrees and all the other colors are assigned numeric values in relation to this. So cyan (the complementary color of red) can be found at either -180 or +180 degrees. Adjusting the Hue slider alters the way colors in the image are mapped to new color values. Figure 4.37 shows an extreme example of how the colors in a normal color image would look if they were mapped by a strong Hue adjustment. As you move the Hue slider left or right the colors in the image are mapped to new values. You get an indication of this transformation by looking at the two color ramps at the bottom of the dialog. The top one represents the original 'input' color spectrum and the lower ramp represents how those colors are translated as output colors.

Saturation adjustments are easy enough to understand. A positive value boosts the color saturation, while a negative value reduces the saturation in an image. By default, these adjustments are applied in the 'Master' edit mode, but you can also choose from one of six preset color ranges with which to narrow the focus of a Hue/ Saturation adjustment. Once you have selected one of these color range options, you can select the Eyedropper tool and move the cursor over the image to sample a new color value. This centers the Hue/Saturation adjustments around the new sampled color. You can select the plus or minus Eyedroppers to add or subtract colors from the selection (or use a *Shift*-click in the image area to add to the color selection and an *alt*-click to subtract).

There is an 'Auto-Select Targeted Adjustment Tool' Adjustment panel option available from the Hue/Saturation Properties panel menu (circled in Figure 4.37). When enabled, this automatically selects the Target adjustment tool when the adjustment layer is made active. In the case of a Hue/Saturation adjustment it automatically selects the Saturation slider and targets the appropriate color range.

When the Colorize option at the bottom is checked, the hue component of the image defaults to red (Hue value 0 degrees), Lightness remains the same at 0% and Saturation at 25%. You could use this to colorize a monochrome image, but I think you will be better off using the Photo Filter adjustment to do this (see page 360).

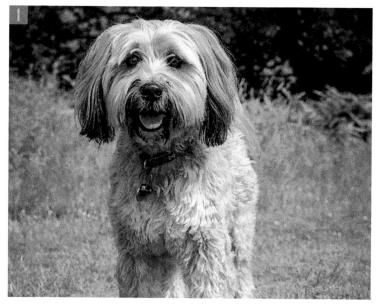

C2 C3 C4
54
201000
€5
63
57
87
5

1 With this photograph I wanted to target the green background and make it less intense. One approach would be to add a Hue/Saturation layer, go to the target color group menu shown here, select 'Greens,' and desaturate.

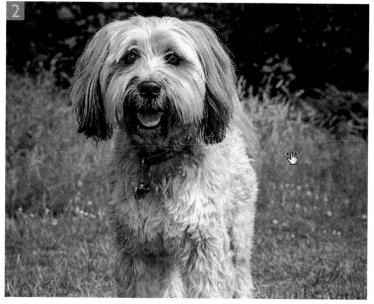

×		4
Properties		
Hue/Saturation		
Preset: Custom	~	
Yellows	~	
Hue:		
Hue:	0	- 5
Saturation:	-45	
▲		
Lightness:	0	-
▲		
8 8 8 🖸 🗆 Colorize		
15°/45°	76°\105°	
x (•) +	2 💿 🏛	

2 Another method (using a Hue/Saturation adjustment) would be to make the target adjustment tool active (circled) and carry out an on-image adjustment by dragging on the color area I wished to modify. This also selected the target color group from the menu, which happened to target the 'Yellows' rather than the 'Greens.' I was then able to click on the image and drag to the left to decrease the saturation.

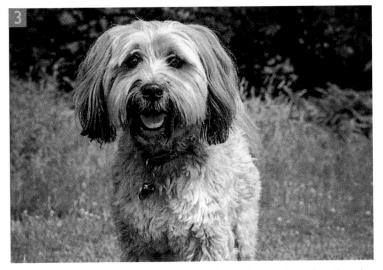

3 I was also able to use the Eyedroppers (circled) to add to or subtract from the color range selection. For this step, I selected the Minus eyedropper and clicked on the background to subtract some yellow/green colors from the selection. I also manually clicked and dragged the sliders in the color ramp at the bottom to fine-tune the color hue selection. The dark shaded area represented the selected color range and the lighter shaded area (defined by the outer triangular markers) represented the fuzziness drop-off either side of the color selection. I also adjusted the Lightness slider to darken the selected colors.

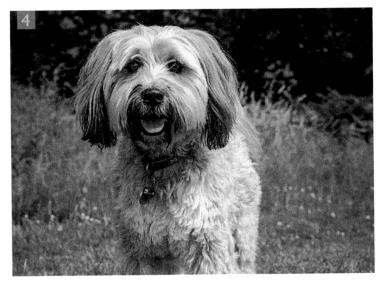

4 In this final step I painted on the adjustment layer mask with black in order to hide the Hue/Saturation mask and prevent this adjustment from affecting the warm tone colors of the dog. Painting with black on the adjustment layer mask restored the color in this region to how it was originally.

Vibrance

The Vibrance adjustment is available as a direct adjustment and as an Adjustment panel option (Figure 4.38). This lets you carry out Camera Raw style Vibrance and Saturation adjustments directly in Photoshop. If you refer back to Chapter 2, you will recall that Vibrance applies a non-linear style saturation adjustment in which the less saturated colors receive the biggest saturation boost, while those colors that are already brightly saturated remain relatively protected as you boost the Vibrance. The net result is a saturation control that allows you to make an image look more colorful, but without the risk of clipping those colors that are saturated enough already. Vibrance adjustments also prevent skin tones from becoming oversaturated as the amount setting is increased. Figure 4.39 shows a comparison between the before version (left) and the after version (right), in which I boosted the Vibrance by 80%. As you can see, this made the blue colors in the background appear more saturated. You will notice that the Vibrance adjustment also increased the saturation of the skin tones, but the saturation boost here is more modest compared to boosting the saturation with the Saturation slider. The Saturation slider below is similar to the Saturation slider in the Hue/Saturation adjustment, but applies a slightly gentler adjustment. It matches more closely the behavior of the Saturation slider in Camera Raw.

Figure 4.38 The Vibrance Adjustment in the Properties panel.

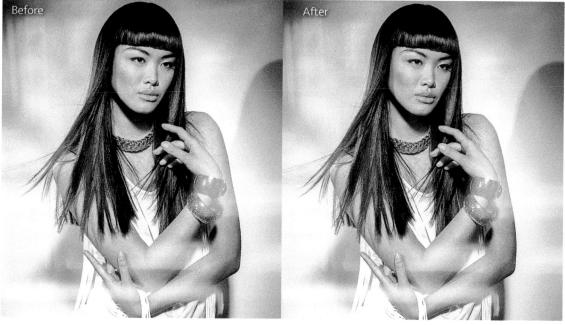

Figure 4.39 A before and after comparison using the Vibrance slider.

Color temperature and film

In the days of color film there were only two choices of film emulsion: daylight and tungsten. Daylight film was rated at 6,500 K and was used for outdoor and studio flash photography, while tungsten film was rated at 3,400 K and was typically used when taking photographs under artificial tungsten lighting. These absolute values would rarely match exactly the lighting conditions you were shooting with, but would enable you to get roughly close to the appropriate color temperature of daylight/strobe lights or indoor/tungsten lighting. Where the color temperature of the lighting was different, photographers would place color correcting filters over the lens to help balance the colors better. The Photo Filter in Photoshop kind of allows you to do the same thing at the post-production stage.

) Filter:	Warming Filter (85)		~
) Color:			
ensity:		40	%

Photo Filter

One of the advantages of shooting digitally is that digital cameras are able to record a white balance reading at the time of capture and apply this to your photos. This can be done either in-camera (selecting the auto-white balance option) or by using the 'As Shot' white balance setting in Camera Raw when processing a raw capture image. If you didn't manage to set the color balance correctly at the time of capture and were shooting in JPEG mode then you'll be stuck with a fixed white balance in the image. But don't despair, because it is possible to adjust the color balance in Photoshop using the Photo Filter adjustment. This is available from the Image \Rightarrow Adjustments menu, or as an image adjustment layer. The Photo Filter effectively applies a solid fill color layer with the blend mode set to 'Color,' although you can achieve a variety of different effects by combining a Photo Filter adjustment with different layer blend modes. The Photo Filter offers a few color filter presets, but if you click on the Color button, you can click on the color swatch next to it and adjust the Density slider to modify the filter's strength. Figure 4.40 shows an example of where the original version (left) had a blue cast. To modify this photograph, I added a Photo Filter adjustment. I selected the Warming (85) filter and raised the Density from 25% to 40%.

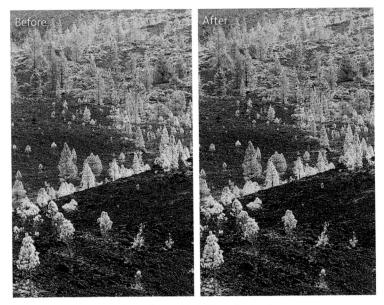

Figure 4.40 Before and after applying a Photo Filter adjustment.

Multiple adjustment layers

By adding multiple adjustment layers you can preview how an image will look using various combinations of adjustment layers, and readjust the settings as many times as you like before you apply them permanently to the photo. For example, you might want to use multiple adjustment layers to apply different coloring treatments to a photo. Instead of producing three versions of an image, all you need to do is add three adjustment layers, with each using a different coloring adjustment, and switch the adjustment layer visibility on or off to access each of the color variations. Saving these layer configurations as Layer Comps can also help here (see page 554).

While it is possible to keep adding more adjustment layers to an image, you should try to avoid any unnecessary duplication. It is wrong to assume that when the image is flattened the cumulative adjustments somehow merge to become a single image adjustment. When you merge down a series of adjustment layers, Photoshop applies them sequentially, the same as if you had made a series of normal image adjustments. So the main thing to watch out for is any doubling up of the adjustment layers. If you add a Curves adjustment layer and need to refine the tone contrast, it is not advisable to add a second Curves layer. Similarly, if you have a Curves adjustment layer and a Levels adjustment layer, it would be better to try and combine the Levels adjustment within the Curves adjustment instead.

Where you do end up with multiple adjustment layers and you want to be able to toggle the visibility, it can help to place these inside a single layer group. This means you can easily turn the multiple image adjustments on or off at once (see Figure 4.41). You can also add a layer mask to a layer group and use this to selectively hide or reveal all the image adjustment layers contained within a layer group.

To summarize, the chief advantages of adjustment layers are the ability to defer image adjustment processing and the ability to edit the layers and make selective image adjustments. The pixel data in an image can easily become degraded through successive adjustments as the pixel values are rounded off. This is why it is better to use adjustment layers, because you can keep revising these adjustments without damaging the photograph until you finally decide to flatten the image.

Figure 4.41 This shows two adjustment layers placed in a layer group, masked by a layer group mask.

Figure 4.42 This shows an example of a darkening adjustment layer combined with a layer mask.

Adjustment layer masks

As you have seen so far, adjustment layers are always accompanied by a pixel image layer mask. As with ordinary layers, these can be used to mask the adjustment layer contents. Whenever an adjustment layer is active, you can paint or fill the adjustment layer mask using black to selectively hide an adjustment effect and paint or fill with white to reveal again. You can carry on editing an adjustment layer mask (painting or filling with black or white) until you are happy with the way the mask is working.

Having the ability to edit an adjustment layer mask means you can apply such layer adjustments selectively. For example, although Photoshop has Dodge and Burn tools they are not really suited for dodging and burning broad areas of a photograph. This is because these tools have to be applied to a pixel layer directly, forcing you to create a copy layer if you wish to keep your edits non-destructive. If you want to dodge or burn a photo in order to darken a sky or lighten someone's face, the best way to do this is by adding an adjustment layer, filling the mask with black, and painting with white to selectively reveal the layer adjustment. In the Figure 4.42 example I added a darkening Curves adjustment layer to an image. A black to white gradient was then added to the pixel layer mask to fade out the adjustment from the middle of the photograph downwards.

Properties panel mask controls

When a layer mask is targeted, the Properties panel will be in 'Masks mode' (Figure 4.43) and can be used to control and refine the layer mask appearance and behavior. Layer masking is a topic I'll be discussing more fully in Chapter 8, but because this is relevant to masking adjustment layers, I thought it best to briefly introduce the Properties panel masking features here first.

When an adjustment layer is added to the layer stack it will have a pixel layer mask, so the default mode for the Properties panel Masks mode shows the Pixel Mask mode options. If you click on the Vector Mask mode button, you can add and/or edit a vector layer mask (see Step 4 on page 365). You can tell which mode is active because it will say Pixel Mask or Vector Mask at the top of the panel.

The Density slider can be used to adjust the density of the mask. When you have a mask applied to a layer or adjustment layer, where the mask is filled with black, this hides the layer contents

Figure 4.43 The Properties panel Masks mode controls.

completely. However, as you reduce the Density, this lightens the black mask color and therefore allows you to soften the mask contrast. So, when Density is set to 50%, a black mask color will only apply a 50% opacity mask and the lighter mask colors are reduced proportionally.

The Feather slider can be used to soften the mask edges up to a 250 pixel radius and with up to 2 decimal places accuracy. Beneath this is the Mask Edge... button which will reveal the Select and Mask options in the Properties panel (Figure 4.44). This can give you even greater control over the mask edges and softness (described more fully in Chapter 8).

The Color Range button takes you to the Color Range dialog, which allows you to make selections based on color. This means you can select colors to add to or subtract from a Color Range selection and see the results applied directly as a mask. Beneath this is the Invert button for reversing a masking effect. At the bottom of the panel are buttons that allow you to: convert a mask to a selection, delete the mask and apply it to the layer, enable/disable the mask and a Delete button to remove a mask.

Figure 4.44 The Properties panel in Select and Mask mode.

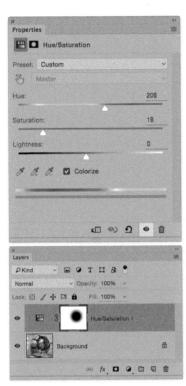

roperties	
Layer Mask	D 13
Density:	100%
Feather:	100.0 px
lefine:	Mask Edge
	Color Range
	Invert
	··· 6 0 m

Editing a mask using the masks controls

1 Here, I added a Hue/Saturation adjustment that applied a blue colorize effect. I made an elliptical selection, selected the pixel layer mask and filled with black to reveal the original colors in the photograph.

2 I then went to the Properties panel in Masks mode and increased the Feather amount to 100 pixels to make the hard mask edge softer.

× Properties	
🖽 🖸 Masks	
Layer Mask	D 13
Density:	50%
Feather:	100.0 px
Refine:	Mask Edge
	Color Range
	Invert
	🚸 👁 💼

3 Let's say I wanted to soften the transition between the masked and unmasked areas. By decreasing the Density I could make the black areas of the mask lighter and thereby reveal more of the adjustment effect in the masked area of the image.

4 This technique is not just limited to pixel masks. In this step I started with a subtractive elliptical pen path shape, applied this as a Vector Mask and used the same Properties panel settings as in Step 2 to soften the vector mask edge.

Image Adjustments as Smart Filters

You can now apply most of the regular image adjustments from the Image \Rightarrow Adjustments menu to smart object layers, all except for the Desaturate, Match Color, Replace Color, or Equalize adjustments.

To create a smart object you can either go to the Filter menu and choose Convert for Smart Filters, or go the Layer menu and select Smart Object \Rightarrow Convert to Smart Object.

Applying image adjustments to smart object layers is the same as when you apply an adjustment layer, but is like adding an adjustment layer in a clipping group with an associated layer. One advantage of this approach is that when you apply an image adjustment to a smart object layer and move that layer the applied image adjustment or series of adjustments will automatically be moved with the layer too. Overall, this means you now have the option to create smart objects and combine adding filters and image adjustments, which in turn can share the same filter mask.

You will notice in the Properties panel in Step 2 that when a Smart Object layer is selected, there is also a Filter mask option (circled) as well as the Layer mask or Vector mask modes.

Of course, if you want to maintain separate masking control of the image adjustments so you can mask areas locally within a Smart Object, then it may be better in these circumstances to stick to using adjustment layers that aren't linked to a Smart Object. However, there is a workaround that was suggested by Julieanne Kost as a means by which you can apply independent layer masking to nested Smart Objects. If you convert a layer to a Smart Object and apply a filter or adjustment you can mask it, as shown in the example opposite. If you then select the Smart Object layer and choose Layer \Rightarrow Smart Object \Rightarrow Convert to Smart Object again, you can nest a new Smart Object within a parent Smart Object. This effectively allows you to mask Smart Object adjustments independently.

1 In this step I opened a layered image in which the layer that contained the Spirit of St Louis airplane was a Smart Object layer. This meant that when this layer was selected I could go to the Image ⇒ Adjustments menu and selected Curves.

2 This opened the Curves dialog, where I applied the adjustment shown here. This adjustment targeted the Smart Object layer contents only, which was effectively the same as applying an adjustment layer in a clipping group. This particular Smart Object layer was also masked by a layer mask.

Figure 4.45 This shows an image with the Crop tool active, but no crop applied yet.

Figure 4.46 This shows the image being cropped, before confirming the crop.

Cropping

To crop an image, select the Crop tool from the Tools panel. When the Crop tool is selected, the crop bounding box overlays the entire image (Figure 4.45). You can then drag any of the corner or side handles to adjust the crop. Or, you can click anywhere in the image area and drag to define the area to be cropped. As you crop an image the outer crop appears shielded (Figure 4.46). As you apply a crop you are operating in crop mode, where the Layers panel temporarily shows a Crop Preview layer. This is just a temporary preview though.

As you drag a crop handle you'll notice how the underlying image moves as you adjust the crop and when a crop is active you can click and drag inside the crop area to reposition the image relative to the crop (and use the keyboard arrows to nudge the image). Both these behaviors make the Photoshop Crop tool more like the one that's in Lightroom, which (in my view) makes it easier to work with. There is also a single undo available when working in a modal crop and while the Crop tool is in use you can click with the *Shift* key held down to then define a new crop area.

Delete cropped pixels

If the Delete Cropped Pixels option is checked in the Crop tool Options bar, the image will be cropped permanently and the Background layer preserved. But if the Delete Cropped Pixels option is unchecked it merely 'trims' the image, preserving the original image contents, including all the layers information, and a layer that was previously a Background layer will be promoted to a normal layer. In Figure 4.47 the Layers panel view on the left shows the Layers panel view for an image that has a regular Background layer mid-crop. If

Figure 4.47 The Layers panel Crop preview modes. Delete Cropped Pixels is unchecked (left) and checked (right).

Delete Cropped Pixels is disabled this displays a Crop Preview layer. If Delete Cropped Pixels is enabled this shows the Crop Preview above a temporary white Color Fill layer. If the Delete Cropped Pixels option is unchecked, a regular Background layer will afterwards become a Layer 0 layer.

Crop ratio modes

The Crop tool Options bar is shown in Figure 4.48. When Ratio is selected you can enter the desired crop ratio settings in the two fields next to the menu in the Options bar. Or, you can select one of the aspect ratio presets listed below. If you select New Crop Preset... you can add a ratio setting as a new Crop tool preset, where the ratio presets use ':' as a separator.

When 'W x H x Resolution' is selected you can enter precise measurement units plus the resolution you wish the cropped image to be. Or, you can select one of the W x H x Resolution presets listed below. When working in the W x H x Resolution mode, the value entered in the first entry field always corresponds to the width and the second value corresponds to the height. You then have the option to click on the double-arrow button to swap these values around to swap between a landscape or portrait mode crop. While a crop is active you can also use the \aleph key to flip the crop between landscape and portrait modes. When resizing a restricted aspect ratio crop box, you can switch between the portrait and landscape orientations by dragging the bounding box from the corner.

If you select New Crop Preset... you can save the settings as a new W x H x Resolution Crop tool preset that uses 'x' as a separator. Alternatively, you can select a cropped image and, with the Crop tool

Figure 4.48 This view of the Crop tool Options bar shows the Crop Aspect Ratio menu.

active, click on the New tool preset button (circled) in the Tool Presets panel to add as a preset based on the current image size settings.

Click the 'Clear' button to clear all the current fields in the Crop tool Options bar to reset the Crop tool to its 'unconstrained' mode. However you configure the Crop tool options, the last used settings are always remembered after exiting the Crop tool.

Crop measurement units

You can constrain a crop to specific dimensions by using the W x H x Resolution option and enter the desired numeric units in the Crop Ratio field boxes plus the following abbreviations: Pixels (px), Inches (in), Centimeters (cm), Millimeters (mm), Points (pt) or Picas (pica).

Crop tool presets

Figure 4.49 Here are the primary options for the Crop tool. If you mouse down on the triangle button next to the Crop tool you will see listed any preloaded Crop tool presets.

Figure 4.49 shows the Crop tool Options bar in normal mode before applying a crop. This shows you the Crop tool presets menu, which will contain the same preset options that appear in the Tool Presets panel. Therefore, you can select a pre-saved crop preset setting that will apply a crop with the required aspect ratio to crop an image and resize it to specific image dimensions and a specific pixel resolution setting. This is useful if you want to crop and resize an image to the desired pixel resolution in one go. As you drag on a corner or side handle the crop can be scaled up or down, preserving the crop aspect ratio. When a fixed crop aspect ratio setting is selected the crop proportions will remain locked. If no Crop tool presets are visible in the Crop tool presets list, try going to the Tool Presets panel and load the *Crop and Marquee.tpl* preset. When saving a new Crop tool preset the name of the tool (either Crop tool or Perspective crop tool) will be added as a prefix (see Figure 4.50 below).

New Crop Preset		New Crop Preset	
Name: Crop Tool 10 x 12 cm 300 ppi	ОК	Name: Perspective Crop Tool 10cm x 12 cm 300 ppi	_ Ок
	Cancel		Cancel

Figure 4.50 This shows the Tool Preset dialog for the Crop tool (left) and Perspective crop tool (right).

Crop overlay display

After you have dragged with the Crop tool and before you commit to the crop, the Crop tool Options bar will change to its crop modal state (Figure 4.51). Here, you have a choice of crop guide overlay options. The default 'Rule of Thirds' option is shown in use in Figures 4.45 and 4.46. This applies a 3×3 grid overlay, which can be useful when composing an image.

There are other overlay options you can choose. The 'Grid' option can be helpful when aligning a crop to straight lines in an image and there are also further options such as Diagonal, Triangle, Golden Ratio, and Golden Spiral overlay options. You can cycle between these overlay options using the **()** key and cycle between the different crop overlay orientations for the Triangle and Golden Spiral modes using the **Shift()** keyboard shortcut.

Figure 4.51 The Crop tool options bar in its modal state, showing the Crop overlay options.

Figure 4.52 The Crop tool options menu.

Crop tool options

The Crop tool options (Figure 4.52) can be accessed from the Crop tool Options bar. The 'Use Classic Mode' option (P) allows you to toggle between the default behavior where the image moves relative to the crop, or the old behavior where the crop bounding box only is moved. Note that some new functionality will be lost if you choose to revert to the Classic mode. The Auto Center Preview option allows you to toggle the 'image moving while resizing' behavior that keeps the crop box centered. The default settings have the crop shield enabled, applying a color that matches the canvas color at 75% opacity. But you can set this to any color you like, such as red or black at 100% opacity. The Auto Adjust Opacity option automatically disables the shield opacity outside the bounding box area as you mouse down with the mouse.

To apply a crop, you can click on the Apply Crop button, doubleclick inside the crop area, or hit the *Enter* or *Return* keys. To cancel a crop, click on the Cancel Crop button or hit the *esc* key.

Front Image cropping

Selecting 'Front Image' (**1**) from the Crop Aspect Ratio menu (refer back to Figure 4.48) loads the current document full image size dimensions and resolution settings (there is also a Front Image button in the Perspective crop tool Options bar).

Disable edge snapping

The edge snapping behavior can be distracting when you are working with the Crop tool. This can easily be disabled in the View \Rightarrow Snap To submenu (or by using the **H** Shift; [Mac], *ctrl* Shift; [PC] shortcut). On a Mac you can also hold down the *ctrl* key to temporarily disable edge snapping.

1 In the following steps the Show Cropped Area option was enabled in the Crop tool options (see Figure 4.52). I selected the Crop tool and dragged across the image to define the crop area. The cursor could then be placed over any of the eight handles in the bounding rectangle to readjust the crop.

2 Dragging the cursor inside the crop area allowed me to move the crop. I could also drag the crop bounding box center point to establish a new central axis of rotation.

3 I could then mouse down outside the crop area and drag to rotate the crop around the center point, which can even be positioned outside the crop area. You normally do this to realign an image that is at an angle.

4 Here, I deselected the Show Cropped Area option from the Crop tool Options bar (you can also use the **()** key shortcut to hide the outer shaded area).

Selection-based cropping

To make a crop based on a selection, all you need to do is select the Crop tool (\bigcirc) and the crop will automatically fit to the selected area. For example, you might want to \textcircled (Mac) \textcircled (PC)-click a layer to make a selection based on a single layer and then execute a crop (see Figure 4.53). Here, I wanted to make a crop of the Earls Court layer, the quickest solution was to \textcircled (Mac), \Huge (PC)-click this layer in the Layers panel and then select the Crop tool (\bigcirc). You can also make a crop based on an active selection by choosing Image \Rightarrow Crop. This instantly crops and automatically matches the bounds of any selection. Where a selection has an irregular shape, the crop is made to the outer limits of the selection and the selection retained.

Figure 4.53 An example of selection-based cropping.

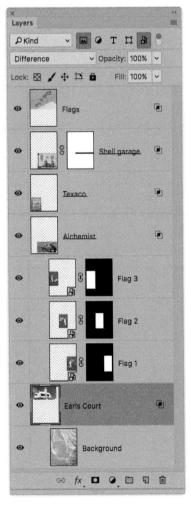

Canvas size

The Image \Rightarrow Canvas size menu item can be used to enlarge the image canvas area, extending it in any direction. This lets you extend (or contract) the image canvas area. If you check the Relative box you can enter the unit dimensions you want to see added to or subtracted from the current image size. Added pixels are then filled using the current background color, or you can also choose other fill options. In Figure 4.54 the image was anchored so that pixels were added equally left and right and to the top of the image only.

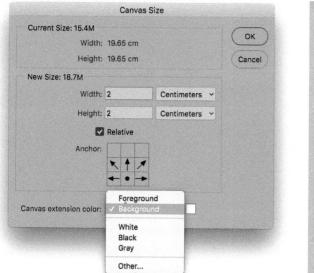

Figure 4.54 Canvas Size can be used to add pixels beyond the canvas bounds.

It is also possible to add to the canvas area without using Canvas Size (see Figure 4.55). To do this, make a full-frame crop, release the mouse and then drag any one of the bounding box handles outside the image and into the canvas area. Double-click inside the bounding box area or hit *Enter* to add to the canvas size. If the starting point image has a Background layer, this step fills the added canvas with the current background color. In this example, the starting point was a non-Background layer, so this added transparency as more canvas was added.

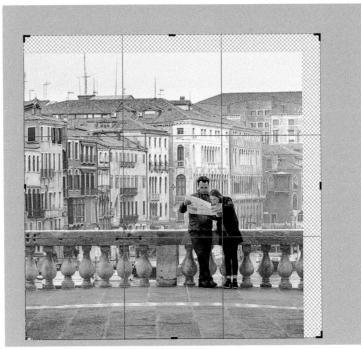

Figure 4.55 Using the Crop tool as a canvas resize tool.

Corner tracking

You will notice how, as you adjust the rotation, the crop bounding box tracks the corners of the image. By this I mean the crop bounding box remains constrained to the non-transparent areas of the original image. This will persist if you select a crop aspect ratio preset. As soon as you drag the corners of the crop bounding box, the crop bounding box no longer tracks the corners of the image. i.e., it is no longer constrained and is able to include transparent areas within a crop.

Content-Aware Cropping

When you crop a photograph it will sometimes be necessary to rotate the crop as you do so, such as to straighten the horizon line. If you check the Content-Aware option in the Crop tool Options bar (Figure 4.56), this allows you to apply a crop that expands to contain the image, instead of contracting to fit inside it. Once you click OK to accept the crop it automatically fills the outer transparent areas using a content-aware fill. Note that the fill selection will overlap the original image slightly.

· · · · · · · · · · · · · · · · · · ·	and the second se				
└┐. → Ratio →	+	100. 00 1.11	da 40		
	Clear	Straighten	HH Q	Delete Cropped Pixels	Content-Aware
				Contra enchiber i maio	oundry mult

Figure 4.56 The Crop tool Options bar with the Content-Aware Crop box checked.

When enabled, the Content-Aware Crop feature disables corner tracking. Wherever there are leftover transparent areas these will be filled using a content-aware fill. There are limits to the amount you can extend the crop area and apply a Content-Aware Crop. If you rotate the crop, or extend the crop bounding box handles to the point where the overall cropped area is 1.4 times the size of the original document, or the crop is 1.5 times wider or taller than the original image, then the Content-Aware Crop will automatically be disabled. The following steps show the Content-Aware Crop feature in action. You will see in the final version how I was able to rotate the image and add more image detail to the surrounding edges. The Step 4 version has a lot more space surrounding the castle compared to the regular cropped version seen in Step 2.

1 This photograph is shown here uncropped and with no straightening.

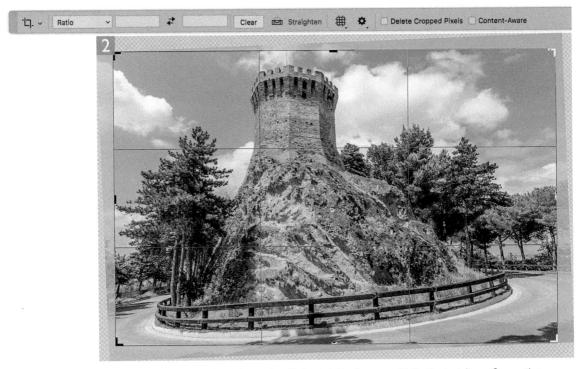

2 In this step I applied a straightening crop with the Content-Aware Crop option unchecked. The corner tracking meant the crop was constricted to inside the image.

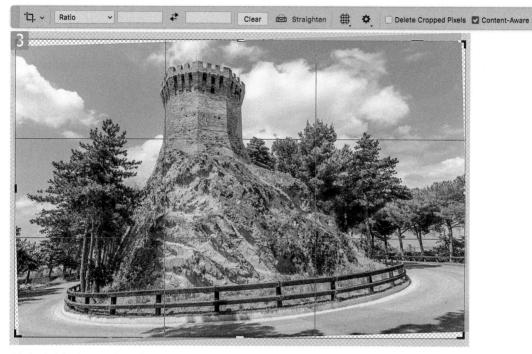

3 I checked the Content-Aware Crop box and repeated the same exercise. With this option checked, the crop rectangle could expand to include more of the image.

4 I clicked the Apply Crop button to apply the crop. This filled the transparent areas with a content-aware fill and there was now more space surrounding the castle.

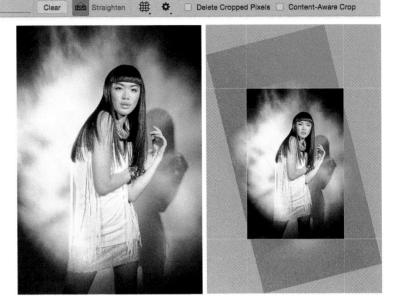

Figure 4.57 An example of an image with big data, showing the cropped version (left) and the Reveal All version (right).

Client: Gallagher Horner. Model: Kelly @ Zone.

Big data

The Photoshop PSD, PDF, and TIFF formats all support 'big data.' This means that if any of the layered image data extends beyond the confines of the canvas boundary, it is saved as part of the image when you save it, even though it isn't visible. When you crop an image that contains a normal, non-flattened Background layer and the 'Delete Cropped Pixels' box is unchecked, Photoshop automatically converts the background layer to a Layer 0 layer (and thereby preserves all the big data). Big data can only be preserved providing the image is saved using the PSD, PDF, or TIFF formats.

If there are layers in the image that extend outside the bounds of the canvas, you can expand the canvas to reveal all of the big data by choosing Image \Rightarrow Reveal All. The cropped image in Figure 4.57 contains multiple layers which when expanded by using the Image \Rightarrow Reveal All command shows the hidden 'big data' that extended outside the cropped view. As long as the Delete Cropped Pixels option is left unchecked when a crop is applied, this allows you to preserve the pixels that fall outside the selected crop area instead of deleting them.

Perspective crop tool

The Perspective crop tool can be used to crop and correct the converging verticals or horizontal lines in a picture with a single crop action. In Figure 4.58 I wanted to correct the perspective distortion in this photograph. Using the Perspective crop tool I was able to accurately reposition the corner handles on the image to match the perspective of the tablet. You can either marquee drag with the tool as usual, or click to define the four corners of the perspective crop, after which you can drag on the corner and/or side handles to adjust the crop shape. Having done this you can click to confirm and apply the crop and, at the same time, correct the perspective. The Perspective crop should work well in most cases, but you may sometimes need to apply a further transform adjustment to compensate for any undesired stretching of the image. You will mostly find it easier to zoom in to gauge the alignment of the crop edges against the converging verticals. Here, it was useful to check the 'Show Grid' option to help gauge the alignment correctly. Note also the 'Front Image' button. Clicking this loads the current document full image size dimensions and resolution settings, so that when you apply the crop the cropped image retains the same size (but may well appear stretched of course).

Modifying a perspective crop

When the Perspective crop bounding box is active you can modify the crop shape by dragging the corner or side handles. If you hold down the *Shift* key as you drag a handle this constrains the movement to vertical or horizontal plane movement only. If you hold down the *all* key as you drag a corner handle this allows you to resize the crop in both planes at once. If you hold down the *all* key as you drag a side handle this allows you to expand the crop equally on both sides at once.

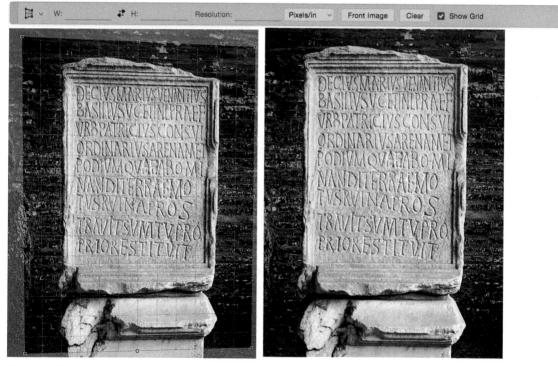

Figure 4.58 The Perspective crop tool is great for correcting perspective.

Amount slider

After you have applied a Content-Aware scale adjustment to a photograph (and before you click OK to apply it), you can use the Amount slider to determine the amount of Content-Aware scaling that is applied to the layer. If you set this to zero, no special scaling is applied and the image will be stretched as if you had applied a normal transform.

Content-Aware scaling

The Content-Aware scale feature can be used to rescale images by compressing the flat portions of an image while preserving the detailed areas. It basically allows you to recompose photographs to fit different proportion layouts. Over the next few pages I have outlined some of the ways you can work with this tool and suggested some practical uses. For example, advertising and design photographers may certainly appreciate the benefits of being able to adapt a single image to multiple layout designs.

To use Content-Aware scaling, you will need an image that's on a normal layer (not a Background layer). Go to the Edit menu and choose Content-Aware Scale (**# all Shift** [Mac], **ctrl all Shift** [PC]). Then drag the handles that appear on the bounding box for the selected layer to scale the image, making it narrower/wider or shorter/taller. The preview will update to show the outcome of the scale adjustment. You can use the Options bar to access some of the extra features discussed here such as the Protect options. The Content-Aware scale feature is clever at detecting which edges you would like to keep and those you would like to stretch or squash, but won't work perfectly on every image. However, it does appear to do a good job of recognizing circular objects and can preserve these without distorting them.

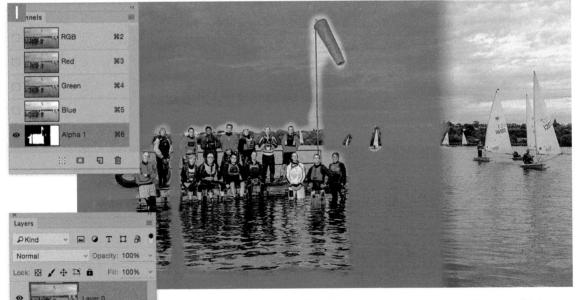

1 Before applying any kind of 'content-aware scaling' you need to double-click the background layer, or create a new merged copy layer. Not all images will need this, but in this instance I created a new channel and painted a filled mask to indicate the sections that should be protected.

2 This shows what the photograph looked like after I had used the Edit \Rightarrow Content-Aware Scale command to compress the image on the side as well as top and bottom. Note that the Alpha 1 channel mask created in Step 1 was selected in the Protect menu.

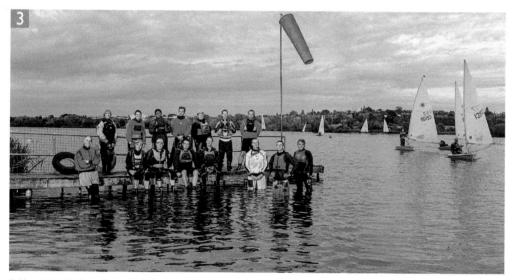

3 Here is the final result, in which there was now less gap between the jetty and the boats on the right. The people in the group now appeared relatively bigger in the scene. Whenever you scale an image using this method, you have to watch carefully for the point where important parts of the picture start to show jagged edges. When this happens, you'll need to ease off and consider scaling the image in stages instead. For example, with this image I applied a second pass Content-Aware scale to reduce the height of the wind sock mast.

0 1

Protect facial features

1 In this example I wanted to show how you can help protect someone's face from being squashed or stretched as you scale an image.

2 In general, you will find that the Content-Aware scale feature does a pretty good job of distinguishing and preserving the important areas of a photograph and tends to scale the less busy areas of a photograph first, such as a sky. However, if you click on the Protect Skin tones button (circled), this ensures that faces in a photograph remain protected by the scaling adjustments. I was able to stretch this picture horizontally so that the man in this photograph was moved across to the right. I was thereby able to stretch the image quite a bit, but without distorting his face and body.

How to remove objects from a scene

1 The Content-Aware scale feature can also be used to selectively remove objects from a scene. The results won't always be completely flawless, but it can still work pretty well where you wish to squash an image tighter and remove certain elements as you do so. To begin with it is important that the layer you are working on is a non-Background layer. You will need to either duplicate the Background layer or double-click to convert it to a normal layer. I hit the results whet he bits that I wished to remove. With the Quick Mask, white protects and black (which appeared here as a red mask overlay) indicates the area to remove.

2 Next, I reselected the RGB composite channel in the Channels panel and selected the Edit ⇒ Content-Aware Scale command. From the Protect menu in the Options bar, I selected the Quick Mask I had just created, and as I scaled the image, the goose on the right started to disappear. As always, it is important to watch carefully for jagged edges and not compact the image too much.

Rotating images

If an image needs to be rotated you can use the Image \Rightarrow Rotate menu to orientate a photo the correct way up, turn it 180°, flip it horizontally, or vertically even. If an image doesn't appear to be perfectly aligned, you can click to select the straighten tool from the Crop tool Options bar (circled in Figure 4.59) and drag across the image along what should be a vertical or horizontal edge in the photo. This will apply a precise image rotation. When the Crop tool is selected you can use the (Mac) (PC) key to temporarily access the Straighten tool. Or, if you are in the Straighten tool mode, you can use the (Mac) (PC) key to switch back to the Crop box editing mode. To rotate an individual layer, make the layer active, select the Ruler tool, and drag to define the edge you wish to appear straight. Then click the Straighten Layer button in the Ruler tool Options bar (Figure 4.60) to straighten.

straighten an image.

Timal v X:507.13 Y:1231.46 W:1149.40 H:71.08 A:-3.5" L1:1151.59 L2: Use Measurement Scale Straighten Layer Clear

Figure 4.60 The Ruler tool Options bar.

Chapter 5

Black and white

I was 11 years old when I first got into photography. My first darkroom was kept under the stairs of our house and, like most other budding amateurs, my early experiments were all done in black and white. Back then, very few amateur photographers were competent enough to know how to process color, so working in black and white was all that most of us knew. For me, there has always been something rather special about black and white photography and digital imaging has done nothing to diminish this. If anything, I would say that the quality of capture from the latest digital cameras coupled with the processing expertise of Photoshop and improvements in inkjet printing have now made black and white photography an even more exciting avenue to explore.

Black and white film conversions

Traditional black and white film emulsions all differ slightly in the way they respond to different portions of the visual spectrum (as well as the colors we can't see). This is partly what gives emulsion films their 'signature' qualities. So in a way, you could say that film also uses standard formulas for converting color to black and white, and that these too are like rigid grayscale conversions. You may also be familiar with the concept of using strong colored filters over the lens when shooting with black and white film and how this technique can be used to emphasize the contrast between certain colors, such as the use of yellow, orange, or red filters to add more contrast to a sky. Well, the same principles apply to the way you can use the Black & White adjustment to mix the channels to produce different kinds of black and white conversions.

Figure 5.1 If you convert a color image to grayscale mode, Photoshop pops the dialog shown here.

Converting color to black and white

Wherever possible you are far better off capturing a scene in full color and using Camera Raw or Photoshop to carry out the color to mono conversion. Of course, if you shoot raw, the original data will always be in color. Following on from that, you will need to use the most appropriate conversion method to get the best black and white results.

Dumb black and white conversions

When you change a color image in Photoshop from RGB to Grayscale mode, the tonal values of the three RGB channels are averaged out to produce a smooth continuous tone grayscale. The formula for this conversion blends 60% of the green channel with 30% of the red and 10% of the blue. The rigidity of this color to mono conversion limits the scope for obtaining the best grayscale conversion from a scanned color original. The Figure 5.1 dialog basically advises you there are better ways to convert to black and white. The same thing is true if you make a Lab mode conversion, delete the a and b channels, and convert the image to grayscale mode, or if you were to simply desaturate the image. There is nothing necessarily wrong with any of these methods, but none allow you to make full use of the information that's contained in a color image.

Smarter black and white conversions

If you capture in color, the RGB master image contains three different grayscale versions of the original scene and these can be blended together in different ways. One way to do this is to use the Black & White image adjustment in Photoshop, which, while not perfect, can still do a good job in providing you with most of the controls you need to make full use of the RGB channel data when applying a conversion. The Black & White slider adjustments will, for the most part, manage to preserve the image luminance range without clipping the shadows or highlights. These adjustments can be applied to color images directly or, by using the Adjustments panel, to add an adjustment layer. The advantage of using an adjustment layer to apply a black and white conversion is you can quickly convert an image to black and white and have the option to play with the blending modes to refine the appearance of the black and white outcome. Let's start though by looking at the typical steps used when working with the Black & White adjustment controls.

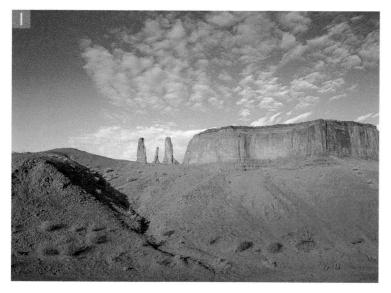

1 The following steps show a basic method for converting a full color original photograph to black and white. The Black & White image adjustment can be applied directly by going to the Image ⇒ Image Adjustments menu, or you can go to the Adjustments panel and click on the Black & White button (circled in red) to add a new adjustment layer.

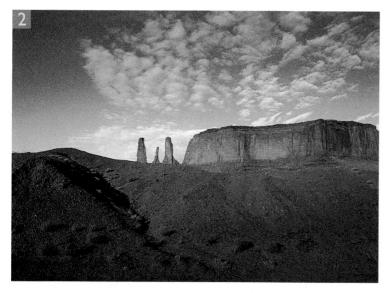

2 To begin with I clicked on the Auto button (circled in blue). This applied an auto slider setting based on an analysis of the image color content. The auto setting usually offers a good starting point for most color to black and white conversions and won't do anything too dramatic to the image. It is immediately better than choosing Image \Rightarrow Mode \Rightarrow Grayscale.

× Adjustments	**
Add an adjustment	
× ••• 🗷 🗹 🗸	
E 57 D @ 6 II	
Properties	
Black & White	
Preset: Default	~
1 Tint	Auto
Reds:	40
A linear	
Yellows:	60
Greens:	40
Cyans:	60
Blues:	20
Magentas:	80
x∏ ©) Layers	<u>ර</u> ම ඕ =
PKind v II O T	пв
Normal ~ Opacity	: 100% ~
Lock: 🖾 🖌 💠 🎞 🔒 🛛 Fill	100% ~
• B	ack & White 1
Background	۵
∞ fx □ •.	

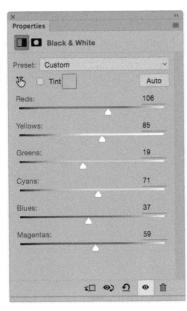

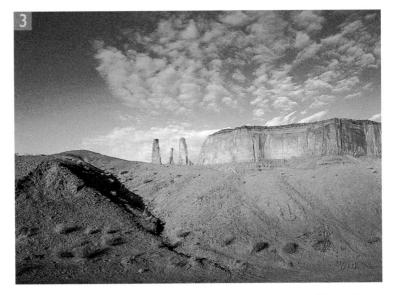

3 If you don't like the auto setting result, you can adjust the sliders manually to achieve a better conversion. In this example, I lightened the Yellows and darkened the Reds slightly.

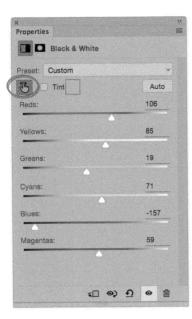

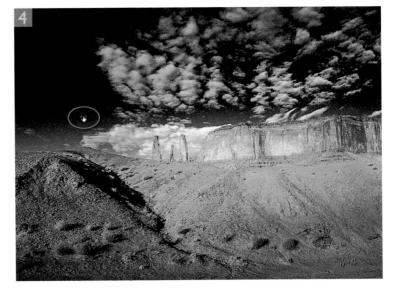

4 Lastly, I clicked on the Target adjustment mode button (circled) for the Black & White adjustment. This allows you to move the cursor over particular areas of interest (such as the sky) and drag directly on the image to modify the Black & White adjustment. This selects the nearest color slider in the Black & White adjustment panel. Dragging to the left will make the tones beneath the Target adjustment tool cursor go darker and dragging to the right, lighter. In the example you see here I dragged the slider to the left to make the blue sky darker.

Black & White adjustment presets

As with other image adjustments, the Black & White adjustment has a Presets menu at the top from where you can select a number of shipped preset settings. Figure 5.3 shows examples of the different outcomes that can be achieved through selecting some of the different presets from this list.

Once you have created a Black & White adjustment setting you would like to use again you can choose Save Preset... from the Properties panel options menu (Figure 5.2). In this example, I saved the slider settings as a custom preset called 'Red Contrast.'

Properties	ack & White		Auto-Select Parameter Auto-Select Targeted Adjustment Too
8 П П	d Contrast	Auto	Save Black & White Preset Load Black & White Preset Delete Current Preset
Reds:		120	Reset Black & White
Yellows: Greens:	•	<u>-10</u>	Close Close Tab Group
Cyans:	•	-50	
Blues:		-85	
Magentas:	∧	120	
	Sav	/e	
Saue Aau	Save black and w	vhite settings in	navezanaranag
Tags:			
Where:	Black and White		

Figure 5.2 Saved presets can be accessed by mousing down on the Presets menu at the top of the Black & White adjustment Properties panel (circled).

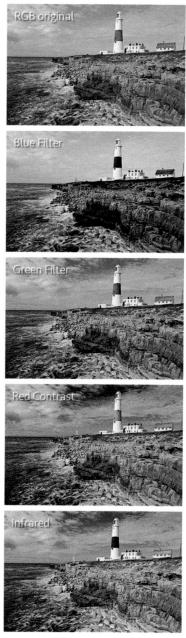

Figure 5.3 This shows examples of different Black & White adjustment presets applied to a color image.

Split color toning using Color Balance

Although the Black & White adjustment contains a Tint option for coloring images, this only applies a single color overlay adjustment and I have never really found it to be that useful. It is nice though to have the ability to apply a split tone coloring to a photograph and one of the easiest ways to do this is by using the Color Balance image adjustment. This is because the Color Balance controls are intuitive and simple to use. For example, if you want to colorize the shadows, select the Shadows option from the Tone menu and adjust the color settings, then select Midtones to make them a different color, and so on. It is best to apply such coloring effects with the adjustment layer set to the Color blend mode. The advantage of this is you can alter the color component of an image without affecting the luminosity. This is important if you want to avoid disrupting the tone levels information.

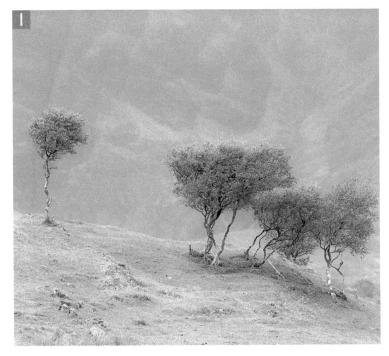

1 I started here with an RGB color image and converted it to monochrome using the Black & White image adjustment. I then added a Color Balance adjustment layer to colorize the RGB/monochrome image. To do this, I went to the Adjustment panel and selected the Color Balance adjustment. In the Properties panel I selected the Shadows option from the Tone menu and adjusted the three color sliders to apply a color cast to the shadows.

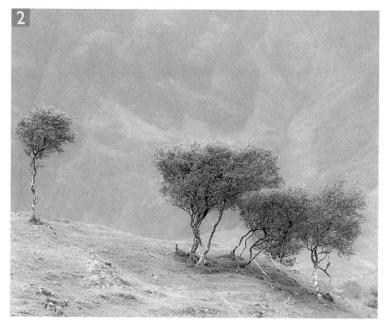

Tone: Midtones		~
Cyan	Red 0	
Magenta	Green -	14
Yellow	Blue -	18

2 I then selected the Midtones Tone menu option and adjusted the color sliders to add a warm color balance to the midtones.

3 Finally I selected the Highlights option from the Tone menu and added a red/yellow cast to the highlights. You will notice that I had Preserve Luminosity checked. This prevented the image tones from becoming clipped. I set the adjustment layer blending mode to Color, which also helped preserve the image luminance information.

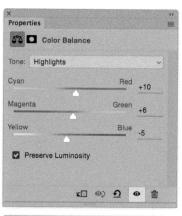

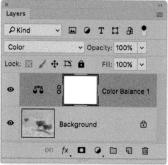

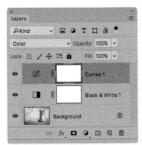

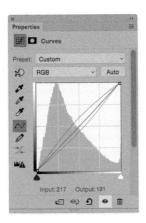

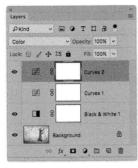

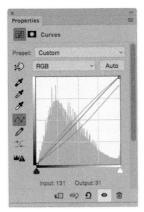

Split color toning using Curves adjustments

The Color Balance method is reasonably versatile, but you can also colorize a photograph by using two Curves adjustment layers and taking advantage of the Layer Style blending options to create a more adaptable split tone coloring effect.

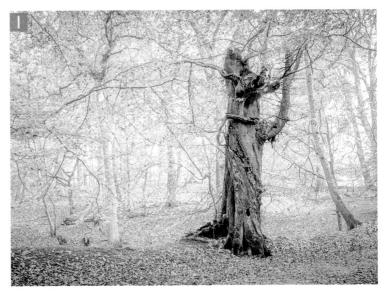

1 To tone this image, I first added a Curves adjustment layer above a Black & White adjustment layer and adjusted the channel curves to apply a blue/cyan color adjustment.

2 I then added a second Curves adjustment above the previous one and this time adjusted the channel curves to apply a sepia colored adjustment.

Double-click in this area of the layer to open the Layer Style dialog.

3 I made the first Curves layer active and double-clicked to open the Layer Style dialog shown here. I then *att*-clicked on the highlight divider triangle in the 'This Layer' 'Blend If' layer options. This enabled me to separate the divider, splitting it into two halves (circled). This allowed me to control where the split between these two points occurred.

4 The advantage of this method is you can adjust the layer opacity and Layer Style blending modes of each individual layer and this offers more flexibility when it comes to deciding how best to color the shadows and highlights.

Photographic toning presets

If you click on the Presets menu, circled red in Step 2, or click on the gradient ramp options, circled blue in Step 2 (and then click on the presets options icon), you can add new sets of gradient map presets. Among these is a set titled 'Photographic Toning' (see Figure 5.4). This set of gradient maps has been specifically designed for creating split toning effects.

Figure 5.4 This shows the gradient map presets in the Photographic Toning set.

Split color toning using a Gradient Map

The coloring techniques shown so far allow you to apply split tone type coloring effects. Of these the Color Balance method is perhaps the easiest to use. However, another way to do this is to add a Gradient Map adjustment layer. When applied using the Normal blend mode the Gradient Map uses a gradient to map the tones in the image to new values. This in itself can produce some interesting effects when combined with standard Photoshop gradients. But if you set the Gradient Map adjustment layer blend mode to Color you can restrict the adjustment so that it can be used just to colorize the image. As you can see in Step 2, the gradient doesn't have to go from dark to light, what counts are the color hue and saturation values that are applied at each stage of the gradient. To edit the colors you just need to click on the gradient ramp to add a new color swatch and double-click a swatch color to open the Photoshop Color Picker and select a new color.

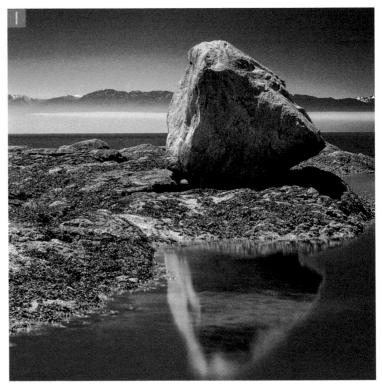

1 Here is a photograph that I wished to apply a duotone type effect to, while keeping the image in RGB mode.

	Gr	adient Editor	~		Prope	ortie
Presets			(*·)	ОК		
200	11			Cancel		
		1.000		Load		ithe
				Save) 🗆 R	eve
lame: Cool/Warr	n			New		
					ET EST	
Gradient Type:	Solid ~					
Gradient Type: Smoothness: 10						
				Ţ		
Smoothness: 10	0 ~ %		3			
		ĺ)			
Smoothness: 10	0 ~ %	Location:) 96			
Smoothness: 10	10 <u>~</u> %			Â		

2 I added a Gradient Map adjustment layer to the image and double-clicked the gradient in the Gradient Map adjustment Properties panel to create a new gradient setting.

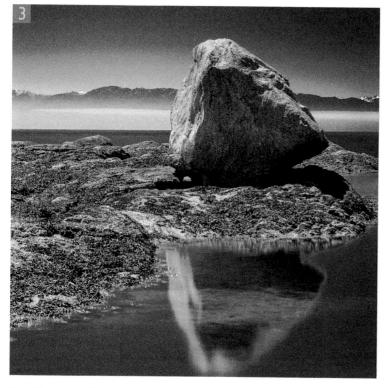

3 I set the Gradient Map layer blend mode to Color and in this instance reduced the layer opacity to 40% to produce the coloring effect seen here.

The extra color sliders

Camera Raw provides you with more sliders to play with than the Black & White adjustment. These allow you to adjust the in-between color ranges such as Oranges, Aquas, and Purples. The Oranges slider is useful for targeting skin tones and the Aquas is useful for adjusting things like the sea. Having these extra sliders provides you with extra levels of tone control.

Camera Raw black and white conversions

You can also use Camera Raw to convert images to black and white. This can be done at the raw processing stage to a raw, JPEG, or TIFF image (providing the TIFF is flattened). Or, you can do so using the Camera Raw filter from the Filter menu.

If you go to the HSL/Grayscale panel and check the Convert to Grayscale box, Camera Raw creates a black and white version of the image, which is produced by blending the color channel data to produce a monochrome rendering of the original. Clicking 'Auto' applies a custom setting that is based on the white balance setting applied in the Basic panel, while clicking 'Default' resets all the sliders to zero. You can manually drag the sliders to make certain colors in the color original lighter or darker, or select the Target adjustment tool (circled in Step 2) to click and drag on the image to make certain colors convert to a darker or lighter tone. The overall tone brightness and contrast should not fluctuate much as you adjust the settings here and this makes it easy to experiment with different slider combinations.

If you want to make a sky go darker you can do what I did in Step 2. Here, I selected the Target adjustment tool, clicked on the sky and dragged to the left. This caused the Aquas and Blues sliders to shift to the left, darkening these tones. I would also suggest sometimes switching over to the Basic and Tone Curve panels to make continued adjustments to the white balance and tone controls as these can also strongly influence the outcome of a black and white conversion.

Pros and cons of the Camera Raw approach

In my view, Camera Raw black and white conversions have the edge over using the Black & White adjustment in Photoshop. This is because the slider controls are better thought out and the addition of the inbetween color sliders (see sidebar) makes it possible to target certain colors more precisely. The Target adjustment tool in Camera Raw is more refined than the one in Photoshop's Black & White adjustment.

An important question to raise here is "When is the best time to convert a photo to black and white?" If you do this at the early Camera Raw stage it limits what you can do to a photo should you then want to retouch the image in Photoshop. I always find it is better to carry out the black and white conversion at the end of the editing process and have the adjustment be reversible. If you are able to carry out all your adjustments in Camera Raw and don't need to use Photoshop this is not a problem. Otherwise, I recommend you apply Camera Raw as a filter to carry out a Camera Raw black and white conversion. But I would recommend you convert the image layer or layers you wish

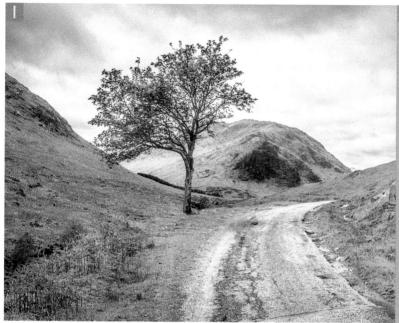

White Balance: As Shot	
Temperature	
	5300
Tint	+13
<u>Auto Default</u>	
Exposure	-0.08
Contrast	-2
Highlights	-100
Shadows	+53
Whites	+47
Blacks	-51
Clarity	+100
/ibrance	0
Saturation	0

1 This shows a color image opened in Camera Raw.

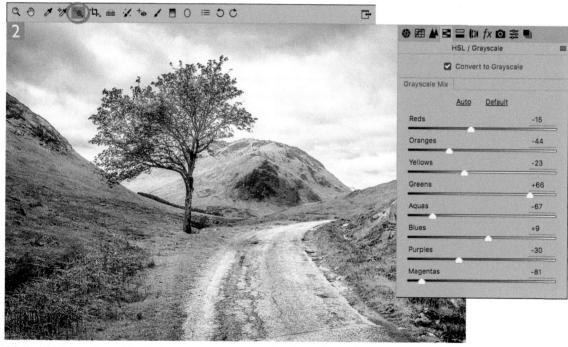

2 In the HSL/Grayscale panel I clicked on the Convert to Grayscale button and, with the help of the Target adjustment tool (circled), clicked and dragged directly on the image to make adjustments that would improve the black and white tone contrast.

to edit into a smart object first though, so the Camera Raw black and white edits remain editable. Another option is to use Lightroom. Here, it is possible to re-import your Photoshop-edited images back into Lightroom and use the Develop module in Lightroom to apply a black and white conversion. The advantage of this approach is that both PSD and TIFF formats can be read and they don't have to be flattened— Lightroom doesn't have a problem processing layered PSD or TIFF format images.

Camera Calibration panel tweaks

Another thing I discovered is you can also use the Calibration panel sliders to affect the outcome of a Camera Raw black and white conversion. As you can see in the following steps, this can enable you to create stronger contrast effects than would be possible using the HSL/Grayscale panel sliders on their own.

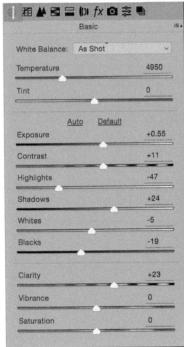

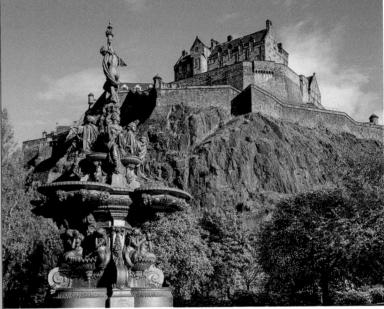

1 This shows a color image opened in Camera Raw. In this step I applied some basic tone and color corrections.

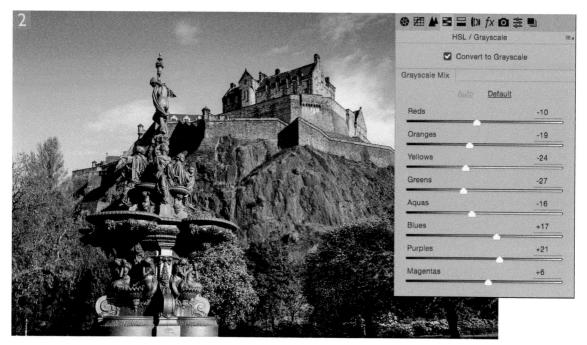

2 Next, I went to the HSL/Grayscale panel and checked the Convert to grayscale checkbox to convert the image to black and white using the Auto setting.

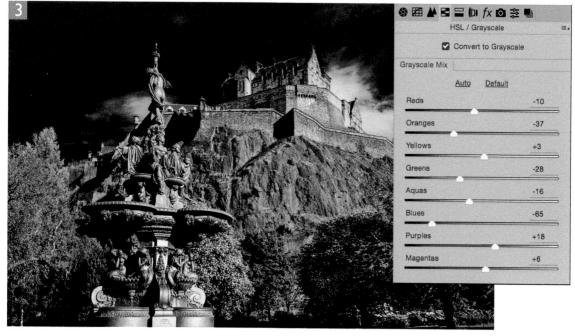

3 I then manually adjusted the Grayscale Mix sliders to make the blue sky darker.

Camera Calibration	
Process: 2012 (Current)	
Camera Profile	
Name: Adobe Standard	•
Shadows	
Tint	+50
Red Primary	
Hue	-10
Saturation	+70
Green Primary	
Hue	-70
Saturation	+30
Blue Primary	
Hue	+75
Saturation	+100

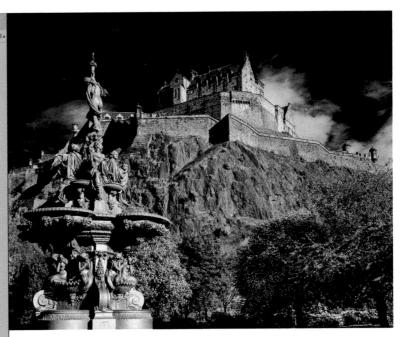

4 In this final step, I went to the Calibration panel and adjusted the Tint Hue and Saturation sliders, as shown here to produce a stronger tone contrast effect.

HSL grayscale conversions

If you set all the Saturation sliders in the HSL panel to -100, you can then use the Luminance sliders in the HSL panel to make almost the same type of adjustments as in the Grayscale mode. One of the chief advantages of this method is you can use the Saturation and Vibrance controls in the Basic panel to fine-tune the grayscale conversion effect, which you can't do when using just the ordinary Grayscale conversion mode. The following steps demonstrate that while this black and white conversion method appears to be fairly similar to a conventional black and white conversion, the ability to adjust the Vibrance and Saturation can have a significant effect on the final outcome. I find that after you adjust the Luminance sliders, you can use Vibrance and Saturation adjustments to apply an adjustment that can act as an amplifier or limiter for the black and white conversion you have just applied. Think of the luminance adjustments as a single adjustment and Vibrance or Saturation being able to intensify, or tame the overall adjustment effect. Having access to these two extra controls gives you more scope to refine the outcome of a black and white conversion.

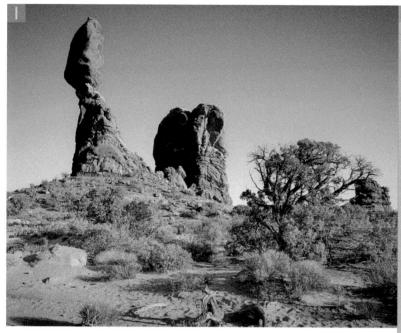

Basic	
White Balance: As Shot	
Temperature	4650
Tint	-8
Auto Defi	
Exposure	0.00
Contrast	0
Highlights	0
Shadows	0
Whites	0
Blacks	0
Clarity	0
/ibrance	0
Saturation	0

1 This shows a color photograph opened in Camera Raw with the default Basic panel settings and As Shot white balance.

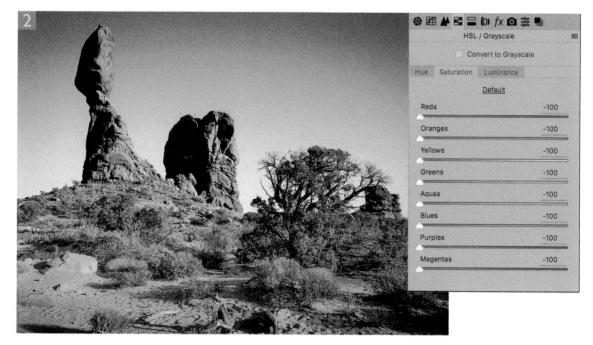

2 I went to the HSL / Grayscale panel. Instead of clicking Convert to Grayscale, I clicked on the Saturation tab and dragged all the Saturation sliders to the left.

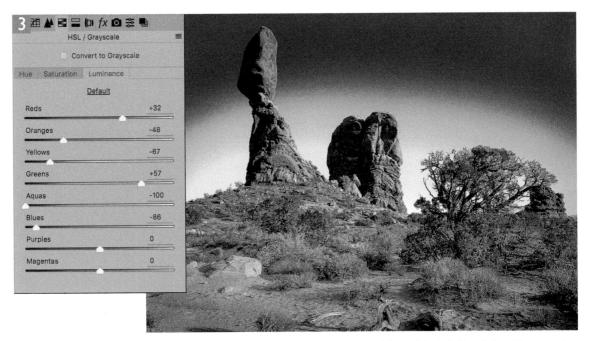

3 I then clicked on the Luminance tab and dragged the individual Color sliders to apply a custom black and white conversion. This is similar to the Grayscale Mix method.

White Balan	ce: Cust	tom	
Temperatur	e		4832
Tint			-56
	Auto	Default	
Exposure		-	0.00
Contrast			-26
Highlights			0
Shadows			+20
Whites			+64
Blacks			-13
Clarity			+21
Vibrance			0
Saturation			-37

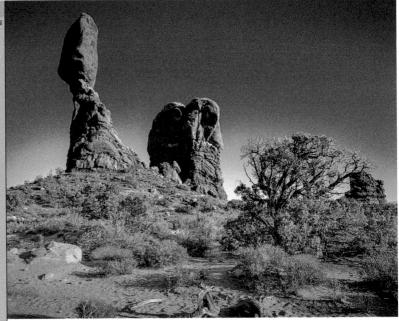

4 I returned to the Basic panel. Here, I adjusted the tone sliders to optimize the tones. I adjusted the Temperature and Tint sliders to adapt the black and white conversion and also reduced the Saturation slider. Finally, I added a Split Toning adjustment.

Camera Raw Split Toning panel

After you have used the HSL/Grayscale panel to convert a photograph to black and white you can use the Camera Raw Split Toning panel to colorize the image. These controls can be used to apply one color to the highlights, another color to the shadows, and then use the Saturation sliders to adjust the intensity of the colors. This is how you create a basic split tone color effect. There is also a Balance slider, which lets you adjust the midpoint for the split tone effect. In Figure 5.5 I applied a warm tone to both the highlights and shadows and adjusted the Balance slider so that the split toning was biased more towards the highlights. The HSL/Grayscale and Split Toning controls are very versatile and can work equally well with non-raw images.

Saturation shortcut

When dragging the Hue sliders in the Split Toning panel you can hold down the *all* key to temporarily apply a boosted saturation to the split tone adjustment and thereby see more clearly the hue value you are applying. This works even when the Saturation sliders are set to zero.

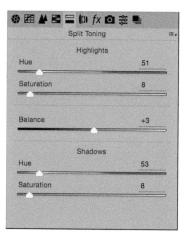

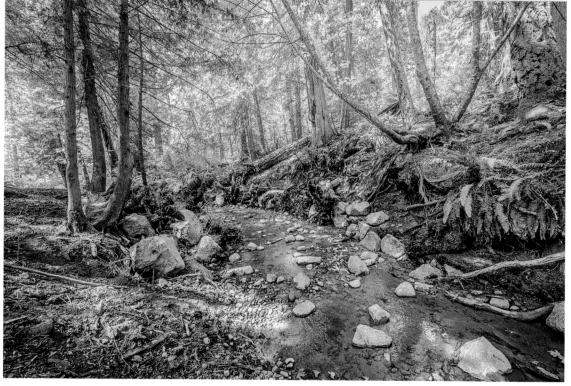

Figure 5.5 This shows an example of a Split Toning adjustment in Camera Raw.

Camera Raw color image split toning

Although the Split Toning panel was designed to be used with black and white images, these controls can be just as useful when editing color photos. While it is possible to apply split toning effects in Photoshop, the Split Toning controls in Camera Raw are directly accessible and easier to interact with.

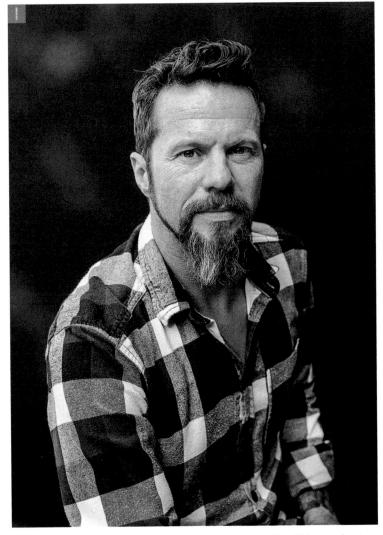

1 Here you can see a photo before I had applied a split toning effect. This started out as a full-color image, although I did apply a -40 Vibrance adjustment to desaturate the colors slightly.

White Balance: Custom	
Temperature	5523
Tint	-4
Auto Default	
Exposure	+0.45
Contrast	+31
Highlights	-50
Shadows	+32
Whites	0
Blacks	0
Clarity	+33
Vibrance	-30
Saturation	0

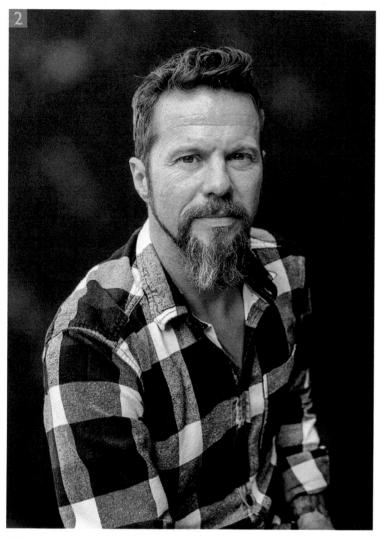

2 I then went to the Split Toning panel and adjusted the Hue and Saturation sliders to create the split toning effect shown here. Essentially, the Hue sliders allow you to independently set the hue color for the highlights and the shadows and the Saturation sliders let you adjust the saturation. As I mentioned on page 405, if you hold down the *att* key as you drag on a Hue slider you'll see a temporary, saturated preview. This lets you set the Hue slider for the desired color, without needing to adjust the Saturation slider first. The Balance slider can be used to adjust the balance between the highlight and shadow colors. This lets you offset the midpoint between the two. What is interesting to note here is that although the Hue values were the same for both the highlights and shadows, the Balance slider can still have a subtle effect on the outcome of any Split Tone adjustment.

-

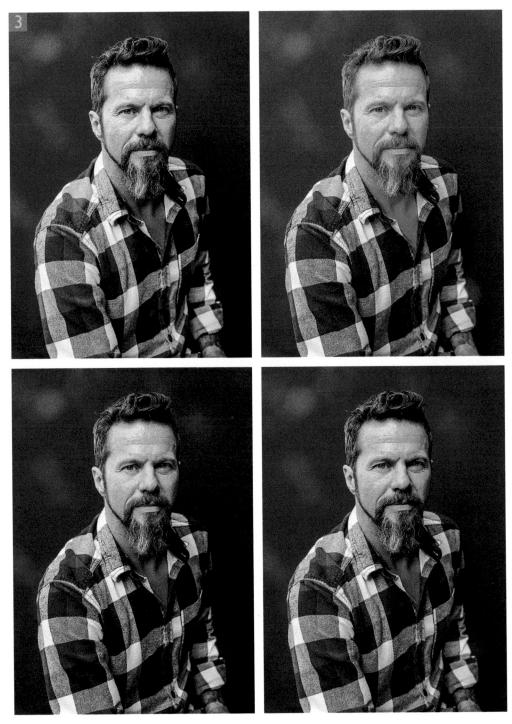

3 To demonstrate the versatility of the Split Toning panel, these four additional looks were created by further tweaking the Split Toning panel settings.

Chapter 6

Extending the dynamic range

For some time now, everyone has become preoccupied with counting the numbers of pixels in a digital capture as if this is the one benchmark of image quality that matters above all else. Size isn't everything though and it is really the quality of the pixel capture we should be concerned with most. The one thing people haven't focused on so much is the dynamic range of a camera sensor. Dynamic range refers to the ability of a sensor to capture the greatest range of tones from the minimum recordable shadow point to the brightest highlights and this is what we are going to focus on here in this chapter.

Other HDR applications

32-bit image editing is also used extensively to make the realistic CGI effects you see in many movies and television programs. These are created using a 32-bit color space to render the computer-generated characters. It is necessary to do this in order to make them interact convincingly with the real world film footage. What usually happens is a light probe image is taken of the scene in which the main filming takes place. This is a sequence of six or seven overlapping exposures of a mirrored sphere, taken to form an omnidirectional HDR image. The resulting light probe image contains all the information needed to render the shading and textures on a computer-generated object with realistic-looking lighting. Paul Debevec is a leading expert in HDR imaging and his website debevec.org contains a lot of interesting information on HDR imaging and its various applications.

High dynamic range imaging

High dynamic range imaging (HDR) is mostly about extending the dynamic range of the camera sensor to capture as wide a range of scenic tones as possible. Over the last few years digital camera sensors have improved significantly and some digital cameras are already capable of capturing a decently wide dynamic range. But in those situations where it is not possible to capture a sufficient range of tones with a single exposure the alternative is to blend an exposure-bracketed series of images together to create a single, high dynamic range image.

Right now there are a lot of photographers interested in exploring what can be done using high dynamic range image editing. For example, using the Merge to HDR Pro feature in Photoshop you can combine two or more images that have been captured with a normal digital camera but shot at different exposures, and blend these together to produce a 32-bit floating point, high dynamic range image. You can then convert this 32-bit HDR file into a 16-bit per channel or 8-bit per channel low dynamic range version, which can then be further edited in Photoshop. In Figure 6.1 you can see examples of what high dynamic range processed images can look like. On the left is a normal exposure image of a wide dynamic range scene. In the middle is a merged, bracketed 32-bit image that was processed using Photomatix Pro. On the right is a merged, bracketed 32-bit image processed using the controls in Camera Raw. You are probably familiar with the typical 'HDR look' where there are obvious halos in the picture. While some photographers seem to like this kind of effect there has been a backlash against the illustrated feel of such images. However, good HDR editing does not always have to be about creating an artificial look.

Basically, high dynamic range image editing requires a whole new approach to the way image editing programs like Photoshop process the high dynamic range image data. In fact, the Photoshop team had to rewrite a lot of the Photoshop code so that some of the regular Photoshop tools could be made to work in a 32-bit floating point image editing environment. Photoshop therefore does now offer a limited range of editing controls such as layers and painting in 32-bit mode. While the Merge to HDR Pro feature in Photoshop can be used do a good job, Camera Raw is also a very effective tool for creating and processing high dynamic range images.

HDR essentials

Camera sensors record the light that hits the individual photosites and the signal is processed and converted into a digital file. I won't complicate things with a discussion of the different sensor designs

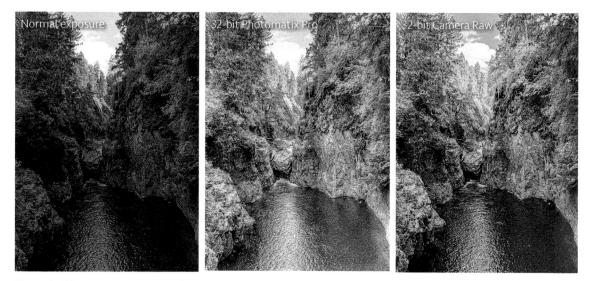

Figure 6.1 This shows a comparison of how a scene can be captured and processed in different ways.

used, but essentially the goal of late has been to design sensors in which the photosites are made as small as possible and crammed ever-closer together to provide an increased number of megapixels. Camera sensors have also been made more efficient so they can capture photographs over a wide range of ISO settings without generating too much electronic noise in the shadow areas or at high ISO settings. The problem all sensors face though is that at the low exposure extreme there comes a point where the photosites are unable to record any usable levels information over and above the random noise that's generated in the background. At the other extreme, when too much light hits a photosite it becomes oversaturated and is unable to record the light levels beyond a certain amount, and may flood over into adjacent photosites. Despite these physical problems we are now seeing improvements in sensor design, as well as in the Camera Raw software, which means it is now possible to capture wide dynamic range scenes more successfully in a single exposure and process them in Camera Raw.

If you go to the DxO Mark by DxO Labs website (dxomark.com) you will find technical reports on most of the leading digital cameras. These evaluate the performance of sensors, indicating their optimum effective performance for ISO speed, color depth, and dynamic range. For example, the latest Nikon D810 scores an impressive dynamic range of 14.8 EV (exposure value), which is better than most medium format digital backs.

Alternative approaches

There are other methods of high dynamic range capture. It is possible to have the sensor quickly record a sequence of images in the time it takes to shoot a single exposure. By varying the exposure time value for each of these exposures the camera software can extract a single high dynamic range capture. The advantage of this approach is that it can be feasible to capture a high dynamic range image with a single shot. So far we have seen a number of consumer digital cameras (and the iPhone) adopt this approach, but so far with limited success.

Bracketed exposures

If the camera sensor is unable to capture the full dynamic range of the scene, the alternative is to use bracketed exposures. The aim here is to capture a series of exposures that are far enough apart in exposure value (EV) so that you can extend the combined range of exposures to encompass the entire scenic tonal range as well as extend beyond the limits of the scenic tonal range. The advantage of doing this is that by overexposing for the shadows you can capture more levels information and this can result in cleaner, noise-free shadow detail. Exposing beyond

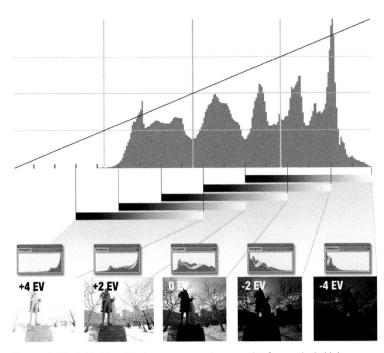

Figure 6.2 Individual bracketed exposures can be merged to form a single high dynamic range image.

the upper range of the highlights allows you to recover information in extreme highlight areas. Shooting bracketed exposures is the only way most of us can realistically go about capturing all of the light levels in any given scene and merge the resulting images into a single HDR file. When this is done right you have the means to create a low dynamic rendered version from the HDR master that allows you to reproduce most if not all of the original scenic tonal range detail.

Figure 6.2 illustrates how individual bracketed exposures when merged to form a single high dynamic range image can extend the histogram scale to encompass the entire luminance of the subject's scenic range.

Photomatix Pro

Photomatix Pro has proved popular with a lot of photographers because it offers excellent photo merging, ghosting control, is good at merging hand held shots and, above all, offers more extensive tone mapping options. Tone mapping with Photomatix Pro is intuitive to work with and also allows you to create those illustration-like effects that are often associated with a high dynamic range image look. One explanation for the difference between the Photoshop HDR conversion method and Photomatix Pro may be because Photoshop uses a bilateral filter for the tone mapping, while Photomatix Pro uses a Gaussian filter, which can produce more noticeable-looking halos. I have quite liked using Photomatix Pro because it is quick to work with and the tone controls are easy to master. However, I now mostly prefer to edit my 32-bit HDR images in Camera Raw because I find it is best for preserving the colors and producing more natural-looking results.

Capturing a complete scenic tonal range

The light contrast ratio from the darkest point in a scene to the brightest will vary from subject to subject, but in nearly every case it will certainly exceed the dynamic range of even the best digital cameras. Our human vision is able to differentiate between light and dark over a very wide range. It is hard to say precisely how good our eyesight is, but it has been suggested that human vision under some circumstances might be equivalent to as much as 1,000,000:1, or 20 EV. Meanwhile, most digital cameras capture a tonal range that's far less than that. For the most part we have to choose our exposures carefully and decide in advance whether we wish to expose for the shadows, for the highlights, or somewhere in between. We also know from experience that you don't always need to record every single tone in a scene in order to produce a good-looking photograph. It is OK after all

@ @ @ W1BY7479_80_81-HDR.tif @ 25% (Layer 0, RGB/32*)*

Figure 6.3 This shows a 32-bit image with the Exposure slider in the status box.

to deliberately allow some highlights to burn out, or let the shadows go black. The most practical solution right now is to shoot a succession of bracketed exposures and from this you can create a single image that is capable of capturing the entire scenic tonal range.

When capturing a high dynamic range image the objective is to make sure you capture the entire contrast range in a scene from dark to light. You can do this by taking spot meter readings and manually working out the best exposure bracketing sequence to use, and how many brackets are required. An alternative (and simpler) approach is to use a standard method of shooting in which you first measure the best average exposure (as you would for a single exposure) and bracket either side of that using either 3, 5, or 7 bracketed exposures at 2 EV apart. This may not be so precise a method, but a 5-bracketed sequence should at the very least double the dynamic range of your camera's sensor.

It is impossible to represent an HDR image on a standard computer display, which is why the Exposure slider is available for 32-bit images as a slider in the status box section of the document window (Figure 6.3). This allows you to inspect an HDR image at different brightness levels. Since the display you are using is most likely limited to a bit depth of 8 or 10 bits, this is the only way one can actually 'see' what is contained in a high dynamic range 32-bit image.

There are several benefits to capturing a high dynamic range. First of all you can potentially capture all the luminance information that was in the original scene and edit the recorded information any way you like. Secondly, a merged HDR image should contain smoother tonal information in the shadow regions. This is because more levels are captured at the bright end of the levels histogram (see 'Digital exposure' on page 142). Because of this the overexposed bracket exposures will have more levels with which to record the shadow detail. When you successfully capture and create an HDR image, there should be little or no shot noise in the shadows and you should have a lot more headroom to edit the shadow tones without the risk of banding or lack of fine detail that is often a problem with normally exposed digital photos.

HDR shooting tips

The first thing you want to do is to set up your camera so it can shoot auto bracketed exposures. Some cameras only allow you to shoot three bracketed exposures, others more. I suggest you check the menu

settings options for your camera to explore the options you have available here. The bracketing should be done based on varying the exposure time. This is because the aperture must always remain fixed so you don't vary the depth of field or the parallax between captures. Next, you want the camera to be kept still between exposures. It is possible to achieve this by hand holding the camera and keeping it as still as possible while you shoot, but for best results you should use a sturdy tripod with a cable release. Even then you may have the problem of mirror shake to deal with (this is where the flipping up of the mirror on an SLR camera can set off a tiny vibration, which can cause a small amount of image movement during the exposure). However, this is mostly only noticeable if using a long focal length lens. It's really when shooting on a tripod that this can be a problem—if you shoot hand held, the vibration will be dampened by you holding the camera. So apart from using a cable release, do enable the mirror up settings on your camera if you can.

The ideal exposure bracket range will vary, but an exposure bracket of five exposures of 2 EV apart should be enough to successfully capture most scenes. If you shoot just three exposures 2 EV apart you should get good results, but you won't be recording as wide a dynamic range. When you shoot a bracketed sequence watch out for any movement between exposures such as people or cars moving through the frame, or where the wind may cause movement. Sometimes it can be hard to prevent everything in the scene from moving. Merge to HDR Pro and Camera Raw are capable of removing some ghosting effects, but it's best to avoid having to select these options if you can.

If you shoot three or five exposures and separate these by 2 exposure values (EV), this should let you capture a wide scenic capture range efficiently and quickly. You can consider narrowing down the exposure gap to just 1 EV between each exposure and shoot more exposures. This can make a marginal improvement to the edge detail in a merged HDR image, but also increases the risk of error if there is movement between the individual exposures.

HDR File formats

Photoshop's 32-bit mode uses floating point math calculations (as opposed to regular whole integer numbers) to describe the brightness values, which can range from the deepest shadow to the brightness of the sun. It is therefore using a completely different method to describe the luminance values in an image.

Bit Depth	Pixel Order	(OK)
(16 bit (Half)	O Interleaved (RGBRGB)	<u> </u>
🕐 24 bit (FP24)	O Per Channel (RRGGBB)	Cancel)
O 32 bit (Float)	Byte Order	
Image Compression	O IBM PC	
O None	O Macintosh	
o LZW	Layer Compression	
ZIP	Sila	
Use Predictor Compression	Discard Layers and Save a Dopy	
Save Image Pyramid		
Save Panapacousy		

Figure 6.4 The TIFF options when saving a 32-bit file as a TIFF.

To save a 32-bit HDR image in Photoshop you are offered a choice of formats. You can use the Photoshop PSD, Large Document format (PSB), or TIFF format (see Figure 6.4). These file formats can also store Photoshop layers, but the downside is the file size will be at least four times that of an ordinary 8-bit per channel image. However, you can use the OpenEXR or Radiance formats to save your HDR files more efficiently. The OpenEXR format compression will very often result in files that are only slightly bigger in size compared to an ordinary 8-bit version of an image. Although you can't save Photoshop layers using OpenEXR, this could still be considered a suitable format choice for archiving flattened HDR images. On the other hand, there is no accepted color management standard for the OpenEXR format. Therefore, when you open such images in Photoshop you need to have an idea about what would be the best profile to apply here, and assign this via the Missing Profile box that pops up when you open the image. In most cases it will be safe to assume this should be your regular RGB workspace (particularly if it was you who saved the OpenEXR file in the first place). The document profile status will refer to the applied RGB space, i.e., Adobe RGB or ProPhoto RGB, followed by 'Linear RGB Profile.' What this means is that the selected profile will use the color primaries of the selected workspace, but in a linear RGB space (which is the same for all 32-bit images that are opened in Photoshop).

How to fool Merge to HDR

It is possible to create a deliberate HDR look from almost any image. I am thinking here of photographers who might want to apply an HDR look to single exposure portraits.

When you blend images together in Photoshop using Merge to HDR Pro, you can't actually fool Merge to HDR Pro by creating artificially lightened or darkened images. This is because Merge to HDR Pro always references to the camera time exposure EXIF metadata information in the file rather than the 'look' of the images. However, you can use the HDR Toning adjustment (Image \Rightarrow Adjustments \Rightarrow HDR Toning) to create a fake HDR look from a normal dynamic range image. The way it does this is to convert an 8-bit, or ideally a 16-bit per channel image to 32-bits per channel mode and then pops the HDR Toning dialog shown in Figure 6.5. This allows you to apply HDR toning adjustments as if it were a true 32-bit HDR original. This only works if you are editing an image that is in RGB or Grayscale mode and has been flattened first. This isn't true HDR to LDR photography, but it does provide a means by which you can create an 'HDR look' from photographs that weren't captured as part of a bracketed exposure sequence.

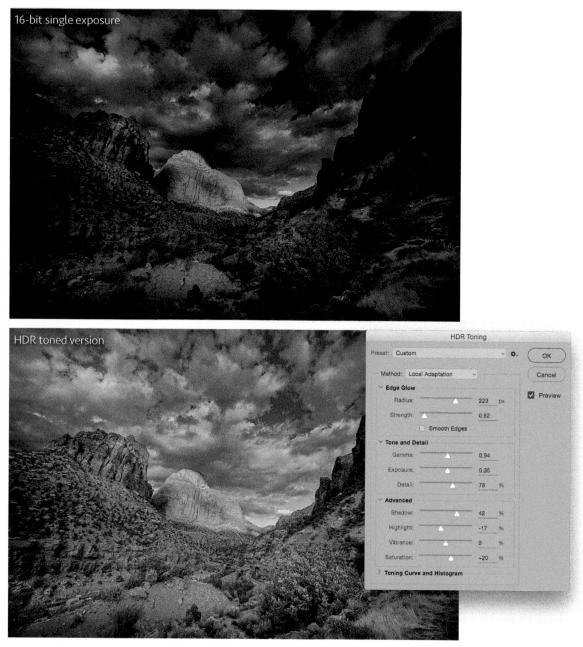

Figure 6.5 This shows an example of HDR Toning being applied to a normal 16-bit per channel image (top) to produce the fake high dynamic range effect shown below.

Camera Raw Smart Objects

Smart Objects store the raw pixel data within a saved PSD or TIFF image (you'll learn more about Smart Objects in Chapter 8). This means you have the freedom to re-edit the raw data at any time. Although it is possible to apply the technique shown here to JPEG images, this won't bring you any real benefit compared with processing a raw image original. The important thing to stress here is that this technique mostly applies to editing raw files.

Basic tonal compression techniques

A simple way to extend the dynamic range of your capture images is to blend two or more exposures together using a simple mask. The following steps show how you can blend two raw images that have been opened in Photoshop as Camera Raw Smart Object layers.

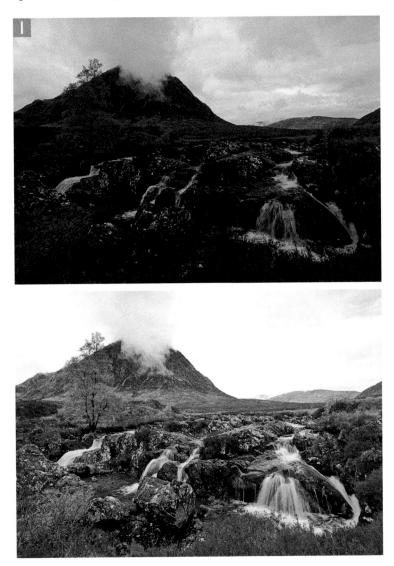

1 When shooting this landscape photo it was not possible to capture the entire scene using a single exposure. It needed one exposure made for the sky and another exposure made for the ground, with a difference of around 2 stops between the two. The photos you see here were captured in raw mode and only the default Camera Raw adjustments had been applied to each shot.

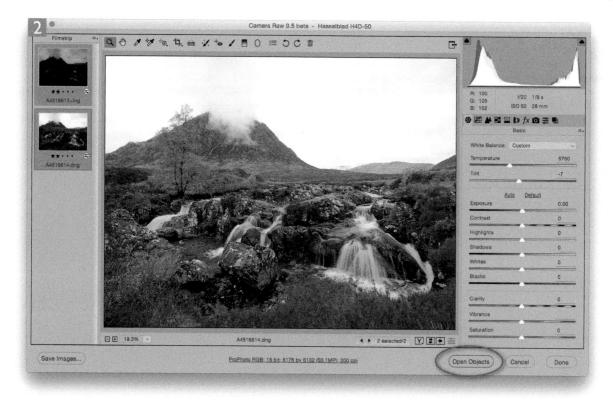

2 I began by opening these two raw images as Smart Objects. To do this, I opened the images via Camera Raw, held down the smart key, and clicked the 'Open Objects' button (circled) to open as Smart Objects in Photoshop. This button usually says 'Open Images' and switches to say 'Open Objects' when the smart key is held down.

3 After opening both raw images as Smart Objects I used the Move tool to drag the darker exposure image to the lighter exposure image window, placing it as a layer (with the small key held down to keep in register). At this stage I could double-click the thumbnails to reopen the images in Camera Raw and re-edit the original settings.

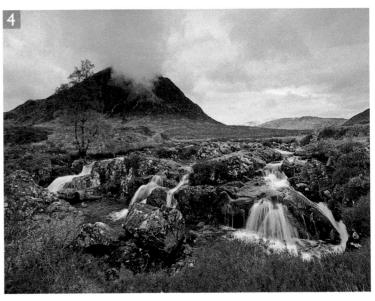

4 With the darker Smart Object layer selected I clicked on the Add Layer Mask at the bottom of the Layers panel (circled) to add an empty new layer mask. I then selected the Gradient tool and added a white to black gradient. This faded the visibility of the top layer.

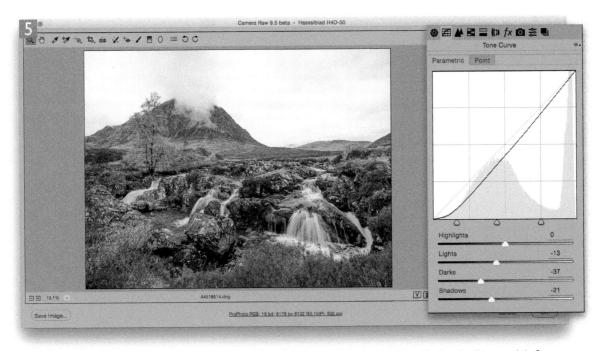

5 I then selected the bottom layer, double-clicked the thumbnail to open it in Camera Raw and made some further tweaks to the Tone Curve panel to adjust the tonal contrast. Once I was done I clicked OK to close the Camera Raw dialog.

6 Whenever you update the Camera Raw settings it usually takes a few seconds after closing the Camera Raw dialog to see the changes updated in the Photoshop document window. To produce the final image shown here, I did a couple more things. I reopened the dark Smart Object layer and adjusted the white balance to make the image slightly cooler. I then selected the Brush tool and painted with white and black on the associated layer mask to fine-tune the mask border edge. In some instances you might find it desirable to apply a mask that precisely follows the outline of the horizon. However, a lot of the time a soft edge mask will work fine. The effect I was trying to achieve here was somewhat similar to placing a graduated filter in front of the lens, except when you do this in Photoshop you have the means to edit the mask edge as much or as often as you like.

Camera Raw adjustments

You won't always be able to set up the camera on a tripod to shoot a series of bracketed exposures. However, Camera Raw does provide you with the ability to effectively edit a raw image and compress the scenic tonal range without needing to rely on multiple exposures. Using Process 2012 I have found less need to rely on Merge to HDR techniques. Quite often, all I need is one properly exposed raw image.

1 Here is a raw image that was processed using the default tone settings. Now, with this photo the camera was able to capture a full range of tones from the shadows to the highlights, but as you can see, it was missing contrast in the highlights, and the shadows were rather dark and lacked detail.

Basic	
White Balance: Custom	
Temperature	5167
Tint	+30
Auto Default	
Exposure	+0.55
Contrast	-18
Highlights	-100
Shadows	+75
Whites	+5
Blacks	-24
Clarity	+33
Vibrance	+27
Saturation	0

2 In Camera Raw I adjusted the Basic panel sliders (as shown here on the right) to achieve the best tone balance. You will notice that I used a negative Highlights adjustment to darken the highlights and a positive Shadows adjustment to bring out more detail in the shadow areas. Having applied these major adjustments to compress the scenic tonal range, all I needed to do was fine-tune the Whites and Blacks sliders to set the highlight and shadow clipping. I also added some Clarity, which I generally find necessary after compressing the tones in the original scene.

Figure 6.6 A close-up view of the 32-bit mode panel in the Merge to HDR Pro dialog after merging a bracketed sequence of photos.

Processing HDR files in Camera Raw

You can use Camera Raw to edit TIFF 32-bit HDR files just as you would a regular TIFF or raw image. What this means is you can use the Basic panel controls in Camera Raw, or Lightroom to edit 32-bit HDR files (providing they have been saved as flattened TIFFs). If you have got accustomed to working with the Camera Raw Basic panel tone controls, your editing experience working on HDR images will not be that much different from when working with regular raw, TIFF, or JPEG images, except the dynamic range you'll have to work with will potentially be that much greater and the Exposure slider range will be increased to + or - 10 stops. In my view, working with the Camera Raw tone adjustments makes it easier to achieve the desired tone balance in an image. The other benefit of using Camera Raw as an HDR editor is you don't always end up with the noticeable 'HDR look' you tend to get when processing HDR files to render low dynamic range versions. In other words, you can avoid getting the rather obvious halos (although some photographers do seem to like this kind of effect).

The Camera Raw HDR TIFF processing

One way to process an HDR image using Camera Raw is to create an HDR 32-bit file, or take an existing 32-bit image and force open it via Camera Raw. To do this the image must be flattened and saved using the TIFF file format. This is a good way to handle existing HDR 32-bit files. Alternatively, you can go to the Photoshop File Handling preferences and check the 'Use Adobe Camera Raw to convert 32-bit files to 16/8 bit' option. Once this is done, when you open a 32-bit image in Photoshop and change the bit depth from 32-bit to 16-bit or 8-bit, this automatically pops Camera Raw in place of the HDR Toning dialog. In effect, it opens Camera Raw as a filter.

Lastly, when you use Merge to HDR Pro for merging bracketed exposures to create a single HDR master, you can choose to tone adjust in Camera Raw. When the Merge to HDR Pro dialog opens and you are in the default 32-bit mode (see Figure 6.6), there is an option to 'Complete Toning in Adobe Camera Raw.' When this is checked, the OK button will say 'Tone in ACR.' Click this and you will be taken to the Camera Raw dialog in Camera Raw filter mode. Once you have finished editing the Camera Raw settings and clicked OK, the processed image will be a 32-bit Smart Object layer image, which means you retain the ability to re-edit the Camera Raw settings.

Creating HDR photos using Photo Merge

The Photo Merge feature in Camera Raw can be used to produce a master HDR DNG file from raw or non-raw images. You will need to start by selecting two or more photos of a subject that has been photographed at different exposure settings, where the aperture remained fixed and only the exposure time value is varied.

The Camera Raw Photo Merge processing technique is slightly different to the Photoshop method. Consequently, while you may find some results you get using the Camera Raw Photo Merge method to be better, you won't always. For example, with the Camera Raw Photo Merge HDR method there is some latitude to allow for small amounts of cloud movement between exposures providing the clouds have not moved too much. If there is more than a slight amount of movement you can select a Deghost option. The deghosting method used in Camera Raw may utilize more than one image to deghost the resulting HDR. When it works it is great, but it can sometimes lead to unwanted artifacts in the final image. If there is no, or very little, movement it is best to leave set to the default 'None' setting if you don't need it. With scenes that have moving content you may want to increase the deghosting amount. In the Figure 6.7 example I merged three bracketed exposures where there was movement in the clouds, trees and water between each exposure. In this instance I selected the 'Medium' Deghost option. If the Show Overlay option is also checked, this highlights the areas where the deghosting will be applied.

You can get good results blending exposure sequences of three or more images, but it also works well when just two exposures are combined. In fact by using two exposures you may actually get better results because you'll lessen the risk of generating artifacts as a consequence of subject movement between exposures. For example, when photographing a landscape subject you might want to capture one exposure for the ground and another for the sky and blend the two using an HDR Photo Merge. It is also important to be aware that Photo Merge HDR DNGs are saved as 16-bit floating point files, where the merged image consists of raw linear RGB data. The DNG files may therefore be quite large in size. You could argue these are not truly raw files, but a DNG produced this way is still mostly unprocessed and allows you to make the creative color and tone decisions when it is opened via Camera Raw. You retain the flexibility to reprocess the resulting HDR Photo Merge DNG any way you like, just as you can with any raw image, where the Exposure range is extended from -10 to +10. Also, as new process versions become available in the future, you will have the ability to make use of newer processing methods and always be able to fine-tune the original raw settings.

Consistent file formats

When processing photos using the Photo Merge feature you cannot mix raw and non-raw files.

Merge preview dialog

Initially, you will see a fast preview in the Merge preview dialog whenever you change any of the merge options and a yellow warning icon will be shown in the top right corner of the preview. This will disappear as a higher quality preview is built.

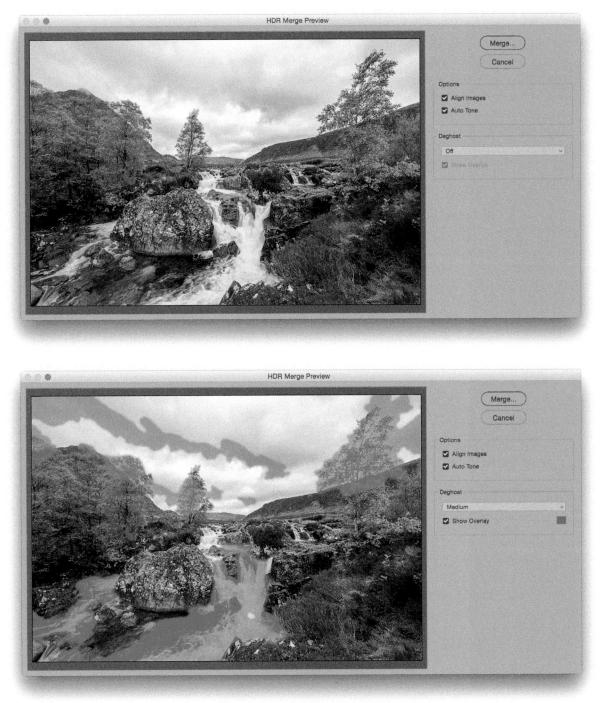

Figure 6.7 In this example I merged three bracketed exposures where there was movement in the clouds, trees, and water between each exposure.

Auto Tone setting

When the Auto Tone box is checked this shows a preview of what the image will look like with an Auto tone correction applied to the merged DNG and will also apply these settings to the final rendered image. If left unchecked, Camera Raw applies the default Basic panel settings.

Camera Raw 9.10 - Canon EOS-1Ds Mark III Filmstrip Select All #A ¥ to / ■ 0 ≔ 5 C m F H Select Rated 7. #A Sync Settings... XS. #M Merge to Panorama. f/11 1/60 s ISO 200 12-24@14 mm W1BY2154.dng ku fx 🖸 🌫 🔳 Basic White Balance: As Sho Temperatur 4650 -5 Tin W1BY2156.dng Auto Exposure 0.00 0 Contrast Highlights 0 Shadows 0 Whites 0 W1BY2166.dng Blacks 0 Clarity 0 Vibrance 0 Saturation 0 ⊡ ± 21.7% W18Y2154.dng 3 selected/3 Y 4 1 Save Images... ProPhoto RGB; 16 bit; 31.7 by 47.55 cm (21.0MP); 300 ppi (Open Images Cancel Done

Steps to produce a Photo Merge DNG

1 I selected three photographs that had been shot with the camera mounted on a tripod and bracket exposed, with 2 EV exposure difference between each shot. I opened these in Camera Raw, which opened in multiple image mode. I clicked on the Filmstrip menu and chose the Select All option. After that I selected Merge to HDR... (all M). If you hold down the Shift key as well (all Shift M) the photos will be processed in headless mode, bypassing the following HDR Merge Preview dialog.

2 This opened the HDR Merge Preview dialog, where Deghost was set to 'Off,' I checked the Auto Tone and Align Images checkboxes. I then clicked the Merge button.

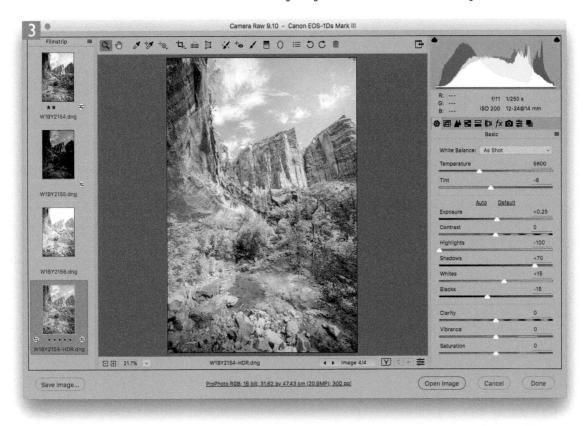

3 This created a merged HDR DNG image that was named using the filename of the most selected image in Step 1 with an -HDR suffix. It added the merged image to the Filmstrip and, because Auto Tone was selected in Step 2, applied Basic panel auto tone settings.

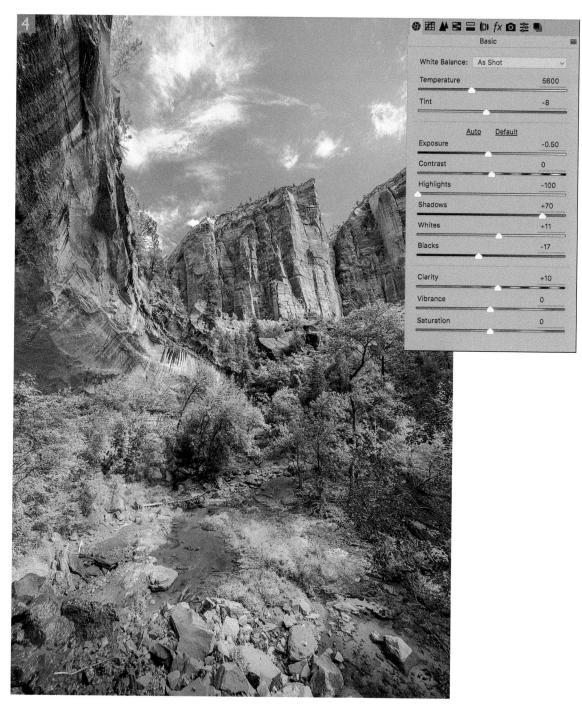

4 I was then able to further edit the HDR DNG image in Camera Raw as a raw image. In this instance I applied a few further image adjustments and added more Clarity to produce the finished version shown here.

Merge to HDR Pro script

There is a 'Merge to HDR' script you can load from the Presets/Scripts folder that allows you to open files or folders of images to process via Merge to HDR Pro. It does not allow you to process layered files, although there are hooks present that could allow this to be scripted.

Merge to HDR Pro

The Photoshop Merge to HDR Pro command can be accessed via the File \Rightarrow Automate menu in Photoshop or via the Tools \Rightarrow Photoshop menu in Bridge. I usually find it best to open via Bridge, where the image alignment is applied automatically.

Response curve

Each time you load a set of bracketed images, Merge to HDR Pro automatically calculates a camera response curve based on the tonal range of images you are merging. As you merge more images from the same sensor, Merge to HDR Pro updates the response curve to improve its accuracy. If consistency is important when using Merge to HDR Pro to process files over a period of time, you might find it useful to save a custom response curve (see Step 3) and reuse the saved curve when merging images in the future.

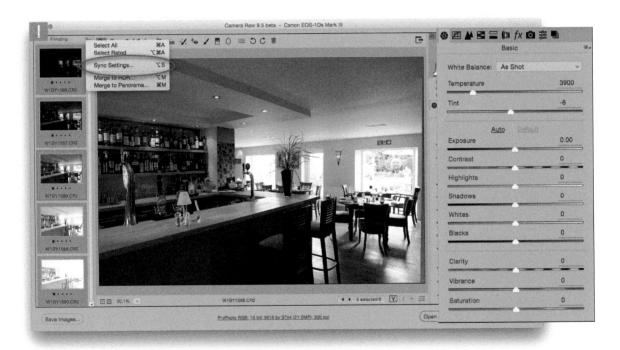

1 The original photos were bracketed using different time exposures at two exposure values (EV) apart. I began by opening a selection of five raw digital capture images via Camera Raw. It was important that all auto adjustments were switched off. In this example, I made sure the Camera Raw Defaults were applied and synchronized across all five selected images. After that I clicked Done to apply.

Batch Rename ☆ # R Create Metadata Template ► Edit Metadata Template ► Append Metadata ► Replace Metadata ► Cache ►	
Photoshop 🕨	Batch Contact Sheet II Image Processor Lens Correction * Load Files into Photoshop Layers Merge to HDR Pro Photomerge Process Collections in Photoshop

2 With the images selected in Bridge I went to the Tools menu and chose Photoshop \Rightarrow Merge to HDR Pro.

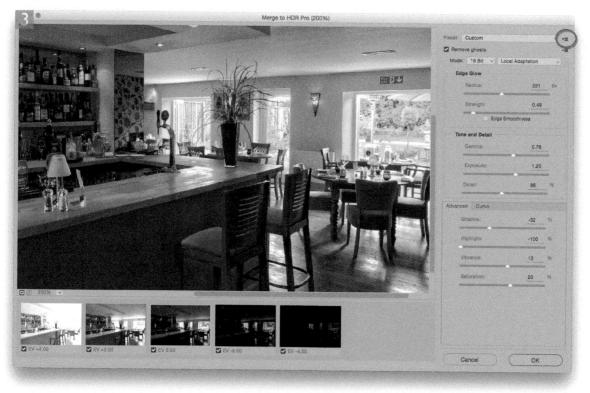

3 When the 8-bit or 16-bit mode is selected you will see the HDR toning options. These allow you to apply an HDR to LDR conversion in one step (the HDR toning controls are described more fully on pages 432–433). If you prefer at this stage to simply save the image as a 32-bit master HDR file, you should select 32-bit from the Mode menu, where the only option available is to adjust the exposure value for the image preview. There is also a fly-out menu in the Merge to HDR Pro dialog (circled) where you can save or load a custom response curve.

Exposure and Gamma

You can use the Exposure slider to compensate for the overall exposure brightness and the Gamma slider to (effectively) reduce or increase the contrast. The controls are rather basic, but they do allow you to create a usable conversion from the HDR image data.

Highlight Compression

The Highlight Compression simply compresses the highlights, preserving all the highlight detail. It can render good midtones and highlights at the expense of some detail in the shadows.

Equalize Histogram

The Equalize Histogram option attempts to map the extreme highlight and shadow points to the normal contrast range of a low dynamic range Photoshop image, but it's a rather blunt instrument to use when converting a high dynamic range image.

Tone mapping HDR images

After you have created a merged 32-bit per channel HDR image, you can save the HDR master using the PSD, PSB, or TIFF formats to preserve maximum image detail plus any layers. Or, you can use the OpenEXR format, which as I explained earlier is a more efficient (though lossy), space saving file format for storing 32-bit images. You can if you like skip saving the merged HDR image and jump straight into the tone mapping stage by selecting the 16-bit per channel or 8-bit per channel option in the Merge to HDR dialog. I think you will find though there are some definite advantages to preserving a master image as an HDR file. There is a real art to tone mapping an image from a high dynamic range to a normal, low dynamic range state and you won't always get the best results at your first attempt. It is a bit like the need to preserve your raw masters as raws and therefore makes sense to save an HDR file as a 32-bit master image first and then use Image \Rightarrow Mode menu to convert from 32-bits to 16-bits or 8-bits per channel. If the 'Use Adobe Camera Raw to convert 32-bit files to 16/8 bit' option is unchecked in the File Handling preferences, this pops the HDR Toning dialog (Figure 6.8). This offers four ways of converting an HDR image to a low dynamic range version: Exposure and Gamma, Highlight Compression, Equalize Histogram, and Local Adaptation. With each the aim is the same: to squeeze all the tonal information contained in the high dynamic range master into a low dynamic range version of the image. Here I am just going to concentrate on the Local Adaptation method.

Local Adaptation

The Local Adaptation method is designed to simulate the way our human eyes compensate for varying levels of brightness when viewing a scene. For example, when we are outdoors our eyes naturally compensate for the difference between the brightness of the sky and the brightness of the ground. The difference in relative brightness between these two areas accounts for the 'global contrast' in the scene. As our eyes concentrate on one particular area, the contrast we observe in, say, the clouds in the sky or the grass on the ground is contrast that is perceived at a localized level. The optimum settings to use in an HDR conversion will therefore depend on the image content. Figure 6.9 shows a photograph of a scene with a high dynamic range. The global contrast would be the contrast between the palm tree silhouetted against the brightly lit buildings in the background, while the localized contrast would be the detail contrast within both the bright and dark regions of the picture (magnified here).

The Radius slider in the Local Adaptation HDR Toning dialog Edge Glow section (Figure 6.8) controls the size of the glow effect, but I prefer to think of this as a 'global contrast' control. Basically, the tone mapping process lightens the shadows relative to the highlights and the tone mapping is filtered via a soft edge mask. At a low setting you'll see an image in which there may be a full tonal range from the shadows to the highlights, but the image looks rather flat. As you increase the Radius this widens the halos, which softens the underlying mask, and this is what creates the impression of a normal global contrast image. You can then use the Strength slider to determine how strong you want the effect to be. At a zero Strength setting the picture will again look rather flat. As you increase the Strength amount, you'll see more contrast in the halos that are generated around the high contrast edges in the image. The Edge Glow Strength slider can therefore be used to soften or strengthen the Radius effect, but you do still need to watch for ugly halos around the high contrast edges.

When the Gamma slider is dragged all the way to the left, there is no tone compression between the shadows and highlights. As you drag the other way to the right, this compresses the shadows and highlights together. The Exposure slider can then be used to compensate for the overall exposure brightness. This slider adjustment can have quite a strong effect. This is because it is applied after the tone mapping stage rather than before.

The Detail slider works a bit like the Clarity slider in Camera Raw and you can use this to enhance the localized contrast by adding more Detail. The Shadow and Highlight sliders are fine-tuning adjustments. These can be used to independently adjust the brightness in the shadows or highlight areas. For example, the Shadow slider can be used to lighten the shadow detail in the darkest areas only. HDR Local Adaptation conversions typically mute the colors so you can use the Vibrance and Saturation sliders to control the color saturation.

Finally, we come to the Toning Curve and Histogram. You can use this to apply a tone enhancing contrast curve as a last step in the HDR conversion process. The histogram displayed here represents that of the source 32-bit image. For this reason you'll notice that the responsiveness as you add points and adjust the curve shape is rather different to a normal Curves adjustment. You can for example, check the Corner box to convert an individual Curve anchor point to a corner point and thereby create a sharp kink in the curve. Overall, you'll find the Histogram panel in Photoshop more useful when gauging the outcome of a conversion. When you are done you can click on the OK button for Photoshop to render a low dynamic range version from the HDR master.

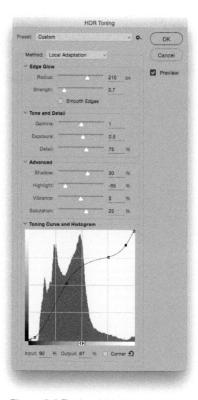

Figure 6.8 The Local Adaptation tone mapping method (also showing the Tone Curve and Histogram options).

Figure 6.9 An example of a subject that has a wide dynamic range and strong global contrast.

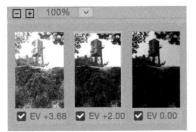

Figure 6.10 When removing ghosts you can select the image to base the anti-ghosting on.

Removing ghosts

It is important to minimize any movement when shooting bracketed exposures, which is why it is best to shoot using a sturdy tripod and cable release. Even so there remains the problem of things that might move between exposures such as tree branches blowing in the wind. To address this the Merge to HDR Pro process in Photoshop utilizes a ghost removal algorithm which automatically tries to pick the best base image to work with and discards the data from the other images in areas where movement is detected. When the 'Remove Ghosts' option is checked in the Merge to HDR Pro dialog you'll see a green border around whichever thumbnail has been selected as the base image (Figure 6.10). You can override this by clicking to select an alternative thumbnail and make this the new base image. For example, if the moving objects are in a dark portion of the photograph, it will be best to select a lighter exposure as the base image. The ghost removal can be effective on most types of subjects, although moving clouds can still present a problem. Skies are also tricky to render because the glow settings can produce a noticeable halo around the sky/horizon edge. This problem can usually be resolved by placing the medium exposure image as a separate layer masked with a layer mask based on the outline of the sky.

How to avoid the 'HDR look'

It has to be said that HDR to LDR converted images can sometimes look quite odd because of the temptation to squeeze everything into a low dynamic range. Just because you can preserve a complete tonal range doesn't mean you should. It really is OK to let the highlights burn out sometimes or let the shadows go black. The Photoshop approach also lets you produce what can be regarded as natural-looking conversions. The Figure 6.11 example shows how the HDR to LDR image process can result in a photo that looks fairly similar to a normal processed image, but with improved image detail in the shadow regions. The top photo here is a single edited image, shot using an optimum exposure processed via Camera Raw and output as a 16-bit file. Below you can see an HDR edited version that was converted to a 16-bit low dynamic range image. I tried to get the two images to match as closely as possible, but you will notice better tone and detail contrast in the roof rafters in the HDR converted version. In the enlarged close-up view you can see there is much more image detail and virtually no shadow noise in the bottom image.

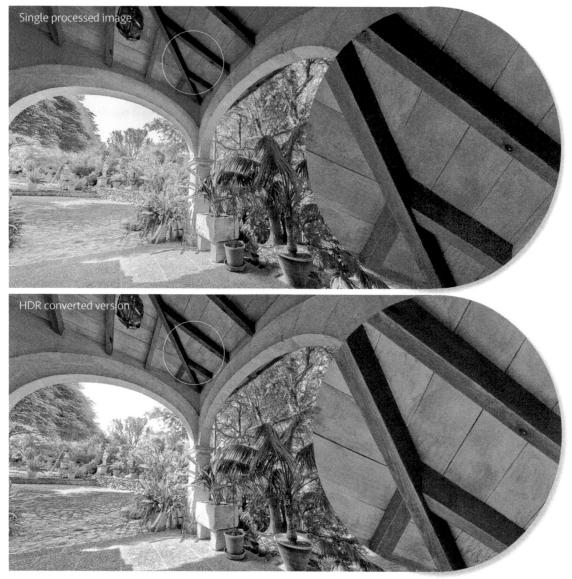

Figure 6.11 A comparison between a single processed image (top) and an HDR converted version (below).

Disable image sharpening

Edge artifacts can occur through heavy use of the Detail slider, or where there is a lot of high contrast edge detail. It can also help if you don't capture sharpen the raw files before you generate a Merge to HDR Pro image. Therefore, always apply the required capture sharpening *after* you have created the HDR toned version.

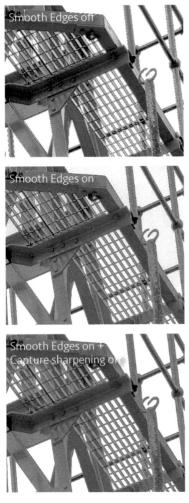

Figure 6.12 This shows an example of Smooth Edges off (top) and on (middle) and Smooth Edges on with capture sharpening off (bottom).

Smooth Edges option

When using the Local Adaptation method, there is a Smooth Edges option. When this is checked it can improve the image quality when toning HDR merged photos. Figure 6.12 shows how this option can improve the appearance of the edges in a photo. I would say this is a problem you are more likely to notice when using a high Detail slider setting, where you can often end up seeing unwanted halos around high contrast edges. Applying edge smoothing won't help get rid of all types of artifacts and it can influence the effect the other HDR toning slider adjustments have on a conversion. You may sometimes need to revisit these after checking the Smooth Edges option.

HDR toning example

1 This 32-bit HDR image that was produced by merging a bracketed sequence of three photographs shot at 2 EV apart.

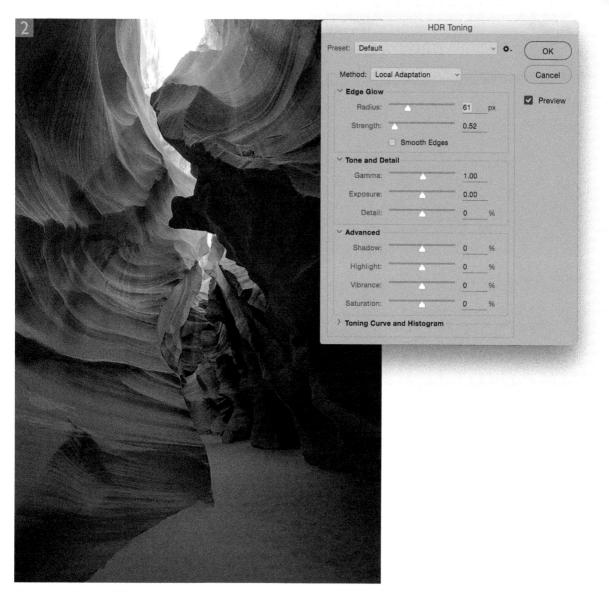

2 I went to the Image \Rightarrow Mode submenu and switched the bit depth from 32-bits to 16-bits per Channel. Because the 'Use Adobe Camera Raw to convert 32-bit files to 16/8 bit' option was unchecked in the File Handling preferences, this opened the HDR Toning dialog. Of the four tone mapping options available I find the Local Adaptation method usually works best. In this step I left all the sliders at their default positions.

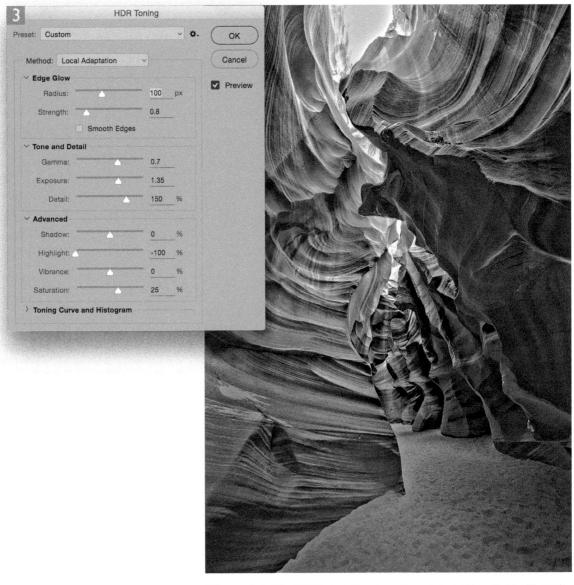

3 Here I adjusted the HDR Toning sliders to produce what might be called the 'illustration look' favored by some HDR photography enthusiasts. I set the Radius slider to 100 pixels and raised the Strength to 0.80. I took the Gamma slider to 0.7, set the Exposure slider to +1.35 and the Detail slider to 150%. I then reduced the Highlight slider to -100% and increased the Saturation slightly, setting it to 25%. Personally, I don't think the Photoshop HDR Toning adjustment is as capable as, say, Photomatix Pro and nor is it as simple to configure, but you can achieve something similar to a Photomatix Pro look.

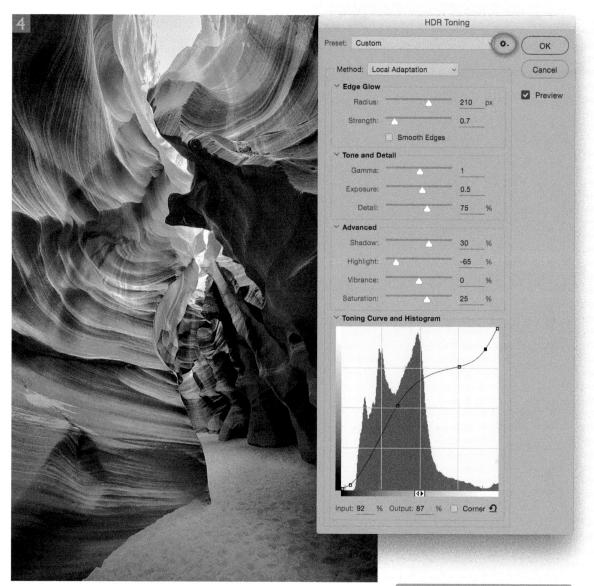

4 In this step I aimed to produce a more natural-looking result. To start with I set the Radius slider to 210 pixels. This was done to create much wider halo edges. I set the Strength slider to 0.7 and the Gamma slider to the default 1.00 setting. Exposure was reduced to 0.5. I also reduced the Detail slider to 75% and made some further tweaks to the Advanced slider settings below. I then adjusted the Toning Curve to fine-tune the final tone mapping (I find it helps to also refer to the Histogram panel in Photoshop as you do this). Lastly, I clicked on the HDR Toning options button (circled), selected Save Preset... and saved the Local Adaptation settings as a new preset, because this could serve as a useful starting point for other HDR conversions of photos shot at the same location.

How to smooth HDR toned images

The following steps show some additional things you can do in Photoshop to retouch an HDR tone mapped image and cure some of the problems created by the tone mapping process.

1 This is an HDR, 32-bit image that was created from a bracket sequence shot 2 EV apart.

2 The 'Use Adobe Camera Raw to convert 32-bit files to 16/8 bit' option was unchecked in the File Handling preferences. I chose Image ⇒ Mode 16-bits, which opened the HDR Toning dialog (and applied the settings shown here. You'll notice I made one of the curve points in the Toning Curve a corner point. This can make it easier to manipulate the tone curve shape, allowing you to adjust two or more portions of the tone curve separately.

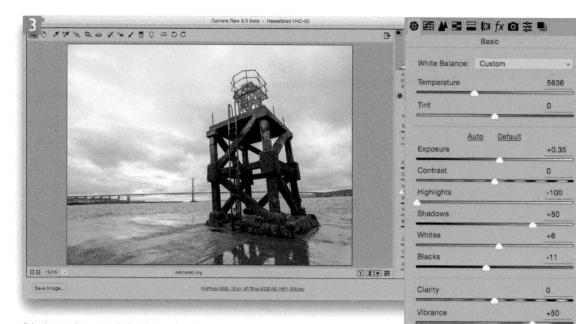

3 In the previous step, I aimed to apply a tone mapping that kept the image looking as realistic as possible. For example, I kept the Edge Glow Radius wide and the Strength low. HDR processing does tend to distort the colors though. In this step I opened the middle exposure image in Camera Raw and adjusted the settings to try and match as closely as possible the HDR processed version.

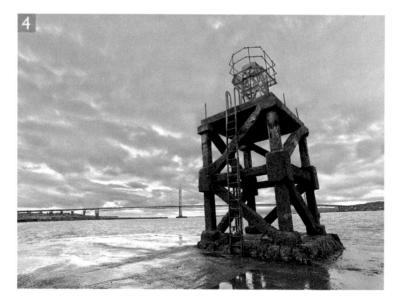

0

Saturation

4 I then opened the image processed in Step 3 as a Smart Object layer and added this as a new layer above the HDR tone mapped version and set the blend mode to Color. This step helped cure some color banding in the highlight regions of the sky.

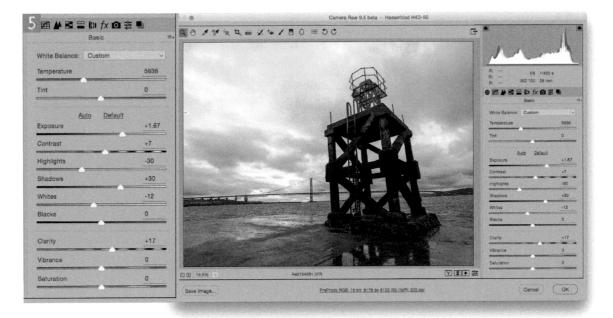

5 I was now happy with everything except the look of the sky. In the previous Step there were noticeable wide-edge halos. I now opened the darkest exposure image and lightened it to get the sky to look roughly as bright as the tone mapped version.

6 I added this too as a Smart Object layer set to the Luminosity blend mode and sandwiched it below the Color mode layer. I added a layer mask filled with black and painted with white to reveal the layer contents in the sky area only. The final version had all the benefits of HDR editing, but without looking as if it had been HDR processed.

Chapter 7

Image retouching

Photoshop has become so successful that its very name is synonymous with digital image retouching. Photoshop retouching tools such as the humble Clone Stamp have been around since the very early versions of the program and have been used and abused in equal measure. The new retouching tools that have been added since then mean that you can now transform images almost any way you want. As my colleague Jeff Schewe likes to say: "You know why Photoshop is so successful? Because reality sucks!" Well, that's Jeff's viewpoint, but then he does come from a background in advertising photography where heavy retouching is par for the course. The techniques described in this chapter will teach you some of the basic procedures, such as how to remove dust spots and repair sections of an image. We'll then go on to explore some of the more advanced techniques that can be used to clean up and enhance your photographs.

Figure 7.1 This shows a Wacom[™] input tablet device.

Basic cloning methods

The Clone Stamp tool and Healing Brush are useful tools to work with at the beginning of any retouching session. You can use these to carry out most basic retouching tasks before you get to the more advanced retouching stages.

Clone Stamp tool

To work with the Clone Stamp tool, hold down the *all* key and click to select a source point to clone from. Release the *all* key and move the cursor over to the point that you wish to clone to, and click or drag with the mouse. If you click to enable the 'Aligned' option, this establishes a fixed relationship between the source and destination points. If this option is unchecked, the source point starts from the same location after each time you lift the pen or mouse until you *all*-click again to establish a new source point. When working with the Clone Stamp, Healing Brush or any of the painting tools, I do find it helps to use a graphics tablet input device (like the Wacom[™] shown in Figure 7.1), as this can help you work more quickly and efficiently.

Clone Stamp Brush settings

As with all the other painting tools, you can change the brush size, shape, and opacity to suit your needs. When working with the Clone Stamp I mostly leave the opacity set to 100%, since cloning at less than full opacity can lead to tell-tale evidence of Clone Stamp retouching. However, when smoothing out skin tone shadows or blemishes, you might find it helpful to switch to an opacity of 50% or less. You can also use lower opacities when retouching areas of soft texture. Otherwise I suggest you stick to using 100% opacity. For similar reasons, you don't want the Clone Stamp to have too soft an edge. For general retouching work, the Clone Stamp Brush shape should have a slightly harder edge than you might use normally with the paint brush tools. When retouching detailed subjects such as fine textures, you might want to use an even harder edge so as to avoid creating halos. Also, if film grain is visible in a photograph, anything other than a harder edge setting may lead to soft halos, which can make the retouched area look slightly blurred or misregistered. If you need extra subtle control, try lowering the Flow rate; this allows you to build an effect more slowly, without the drawbacks of lowering the opacity.

🛛 🕹 🗸 🐨 🖹 Mode: Normal 🔷 Opacity: 100% 🗸 🗭 Flow: 100% 🗸 🕼 🖬 Aligned Sample All Layers 🗸

1 The best way to disguise Clone Stamp retouching is to use a full opacity brush with a medium hard edge at 100% opacity. It is a good idea to add a new empty layer above the Background layer, which you can do by clicking on the Add New Layer button (circled in blue). This lets you keep all the clone retouching on a separate layer, and it was for this reason I chose to have the 'All Layers' Sample option selected in the Options bar (circled in red) so that all visible pixels were copied to this new layer.

2 The 'Aligned' option is normally checked by default in the Options bar. Here, I used the all key to set the sample point on an undamaged part of the wall and was able to click on the area shown here to set the destination point.

3 I then dragged to paint with the Clone Stamp. Photoshop retains the clone source/ destination relationship for all subsequent brush strokes until a new source and destination are established. In situations like this you may find the Clone Source panel 'Show Overlay' option proves useful (see page 448).

Healing Brush

The Healing Brush can be used in more or less the same way as the Clone Stamp tool to retouch small blemishes, although it is important to stress here that the Healing Brush is more than just a magic Clone Stamp and has its own unique characteristics. These differences need to be taken into account so that you can learn when it is best to use the Healing Brush and when it is more appropriate to use the Clone Stamp.

To use the Healing Brush, you again need to establish a sample point by all-clicking on the portion of the image you wish to sample from. You then release the all key and move the cursor over to the point where you want to clone to and click or drag with the mouse to carry out the Healing Brush retouching. If you are using a pressure sensitive tablet such as a Wacom[™] tablet, the default brush dynamics will be size sensitive, so you can use light pressure to paint with a small brush, and heavier pressure to apply a full-sized brush. The Healing Brush works by sampling the texture from the source point and blends the sampled texture with the color and luminosity of the pixels that surround the destination point. The Healing Brush reads the pixels within a feathered radius that is up to 10% outside the perimeter of the Healing Brush cursor area. By doing so, the Healing Brush is able to calculate a smooth transition of color and luminosity within the area that is being painted (always referencing the pixels outside the perimeter of the Healing Brush cursor area). It is for these reasons that there is no need to use a soft-edged brush and you will always obtain more controlled results through using the Healing Brush with a 100% hard edge.

Once you understand the fundamental principles that lie behind the workings of the Healing Brush, you will come to understand why the Healing Brush may sometimes fail to work as expected. You see, if the Healing Brush is applied too close to an edge where there is a sudden shift in tonal lightness, it will attempt to create a blend with the pixels immediately outside the Healing Brush area. So when you retouch with the Healing Brush you need to be mindful of this intentional behavior. However, there are things you can do to address this. For example, you can create a selection that defines the area you are about to retouch. This will constrain the Healing Brush work so that it is carried out inside the selection area only. My advice is to always constrain the selection slightly to prevent the Healing Brush reading past the selection edge. Therefore, use Select \Rightarrow Modify \Rightarrow Contract and shrink by at least 1 pixel in order to prevent edge contamination.

		Current L	ayer
V 125 V Mode: Normal	v Source: Sampled Pattern	Aligned Sample - Current &	Below 🔯 🧭 Diffusion: 7 🗸
		All Layers	

1 I selected the Healing Brush from the Tools panel and selected a hard-edged brush from the Options bar. The brush blending mode was set to Normal, the Sample source was set to 'Current & Below' and the Aligned box left unchecked.

2 I added a new empty layer and *all*-clicked to define the source point, which in this example was an area just to the right of the trash bin. I then released the *all* key, moved the cursor over to where the bin was and clicked to remove it using the Healing Brush. Here is an example where having the Clone Source Show Overlay visible (see page 448) ensured the bricks were carefully aligned.

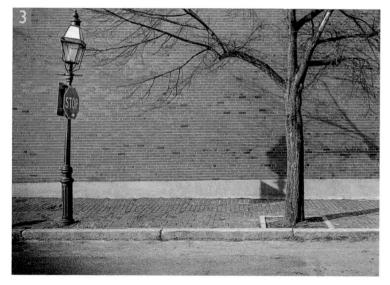

3 This shows the final image with the trash bin removed from the scene.

×			<4
Clone Source			-
1	-1	11	
Offset:	a	W: 100.0%	- [6
X: 0 px		H: 100.0%	
Y: 0 px		⊿ 0.0	• ত
Frame Offset: 0			Frame
Show Overla	у	Clipped	
Opacity: 1009	%	🗍 Auto Hi	de
Normal	~	Invert	

Figure 7.2 This shows the Clone Stamp tool being used with the Show Overlay and Clipped options checked in the Clone Source panel.

Clone Source panel and clone overlays

If the 'Show Overlay' and 'Clipped' options are both checked in the Clone Source panel, a preview of the clone source is shown inside the cursor area. Figure 7.2 shows the Clone Stamp tool being applied where the 'Show Overlay' and 'Clipped' options were both enabled. You could choose to have the 'Show Overlay' option switched on all of the time, but there is often a slight time delay while the cursor updates its new position, which can at times be distracting. I therefore suggest you only enable it when you really need to. The Clone Source panel was also implemented with video editors in mind. This is because it can sometimes be desirable to store multiple clone sources when cloning in exact registration from one frame to another across several frame images in a sequence. Hence, there are five sample points at the top and each can be configured with a separate source point.

Choosing an appropriate alignment mode

You can use the Clone Stamp and Healing tools with the Aligned option checked or unchecked. When the Clone Stamp tool is selected and the Aligned option is unchecked, the source point remains static and each application of the Clone Stamp makes a copy of the image data from the same original source point (see Figure 7.3). I tend to use the Clone Stamp tool in aligned mode. This is because when you use the Clone Stamp you can preserve the relationship between the source and destination points, and sample a new source point as necessary. You can even clone data from a separate document. In Figure 7.4 I alt -clicked to sample with the Clone Stamp from the image document window on the right and then clicked and dragged in the window on the left to clone to this document window.

If you try to use the Clone Stamp over an area where there is a gentle change in tonal gradation, it will be almost impossible to disguise the retouching work, unless the point you are sampling from and the destination point match exactly in tone and color. It is in these situations that you are usually better off using the Healing Brush. For most types of Healing Brush work I suggest you use the non-aligned mode (which happens to be the default setting for this tool). This allows you to choose a source point that contains the optimum texture information with which to repair a particular section of a photograph. You can then keep referencing the same source point as you work with the Healing Brush. Basically, when the source area is unrestricted I suggest you choose the aligned mode for the Clone Stamp tool. If the source area is restricted and you don't want to pick up from other surrounding areas, choose non-aligned.

Figure 7.3 In this example the Aligned option was unchecked and the source point remained static and each application of the Clone Stamp.

Figure 7.4 In this example the clone source was from the window on the right and the destination, the document window on the left.

Ignore adjustment layers

When 'Ignore Adjustment Layers' is enabled, Photoshop ignores the effect any adjustment layers might have when cloning the visible pixels. Therefore, when the 'All Layers' sample option is selected this prevents adjustment layers above the layer you are working on from affecting the retouching carried out on the layers below.

Clone and healing sample options

The layer sample options (Figure 7.5) let you decide how the pixels are sampled when you use the Clone Stamp or Healing Brush tools. 'Current Layer' samples the contents of the current layer only and ignores all other layers. The 'Current & Below' option samples the current layer and visible layers below (ignoring the layers above it), while the 'All Layers' option samples all visible layers in the layer stack, including those above the current layer. The Spot Healing Brush only has a 'Sample All Layers' option in the tool Options bar to check or uncheck.

Sampling other layers allows you to carry out all your Clone Stamp and Healing Brush work to an empty new layer. The advantage of this approach is you can keep all your retouching work separate and leave the original Background layer untouched. If the Ignore Adjustment Layers button (circled) is turned on, Photoshop ignores the effect any adjustment layers above the selected layer are having on the image (see sidebar).

Figure 7.5 In this example the All Layers option allowed me to sample from layers above and below and carry out the retouching to a separate layer (which for the sake of clarity is shown here in isolation). Because the Ignore Adjustment Layers option was checked (circled above), Photoshop ignored the effect the Curves adjustment layer would otherwise have on the sampled pixels.

fx D O D 0 🛍

Layer 0

Better healing edges

Since the Healing Brush blends the cloned source data with the edges that surround the destination point, you can improve the efficiency of the Healing Brush by increasing the perimeter size for the Healing Brush cursor.

If you change the Healing Brush to an elliptical shape, you will tend to produce a more broken-up edge to your healing work and this can sometimes produce an improved healing blend (Figure 7.6). To adjust the shape and hardness of the Healing Brush or Spot Healing Brush, select the Healing/Spot Healing Brush tool and mouse down on the brush options in the tool Options bar. Set the hardness to 100% and drag the elliptical handles to make the brush shape more elliptical. If you are using a Wacom[™] tablet or other pressure sensitive input device, the brush size is linked by default to the amount of pen pressure applied.

There are two explanations for why this works. Firstly, a narrow elliptical brush cursor has a longer perimeter. This means that more pixels are likely to be sampled when calculating the healing blend. The second thing you will notice is that when the Healing Brush is more elliptical, a randomness is introduced into the angle of the brush. Try changing the shape of the brush as shown below and as you paint, you will see what I mean.

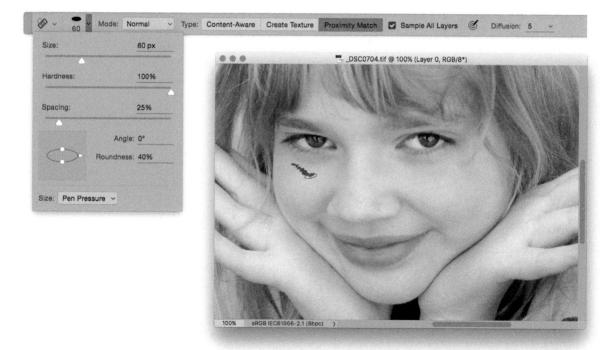

Figure 7.6 Working with an elliptical shaped Healing Brush shape.

Figure 7.7 The Spot Healing Brush warning dialog.

Spot Healing Brush

The default healing tool in Photoshop is the Spot Healing Brush. To use this tool just click on the marks or blemishes you wish to remove. It then automatically samples the replacement pixel data from around the area you are trying to heal. If the Spot Healing Brush is selected in the Tools panel and you try to use the *M* key to establish a source point to sample from (thinking you have just selected the ordinary Healing Brush), you will be shown a warning dialog explaining there is no need to create a sample source when using this tool (Figure 7.7).

The Spot Healing Brush has three basic modes of operation: Proximity Match, Create Texture, and Content-Aware. These modes can be selected via the Spot Healing Brush Options bar (Figure 7.8). In 'Proximity Match' mode it analyzes the data around the area where you are painting to identify the best area to sample the pixel information from. It then uses the pixel data that has been sampled in this way to replace the pixels beneath where you are painting. With the Proximity Match mode selected you can use the Spot Healing Brush to click away and zap small blemishes. When you are repairing larger areas in a picture you will usually obtain better results if the brush size is slightly smaller than the area you are trying to retouch and you then click and drag to define the area you wish to repair. As you work with the Spot Healing Brush you'll notice how it is mostly quite smart at estimating which are the best pixels to sample from. Sometimes though, the Spot Healing Brush will choose badly, so it pays to be vigilant and understand how to correct for this. If you are removing marks close to an edge, it is usually best to apply brush strokes that drag inwards from the side where the best source data exists (see Figure 7.9). This is because in Proximity Match mode the Spot Healing Brush intelligently looks around for the most suitable pixel data to sample from, but if you drag with the brush it looks first in the direction from where you dragged. By dragging with the tool you can give the Spot Healing Brush a better clue as to where to sample from. In the Figure 7.9 example I could prompt it to sample from the area of clear skin that didn't have loose hairs.

If the Proximity Match mode fails to work you may in some instances want to try using the Create Texture mode. Rather than sampling an area of pixels from outside the cursor it generates a texture pattern within the cursor area based on the surrounding area. It may just occasionally offer a better result than the Proximity Match mode, but you'll find that the Content-Aware mode does the same kind of thing only more successfully.

Healing blend modes

You'll notice in Figure 7.8 that there are a number of different blend modes available for when working with the Spot Healing Brush (as well as the main Healing Brush). Most of the time you will find that the Normal blend mode works fine and you will get good results, but when retouching some areas you'll find the Replace blend mode may work more successfully, especially when using the Content-Aware mode (which is discussed next). The edge hardness can also be a factor here, but I find that by adjusting the softness of the brush when using the Replace blend you can get improved results. The Replace blend preserves more of the texture in the boundary edges and the difference is therefore more pronounced as you soften the edge hardness. When using the Content-Aware mode this can make a difference when painting up close to sharp edges. In the Normal blend mode you may still see some edge bleeding, whereas in Replace mode the edges are less likely to bleed. I generally find that for detailed areas such as when retouching out the wires that overlapped the rocks in the Figure 7.11 example, the Replace mode worked more effectively. The other blend modes include items such as Darken, Lighten, and Color. Now, if you refer to the later section on beauty retouching you can see how these might be useful where you wish to apply healing to an image so that, say, only the darker pixels or lighter pixels get replaced. This can be useful where you wish to minimize the amount of change that takes place in an image. For example, the Lighten blend mode would be an appropriate choice for getting rid of dark marks against a light color. By selecting the Lighten mode you should be able to target the retouching more effectively in removing the dark marks. Similarly, you could use the Darken mode to remove light marks against a dark background.

Spot healing in Content-Aware mode

When working with the Spot Healing Brush in the default Proximity Match mode you have to be careful not to work too close alongside sharply contrasting areas in case this causes the edges to bleed. The Content-Aware mode for the Spot Healing Brush intelligently

Figure 7.9 In Proximity Match mode, the Spot Healing Brush automatically searches to find the best area to sample from.

h

Figure 7.10 The Stroke Path dialog.

works out how best to fill the areas you retouch. The content-aware healing does make use of the image cache levels set in the Photoshop performance preferences to help speed up the healing computations. So, if you have the Cache limit set to 4 or fewer levels, this can compromise the performance of the Spot Healing Brush in Content-Aware mode when carrying out big heals. It is therefore recommended you raise the cache limit to 6 or higher.

Let's now look at what the Spot Healing Brush is capable of when used in Content-Aware mode. In the Figure 7.11 example there were a number of cables and wires in this photograph that spoiled the view. By using the Spot Healing Brush in Content-Aware mode I was able to carefully remove all of these to produce the finished photo shown below. Although the end result showed this tool could work quite well I should point out that you do still have to apply a certain amount of skill in your brush work and choice of settings in order to use this tool effectively. To start with I found that the Normal blend mode worked best for retouching the cables that overlapped the sky, since this blend mode uses diffuse edges to blend seamlessly with the surroundings. I also mostly used long, continuous brush strokes to remove these from the photograph and achieve a smooth blended result with the rest of the sky. When retouching the rocks I gradually removed the cables bit by bit by applying much shorter brush strokes and using the Replace blend mode. I find that you need to be quite patient and note carefully the result of each brush stroke before applying the next. You'll discover that dragging the brush from different directions can also influence the outcome of the heal blend retouching and you may sometimes need to carry out an undo and reapply the brush stroke differently and keep doing this until you get the best result. I also find that you can disguise the retouching better by adding extra, thin light strokes 90° to the angle of the first, main brush stroke and this too can help disguise your retouching work with the Spot Healing Brush used in this mode.

Stroking a path

A useful tip is to use the stroke path option in conjunction with the Spot Healing Brush to apply a precisely targeted spot heal brush stroke. For example, to retouch the cables in the Figure 7.11 photo, I selected the Pen tool and used it to create an open path that followed the line of one of the cables. With the path still active, I went to the Paths panel fly-out menu and choose 'Stroke Path.' This opened the Stroke Path dialog shown in Figure 7.10. Here, I selected the Spot Healing Brush here and clicked OK, this applied a Spot Healing Brush stroke that followed the direction of the path.

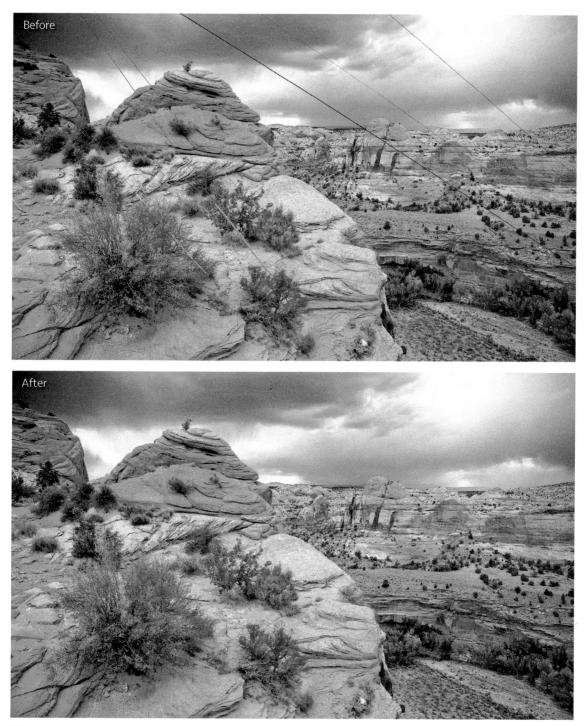

Figure 7.11 This shows a before version (top) and after version (bottom), where I had used the Spot Healing Brush in Content-Aware mode to retouch the image.

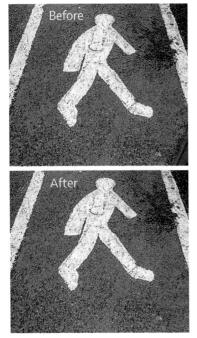

Figure 7.12 A before and after view using the Spot Healing Brush.

Diffusion slider for the Healing tools

The Spot Healing, Healing Brush, and Patch tool (in Normal mode) Toolbar options include a Diffusion slider. This can be used to control how the pasted region adapts to the surrounding image area. For example, you will find that a low Diffusion setting, such as a value of 2, will be ideal when editing images that contain a lot of noise or detailed texture, while a higher value is more suitable for areas that contain smooth texture. The following steps show how adjusting the Diffusion slider setting when using the Patch tool (which is described in more detail in the following section) can help improve the edge blending in a noisy image shot at ISO 104800.

Another recent improvement is the way the healing tools behave as you retouch close to the edges of a picture. In earlier versions of Photoshop it could sometimes often prove difficult to get a successful blend when using any of the healing tools close to the document bounds. In the Figure 7.12 example the photograph included a black drain cover in the bottom right of the image. Using the Spot Healing Brush I painted over the drain cover to remove it from the photo, which successfully filled in the corner without any contamination.

1 I selected the Patch tool in 'Patch Source from Destination' mode and drew a selection to define the outer area of the flower pattern on this cabinet. I dragged downward to sample a clean area at the bottom to replace the source area.

2 In this step I set the Diffusion slider to 7. This is an optimum setting for blending smooth-textured photographs using the healing tools in Photoshop. But because the image was very noisy the edge blending was very noticeable, as can be seen in the close-up view on the right.

3 I undid the last step and repeated the Patch tool retouching using a Diffusion slider setting of 1. As you can see in the close-up view, the blending was much improved.

Use Pattern option

\$

P 14

1

7. 2. 0.

5

0

The Use Pattern button in the Options bar lets you fill a selected area with a pattern preset using a healing type blend.

Patch tool

The Patch tool uses the same algorithm as the Healing Brush to carry out its blend calculations, except the Patch tool uses selection-defined areas instead of a brush. When the Patch tool is selected, it initially operates in a Lasso selection mode, where you can also hold down the (all key to temporarily convert the tool to become a Polygonal lasso tool with which to draw straight line selection edges. The selection can be used to define the area to 'patch from' or 'patch to.' It so happens you don't actually need the Patch tool to define the selection; any selection tool or selection method can be used to prepare a Patch selection. Once you have made the selection, select the Patch tool and click and drag. In Source mode you drag the Patch tool selection area to a new destination point to replace the pixels in the original source selection area with those sampled from the new destination area. In Destination mode you drag the Patch tool selection area to a new destination point to copy the pixels from the original source selection area and clone them to the new destination area. The Patch tool provides an image preview inside the destination selection area as you drag to define the patch selection.

1 In this example I wanted to demonstrate how you can use the Patch tool to quickly copy a large area of an image in one go. When you select the Patch tool you can use it just like the Lasso tool to draw around the outline of the area you wish to patch or copy, and loosely define a selection area. However, as was mentioned in the main text you can use any selection tool method you like to define the selection as you prepare an image for patching.

2 Having defined the area I wanted to copy, I made sure that the Patch tool was selected (and was in the Destination mode). I then dragged inside the selection to locate an area of the image that I wanted to patch. As I dragged the patch selection, I was able to position the road markings precisely where I wanted them to be placed. In this instance I reckoned it would work best if I had the Transparent box checked in the tool Options bar (as shown in Step 1).

3 As I released the mouse, Photoshop began calculating a healing blend, analyzing the pixels from the source area (that I had just defined) and used these to merge them seamlessly with the pixels in the destination selection area. The Patch tool repair will usually work effectively first time. If it doesn't look quite right, I suggest deselecting the selection and use either of the Healing Brushes (or the Clone Stamp) to fine-tune the result.

Transparent mode

In Transparent mode you can use the Patch tool in the Source or Destination mode to blend selected areas transparently. In Figure 7.13 below you can see a before and after example where the Patch tool was applied using the Patch tool in Destination mode with the Transparent option checked.

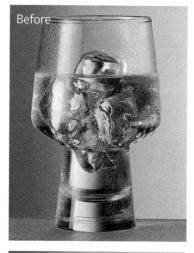

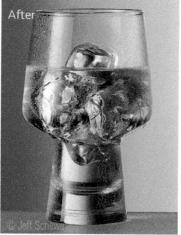

Figure 7.13 This shows an example of the Patch tool applied in Transparent mode to copy an ice cube in a glass and have it blend transparently.

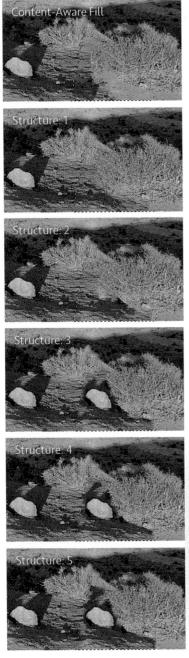

Figure 7.14 Examples of content-aware fill outcomes using different adaptation methods.

The Patch tool in Content-Aware fill mode

Basic content-aware filling can be done by making a selection, choose Edit \Rightarrow Fill and fill using the Content-Aware fill mode (as shown below). There is also a Content-Aware mode when working with the Patch tool. The following steps show a comparison between the use of the Edit \Rightarrow Fill command and the Patch tool in Content-Aware mode. Note that when the Sample All layers option is checked, you can apply a Patch tool content-aware fill to an empty new layer.

1 This photograph was taken at sunset and you can see the shadow of the tripod and camera. To remove this from the photo, I first made a rough Lasso selection to define the outline of the shadow.

	Fill		
Contents:	Content-Aware	~ (ок)	
Options		Cancel	
Color Adaptat	on		
Blending			
Mode:	Normal Y		1-
Opacity:	100 %		
Preserve Tran	sparency		ALONG AL
			Land and the second
	and the second		

2 In this step I went to the Edit menu and chose Fill... (Shift F3). This opened the Fill dialog. In the Contents section I selected 'Content-Aware' from the pop-up menu and clicked OK to fill the selected area. Figure 7.14 compares this result with the subsequent Content-Aware patch fill methods.

	Normal	
🗘 🗸 🗖 🖸 🗗 Patch:	✓ Content-Aware	Structure: 4 🗸 Color: 0 🖌 🖸 Sample All Layers

🗘 🗸 🗖 🔂 🖻 Patch: Content-Aware 🗸 Structure: 1 🗸 Color: 0 🗸 🗹 Sample All Layers

3 I undid the content-aware fill, selected the Patch tool and in the Patch tool Options bar chose the Content-Aware option. I added an empty new layer and with the 'Sample All Layers' option checked, dragged the selection to the left and released the mouse. With the selection still active, I was able to select different Structure settings, finally choosing a Structure setting of 1. You can see the results of all the different Structure settings in Figure 7.14.

4 Here is the final version with the shadow successfully removed.

Structure control

With a regular Content-Aware Fill feature you have no control over how the fill is applied. However, if you choose the Patch tool method you do have more control over the Content-Aware Fill calculations. For example, when you drag a patch selection you manually define which areas you would wish the Content-Aware Fill to sample from. This can make a big difference to the final outcome. The other thing you can control is the Structure setting. In Step 3 on the previous page I dragged the Patch tool selection to the left to indicate the area to sample from. After letting go with the mouse, Photoshop carried out a Content-Aware Fill. I was then able to select different Structure settings to see which worked best. For instance, when Structure is set to 5, Photoshop uses a rigid sampling from the surrounding area and when it's set to 1, it tends to jumble things up more. The default setting is 3, which is a good starting point. In the previous example though, I found that the 1 setting happened to produce the best-looking result.

In most cases the Content-Aware Fill feature will work well. All you have to do is to make a rough selection around the outline of whatever it is that you wish to remove from a scene and let the Content-Aware Fill do the rest. Photoshop can usually create a convincing fill by sampling pixel information from the surrounding area. If you don't get a satisfactory result straight off, there are a couple of things you can do to make it work better. For example, you can expand the selection slightly before applying a Content-Aware Fill. To do this, choose the Refine Edge command or go to the Select menu and choose Modify ⇒ Expand. It can also help sometimes if you apply a Content-Aware Fill more than once. As you apply subsequent fills you may see the filled area improve in appearance each time you do this.

To improve the effectiveness of a Content-Aware Fill you can use a layer mask to hide areas of an image you would like the Content-Aware Fill to ignore when filling a selection. For example, start with a Background layer, double-click to convert this to a regular layer and add an empty layer mask to that layer. Then with black as the foreground color, paint with black to hide the bits you don't want Content-Aware Fill to pick up. Now make a regular selection and apply the Content-Aware Fill. When you are done you can delete the layer mask to reveal the entire layer again.

Incidentally, If you make a selection on a background layer, or a flattened image and hit Delete, this pops the Fill dialog box. This allows you to choose how you wish to fill the selected areas and will have Content-Aware Fill selected by default. If you want to bypass this and apply the previous default behavior, you can use **#** *Delete* (Mac), *ctrl Delete* (PC) to fill using the background color.

Content-Aware move tool

The Content-Aware move tool works in a similar way to the Patch tool in Destination mode, except it lets you either extend a selected area or move it and fill the initial selected area. In doing so it offers you the same adaptation methods as provided for the Patch tool in the Content-Aware Fill mode (see the Options bar in Figure 7.15). You can cleverly adjust selected areas to make objects appear taller, shorter, wider, or thinner or to move selected items. It also uses face detection to help get improved results when editing photos that feature people. Basically, the Content-Aware move tool can be used to manually resculpt a photograph.

Border textures

The Content-Aware move tool tends to produce better-looking results when the surrounding area has a lot of texture detail to work with. To produce a good blend you should have at least 10% space around the surrounding edges for the Content-Aware move tool to work with.

X - D C C Mode / Move Structure: 4	✓ Color: 0 ~ Sample All Layers ☑ Transform On Drop
------------------------------------	--

~ Color: 0

~

Sample All Layers 🖸 Transform On Drop

Mode: Move

~

569

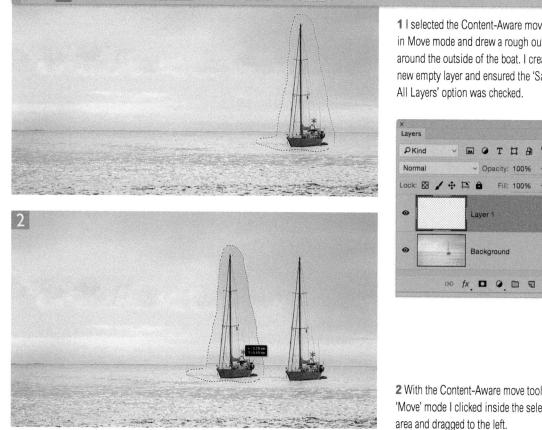

Structure: 4

1 I selected the Content-Aware move tool in Move mode and drew a rough outline around the outside of the boat. I created a new empty layer and ensured the 'Sample All Layers' option was checked.

> T n A

Fill: 100%

A

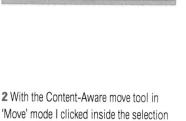

3 When I released the mouse this caused the original selection area to fill using a Content-Aware type fill and left a copy of the boat just to the left of the original.

Sample All Layers 🖸 Transform On Drop

4 As with the Patch tool, the Content-Aware move tool has options for controlling the adaptation method. You can access these from the Adaptation menu shown above. To achieve the result shown in Step 3, the adaptation Structure was set to 7 and Color set to 10, but on the right I have shown the outcomes had I selected other options instead.

560

Mode: Move

~

Structure: 7

v Color: 10

* *

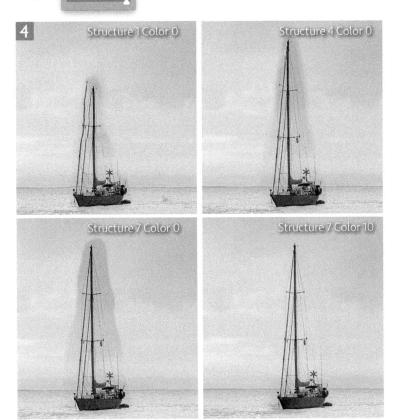

Content-Aware move tool in Extend mode

When the Content-Aware move tool is used in the Extend mode you can use it to move selected areas and have these blend with the original image, rather than fill the original selected area. For example, you can use this to make buildings taller or stretch someone's neck. The Content-Aware move tool also performs a Content-Aware type fill with its surroundings as you create a new blend. In the example shown below I used the Content-Aware move tool to extend a couple of palm trees to make them taller. Should you use this tool in Extend mode to make something more compact you will need to ensure the area on the side opposite to the direction you intend dragging is big enough to create a suitable overlap. This is because as you move the selection you need to have an adequate picture area to reference to cover up whatever it is you are making smaller.

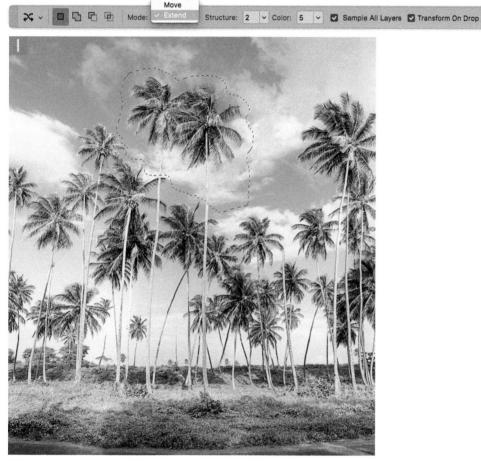

1 I began here by selecting the Content-Aware move tool in Extend mode and made a freehand selection of the two palm trees in the middle of the photo.

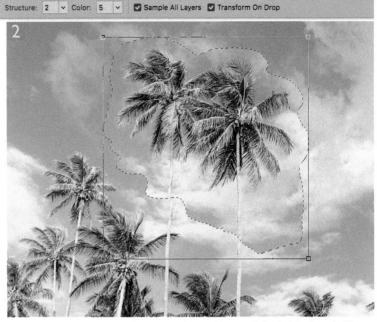

2 I added an empty new layer above the background layer and checked the Sample All Layers box in the Content-Aware move tool Options bar. I then clicked inside the selection and dragged upwards to extend the length of the palm tree trunks. As I released the mouse, a Transform box was added to the selected area.

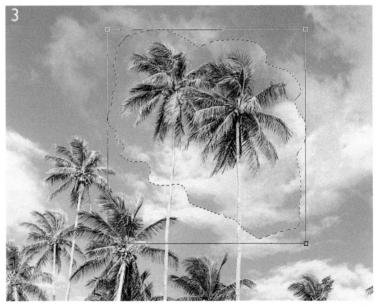

3 As you can see in Step 3, the Content-Aware Extend move resulted in the tree trunks in the transform selection not being aligned with those below. I therefore dragged the corner handles to scale the transform selection.

🗙 🗸 🗖 🖸 🖻 🖻 Mode: Extend 🖌 Structure: 2 🗸 Color: 5 🖌 🗹 Sample All Layers 🖸 Transform On Drop

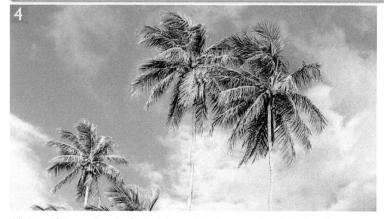

4 I clicked OK to confirm the Content-Aware Extend move and apply the transform. However, with the Structure setting set to 2, the palm tree trunks did not align correctly.

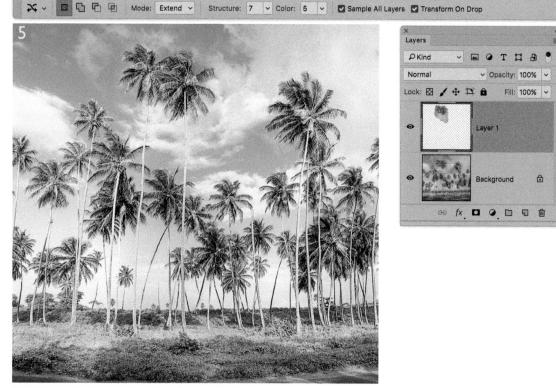

5 At this stage the Content-Aware Extend move selection was still active, but the marching ants were hidden. I was therefore able to adjust the Structure and Color settings to update the Content-Aware Extend move result. In this step, I set the Structure to 7, which resulted in the palm tree trunks blending perfectly.

Enhanced content-aware color adaptation

When the Content-Aware option is selected in the Fill dialog you will see a Color Adaptation option. Also in the Options bar for the Patch tool and Content-Aware move tool is also a Color slider, which provides more refined control over the color adaptation. A zero setting means no Color adaptation occurs. As you increase this value more color blending occurs up to a maximum blend setting of 10. The Content-Aware algorithm generally has a preference for smoothness over texture. Increasing the Color adaptation further improves the smoothness and this method of filling and repairing is mainly useful when working on smooth graduated areas. The best Color setting to apply is usually within the 3–7 range. A setting higher than this may tend to overcompensate, but in the following example, I ended up selecting the maximum 10 setting.

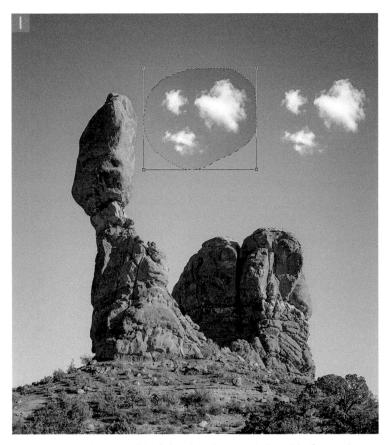

1 To demonstrate the power of the Color adaptation controls, I used the Content-Aware move tool in Move mode to move the cloud selection in this photograph.

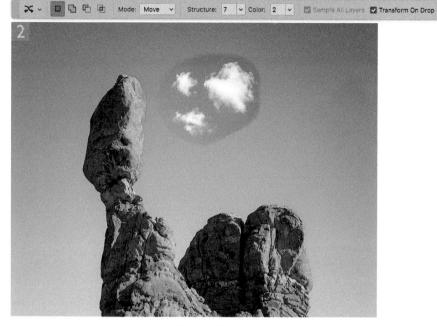

2 In this example the Structure was set to the default 7 setting with a Color adaptation setting of 2. However, the moved selection did not blend well around the selection edge.

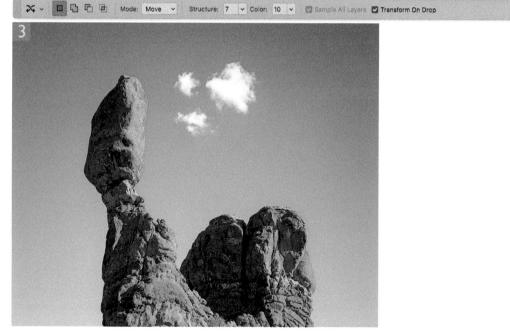

3 Here, I used the Content-Aware move with a Color setting of 10 to produce a smoother-looking result.

Content-Aware move with transformations

The following steps show how you can apply a transform adjustment as you carry out a Content-Aware move tool adjustment, whether you are using the Extend or Move mode.

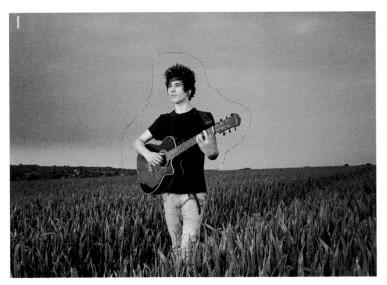

1 To begin with I selected the Content-Aware move tool and clicked and dragged to define a rough outline of the guitar player.

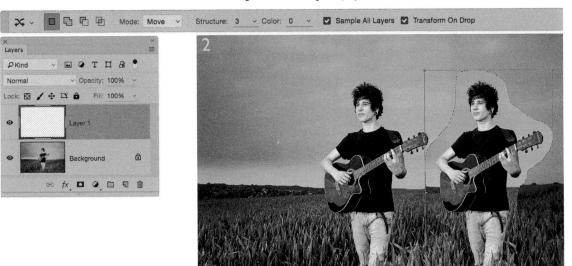

2 I added a new layer and checked 'Sample All Layers' and 'Transform On Drop' in the Options bar. I then clicked inside the selection with the content-aware move tool and dragged to the right. This created a temporary duplicate of the original selection.

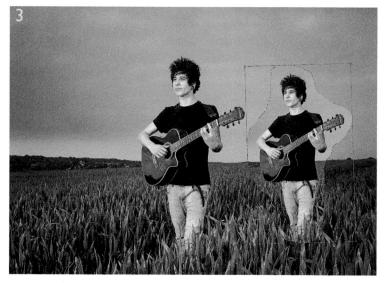

3 Because 'Transform On Drop' was checked I was able to scale the copied pixels and in this instance rotate slightly as well, making sure I matched the horizon line.

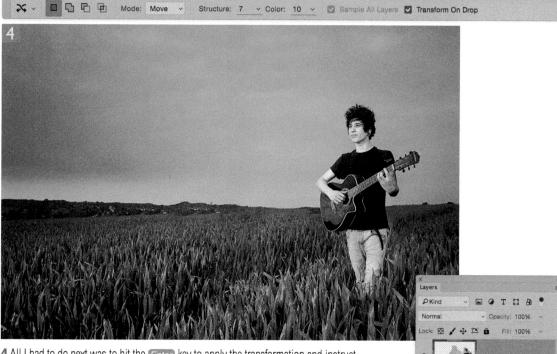

4 All I had to do next was to hit the <u>Enter</u> key to apply the transformation and instruct Photoshop to blend the transformed pixels with the underlying image and, at the same time, delete and fill the original pixel selection area. These edits were added to the new layer and I was also able to fine-tune the Structure and Color sliders to obtain the optimum blend.

 PKind
 Image: Compactive 100%

 Normal
 Opacity: 100%

 Lock:
 Image: Compactive 100%

 Image: Compactive 100%

Working with the Clone Source panel

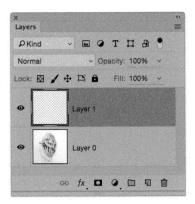

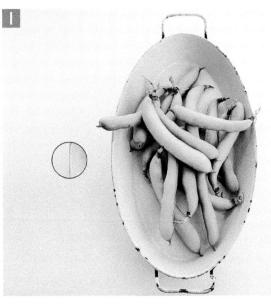

1 Here I wanted to show how you can work with the Healing Brush or Clone Stamp tools to clone at an angle. I added a new layer and sampled a side of the bowl with the Healing Brush.

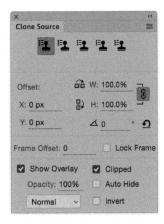

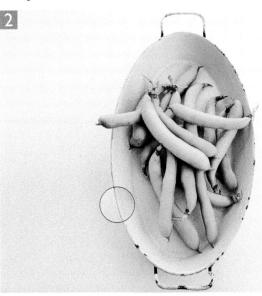

2 I then went to the Clone Source panel and adjusted the angle. The best way to do this is double-click to highlight the angle field, place the cursor over the area to be cloned, and use the keyboard arrow keys to adjust the angle value up or down. You can also hold down the *Shift* key to boost the arrow key adjustment.

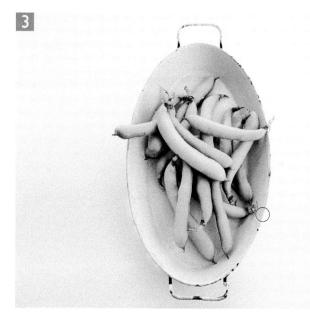

× Clone Source			**
E E	-12	. 1 1	
Offset:	66	W: 100.0%	- -
X: 0 px	8	H: 100.0%	- -
Y: 0 px		<u>م ع.o</u> °	ົ
Frame Offset: 0			Frame
Show Overla	iy	Clipped	
Opacity: 100	%	Auto Hid	9
Normal	~	Invert	

3 After making a first successful clone I found it was necessary to double-click the angle field again to make it active. I then positioned the cursor and once more adjusted the angle.

4 Here you can see the finished result. Getting the angle just right each time was quite tricky, so some patience was required.

Perspective retouching

d Size: 100

⊞ ()

1/

#

b G

The Vanishing Point filter in the Filter menu can be used to retouch photographs while matching the perspective. I have provided here a quick example of how one might use the Vanishing Point filter to retouch out some road markings. For more details about working with this filter, there is a PDF you can download from the book website.

Vanishing Point

OK

1 To begin with I created a Background copy layer and chose Filter ⇒ Vanishing point and used the Create plane tool () to define the road perspective. I selected the Stamp tool (), and with the Heal mode enabled, removed the unwanted road markings.

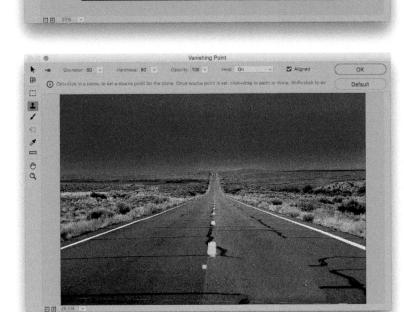

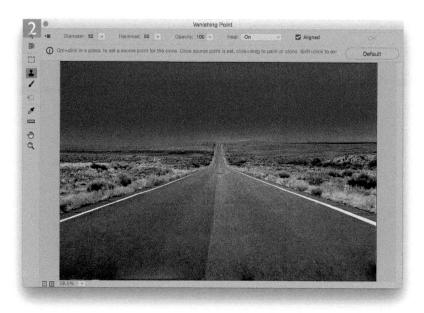

2 This shows how the road looked after retouching it using the Vanishing Point filter.

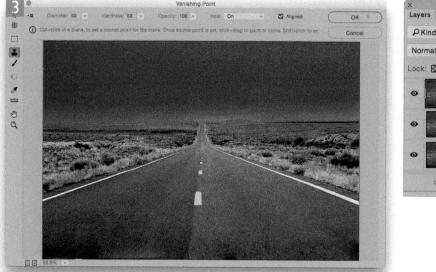

3 I copied the Background Copy layer to make a new copy layer. To this I added a single yellow dash line in the middle of the road (I copied this from the original Background layer). I then opened the Vanishing Point filter a second time (the previously created perspective plane was still saved) and used the Stamp tool in Heal mode again to clone the yellow dash down the middle of the road.

While it is great that Photoshop has so many tools that can be used to retouch photographs, this does raise the question as to how much use of Photoshop is OK. There has been much public and internal industry debate on this subject. It is therefore important for any photographer who is involved with the use of Photoshop to at least have an understanding of what the issues are.

Broadly speaking, the context is important when determining what level of retouching is appropriate. With advertising images people are visually literate enough to understand that the images created for stills adverts often involve a lot of intricate image editing. While there are industry guidelines to ensure the products advertised are presented truthfully, it is perfectly acceptable to combine multiple elements in a single picture or add a new sky. However, this practice would be questionable in other areas of photography, especially in news reporting. Here, it would be regarded as a betrayal of trust to alter the essential truth in a captured scene, even if the change is simply aesthetic, such as removing a distracting shadow (as opposed to adding extra people to a crowd scene). Unfortunately, photo journalists have yet to agree among themselves how to define those limits. It has become such a contentious issue that photo journalist photographers have been penalized for any use of Photoshop - even just heavy tone adjustments. This is crazy when you consider how legendary Magnum photographers, for example, have used the darkroom to dodge and burn their photographs.

Irrespective of what the industry guidelines say, there are wider concerns about the over-use of Photoshop on models and celebrities, and, in particular, how this affects the body image expectations of young women. Photographers and Photoshop retouchers have the responsibility as well as the opportunity to influence how people are portrayed. Among the professionals I know I see a trend towards the use of less retouching or, at least, less obvious retouching and ensuring their subjects still look human. At the same time, fashion images are an expression of creativity in clothes, hair, makeup, and photography. It is at the end of the day a fantasy and credit should be given to the viewer who can see these images for what they are. We should be able to look at a magazine or beauty ad and recognize that.

Portrait retouching

Here is an example of a restrained approach to retouching. Of course you can retouch portraits as if they were fashion shots and some publications may demand this, but I thought I would start off by showing a more subtle approach to portrait retouching.

1 With this photograph of my tech editor, Rod Wynne-Powell, the main problem was the reflections in the glasses.

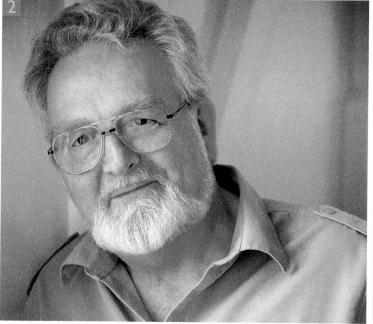

1 Here, I added a spotting layer and a masked Curves adjustment layer to remove the reflections. I added two further masked Curves adjustment layers to dodge and lighten the eyes. Having done that I added an empty new layer and used the Spot Healing Brush to retouch some of the wrinkles, while preserving the skin texture.

Photograph: Jeff Schewe

Getting the balance right

The Brush tool is a good tool with which to smooth the skin tones. I happen to prefer the manual painting approach rather than simply blurring the skin texture. This is because the painting method offers more control over the retouching.

Beauty retouching

Beauty photographs usually require more intense retouching, where the objective is to produce an image in which the model's features and skin appear flawless. This can be done through a combination of spotting and paint brush work.

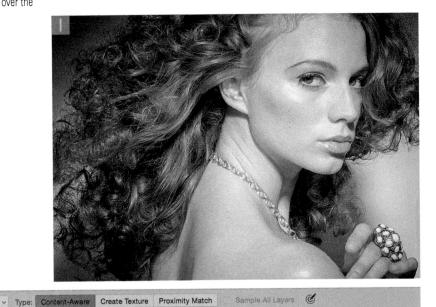

Layers Rind u A Normal ✓ Opacity: 100% ✓ Lock: 🖾 🖌 🕂 🛱 🏛 Fill: 100% ~ VA Retouching Spotting 6 Background 0 GÐ fx 🖸 🖉 🗊 🗊 前

Mode: Normal

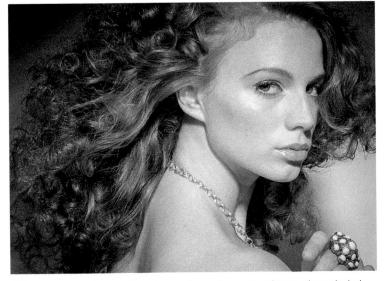

1 The top photograph shows the before version and below, how the same image looked after I had added a new empty layer and carried out some basic spotting work with the Healing Brush. Here, I removed the neck lines and got rid of unwanted stray hairs.

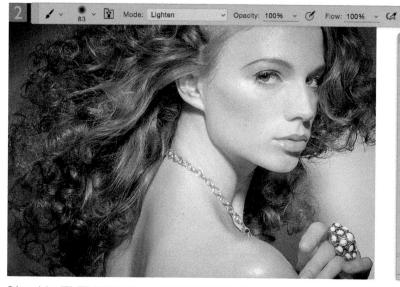

2 I used the **E C (**Mac), **C (Mac)**, **(Mac)**, **(Mac)**, **(Mac)**, **(Mac)**, **(Mac)**, **(Mac)**,

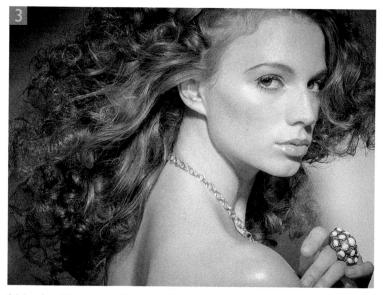

3 I then faded the opacity of the painted layer to 50% and added a layer mask so that I could carefully mask the areas where the paint retouching had spilled over. Lastly, I added a new layer above to retouch the shaded areas in the eyes.

Client: Gallagher Horner

Liquify tools

🦉 Forward warp tool (W)

Provides a basic warp distortion to stretch the pixels in any direction you wish.

🖌 Reconstruct tool (R)

Can be used to reverse a distortion and make a selective undo.

😹 Smooth tool (E)

Smoothes out ripples in the mesh caused by multiple, small warp tool applications.

Twirl clockwise tool (C)

Twists the pixels in a clockwise direction. Hold down the *an* key to switch tool to twirl in a counterclockwise direction.

Pucker tool (S)

Shrink the pixels and produce an effect similar to the 'Pinch' filter.

🗇 Bloat tool (B)

Magnify the pixels and produce an effect similar to the 'Bloat' filter.

📧 Push left tool (0)

Pushes the pixels at 90° to the left of the direction in which you are dragging. Hold down the *att* key to switch tool to push the pixels 90° to the right.

Freeze mask tool (F)

Protects areas of the image. Frozen portions are protected from further Liquify distortions.

🚺 Thaw mask tool (D)

Selectively or wholly erase the Frozen area.

🙎 Face tool (A)

Used to directly manipulate facial features (see Facial Liquify section).

🖑 Hand tool (H)

For scrolling the preview image.

🔍 Zoom tool (Z)

Used for zooming in or zooming out (with the *att* key held down).

Liquify

The Liquify filter can be used to carry out freeform pixel distortions. When you choose Filter \Rightarrow Liquify (\Re Shift X [Mac], ctrl Shift X[PC]), you are presented with the Liquify filter modal dialog. To use Liquify efficiently, I suggest you first make a marquee selection of the area you wish to manipulate before you select the filter, and once the dialog has opened use the \Re (Mac), ctrl (PC) keyboard shortcut to enlarge the dialog to fit the screen.

Basically, you can use the Liquify tools to manipulate the image and when you are happy with your liquify work, click the OK button or hit *Enter* or *Return*. Photoshop then calculates and applies the liquify adjustment to the selected image area. The individual Liquify tools are explained in the column on the left, while Figure 7.16 provides a visual guide as to what they can do.

The easiest tool to get to grips with is the Forward warp tool, which allows you to simply click and drag to push the pixels in the direction you want them to go. However, I also like working with the Push left tool, because you can also use it very effectively to squash or stretch items. When you drag with the Push left tool it shifts the pixels 90° to the left of the direction you are dragging in and when you *alt* drag with the tool, it shifts the pixels 90° to the right. The key to working successfully with the Liquify filter is to use gradual brush movements and build up the distortion in stages.

Liquify filter controls

Once you have selected a tool to work with you will want to check out the associated tool options that are shown in the Liquify dialog options (Figure 7.17). These are applied universally to all the Liquify tools and include: Brush Size, Brush Density, Brush Pressure, and Brush Rate options. All the tools (apart from the Hand and Zoom tool) are displayed as a circular cursor with a crosshair in the middle. You can use the square bracket keys **1 1** to alter the tool cursor size. You can also adjust the cursor size by right mouse dragging with the **a***lt* key in the Preview area. The maximum brush size here is 15,000 pixels. I highly recommend that you use a pressure sensitive pen and pad such as the Wacom[™] system but, if you do so, make sure that the Stylus Pressure option is checked and that the Brush Pressure setting is reduced to around 10–20%.

Forward warp tool

Twirl tool

Bloat tool

Reconstruct tool

Twirl tool (with all key held down)

Push left tool (pushed up)

Smooth tool

Pucker tool

Push left tool (pushed down)

Figure 7.16 These illustrations give you an idea of the range of distortion effects that can be achieved using the Liquify tools listed on page 480.

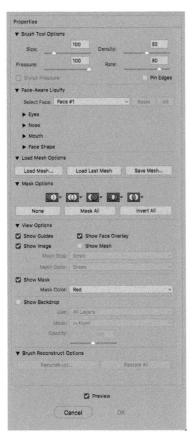

Figure 7.17 The Liquify dialog options.

On-screen cursor adjustments

Providing you have 'Use Graphics Processor' enabled in the Photoshop Performance preferences, you can apply on-screen cursor adjustments in the Liquify dialog preview. This means if you hold down the *ctro* keys (Mac), or the *att* key and right-click (PC), dragging to the left makes the brush cursor size smaller and dragging to the right, larger (and keeps the cursor position centered as you do so). If you drag upwards with these same keys held down you can decrease the brush pressure settings, and dragging downwards will increase the brush pressure (see Figure 7.18).

If you hold down the 💽 key the Cancel button changes to 'Reset'. But in addition now, if you hold down the 🔀 (Mac), *ctrl* (PC) key, the Cancel button changes to 'Default', which returns the controls to the 'factory original settings'.

Pin Edges

When the Pin Edges option is checked, this prevents the image edges from warping inwards as you manipulate the underlying Liquify mesh.

Figure 7.18 The Liquify dialog heads up display cursor.

Saving and loading the mesh

The Liquify dialog has 'Save Mesh,' 'Load Mesh,' and 'Load Last Mesh' buttons. When you save a mesh you have the option to work on the image again at a later date and reload the previous mesh settings. So, for example, if you have a saved mesh, this gives you the option to duplicate the original layer, reapply the previously used mesh and reedit the image contents in Liquify. Another thing you can do is to edit a low resolution version first, save the mesh and then reload and apply this mesh to the full resolution version later.

To reapply a Liquify filter using the last applied settings, go to the Filter menu and choose Liquify Filter from the top of the Filter menu.

Figure 7.19 An example of a freeze mask applied in Liquify.

Mask options

The Mask options can utilize an existing selection, layer transparency, or a layer mask as the basis of a mask to freeze and constrain the effects of any Liquify adjustments. Freeze masks can be used to protect areas of a picture before doing any Liquify work. In the example shown in (Figure 7.19) a freeze mask was loaded from an Alpha 1 layer mask (see Figure 7.20). The frozen area was then protected from subsequent distortions so I could concentrate on applying the Liquify tools to just those areas I wished to distort. Frozen mask areas can be unfrozen using the Thaw mask tool.

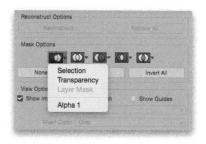

Figure 7.20 Mouse down on the arrow next to the Mask options to load a mask from the pop-up menu.

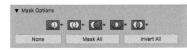

Figure 7.21 The Mask options.

▼ View Options		
Show Guides	Show Face Overlay	
Show Image	Show Mesh	
Mesh Size:	Large	~
Mesh Color:	Green	~
Show Mask		
Mask Color:	Red	v
Show Backdrop		
Use:	All Layors	v
Mode:	In Front	Ý
Opacity:	50	
	Stational Contractory	

Figure 7.22 The Liquify View options.

Amount	100	(ок
and an and a star and an and a star and a sta		Cancel

Figure 7.23 The Revert Reconstruction dialog.

Of the available mask options (Figure 7.21) the first is 'Replace Selection' (.). This replaces any existing freeze selection that has been made. The other four options allow you to modify an existing freeze selection by 'adding to' (.), 'subtracting from' (.), 'intersecting' (.), or creating an 'inverted' selection (.). You can then click on the buttons below. Clicking on 'None' clears all freeze selections, clicking 'Mask All' freezes the entire area, and clicking 'Invert All' inverts the current frozen selection.

View options

The View options are shown in Figure 7.22. The 'Show Mesh' option lets you see a mesh overlay revealing the underlying Liquify distortion and the mesh grid can be displayed at different sizes using different colors. This can help you pinpoint the areas where a distortion has been applied. You can use the check boxes in this section to view the mesh on its own or have it displayed overlaying the Liquify preview image (as shown in the Figure 7.16 examples). The 'Show Guides' option enables guides that may have been added to the image in Photoshop and can be referenced when applying a distortion. The 'Show Mask' option makes the freeze mask overlay visible and allows you to choose a mask color.

The Show Backdrop option is normally left unchecked. If the Liquify image contents are contained on a layer, then it is possible to check the Show Backdrop option and preview the liquified layer against the Background layer, all layers, or specific layers in the image. Here is how this option might be used. Let's imagine for example that you wished to apply a Liquify distortion to a portion of an image and you started out with just a flattened image. You then make a selection of the area you wish to work on and make a copy layer via the selection contents using **H U** (Mac), *ctrl* **U** (PC). Once you have done this, as you apply the Liquify filter you can check the Show Backdrop checkbox and set the mode to Behind. At 100% opacity the Liquify layer covers the Background layer completely, but as you reduce the opacity you can preview the effect of a Liquify distortion at different opacity percentages. This technique can prove useful if you wish to compare the effect of a distortion against the original image or a target distortion guide (as in the step-by-step example at the end of the chapter).

Reconstructions

If you apply a Liquify distortion and click on the Reconstruct button, this opens the Revert Reconstruction dialog shown in Figure 7.23. By setting the Amount to anything less than 100, you can decide by how much to reduce the current overall image liquify distortion—the reconstruction is applied evenly to the whole image and allows you to unwarp by however much you like. As you do this the distortion will be preserved for any areas that have been frozen using the freeze tool. If you click on the 'Restore All' button the entire image is restored in one step (ignoring any frozen areas). There is a reconstruct tool (**(R)**), which can be used to selectively paint over any areas where you wish to selectively undo a warp, and a smooth tool (**(E)**) that can be used to smooth out ripples in the mesh caused by multiple, small warp tool applications. While working within the Liquify dialog, you also have multiple undos at your disposal. To compare a before and after preview, toggle the preview box at the bottom (**(P)**).

Face-Aware Liquify adjustments

The Face-Aware Liquify controls can be used to distort facial features, whether the face is upright (as shown below), or slightly tilted. Figure 7.25 shows an example of a before and after photograph taken of myself (the normal me is on the left by the way), along with an expanded view of the Face Liquify controls (Figure 7.24).

The Face-Aware Liquify feature works best on faces that face the camera directly. When a face is detected, the Face tool is selected automatically and the Select Face menu used to select the desired face to work on. If the photograph contains more than one person you can select the desired individual by choosing Face #1, Face #2, etc. (these are selectable from left to right). The following sections provide

▼ Face-Aware Liquify			
Select Face: Face #1		~	Reset All
▼ Eyes			
Eye Size:	20	8	10
Eye Height:	15	8	15
Eye Width:	-20	8	-20
Eye Tilt:	0	ß	0
Eye Distance:			0
▼ Nose		and a second second	
Nose Height:			-5
Nose Width:			-15
▼ Mouth			
Smile:			15
Upper Lip:			15
Lower Lip:			25
Mouth Width:			-4
Mouth Height:			0
▼ Face Shape			and the second second second
Forehead:			10
Chin Height:			0
Jawline:			30
Face Width:			0

Figure 7.24 Face-Aware Liquify controls.

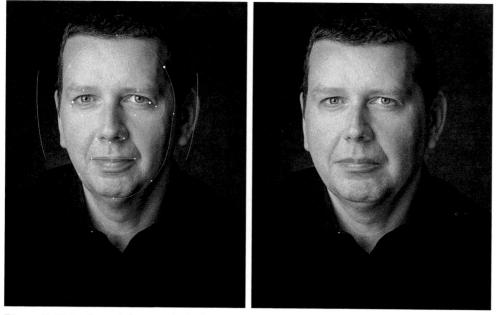

Figure 7.25 A before and after example of a Face-Aware Liquify distortion.

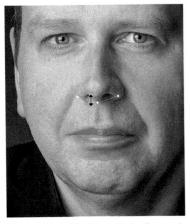

Figure 7.26 Working with the Face tool to adjust a Facial Liquify parameter.

Figure 7.27 Working with the Face tool to fine-tune the facial distortion.

Face-detection improvements

This latest version of Photoshop CC has an updated face-detection algorithm that recognizes faces at rotations/angles and partial faces better. It also does a better job in defining the edges of the face. Consequently you'll see better results when working with Face-Aware Liquify adjustments. slider controls to adjust the: Eyes, Nose, Mouth, or Face Shape. You can click and drag on these sliders to adjust the individual parameters to change the facial characteristics. With the Eye settings you have individual controls for the left and right eyes, while checking the Link icon locks them. With the Face tool active you can click and drag on the image directly. As you do this, outline guides will appear, although you can hide these by unchecking the Show Face Overlay box in the View options (Figure 7.22). You can see an example of the different available guides in the before version image in Figure 7.25. If you click and drag on the image you can adjust these directly with on-preview adjustments. Where you see a double-arrow cursor (see Figure 7.26) this means you are adjusting one of the Facial Liquify parameters and the corresponding slider will move accordingly. Where you see a Move tool cursor (see Figure 7.27), this means you can click and drag up and down or left and right to manipulate the face directly, independently of the Facial Liquify slider settings. Therefore, the Face tool gives you the means to edit the Facial Liquify settings via on-preview adjustments, or to fine-tune directly. You also have access to all the other regular Liquify tools to combine with the Face-Aware Liquify adjustments.

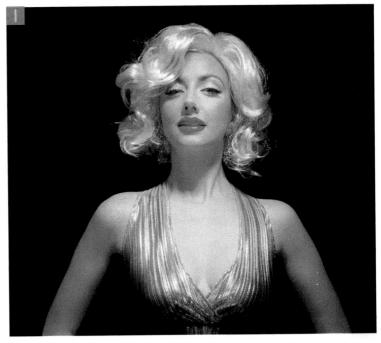

1 I wanted to show a practical example of where the Face-Aware Liquify controls might prove useful. Here is a picture of a model who was photographed to look like Marilyn Monroe. The photography, lighting, dress, makeup, and wig all help to achieve the desired result. However, using Face-Aware Liquify it was possible to make her look even more 'Marilyn like.'

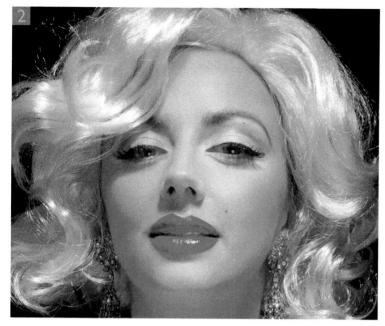

2 In this step I opened the Liquify filter and applied the Face-Aware Liquify settings shown here to adjust the shape of the eyes, nose, mouth, and overall face shape.

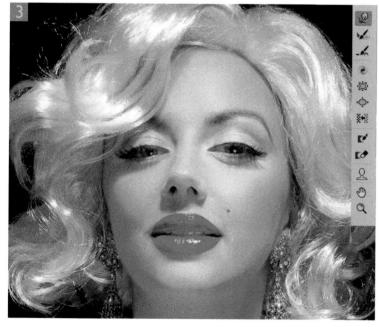

3 Having done that I used the Forward warp tool to flatten the line of the upper lip. Marilyn had more angled eyebrows so I also used the Bloat tool to make the eye on the right slightly bigger. I applied the Liquify filter and then retouched the beauty spot to make it slightly bigger.

Select Face: Face #1		~	Reset
Eyes			
Eye Size:	44	8	44
Eye Height:	0	ß	0
Eye Width:	19	8	19
Eye Tilt:	-4	3	-4
Eye Distance:			14
Nose			
Nose Height:			77
Nose Width:			17
Mouth			
Smile:			0
Upper Lip:			19
Lower Lip:			-44
Mouth Width:			0
Mouth Height:			-33
Face Shape			
Forehead:			94
Chin Height:			-52
Jawline:			-82
Face Width:			100

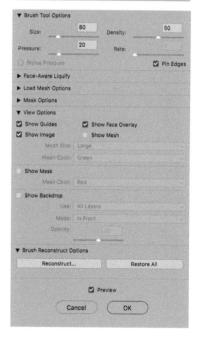

Photograph: © Andrew Sydenham, for the cover of *Amateur Photographer* magazine.

Liquify performance

If you are coming to Photoshop CC from Photoshop CS6 you will certainly see a noticeable improvement in performance. Liquify now runs faster, maybe as much as 16 times faster, when working on large documents. Also, zooming in on large documents is much faster now and aliasing has been removed when zooming levels at in-between full magnification views (i.e. at 33% and 66%).

Previously, the cursor ring and cross hairs showed different thicknesses in CS6 and this was due to differences in GPU cards. This problem has now been ironed out so that cursor rings and cross hairs are smoother and thinner, and the cross hairs are now made smaller on the Macintosh interface. You will also notice that the Photoshop preferences for cursors now determine the cursor appearance in Liquify as well. The brush slider responsiveness is now non-linear in behavior. In other words, the slider control feels more natural and this is especially noticeable when you use the bracket keys (**1**) to adjust the cursor size.

Also, each tool in Liquify now remembers its own settings for size, density, pressure and rate. When you switch tools, the new tool will always remember its last-used settings.

Smart Object support for Liquify

Photoshop provides Smart Object support for the Liquify filter. Liquify has not always supported Smart Objects because the Liquify filter relied on the creation of an internal mesh file, which would be automatically deleted once you clicked OK to apply a mesh edit. When a document or layer is converted to a Smart Object, Liquify saves a compressed mesh within the document. This means that when you choose to re-edit a (smart object) Liquify filter setting the mesh can be reloaded. While the mesh saved is compressed, this will still cause an image document to increase in size when saved.

When working with any of the Liquify controls, including with the Face-Aware sliders, these too can be applied to a Smart Object. For example, you can apply Liquify effects to a video layer that has been converted to a Smart Object.

Targeted distortions using Liquify

Now that we have the Puppet warp tool in Photoshop you may be wondering if we still need to use Liquify. After all, Puppet Warp does allow you to work on an image layer directly rather than via a modal dialog. Although I am a fan of Puppet Warp, I do still see a clear distinction between the types of jobs where it is most appropriate to use Puppet Warp and those where it is better to use Liquify. In the example shown here, the Liquify filter was still the best tool to use because you can use the paint-like controls to carefully manipulate the mesh that controls the distortion. Plus you can also use the Freeze tool (which is unique to Liquify) to control those parts of the image that you don't want to see become distorted. Every job is different and you'll need to decide for yourself which is the most appropriate distortion tool to use and which can best help you achieve the result you are after.

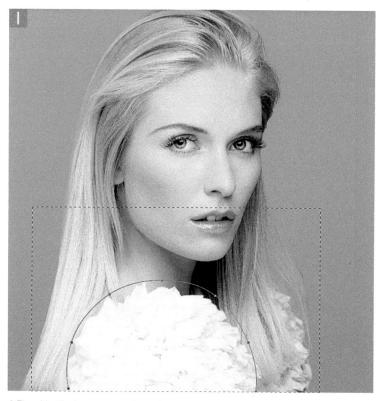

 Layers
 Image: Constraint of the state of the stat

1 The objective here was to enlarge the rosette on the shoulder using the Liquify filter. This first step was to create a guide for subsequent Liquify work. I created an empty new layer (Layer 1) and used the Pen tool to draw a path outline and stroked this path using the brush tool. I then made a selection of the area of interest and used $(\mathcal{H}_{\mathcal{I}})$ (Mac), (\mathcal{PC}) to copy the Layer 0 selected area. I then $(\mathcal{H}_{\mathcal{I}})$ (Mac), (\mathcal{PC}) -clicked the copied layer to reactivate the selection. This is important as having a selection active forces Liquify to load the selected area only.

0	Liq	quify (bookshoots_090729_0174-liqu	fy2.tif @ 48.6%)			
2 Martin Contraction			Properties			
h.			▼ Brush Tool Options			
2			Size:	125	Density:	50
\$ ◆			Pressure:	20	Rate:	
N			🗋 Stylus Pressure			Pin Edges
,	Provide States		Face-Aware Liquity			
		ter and the state of the state	► Load Mesh Options			
2			Mask Options			
			View Options			
1.4.4.4.4.1			Show Guides	🗍 Sh	ow Face Overlay	
		1 2 1	Show Image	🖬 Sh	ow Mesh	
			Mesh Size	Large		v
a state for and	1 1 1 1 1 1 1 1 1 1 1 1 1 1 1 1 1 1 1		Mesh Color	Gray		~
			Show Mask			
			Mask Color	Red		~
			Show Backdrop			
			Use	Layer 1		v)
			Mode	In Front		~
			Opacity		75	
E ● 48.6% ♥						

2 I chose Filter ⇒ Liquify, checked the 'Show Backdrop' option and made Layer 1 appear in front of the target layer to be retouched here. I then used the Freeze mask tool to protect the model's face from being edited. You can also see here that I had the mesh visible.

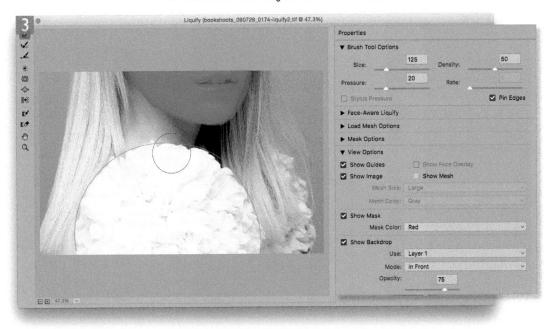

3 I then selected the Forward warp tool and, with a succession of low pressure strokes, gradually warped the rosette so that it matched the outline of the Layer 1 guide. When I was happy with the way the image looked, I clicked OK to apply the Liquify distortion.

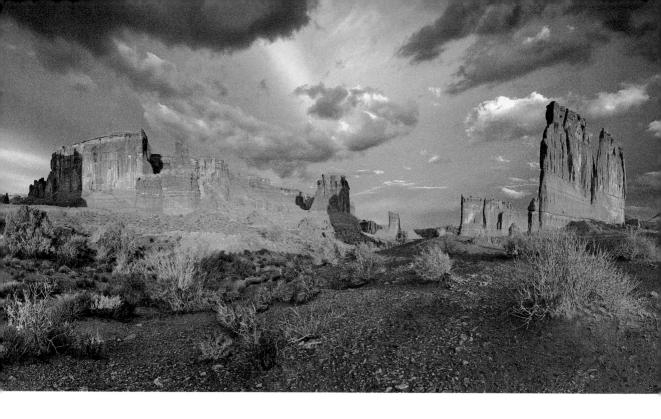

Chapter 8

Layers, selections, and masking

For a lot of photographers the real fun starts when you can take a series of photographs with the intention of combining them into a composite image. This chapter explains the different tools and techniques that can be used for creating composite photographs as well as the intricacies of working with layers, channels, mask channels, and pen paths. To begin with I shall focus on some of the basic principles such as how to make a selection and the interrelationship between selections, alpha channels, and the Quick Mask mode.

Figure 8.1 A selection is represented in Photoshop using marching ants.

Selections and channels

Whenever you read about masks, mask channels, image layer mask channels, alpha channels, quick masks, or saved selections, people are basically talking about the same thing: an active, semipermanent, or permanently saved selection.

Selections

There are several ways you can create a selection in Photoshop. You can use any of the main selection tools such as the Lasso tool or the Select \Rightarrow Color Range command, or convert a channel or path to a selection. Whenever you create a selection, it will be defined by a border of marching ants (Figure 8.1). It is important to remember that selections are only temporary—if you make a selection and accidentally click outside the selected area with the selection tool, the selection will be lost, although you can always restore a selection by using the Edit 🖙 Undo command. As you work on a photo in Photoshop, you will typically use selections to define specific areas of an image where you wish to edit the image or maybe copy the pixels to a new layer and when you are done, you'll deselect the selection. If you end up spending any length of time preparing a selection, you'll maybe want to save such selections by storing them as alpha channels (also referred to as 'mask channels'). To do this, go to the Select menu and choose Save Selection... The Save Selection dialog box then asks if you want to save the selection as a new channel (Figure 8.2). If you select a preexisting channel from the Channel menu you will have the option to replace, add, subtract, or intersect with the selected channel. If you are creating a new alpha channel, you can also click on the 'Save selection

Destinatio	n		ОК
Document:	W1BY0530.tif	~	Un
Channel:	New	~	Cancel
Name:	Outline mask		
Operation	1		
O New C	hannel		
Add to	Channel		
Subtra	ct from Channel		
	ct with Channel		

Figure 8.2 To save a selection as a new alpha channel you can choose Select \Rightarrow Save Selection and select the New Channel button option.

as a channel' button at the bottom of the Channels panel. This will convert a selection to a new channel. If you look at the Channels panel view in Figure 8.3, you will notice how a saved selection was added as a new alpha channel (this will be channel #6 in RGB mode, or #7 if in CMYK mode). Channels can be viewed independently by clicking on the channel name. However, if you keep the composite channels selected and click on the empty space next to the channel (circled), you can preview a channel as a quick mask overlay. You can also click on the 'Create new channel' button, then fill the new empty channel with a gradient or use the Brush tool to paint in the alpha channel using the default black or white colors. Once you create a new channel it is preserved when you save the image.

To load a saved channel as a selection, choose 'Load Selection...' from the Select menu and select the appropriate channel number from the submenu. Alternatively, you can (Mac), *otri* (PC)-click a channel in the Channels panel, or highlight a channel and click on the 'Load channel as a selection' button.

The marching ants indicate the extent of an active selection and any image modifications you carry out are applied within the selected area only. Remember though, all selections are only temporary and can be deselected by clicking outside the selection area with a selection tool

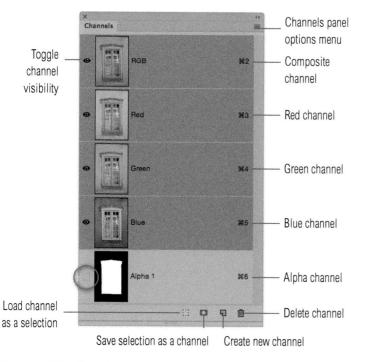

Reload selection shortcuts

To reload a selection from a saved mask channel, choose Select ⇒ Load Selection... You can also (ℜ) (Mac), (PC) + click a channel to load it as a selection. To select a specific channel and load it as a selection, use (ℜ) (¬>) + channel # (Mac), (T() (¬) + channel # (PC) (where # equals the channel number).

To select the composite channel, use **#2** (Mac), *ctrl* **2** (PC) and use **#3** (Mac) *ctrl* **3** (PC) to select the red channel, **#3 4** (Mac), *ctrl* **4** (PC) to select the green channel, **#3 5** (Mac), *ctrl* **5** (PC) to select the blue channel and subsequent numbers to select any additional mask/alpha channels that are stored in an image.

Figure 8.3 The Channels panel.

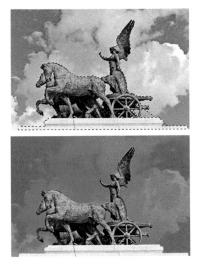

Figure 8.4 An example of a Selection view (top) and Quick Mask (below).

or by choosing Select \Rightarrow Deselect (**#D** [Mac], *ctrl***D** [PC]). If you find the marching ants to be distracting you can temporarily hide them by going to the View menu and deselecting 'Extras.' Or, you can use the **#H** (Mac), *ctrl***H** (PC) keyboard shortcut to toggle hiding/ showing them (though this is dependent on how you have configured the **#H** (Mac), *ctrl***H** (PC) behavior [see page 36]).

Recalling the last used selection

The last used selection is often memorized in Photoshop. Just go to the Select menu and choose 'Reselect' (**H** Shift **D** [Mac], *ctt* Shift **D** [PC]).

Figure 8.5 The Quick Mask mode button at the bottom of the Tools panel.

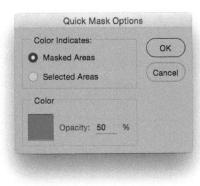

Figure 8.6 The Quick Mask Options.

Quick Mask mode

You can also preview and edit a selection in Quick Mask mode, where the selection will be represented as a transparent colored mask overlay. In Figure 8.4 the top image shows an active selection and the bottom image shows the same selection displayed as a Quick Mask. If a selection has a feathered edge, the marching ants boundary will only represent the selected areas that have more than 50% opacity. Therefore, whenever you are working on a selection that has a soft edge you can use the Quick Mask mode to view the selection more accurately. To switch to Quick Mask mode from a selection, click the Quick Mask icon in the Tools panel, just below the foreground/background swatch colors, or use the 💽 keyboard shortcut to toggle back and forth between the selection and Quick Mask modes. Figure 8.5 shows the Selection mode (left) and Quick Mask mode (right). You can toggle between the two by clicking on the Quick Mask button. Double-click to open the Quick Mask Options shown in Figure 8.6, where you can alter the masking behavior and choose a different color from the Color Picker (this might be useful if the Quick Mask color is too similar to the colors in the image you are editing). Whether you are working directly on an alpha channel or in Quick Mask mode, you can use any combination of Photoshop paint tools, or image adjustments to modify the alpha channel or Quick Mask content.

Creating an image selection

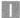

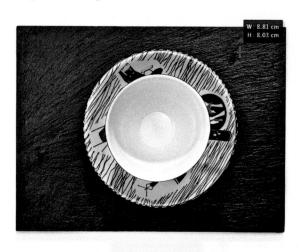

1 In this example I selected the Elliptical marquee tool and dragged with the tool to define the shape of the cup and saucer. Note how you get to see a heads up display of the selection dimensions.

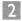

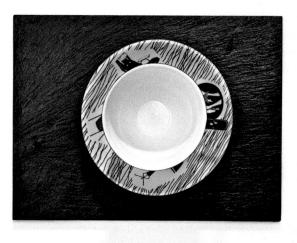

2 Now that I had created this selection I could use it to modify the image. With the selection still active, I added a new Curves adjustment layer to cool the cup and saucer. When you add an adjustment layer and a selection is active, the selection automatically generates a layer mask and the mask in this instance appears in the Channels panel as 'Curves 1 Mask.'

You can modify the shape of a selection using the *Shift* and *all* modifier keys. If you hold down the *Shift* key you can add to a selection. If you hold down the *alt* key you can subtract from a selection and if you hold down the *Shift* (Mac), *alt Shift* (PC) keys you can intersect a selection as you drag with a selection tool. The Magic wand is a selection tool too, but here all you have to do is to click (not drag) with the Magic wand, holding down the appropriate keys to add or subtract from a selection. If you select either the Lasso or one of the marquee tools, place the cursor inside the selection and click and drag, this moves the selection boundary position, but not the selection contents.

Alpha channels

An alpha channel is effectively the same thing as a mask channel and when you choose Select \Rightarrow Save Selection..., you'll be saving the selection as a new alpha channel. These are saved and added in numerical sequence immediately below the main color channels. Just like normal color channels, an alpha channel can contain up to 256 shades of gray in 8-bits per channel mode or up to 32,000 shades of gray in 16-bits per channel mode. You can select a channel by going to the Channels panel and clicking on the desired channel. Once selected, it can be viewed on its own as a grayscale mask and manipulated any way you like using any of the tools in Photoshop. An alpha channel can also effectively be viewed in a 'quick mask' type mode. To do this, select an alpha channel and then click on the eyeball icon next to the composite channel, which is the one at the top of the Channels panel list (see Figure 8.3). You will then be able to edit the alpha channel mask with the image visible through the mask overlay. There are several ways to convert an alpha channel back into a selection. You can go to the Select menu, choose Load Selection ... and then select the name of the channel. A much simpler method is to drag the channel down to the 'Make Selection' button at the bottom of the Channels panel, or 🎛 (Mac), *ctrl* (PC)-click the channel in the Channels panel.

Modifying an image selection

1 Here, I started off with a Rectangular marquee selection. I then selected the Elliptical marquee tool and dragged across the image with the *an* key held down. This allowed me to subtract from the original Rectangular marquee selection.

2 As with the previous example I added a Curves adjustment that used the current active selection to create the masked adjustment layer seen here. I then adjusted the Curves to make the place mat appear cooler in color.

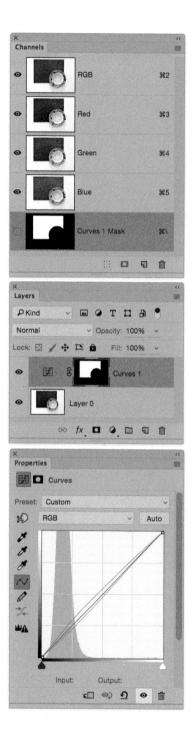

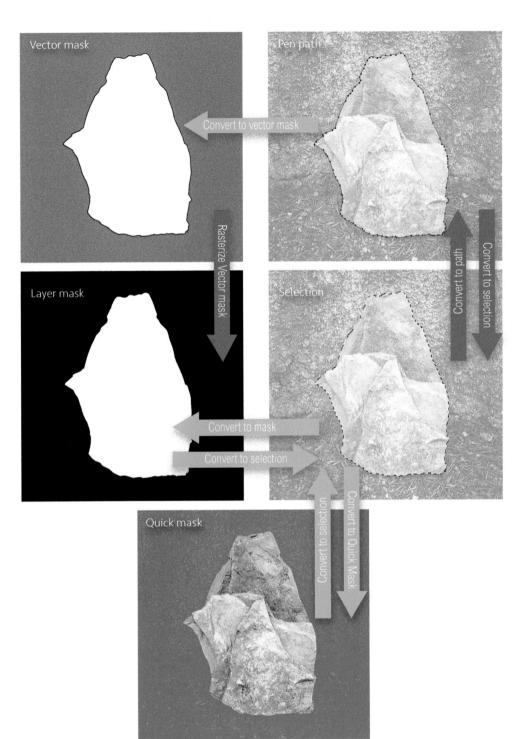

Figure 8.7 This diagram illustrates the interrelationship between pen paths, vector masks, alpha channels, selections, and quick masks.

Selections, alpha channels, and masks

What should be clear by now is there is an interrelationship between selections, quick masks, and alpha channel masks. This also extends to the use of vector paths and vector masks. The Figure 8.7 diagram illustrates the interrelationship between pen paths, vector masks, alpha channels, selections, and quick masks.

Starting at the top right corner, we have a path outline that has been created using the Pen tool in Photoshop. A Pen path outline can be saved as a path and an active path can be used to create a vector mask, which is a layer masked by a path (see pages 593–602). A vector mask can also be rasterized to create a layer mask (a layer that is masked by an alpha channel). Meanwhile, a path can be converted to a selection and a selection can be converted back into a work path. If we start with an active selection, you can view and edit a selection as a quick mask and a selection can also be converted into a mask and back into a selection again.

The red arrows indicate that some data loss is incurred during the conversion from one state to the other. This is because when you convert vector data to become a pixel-based selection, what you end up with is not truly reversible. Drawing a pen path and converting the path to a selection is a convenient way to make an accurate selection. But, if you attempt to convert a selection back into a path again, you won't end up with an identical path to the one that you started with. Basically, converting vectors to pixels is a one-way process. More specifically, a selection or mask can contain shades of gray, whereas a path merely describes a sharp outline where everything is either selected or not.

When preparing a mask in Photoshop, most people will start by making a selection to define the area they want to work on and save that selection as an alpha channel mask. This allows you to convert the saved alpha channel back into a selection again at any time in the future. The other way to prepare a mask is to use the Pen tool to define a path outline and then convert the path to a selection. If you think you will need to reuse the path again, such as to convert to a selection again at a later date, it is worth remembering to save the work path with a meaningful name, rather than the default 'Path 1', etc., in the Paths panel.

The subject of working with vector masks and layer masks is covered in more detail later on in this chapter, but, basically, a layer mask is an alpha channel applied to a layer that defines what is shown and hidden on the associated layer. And a vector mask is a path converted to a vector mask that defines what is shown and hidden

Figure 8.8 The left half is rendered without anti-aliasing and the right half uses anti-aliasing to produce smoother edges.

Figure 8.9 The Feather Selection dialog can be used to feather the radius of a selection.

Apply effect at canvas bounds

The Smooth, Expand, Contract, and Feather commands have an 'Apply effect at canvas bounds' option. This prevents the applied setting being constrained by the document size limits. on the layer. There are good reasons for having these different ways of working and there are a few practical examples in this chapter that show when to use either of these two main methods of masking.

Anti-aliasing

Bitmapped images are made up of a grid of pixels and without antialiasing, non-straight lines would be represented by a jagged sawtooth of pixels. Photoshop gets round this problem by anti-aliasing the edges, which means filling the gaps with in-between tonal values, so that non-vertical/horizontal sharp edges are rendered smoother by the anti-aliasing process. Figure 8.8 shows a graphic where the left half is rendered without anti-aliasing and the right half uses anti-aliasing to produce smoother edges. Wherever you encounter anti-aliasing options, these are normally switched on by default and there are only a few occasions where you might find it useful to turn these off.

If you have an alpha channel where the edges are too sharp and you wish to smooth them, the best way to do this is to apply a Gaussian Blur filter using a Radius of 1 pixel or less. Or, you can paint using the Blur tool to gently soften the edges in the mask that need the most softening.

Feathering

Whenever you do any type of photographic retouching it is important to always keep your selections soft. If the edges of a picture element are defined too sharply it will be more obvious to the viewer that a photograph has been retouched. The secret to good compositing is to make sure the edges of the picture elements blend together smoothly.

There are two ways to soften the edges of a selection. You can go to the Select menu and choose Modify \Rightarrow Feather (Shift F6) and adjust the Feather Radius setting (Figure 8.9). Or, if you have applied a selection as a layer mask, you can use the Feather slider in the Masks mode of the Properties panel to feather the mask. A low Feather Radius of between 1 or 2 pixels should be enough to gently soften the edge of a selection outline, but there are times when it is useful to select a much higher Radius amount. For example, earlier on page 364, I used the Elliptical marquee tool to define an elliptical selection, applied this as a Levels adjustment layer mask and feathered the selection by 100 pixels in the Properties panel Masks mode. This allowed me to create a smooth vignette that darkened the outer edges of the photo. The maximum feather radius allowed is 1000 pixels and Photoshop supports feather values up to two decimal places.

Layers

Layers play an essential role in all aspects of Photoshop work. Whether you are designing a Web page layout or editing a photograph, working with layers lets you keep the various elements in a design separate. Layers also give you the opportunity to assemble an image made up of separate, discrete components and have the flexibility to make any edit changes you want at a later stage. You can also add as many new layers as you like to a document up to a maximum limit of 8000. The Photoshop layers feature has evolved in stages over the years, including new ways for selecting multiple layers and linking them together. First let's look at managing layers and the different types you can have in a Photoshop document.

Layer basics

Layers can be copied between open documents by using the Move tool to drag and drop a layer (or a selection of layers) from one image to another. If you hold down the *Shift* key as you do this the layers are positioned centered in the destination image. To duplicate a layer, drag the layer icon to the New Layer button and to rename a layer in Photoshop, simply double-click the layer name. To remove a layer, drag the layer icon to the Delete button in the Layers panel and to delete multiple layers, use a *Shift*-click, or \mathfrak{R} (Mac), *cttt* (PC)-click to select the layers or layer groups you want to remove and then press the Delete button at the bottom of the Layers panel. There is also a 'Delete Hidden Layers' command in both the Layers panel submenu and the Layer \Rightarrow Delete submenu. In addition there is a File \Rightarrow Scripts menu item that can be used to delete all empty layers (see Figure 8.10). Layer visibility can be controlled by toggling the eyeball icon next to each layer, or by using the \mathfrak{R} + comma (Mac) *cttt* + comma (PC) shortcut.

To rename a layer, double-click the layer name in the layers panel to highlight the text. Use *Tab* to go to the next layer down and rename. Use *Shift Tab* to go to the next layer up.

Image layers

The most common type of layer is a pixel image layer. New documents have a default *Background* layer and you can convert a Background layer to a regular layer by simply clicking on the Background layer lock icon. New empty image layers can be created by clicking on the Create new layer button in the Layers panel (Figure 8.14). They can also be created by duplicating the contents of a selection to create a new layer within the same document. To do this, choose Layer \Rightarrow New \Rightarrow Layer

Image Processor...

Delete All Empty Layers

Flatten All Layer Effects Flatten All Masks

Layer Comps to Files... Layer Comps to PDF... Layer Comps to WPG...

Export Layers to Files...

Script Events Manager...

Load Files into Stack... Load Multiple DICOM Files... Statistics...

Browse...

Figure 8.10 This shows the File \Rightarrow Scripts menu, where there is also an item called 'Delete All Empty layers'.

Copy and Paste layers

You can now copy and paste layers in Photoshop, both inside a document and between documents, using the Copy (#C [Mac], *ctrl* C [PC]), Paste (**H**V [Mac], *ctrl*V [PC]), and Paste In Place (# Shift V [Mac], ctrl Shift V [PC]) commands. When you paste a layer between documents with different resolutions, the pasted layer retains its pixel dimensions. Copying a shape layer and pasting will only work so long as the shape path is not also selected. Similarly copying a layer with a vector mask and pasting will only work providing the vector mask path is not also selected. If a shape path or vector mask path are selected, copying copies just the path only to the clipboard.

Figure 8.11 A vector shape layer.

Figure 8.12 A text layer.

Figure 8.13 An adjustment layer with a pixel layer mask.

via Copy, or use the \mathfrak{H} (Mac), \mathfrak{ctr} (PC) keyboard shortcut. This copies the selection contents to create a new layer. You can use this shortcut to copy multiple layers or layer groups. Also, you can cut and copy the contents from a layer by choosing Layer \mathfrak{D} New \mathfrak{D} Layer via Cut or use \mathfrak{H} Shift (J) (Mac), \mathfrak{ctr} Shift (J) (PC).

Vector layers

Vector layers is a catch-all term used to describe layers where the layer is filled with a solid fill or pattern and the outline defined using a vector layer mask. A vector layer is created whenever you add an object to an image using one of the shape tools, or draw a path using the Shape layer mode, or when you add a solid fill layer from the adjustment layer menu. Figure 8.11 shows an example of a vector layer, which in this case was a solid fill layer masked by a vector mask.

There is an option in the Properties panel fly-out menu that forces Photoshop to open the Properties panel whenever you add a new vector shape layer.

Text layers

Type fonts are defined using vector data, which means that Text layers are also essentially vector-based shape layers. When you select the Type tool in Photoshop and click or drag with the tool and begin to enter text, a new text layer is added to the Layers panel. Text layers are symbolized with a capital 'T,' and when you hit *Return* to confirm a text entry, the layer name displays the initial text for that layer, making it easy for you to identify (see Figure 8.12). Text layers can be re-edited at any time. Double-click in the text layer 'T' icon to highlight the text and make the Type tool active (double-click the name area to rename a layer and double-click the clear area to open the Layer Style dialog).

Adjustment layers

Adjustment layers allow you to apply image adjustments as editable layers. You can toggle adjustment layers on or off by clicking the layer eyeball icon (see Figure 8.13). The chief advantages of working with adjustment layers are that you can re-edit the adjustment settings at any time. Adjustments added as adjustment layers can be selectively edited by painting on the associated layer mask using black to hide, or white to reveal. You can also adjust the blending mode and layer opacity.

Layers panel controls

Figure 8.14 shows an overview of the Layers panel controls for the Figure 8.15 layered image. You can choose which layers are to be viewed by selecting and deselecting the eye icons. The blending mode options determine how a selected layer will blend with the layers below, while the Opacity controls the transparency of the layer contents and the Fill opacity controls the opacity of the layer contents independent of any layer style (such as a drop shadow) which might have been applied to the layer. Next to this are the various layer locking options. At the bottom of the panel are the layer content controls for Layer linking,

Layer visibility undo

If you go to the History panel options and check 'Make Layer Visibility Changes Undoable,' you can make switching the Layer visibility on and off an undoable action. This sounds like a good idea, but can cause confusion when you need to undo a previous step and it undoes the layer visibility instead.

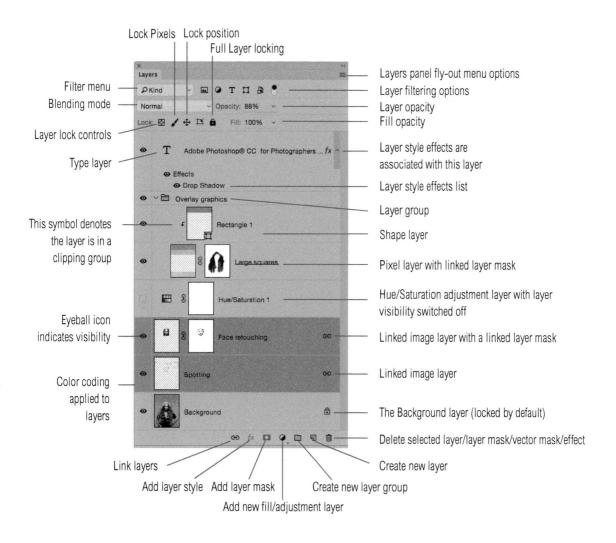

Figure 8.14 An overview of the Photoshop Layers panel controls.

adding Layer styles, Layer masks, Adjustment layers, New groups, and New layers as well as a Delete layer button. All the other essential layer operation commands are located in the Layers panel fly-out menu options.

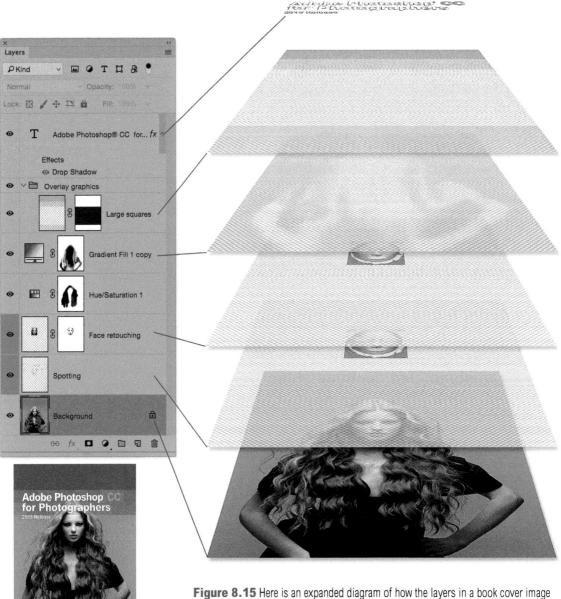

Figure 8.15 Here is an expanded diagram of how the layers in a book cover image file were arranged inside Photoshop. The checkerboard pattern represents transparency and the layers are represented here in the order they appear in the Layers panel.

Layer styles

You can use the Layer style menu at the bottom of the Layers panel (see Figure 8.14) to apply different types of layer styles to an image, shape or text layer. This feature is really of more interest to graphic designers rather than photographers, but you'll find descriptions of the various layer styles in the online Help Guide.

Adding layer masks

You can hide the contents of a layer either wholly or partially by adding a layer mask, a vector mask, or both. Masks can be applied to any type of layer: Pixel layers, Adjustment layers, Type layers, or Shape layers. Image layer masks are defined using a pixel-based mask, while vector masks are defined using path outlines. Click once on the Add Layer Mask button to add a layer mask and click a second time to add a vector mask (in the case of shape layers a vector mask is created first and clicking the Add Layer Mask button adds a layer mask). You will also notice that when you add an adjustment layer or fill adjustment layer a layer mask is added by default.

The most important thing to remember is that whenever you apply a mask you are not deleting anything; you are only hiding the contents. By using a mask to hide rather than to erase unwanted image areas you can go back and edit the mask at a later date. To show or hide the layer contents, first make sure the layer mask is active. Select the Brush tool and paint with black to hide the layer contents and paint with white to reveal. To add a layer mask based on a selection, select a layer to make it active, make a selection, and click on the Add Layer Mask button at the bottom of the Layers panel, or choose Layer \Rightarrow Layer Mask \Rightarrow Reveal Selection. To add a layer mask to a layer with the area within the selection hidden, *all*-click the Layer Mask button in the Layers panel, or choose Layer \Rightarrow Layer Mask \Rightarrow Hide Selection.

In Figure 8.16 the Layers panel contains two layers. The selected layer is the one highlighted here. The dashed border line around the layer mask icon indicates the layer mask is active (as opposed to the image layer itself) and edit operations would be carried out on the layer mask only. There is no link icon between the image layer and the layer mask; so the image layer or layer mask can be moved independently of each other. In Figure 8.17 the border surrounding the vector mask indicates the vector mask only. The image layer, layer mask, and vector mask are all linked; therefore if the Move tool is used, the image layer and layer masks will move in unison.

Figure 8.16 A Layers panel view with a layer mask selected.

Figure 8.17 A Layers panel view with a layer mask and vector mask, with the vector mask selected.

A	Apply mask to	layer before ren	noving?
Ps	Don't show a	gain	
	Delete	Cancel	Apply

Figure 8.18 The remove layer mask options dialog.

Figure 8.19 The layer mask contextual menu options.

Figure 8.20 The Layers panel Add Layer Mask button (circled).

Viewing in Mask or Rubylith mode

The layer mask icon preview provides you with a rough indication of how the mask looks, but if you *all*-click the layer mask icon the image window view switches to display a full image view of the mask. If you *Shift* (Mac), *all Shift* (PC)-click the layer mask icon, the layer mask is displayed as a quick mask type transparent overlay. Both these steps can be toggled.

Copying or removing a layer mask

You can use the *alt* key to drag/copy a layer mask across to another layer in the same document. To remove a layer mask, select the mask in the Layers panel and click on the Delete button (or drag the layer mask to the Delete button). A dialog box then appears asking if you want to 'Apply mask to layer before removing?' (Figure 8.18). There are a couple of options here: if you simply want to delete the layer mask, then select 'Delete'. If you wish to remove the layer mask and at the same time apply the mask to the layer, choose 'Apply.'

To temporarily disable a layer mask, choose Layer \Rightarrow Layer Mask \Rightarrow Disable. To reverse, choose Layer \Rightarrow Layer Mask \Rightarrow Enable. You can also *Shift*-click a mask icon to temporarily disable the layer mask (when a layer mask is disabled it will appear overlaid with a red cross). A simple click then restores the layer mask again (but to restore a vector mask you will have to *Shift*-click again). Alternatively, *cttl* (Mac) or right mouse-click the mask icon to open the full list of contextual menu options to disable, delete, or apply a layer mask (see Figure 8.19).

Adding an empty layer mask

To add a layer mask to a layer so that the layer contents remain visible, just click the Layer Mask button in the Layers panel (Figure 8.20). Or, choose Layer \Rightarrow Add Layer Mask \Rightarrow Reveal All. To add a layer mask to a layer that hides the layer contents, *all*-click the Add Layer Mask button in the Layers panel. Or, choose Layer \Rightarrow Add Layer Mask \Rightarrow Hide All. This adds a layer mask filled with black, enabling you to selectively paint with white to reveal some of that layer.

Thumbnail preview clipping

A right mouse-click on a layer thumbnail opens the contextual menu shown in Figure 8.21 where you can choose to clip thumbnails to the layer or document bounds. This option affects the layer contents visibility in the Layers panel (but does not affect the associated pixel/ vector layer masks). Once selected this option remains persistent for all document Layers panel views.

1 This shows a composite image made up of a Background layer plus an additional pixel layer masked with a layer mask.

2 att -clicking the layer mask icon lets you preview a layer mask in normal mask mode.

3 If instead you Shift (Mac), all Shift (PC)-click the layer mask icon, you can preview a layer mask in Quick Mask mode. The mask can be edited more easily in either of these preview modes. The backslash key (N) can be used to toggle showing the layer mask as a quick mask and return to normal view mode again.

× Layers Doc	cument bounds	*
Rind	T I A	٠
Hard Light	~ Opacity: 100%	~
Lock: 🖾 🖌		~
•	B Layer 2	
0	Background	
GÐ f	×. ◘ •. □ □ =	

Blending Options... Edit Adjustment...

Select Pixels

Add Transparency Mask Subtract Transparency Mask Intersect Transparency Mask

No Thumbnails Small Thumbnails Medium Thumbnails ✓ Large Thumbnails

✓ Clip Thumbnails to Layer Bounds Clip Thumbnails to Document Bounds

× No Color Red

Figure 8.21 The layer thumbnail contextual menu lets you determine whether a thumbnail preview clips to the document bounds (top) or the layer bounds (below).

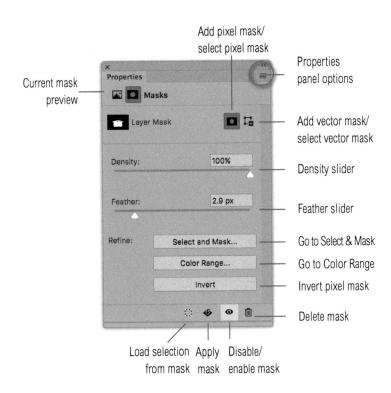

Figure 8.22 The Properties panel Masks mode controls.

Properties panel in Masks mode

The Properties panel Masks mode controls are all identified in Figure 8.22. The pixel mask/vector mask selection buttons are at the top and can also be used to add a mask (providing a pixel or vector mask is already present). Below, are the Density and Feather sliders for modifying the mask contrast and softness. The Density slider lets you preserve the mask outline but fade the contrast of the mask in a way that is completely re-editable. Next are the Refine buttons, which are only active if a pixel mask is selected. The Select & Mask button opens the Select and Mask dialog, which can allow you to further modify the edges of a mask. The Color Range button opens the Color Range dialog, where you can use a Color Range selection to edit a mask. The Invert button inverts a pixel mask, but if you want to do the same thing with a vector mask you can do so by selecting a vector path outline and switching the path mode (see page 600). At the bottom of the panel are buttons for loading a selection from a mask and applying a mask (which deletes the mask and applies it to the pixels) and a Delete Mask button.

Figure 8.23 shows the Properties panel Masks mode options menu, where you can use the menu options shown here to add, subtract or

Figure 8.23 The Properties panel Masks mode panel controls are accessible from the menu circled in Figure 8.22. intersect the current mask with an active selection. Imagine you want to add something to a selection you are working on. You simply choose the 'Add Mask to Selection' option to add it to the current selection.

Working with the Quick selection tool

The Quick selection tool is grouped with the Magic wand in the Tools panel. It is a more sophisticated kind of selection tool compared to the Magic wand and offers some interesting smart processing capabilities. Basically, you use the Quick selection tool to make a selection based on tone and color by clicking or dragging with the tool to define the portion of the image that you wish to select. You can then keep clicking or dragging to add to a selection without needing to hold down the Shift key as you do so. You can then subtract from a quick selection by holding down the all key as you drag. What is clever about the Quick selection tool is that it remembers all the successive strokes that you make and this provides stability to the selection as you add more strokes. So, as you toggle between adding and subtracting, the quick selection temporarily stores these stroke instructions to help determine which pixels are to be selected and which are not. The Auto-Enhance option in the Options bar can help reduce any roughness in the selection boundary, as it automatically applies the same kind of edge refinement as you can achieve manually in the Select and Mask dialog using the Radius, Smooth, and Contrast sliders.

Sometimes you may find it helps if you make an initial selection and then apply a succession of subtractive strokes to define the areas you don't want to be included. You won't see anything happen as you apply these blocking strokes, but when you go on to select the rest of the object with the Quick selection tool, you should find that as you add to the selection, the blocking strokes you applied previously help prevent leakage outside the area you wish to select. In fact, you might find it useful to start by adding the blocking strokes first, before you add to a selection. This aspect of Quick selection tool behavior can help you select objects more successfully than is possible with the Magic wand. However, as you make successive additive strokes to add to a selection and then erase these areas from the selection, you'll have to work a lot harder going back and forth between adding and subtracting with the Quick selection tool. In these situations it can be a good idea to clear the quick selection memory by using the 'double Q trick.' If you press the Q key twice, this takes you from the selection mode to the Quick Mask mode and back to selection mode again. The stroke constraints will be gone and you can then add to or subtract from the selection more easily since you will have now cleared the quick selection memory.

Quick selection brush settings

The Quick selection tool brush settings are the same as for the other paint tools, except adjusting the brush hardness and spacing won't really have any impact on the way the Quick selection tool works. If you are using a pressure sensitive tablet it is worth checking that the Pen Pressure option is selected in the Brush options menu, as this allows you to use pen pressure to adjust the size of the Quick selection tool brush (see Figure 8.24).

Figure 8.24 This shows the Quick selection tool brush options.

V - V V Sample All Layers Auto-Enhance Select and Mask...

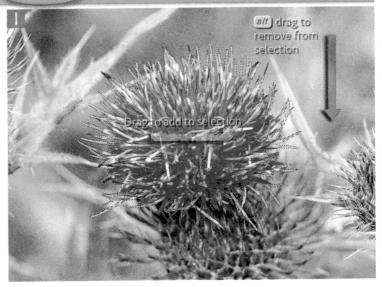

1 In this example, I selected the Quick selection tool, checked the Auto-Enhance edge option (circled), and dragged to make an initial selection of the flower. Then, with the key held down, I dragged around the outer perimeter of the flower to define the areas that were to be excluded from the selection. I then continued clicking and dragging to select more of the flower petals to fine-tune the selection edge.

2 This shows the above selection converted to a layer mask that hid the outer, unselected areas. The selection isn't perfect, which is where Select and Mask comes in. This combines the Quick selection tool with advanced mask refinement options.

Select and Mask

Select and Mask (Figure 8.25) can be accessed via the Select menu, by clicking on the Select and Mask button in the Properties panel, using **EXER** (Mac), *ctrl alt* **R** (PC), or double-clicking a layer mask. The first time you double-click a layer mask, Photoshop will ask if you wish this action to pop the Properties panel, or enter Select and Mask (see Figure 8.26). If a selection is active you can also hold down the Shift key as you choose Select => Select and Mask to open legacy Refine Edge dialog.

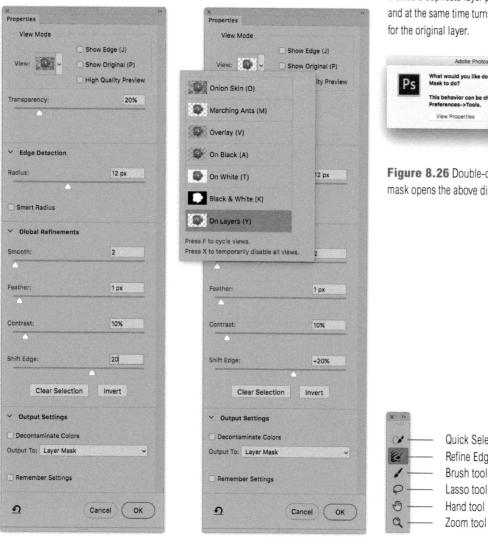

Select and Mask a one-way process

Unlike the Properties panel Masks mode controls, once a Select and Mask adjustment has been applied it is non-editable. If you think you might need to re-edit the Select and Mask settings you should select the New Layer with Layer Mask option from the Output To menu in the Select and Mask Advanced Output Settings section. This creates a duplicate layer plus layer mask, and at the same time turns off the visibility

Figure 8.25 The Properties panel showing the Properties panel Select and Mask options plus the Select and Mask Tools panel.

Select and Mask combines the Quick Selection tool plus former Refine Edge controls to create and/or modify selections or masks utilizing the Truer Edge[™] algorithm to allow complex outline masking.

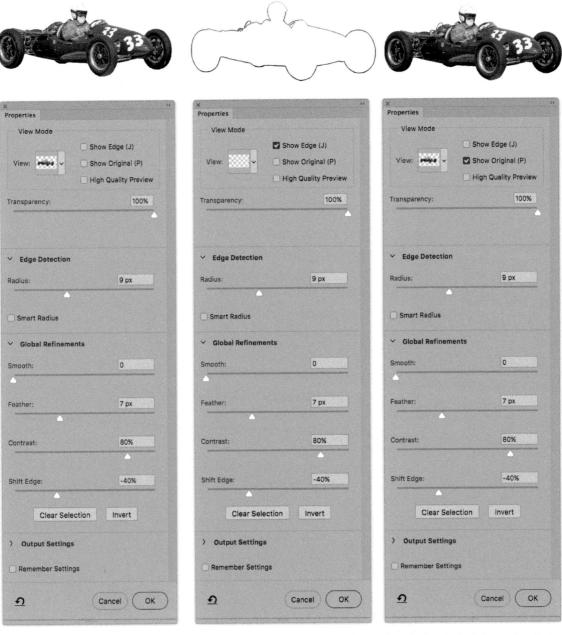

Figure 8.27 Examples of how the Show Edge and Show Original view modes affect the image appearance.

View modes

The initial Select and Mask view mode shows the targeted layer in Onion Skin mode (). This lets you use the Transparency slider to adjust the relative opacity of the masked layer relative to its unmasked state. The other view modes can be accessed from the pop-up menu shown in Figure 8.25. You'll also notice here the keyboard shortcuts these can be used to quickly switch between the different view modes.

In the View Mode section, the Show Edge option ()) displays the selection border where the edge refinement occurs, while Show Original ()) allows you to quickly display the image without a selection preview. Figure 8.27 shows examples of how the Show Edge and Show Original image view modes might appear. On the left you can see an image masked using the On White mask view mode. In the middle is a preview with the Select and Mask settings adjusted and the Show Edge ()) option checked. This displays the Select and Mask boundary only. On the right is a preview with the Show Original ()) option checked. This allows you to view the masked image and compare the original version against the Select and Mask masked version (left). When High Quality Preview is checked you will see a better quality preview as you mouse down working with the Refine Edge Brush tool. Disabling this option allows you to work faster.

Mask creation

The Select and Mask selection tools can then be used to create a selection (if the starting point is a layer mask, skip to the next section). The Quick selection tool () operates in the same way as the one in the main Tools panel. You can use this to create an automatic selection based on sampled tones and colors. Hold down the all key to subtract from the selection. You can also use the Brush tool () or Lasso tool () to add to a selection (hold down the all key to subtract) and use the () key to toggle between the normal Lasso and Polygonal lasso tool modes. The Clear Selection button at the bottom can be used to clear and start over. Or, you can use the Invert button to invert a selection or mask. Use the () key to toggle switching the mask mode on and off. This latest version has an improved algorithm that provides more accurate and realistic results when subtracting the foreground when the foreground and background color are visually similar.

Edge detection

The Edge Detection section lets you control how the Truer Edge™ algorithm processing is used to refine the edge boundaries. First, you need to adjust the Radius to whatever setting is appropriate for the type of image you are masking. If the edges to be masked are uniformly fine,

Transparency slider settings

The Overlay view mode transparency settings have been decoupled from "On White" and "On Black" view mode transparency settings. This means the Overlay view mode Transparency settings can now be set independently from the "On White" and "On Black" transparency settings.

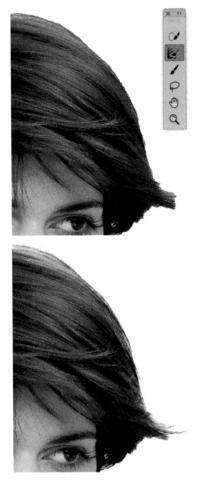

Figure 8.28 Here, the Refine Edge brush tool was used to manually edit a mask edge.

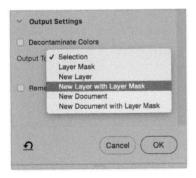

Figure 8.29 The Output To menu options in the Output Settings section.

sharp edges, then a low Radius setting will work best. For example, a Radius of 1 pixel would be suitable for a selection that contained a lot of fine edges such as a wire fence. If the edges you wish to mask are soft and fuzzy, then a wider Radius setting will work best. I suggest you aim to set the Radius here as wide as you can get away with. However, the Smart Radius option can often help improve the mask edge appearance. This is because it analyzes the border edges and automatically adjusts the Radius according to whether the border transition area has a hard or soft edge. With hair selections in particular, you'll find it helps if you check the Smart Radius option. This is usually the best starting point to produce the best hair mask.

The Refine Edge brush tool (\swarrow) can be used to refine the mask edges. Select the Refine Edge brush tool from the Select and Mask Tools panel and brush along the edges of the mask to detect fine edge detail. For example, Figure 8.28 shows how this tool was used to reveal fine strands of hair that were otherwise obscured by the original mask. You can set a narrow or wide Radius in Select and Mask and then paint using the Refine Edge brush tool to further refine the edges. Use the square bracket keys (**1**) to determine the optimum brush size to work with and for best results work close-up at a 100% view. Also, when working with the Refine Edge brush a softer edge radius is now obtained in the uncertain region. The softer border helps blend the results of the refined mask and the original mask.

The Refine Edge brush tool can do a good job of fine-tuning the edges of a mask, but can sometimes erase sections that should remain solid. The Brush tool can therefore be used to restore mask opacity by painting directly on the image (or erase by switching to erase mode).

Global Refinements

There are four sliders in the Global Refinements section. The Smooth slider is designed to smooth out jagged selection edges but without rounding off the corners. The Feather slider uniformly softens the edges of the selection and produces a soft edged transition between the selection area and the surrounding pixels, while the Contrast slider can be used to make soft edges crisper and remove artifacts along the edges of a selection (which are typically caused when using a high Radius setting). When compositing photographic elements you usually want the edges of a mask to maintain a certain degree of softness, so you don't necessarily want to apply too much contrast to a mask here. Some images may need high contrast edges, but you are usually better off relying on the Smart Radius option combined with the Refine Edge brush tool to refine such a selection/mask edge.

If you want to achieve a more aggressive smoothing you can combine adjusting the Feather and Contrast sliders. Simply increase the Feather slider to blur the mask and then increase the Contrast to obtain the desired edge sharpness.

The Shift Edge slider is like a choke control. It works on the mask a bit like the Maximum and Minimum filters in Photoshop. You can use this slider to adjust the size of the mask in both directions, making it shrink or expand till the mask fits correctly around the object you are masking. I usually find the Shift Edge slider is the most useful for adjusting the selection/mask shape. I follow this by using the Feather and Contrast sliders should I need to refine the mask further.

Output Settings

Lastly, we have the Output Settings section (see Figure 8.29). This can be used to determine how the masked image layer blends with the image layers below it. This step is crucial to making a successful mask. If the pixels around the outer edges of a mask (picked up from the original background) don't match those of the new background the masking won't look natural. Whenever you need to successfully blend a masked image layer with the other layers in a new image, check the Decontaminate Colors option to remove any of the last remaining background colors that were present in the original photo. This can improve the blend between the masked layer and the layer below (see Figure 8.30).

The Output Settings section lets you output the refined selection in a variety of ways, either as a modified selection, as a layer mask, as a new layer with transparent pixels, as a new layer with a layer mask, or as a new document: either with transparent pixels or with a layer mask.

You can click on the Remember Settings button at the bottom of the Select and Mask dialog to keep this as the new default setting. There is full support to record Select and Mask parameters in a Photoshop action, plus there is backward compatibility for actions that have been recorded using the previous Refine Edge feature.

Select and Mask performance

If Select and Mask appears to run slowly, check the Photoshop Performance preferences. If the Cache setting is low, try setting the Cache to 4 or higher. You need to bear in mind that Photoshop monitors the images you typically edit and auto-configures the Cache size in the Performance preferences to match your typical image editing usage (it does this after 5 launches since the last manual preferences configuration). If you have recently edited a lot of low resolution Web-sized images, Photoshop may have adjusted the preferences to set a low Cache setting. It's therefore worth checking the Performance preferences every now and then.

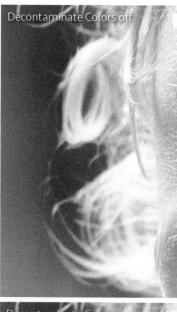

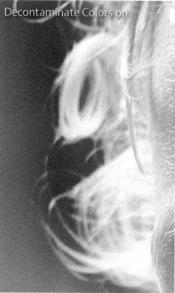

Figure 8.30 A close-up comparison between a Select and Mask-edited masked layer (top) and where the Decontaminate Colors option was switched on (below).

1 In this step I went to the Select menu and chose Select and Mask. This revealed the Properties panel and the associated Toolbar. To start with, I worked using the Onion Skin view mode. I selected the Quick selection tool and painted over the artist in the photograph to create an outline of him and the canvas below.

2 Working here in the Overlay view mode with red selected as the overlay color at 60% Opacity, I continued to edit the selection and was able to select more of the subject using the Quick selection tool.

3 Having defined the initial selection, I checked the Smart Radius option and switched to the On Layers view mode to check the outline of the hair. At the 10.0 pixel setting, Smart Radius did a fairly good job of smoothing the selection, but some of the fine loose hairs were hidden from view.

Show Edge (J)
Show Original (P)
High Quality Preview
10 px
ints
15

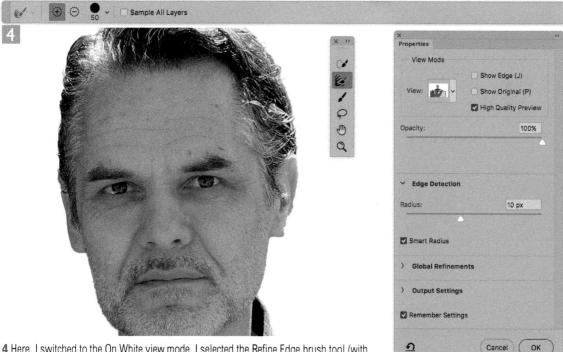

4 Here, I switched to the On White view mode. I selected the Refine Edge brush tool (with High Quality Preview checked) and painted around the head to reveal the missing strands of hair.

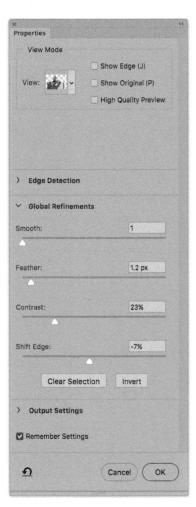

5 I then opened a separate photograph, which had been shot at the same time. I dragged the raw image from the Finder to place it as a smart object layer below the artist portrait layer and scaled it up in size.

6 In this step I selected the artist portrait layer and adjusted the Global Refinements settings. I set the Smooth slider to 1 to smooth out the jagged selection edges. I set the Feather to 1.2 pixels to make the selection edges uniformly smoother and set the Contrast to 23% to then make the softer edges appear crisper. I also set the Shift Edge slider to -7%, which shrunk the mask slightly.

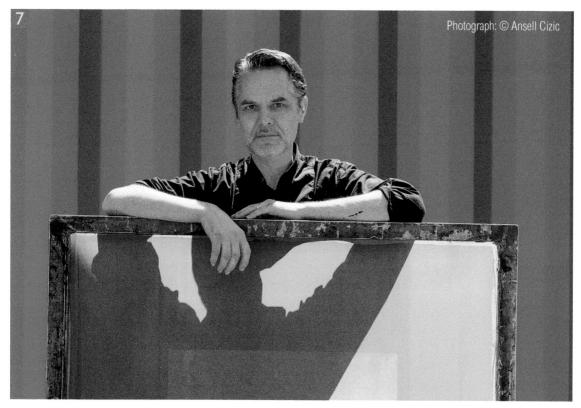

Properties	
View Mode	
	Show Edge (J)
View: 💉 🗸	Show Original (P)
	High Quality Preview
> Edge Detection	
> Global Refineme	ents
✓ Output Settings	
Decontaminate Co	
Output To: New Lay	
Output to: New Lay	er with Layer Mask 🔹 🗸
Remember Setting] 5
<u>•</u>	Cancel OK

Select and Mask is primarily designed as a tool for improving edge masks. However, it can also be used to create interesting raggededge borders that look similar to those one might produce using a darkroom printing technique.

The Select and Mask effect is achieved by using the Radius slider to create the ragged border. A wide Radius will usually work best with the Smart Radius option disabled. Basically, the rough edges you see are actually based on the image itself so it is the image content that determines the outcome of the Select and Mask adjustment. The Feather, Contrast, and Shift Edge adjustments can then be used to modify the main effect. In addition to this you can also select the Edge detection tool and carefully paint along sections of the edge to further modify the border and generally roughen it up a little more. Above all you have to be patient as you do this and apply small brush strokes a little at a time, but the results you get can be pretty interesting.

1 The first step was to make a copy of the background layer (using ∰) [Mac], [PC]) and fill the original background layer with a solid color, such as white. I then made a rectangular marquee selection, went to the Select menu and chose Modify ⇒ Smooth and applied an appropriate Sample Radius (in this case 50 pixels).

2 I then went to the Select menu and chose Select and Mask... (#* SR [Mac], ctr(alt R [PC]). The main controls I adjusted here were the Radius, to produce a wide border effect. The Contrast slider was used to 'crispen' the edges, Feather was used to smooth them slightly and a positive Shift Edge adjustment was used to expand the border edge. I also used the Refine Edge brush tool (circled) to manipulate some sections of the border to create a rougher border. In the Output To section I selected 'Layer Mask.' This automatically generated a pixel layer mask for the layer based on the current selection.

3 Here you can see an alternative border effect in which I again started with a smoothed marquee selection that was closer to the edges of the photo. This time I filled the Background color with black and used a 33 pixel Radius, a higher Contrast, and a softer Feather adjustment to create a tighter border edge. As in Step 2, I also applied a few Refine Edge brush strokes to roughen the edge slightly.

View Mode	
27.00000	Show Edge (J)
	Show Original (P)
1	High Quality Preview
Opacity:	100%
 Edge Detection 	
Radius:	50 px
	▲
Smart Radius	
 Global Refinements 	
Smooth:	0
-eather:	1 px
Contrast:	15%
	1378
Shift Edge:	+40%
Clear Selection	on invert
 Output Settings 	
Decontaminate Colors	
Dutput To: Layer Mask	¥
Remember Settings	

Focus Area

The Focus Area feature in the Select menu is a selection tool for making selections based on the sharpest point of focus. This can be useful for cutting out objects shot against an out-of-focus background.

When creating such a selection you have the option of overriding the Auto option and manually adjusting the In-Focus Range slider. This can help refine the selection. You can also click on the Focus Area add and Focus Area subtract tools to add to or remove from a focus area selection (just like you would when working with the Quick selection tool). The Focus Area selection will always have a hard edge, but this can be improved by checking the Soften Edge box at the bottom. You can also modify by clicking the Select and Mask... button where you can fine-tune the selection edges as desired.

If the In-Focus Range selection happens to include a lot of the out-of-focus background area this could be because the Focus Area selection is picking up noise. If this happens expand the Advanced options, deselect the auto option and gradually increase the Noise slider to see if this clears up the selection area. Basically, with higher ISO images you will need to increase the slider setting. However, sometimes when the Noise slider is set high, everything will be selected. So it is best to make small careful adjustments and if it's not looking right check the Auto option to reset to Auto mode again.

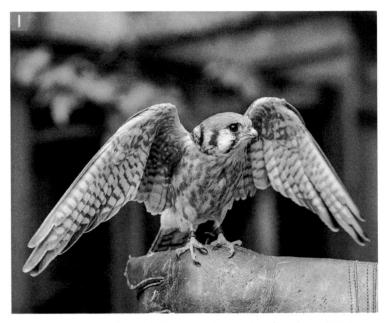

1 Here is a photograph of a kestrel photographed using a long focus lens, where the background was out of focus.

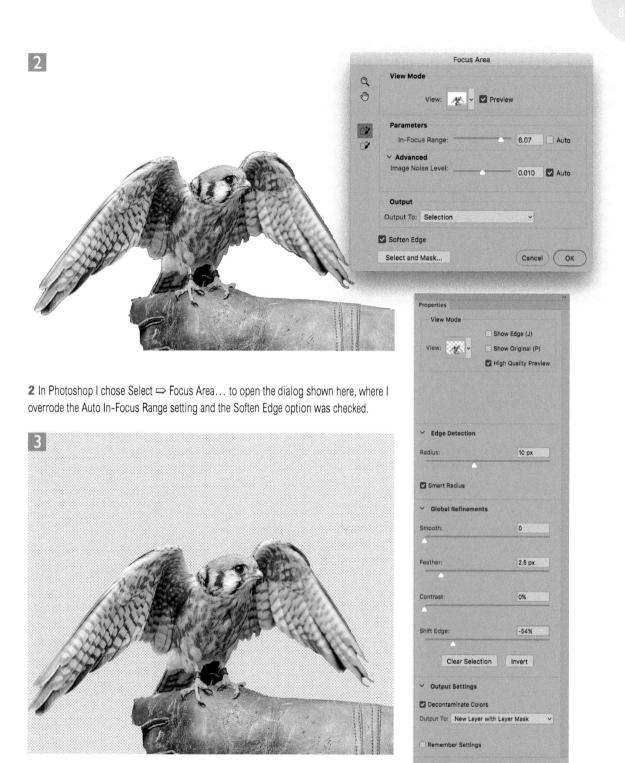

3 Finally, I clicked on the Select and Mask... button where I made further fine-tuned adjustments to the selection outline.

Cancel

(OK

<u>•</u>

1 This shows a photograph taken of a sailing ship mast against a deep blue sky. To start with, I went to the Select menu and chose 'Color Range...'

x (*)Layers (*)

Color Range masking

So far I have shown how to replace the background using the Quick selection tool, Select and Mask and the Focus Area feature. Let's now look at how to create a cut-out mask of a more tricky subject where the above methods would not be of so much use. Advanced users might be tempted to use channel calculations to make a mask. That can work, but there is a much simpler way. Color Range can also be considered an effective tool for creating mask selections that can be used when compositing images.

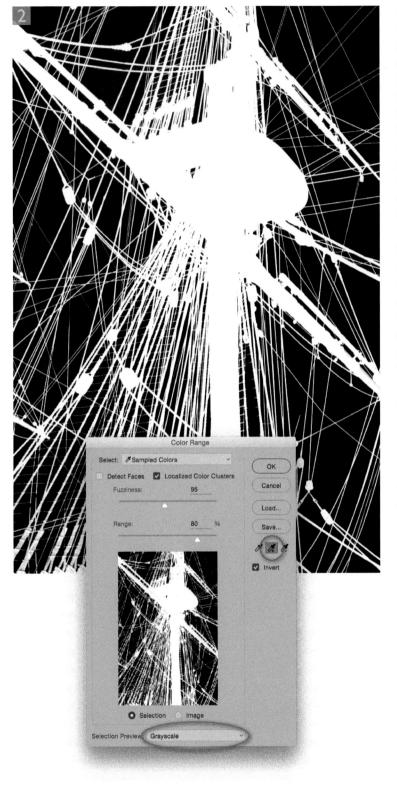

2 This opened the dialog shown below. With the standard eyedropper selected, I was able to simply click with the eyedropper anywhere in the image window to sample a color to mask with. In this instance I clicked in the blue sky areas to select the sky and checked the Invert box so I was able to create the inverted selection shown here. To create a more accurate selection, I checked the 'Localized Color Clusters' box and used the Plus eyedropper (circled in blue) to add to the Color Range selection.

You can click or drag inside the image to add more colors to the selection and also use the Minus eyedropper (or hold down the all key) to subtract from a selection. The Fuzziness slider increases or decreases the number of pixels that are selected based on how similar the pixels are in color to the already sampled pixels, while the Range slider determines which pixels are included based on how far in the distance they are from the already selected pixels. The Color Range preview is rather tiny, so you may find it helps to do what I did here, which was to select the Grayscale Selection Preview (circled in red) so I could view the edited mask selection in the fullsize image window.

3 Having made the selection I clicked on the 'Add layer mask' button in the Layers panel to convert the active selection to a layer mask, which masked the Ship mast layer. I then wanted to blend the masked image with a photograph of a cloudy sky. To do this I used the Move tool to drag the cloudy sky image to the ship mast image and placed it as a layer at the bottom of the layer stack. Shown here is the layered image with the cloud sky layer visible and the layer visibility for the masked Ship mast layer turned off.

4 This shows a 100% close-up view of the masked layer overlaying the sky layer with the Ship mast layer visibility switched back on. With the Ship mast layer mask targeted. I clicked on the Select and Mask... button in the Properties panel to open the Select and Mask dialog.

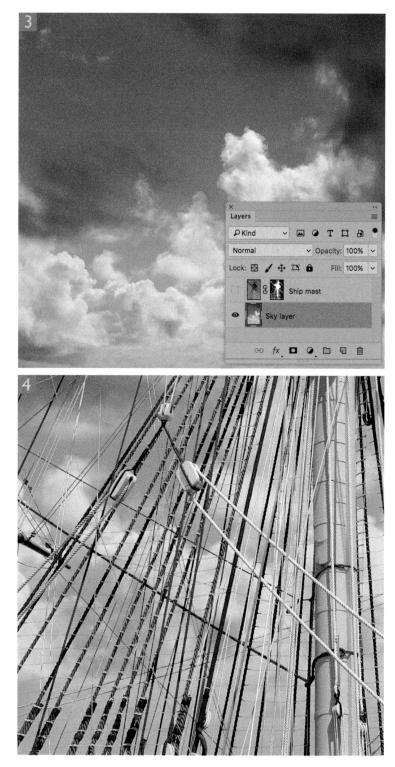

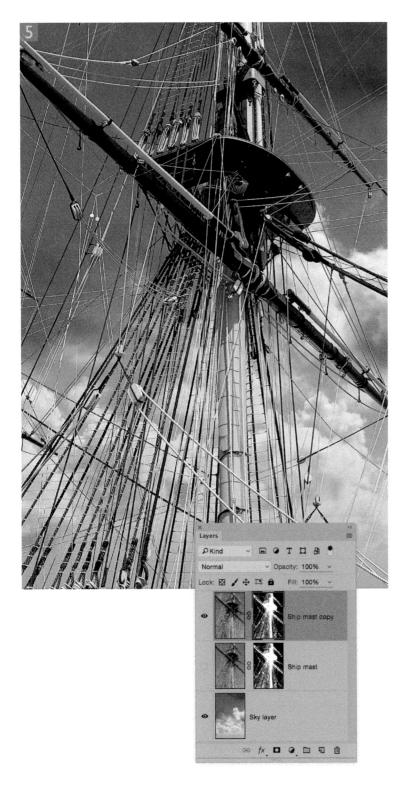

5 This shows the finished composite image, in which I used the Select and Mask controls to fine-tune the mask edges. Here, I selected the 'On Layers' view mode. I was then able to preview the Select and Mask adjustments on a layer mask that actively masked the Ship mast layer. I didn't have to do too much here. I applied a Feather of 0.5 pixels and contracted the mask by -15%. I checked the Decontaminate Colors option, selected New Layer with Layer Mask from the Output To menu and clicked OK.

View Mode	
	Show Edge (J)
View: 😿 🗸	Show Original (P)
	High Quality Preview
Opacity:	100%
for an and the second se	
Edge Detection	
Global Refineme	nts
mooth:	0
eather:	0.05 px
Contrast:	0%
Shift Edge:	-15%
Clear Sele	ction Invert
 Output Settings 	
Decontaminate Co	
Dutput To: New Lay	
Remember Setting	JS
Ð	Cancel OK

Lavers

p Kind

Normal

Lock: 🕅

+++

GO fx.

: . O T I & .

Layer 1

Background

00.0

\$ Opacity: 100% *

Fill: 100% -

8

0 4

The layer blending modes allow you to control how the contents of a layer will blend with the layer or layers immediately below it. The Layer blend modes can be adjusted via the Layers panel. These same blend modes can also be used to control how the paint and fill tools interact with an image (you can also alter the blend modes in Photoshop and the results you get when blending together the two images in Figure 8.31.

values of the composite pixels below (the opacity was set here to 80%).

PKin

Layers Q Kind

Dissol

Dissolve

This combines the blend layer with the base using a randomized pattern of pixels. No change occurs when the Dissolve blend mode is applied at 100% opacity, but as the opacity is reduced, the diffusion becomes more apparent (the opacity was set here to 80%). The dissolve pattern is random, which is reset each time the application launches. There is actually a good example of the Dissolve blend mode in use on page 635.

Disso

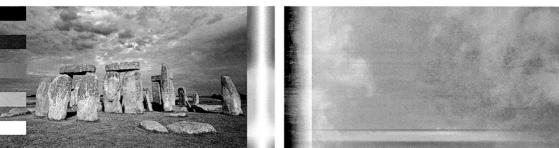

Darken

The Darken mode looks at the base and blending pixel values and pixels are only applied if the blend pixel color is darker than the base pixel color value.

× Layers PKind

Darken

Layers PKind

Multiply

× Layers PKind

Layers PKind

Lavers PKind

Darker Color

Linear Burn

Color Burn

Multiply multiplies the base by the blend pixel values, always producing a darker color, except where the blend color is white. The effect is similar to viewing two transparency slides sandwiched together on a lightbox.

Color Burn

This darkens the image using the blend color. The darker the color, the more pronounced the effect. Blending with white has no effect.

Linear	Burn
--------	------

The Linear Burn mode produces an even more pronounced darkening effect than Multiply or Color Burn. Note that the Linear Burn blending mode clips the darker pixel values and blending with white has no effect.

Darker Color

Darker Color is similar to the Darken mode, except it works on all the channels instead of on a per-channel basis. When you blend two layers together only the darker pixels on the blend layer remain visible.

TI A

Oni

11

100%

R п T

100%

ТП A

city: 100%

п

Burner and	Multiplies the inverse of the ble
a second	make a lighter color, except whe
a seat of the second second	to printing with two pogetives of

This mode looks at the base and blending colors and color is only applied if the blend color is lighter than the base color.

Lavers PKind

Lighten

Screen

end and base pixel values together to always ere the blend color is black. The effect is similar to printing with two negatives sandwiched together in the enlarger.

> × Layers PKind

Layers PKind

Layers Rind

Lighter Colo

11 A

Linear Dodge (Add)

Color Dodge

Color Dodge

Color Dodge brightens the image using the blend color. The brighter the color, the more pronounced the result. Blending with black has no effect (the opacity was set here to 80%).

Linear Dodge (Add)

This blending mode does the opposite of the Linear Burn tool. It produces a stronger lightening effect than Screen or Lighten, but clips the lighter pixel values. Blending with black has no effect.

Lighter Color

Lighter Color is similar to the Lighten mode, except it works on all the channels instead of on a per-channel basis. When you blend two layers together only the lighter pixels on the blend layer will remain visible.

т

1005

Overlay

The Overlay blending mode superimposes the blend image on the base (multiplying or screening the colors depending on the base color) while preserving the highlights and shadows of the base color. Blending with 50% gray has no effect.

> Layers PKind

Soft Light

Layers QKind

Hard Light

PKind

× Lavers PKind

Linear Light

Soft Light

This darkens or lightens the colors depending on the base color. Soft Light produces a more gentle effect than the Overlay mode. Blending with 50% gray has no effect.

Hard Light

Hard Light multiplies or screens the colors depending on the base color. Hard Light produces a more pronounced effect than the Overlay mode. Blending with 50% gray has no effect.

Vivid Light

This applies a Color Dodge or Color Burn blending mode, depending on the base color. Vivid Light produces a stronger effect than Hard Light mode. Blending with 50% gray has no effect.

Linear Light

Linear Light applies a Linear Dodge or Linear Burn blending mode, depending on the base color. Linear Light produces a slightly stronger effect than the Vivid Light mode. Blending with 50% gray has no effect.

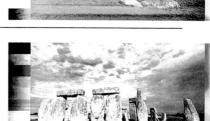

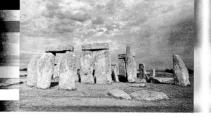

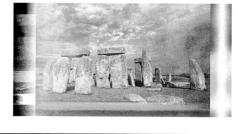

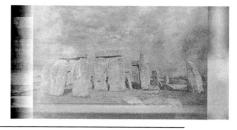

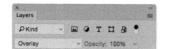

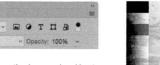

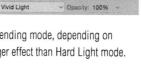

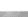

Pin Light

This applies a Lighten blend mode to the lighter colors and a Darken blend mode to the darker colors. Pin Light produces a stronger effect than Soft Light mode. Blending with 50% gray has no effect.

Lavers

Laver

QKing

Hard Mix

Layers

PKind

Difference

PKind Exclusion

Laver

PKind

Subtract

Hard Mix

Hard Mix produces a posterized image consisting of up to eight colors: red, green, blue, cyan, magenta, yellow, black, and white. The blend color is a product of the base color and the luminosity of the blend layer.

Difference

This subtracts either the base color from the blending color or the blending color from the base, depending on whichever has the highest brightness value. In visual terms, a 100% white blend value inverts the base layer completely (i.e., turns to a negative). A black value has no effect and values in between partially invert the base layer. Duplicating a Background layer and applying Difference at 100% produces a black image. Difference is often used to detect differences between two layers in exact register.

Exclusion

The Exclusion mode is a slightly muted variant of Difference. Blending with white inverts the base image.

Subtract

This simply subtracts the pixel values of the target layer from the base layer. Where the result ends up being a negative value it is displayed as black.

n A

n A т

п

Divide

Hue

This example doesn't really show you anything useful, but the Divide blend mode does have useful applications such as when carrying out a flat field calibration (see the website for more on how this blend mode can be used).

This preserves the luminance and saturation of the base image, replacing the hue color with the hue of the blending pixels.

Saturation

Saturation preserves the luminance and hue values of the base image, replacing the saturation values with the saturation of the blending pixels.

Color

Color preserves the luminance values of the base image, replacing the hue and saturation values of the blending pixels. Color mode is particularly suited to hand-coloring photographs.

Luminosity

This mode preserves the hue and saturation of the base image while applying the luminance of the blending pixels.

Auto

In most cases it is best to use the Auto option first to see what it does before considering the alternative layout options. Auto very often produces the best results.

Perspective

The Perspective layout can produce good results when the processed photos are shot using a moderate wide angle lens or longer, but otherwise produces rather distorted, exaggerated composites.

Cylindrical

The Cylindrical layout ensures photos are aligned correctly to the horizontal axis. This is useful for keeping the horizon line straight when processing a series of photos that make up an elongated panorama.

Spherical

This can transform and warp the individual photos in both horizontal and vertical directions. This layout option is more suitable when aligning multiple row panoramic image sequences.

Collage

This positions the photos in a Photomerge layout without transforming the individual layers, but does rotate them to achieve the best fit.

Reposition

The Reposition layout simply repositions the photos in the Photomerge layout, without rotating or transforming them.

Creating panoramas with Photomerge

The Photomerge feature can be used to stitch individual photos together to build a panorama image. There are two ways you can do this. You can go to the File \Rightarrow Automate menu in Photoshop and choose Photomerge... This opens the dialog shown in Step 2, where you can click on the Browse... button to select individual files to process. If you have images already open in Photoshop, then click on the 'Add Open Files' button to add these as the source files. Alternatively, you can use Bridge to navigate to the photos you wish to process and open Photomerge via the Tools \Rightarrow Photoshop submenu. Actually, there is now also a third way, which is to use the Photo Merge feature in Camera Raw. This is covered in the next section.

To get the best Photomerge results, there needs to be a significant overlap between each exposure. You should typically aim for at least a 25% overlap between each image, or more if you are using a wide angle lens. Photomerge is even optimized to work with fisheye lenses, providing Photoshop can access the lens profile data (see page 642), but with wide angle/fisheye lenses you should aim for maybe as much as a 70% overlap between each image. In the majority of cases the Auto layout option is all you will need to get a good-looking panorama.

When preparing images for stitching with Photomerge, it does not necessarily matter whether lens profile corrections have been applied in Camera Raw or not. However, Photomerge may do a better job if a good profile lens correction has been applied beforehand.

1 To create a Photomerge image, I started by selecting the three photographs shown here in Bridge. I then went to the Tools menu in Bridge and chose Photoshop \Rightarrow Photomerge...

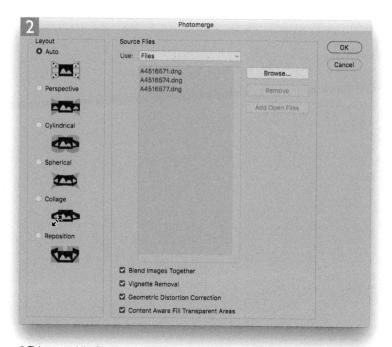

2 This opened the Photomerge dialog, where you'll note that the selected images were automatically added as source files. Here, I selected the 'Auto' layout option; I checked the four options at the bottom and clicked OK to proceed.

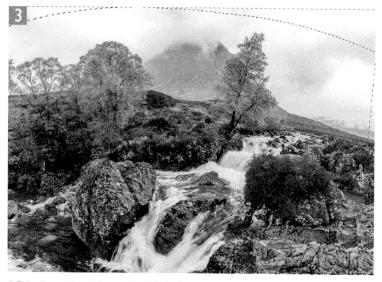

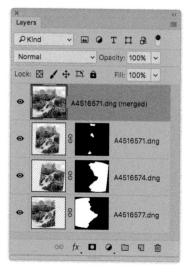

3 This aligned the photos and included a blend step to blend the tones and colors between the layers, followed by an auto layer mask step in which the individual layers ended up being masked so that each part of the Photomerge image consisted of no more than one visible layer. Selecting Content-Aware Fill Transparent Areas in the Photomerge dialog added a merged layer with the outer edges filled using a Content-Aware fill.

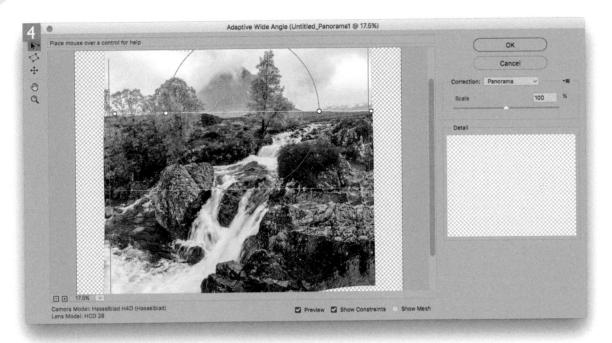

4 I merged the layers in Step 3 and applied the Adaptive Wide Angle filter. While some have thought of this filter as being specially for architectural photography, it also happens to be very useful when used on panorama landscape images. Sometimes the constrain area tool may be all you need. With this image I found it best to apply multiple constraint lines. For more about working with this filter, see page 644.

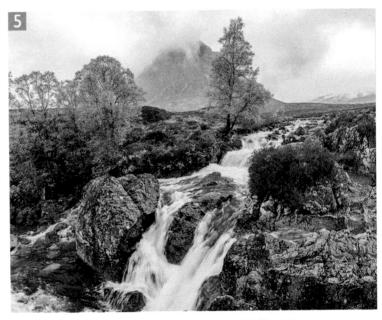

5 This shows the processed image, which I then cropped in Photoshop.

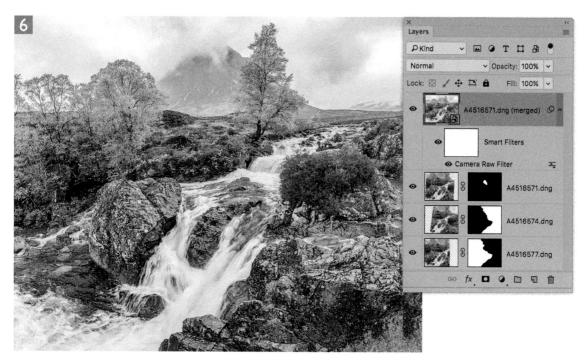

6 You may have noticed that the composite image in the preceding steps looked rather dark. This was deliberate. You see, the Photomerge command does end up recalculating the brightness levels across the whole of the composite panorama area. In doing so this can cause the end points to become clipped, even though the end points may not have been clipped in the original source layers. To prevent this it is a good idea to compress the tone range in the images you are about to process so you have a safe margin of clipping. To create the final version shown here, I converted the top layer to a Smart Object and applied some Camera Raw filter adjustments.

Blending options

The 'Blend Images Together' option completes the Photomerge processing because it adds layer masks to each of the Photomerged layers (see the Layers panel view in step 3). You can always choose not to run this option and select the Edit Auto-Blend Layers option later to achieve the same end result (see page 547). 'Vignette Removal' and 'Geometric Distortion Correction' are optional and can help improve the result of the final image blending, especially if you are merging photos that were shot using a wide-angle lens. When the Geometric Distortion Correction checkbox is enabled, Photomerge aims to create a better stitch result by directly estimating the lens distortion in the individual image layers. Photomerge does not need to reference the lens profile information except when it comes to handling fisheye lens photos.

Photomerge vs. Photo Merge

The Photoshop method is referred to as a Photomerge, while the Camera Raw process is referred to as a Photo Merge. This is a subtle distinction that helps differentiate between the two different methods.

Panorama Photo Merges in Camera Raw

The Photo Merge feature in Camera Raw allows you to process multiple selections of images to create either a panorama stitch or an HDR image. Photo Merge saves these as demosaiced DNGs and as raw linear RGB data. The resulting images are only partially processed, so you still retain the ability to apply Camera Raw edits and update to later process versions as they become available.

Essentially, you can merge raw files to create an unprocessed master, which will allow you to fine-tune the settings at the post-Photo Merge stage, adjusting things like the white balance and endpoint clipping. This can be particularly helpful when using the Photo Merge feature in the Panorama mode. As I mentioned on the previous page, conventional Photoshop Photomerge processing has a tendency to cause the highlight values to clip. You might carefully set the highlight end points at the pre-Photomerge stage only to find them clipped in the resulting Photomerge composite. The Camera Raw Photo Merge method means you avoid this problem and maintain full control over the tones and avoid undesired clipping.

Creating Photo Merge panoramas

To create a Photo Merge panorama you need to open in Camera Raw a series of images that are to be stitched together to form a panoramic view and then choose Select All, followed by Merge to Panorama... You will then be taken to a Panorama Merge Preview dialog, where you can select the desired projection method and click Merge. Initially, you'll see a fast preview. Whenever you change any of the merge options, a yellow warning icon may appear in the top right corner. This will go away as a higher quality preview is built. When carrying out a Photo Merge panorama the existing develop settings are applied as the initial develop settings to the resulting DNG panorama. However, you can quite easily apply any custom settings you like. Lens warp, vignette, and chromatic aberration are applied to the images before stitching although settings that are not meaningful to the Photo Merge panorama process (such as local corrections and lens profiles) are ignored. The full-size merge is performed in the background so you can continue to edit other photos or queue up other merges while you wait.

The panorama projection options

There are three Projection options in the Panorama Merge dialog (see Figure 8.32). The Cylindrical mode ensures the photos are correctly aligned to the horizontal axis. This mode is appropriate when merging photographs that make up a super-wide panorama, as it ensures the horizon line is kept as straight as possible. The Perspective mode can produce good results when processing a sequence of images that capture a relatively small angle of view. Crucially, it preserves straight edges, which can then be corrected using the Transform controls. For this reason the Perspective projection method is the best one to choose for processing architectural subjects. The Spherical mode transforms the photos both horizontally and vertically. This mode is more adaptable when it comes to aligning tricky panoramic sequences. For example, if you shoot a sequence of images that consists of two or more rows of images, the Spherical projection mode may produce better results than the Cylindrical method.

Figure 8.32 The Camera Raw Photo Merge Panorama projection options.

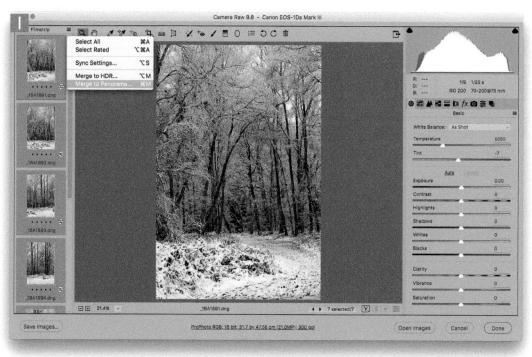

1 To begin with, I selected seven photographs that had been shot in raw mode and photographed in a panorama sequence. I opened these in Camera Raw, chose Select All, and then selected Merge to Panorama... (**H** M [Mac], *ctrl* M [PC]) from the Filmstrip menu. You can also hold down the *Shift* key as you do this, or use the **H** *Shift* M (Mac), *ctrl Shift* M (PC) shortcut to bypass the Panorama Merge Preview dialog shown in Step 2, and open in Headless mode.

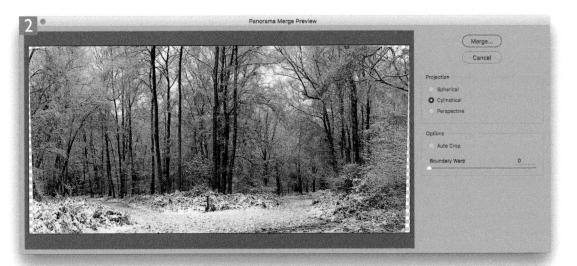

2 This prompted Camera Raw to analyze the raw image data of the selected files and generate a preview in the Panorama Merge Preview dialog shown here. This gave me the option to select the most appropriate projection method. In this instance I reckoned the Cylindrical option would produce the best result. I decided to leave the Auto Crop box unchecked. If any source images happen to be unused in the resulting panorama, you'll see a warning message.

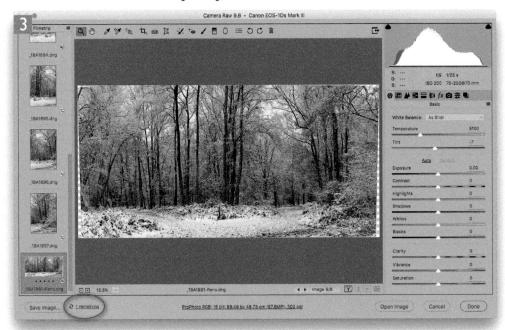

3 Having configured the settings in the Panorama Merge dialog, I clicked the Merge button. This initiated the Photo Merge process (to view status or cancel a merge, click on the link in the lower left area of the Camera Raw dialog [circled]).

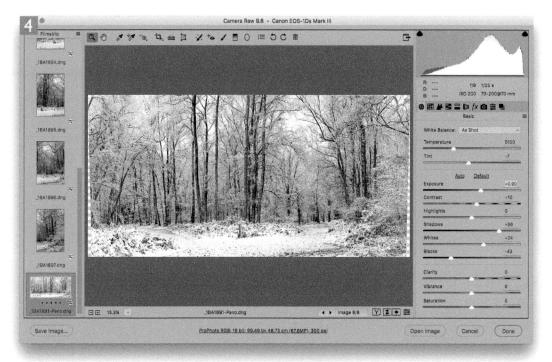

4 Shown here is the fully processed panorama merge. This composite retained the Camera Raw settings that were applied to the original, most selected image.

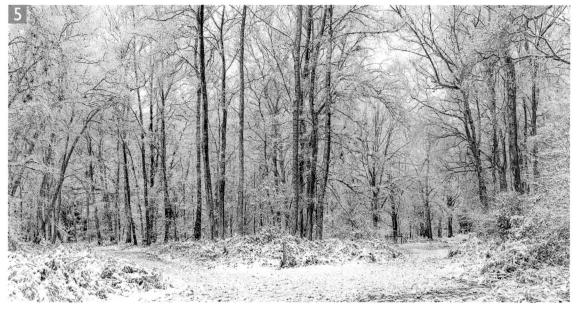

5 I was then able to crop the composite and further edit the Camera Raw settings to produce the modified version shown here.

Photo Merge Boundary Warp

In most instances you will find that the panorama preview will be an irregular shape. It can help to try using different projection methods, but ultimately you have to choose to either crop the image, use a content-aware fill to fill the outer edges, or warp the image. The Boundary Warp slider can be used to warp the shape of the panorama stitched image so that the boundary of the Photo Merge image fills to the edges of the canvas. You can look at this as a way of 'unwrapping' the image to make the most of the available image content and avoid having to crop.

The effectiveness of this approach is dependent on the type of subject. It works best on landscape subjects, such as the example shown opposite. It won't work well with photographs taken of buildings, or where the horizon line is visible and is likely to become bent. It is also dependent on the amount of distortion that's induced as a result of a Boundary Warp adjustment. This is why the Boundary Warp feature is offered as a slider, so you have complete control over the amount of warp adjustment you apply.

Panorama Photo Merges and the Adaptive Wide Angle filter

Camera Raw-generated panoramas now contain the metadata that allows them to be processed via Adaptive Wide Angle filter. This means you now have the option to take panorama DNGs that have been generated using the Panorama Photo Merge feature, save them as a TIFF variant and open them in Photoshop to apply the Adaptive Wide Angle filter.

The constraint lines you apply via the Adaptive Wide Angle filter are able to access the required metadata information that allows you to align the constraints to the straight edges in a photograph. The lens profile metadata in a Boundary warp image that's made accessible to the Adaptive Wide Angle filter won't necessarily be strictly correct. Nevertheless, having this metadata present does enable the Adaptive Wide Angle filter to work better with it than without.

Panorama Merge Preview	
	Merge Cancel Projection © Spherical
	Cylindrical Perspective Options Auto Crop
	Boundary Warp 0

1 This shows the Panorama Merge Preview dialog for a composite stitch created from three raw images. In this instance the Boundary Warp slider was left set at zero.

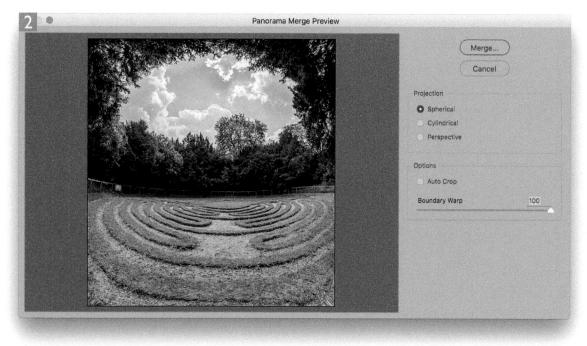

2 In this step I set the Boundary Warp to 100, which warped the image such that the boundary filled to the edges of the frame.

Applying Photoshop filters

All of the Photoshop painting tools and filters will work on the document window view area only. If you wish to run a filter on the entire panorama, you need to first open up the source panorama.

Editing spherical panoramas in Photoshop

It is possible to use Photomerge in Photoshop, or better still PTGui, to create spherical panoramas. However, one major problem with editing these kinds of image is the curved lines. A more intuitive way to do the editing is to put the image into a panoramic view mode and edit the image within that viewer environment. To do this, open a prepared spherical panorama image like the one below in Photoshop and choose $3D \Rightarrow$ Spherical Panorama \Rightarrow New Panorama Layer From Selected Layer. With the Move tool selected, you can click and drag to look around inside the panorama. You can also adjust the Field of View via the Properties Panel. Essentially, this allows you to place a virtual camera within the 3D view and choose a desired angle of view.

In the default Texture mode you can work fairly quickly. To match the perspective of the scene, select the Projection Paint System mode. For example, if working with the Clone Stamp tool you will want to select Projection so that the source and target align correctly. Painting can be particularly difficult at the North and South pole. Depending on the resolution of the document and the panorama itself, you may experience artifacts when painting in those areas. To help get around this, create an empty new layer above the panorama layer, select the Brush tool and work on the image. Before you move the camera again, first select Merge Down from the Layers Panel menu or use **(H)** (Mac), **ett (**PC).

To output a flat perspective image based on the current document window view, first select Layer \Rightarrow Flatten Image.

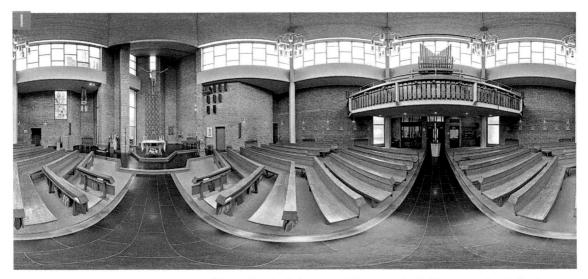

1 I opened a spherical panorama Photomerge that had been merged and edited in Photoshop to create a 360° wraparound image.

2 In Photoshop I went to the 3D menu and chose Spherical Panorama

→ New Panorama Layer from Selected layer. I was now able to view and inspect the spherical panorama in a flat perspective.

3 In the Properties panel I adjusted the Field of View (FOV) setting to that of an 8 mm lens camera angle. I was able to use the Move tool to move around the scene, but also use the widgets (circled) to navigate the scene.

4 I selected the Clone Stamp tool to edit the photo and remove the fire extinguisher in the bottom right corner. In the Properties panel I selected Projection from the Paint System menu. This ensured the Clone Stamp editing matched the perspective of the current view.

× « Properties
3D Camera
View: Custom View 2
Perspective D Orthographic
FOV: 8 v mm lens v
Depth Of Field
Distance: V Depth: V
Stereo
Stereo View:
x « Layers
₽Kind ~ ■ @ T 🛱 🖗 •
Normal
Lock: 🖾 🖌 🕂 🏛 🔒 🛛 Fill: 100% 🗸
Layer 1 Layer 1 Textures Diffuse SphericalMap fx C fx fx
X « Properties
Texture
Paint System: V Projection
Paint On: Diffuse
Paint Falloff
Min: 90° × Max: 90° ×
Select Paintable Area
Render Settings

Depth of field blending

ms. 1 hidder

The Edit \Rightarrow Auto-Blend Layers command allows you to blend objects that were shot using different points of focus and blend them to produce a single image with optimal focus.

be Bride

1 I began by going to Bridge and selected a group of photographs to process. These were photographed at a fixed aperture and with the camera mounted on a tripod and shot at different points of focus. I went to the Tools menu and chose Photoshop ⇒ Load Files Into Photoshop Layers.

2 This opened the four selected photos as a multi-layered image in Photoshop. With all the layers selected, I went to the Edit menu, chose 'Auto-Align Layers...' and selected the Auto projection option. This aligned the layers as shown here, where each layer was focused on a point within the scene. The closest focus image was at the top of the layer stack.

7541 dn

3 The next step was to merge the layered photos. I did this by going to the Edit menu again and selected 'Auto-Blend layers...' I selected 'Stack Images' and made sure the 'Seamless Tones and Colors' option was checked. Checking 'Content Aware Fill Transparent Areas' also ensured the outer edges were filled as I did so.

4 To get the best results it is important to carry out the Auto-Align step before you apply the Auto-Blend. As you can see, this last step carried out a pixel blending of the individual layers and added layer masks to each based on a calculation made of where the sharpest detail was on each layer. The success of this depth of field blending technique is also down to the care with which you shoot the original photographs. The more pictures you shoot, bracketed at different focal distances, the better the end result will be.

Figure 8.33 To color code a layer or layer selection, use a right mouse-click on a layer to access the contextual menu.

Working with multiple layers

Layers have become an essential feature in Photoshop, allowing complex montage work to be carried out. But as the layers features have evolved there has been the need to manage them more efficiently.

Color coding layers

One way to manage layers better is to color code them. This can be done by selecting a layer (or layers) and using the contextual menu shown in Figure 8.33 to pick the desired color label to color code the layer (the contextual menu varies depending on whether you click the layer thumbnail or just the layer).

Layer group management

Multi-layered images can be unwieldy to navigate, especially when you have lots of layers in an image. They can therefore be organized more efficiently if you place them into groups. Layer groups have a folder icon and the general idea is you can place related layers together inside a single layer group and the layer group can then be collapsed or expanded (the layer group icon reflects this). Therefore, if you have lots of layers in an image, layer groups can make it easier to organize the layers and layer navigation is made simpler.

To create a layer group, click on the 'Create a new group' button in the Layers panel. This adds a new layer group above the current target layer. **(Mac)**, *Clif* (PC)-clicking on the same button adds a layer group below the target layer.

To create a layer group from a layer selection, select the layers you wish to add to a new group and click on the 'Create a new group' button. You can also choose Layer \Rightarrow Group Layers. Or, simply select the layers in the Layers panel and use **H** G (Mac), *ctrl* G (PC). To see the interim New Group from Layers dialog, choose Layer \Rightarrow New \Rightarrow Group from Layers..., or *alt*-click the Create a new group button.

In Figure 8.34, I used a *Shift*-click to select the three retouching layers near the bottom of the layer stack. I then went to the Layers panel fly-out menu and chose 'New Group from Layers...' I named the new group 'Retouching work' and selected a red color to color code the layers within this group. Once I had done this, the visibility of all layers within the group could be switched on or off via the layer group eyeball icon and the opacity of the group could be adjusted as if all the layers in the group were a single merged layer.

Figure 8.34 When a Photoshop document ends up with this many layers, the layer stack can become difficult to manage, but it is possible to organize layers within layer groups.

The layer group visibility can be toggled by clicking on the layer group eye icon. It is possible as well to adjust the opacity and blending mode of a layer group as if it were a single layer, while the subset of layers within the layer group itself can have individually set opacities and use different blending modes. You can also add a layer mask or vector mask to a layer group and use this to mask the layer group visibility, as you would with individual layers. To reposition a layer in a layer group, click on the layer and drag it up or down within the layer stack. To move a layer into a layer group, drag it to the layer group icon or drag to an expanded layer group. To remove a layer from a layer group, just drag the layer above or below the group in the stack (see page 550). You can lock all layers inside a layer group via the Layers panel fly-out submenu.

Collapse all layers

The Layers panel menu has a 'Collapse All Groups' menu item. You can use this to collapse all layer groups in a layered image document.

Managing layers in a group

The following steps show in more detail how layer groups and the layer group contents can be managed.

1 Layers can be moved into a layer group by mousing down on a layer and dragging the layer into the desired layer group.

2 The same method can be used when you want to move a layer group to within another layer group. Mouse down and drag the group to another layer group.

4 To remove a layer or layer group from a group, just drag it out of the layer group until you see a bold line appear on the divider above or below the layer group.

3 You can move multiple layers at once. Make a *Shift* select, or **H** (Mac), *ctrl* (PC) layer selection of the layers you want to move and then drag them to the layer group.

5 Here is a view of the Layers panel with the 'Retouching adjustments' group now outside and above the 'Master retouching' layer group.

Clipping masks

Clipping masks can be used to mask the contents of a layer based on the transparency and/or opacity of the layer or layer group beneath it. So, if you have two or more layers that need to be masked identically, one way to do this is to apply a layer mask to the first layer and then use this to create a clipping mask for the layer or layers above. Once a clipping mask has been applied, the upper layer or layers will appear indented in the Layers panel. For example, in Figure 8.35 the Gradient Fill layer forms a clipping mask with the masked image layer below it. You can alter the blend mode and opacity of the individual layers in a clipping group, but it is the transparency and opacity of the lower (masked) layer that determines the transparency and opacity of all the layers in the clipping mask group.

The main advantage of using clipping masks is that whenever you have a number of layers that are required to share the same mask, you only need to apply a mask to the bottom-most layer. Then when you create a clipping mask, the layer (or layers) in the clipping mask group will all be linked to this same mask. So for example, if you edit the master mask, the mask edit changes you make are simultaneously applied to the layer (or layers) above it.

How to create a clipping mask

To create a clipping mask, select a single layer or make a *Shift* selection of the layers you want to group together and choose Layer \Rightarrow Clipping Mask \Rightarrow Create. Alternatively, *alt*-click the border line between the layers. This action toggles creating and releasing the layers from a clipping mask group. You can use the **H C** (Mac), *ctrl alt* **G** (PC) keyboard shortcut to make the selected layer or layers form a clipping mask with the layer below. Or, whenever you add an adjustment layer you can create a clipping mask with the layer below by clicking on the Clipping Mask button in the Properties panel. This allows you to toggle quickly between a clipping mask and non-clipping state (see Figure 8.36).

You can also create clipping masks at the same time as you add a new layer. In the example that's shown on the next few pages, you can see how I *alt*-clicked the 'Add New Adjustment Layer' button, which opened the New Layer dialog. This allowed me to check the 'Use Previous Layer to Create Clipping Mask' option (the same thing applies when you *alt*-click the 'Add New Layer' button).

Figure 8.35 An example of a clipping mask formed by the Gradient Fill layer.

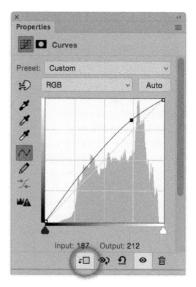

Figure 8.36 This shows the Clipping Mask button in the Properties panel.

Adding an adjustment layer as a clipping mask

The following steps show how I was able to create a clipping mask between a Hue/Saturation adjustment layer and a regular layer below.

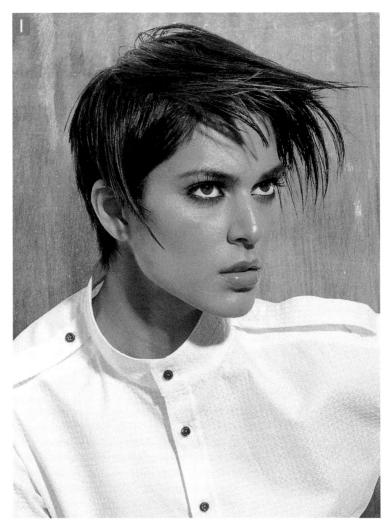

1 This shows a composite image in which I had carried out most of the retouching on the face and added a layer containing a masked canvas backdrop image. In this instance, the mask allowed the model image layer and retouching layers to show through from below.

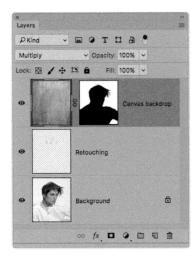

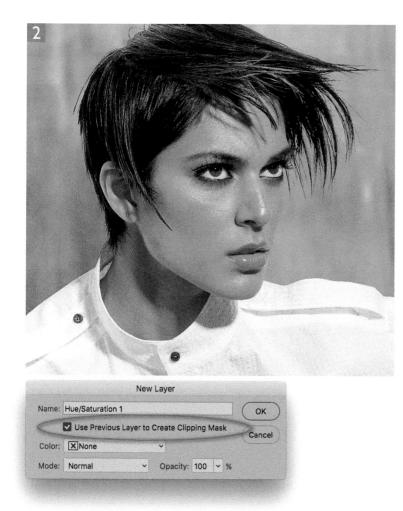

2 I held down the *att* key as I clicked on the 'Add New Adjustment Layer' button (circled in the Layers panel) to add a new Hue/Saturation adjustment layer to mute the backdrop color. This opened the New Layer dialog shown above, where I checked 'Use Previous Layer to Create Clipping Mask.' This created a clipping mask with the canvas backdrop layer. The Hue/Saturation adjustment was therefore masked by the layer mask below.

Masking layers within a group

I use clipping masks quite a lot, but there is also another way that you can achieve the same kind of result and that is to make a selection of two or more layers and place them into a masked layer group (choose Layer \Rightarrow Group Layers). With the layer group selected, click on the Add Layer Mask button in the Layers panel to add a layer mask to the group. As you edit the layer mask for the layer group, you can simultaneously mask all the layer group contents.

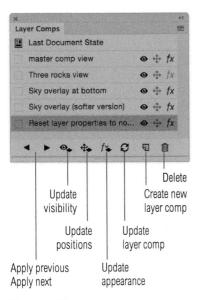

Layer Comps panel

As you work on a layered file you may find yourself not being sure which combination of layer settings looks best, or you may wish to incorporate different treatments within the one image document. In these kinds of situations the Layer Comps panel (Figure 8.37) can prove useful, because among other things, you can use it to store saved layer settings. This means you can experiment using different combinations of layer options and save these as individual layer comps. It is a bit like having the ability to save snapshots, except unlike history snapshots, layer comps are saved permanently with the file. You can save the current layer settings using the following criteria: you can choose whether to include the current layer visibility, the current position of the layer contents and, lastly, the current Layer Style settings, such as the blend mode, opacity or other blending options.

To save a layer comp setting, click on the 'Create new layer comp' button in the Layer Comps panel. This will open the dialog shown below in Figure 8.38. Here, you can give the new layer comp setting a name and select which attributes you wish to include. Once you have done this the new layer comp will be added to the Layer Comps panel list.

The Layer Comps panel uses icons to signify which attributes (visibility, position and appearance) have been saved for each layer comp. The buttons at the bottom allow you to update these attributes independently (for visibility, position and appearance), or update everything. Should a smart object's status invalidate other existing layer comps, you'll see a warning indicator icon.

If you go to the File \Rightarrow Scripts menu, click Browse... and navigate to the Photoshop Presets/Scripts folder you will find a number of script options. Layer Comps to Files... can be used to generate separate files from layer comps and Layer Comps to PDF... allows you to generate a PDF document based on the layer comps created.

Na	ame: Master comp view	(ок
Apply to Layers	vers: 🗹 Visibility	Cancel
	Position	
	Appearance (Layer Style)	
Comn	nent:	

Figure 8.38 The New Layer Comp dialog. Here, just the Visibility and Appearance (Layer Style) options are checked.

1 This multi-layered, composite image contained a variety of pixel and adjustment layers that used a number of different blending modes.

2 As I experimented with different versions of this composite, I saved each as a separate layer comp state. In the example shown here, I created a layer comp in which all but one of the layers were made visible and with fine-tuned adjustments to the layer blending.

Figure 8.39 To link two or more selected layers, click on the Link button at the bottom of the Layers panel.

Layer linking

When working with two or more layers you can link them together, creating links via the Layers panel. Start by *Shift*-clicking to select contiguous layers, or **H** (Mac), *cttl* (PC)-clicking to select discontiguous layers. At this point you can move the selected layers, apply a transform, or make the layers form a new layer group. If you need to make such a layer selection linking more permanent, the layers can be formally linked together by clicking on the Link Layers button at the bottom of the Layers panel (circled in Figure 8.39). When two or more layers are linked by layer selection or formal linking, any moves or transform operations are applied to the layers as if they were one. However, they still remain as separate layers, retaining their individual opacity and blending modes. To unlink, select the layer (or layers) and click on the Link button to turn the linking off.

Multiple layer opacity adjustments

If you make a selection of layers, you can use the Opacity or Fill adjustment to adjust the values for all the layers in a layer selection. However, you need to be aware that a multiple layer selection opacity adjustment will override any adjustments that have already been made to individual layers. There are a few restrictions though. In the case of layer groups you'll only be allowed to make opacity changes and locked layers won't allow changes for either Opacity or Fill. Where these restrictions apply in a layer selection, the most restrictive layer will determine which fields are available to edit. So if you try this out and it doesn't appear to work, it may be because you may have a locked layer selected.

Selecting layers

You can use the **H** (Mac), *ctt/ alt* (PC) shortcut to select all layers (except a Background layer) and make them active.

Layer selection using the Move tool

When the Move tool is selected and the Auto-Select option is checked in the Move tool options, you can auto-select layers (or layer groups) by clicking or dragging in the image. For example, in Figure 8.40 Auto-Select Layer was checked. I was able to marquee drag with the Move tool from outside the document bounds to make a layer selection of all the layers within the marqueed area, but the Move tool marquee had to start from outside the document bounds; i.e., you must start from the canvas area and drag inwards. In the example shown here, the AutoSelect and Layer options were selected and only the layers that came within the Move tool marquee selection were selected by this action.

You can use the contextual menu to auto-select specific layers. In Figure 8.41 I moused down on the image using a right mouse-click to access the contextual menu. This lists all the document layers that are immediately below the mouse cursor. If a layer group is selected, the layers within the layer group will appear indented in the list. You can also use \mathfrak{R} \mathfrak{C} (Mac), \mathfrak{C} \mathfrak{M} all + right mouse (PC)-click to autoselect layers when the Move, Marquee, Lasso, or Crop tools are selected.

Auto-Select shortcut

If Auto-Select Layer is unchecked, you can hold down the **(Hac)**, **(PC)** key to toggle auto-selecting layers or layer groups as you click or drag using the Move tool.

Figure 8.40 The Move tool can be used to make a selection of layers.

Figure 8.41 With the Move tool selected, you can use the contextual menu to select individual layers.

Layer selection using the Path selection tools

In the Path selection and Direct selection Options bar there is an option that allows you to select All Layers/Active Layers (see Figure 8.42). The All Layers mode retains the original Photoshop CC behavior. When Active Layers is chosen, the Path selection tools are only able to affect the layers that are currently active in the Layers panel. The steps shown on the following page help explain this more clearly.

Align Edges Constrain Path Drago

Figure 8.42 This shows the Options bar for the Path selection tool and the pop-up menu offering a choice of All Layers or Active Layers.

In the original Photoshop CC program, you could use the Path selection or Direct selection tools to double-click on a vector path as a shortcut to switch to an isolation mode filter view of just that layer in the Layers panel. You could then double-click again on the path to toggle and revert to a full layer view again. This can still be done when you are in All Layers mode, but not if you have Active Layers selected. If this proves to be a problem, flipping between these two modes can be assigned a keyboard shortcut. To do this, open the Keyboards Shortcuts and menus dialog (Figure 8.43). Select Shortcuts For: Tools and scroll to the bottom of the list, where you can assign a shortcut to toggle the All Layers/Active Layers mode behavior.

Tool Panel Command Shortout de	nodified) × Can tage 10 cept ndo cefault
Tool Panel Command Shortcut Clean Mixer Brush Lues A	cept
Tool Panel Command Shortout Ui Clean Mixer Brush Uise /	ndo
Clean Mixer Brush Use J	
Lise 4	befault
Toggle Mixer Brush Auto-Load	
Toggle Mixer Brush Auto-Clean	
Toggle Mixer Brush Sample All Layers Add S	hortcut
Sharpen Erodible Tips	Shortcut
Direct Selection Mode Toggle	onorcou
Toggle Brush Airbrush Mode	
Toggle Brush Pressure Controls Size	harize
Toggle Brush Pressure Controls Opacity	

✓ Select: ✓ Active Layers

Fill: Stroke:

1 In this example the All Layers option was selected in the Path selection tool Options bar. When I marquee dragged across the whole image with the Path selection tool all the vector path layers became selected and with it the layers in the Layers panel associated with these paths. This was regardless of whatever layer selection might have been in place.

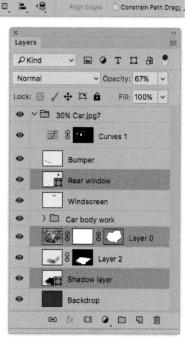

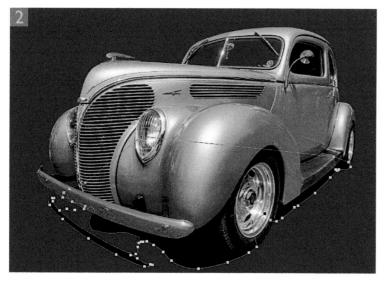

2 In this next example, just the three layers at the bottom were made active in the Layers panel. I set the Path selection tool Options bar to Active Layers mode and marquee dragged across the whole image again. This time only the vector paths associated with the active layers in the layer selection made in the Layers panel were selected and the Layers panel selection remained unchanged.

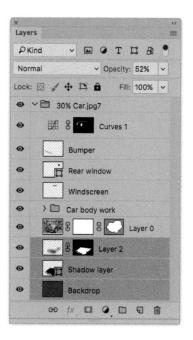

Layer mask linking

Layer masks and vector masks are linked by default to the layer content and if you move a masked layer or transform the layer content, the mask is adjusted along with it (as long as no selection is active). When the Link button (()) is visible, the layer and layer mask are linked. It can sometimes be desirable to disable the link between the layer mask/vector mask and the layer it is masking. When you do this, movements or transforms can be applied to the layer or layer/vector mask separately. You can tell if the layer, layer mask, or vector mask are selected as a thin black dashed border surrounds the layer, layer mask, or vector mask icon.

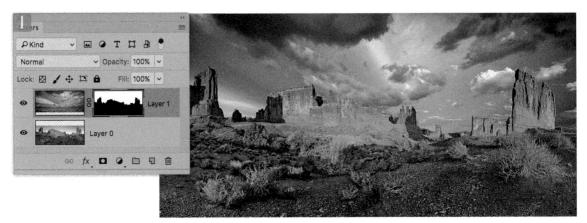

1 This photograph contained a clouds layer masked by the outline of the rocks. The layer and layer mask are normally linked and here you can see a dashed border surrounding the layer mask, which means the layer mask was currently active.

2 I clicked on the link icon between the layer and the layer mask, which disabled the link between the mask and the layer. Now, when the layer was selected (see the dashed border around the layer thumbnail), I could move the sky layer independently of the layer mask.

Layer locking

The layer locking options are at the top of the Layers panel just below the blend mode menu. Photoshop layers can be locked in a number of ways. To apply one of the locking criteria listed below, you need to first select a layer and then click on one of the Lock buttons. These have a toggle action, so to remove the locking, just click on the button again. The same applies to locking/unlocking multiple layers.

The options below mainly refer to image layers. When working with non-pixel layers you can only have the option to lock the layer position or lock all.

Lock Transparent Pixels

When Lock Transparent Pixels is enabled (Figure 8.44), any painting or editing you do is applied to the opaque portions of the layer only. Where the layer is transparent or semi-transparent, the level of layer transparency will be preserved.

Lock Image Pixels

The Lock Image Pixels option (Figure 8.45) locks the pixels to prevent them from being edited (with, say, the Brush tool or Clone Stamp). If you attempt to paint or edit a layer that has been locked in this way, you will see a prohibit warning sign. This lock mode does still allow you to move the layer contents though.

Lock Layer Position

The Lock Layer Position option (Figure 8.46) locks the layer position only. This means that while you can edit the layer contents, you won't be able to accidentally knock the layer position with the Move tool or apply a Transform command.

Lock All

You can select combinations of Lock Transparent Pixels, Lock Image Pixels, and Lock Layer Position, plus you can also check the Lock All option (Figure 8.47), or use the \mathfrak{H} (Mac) *cttl* (PC) shortcut. When this option is selected, the layer position is locked, the contents cannot be edited and the opacity or blend modes cannot be altered. However, the layer can still be moved up or down the layer stack.

Figure 8.44 The Lock Transparent Pixels layer option.

Figure 8.45 The Lock Image Pixels option.

Figure 8.46 Lock Layer Position option.

Figure 8.47 The Lock All box locks absolutely everything on the layer.

Generator syntax

If you target a layer or layer group that uses Generator syntax, this can influence how assets are exported. But the extended tagging must include a file format tag that matches the format that is being exported. For instance, if you name a layer group '30% Car.jpg70%' and export using JPEG, this will save a full resolution JPEG and alongside it a 30% scaled image saved as a 70% quality JPEG. If you were to export as a PNG, say, then the extended tagging will be ignored and just a full-size PNG file will be exported.

Export options

RGB mode images can be exported via the File \Rightarrow Export menu and also via the Layers panel. This essentially provides an alternative way to export images or layer selections (via the Layers panel) in a way that is faster and with fewer steps than using Save for Web. There are two export options: Quick Export and Export As.... Quick Export is a quick way to export files using a Web-compatible file format. Export As... pops a dialog that gives you more options.

First, I suggest you go to the Export preferences (Figure 8.48), where you can configure what happens when you choose an export option. The Quick Export Format section lets you choose which format the files should be saved in when applying a quick export and whether transparent pixels should be preserved or not. The Quick Export Location section offers two options: to ask each time where the asset files should be saved, or export to an assets folder next to the current document.

When you choose File \Rightarrow Export \Rightarrow Quick Export as..., or go to the Layers panel menu and choose Quick Export as..., the assets saved will depend on what is selected in the document and whether Generator extended tagging has been utilized (see PDF on website for more about working with Generator in Photoshop). In general, when you choose Quick Export, this exports a full resolution version of the image saved using the specified format. If a layer or layer group is targeted and extended (Generator) tagging has been used in the naming, a full resolution version will get exported as well as one with the attributes specified using the Generator syntax.

If you want more control over the export process, choose File \Rightarrow Export \Rightarrow Export as... This opens the Export As dialog shown in Figure 8.49, where you have complete control over the file format selection and file format settings. The last used file format and other export settings are always remembered when choosing File \Rightarrow Export \Rightarrow Export As. As with Quick Export, the export location depends on the settings configured in the Export preferences.

The Image Size section can be used to determine the output file size and below it the Canvas Size can be set independently, allowing you to export an image with an added canvas area (as shown in Figure 8.49). The height and width controls can also be adjusted using the arrow controls and scrubby sliders. The width, height, and Scale dialogs are all linked so that when a custom value is entered to one setting the other two will update automatically.

	Preferences	
General Interface Vorkspace	Quick Export Format PNG V Transparency Smaller File (8-bit)	ОК
Workspace Tools History Log File Handling Export Performance Scratch Disks Cursors Transparency & Gamut Unite & Rulers Guides, Grid & Silces Plug-Ins Type 3D Technology Previews	Quick Export Location Ask where to export each time Export files to an assets folder next to the current document Metadata Copyright and Contact Info Color Space Convert to sRGB	Prev Next

Figure 8.48 The Export preferences.

0	Export As		
Scale All		File Settings	File format options
Size: Suffix: +		Format: JPG ~	
1x * none		Quality: 66%	
D4472375-Edit JPG 1602 x 1110 288 2 KB		Image Size	
			Image size options
		Height: 985 p	
	1361	Scale: 33.32%	
		Resample: Bicubic Automatic	
		Canvas Size	Canvas size options
		Width: 1600 p	
		Height: 1100 p	4
		Reset	Reset canvas
		Metadata	Metadata options
		O None	inotadata optiono
		Copyright and Contact Info	
		Color Space	Color Space
		Convert to sRGB	
		Ernbed Color Profile	options
		Learn more about export options,	
Previewing: D4AT2375-Edit	Ø 00.87% Ø	Cancel Export All	C
			Switch background
			color from light
Finner 0, 40 The Expert Draview	dialaa		
Figure 8.49 The Export Preview	dialog.		to dark

Figure 8.50 The Libraries panel.

1 4 A fx

Metadata and Color Space sections

The Export includes a Metadata section where you can choose to export with None, or with Copyright and Contact information. In the Color Space section there is an option to 'Convert to sRGB.' If you use the Save for Web method to export, you do also have the option to include a profile on export. For exports that are destined to appear in a website there is a good reason to not include a profile. In the absence of a profile all Web browsers will assume sRGB. This allows Web designers to economize on the file size by omitting the profile data from the file and thereby reduce the overall file size. But for nearly everything else it is essential a profile is included. Therefore, it is mostly best to have the Embed Color Profile option is checked.

Exporting layers

You can also export individual layers. To do this, target a specific layer or layer group and choose Quick Export As..., or Export As... from the Layers panel menu. In the case of a layer group, you will be exporting a merged version of the layers contained in the group. If you select a number of individual layers and choose Quick Export As..., you'll export separate files for each layer. If you choose the Export As... option you'll see a filmstrip of the selected layers appear down the left-hand side of the Export Preview dialog, which allows you to see the layers listed. When you click Export..., again, all the layers will be exported as separate files.

Creative Cloud Libraries

The Libraries panel can be accessed via the Windows menu. This panel can be used to hold library collections of graphic assets, text styles, layer styles, and colors. They are also synced to your Adobe Creative Cloud account, which means they can be easily shared across other Adobe programs as well as with machines that share the same account. Figure 8.50 shows the Libraries panel where in the top screen shot I clicked on the top menu to select 'Create new Library...' The bottom panel shows how I was then asked to name the new library. As you work on a project you can click on the buttons at the bottom of the panel to add assets to build a library of design elements associated with a particular job. You can then save these as individual creative libraries, to be reused on other, similar projects. Essentially, this feature is like a super clipboard. Normally when you copy something only one item can be stored at a time in the clipboard memory. Using libraries you can use this as a place to store multiple design assets and share these via the Creative Cloud.

æ 🗊

Adding and linking assets

Assets can be added by dragging a layer, swatch, layer style or character style to the Libraries panel. Stored assets can then be added to other documents by dragging from the Libraries panel. Assets in Creative Cloud Libraries are linked so that when a change is made to a graphic or layer, it updates any document that uses that asset. You can therefore update assets across Photoshop, Illustrator, or InDesign projects, wherever those assets are being used.

In the Figure 8.51 example I used the Libraries panel to store a number of graphic assets that were associated with a house build project, along with a few custom color samples. When loaded I could simply drag and drop graphic elements from this panel, or click on a color sample to load this as the foreground color. The Search box is circled in Figure 8.51. You can use the pop-up menu on the right to pick what it is you want to search. You can use this to search the current library, all libraries, or Adobe Stock.

Figure 8.51 This shows the Libraries panel with Colors and Graphics elements added for a project I was working on.

1 If you click on Collaborate... in the Libraries panel fly-out menu, this takes you to the web page shown here. In this example it opened an ME Photography library. I clicked on the Share menu and selected 'Collaborate' to invite other users to share this library.

Invite Collaborators	×
ME Photography Can edit allows collaboration of delete the contents of the Can view limits collaboration commenting on the library	is library. ors to viewing and
	2 Collaborators 🔺
Martin Evening	Owner
Rod Wynne-Powell	Can edit 👻 兴
Enter email addresses	Can edit 💌
Remove all users	Invite

2 This shows the Collaborators pop-up window, where I could enter an email address to invite other people to share this particular library.

Create library assets from documents

Whenever you open or create a document with content, such as character styles, color fill layers, or layer styles, there is an easy way to add such content to the Libraries panel. Click on the Library from Document button (circled in Figure 8.52), or select 'Create New Library from Document' from the Libraries panel fly-out menu. This opens the New Library from Document dialog that is shown below in Figure 8.53. By checking the assets that appear listed here you can select which assets are to be pulled from the document to create a new CC Library. As you can see below. If smart objects are present you can choose for these to be added to the library and replaced with linked smart objects in the original source document.

Import Frequently Us	ed Assets
Import assets to a library so you can documents, access them from other and share them with tea	desktop and mobile apps,
Learn more about L	ibraries
Character Styles	7 items
Colors	9 items
Layer Styles	5 items
Smart Objects	3 items
Move smart objects to library	and replace with links
Cancel	New Library

Figure 8.53 The New Library from Document dialog.

Figure 8.52 The Libraries panel.

Figure 8.54 This shows the Layers panel for a multi-layered image and the filter layer options that are available.

Smarter naming when merging layers

When you merge a selection of layers together in Photoshop, the usual convention has been for the merged layer to take on the name of the uppermost layer in that layer selection. However, Photoshop is smart enough that it ignores any of the default layer names such as 'Layer 1' or 'Curves' and uses the topmost, manually renamed layer to name the merged layer. It is a subtle change in behavior that makes some sense. A downside of this recent change is that some Photoshop actions can fail to work correctly as a result of this.

Layer filtering

Layer filtering can be used to determine what gets displayed within the Layers panel depending on the selected criteria. To filter the layers in an open document, select one of the filter options from the menu shown in Figure 8.54. Here, you can choose to filter the layers by Kind, Name, Effect, Mode, Attribute, Color, Selected, or Artboard. You'll notice there is also a switch in the top right of the Layers panel. This is colored red when a filter of any kind is active and you can click on this switch to toggle the layer filtering on or off. Note that none of the filtering options are recordable as actions.

When the default Kind option is selected you can filter using the small buttons to the right of the Filter menu and search using the following criteria: Pixel layers (\blacksquare), Adjustment layers (\bigcirc), Type layers (\bigcirc) Shape layers (\boxdot), or Smart Objects (B).

Examples of layer filtering can be seen in Figure 8.55. Top left shows a filter search by 'Kind,' to search for adjustment layers only. Top middle, shows a search by 'Kind' for Smart Objects only. Top right shows a search by 'Mode' to filter by the Lighten blending mode. Bottom left shows an 'Attribute' search for layers that are linked. Bottom middle shows a 'Color' search for layers that are color coded yellow. If you filter by 'Name' you can search for any layers that match whatever you type into the text box. So, for instance, in the bottom right example I typed 'retouching.' This revealed all the layers with the word 'retouching' in the layer names. It so happens you can also use the Select \Rightarrow Find Layers menu command ($\Re \otimes Shift \models$ [Mac], $ctt \otimes Shift \models$ [PC]) to carry out a layer filter search by 'Name'.

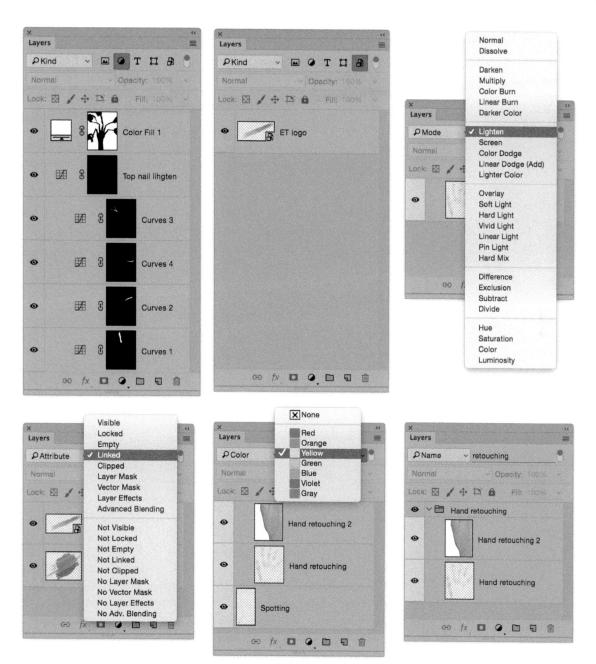

Figure 8.56 Invoking isolation mode.

Figure 8.57 The path selection/direct selection contextual menu.

Isolation mode layer filtering

Isolation mode is an additional layer filtering option that can be used to filter the active selected layers in a document. This means you can specify a subset of layers within a document and isolate them so that only these layers are visible in the Layers panel (although all other layers will remain visible in the document). Tool use then becomes restricted to just the selected layers, but you can add, duplicate, reorder, or delete any of the visible layers while they are in this filtered, isolated state. You can modify an isolated layer selection by targeting a layer and choose 'De-isolate Layer' from the Select menu or contextual menu (use *cttt*] [Mac], or a right mouse-click to access).

To invoke the isolation mode, make a selection of layers active and choose the 'Isolate Layers' option via Photoshop's Select menu, or choose the Selected filter mode from the Layers panel filtering options. To undo, select 'Isolate Layers' again, or click on the filter switch ()) to disable the filtering. In Figure 8.56 three pixel layers were active. When layer filtering was enabled using the 'Selected' mode only these three layers remained visible within the Layers panel.

When either the Path selection or Direct selection tools are active you can use *(Mac)*, or a right mouse-click to access the contextual menu and choose 'Isolate Layers' to enable/disable the isolation mode layer filtering (see Figure 8.57) and double-clicking on an active shape layer path using either of these tools automatically isolates the targeted layer. Double-click again to de-isolate the layer again (providing you are in All Layers mode [see page 558]).

You can also invoke 'Isolate Layers' via the contextual menu for the Move tool. Although tool usage is restricted to the selected layers only, when the Move tool is selected and in Auto-select layer mode, you can click with the Move tool on the image to auto-add additional layers to an isolation mode filtered selection.

Whenever a layer filter is active most normal layer functions will remain active. This means that you can still edit layers, reorder or delete them. Layer filter settings aren't saved when you close a document, but the layer filtering settings do remain sticky for as long as a document remains open in Photoshop and any layer filters you apply will also be persistent for each individual document. Only one filter type can be active at a time, so it is currently not possible to apply multiple filter criteria to the layers in an image. And, when filtering a new document, you will always encounter the normal default layer filtering state when filtering for the first time.

Transform commands

The Image \Rightarrow Image Rotation menu options are shown in Figure 8.58. These can be used to rotate or flip an image. For example, you can rotate an image 180° where a photo has been scanned upside down.

The Transform commands are all contained in the Edit \Rightarrow Transform menu (Figure 8.59) and these allow you to apply transformations to individual or linked groups of layers. To apply a transform, you can select a layer or make a pixel selection of the area you wish to transform and choose Edit \Rightarrow Transform. Another option is to check the Show Transform Controls box in the Move tool Options bar (Figure 8.60).

The main Transform commands include: Scale, Rotate, Skew, Distort, Perspective, and Warp, and these can be applied singly or combined in a sequence before clicking the Commit Transform box (\checkmark), clicking *Enter*, or double-clicking within the Transform bounding box to apply the transformation. The interpolation method used when calculating a transform can be selected from the Interpolation menu in the modal Transform Options bar (see next page).

You can apply any number of tweaking adjustments before applying the actual transform and you can use the undo command to revert to the last defined transform preview setting. You can also adjust the transparency of a layer mid-transform. This means you can modify the opacity of the layer as you transform it. For example, this can help you align a transformed layer to the other layers in an image.

In addition to the Transform menu options is a Free Transform command. Of all the transform options available, the Free Transform is the most versatile and the one you'll want to use most of the time. To apply, choose Edit \Rightarrow Free Transform or use the HT (Mac), ctrl (MC) (PC) keyboard shortcut and modify the transformation using the keyboard controls as indicated on the following pages. When you are in transform mode, the Transform Options bar also offers you precision controls for fine-tuning a transform.

Image Layer	Type S	elect	Filter	3D	View	Windo
Mode		Þ			112010	-
Adjustments		•				
Auto Tone	û X	L				
Auto Contrast		-				
Auto Color	û H	В				
Image Size	XX	1				
Canvas Size	X7	C				
Image Rotation	ALC: LANGER	2000	180°			VON CONTRACT
Crop			90° CW			
Trim			90° CC1	W		
Reveal All			Arbitrar	ry		
Duplicate			Flip Car	nvas H	orizon	tal
Apply Image			Flip Car	nvas \	ertical	
Calculations		100	est constant	a la cara		ताम्हतः
Variables						
Apply Data Set.						
Trap						
Analysis						

Figure 8.58 The Image

→ Image
Rotation submenu.

in Image Layer Ty	and an entropy of the second second	Filter	3D	View
Undo Load Selection	жZ			
Step Forward	①第Z			
Step Backward	₹¥Ζ			
Content-Aware Scale	天豆湯C			
Puppet Warp	C 0 00 C			
Free Transform	¥T			
Transform		Again		0 X T
Auto-Align Lavers		riguin		
Auto-Blend Lavers		Scale		
		Rotate		
Define Brush Preset		Skew		
Define Pattern		Distor	t	
Define Custom Shape		Persp	ective	
		Warp		
Purge	•			
		Rotate	180	e March
Adobe PDF Presets		Rotate	90°	CW
Presets	•	Rotate	90°	CCW
Remote Connections				
		Flip H	orizo	ntal
Color Settings	12 3€ K	Flip Ve	ertica	l.
Assign Profile	1	of the second second		and the second second
Convert to Profile				
Keyboard Shortcuts	てひ第K			
Menus	N # O Z			

Figure 8.59 The Edit ⇒ Transform submenu.

🕂 🕂 🗸 🖸 Auto-Select: Layer 🗸 🖾 Show Transform Controls 🏋 👬 🗽 🚔 🚔 🚔 🚔 🚔 🚔 🚔 👘 👭 👭 🖬 30 Mode: 😒 💿 🎲 🍫 🕬

Figure 8.60 The 'Show Transform Controls' box in the Move tool Options bar.

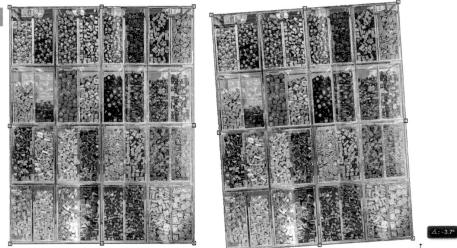

" H: 0.00

° V: 0.00

Interpolation:

H: 100.00%

▲ 0.00

1 You can rotate, skew, or distort an image in one go using the Edit \Rightarrow Free Transform command. The following steps show you some of the modifier key commands that can be used to constrain a free transform adjustment. You can place the cursor outside the bounding border and drag in any direction to rotate the image. If you hold down the *Shift* key as you drag, this constrains the rotation to 15° increments. You can also move the center axis point to change the center of the rotation.

0 ~

Bicubic ~ 👮

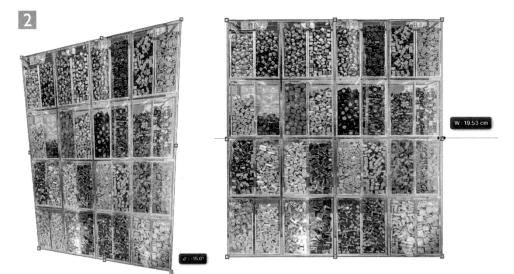

2 If you hold down the \mathfrak{H} (Mac), \mathfrak{CIII} (PC) key as you click any of the handles of the bounding border, this will allow you to carry out a free distortion. If you want to constrain the distortion symmetrically around the center point of the bounding box, hold down the \mathfrak{CIII} key as you drag any handle.

3 To skew an image, hold down the **H** (Mac), *ctr(alt* (PC) keys and drag any one of the corner handles. To carry out a perspective distortion, hold down the **H Shift** (Mac), *ctr(alt Shift* (PC) keys in unison and drag on one of the corner handles. When you are happy with any of the new transform shapes described here, press *Enter* or *Return* or double-click within the transform bounding box to apply the transform. Press *esc* if you wish to cancel.

Repeat Transforms

After you have applied a transform to an image layer or image selection, you can get Photoshop to repeat the transform by going to the Edit menu and choosing: Transform \Rightarrow Again (the shortcut here is # Shift T [Mac], *cttl* Shift T [PC]). This can be done to transform the same layer again, or you can use this command to identically transform the contents of a separate layer. I generally find the Transform Again command is most useful when I need to repeat a precise transform on two different layers, or a similar layer object.

Interpolation options

The Interpolation menu allows you to select one of the following options: Nearest Neighbor, Bilinear, Bicubic, Bicubic Smoother, Bicubic Sharper, or Bicubic Automatic. These are the same as the interpolation options in the General preferences except there is no option to apply a Preserve Details interpolation to a transformation. Whatever Options bar interpolation method you select will remain sticky.

Numeric Transforms

When you select any of the Transform commands from the Edit menu, use the Free Transform shortcut (**H** [Mac], *ctrl* [PC]) or check 'Show Transform Controls' in the Move tool options and drag a Transform bounding box handle. The Options bar displays the Numeric Transform options shown in Figure 8.61. These can be used to accurately define a transformation. For example, a Numeric Transform can commonly be used to change the percentage scale of a layer, where you would enter the scale percentages in the Width and Height boxes. If the Constrain Proportions link icon is switched off you can set the width and height independently. You can also change the central axis for the transformation by repositioning the highlighted dot (circled) from its default center position. For example, if you click in the top left corner you can have all transforms (including numeric transforms) default to centering from the top left corner. Alternatively, you can manually click on the bounding box center axis point and drag it anywhere you like to create a new center of transformation.

Mil (2000): 513.50 px Δ Y: 395.00 px W: 85.89% ∞ H: 68.33% Δ 0.00 ° H: 0.00 ° V: 0.00 ° Interpolation: Bloubic ∨ 要 O ✓

Figure 8.61 This shows the Options bar in Transform mode.

Transforming paths and selections

You can also apply transforms to Photoshop selections and vector paths. For example, whenever you have a pen path active, the Edit menu switches to show 'Transform Path.' You can then use the Transform Path commands to manipulate a pen path or a group of selected path points (the path does not have to be closed). You just have to remember you can't execute a regular transform on an image layer (or layers) until *after* you have deselected any active paths.

To transform an active selection, choose Select \Rightarrow Transform Selection. Transform Selection works just like the Edit \Rightarrow Free Transform command. You can use exactly the same modifier key combinations to scale, rotate, and distort the selection outline. Or, you can use *ettil* (Mac), or right mouse-click to call up the contextual menu of transform options. But it is important to note here that if you choose Edit \Rightarrow Transform, this transforms the selection contents.

Transforms and alignment

When you have more than one layer in an image, the layer order can be changed via the Layer \Rightarrow Arrange submenu (Figure 8.62), which can be used to bring a layer forward or send it further back in the layer stacking order. You can also use the following keyboard shortcuts. Use **#1** (Mac), *ctrl* (PC) to bring a layer forward and **#1** (Mac), *ctrl* (PC) to send a layer backward. Use **#Shift1** (Mac), *ctrl* Shift1 (PC) to bring a layer to the front and **#Shift1** (Mac), *ctrl* Shift1 (PC) to send a layer to the back.

If two or more layers are linked, these can be aligned in various ways via the Layer \Rightarrow Align menu (Figure 8.63). To use this feature, first make sure the layers you want to align are selected in the Layers panel, or are linked together, or in a layer group. The Align commands can then be used to align the linked layers using the rules shown in the submenu list; i.e. you can align to the Top Edges, Vertical Centers, Bottom Edges, Left Edges, Horizontal Centers, or Right Edges. The alignment will be based on whichever is the topmost layer, left-most layer, etc., There is also a Distribute submenu, which contains an identical list of options to the Align menu, but is only accessible if you have three or more layers selected, linked, or in a layer group. The Distribute commands allow you to distribute layer elements evenly based on the Top, Vertical Centers, Bottom, Left, Horizontal Centers, or Right edges. So for example, if you had three or more linked layer elements and you wanted them to be evenly spread apart horizontally and you also wanted the distance between the midpoints of each layer element to be equidistant, you would select the layers and choose

Layer \Rightarrow Distribute \Rightarrow Horizontal Centers.

Rather than use the Layer menu options you can click on the Align and Distribute buttons in the Move tool Options bar (Figure 8.64). The alignment options (shaded blue) will only become available when two or more layers are selected and the distribution options (shaded green) only available when three or more layers are selected. Shaded in red is the Auto-Align Layers button. Clicking this is the same as choosing: Edit \Rightarrow Auto-Align Layers when two or more layers are selected. Generally, I would say the Align and Distribute features are perhaps more useful for graphic designers, where they might need to precisely align image or text layer objects in a Photoshop layout.

Layer Type Select Filter 3D View Window Help

Figure 8.62 The Layer ⇒ Arrange submenu.

Figure 8.63 The Layer ⇒ Align submenu.

🕂 🗸 🖸 Auto-Select: Layer 🗸 🗋 Show Transform Controls 🎹 👭 且 🖀 🌲 🚟 🛣 🏦 👫 👫 👫 👪 SD Model: 😒 🖄 🚸 🍲 🖦

Figure 8.64 This shows the Move tool Options bar with multiple layers selected.

Warp transforms

The Warp transform is an extension of the Free Transform command and allows you to combine a Free Transform and a Warp Distortion in a single pixel transformation. It has to be said that the magic of the Warp Transform has been somewhat superseded by the Puppet Warp adjustment, but it is still nonetheless a useful tool to work with. Warp Transforms are ideally suited for editing large areas of a picture where Puppet Warp is less able to match the fluid distortion controls of the Warp Transform.

To apply a Warp Transform you need to select a layer or an image selection and choose Edit \Rightarrow Transform \Rightarrow Warp. Alternatively, choose Edit \Rightarrow Free Transform (**H** [Mac], *ctrl* [PC]) and click on the Transform/Warp mode selection button in the Options bar (circled in Figure 8.65). Once selected, you will be in the default Custom warp mode, but you can also select from any of the preset warp mode options listed in the Warp menu on the left. When you select one of these preset options, you can adjust the warp settings using the Options bar controls. These allow you to control the Bend, Horizontal, and Vertical percentage distortion.

When the Warp option is selected you can control the shape of the warp bounding box using the bezier handles at each corner. The box itself contains a 3×3 mesh and you can click in any of the nine warp sectors, and drag with the mouse to fine-tune the warp shape. What is also great about the Warp Transform is the way that you can make a warp overlap on itself (as shown on the page opposite).

You can only apply Warp Transforms to a single layer at a time, but if you combine layers into a Smart Object, you can apply nondestructive distortions to multiple layers at once. For more about working with Smart Objects see pages 586–589.

0

None

田

Bend: 50.0

% H: 0.0

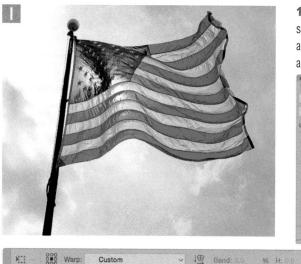

1 In this example I separated the US flag from the flag pole on a separate layer and placed both these elements as individual layers above a separate sky backdrop. I then converted the Flag layer to a Smart Object.

96 V: 00

2 Interest of the second secon **2** I went to the Edit menu and selected Edit \Rightarrow Transform \Rightarrow Warp. The default option is the 'Custom' mode, where I had access to the bezier control handles at the four corners of the warp bounding box. These could be adjusted in the same way as you would manipulate a pen path to control the outer shape of the warp. Here, I was able to drag the corner handles and click inside any of the nine sectors and drag with the mouse to manipulate the flag layer, just as if I were stretching the image on a rubber canvas. You'll note how I was even able to adjust the warp so that the flag twisted in on itself.

0

~

3 In Step 2 the warp preview in the bottom right corner had some sky area included with the warp. This is just how the preview is rendered when warping an image. Once the warp had been applied, the warped image appeared as expected. Because the Flag layer remained as a Smart Object I could still continue to edit the Flag layer shape non-destructively.

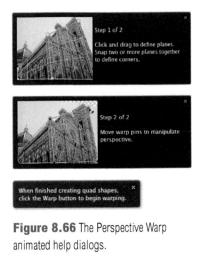

Switch to Warp mode

Perspective Warp

The Edit \Rightarrow Perspective Warp command can be used to warp photos to correct or alter the perspective (providing you have 'Use Graphics Processor' enabled in the Photoshop \Rightarrow Performance preferences). For example, Perspective Warp can be used to manipulate the perspective in parts of your image, while maintaining the original perspective in other areas. It is particularly well suited to images of architectural subjects. One way to use this tool is to correct the perspective of a building in a photograph, where you might wish to make a building's perspective look more correct, but without distorting everything else in the photograph. You can also use Perspective Warp to manipulate the perspective in a layer to match the perspective of the underlying image. Or, as shown in the following example, you can use it to simply change the perspective view in a single image.

When you apply a Perspective Warp you will initially be working in the Layout mode (), where you'll need to define the warp planes. You do this by clicking and marquee dragging to define the first warp plane and then click on the corner handles to adjust the shape. The animated Perspective Warp help screens shown in Figure 8.66 demonstrate how the Perspective Warp tools can be used. These can be made to go away after the first time you use Perspective Warp. Subsequent warp planes can be added to define the other object planes and these will automatically snap-align to the edges of the existing planes. You can hold down the () (Mac) (PC) key while drawing quads to place them close but without joining. Once you have done this you can click on the Warp button to switch to Warp mode () to access the Warp controls shown in Figure 8.67 below to help manage the Perspective warp distortion.

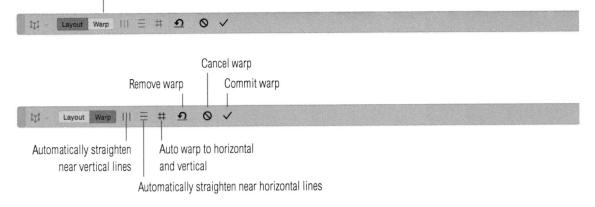

Figure 8.67 The Perspective warp Options bar in Layout mode (top) ((1)) and Warp mode ((1)) below.

1 I opened this image, and used **(H)** (Mac), *etcl* **(**PC) to duplicate the Background layer and chose Layer ⇒ Smart Objects ⇒ Convert to Smart Object.

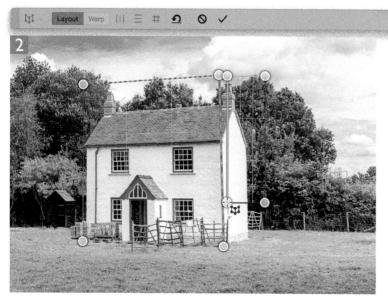

2 I went to the Edit menu and chose Perspective Warp. I began in Layout mode by marquee dragging over the front of the house to add the first quad plane. I then clicked on the quad plane corner pins to fine-tune their placement and align with the front of the house. You can also use the keyboard arrow keys to nudge a selected quad pin. I then clicked and dragged to add a second quad plane. As this second quad plane edge met the first quad plane the two edges appeared highlighted blue and the second plane snapped to the edge of the first.

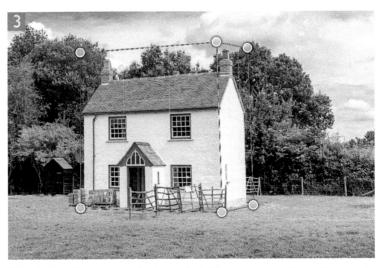

3 Continuing in Layout mode, I fine-tune adjusted the corner pin positions of the second quad plane.

Warp Options bar align buttons

The buttons in the Perspective Warp Options bar can be used to auto straighten the verticals, auto straighten the horizontals, or auto straighten both.

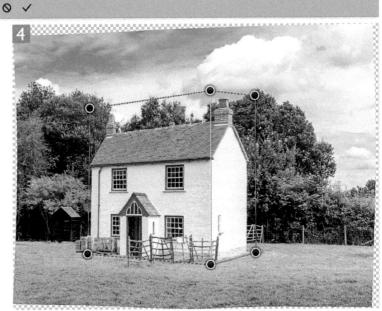

4 I then clicked on the Warp button (*W*) in the Options bar to prepare the layer for warping (you can use the *M* key to hide the plane grids when working in the Warp mode). If you hold down the *Struct* key as you click on a segment between two pins the segment turns yellow and will automatically snap to the horizontal, vertical, or a 45° angle (*Struct* click again to disable). Lastly, I clicked *Enter* to OK the Perspective Warp adjustment. When the layer contents were fully revealed you can see how the overall image shape was warped as a result of the Perspective Warp adjustment.

- 8

Puppet Warp

Whenever you are editing a normal, non-background layer the Puppet Warp feature will be available from the Edit menu. This is a truly outstanding feature for anyone who uses Photoshop to do retouching work. While the Liquify filter, Warp transform, and Perspective Warp are great, the main benefits of working with the Puppet Warp tool are that the warp response feels that much more intuitive and responsive. As you edit the pins, the other elements of the photograph warp in a way that can help the warping effect look more natural. The other advantage is you can edit the layers directly in Photoshop without having to do so via a modal dialog. Or rather it seems to be non-modal whereas in fact the Puppet tool is really still modal—it's just that you are able to work on a layer directly rather than via a dialog interface (as is the case with Liquify).

The best way to truly appreciate Puppet Warp is to watch a movie demo, such as the one on the book's website, or better still, try it out for yourself. The Puppet Warp tool Options bar (Figure 8.68) offers three modes of operation. The Normal mode applies a standard amount of flexibility to the warp movement between the individual pins, while the Rigid mode is stiffer and good for bending things like hands. The Distort mode provides a highly elastic warp mode which can be good for warping wide-angle photographs. The Puppet Warp function is based on an underlying triangular mesh. The default Density setting is set to Normal, which is the best one to choose in most instances. The More points Density option provides more precise warping control but at the expense of speed since the processing calculations are more intense. The Fewer Points setting allows you to work faster, but you may get unpredictable or unusual warp results. There is also a Show Mesh option that allows you to show or hide the mesh visibility.

The next thing to do is to add some pins to the mesh. These can be applied anywhere, but it is important you add at least three pins before you start manipulating the image, since the more pins you add, the more control you'll have over the Puppet Warp editing. The thing to bear in mind here is that as you move a pin, other parts of the layer will move accordingly, and perhaps do so in ways that you hadn't expected.

Figure 8.68 The Puppet Warp Options bar.

Figure 8.69 An example of rotating a selected pin.

Figure 8.70 This shows the pin contextual menu.

This is the result of the Puppet Warp tool intelligently working out how best to distort the layer. As you add more pins to different parts of the layer you will find that you gain more control over the Puppet Warp distortions. The keyboard arrow keys can also be used to nudge the selected pin location, but if you make a mistake with the addition or placement of a pin you can always use the Edit \Rightarrow undo command, or hold down the *all* key to reveal the scissors cursor icon and click on a pin to delete it. Or, you can simply select a pin and hit the *Delete* key.

In order to further tame the Puppet Warp behavior, you can use the Expansion setting to modify the area covered by the mesh. This can have the effect of dampening down the Puppet Warp responsiveness, but should be considered essential if you want to achieve manageable distortions with the Puppet Warp. The default setting of 2 pixels provides precise control over the warp distort movements, but this won't help with every image. If you find your Puppet Warp editing is hard to control, try increasing the Expansion amount.

The Puppet Warp mesh is mostly applied to all of the selected layer contents, including the semi-transparent edges, even if only as little as 20% of the edge boundary is selected. And if this fails to include all the desired edge content you can always adjust the Expansion setting to include more of the layer edges.

Pin rotation

The Rotate menu normally defaults to 'Auto'. This rotates the mesh automatically around the pins based on the selected mode option (Rigid, Normal, or Distort). When a pin is selected you can hold down the *all* key and hover the cursor close to a pin. This reveals the rotation circle that also allows you to set the pin rotation manually (see Figure 8.69). Be careful though, because if you happen to all-click a pin, this will delete it. As you rotate a pin, the rotation value will appear in the Puppet Warp Options bar. This extra level of control can allow you to twist sections of an image around a (movable) pinpoint as well as alter the degree of twist between this and the other surrounding pins. In the case of the puppet image example shown in Figure 8.69, this gave me better control over the angle of the strings. See also Figure 8.70, which shows the pin contextual menu. This offers quick access to a list of useful options for modifying pins that have been added using Puppet Warp (*ctrl*-click or use a right mouse-click to reveal the contextual menu shown here). 'Set Auto Rotation' can be used to reset the pin rotation.

Pin depth

The pin stacking order can be changed by clicking on the buttons in the tool Options bar. Where a Puppet Warp distortion results in elements overlapping each other, you can decide which section should go on top and which should go behind. You can either click on the move up or move down buttons shown in Figure 8.71, or use the **1** key to bring a pin forward and use the **1** key to send a pin backward (or use the pin contextual menu shown in Figure 8.70). The preview you see in the Puppet Warp edit mode will include the Extension area, but this won't be seen in the final render. Basically, this is a mechanism that allows you to determine whether warped elements should go in front of or behind other elements in a Puppet Warp selection.

Multiple pin selection

You can select multiple pins by *Shift*-clicking the individual pins. Once these are selected, you can drag them as a group using the mouse, or use the arrow keys to nudge their positions. You can *Shift*-click again to deselect an already selected pin from a selection. However, operations which affect a single selected pin, such as rotation and pin depth, are disabled when multiple pins are selected.

While in Puppet Warp mode, you can also use $\mathfrak{H}(A)$ (Mac), $\mathfrak{Ctrl}(A)$ (PC) (or the contextual menu) to select all the current pins and you can use the $\mathfrak{H}(D)$ (Mac), $\mathfrak{ctrl}(D)$ (PC) shortcut to deselect all pins. Also, if you hold down the \mathfrak{H} key, you can temporarily hide the pins, but leave the mesh in view.

If you have multiple objects on a single layer, the Puppet Warp mesh is applied to all non-transparent areas on that layer, allowing you to apply Puppet Warp distortions to each layer element individually.

Smart Objects

If you convert a layer to a Smart Object before you carry out a Puppet Warp transform this will allow you to re-edit the Puppet Warp settings. You can also use the Puppet Warp feature to edit vector or type layers. However, if you apply the Puppet Warp command to a type or vector layer directly, the Puppet Warp process automatically rasterizes the type or vector layer to a pixel layer. Therefore, in order to get around this I suggest you select the layer and choose Filter \Rightarrow Convert to Smart Filters first, before you select the Puppet Warp command.

Figure 8.71 The pin depth controls let you move the selected pin positions on a Puppet Warp selection up or down.

1 The first step was to create a selection outline of the subject, Michael Smiley, copy as a new layer, and place a white background layer below. I then converted the targeted layer to a

Smart Object.

2 I made sure the puppet layer was selected, then went to the Edit menu and chose Puppet Warp. This added a triangular mesh to the layer contents and the Options bar revealed the options for the Puppet tool. Here, I chose the 'Rigid' Mode and Normal Density option for the mesh. I also set the Expansion option to 15 pixels, as this would give me better control over the warp adjustments. I was then ready to start adding some pins. The more pins you add, the more control you have over the Puppet Warp effect.

📌 🗸 Mode: Rigid 🗸 Density: Normal 🔷 Expansion: 15 px 🗸 🗹 Show Mesh Pin Depth: 🔧 +😫 Rotate: Fixed 🗸 0 👘 💁 🚫 🗸

2

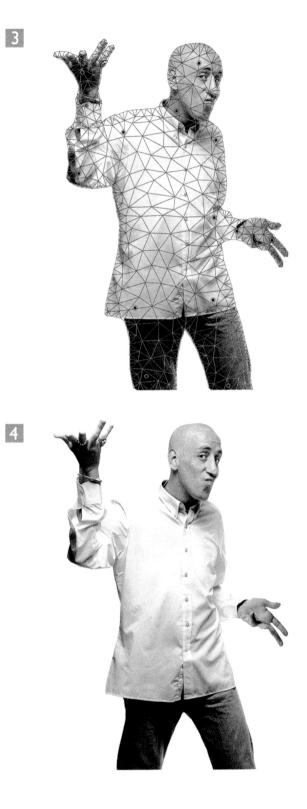

3 The next step was to begin warping the layer. All I had to do was to click to select a pin and drag to reshape the image. The interesting thing here is that as you move one part of the layer, other parts adjust to suit.

4 Lastly, I dragged the pins on the legs further apart to adjust the leg positions. When I was done, all I had to do was hit the Enter key. Now, because I had prepared this layer as a Smart Object you'll notice how the Puppet Warp adjustment was added as a Smart Object in the Layers panel. This meant if I wanted to re-edit the Puppet Warp settings, I could do so by double-clicking the Puppet Warp Smart Object and carry on editing.

Smart Filters

Near the top of Filter menu is a 'Convert for Smart Filters' option. Selecting this is the same as choosing 'Convert to Smart Object' from the Layers menu or Layers panel fly-out menu. With Smart Objects/Smart Filters you can apply most Photoshop filters, but not all (including some third-party filters). However, you can enable all filters to work with Smart Objects by loading the 'EnableAllPluginsforSmartFilters.jsx' script. This is explained later on page 608.

Smart Objects

One of the main problems you face when editing pixel images is that every time you scale an image or the contents of an image layer, pixel information is lost. And, if you make cumulative transform adjustments, the image quality can degrade quite rapidly. However, if you convert a layer or a group of layers to a Smart Object, this stores the layer (or layers) data as a separate image document within the master image. Figure 8.72 shows how you can promote any layer or group of layers to a Smart Object. A Smart Object becomes a fully editable, separate document stored within the same Photoshop document. The Smart Object data is therefore 'referenced' by the parent image and edits applied to the Smart Object layer are applied to the proxy instead of to the pixels that actually make up the layer. The principal advantage is you can repeatedly scale, transform, warp, or apply a filter to a Smart Object in the parent image without affecting the integrity of the pixels in the original.

With Smart Object layers you can use any of the transform adjustments described so far plus you can also apply filters to a Smart Object layer (known as Smart Filtering), or apply image adjustments. What you can't do is edit a Smart Object layer directly using, say, the Clone Stamp tool or paint brush, but you can double-click a Smart Object layer to open it as a separate image document. Once opened you can then apply all the usual edit adjustments before closing it, after which the edit changes will be updated in the parent document.

Figure 8.72 The relationship between a Smart Object and its constituent layers.

Smart Object workflow

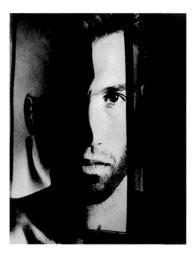

1 Here is a photograph of a book that shows a couple of my promotional photographs, where let's say I wanted to place the photograph shown on the left so that it matched the scale, rotation, and warp shape of the photograph on the right-hand page.

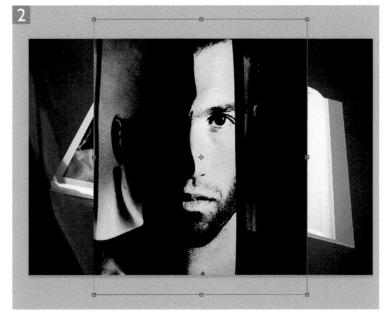

2 I used the Move tool to drag the photograph across to add it as a new layer. I then went to the Layers panel menu and chose 'Convert to Smart Object.' This action preserved all the image data on this layer in its original form. I then went to the Edit menu and chose Transform ⇒ Free Transform. Because the layer boundary exceeded the size of the Background layer, I used the **(Mac)**, **(Mac)**, **(PC)** shortcut to quickly zoom out just far enough to reveal the Transform bounding box handles.

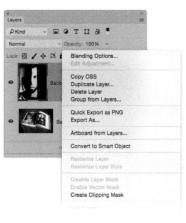

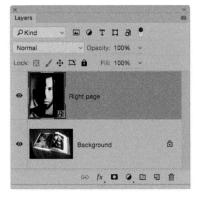

3 I then scaled the Smart Object layer, reducing it in size so it more closely matched the size of the photograph on the page. I also dragged the cursor outside the transform bounding box, to rotate the photograph roughly into position.

4 After that, I clicked on the Warp button in the Options bar (circled). This allowed me to fine-tune the position of the Smart Object layer, by using the corner curve adjustment handles to modify the outer envelope shape. I then moused down inside some of the inner sections and dragged them so that the inner shape also matched the curvature of the page.

Linked Smart Objects

In Photoshop you can create linked Smart Objects, where instead of having embedded Smart Object assets, the Smart Object exists as a link to an external file. A Smart Object link to an external file can be edited independently and updated in Photoshop. This will work with all the usual supported file formats, including raw files (with linked Smart Objects there is support for XMP sidecar files when linking to Camera Raw-edited files). You can therefore have Smart Objects that are either embedded or linked. However, images that contain linked Smart Objects must be saved using the PSD format.

The Layers panel displays these two kinds of Smart Objects using different icons: one for embedded and one for linked Smart Objects. For example, Figure 8.73 shows a Layers panel view of a layered image that uses Smart Objects. Layer 0 is an embedded Smart Object to which I applied a Blur Gallery filter effect as a Smart Filter. The selected layer and the layer below it are both linked Smart Object layers, which means the layer contents are linked to an external file. This Layers panel view shows the layers in a normal, 'updated' state.

Creating linked Smart Objects

To create a linked Smart Object, *all*-drag an image document from the Finder/Explorer, or from Bridge to an open image document in Photoshop. This places the dragged document as a layer, where you will see a placed image bounding box. Click *Enter* to confirm and create a linked Smart Object. You will then see the Smart Object layer appear in the Layers panel as a linked Smart Object.

You can also create Smart Object layers via the File menu. If you choose File \Rightarrow Place Embedded, this will embed the file in the parent image, i.e., the same behavior as used currently in Photoshop. If you choose File \Rightarrow Place Linked, this allows you to select an external file and link it to the image document.

Once you have created a linked Smart Object, if you move or rename the parent image the relative linking within it will be retained. Even so, one of the dangers of using linked Smart Objects is that it is still inherently less safe than embedding. You must take care to ensure the links to the linked asset files are preserved. This is a similar situation to video editing, where the links to various media: video clips, stills, and audio have to be maintained. Figure 8.74 shows the same Layers panel view, but where the link to one of the linked Smart Objects is missing. Here, you can see a red question mark next to the linked Smart Object badge.

Figure 8.73 This shows a Layers panel view of a layered image with Smart Objects.

Figure 8.74 A Layers panel view where a linked Smart Object link is missing.

Figure 8.75 The status bar has a Smart Objects option that shows the current status for linked Smart Objects.

If you go to the Status bar at the bottom of the application screen, or bottom of the image document window (Figure 8.75), there is a 'Smart Objects' option, which allows you to see the latest status for any Smart Objects in the current image. This indicates how many Smart Objects in an opened document are either missing or need to be updated. This is also available as a selectable option in the Info panel. When you click on a Smart Object layer, the Properties panel provides more information about the current Smart Object layer status. Figure 8.76 shows a Properties panel view for a linked Smart Object. Here, you can click on the Edit Contents button to edit the original Smart Object layer/image, or click on the Embed button to convert a linked Smart Object to a regular embedded Smart Object. Figure 8.77 shows a Properties panel view for an embedded Smart Object. Here, you can click on the Convert to Linked button to convert an embedded Smart Object to a linked Smart Object. This opens the system navigation dialog, which prompts you to choose somewhere to store the linked Smart Object file.

You can also convert a Linked Smart Object to an Embedded Smart Object by choosing Layers \Rightarrow Smart Objects \Rightarrow Embed Linked, or Embed All Linked. If you wish to reverse this process you can convert an embedded Smart Object to a linked package file. To do this, go to the Layers menu and choose Smart Objects \Rightarrow Convert to Linked...

C Linked Sm W: 4990 px	H: 2864 px
W: 4990 px X: 1 px	Y: 0 px
Don't Apply La	yer Comp
Ed	it Contents
	Embed

Figure 8.76 The Properties panel showing the Smart Object status.

Figure 8.77 The Properties panel status for an embedded Smart Object.

Resolving bad links

Figure 8.78 shows a Properties panel view for a linked Smart Object with a broken link. If a link is missing on opening you will see the dialog shown in Figure 8.79. This alerts you to any missing links Photoshop can't find. Maybe the linked Smart Object has been deleted? To update a bad link, click on the red question mark icon in the Properties panel and choose 'Resolve broken link...' from the menu. Alternatively, use a right mouse-click on the Smart Object layer in the Layers panel to open the contextual menu and select 'Resolve broken link...' from this menu.

anno	t locate linked	455916;					OK
	Relink 8	/Volumes/Hard driv	e 2/PSCS7 book/New im	ages/Chapter 9/Banne	r images//LV-200	6-105.tif	Canor

Figure 8.78 The Properties panel status for a linked Smart Object with a broken link.

Figure 8.79 This shows the missing assets dialog that will appear when opening a parent image and the linked Smart Objects can't be found.

You can use the Layers panel layer contextual menu (shown in Figure 8.80) to resolve broken links and update them. The update process only modifies the currently selected Smart Object (or duplicate thereof), rather than all linked Smart Objects. Choosing 'Update All Modified Content' updates all Linked Smart Objects in the document. You can use 'Replace Contents...' to change the source file for a Linked Smart Object.

	Blending Options
	Duplicate Layer Delete Layer Group from Layers
	Quick Export as PNG Export As
	Artboard from Layers
	Convert to Smart Object Reveal in Finder
03000	Update Modified Content
	Update All Modified Content Edit Contents Relink to File Relink to Library Graphic License Image Replace Contents Embed Linked
	Rasterize Layer

Figure 8.80 The Layers panel contextual menu for a selected layer.

Packaging linked embedded assets

To share files that contain Linked Smart Objects and make them portable, there is a Package... command available via the File menu. When you have an image open that contains Linked Smart Objects, this allows you to save a copy of the master to a packaged folder containing the master image plus a folder that contains the linked Smart Object files. The Package command currently packages image asset files only and does not yet include other assets such as fonts.

To avoid redundancy, where there are multiple instances of Linked Smart Objects pointing to the same source file the Package operation only creates one copy of a Linked Smart Object source image.

Layers panel Smart Object searches

The search feature in the Layers panel can be used to find both Linked and Embedded Smart Objects. Figure 8.81 shows the Smart Object filter options for the Layers panel where the view on the left shows the normal Layers panel view and the view on the right shows a filtered search to show embedded Smart Objects only. Basically, a search can be carried out to find up-to-date, out-of-date, or missing Smart Objects, as well as Embedded Smart Objects.

Figure 8.81 This shows the Layers panel view and Smart Object filter options (left) and a filtered state (right).

Photoshop paths

If you need to define a complex outline you will usually find it best to draw a path and convert this to a selection. This is quicker than using selection tools like the magic wand or lasso, or painting on a mask.

The Paths panel is shown in Figure 8.82. The Fill path button fills the current path using the current foreground color. The Stroke path button strokes a path using a currently selected painting tool. The Load path as a selection button can be used to convert a path to a selection. Another way to do this is to select the path and hit (# Return (Mac), Ctrl Return (PC). You can then click on the Add Layer Mask button in the Layers panel to add as a layer mask and isolate the object (see Figure 8.83). If a path is selected, clicking the Add mask button adds a vector mask based on that path (see Figure 8.83). Alternatively, you can click twice on the Add Layer Mask button in the Layers panel. This adds a layer mask first, then a vector mask. Or, go to the Layer menu and choose Vector Mask \Rightarrow Current Path. An active selection can be converted to a path by clicking on the 'Make work path from selection' button. Or, you can choose the Make work path option from the Paths panel fly-out menu. Clicking the Create new path button creates a new empty path and you can remove a path by clicking the Delete path button.

Figure 8.82 The Paths panel.

Figure 8.83 This shows a guitar outline masked by a selection (middle) and vector path (right).

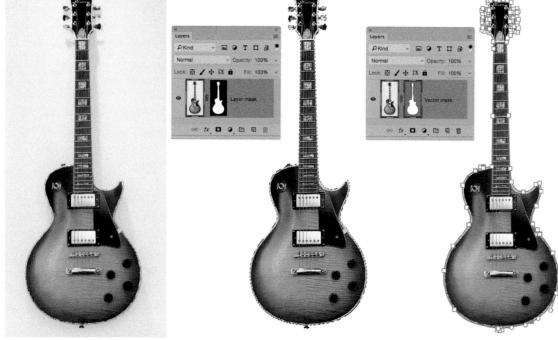

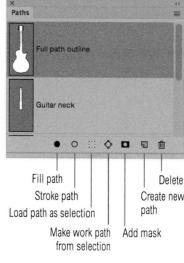

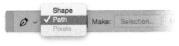

Figure 8.84 The Pen tool mode menu.

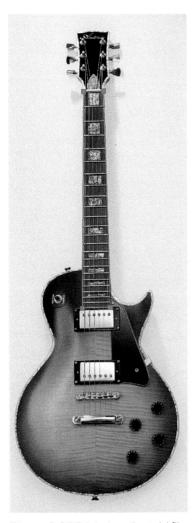

Figure 8.85 This is the path tutorial file, which can be found on the book website.

Pen tool modes

The Pen tool has two modes (Figure 8.84). If the Pen tool is in 'Shape' mode, when you draw with the Pen tool this creates a vector mask path outline that masks a solid fill layer filled with the current foreground color. Selecting the Path mode allows you to create a regular pen path without adding a fill layer to the document. Because any path outline can be used to generate a vector mask I suggest you keep the pen tool in the default 'Path' mode. The Pixels mode is grayed out and is only active when using the vector Shape tools.

Drawing paths with the Pen tool

Unless you have worked previously with a vector-based drawing program (such as Adobe Illustrator), drawing with the Pen tool will probably be an unfamiliar concept. It is difficult to get the hang of it at first, but I promise you this is a skill that's well worth mastering. It's a bit like learning to ride a bicycle: once you have acquired the basic techniques, everything else should soon fall into place. Paths can be useful in a number of ways. The main reason why you might want to use a pen path would be to define a complex shape outline, which in turn can be applied as a vector mask to mask a layer, or be converted into a selection. You can also create clipping paths for use as a cut-out outline in a page layout, or you can use a path to apply a stroke using one of the paint tools.

Pen path drawing example

To help you understand how to create a pen path let's start with the task of following the simple contours of the guitar that's illustrated in Figure 8.85 (you will find a copy of this image as a layered Photoshop file on the book website). This image contains a saved path outline of the guitar at a 200% view. The underlying image is therefore at 200% its normal size, so if you open this at a 100% view, you are effectively able to work on this demo image at a 200% magnification. The Background layer contains the Figure 8.85 image and above it there is another layer of the same image but with the pen path outlines and all the points and handles showing. I suggest you make this layer visible and fade the opacity as necessary. This will then help you to follow the handle positions when trying to match the path outlines. Let's begin by making an outline of the guitar fretboard (as shown in Figure 8.85). Click on the corner sections one after another until you

reach the point where you started. As you approach this point you will notice a small circle appears next to the cursor. This indicates you can now click on it to close the path. If you have learned how to draw with the Polygon lasso tool, you will have no problem drawing this path outline. Actually, this is easier than drawing with the Polygon lasso because you can zoom in if required and precisely adjust each and every point. To reposition, hold down the \mathfrak{K} (Mac), *ctrl* (PC) key to temporarily switch the Pen tool to the Direct selection tool and drag a point to realign it precisely. After closing the path, hit \mathfrak{K} *Enter* (Mac), *ctrl Enter* (PC) to convert the path to a selection, and click *Enter* on its own to deselect the path.

You can reposition a point during the path creation with the Pen tool by holding down the spacebar. Add a point, keep the mouse held down, press the spacebar, and you can then reposition it.

Now try following the guitar body shape (Figure 8.86). This will get you to learn the art of drawing curved segments. The beginning of any curved segment starts by you clicking and then dragging the handle outward in the direction of the intended curve before adding a new anchor point. To understand the reasoning behind this, imagine you are trying to define a circle by following the imagined edges of a square box containing the circle. The direction and length of the handles define the shape of the curve between each path point. To continue a curved segment, click and hold the mouse down while you drag to complete the shape of the end of the previous curve segment (and predict the initial curve angle of the next segment). This is assuming that the next curve will be a smooth continuation of the last. If there happens to be a sharp change in direction for the outline you are trying to follow you will need to add a corner point. You can convert a curved anchor point to a corner point by holding down the *alt* key and clicking on it. Click to place another point and this will now create a straight line segment between these two points. Or, you can click and drag to create a new curved segment with a break in direction from the corner point. Now, if you hold down the 🔀 (Mac), *ctrl* (PC) key you can again temporarily access the direct selection tool and reposition the points. When you click on a point or a segment with this tool the handles are displayed and you can use the direct selection tool to adjust these and refine the curve shape.

To define the entire guitar, including the headstock, you can practice making further curved segments and adding corner points around the tuning pegs.

Figure 8.86 Drawing curved segments with the Pen tool.

0 N A tO O

Figure 8.87 Shown here are the main tools you need to edit a pen path.

Copying and pasting paths

Here is what now happens when you copy and paste a path. If you select a layer that contains no paths, i.e., a bitmap layer, pasting the path data creates a new vector mask. If you select a layer that contains a path, such as a Shape layer (with no path selected), pasting a path replaces the current Shape in the layer. If you do so with the Shape layer path selected this combines the pasted path with the current path. Similarly, if you select a layer with a vector mask, but the vector mask is not selected, then pasting path data replaces the vector mask path. But if you select a layer with a vector mask, and the vector mask is selected, then pasting will paste the path data into the vector mask, combining it with the existing path.

Pen tool shortcuts summary

When the Pen tool is selected you can access all of the pen path tools shown in Figure 8.87 without actually having to actually switch tools in the Tools panel. To add new continuing anchor points to an existing path just click with the Pen tool. Instead of selecting the Convert point tool (second along) you can use the *alt* shortcut to convert a curve anchor point to a corner anchor point (and vice versa). If you want to convert a corner point to a curve, you can *alt* + mouse down and drag.

Instead of selecting the Direct selection tool (third along), you can use the \mathfrak{H} (Mac), *etrl* (PC) key. The Direct selection tool can be used to click on or marquee anchor points and reposition them. You can edit a straight line or curved segment by selecting the Direct selection tool, clicking on the segment and dragging. With a straight segment the anchor points at either end will move in unison. With a curved segment, the anchor points remain fixed and you can manipulate the shape of the curve as you drag.

To add an anchor point to an existing path, rather than selecting the Add anchor point tool (fourth along) you can simply click on a path segment. To remove an anchor point, you can click on it again rather than select the Delete anchor point tool (fifth along). When an anchor point is selected and you need to position it accurately, you can nudge using the arrow keys on the keyboard and use the *Shift* key to magnify the nudge movement.

Pen tool options

One way to make the learning process somewhat easier is to enable the Rubber Band mode, which is hidden away in the Pen Options on the Pen tool Options bar (Figure 8.88). In Rubber Band mode, you will see the segments you are drawing take shape as you move the mouse cursor and not just when you mouse down again to define the next path point. As I say, this mode of operation can make path drawing easier to learn, but for some people it can become rather distracting once you have got the basic hang of how to follow a complex outline using the various pen path tools.

Figure 8.88 The Pen tool Options bar with the Rubber Band and Path Display options.

Path display options

The Path Display options can be used to control the path appearance. Here, you can adjust the thickness and color of the path outline. With the advent of high resolution displays for Mac and PC, the visibility of pen paths in Photoshop has been a real problem. This has been solved by allowing users to adjust the path width thickness and color. The default setting is 1 pixel. This is perhaps a little too wide for precision work, but you can select other options from the Thickness menu. You can also type in a specific Thickness value as long as this is between 0.5 and 3.0 pixels. The default pen path color is blue, but you can mouse down on the Color menu to select other path color options.

Curvature Pen tool

The Curvature pen tool is similar to the one in Adobe Illustrator. It is like a simplified version of the regular Pen tool and can help you draw smooth, flowing lines. Normally you need to have some idea of the direction to drag the handles in order to create your intended curve shape. With the Curvature pen tool you simply click and click to create a series of curves. No dragging is required here, as Photoshop works this all out for you. To edit a path using the Curvature Pen tool you can push or pull the path segments directly, instead of having to manually modify the bezier handles. You double-click to switch between adding a curved and a non-curved segment.

The Curvature pen tool is designed to make it easier to produce a series of smooth flowing curves. Figure 8.89 shows a sequence of path segments created using the Curvature Pen tool. These segments were created using a series of single clicks. The first two clicks created a straight line segment. However, a third click created a curved segment between the second and third anchor point, but this also changed the first segment to a curved segment. Subsequent clicks added more curved segments, where each new segment also changed the shape of the one before it. With this in mind you can see how the Curvature Pen tool is not always the most appropriate type of tool to use to define a subject outline. The reason being that each anchor point you add affects the shape of the two preceding path segments. In some cases this is a good thing because it helps you to draw smoother shaped curves. But equally, it can be a frustrating experience, as you have less control compared to the regular Pen tool. It is nonetheless a useful tool for creating smooth shape outlines. To toggle between a smooth and a corner point while working with the Curvature pen tool, double-click or alt -click a point.

Pen tool shortcut tip

You can if you like, edit the tool shortcuts so that pressing **P** or **Shift P** toggles between just the normal Pen tool and Curvature pen tool.

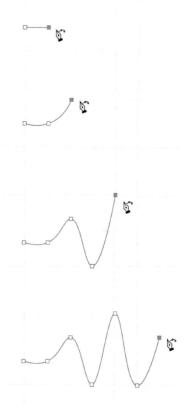

Figure 8.90 The Path selection tool (left) and Direct selection tool (right).

Figure 8.91 More than one path can be selected at a time in the Paths panel.

Path selection tools

Once you have created a path, the path selection tools can be used to select the anchor points (Figure 8.90). Both share the A keyboard shortcut. Marquee dragging or clicking on a path with the Path Selection tool activates the path and selects all the points on it. Marquee dragging or clicking on a path with the Direct selection tool activates the path, but only selects the anchor points or segments you marqueed or clicked on. Clicking with either tool away from the path deselects the path and anchor point selection.

If you have a path selected with multiple anchor points activated, a mouse-click on an anchor point with the Direct selection tool will make that single anchor selected and deselect all the other points. However, if you make a selection of a few anchor points and you wish to preserve this selection, you'll need to click and hold with the mouse and drag. The anchor point selection will then be preserved. So, when you single-click on an anchor point it deselects all the anchor points. But when you click and drag the selection is preserved.

Paths panel selections

In the Paths panel, it is possible to select multiple paths, more or less in the same way as you can select multiple layers via the Layers panel (see Figure 8.91). For example, you can use the *Shift* key to select a contiguous range of paths from the Paths panel to make them active, or you can use the **(Mac)**, *ctrl* (PC) key to make a discontiguous path selection.

Multiple selected paths can be deleted, duplicated, or moved. You can duplicate a path or multiple path selection by dragging it to the New path button in the Paths panel, or you can simply *all* drag a selected path (or paths) in the Paths panel to create duplicates.

The Path selection tool and the Direct selection tools are also multi-path savvy. You can select the paths you wish to target via the Paths panel and then use the Path selection or Direct selection tool to select the targeted paths only as you drag on canvas. Let's say you had two paths selected in the Paths panel. You could use the Path selection tool or Direct selection tool to target either or both selected paths via on-canvas dragging. Figure 8.93 shows an example of how multiple path selection can work in practice. In the example shown here, three paths were first selected via the Paths panel: the guitar head, neck, and main body. With these paths 'activated' via the Paths panel (Figure 8.92), I selected the Path selection tool ((A)) and dragged on the image to select one or more of the activated paths. In the left-hand example I dragged to select the Guitar Body path only and make that selected. In the middle example I dragged to select the head and neck only. In the right-hand example, I dragged to select the head first, then held down the Shift key to drag and select the body as well, making both paths selected. To help make the above points clearer, I have shaded the selected paths in green.

The main thing to understand here is that clicking on a path or multiple paths in the Paths panel 'activates' them. To then 'select' a path or paths, you'll need to click on a path outline in the image, or marquee drag with the Path selection or Direct selection tool.

Figure 8.92 The Paths panel.

Figure 8.93 Examples of pen path selections made using the Path selection tool based on the above Paths panel selection.

Hiding/showing layer/vector masks

You can temporarily hide/show a layer mask by *Shift*-clicking on the layer mask icon. Also, clicking a vector mask's icon in the Layers panel hides the path itself. Once hidden, hover over it with the cursor and it will temporarily become visible. Click it again to restore the visibility.

Vector masks

A vector mask is just like an image layer mask, except the mask is described using a vector path. A big advantage of using a vector mask is it can be further edited using the Pen path or Shape tools. To add a vector mask from an existing path, go to the Paths panel, select a path to make it active, and choose Layer \Rightarrow Add Vector Mask \Rightarrow Current Path. Alternatively, go to the Properties panel in Masks mode and click on the 'Add Vector Mask' button (see Figure 8.22 on page 508).

Figure 8.94 shows how a vector mask can be created from a currently active path such as the active path in the image on the left. The path mode influences what is hidden and what is revealed when the path is converted to a vector mask. If a path is created in the 'Subtract Front Shape' mode (as in the middle example), the area inside the path outline is hidden (the gray fill in the path icon represents the hidden areas). If the path is created in the 'Combine Shapes' mode (as in the right-hand example) everything outside the path outline is hidden. However, it is very easy to alter the path mode. Select the path selection tool and click on the path to make all the path points active. You can then click on the path mode menu (circled in the Options bar) to switch between the different path modes.

Align Edges 🔅 Constrain Path Dragging

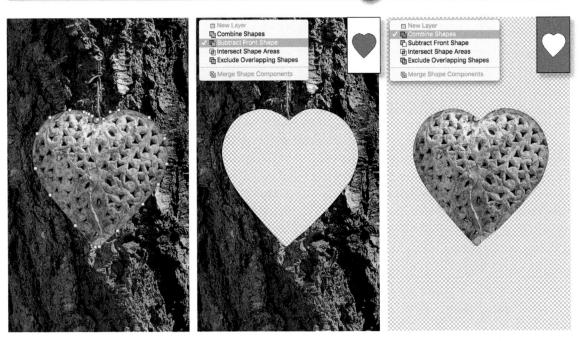

60

Figure 8.94 Examples of how a vector mask can be used to mask a layer.

Isolating an object from the background

Let's now look at a practical example of where a vector path might be used in preference to a pixel layer mask to mask an object. Remember, one of the benefits of using a vector mask is that you can use the Direct selection tool to manipulate the path points and fine-tune the outline of a mask.

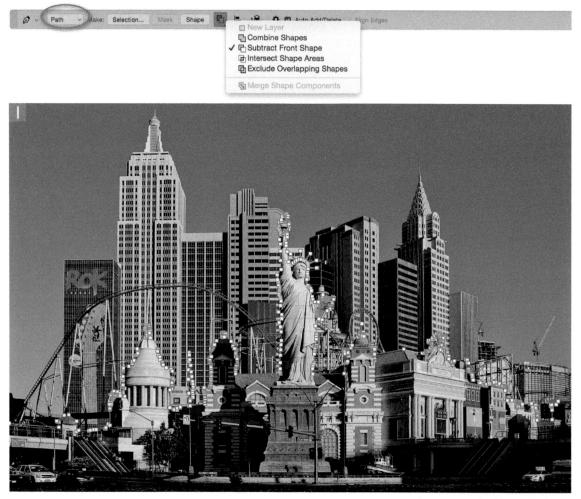

1 Here, I used the Pen tool to define the outline of the buildings in the foreground. The Pen tool was in the Path mode (circled in the Options bar). Because I wanted to create a path that selected everything outside the enclosed path, I checked the Subtract Front Shape option before I began drawing the path. When the path was complete, I went to the Paths panel, double-clicked the 'Work Path' name, and clicked OK to rename it as 'Path 1' in the Save Path dialog. This saved the work path as a new permanent path. It is important to remember here that a work path is only temporary and will be overwritten as soon as you deselect it and create a new work path.

TIA

Preset: Custom	¥
35 Master	
lue:	0
Saturation:	-100
ightness:	0
1 1. 1. Colorize	

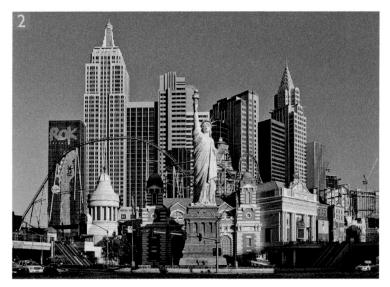

2 With the Path 1 active, I clicked on the 'Add New Adjustment Layer' button in the Layers panel and selected Hue/Saturation. I then set the Saturation to –90. As you can see, this applied a desaturating adjustment to the isolated buildings in the background.

3 In this final step I added a Curves adjustment layer in a clipping group with the vector masked Hue/Saturation layer. With the Curves adjustment I applied an adjustment that darkened the midtones, but lightened the shadows.

x Layers P Kind

Chapter 9

Blur, optical, and rendering filters

One of the key factors behind Photoshop's success has been the program's support for plug-in filters. A huge industry of third-party companies has grown in response to the needs of users wanting extra features within Photoshop. Instead of covering all the hundred or more filters that are supplied in Photoshop, I have just concentrated here on those filters that I believe are useful for photographic work. In particular, I have concentrated on those filters that relate to blurring, optical, and perspective corrections, plus rendering. I also show you ways you can use the Smart Filters feature to extend your filtering options.

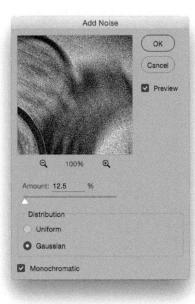

Figure 9.1 The Noise \Rightarrow Add Noise filter can be used to add artificial noise.

Figure 9.2 The Average Blur can be used to merge the pixels within a selection.

Filter essentials

Most Photoshop filters provide a preview dialog with slider settings that you can adjust, while some of the more sophisticated plug-ins (such as the Lens Correction filter) are like mini applications operating within Photoshop. These have a modal dialog interface, which means that whenever the filter dialog is open, Photoshop is pushed into the background and this can usefully free up already-assigned keyboard shortcuts. With so many effects filters to choose from, there are plenty enough to experiment with. The problem is that you can all too easily get lost endlessly searching through all the different filter settings. Here, we shall look at a few of the ways filters can enhance an image, highlighting those that are most useful. Most of the essential filters, such as those used to carry out standard production image processing routines are all able to run in 16-bit RGB mode. Some, however, are limited to 8-bit RGB mode processing.

Blur filters

There are 16 different kinds of blur filters you can apply in Photoshop and each allows you to blur an image differently.

You don't really need to bother with the basic Blur and Blur More filters, but what follows are some brief descriptions of the blur filters I do think you will find useful.

Gaussian Blur

The Gaussian Blur is a good general purpose blur filter and can be used for many purposes from blurring areas of an image to softening the edges of a mask. However, the Gaussian Blur can sometimes cause banding to appear in an image, which is where it may be useful to use the Noise \Rightarrow Add Noise filter afterwards to help disguise this (see Figure 9.1).

Average Blur

The Average Blur simply averages the colors in an image or a selection. At first glance it doesn't do a lot, but it is still a useful filter to have at your disposal. Let's say you want to analyze the color of some fabric to create a color swatch for a catalog. The Average filter merges all the pixels in a selection to create a solid color and you can then use this to sample with the eyedropper tool to create a new Swatch sample color (see Figure 9.2).

Adding a Radial Blur to a photo

The Radial Blur can do a good job of creating blurred zoom lens effects. For example, the Zoom blur mode (shown in Figure 9.3) can be used to simulate a zooming camera lens. You can also drag the center point in the filter preview dialog to approximately match the center of interest in the image you are about to filter (I added a radial gradient to the Smart Filters mask to hide the blur effect in the center). For legacy reasons the Radial Blur filter offers a choice of render settings. This is because the filter was devised before the age of GPU processing. For optimum results, select the Best mode. If you just want to see a quick preview you can always select the Draft mode option. Now that Photoshop features a new Blur Gallery Spin Blur filter effect, the Spin mode is less relevant.

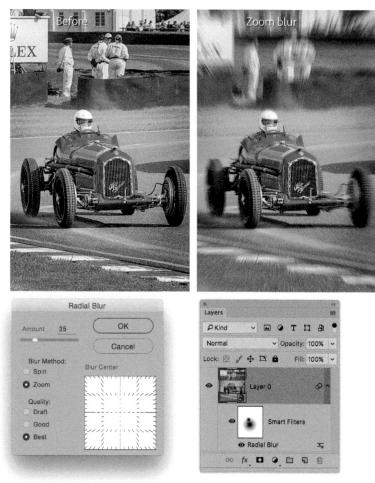

Figure 9.3 You can use the Radial Blur filter in Zoom mode to create zoom lens effects such as in the example shown on the right.

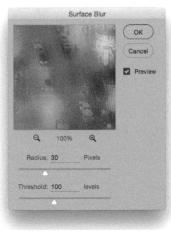

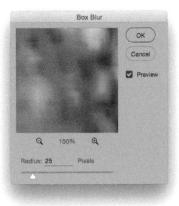

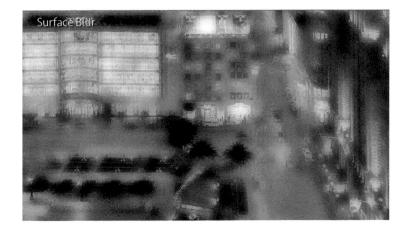

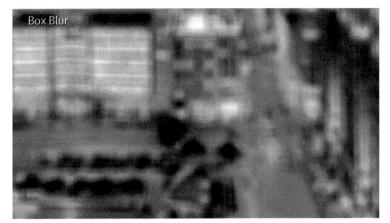

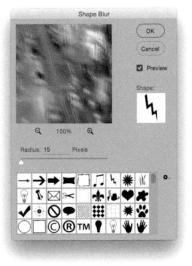

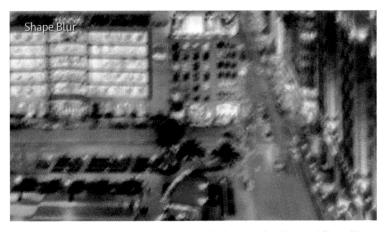

Figure 9.4 This shows from top to bottom, the Surface Blur, Box Blur, and Shape Blur filters applied to the same image.

Surface Blur

This Surface Blur filter (Figure 9.4) is like an edge-preserving blur filter. The Radius adjustment is identical to that used in the Gaussian Blur filter, so the higher the Radius, the more it blurs the image. Meanwhile, the Threshold slider determines the weighting given to the neighboring pixels and whether these become blurred or not. Basically, as you increase the Threshold this extends the range of pixels (relative to each other) that become blurred. So as you increase the Threshold, the flatter areas of tone are the first to become blurred and the high contrast edges remain less blurred (until you increase the Threshold more). Significant performance improvements have been made to the Surface Blur filter in this latest release of Photoshop CC.

Box Blur

The Box Blur uses a simple algorithm to produce a square shape blur. It is a fairly fast filter and is useful for creating quick 'lens blur' type effects and certain other types of special effects. The Box Blur is no match for the power of the Lens Blur filter, but it is nonetheless a versatile and creative tool.

Shape Blur

The Shape Blur filter lets you specify any shape you like as a kernel with which to create a blur effect and you can then adjust the blur radius accordingly. In Figure 9.4 (bottom image) I selected a lightning shape.

Fade command

Filter effects can be further refined by fading them after you have applied the filter. The Fade command is referred to at various places in the book (you can also fade image adjustments and brush strokes, etc.). Choose Edit \Rightarrow Fade Filter and experiment with different blending modes. The Fade command is almost like an adjustment layer feature, but without the versatility and ability to undo later. It makes use of the fact that the previous undo version of the image is stored in the undo buffer and allows you to apply different blend modes, but without the time-consuming expense of having to duplicate the layer first. Having said that, the History feature offers an alternative approach whereby if you filter an image once or more than once, you can return to the original state and paint in the future (filtered) state using the History Brush or make a fill using the filtered history state (provided non-linear history has been enabled in the History panel options).

Enabling Lens Blur as a Smart Filter

Smart Filters are mainly intended for use with value-based filters only, such as the Add Noise or Unsharp Mask filter. They are not intended for use with filters such as Lens Blur because the Lens Blur filter can sometimes make calls to an external alpha channel, and if the selected alpha channel were to be deleted at some point, this would prevent the Smart Filter from working. However, so long as you are aware of this limitation, it is still possible to enable Smart Filters to work with filters like Lens Blur. You first need to go to the Adobe website and search for the following script: EnableAllPluginsforSmartFilters.jsx. This then needs to be placed in a suitable folder location such as the Adobe Photoshop CC/Presets/Scripts folder. Then, go to the File ⇒ Scripts menu in Photoshop and choose Browse... This opens a system navigation window. From there you'll want to locate the above script. Once you have done this, you can click Load or double-click to run it, which will pop the Script Alert dialog shown in Figure 9.5. If you wish to proceed, click 'Yes.' The Lens Blur, as well as all other filters will now be accessible for use as Smart Filters. If you want to turn off this behavior, run through the same above steps and click 'No' when the Script Alert dialog shows.

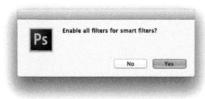

Figure 9.5 The Script Alert dialog.

Lens Blur

If you want to make a photograph appear realistically out of focus, it is not just a matter of making the detail in the image more blurred. Consider for a moment how a camera lens focuses a viewed object to form an image that is made up of circular points on the film/sensor surface. When the radius of these points is very small, the image is considered sharp and when the radius is large, the image appears to be out of focus. It is particularly noticeable the way bright highlights tend to blow out and how you can see the shape of the camera lens iris in the blurred highlight points. The Lens Blur filter has the potential to mimic the way a camera lens forms an optical image and the best way to understand how it works is to look at the shape of the bright lights in the night-time scene opposite, which shows an image before and after I had applied the Lens Blur filter.

The main controls to concentrate on are the Radius slider, which controls the amount of blur that is applied to the image, and the Specular Highlights slider, which controls how much the highlights blow out. To add more lens flare, increase the Brightness slightly and carefully lower the Threshold amount by one or two levels and check to see how this looks in the preview area. The Iris shape controls (Blade Curvature and Rotation) should be regarded as fine-tuning sliders that govern the shape of the out-of-focus points in the picture. You can select from a menu list of different iris shapes and then use these sliders to tweak the iris shape. The results of these adjustments will be most noticeable in the blown-out highlight areas. If you want to predict more precisely what the Lens Blur effect will look like it is best to have the 'More Accurate' button checked.

Depth of field effects

With the Lens Blur filter you can also use a mask channel to define the areas where you wish to selectively apply the Lens Blur. This allows you to create shallow depth of field effects, such as in the example shown on the right. Basically, you can use a simple gradient (or a more complex mask) to define the areas that you wish to remain sharp and those that you want to have appear out of focus. You can then load the channel mask as a Depth Map in the Lens Blur dialog and use the 'Blur Focal Distance' slider to determine which areas remain sharpest.

1 In this example, I created a mask channel called Alpha 1, where a gradient went from white to black and I painted with gray over areas I wished to preserve.

	Lens Blur (100%)			
4	1	ОК	ОК	
	2	Cancel	Cancel	
		Faster O More Accurate	Preview	
		Depth Map Source: Alpha 1	G Faster O More Accurate	e
		Blur Focal Distance 117	Depth Map	
Anna .		Invert	Source: Alpha 1	~
hit - that -		Iris Shape: Hexagon (6)	Blur Focal Distance	117
		Radius 85		
	a guinner?	Blade Curvature 0	Invert	
	A DECEMBER OF THE OWNER	Rotation 0	Iris	
		Specular Highlights	Shape: Hexagon (6)	~
	The second	Brightness 24	Radius	65
		Threshold 196	Blade Curvature	0
		Noise Amount 0		0
	ALL T	Distribution	Rotation	0
		O Uniform Gaussian		
] 100% 😒		Monochromatic	Specular Highlights	
A REAL PROPERTY OF A REAL PROPER			Brightness	24
			Threshold	196
hen loaded the Alpha	1 channel in the Lens Blur filter dialog t	o use as a depth map.	Noise	
the Alpha 1 channel	selected, I could now adjust the Blur For	cal Distance slider	Amount	0
	ere I wanted the image to remain sharp.			0
	a in the Depth Man equires shannel	the setting applied here	Distribution	

is linked to the gray shades in the Depth Map source channel.

Figure 9.6 The Blur Tools controls.

×		44
Effects	Motion Effects Noise	
Bokeh		
Light B	lokeh:	5%
		an terpegra kontragiona
Bokeh	Color:	0%
Light R	lange:	
191	-	255

Figure 9.7 The Blur Effects controls.

Figure 9.8 A typical lens bokeh effect.

Blur Gallery filters

The Lens Blur filter has enough slider controls for you to create fairly realistic-looking Lens Blur effects, but does suffer from certain limitations. Firstly, it can be quite slow to work with and therefore a painstaking experience to tweak the sliders in search of an optimum blur setting. The sheer number of sliders can also be considered quite intimidating, which may put some people off using this filter. While it is possible to create blur maps that can be used in conjunction with the Lens Blur filter, it is this aspect of its design that limits it from being accessible as a Smart Filter (though as I point out on page 608 it is possible to overcome this). The Blur Gallery filters offer a more simplified interface for applying Lens Blur effects. Overall these are a lot quicker to work with than the Lens Blur filter, have fewer controls to bother with, and the blur effects can easily be edited. These are all available from the Filter \Rightarrow Blur Gallery menu. When a Blur Gallery filter is selected this opens the two panels shown on the left. In this semi modal state you actually have access to all five Blur Gallery filter modes via the Blur Tools panel shown in Figure 9.6.

The Blur Gallery filters offer quite a lot of options for being creative, but there are some restrictions you need to be aware of. You can only apply this filter to RGB or CMYK images. It won't work on grayscale images, alpha channels, or layer masks.

Iris Blur

Let me start first with the Iris Blur filter. The Blur slider controls the strength of the blur effect and allows you to apply much stronger blurs than you can with Lens Blur. The Effects panel (Figure 9.7) contains the Blur Effects controls. The term 'bokeh' refers to the appearance of out-of-focus areas in a picture when photographing a subject using a shallow depth of focus (see Figure 9.8). What happens when you do this is that out-of-focus objects in a scene are focused as large, overlapping circles at the plane of focus. Objects that are in focus are also focused as overlapping circles, but an image is perceived to be sharp when those circles are small enough that they create the illusion of sharpness. The circles aren't actually circles-they are determined by the shape of the lens iris, which is usually pentagonal or hexagonal in shape. So, to create a bokeh-type effect in Photoshop, the Iris Blur filter applies a hexagonal iris shape blur to the image. The Light Bokeh slider lets you control the intensity of the bokeh effect by working in conjunction with the Light Range sliders to 'blow out' selected tonal areas and create bright, out-offocus highlights. With the Lens Blur filter you have a Brightness and a single Threshold slider that control the appearance of the specular

highlights. The Light Range control in the Blur Effects panel is a little more sophisticated. There are two sliders: one for the highlights and one for the shadows. What happens here is the filter uses an inverse high dynamic range tone mapping to create a pseudo high dynamic range between the two slider points. By adjusting the shadow and highlight sliders, Photoshop can intensify the tonal range between these two points. This simulates a real-life subject brightness range and then applies the blur effect to the data. This is an important difference and is what helps make the Blur Gallery effects look more realistic compared with other blur methods. Basically, this gives you the flexibility to apply the bokeh effect to any tone area in the image you like and not just the highlights. For example, you can have a bokeh effect applied to the midtones or the shadows only. The Bokeh Color slider can be used to specifically intensify the color saturation of the bokeh effect. The default setting of zero will work best in most cases, but some shots may benefit from increasing the Bokeh Color slider setting.

Ellipse field controls

The Iris Blur filter ellipse field controls are shown in Figure 9.9 below. By default this initially appears centered in the image. You can click on the center pin to reposition and drag any of the four outer ellipse handles to adjust the shape and angle of the radius field. There is also a radius roundness knob that you can drag to make the ellipse field rounder or squarer. In between the center and the outer radius are

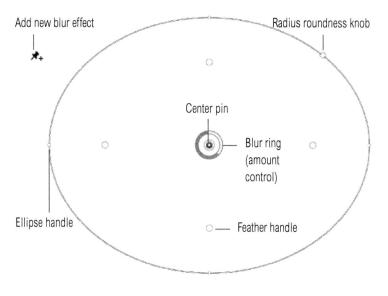

Figure 9.9 The Iris Blur ellipse field controls.

Faster graphics processing

Blur Gallery filters are able to make use of what is known as 'Mercury Graphics' processing in Photoshop. If 'Use Graphics Processor' is enabled in the Performance preferences this can help speed up the time it takes to render the Blur Gallery previews in mouse-up mode as well as when processing the final render. Depending on the card this can make a big difference to final render times. You should also notice a more accurate preview while making blur adjustments or when moving a pin. However, this preview enhancement will only be noticed if using a graphics card that supports 1 GB of VRAM or higher. For example, Intel HD 4000 and AMD Trinity APU cards will support improved mousedown previews.

the feather handles. You can drag on any of these to adjust the overall hardness/softness of the blur effect edge relative to the center or outer ellipse edge and if you hold down the *alt* key you can click and drag any of these four pins independently.

Just outside the pin in the center is a blur ring. This indicates the blur amount applied to the effect. Click on the ring and drag clockwise to strengthen the blur effect and drag anti-clockwise to reduce the blur amount. As you move the mouse around the image you'll see an 'add new pin' icon. If you click, this adds a new blur effect with accompanying ellipse field controls. Hold down **(**) to temporarily hide the on-image field control display.

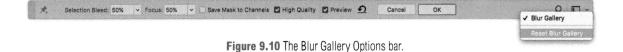

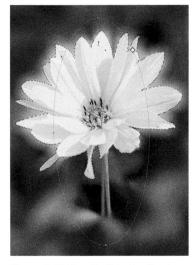

Figure 9.11 Here, the Selection Bleed amount was increased to let the unselected area to bleed into the selection area.

Blur Tools options

The Blur Gallery Options bar (Figure 9.10) provides additional controls. You can use the drop-down menu on the right to reset the Blur Gallery panel positions and settings. If one of the Blur Gallery panels appears to be missing, select Reset Blur Gallery to make all the panels visible again. The Selection Bleed slider controls the extent to which areas outside the selection can bleed into the area that's selected (there must be an active selection for this to be enabled). In Figure 9.11 I selected everything but the flower and as I blurred the selected area, I set the Selection Bleed in the Options bar to 50%. This deliberately allowed the areas outside the selection to blend into the blurred area. To help make the edges look more convincing, only a small amount of bleed should be applied, but you can also use this as a way to produce creative edge bleed effects by applying a heavy blur with a high Selection Bleed value. The Focus slider lets you control how much the focus in the center is preserved. At 100%, everything from the center outwards is kept sharp. As you reduce the amount the center becomes more out of focus. When multiple Pins are placed this does allow you to preserve the non-blurred area properties for each specific pin (this is a per-pin setting). The 'Save Mask To Channels' checkbox lets you save an alpha channel that contains a blur mask based on the feathered area. This could be useful if you felt you needed to add noise later to a blur effect based on the same degree of feathering. Lastly, checking the High Quality checkbox will result in more accurate bokeh highlights.

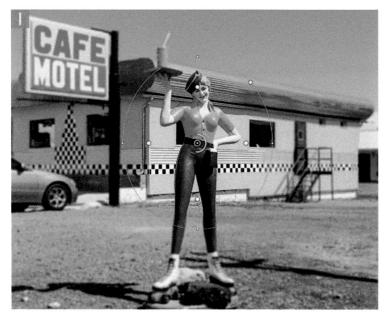

1 When applying the Blur Gallery filter in Iris Blur mode, the ellipse field controls will be shown, where you can edit the controls and adjust the Blur Tools settings.

2 I dragged the outer ellipse handles to rotate and increase the size of the radius field, and dragged the Radius roundness knob to make the radius slightly squarer. I then held down the *and* key to drag the inner feather handles to independently adjust the hardness/softness of the blur edge for all four corners. Lastly, I adjusted the Effects panel sliders to create the bokeh effect seen here.

×	••
Blur Tools	
► Fleid Blur	
▼ Iris Blur	
Blur:	25 px
► Tilt-Shift	
Path Blur	
► Spin Blur	
Effects Motion Effects Nois	ie
Bokeh	
Light Bokeh:	0%
Bokah Color:	0%
	0.96
Light Range:	
	055
191	255
×	and the second se
	40
x Blur Tools ▶ Field Blur	**
x Blur Tools ▶ Field Blur	۰۰ ۱
x Blur Tools ▶ Field Blur ▼ Iris Blur	**
x Blur Tools ▶ Field Blur ▼ Iris Blur	۰۰ ۱
x Biur Tools Field Blur Iris Blur Blur: Tiit-Shift	•
x Bior Tools Field Blur Iris Blur Blur: Tilt-Shift Path Blur	•
s Blur Tools Field Blur Iris Blur Blur: Tilt-Shift	•
s Blur Tools Field Blur Tiris Blur Blur: Tilit-Shift Path Blur	•
s Blur Tools Field Blur Tiris Blur Blur: Tilit-Shift Path Blur	•
x Bior Tools Field Blur Iris Blur Blur: Tilt-Shift Path Blur	•
s Blur Tools Field Blur Tiris Blur Blur: Tilit-Shift Path Blur	•
x Bior Tools Field Blur Iris Blur Blur: Tilt-Shift Path Blur	•
x Blar Tools Field Blar Iris Blar Blar Blar - Tilt-Shift Fath Blar - Spin Blar	25 px
K Blar Tools Field Blar Iria Blar Blar: Titl-Shift Path Blar Spin Blar Effects Motion Effects Notice	25 px
x Bilur Tools Field Blur Iris Blur Blur: Tili-Shift Path Blur Spin Blur Spin Blur	25 px
K Blar Tools Field Blar Iria Blar Blar: Titl-Shift Path Blar Spin Blar Effects Motion Effects Notice	25 px
x Bilur Tools Field Blur Iris Blur Blur: Tili-Shift Path Blur Spin Blur Spin Blur	25 px
x Bilur Tools Field Blur Iris Blur Blur: Tili-Shift Path Blur Spin Blur Spin Blur	25 px

250

Light Rang

187

Figure 9.12 A close-up view of the image before and after adding noise to a blur effect.

Noise panel

One of the problems you get when adding Blur Gallery effects is that the blur effect also blurs the underlying noise structure of the image. Now, this is not such a problem if the image you are working on has no visible noise. But when editing a high ISO capture, the Noise panel can come in handy. This is because it can be used to add noise to the blurred areas, simulating the noise in the original image. In Figure 9.12 the top view shows the outcome where no noise being added and below where a noise grain effect was added to the Blur Gallery effect.

When working with any of the Blur Gallery filters you simply go to the Noise panel shown in Step 2. Here, you can select a noise method from the menu (Gaussian, Uniform, or Grain) and adjust the Amount slider to determine how much noise should be added. In Grain mode, the controls are the same as those found in the Camera Raw Effects panel and you can adjust the Size and Randomness sliders to match the graininess of the original image. The Color slider controls the monochrome to color ratio (this can help you match the color noise appearance). Lastly, there is the Highlights slider. This can be used to reduce the noise in the highlight areas to achieve better highlight/ shadow matching.

1 This photograph was shot using the Canon EOS 550D at 6400 ISO. As one might expect, there is a fair amount of luminance and color noise visible in this image. It can be treated to some extent using the Detail panel, but not completely.

2 I went to the Filter menu and chose Blur Gallery \Rightarrow Iris Blur. I manipulated the iris shape to achieve the desired shape and applied a 35 pixel blur. However, the blur effect also blurred the underlying grain in the image.

3 To correct this, I enabled noise in the Noise panel, set the mode to 'Grain' (circled), and adjusted the Amount slider to add more noise, setting the Size to 25% and the Roughness to 50%. I then went to the Color slider and set this to 15% (to make the added noise less monochrome). With the Highlights slider I left this set to 100%. Basically, these controls allow you to kind of mimic the appearance of the underlying grain in a photograph.

Blur Tools	
 Field Blur 	
▼ Iris Blur	
Blur:	35 px
	and the second second second
Tilt-Shift	
Path Blur	
Spin Blur	
Rects Motion Effects	Noise
flects Motion Effects Gaussian	
Gaussian	-
Gaussian	-
Gaussian Amount:	-
Gaussian Amount:	-
Gaussian Amount: Size:	
Gaussian Amount: Sizes: Hougtiness:	0.00%
Gaussian Amount: Sizes: Hougtiness:	-
:Rects Motion Effects Gaussian Amount: Stop: Fougtiness: Color: Highlights:	0.00%

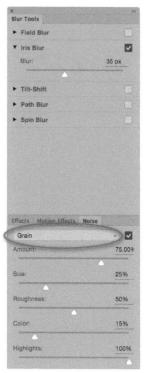

Multiple blur effects

With both the Tilt-Shift and Iris blur filters, the pins within each effect will interact with each other using what is essentially a Multiply blend mode. When multiple effects are combined the resulting blur radius fields from each effect are added together. Also at the same time, the areas of clarity are added together so that where there is an overlap the clarity is always preserved. This means you can easily combine different kinds of Blur Gallery effects to produce a 'merged' blur effect.

Figure 9.14 This shows an example of how tilt-shift distortion should be expected to work when a lens is tilted.

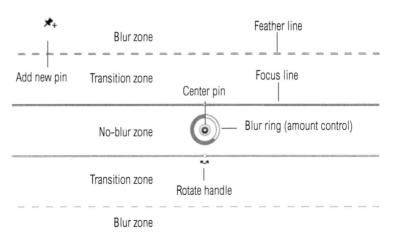

Figure 9.13 The Tilt-Shift blur controls.

Tilt-Shift blur

The Tilt-Shift blur filter can mimic both the blur and distortion effect you would get when shooting with a view camera where you can tilt the film plane and also the effect you can get when shooting with a Lens Baby[™] lens. You can also combine multiple Tilt-Shift blur effects with one or more other Blur Tools effects to achieve any kind of blur effect.

When you apply a Tilt-Shift blur you'll see a pin in the center with two solid focus lines either side of the pin (see Figure 9.13). These indicate the no-blur zone in which the image will remain in focus. Beyond are the dotted feather lines. Between the focus and feather lines is the transition zone where the image fades from being in focus to out of focus, as set by the Blur slider in the Blur Tools panel. You can adjust the width of these lines by dragging on them. To relocate a blur effect, click and drag inside the no-blur zone. To adjust the Tilt-Shift blur angle, click and hold anywhere outside the central no-blur zone and drag with the mouse (you'll see a double-headed arrow cursor). To remove a blur effect, just hit the Delete key. You can hold down \blacksquare to temporarily hide the on-image display. New Tilt-Shift blur effects can be added by clicking anywhere in the image.

The Distortion slider can be used to add a distortion effect. If you apply a blur, adjust the Distortion slider and move the center pin from side to side you'll see the distortion effect change as you do this (centering around where the center pin is placed). Figure 9.14 shows how a tilt-shift distortion should be expected to work when a lens is tilted. In the top direction the circles of confusion are more elliptical, stretching outwards from the center and becoming more elongated towards the corners. This can be simulated using a positive Distortion with the Tilt-Shift blur filter. On the opposite axis the distortion is circumferential. This can be simulated by adding negative Distortion.

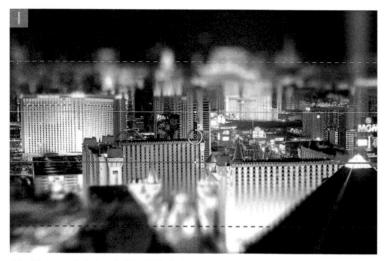

1 In this example I placed a Tilt-Shift pin in the middle of the image. I increased the blur effect to 80 pixels and applied a maximum +100% Distortion. Both sides of the pin appear blurred, but by default the Distortion setting affected the bottom section only. As you can see, the positive distortion created stretched ellipses radiating from the center towards the bottom corners of the picture. If I were to reposition the central pin, the ellipses would reface to the new pin position.

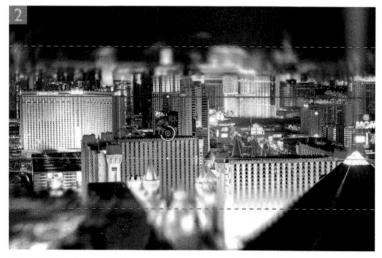

2 To distort the top half of the picture, I added a new pin next to the first. Here, I clicked and held the cursor just below the no-blur/transition zone line and dragged to rotate the Blur effect 180°. By default the same blur settings were applied to this second pin. All I did here was set the Distortion to -100% to create a circumferentially oriented distortion in the top half of the picture and adjusted the settings slightly. Alternatively, you can check the 'Symmetric Distortion' box to apply a mirrored distortion without needing to add a second pin. However, in this instance a symmetric distortion always shares the same Distortion slider setting.

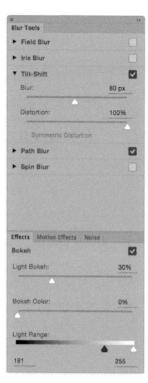

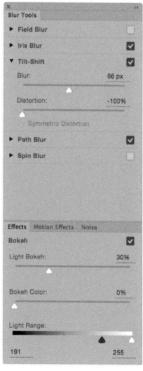

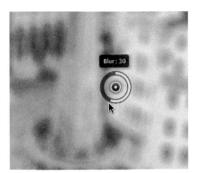

Figure 9.15 A blur amount display appears as you interactively click and drag on the outer blur ring.

×	
Blur Tools	
▼ Field Blur	
Blur:	30 px
► Iris Blur	
► Tilt-Shift	
► Path Blur	
► Spin Blur	
Effects Motion Effects Noise	
Bokeh	
Light Bokeh:	16%
<u> </u>	Arrest 612 - An April 2005
Bokeh Color:	0%
Analysis and a second s	inequalities and the second
Light Range:	
•	
135	196

Blur ring adjustments

The Blur ring has a central pin and an outer ring, which indicates the blur amount applied to that pin. As you adjust the Blur slider the outer ring provides a visual indication of the blur amount that's been applied (see Figure 9.15). It is also possible to click and drag on this ring to adjust the blur amount.

Field Blur

The Field Blur effect can be used to apply a global blur effect. As with the Iris and Tilt-Shift blurs, you have a Blur slider in the Blur Tools panel and the usual set of Bokeh sliders in the Blur Effects panel below. You can use this filter to apply an overall lens blur type of effect, but as you can see in the accompanying example, by adding further pins it is possible to create different kinds of custom gradient blur effects.

1 When you apply the Field Blur filter you'll see a pin in the middle of the frame set to a default 15 pixel-wide blur. What I did here was to increase this to 30 pixels to apply an all-over blur effect to the image and dragged the pin over to the left.

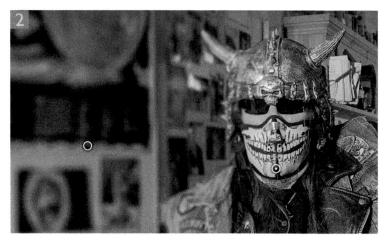

2 In this step I added a second pin on top of the subject's face and set the blur amount to zero pixels. This created an area of clarity that counteracted the effect of the first pin. Essentially, when you have two pins placed like this, you can create a simple blur gradient.

3 You can keep on adding more Field Blur pins to create more complex blur gradients. In this step I added an extra no-blur pin below the second pin and five extra 30 pixel blur effect pins to achieve the combined blur effect shown here.

Blur Tools	
Field Blur	
Blur:	0 px
	Contradiction of the State of Contradiction of the State of Contradiction of the State of Contradiction of C
► Iris Blur	
► Tilt-Shift	
► Path Blur	
► Spin Blur	
Effects Motion Effects	Noise
Effects Motion Effects Bokeh	Noise
Bokeh	
Bokeh	
Bokeh Light Bokeh:	№ 16%
Bokeh Light Bokeh:	№ 16%

Figure 9.16 The Spin Blur controls in the Blur Tools panel.

Spin Blur

When the Spin Blur effect is selected you can apply a spin blur of varying intensity. The effect this filter produces is similar to the Radial Blur filter in Spin mode, but because it is applied as a Blur Gallery filter you have a lot more interactive control over the final effect. For example, you can apply an elliptical shaped blur, recenter the blur effect, and adjust the Blur angle (see Figure 9.16) while being able to see a live preview.

You can adjust the Spin blur by dragging the Blur Angle slider to increase or decrease the strength of the effect (or click and drag on the blur ring). You can then drag the handles to change the Spin blur size and shape, and drag the feather handles to adjust the feathering. You can reposition by click-dragging anywhere inside the ellipse area and further spin blurs can be added by clicking anywhere else in the image area. You can also have them overlap.

The rotation center point can be adjusted by *all* dragging the blur ring. This allows you to create spin blurs on objects that are viewed from an angle. To copy a Spin Blur, click inside a Blur ring, hold down the **H** key (Mac) *ctrl* key (PC) and then the *all* key, and with both keys held down drag to copy to a new location within the image. To hide the blur ring go to the View menu and deselect 'Extras,' or use the **H** (Mac) *ctrl* (PC) shortcut.

1 I created this image by taking a photograph of a 4x4 vehicle that was shot in a town, cutting it out, and placing as a layer above a photograph shot in a deserted landscape.

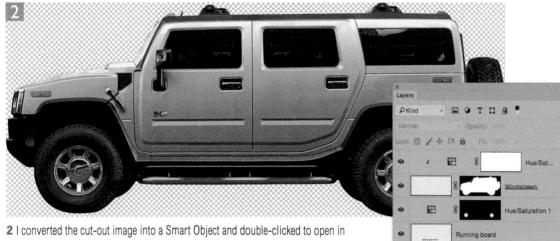

I converted the cut-out image into a Smart Object and double-clicked to open in Photoshop as a separate document. I then carried out a number of edits and converted the Background layer to a Smart Object ready to apply a Spin Blur filter effect to the wheels.

ayer 1

Window shadow

ce fx 🖸 O 🛅 🖬 🏥

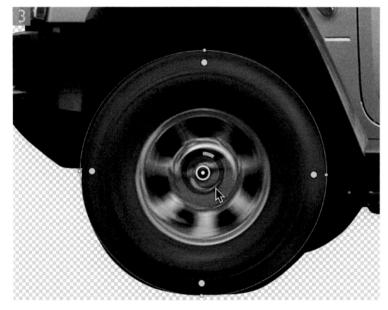

3 Next, I went to the Filter menu and chose Blur Gallery \Rightarrow Spin Blur... I dragged the Spin Blur ellipse over to the front wheel and manipulated the shape so that the Spin Blur ellipse matched the shape of the tire. I then applied a 35° Blur Angle via the Blur Tools panel Spin Blur section.

Focus

4

Selection Bleed

Cancel

OK

4 I held down the **GE** key (Mac) **CH** key (PC) and then the **CH** key, and clicked on the Blur ring center and dragged to create a duplicate of the first Spin Blur effect. I dragged to position this second Spin Blur effect over the rear wheel. Once done, I checked the High Quality option in the Options bar and clicked the OK button. This applied the Spin Blur effect as an editable Smart Filter to the 4x4 car layer.

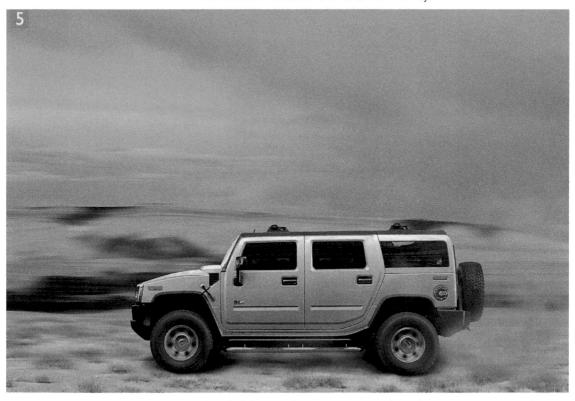

Save Mask to Channels Z High Quality Z Preview 🧕

5 Lastly, I chose File Save to save the edited Smart Object layer and closed the Smart Object document window. The original image with the 4x4 plus landscape was now updated to show the vehicle wheels in motion.

Path blur

The Path Blur filter can be used to create a motion blur effect along a user-drawn path. Basically, by adjusting the path shape you can manipulate the shape and direction of the motion blur to create an effect similar to camera shake, such as when photographing a moving subject with the shutter set to a slow shutter speed. You can manipulate the curve shape to control the length and curvature of the Path Blur, click on the path to add more control points and click on existing curve points and drag to further modify the shape. You can also all-click on a Path Blur control point to convert it to a corner point, or convert a corner point back to a smooth point.

The Blur Tools panel Path Blur controls are shown in Figure 9.17. Checking the Edit Blur Shapes box lets you enable/disable the blur direction arrows. When enabled, the path blur shape will have red blur direction arrows at either end point. You can click on a path blur shape end point, or a blur direction arrow and click and drag to determine the blur direction (the End Point Speed) and adjust the angle. The blur directional arrows also have a midpoint control you can click on and drag to further alter the shape of the blur direction. To disable an end point blur direction arrow, hold down the **X** key (Mac) *ctrl* key (PC) and hover over a path blur end point; you'll see a filled circle appear next to the cursor. Click on the end point to disable. Hold down the **X** key [Mac] *ctrl* key [PC] and click again to enable. If you hold down the *Shift* key you can click and drag a blur direction arrow at one end and simultaneously move the arrow at the other end as well.

It helps to understand here that the defined blur shapes at the two ends of a path are interpolated between the two end points. Also, as you add more path blur shapes to an image these will interplay with each other and it is this aspect of the Path Blur filter that provides lots of opportunities to produce creative blurring effects. To add a new path blur keep clicking to add more control points and press *Enter* or *esc* to end the path blur shape, or just click on the last control point. To reposition a complete path blur, hold down the **X** key (Mac) *ctrl* key (PC) and click on the blue path or a control point and drag to relocate. To remove a control point, select a path blur control point and hit the *Delete* key. To duplicate a Path blur, hold down **X** *alt* (Mac) *ctrl alt* (PC) as you drag a blur path or one of the control points.

The overall blur strength can be controlled by adjusting the Speed slider in the Path Blur section of the Blur Tools panel. There are two starting point modes here: Basic Blur and Rear Sync Flash (examples of which are shown in the following two examples). The Taper slider can be used to dampen the path blur effect and adjust the edge fading from either end. The Speed and Taper sliders affect all path

Figure 9.17 The Path Blur controls in the Blur Tools panel.

blur shapes equally, while the End Point Speed slider independently governs the blur direction arrows depending on which is selected. The Centered Blur checkbox controls the way the blur shapes are calculated. This box is checked by default to ensure the blur shape for any pixel is centered on that pixel. This produces a more controlled behavior when editing path blur shapes. When it's unchecked it will sample from one side of any pixel only and will flow around a lot more. In the Options bar is a High Quality checkbox (see Figure 9.18). Check this to produce high-quality rendering to prevent any jaggedness appearing in a Path blur effect.

110	A 12 19 19 19 19	Colordine Bloods		Cours Marsh to Observate	THE CONTRACT	AND Desident	A	OK I	
100 X	14110395555	Selection Bleed:	Focus:	Save Mask to Channels	High Quality	Preview	Cancel	UK	
	120022230000				in and the second se	Constant Constant State State	and the second se	A REAL PROPERTY AND A REAL	

Figure 9.18 The Blur Tools Options bar.

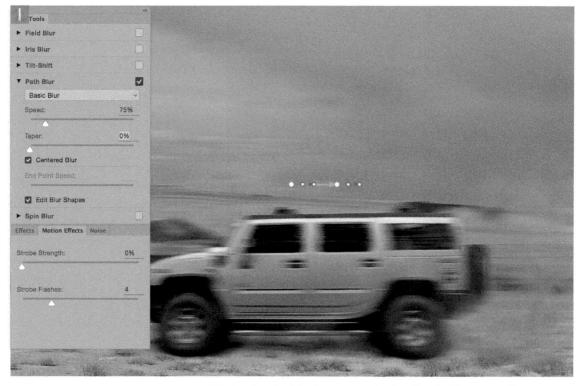

1 To show how the Path Blur can be used as I continued editing a copy of the car layer Smart Object. In this step I applied a simple, linear Path Blur filter using the Basic Blur mode with a Speed setting of 75%.

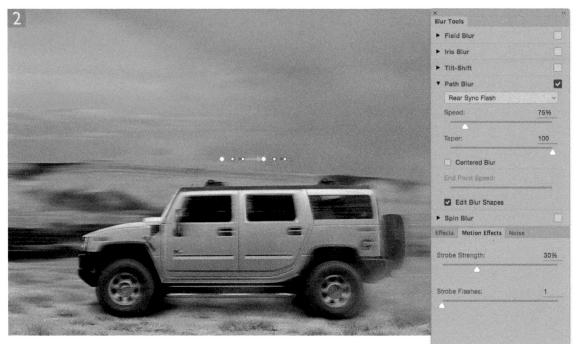

2 I modified the effect by setting the Blur mode to Rear Sync Flash. This action enabled the Strobe Strength slider in the Motion Effects panel, setting the Strobe Strength to 20%. In this step I increased the Strobe Strength to 30% and set the Taper setting to 100.

Motion Blur Effects panel

The Motion Effects panel sliders (Figure 9.19) can be used to create multiple strobe/flash effects. These can be used to determine how many times the image will be repeated and how much blur there will be between each flash exposure. The Strobe Flashes slider can be used to set the number of strobe flash exposures (from 1 up to 100). Increasing the Strobe Strength slider creates a stronger and more noticeable strobe effect, where the blur strength gradually diminishes (depending on the Taper setting in the Blur Tools panel).

Figure 9.19 The Motion Blur Effects panel.

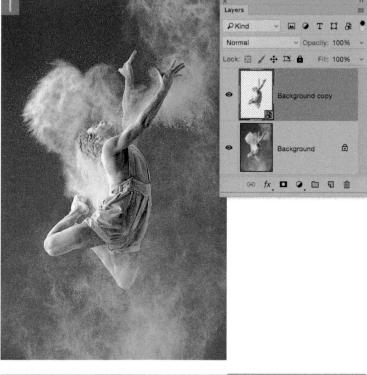

2 I went to the Filter menu and chose Blur Gallery \Rightarrow Path Blur...This shows the Path Blur filter applied using the default settings, with the Basic Blur mode selected and the Speed set to 50%.

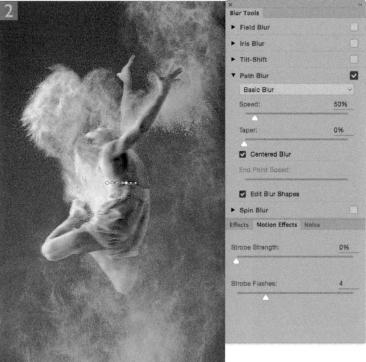

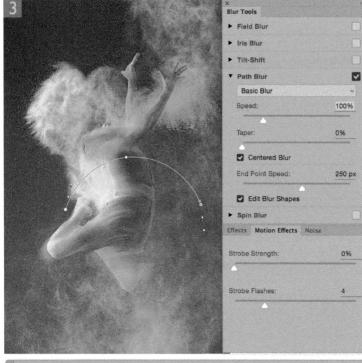

3 In this step I manipulated the path blur handles to create the arc shape seen here. I also edited the path blur end points and clicked and dragged the red handles to define the beginning and end blur directions (the length of the red handles is also linked to the End Point Speed slider). I also increased the Speed amount, applying a 100% setting.

🖈 🚽 Selection Bleed:

Focus:

Save Mask to Channels I High	n Quality 🖸	Preview 1
× Blur Tools ► Field Blur	*	4 Finally,
 ► Iris Blur ► Tilt-Shift 		panel and and set th
▼ Path Blur Custom		In additio two path I
Speed:	350%	amount to bar I also
Taper:	30%	clicked Ol Smart Ob
	250 px	omarcos
Edit Blur ShapesSpin Blur		
Effects Motion Effects Noise		
Strobe Strength:	80%	
Strobe Flashes:	4	
		Photograp

4 Finally, I went to the Motion Effects panel and set the Strobe Strength to 80% and set the number of Strobe Flashes to 4. In addition to this I further manipulated the two path blur end points and set the Speed amount to 350%. In the Path Blur Options bar I also checked the High Quality box and clicked OK to apply the filter effect to the Smart Object layer.

Cancel

OK

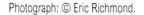

Smart Object support

Photoshop CC provides Smart Object support for all the Blur Gallery filters (see page 632 for more about Smart Objects and Smart Filters). Having the ability to apply the Blur Gallery filters to Smart Objects opens up a number of interesting opportunities. For example, it means you can apply Blur Gallery filters non-destructively and easily toggle the Smart Object/Smart Filter visibility on or off like any other Smart Filter effect. You can combine Blur Gallery filters with other filter effects and create different results by placing other filter effects above or below a Blur Gallery smart filter.

Blur Gallery filters on video layers

Interestingly, you can apply Blur Gallery filters to a video layer. This means you can easily apply effects such as a Tilt-Shift Blur filter to a video clip to produce the classic miniaturized viewpoint effect (see opposite). One thing to be aware of is if you apply a Blur Gallery filter effect to a video layer as a smart object and check the 'Save Mask to Channels' option this will cause an alpha channel for each video frame to be saved to the Channels panel. Now, it so happens Photoshop only stores up to 99 channels and can therefore soon max out. So be sure to keep the 'Save Mask to Channels' option unchecked to prevent this happening.

Smart objects and selections

If you apply a Blur Gallery filter to a Smart Object layer with a selection active, the filter effect is applied to the whole layer and the active selection is used to create a smart filter mask (see page 630). However, it also means that the Selection Bleed is fixed at 100%— the Selection bleed setting appears grayed out in the options bar (see Step 2) and you won't be able to edit the Selection Bleed setting. To be honest, I am not sure why this should be the case, as it does seem to limit the effectiveness of converting a layer to a Smart Object and using a Blur Gallery filter in conjunction with a mask. As can be seen in the example over the next couple of pages, it is not always a good idea to convert a layer to a Smart Filter when using the Blur Gallery filters.

Applying a Blur Gallery filter to a video clip

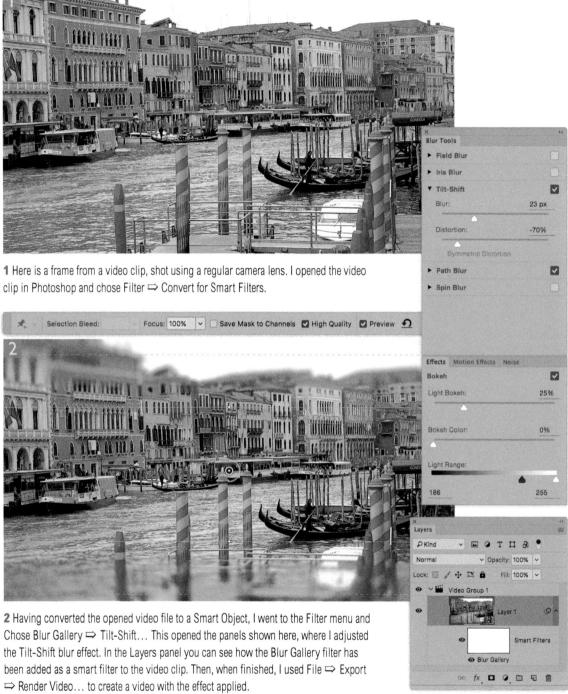

Blur Gallery filter with a smart object plus mask

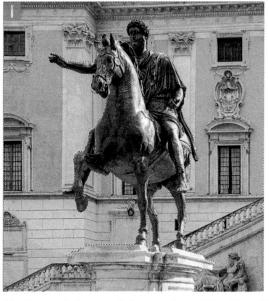

1 In this example I converted a layer to a Smart Object (Smart Filter) and loaded a selection that selected everything but the statue.

2 I went to the Filter menu, selected Blur Gallery \Rightarrow Field Blur... and applied the settings shown here. You will notice in the Options bar the Selection Bleed option (circled) was grayed out.

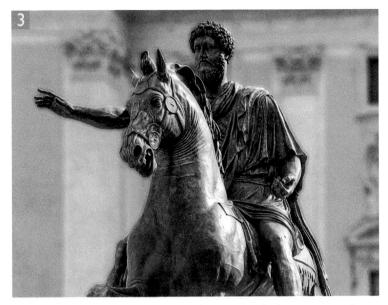

3 I clicked OK in the Options bar to apply the filter and the selection was converted into a mask that masked the Smart Filter layer. This did result in some selection bleed around the edges of the statue, but I was at least able to re-edit the filter settings.

4 The alternative was to not process the image as a Smart Object. Here, I loaded the same selection as in Step 1 and applied the same filter settings to a Background Copy layer with Selection Bleed set to 0% (circled). This method resulted in no edge bleed.

Third-party plug-ins

Third-party plug-ins should have an embedded 'Smart Filter' marker that automatically makes them compatible with Smart Filters in Photoshop. If that isn't the case, then enabling all filters as Smart Filters (as described on page 608) will help your get around such restrictions, but with the proviso that any filter you apply as a Smart Filter must be a 'value-based' filter if it is to fit in successfully with a Smart Filter workflow. Some Photoshop filters, as well as advanced third-party filters, require the use of things like external channels or texture maps in order to work correctly. Since this information can't be stored safely within the Smart Object itself, this can prevent a Smart Filter from working reliably.

Smart Filters/Smart Objects

Smart Filters can be used to package a layer or selection of layers to allow things like filter adjustments or transform adjustments to be applied in a way that allows the contents to be edited non-destructively. This can be particularly useful when working with some of the blur filters discussed in this chapter, as you may very often need the ability to re-edit the blur amount. I have already shown a couple of examples earlier of Smart Filters in use, such as when applying the Spin Blur and Motion Blur filters.

When you go to the Filter menu and choose Convert for Smart Filters, you are basically doing the same thing as when you create a Smart Object. If a layer or group of layers have already been converted to a Smart Object, there is no need to choose 'Convert for Smart Filters.'

You can switch Smart Filters on or off, combine two or more filter effects, or mask the overall Smart Filter combination. The Smart Filter blending options let you control the opacity and blend modes for individual filters. Figure 9.20 shows how you can group layers into a Smart Object and then apply a Photoshop filter to the combined layers within a single Smart Object layer. The multi-layered image can still be accessed and edited by double-clicking the Smart Object thumbnail.

While Smart Filters are non-destructive, this flexibility comes at the cost of larger file sizes (making the file size 4 to 5 times bigger), plus a slower workflow switching between the Smart Object and parent documents, not to mention longer save times.

AS SE N

0.92

28/

DB7

%E

.

☆₩E

20%

Double-click to edit a Smart Object

Figure 9.20 You can make a selection of one or more layers in a document and convert these into a Smart Filter/Smart Object.

Panel Options... Close Close Tab Group

Applying a Smart Filter to an image

The following steps provide a brief introduction to working with the Adaptive Wide Angle filter as a Smart Filter.

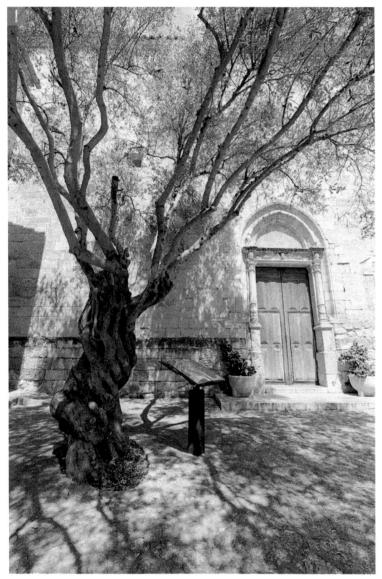

1 To apply the Adaptive Wide Angle filter as a non-destructive Smart Filter, the Background layer first had to be converted to a Smart Object. To do this I went to the Filter menu and chose 'Convert for Smart Filters.' This converted the Background layer into the Smart Object layer shown here in the Layers panel.

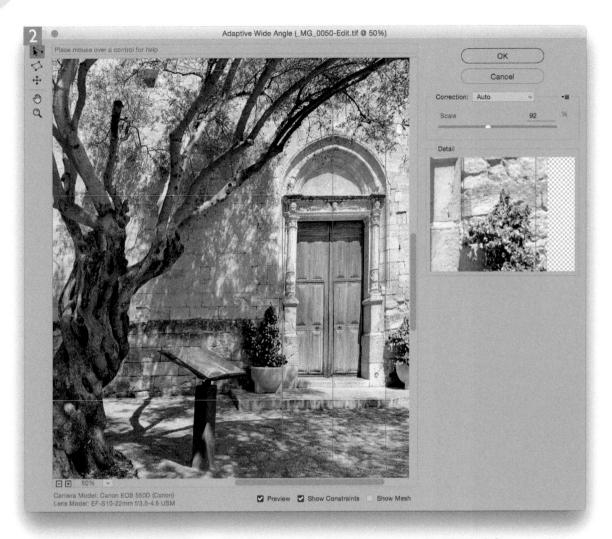

2 I then went to the Filter menu, selected the Adaptive Wide Angle filter and applied the adjustments shown here, where I used the Adaptive Wide Angle filter to correct the perspective in the original photograph. If you check the Layers panel you will notice that after I had applied the Adaptive Wide Angle filter, this added a Smart Filter layer to the layer stack. I could now click the filter name eye icon (circled) to switch the adjustment on or off.

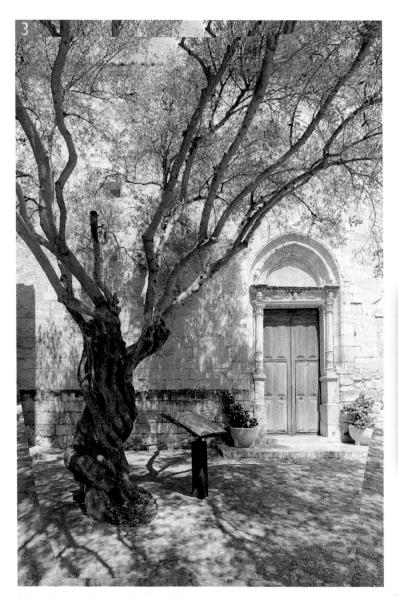

3 I then double-clicked on the Smart Filter blend options button (circled in blue). Here, I found it useful to select the Dissolve blend mode as this blend mode helped reveal the uncorrected version of the image behind the perspective-corrected version. I then double-clicked the Smart Object layer itself (circled in red). This popped the warning dialog shown on the right, which indicated that any subsequent changes I might make to the Smart Object image would need to be saved before closing the document window. It also reminded me that you should always save to the same location (in practice this should never be an issue if you always use the File \Rightarrow Save command rather than File \Rightarrow Save As...).

4 Here you can see the original Smart Object image document, but without the Adaptive Wide Angle filter. I could now edit this document as one would do normally. I added a number of layers which were used to selectively lighten or darken various parts of the photograph. When I closed the document window a dialog box prompted me to choose 'Save.' As I pointed out in Step 3, this must be done in order to save the Smart Object back to the parent document.

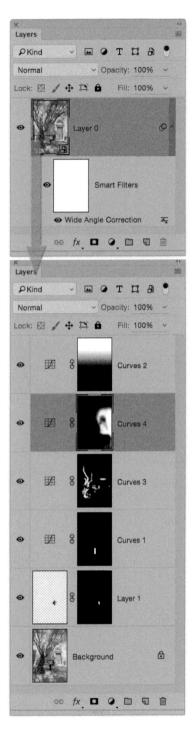

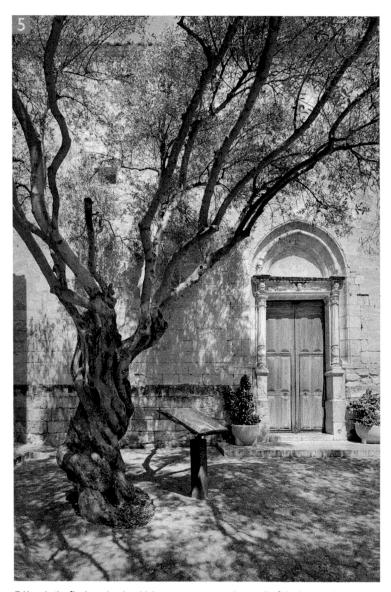

5 Here is the final version in which you can now see the result of the image adjustments applied to the Smart Object image combined with the Adaptive Wide Angle filter I had applied as a Smart Filter (filtering the entire image). In addition to this, I added a few layers including a retouch layer to neatly fill in the edges at the bottom, a Photo Filter layer to adjust the color slightly, and a layer to darken the edges of the image. Nearly all of the adjustments I had just applied to this photograph, including the Adaptive Wide Angle filter settings, remained fully editable.

Lens Corrections

The Photoshop Lens Correction filter (Figure 9.21) can be accessed via the Filter menu or by using the **H**Shift **R** (Mac) **etr** Shift **R** (PC) shortcut. The Auto Correction tab is shown by default. Here you'll find various options that are intended to fix common lens defects. We'll start with the Correction section. The Geometric Distortion option can be used to correct for basic barrel/pincushion distortion. Next we have the Chromatic Aberration option, which can be used to counter the tendency some lenses have to produce color fringed edges. Below that is the Vignette option, which can be used to correct for darkening towards the edges of the frame, which is a problem most common to wide-angle lenses. If you check the Auto Scale Image option this ensures the original scale is preserved as much as possible when applying a Lens Correction.

Basically, if you apply an auto lens correction to an image, the EXIF metadata information is used to automatically select an appropriate lens profile in the Lens Profiles section below. For this to happen the EXIF

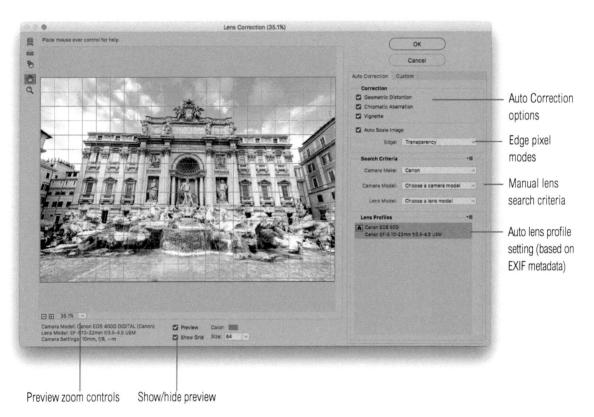

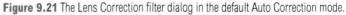

camera and lens metadata must be present. If the image you are editing is missing the EXIF metadata (i.e., it is a scanned photo) and you happen to know which camera and lens combination was used, you can use the Search Criteria section to help pinpoint the correct combination. It is important to appreciate here that the camera body selection is important as the lens correction requirements will vary according to which camera body type is selected. Some camera systems capture a full-frame image (therefore making full use of the usable lens coverage area), while compact SLR cameras mostly have sensors that capture a smaller area. Once you have selected the correct lens profile you can compare a before and after view of the auto lens correction by toggling the Preview button at the bottom.

Video file Lens Corrections

You can apply the Lens Correction filter to video clips by opening a video file in Photoshop and applying the Lens Correction filter as a Smart Object. This can greatly improve the appearance of your video footage, providing, that is, you have a lens profile for the camera and lens used.

Custom lens corrections

The Custom tab options are shown in Figure 9.22. The Geometric Distortion section contains a Remove Distortion slider that can correct for pincushion/barrel lens distortion. Alternatively, you can click to select the Remove distortion tool and drag toward or away from the center of the image to adjust the amount of distortion in either direction. Overall, I find the Remove Distortion slider offers more precise control.

The Chromatic Aberration section contains three color fringe fixing sliders for fixing the red/cyan, green/magenta, and blue/yellow fringing.

The Vignette section contains Amount and Midpoint sliders, which are also identical to those found in the Camera Raw Lens Corrections panel and these can be used to manually correct for any dark vignetting that occurs at the corners of the frame.

The Transform section controls can be used to correct the vertical and horizontal perspective view of a photograph such as the vertical keystone effect you get when pointing a camera upwards to photograph a tall building, or to correct the horizontal perspective where a subject wasn't photographed straight on.

You can adjust the rotation of an image in a number of ways. You can click and drag directly inside the Angle dial, but I mostly recommend clicking in the Angle field (circled in Figure 9.22) and using the up and down keyboard arrow keys to nudge the rotation in either direction by small increments. The other option is to select the Straighten tool and

Scanned image limitations

The chromatic aberration and vignetting adjustments are always applied relative to the center of the image circle. In the case of digital capture images the auto correction adjustments will work precisely so long as the source image has not been cropped. In the case of scanned images things get a little trickier since the auto corrections will only work correctly if the source image has been precisely cropped to the exact boundaries of the frame. Lens Correction tools: Remove distortion tool; Straighten tool; Move grid tool; Hand tool; Zoom tool

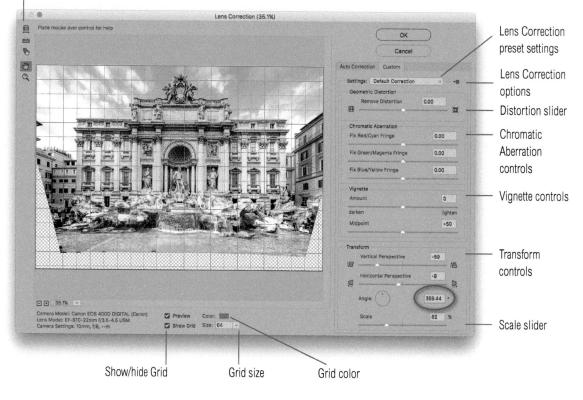

Figure 9.22 The Lens Correction filter dialog in Custom mode.

drag to define what should be a correct horizontal or vertical line. The image will then rotate to align correctly.

The Scale slider can be used to crop a picture as you apply a correction. Alternatively, you may wish to reduce the scale in order to preserve more of the original image (as shown in Step 2 opposite). The grid overlay can be useful to help judge the alignment of the image. The grid controls at the bottom of the Lens Correction filter dialog also enable you to change the grid color, adjust the grid spacing, and toggle showing or hiding the grid. If you select the Move grid tool this allows you to adjust the grid position by dragging in the preview window.

As you apply Lens Correction Transform adjustments, the shape of the image may change. This leaves the problem of how to render the outer pixels. The default setting uses the Transparency mode, although you can choose to apply a black or white background. Alternatively you can choose the Edge Extension mode to extend the edge pixels. This may be fine with skies or flat color backdrops, but is otherwise quite ugly and distracting.

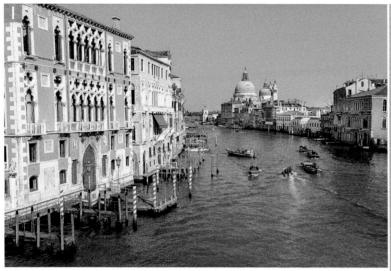

1 In this example I checked all the Auto Correction options to apply an auto lens correction to the photograph, which in this case was based on the EXIF metadata contained in the original photo.

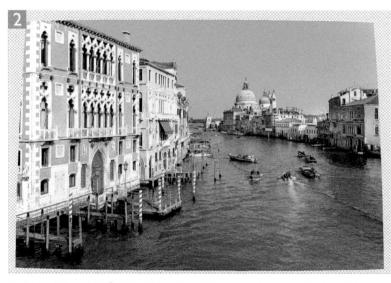

2 I then switched to the Custom mode and applied a custom lens correction to further correct for the perspective angle this photograph was shot from. Basically, I adjusted the Vertical Perspective slider and made a minor adjustment to the angle of rotation. You'll also note that I adjusted the Scale slider to reduce the scale size and preserve more of the image.

etti	ings: Default Correction	~	- 1
Geo	ometric Distortion		
Remove Distortion		0.00	- <u></u>
Chr	omatic Aberration		
Fix Red/Cyan Fringe		0.00	
Fix Green/Magenta Fringe		0.00	
Fix	Blue/Yellow Fringe	0.00	
Vig	nette		
Amount darken Midpoint		1	0
		lighten	
			+50
ran	sform		
图	Vertical Perspective	+9	- 18
Ē	Horizontal Perspective	0	
	Angle:	0.15]。
	and the second		

Figure 9.23 You can choose to prefer raw profiles via the Search Criteria section flyout menu options in the Lens Correction filter dialog.

Selecting the most appropriate profiles

If the camera/lens combination you are using is matched by one of the Adobe lens correction profiles that was installed with Photoshop, then that's the option you'll see selected in the Lens Profiles section (Figure 9.23). If no lens correction profile is available (because the necessary lens EXIF metadata is missing), you'll see a 'No matching lens profiles found' message. The Search Criteria section can then be used to carry out a manual search using the Camera Make, Camera Model, and Lens Model menus to find a compatible camera/lens profile combination. If you like, you can create your own custom profiles using the Adobe Lens Profile Creator program (see below).

The Lens Correction filter can make use of profiles created from raw files or from rendered TIFF or JPEG capture images. This means that two types of lens profiles can be generated: raw and non-raw lens profiles. In terms of the geometric distortion and chromatic aberration lens correction, you are unlikely to see much difference between these two types. With regards to the vignette adjustment, here it matters more which type of source files were used. In the case of raw files, the vignette estimation and removal is measured directly from the raw linear sensor data. Now, if the Lens Correction filter were able to process raw files directly this would result in more accurate lens vignette correction results. Since the Lens Correction filter is used to process rendered image files such as JPEGs and TIFFs, it is therefore better to use the non-raw file generated lens profiles, where available. It is for this reason that the Lens Correction filter dialog displays non-raw lens correction profile by default and only shows a raw profile version if there is no non-raw profile version available on the system. The raw profile versions are therefore only available as a backup. However, if you go to the Search Criteria section and mouse down on the fly-out menu you can select the 'Prefer Raw profiles' option (see Figure 9.24). When this is checked the Lens Correction filter automatically selects the raw profiles first in preference to the non-raw versions. Overall I recommend you stick to using non-raw profiles as the default option. If you have access to the raw original file, you are overall better off applying the lens corrections in Camera Raw or Lightroom first, rather than using the Lens Corrections filter in Photoshop.

Adobe Lens Profile Creator

You can use the Adobe Lens Profile Creator 1.04 program to build your own custom lens profiles that characterize the specific geometric distortion, lateral chromatic aberration, and vignetting optical aberrations in your own lenses. It is available as a free download. Go to the Lens Profiles fly-out menu and choose 'Browse Adobe' Lens Profile Creator Online...' This leads you to a page from where you can download the program. Basically you need to print out one of the supplied charts onto matte paper and then photograph it as described in the Creating lens profiles PDF on the book website. When using the Adobe Lens Profile Creator program you can use the File menu to choose 'Send Profiles to Adobe' (**H**S) [Mac] *ctri all* S [PC]). This allows you to share lens profiles you have created with other users (see Figure 9.24).

Interpolating between lens profiles

The zoom lens characteristics will typically vary at different focal length settings. Therefore to get the best lens profiles for such lenses you may need to capture a sequence of lens profile shots at multiple focal length settings such as at the widest, narrowest, and mid focal length settings. The Adobe Lens Profile Creator program can then use the multiple lens capture images to build a more comprehensive profile for a zoom lens. You can also build lens profiles based on bracketed focusing distances. For example, this might be considered a useful thing to do with macro lenses, where you are likely to be working with the lens over a range of focusing distances.

Lens Correction profiles and Auto-Align

The Auto-Align feature utilizes the same lens correction profiles as those used by the Lens Correction filter dialog. This is why you should mostly see much improved performance in the way the Auto-Align feature is able to stitch photos together. Adobe have also added caching support so that the Lens Correction and Auto-Align Layers dialogs open more speedily on subsequent launches after the first time you open either dialog.

Auto-alignment also works well for fisheye photos that have been shot in portrait mode. However, for this to work properly it is necessary that all the source images are shot using the same camera, lens, image resolution, and focal length. If these above criteria are not met, then you will most likely see a warning message.

Batch lens correction processing

You can batch process images to apply lens corrections by choosing File \Rightarrow Automate \Rightarrow Lens Correction... This opens a batch processing dialog where you can choose to configure the lens correction filter settings to batch process images and save them to a selected destination folder.

Figure 9.24 The 'Send Profiles to Adobe' dialog.

Adaptive Wide Angle filter

So, if Camera Raw and Photoshop provide the ability to make automatic lens profile corrections, why do we also need an Adaptive Wide Angle filter? It does seem like an odd addition until, that is, you understand the logic behind this feature and why it can be so useful.

Essentially, the problem is this: how do you take a wide-angle, spherical field of view and represent it within a rectangular frame? One approach is to preserve the spherical field of view without distorting the image. This is what fisheye lenses do. The other approach is to apply a perspective-type projection, which attempts to correct the image so that straight edges in the scene appear straight. While some rectilinear lenses can be very good, the problem with a perspective projection is that objects can appear more stretched towards the edges of the frame and round objects become more egg-shaped. I suppose in this instance you could sum up the problem as 'How do you squeeze a round peg into a square hole?' Artists over the centuries have overcome this problem by combining multiple perspective projections in a single image, or they have adapted the perspective of some objects to avoid the effects of perspective distortion. They have effectively deviated from painting in true, camera lens-like perspective.

In the world of photography we have so far been limited to what perspective projection lenses have been able to do at the point of capture and what programs like Photoshop can do in the post-processing. What's been missing until now has been the means to manipulate the field of view and determine precisely which lines should remain straightsomething no camera lens can achieve. The Adaptive Wide Angle filter is the result of research which came out of University of California, Berkeley into Image Warps for Artistic Perspective Manipulation (Robert Carroll, Maneesh Agrawala, and Aseem Agarwala). The clue here is in the title: this is an artistic tool that can be used to manipulate the appearance of a wide-angle view such that you can take extreme wide-angle photographs and apply constraint lines to create more natural-looking images, where the entire mapping is as shapepreserving as possible. This filter has a number of uses. It can be used to uniquely change the perspective composition of a scene to produce an end result where the perspective looks more natural. It can be used to explore different artistic perspective interpretations, or it can be used to match the visual perspective in another scene. This could be particularly useful if you are required to blend two images together where it is necessary to get the perspective in one image to match more closely the perspective in the other-something that has been impossible till recently.

If you want to test this filter out you should ideally do so using ultra wide-angle images, such as those shot with a fisheye lens or an ultra wide perspective correcting lens, such as a lens with an effective focal length of 24 mm lens on a full-frame 35 mm SLR system or wider. You could try using this filter to edit other types of images, but is really intended as a correction tool for extreme wide-angle photographs.

Figure 9.25 shows three variations of the same image. The top version shows the original fisheye lens photo with no lens corrections applied to it. The middle version shows the same image with an auto lens profile correction. The bottom version shows how the image looked after using the Adaptive Wide Angle filter with custom constraint adjustments.

The Adaptive Wide Angle filter combines the technology utilized in the Lens Correction filter with Puppet Warp distortions. When using this filter it will not be necessary to apply a lens correction first via Camera Raw or Photoshop, and in fact will work better if you don't. After all, since this filter can be used to make user-indicated distortion corrections, it is better to begin with an image that has had no distortion corrections applied to it, especially in the case of fisheye lenses, where it would be trickier to use corrected fisheye images as your starting point. This is because the Adaptive Wide Angle filter makes use of the Adobe Lens profiles to refine the lens distortion. As a consequence of this if you correct the lens distortion in Camera Raw first (or use the Lens Correction filter) this may potentially confuse the Adaptive Wide Angle filter. Generally speaking, the Adaptive Wide Angle filter is robust enough to cope with minor corrections, but if you choose to correct a fisheye image first, the Adaptive Wide Angle filter will have trouble processing the image correctly. Some cameras may apply automatic lens corrections when you shoot in JPEG mode. It is therefore better to shoot in raw mode if you intend processing photos using the Adaptive Wide Angle filter.

With photos that have been shot using a tilt-shift lens the user will have the opportunity to adjust the center of the optical axis and apply a certain amount of perspective correction at the time of capture. Such photos may still benefit from being processed using the Adaptive Wide Angle filter. However, it is absolutely paramount you have access to an accurate lens profile and the Auto mode is selected in the Correction options.

Basically, the filter allows you to indicate which lines in a scene should be straight or horizontal/vertical. As these constraints are applied, the filter smoothly applies a Puppet Warp type adaptive warp projection to the image between the constraint lines and image boundary. In other words, you get to define which are the salient

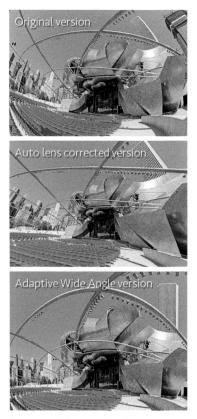

Figure 9.25 A comparison between an auto lens correction and working with the Adaptive Wide Angle filter.

lines in the image that should appear straight and the image data is progressively warped to match the constraints you have applied and will continue to update as you add more constraints.

When correcting a fisheye lens image such as the one shown in Figure 9.25, it should not be necessary to apply many more constraint lines than one horizontal and two vertical constraints. Three constraint lines was all that was needed in this example to achieve the main distortion effect you see here. As it happens, I did end up adding a few extra constraints to fine-tune this particular image, but once the main key constraint lines had been added the adaptive wide-angle adjustment was mostly complete.

How the Adaptive Wide Angle filter works

When you first open an image in the Adaptive Wide Angle filter it will search the lens profiles database to see if there is lens profile data that matches the image's lens EXIF metadata. If a lens profile is present the Correction section of the filter dialog will show 'Auto.' If not, you may want to see if one is available online. Go first to the Lens Correction filter and apply it to the same image. Click on the Search Online button. This will show a list of other user-created lens profiles that may possibly match. You can then select one of these and go to the Lens Profiles fly-out menu and choose 'Save Online Profile Locally.' This will then save the profile to the lens profile database on your computer and automatically be available the next time you open the Adaptive Wide Angle filter.

What the Adaptive Wide Angle filter does is it reads in the EXIF lens metadata, locates an appropriate lens profile and, based on this, assesses which is the best projection method to use. When the Preview box is checked, the preview shows an initial distortion correction that you can then refine further using the constraint controls. This initial preview will show what is known as a 'shape conformal' projection, as opposed to a perspective-accurate projection. With this type of projection the emphasis is on preserving shapes proportional to the distance from the viewer. As you add constraint lines you are essentially overriding this projection and telling it to add more perspective. Essentially, the filter lets you selectively apply a perspective projection to the image.

As you apply constraints to the preview some parts of the image will be more squashed together and other parts will become stretched apart. The Scale slider can therefore be used to adjust the scale of the image relative to the dimensions of the original document.

Applying constraints

It helps to understand that because the Adaptive Wide Angle filter is able to use the Lens profile information for the lens the photo was taken with (based on your file's EXIF metadata) it therefore knows how to calculate to make all the edges straight. As you apply constraint lines to the image you are selectively overriding the shape conformal projection and telling the filter you want to apply a perspective-type projection to this particular section of the image.

The Adaptive Wide Angle filter tools and their associated shortcuts are shown in Figure 9.26. Typically you would select the Constraint tool (C) first from the tools section and drag along an edge to define it as a straight line. As you do this the constraint line will appear to magically know exactly how much to bend. Well, it's not magic really, as the filter already knows how much to bend based on the Lens Profile data. So, as you add constraints you'll see the lines in your image straighten. If you hold down the Shift key as you do so, you can both straighten an edge and make it a vertical or horizontal line. Where possible, the trick here is to use a minimum of two vertical constraints to apply vertical corrections left and right, plus a single horizontal constraint to match the horizon line. It is best to first align these constraints to known edges in the image preview and once you have done this it is easy enough to edit the constraint lines by clicking on the end points and dragging them to the edge of the frame. This is often crucial, because by doing so you are able to apply an even smoother correction across the entire width and height of the image area. You can hold down the 🕅 key to switch to a magnified view (to 200% from a 100% view and 100% from smaller magnifications). Also, at views less than 100%, clicking and dragging a handle will show a 100% loupe view. In Figure 9.27 I selected a constraint handle to edit it; this displayed the loupe, with a magnified view, also available by holding down the 🙆 key. This can make precise placement easier. Once you have got these first three constraint lines to extend edge to edge, you should end up with a fairly satisfactory distortion where you'll only need to add further constraint lines where these are absolutely necessary. As you edit the constraints you'll probably notice how they may follow an odd kink here and there (this can be because the underlying mesh has so far been unevenly warped and the lens profile information guides the constraint line accordingly).

Figure 9.26 The Adaptive Wide Angle filter tools.

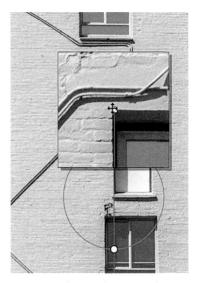

Figure 9.27 As you select a constraint handle to edit it, you'll see a magnified loupe.

Rotating a constraint

If you click to select a constraint, you'll see two handles appear on the constraint line. If you click on one of these and drag you will see an overlaying circle and you can drag to apply an arbitrary rotation to the constraint. A green line appears as you do this and the edited constraint will afterwards be colored green (instead of magenta). This is because the constraint is no longer vertical. This can be particularly useful when editing architectural photos where you wish to correct the converging verticals and remove a keystone effect. While it is possible to make the converging vertical lines go perfectly vertical, it may not always be best to force them to do so; allow them instead to converge just slightly. When applying vertical constraints, you can adjust the orientation angle for each constraint line.

In Figure 9.28 I applied two vertical constraints to straighten the converging verticals. To keep the perspective looking natural, I edited the orientation of the constraints, setting the one on the left to 95° and the one on the right to 88°.

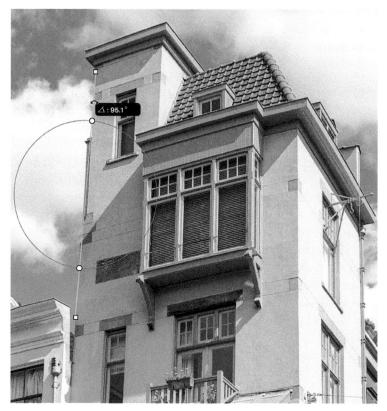

Figure 9.28 This shows a close-up section of a building where I had applied two vertical constraints to straighten the converging verticals.

Saving constraints

When you work with the Adaptive Wide Angle filter you will usually need to make a fair number of intricate adjustments. To keep the work editable you can save the constraints as a settings file. To do this, go to the Correction menu shown in Figure 9.29, which includes the Preferences, Load Constraints... and Save Constraints... options. If you select 'Save Constraints...' the constraint settings file is named the same as the image, which can make it easier to locate. When you need to load these constraint settings again you can then go to the same menu and choose 'Load Constraints...' However, while a settings file can be shared with other images, it will only do so providing the embedded EXIF lens metadata matches exactly. To avoid losing any work, hit the esc key before you exit. This will pop a dialog reminding you to apply or save the constraint settings first.

The other thing you can do is to convert an image to a Smart Filter before you apply the Adaptive Wide Angle Filter. If you do this, you can create and save a number of different correction settings for a particular photo.

Constraint line colors

When you go to the fly-out menu shown in Figure 9.29 you can open the Preferences shown in Figure 9.30. This allows you to edit the color swatches, choose new colors for the different constraint guide modes, and set the size of the floating loupe (see Figure 9.27). Here, the constraint colors are colored as follows. Unfixed constraints are colored cyan, horizontals colored yellow, verticals magenta, fixed orientation constraints green, and invalid constraints are colored red, indicating that the constraint you are trying to apply can't be calculated.

Polygon constraints

The polygon constraints tool (**Y**) can be used to define specific areas of a picture where you wish to apply a perspective correction. Just make a succession of clicks to define an area that you wish to see corrected. For example, if you were to click in all four corners of the preview area, the effect would be similar to applying a lens correction to the entire image. The polygon constraint tool is therefore useful for correcting areas of an image where there are no straight lines available to reference, or where you need to correct, say, a building facade or a large expanse of tiled flooring. You can also add horizontal/vertical oriented constraints to just outside the edges of a polygon constraint as a way to control the overall polygon distortion.

Figure 9.29 The Adaptive Wide Angle filter Correction menu options.

Constraint Colors	
Unfixed Orientation:	
Horizontal:	
Vertical:	
Fixed Orientation:	
Invalid:	
Mesh	
Mesh Color:	
Floating Loupe	
Show loupe when dragging	
Loupe Size 140	
OK Cancel	\supset

Figure 9.30 This shows the Adaptive Wide Angle preferences dialog.

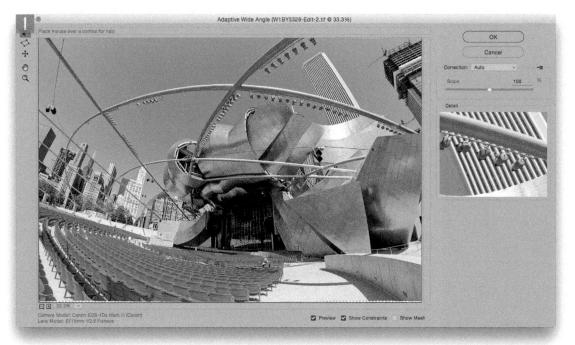

1 This shows a photograph shot with a 15 mm fisheye lens, opened in the Adaptive Wide Angle filter prior to making any corrections.

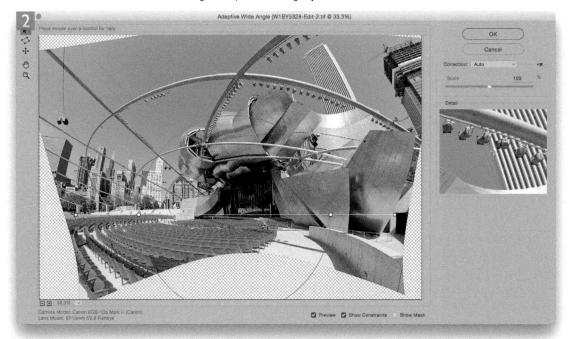

2 To start with, I selected the constraint tool and with the *Shift* key held down dragged across the horizon to correct the horizontal distortion.

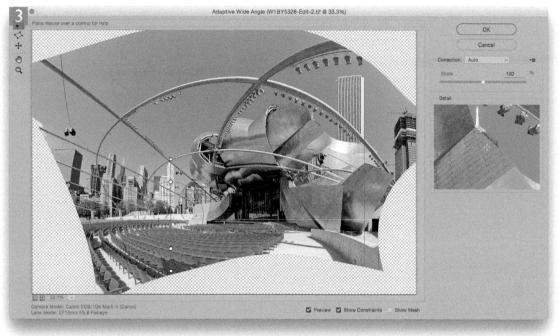

3 I again held down the *Shift* key and this time added a succession of vertical constraints to selectively correct for the vertical distortion. When I was done I clicked OK.

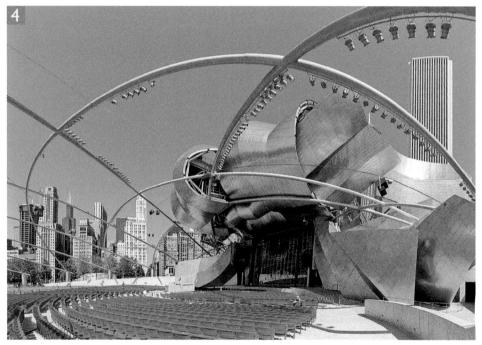

4 Here you can see the final, corrected version. If you refer back to Figure 9.25 you can also compare this with the original and a standard 'lens corrected' version.

Calibrating with the Adaptive Wide Angle filter

If you are processing images that have no EXIF lens data then the Adaptive Wide Angle filter will have nothing to work from. In these situations it is possible to calibrate the filter so that it is able to determine the curvature of the lens.

The example shown in Figure 9.31. It is really a method that can only be applied to fisheye lenses. If you select the constraint tool and no EXIF lens data is detected, after you click to add a constraint this will produce a straight constraint line with a midpoint handle. What you have to do next is to click on the midpoint handle and drag to make the constraint line match a known vertical or horizontal line in the image (you can see this taking place in the example below). After you have carried out the initial calibration you should find it quite easy to add further constraint lines to constrain the other edges.

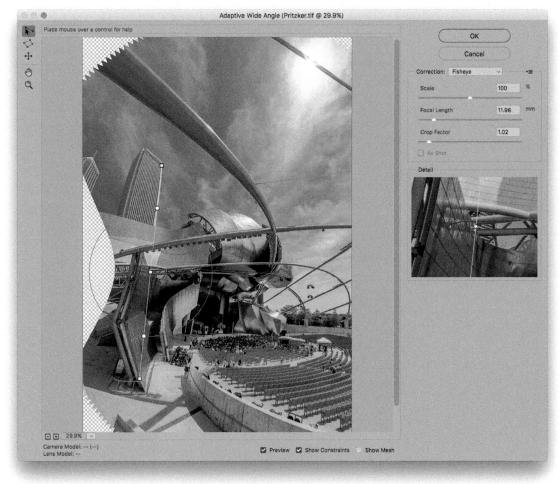

Figure 9.31 Calibrating a photo with no embedded EXIF lens data.

Editing panorama images

It is possible to use the Adaptive Wide Angle filter to correct Photomerge panorama images. However, for this to work, the panorama must be generated using Photomerge in Photoshop CS6 or later, or created using Photo Merge in the latest version of Camera Raw. This is because the filter relies on lens metadata information being added to the file as the panorama is generated, so it won't be able to process older panoramas in this way. When preparing a Photomerge panorama you need to make sure that you use just the Cylindrical or Spherical projection methods (see page 535). When you open a Photoshop CS6 or later panorama image via the Adaptive Wide Angle filter, you'll see it open in 'Panorama' mode.

Since first experimenting with the Adaptive Wide Angle filter I have found that it is useful for editing not just architectural photographs, but almost any Photomerge panorama that has been created in Photoshop. More recently, I have been shooting panorama stitch images using a 14 mm, rectilinear fisheye lens and post-editing the Photomerge panoramas using the Adaptive Wide Angle filter to tame the perspective (see Figure 9.32). The benefit of this approach is that one can capture a highly detailed panorama that holds an extremely wide view yet not have it look like a typical, ultra wide-angle photograph. The perspective view one can achieve reminds me of the work of classical landscape painters, who, as I mentioned earlier, played fast and loose with perspective to create idealized landscape views.

The Adaptive Wide Angle filter can also be used in the way that's described here to process 1:2 full-spherical (180 degrees by 360 degrees) Photomerge panoramas. When editing a Photomerge file, the Adaptive Wide Angle filter needs to be able to read metadata information such as the focus length and where the center of the panorama is. This is all figured out as the images are stitched together in Photomerge. Note that checking the Geometric Distortion Correction checkbox box in Photomerge should not necessarily affect the Adaptive Wide Angle filter.

The following steps show how I managed to correct the distortion in such an image, where I had, rather ambitiously, shot the seven images that made up this panorama using an extreme wide-angle lens. Up until recently it would not have been possible to do much to correct the major distortion in this stitched panorama.

Figure 9.32 A wide-angle panorama made from six photographs, using a 14 mm lens.

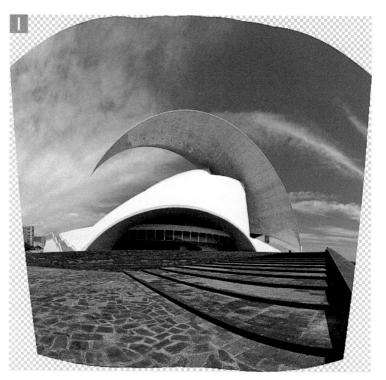

1 Here you can see a Photomerge image created in Photoshop using the Cylindrical layout/projection mode.

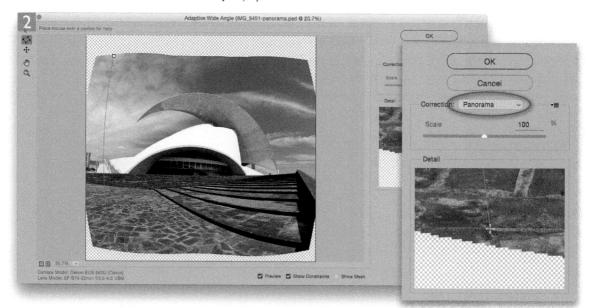

2 When I applied the Adaptive Wide Angle Filter to the image in Step 1, it opened using the Panorama correction method (circled). To begin with, I held down the *Shift* key to add a vertical constraint to the image.

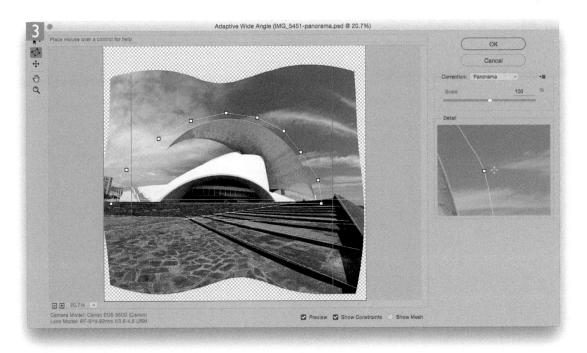

3 In this step I added further vertical, horizontal, and regular constraint lines to correct the distortion in the image. Since there weren't any straight lines to align to on the opera house, I used the Polygon constraint tool to define the shape of the building. I hit *Enter* to close the polygon, which corrected the distortion inside the defined area.

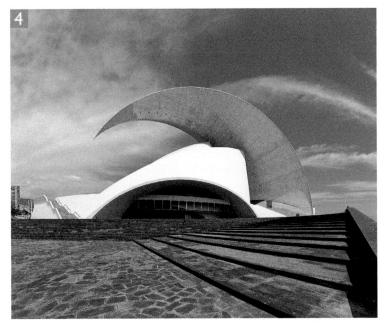

4 I clicked OK to produce the perspective-corrected version shown here.

Flame filter tips

To generate a flame effect, the selected paths must be between 50 and 50,000 pixels. This filter won't work with text layers or shape layers. However, you can select a Type layer and choose Type ⇔ Convert to Shape. Create a copy path of the shape path, select this path, create an empty new layer and then apply the Flame filter. Likewise, with Shape layers, make a copy path, create a new layer, and then apply the Flame filter.

Flame filter

The Flame and Tree filter effects can be found in the Filter \Rightarrow Render menu. These can be used to add scripted pattern objects to a photograph.

Let's look at Flame first. This render filter can produce flames that look fairly realistic. You could say they pass a Photoshop version of the Turing test, where the end result can be good enough to convince viewers the added flames are real. The trick is to start by defining the path or paths for the flames to follow and after that, know how to manage the slider controls to produce the desired flame effect. This filter is not compatible with Smart Objects, so you have to rely solely on the preview as you adjust the settings and click OK to see what the final outcome will look like. If you want to fine-tune the filter effect my suggestion is to undo the filter and reapply by holding down the all key as you re-select 'Flame' from the top of the Filter menu. This will reload the filter with the last used settings. Readjust these and apply again. To save time you can choose a low-quality render setting first and reapply using a higher-quality render setting. The following steps show how I was able to add some extra flames to a photograph of a freshly lit barbecue.

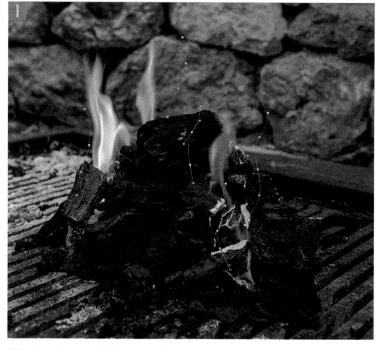

1 Here is a photograph of a barbecue fire about to catch light. To prepare this image to add more flames, I selected the Pen tool and added a number of open paths.

		Preset: Custom ~	ОК
		Basic Advanced	Reset
· · ·		Flame Type: 1. One Flame Along Path	~
	al a	Lotgen - 700	Cancel
	d l	CL Rasserbas Longh	
	6	Width: 58	
		Poglat 0	
		Interval: 37	
14 Apr.		🛱 - Adjurat latine at for Loops	
		Use Custom Color for Flames	
		Custom Color for Fiames:	
		Quality: High (Slow)	

2 I added an empty new layer above the Background layer and chose Filter \Rightarrow Render \Rightarrow Flame... This opened the Flame dialog, where I entered the settings shown here to create the desired flame effect and sampled the color from the flames in the actual image.

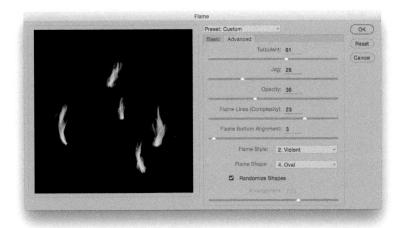

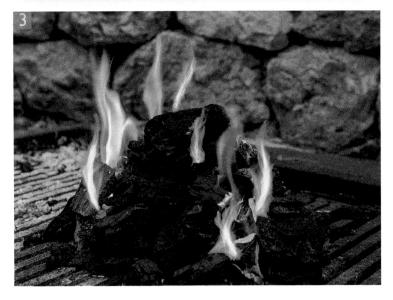

3 This shows the final image with the extra flames added to the layer.

Figure 9.33 Two Flame Type options.

Figure 9.34 The Flame Style options.

Flame filter controls

The flame effect can be modified by selecting an option from the Flame Type menu. Figure 9.33 shows the Include One Flame Along Path (top) and Multiple Flames One Direction (bottom) options. The Length slider and Randomize Length check box will only become active when one of the multiple flame style options is selected. The Width slider controls the pixel width of the flame effect, while the Angle slider determines the flame angles when the following flame styles are selected: Multiple Flames One Direction, Multiple Flames Path Directed, or Multiple Flames Various Angle. The Interval slider is active when any multiple flame style is selected. Increasing the Interval creates wider gaps between the flames. If the path forms a loop, checking the Adjust Interval for Loops option ensures the gap between the flames will be uniform or even.

The flame effects are constructed with lines. Increasing the Flame Lines setting adds more complexity to the flame effect. The Turbulent slider determines how rough or how smooth a flame effect will be. A low Jag setting will produce a smoother effect and a higher setting appear more jagged. The Opacity slider can be used to control the brightness of the flame effect. It is important to ensure the flame effect is not too bright, or else the flame highlights will be clipped. One thing to watch out for is the way the Opacity slider also affects the flame shape as you adjust the slider. With the Flame Bottom Alignment slider, when this is set to zero, each of the lines that create the flame will be evenly aligned. As you increase the slider setting they will be more randomized.

There are three Flame styles: Normal, Violent, and Flat. These are shown in Figure 9.34. As you can see, these alter the characteristics of the flame effect. The Flame Shape menu has the following options: Parallel, To The Center, Spread, Oval, and Pointing. These options determine the overall shape of the flame effect. The default color is very flame-like, but if you are attempting to match existing flames in a photograph you can do what I did in Step 2 on the preceding page, where I checked the Use Custom Color for Flames option. This popped a color picker, which allowed me to sample the flame colors in the photo and use these to generate flames that matched even more closely the real flames. The Quality menu can be used to select the desired render setting. When adjusting the sliders it can help to have this set to Draft mode. When it comes to rendering the final effect you can choose a higher-quality setting. Lastly there is the Randomize Shapes button. When checked, the flame shape will be different every time a flame is created. When unchecked you can adjust the Arrangement slider to generate slightly different types of flame effect.

Tree filter

The Tree filter uses the same type of rendering script process as the Flame filter to generate different types of trees. Unlike the Flame filter the results are not quite good enough to look photo-realistic, but even so it is still quite impressive. If you were to blur the results when adding to a blurred background, the rendered trees could look quite convincing. Otherwise, it is perhaps more a tool for illustrators and architects. At the top of the dialog there is a Base Tree Type menu, where you'll find a list of 34 different tree types. You can then choose to adjust the Light Direction, the Leaves Amount, and Leaves Size. Below that are sliders to control the Branches Height and Branches Thickness.

The following steps show how I was able to use the Tree filter to create trees that would blend into a landscape photo.

eset: Custom	
Basic Advanced	
Base Tree Type: 1: Oak Tree	~
Light Direction: 168	
Leaves Amount: 100	
Leaves Size: 119	
Branches Height. 199	
Branches Thickness: 159	
Default Leaves	
Leaver Type: 18. Leaves 16	
Randomize Shapes	
Arrangement: 13.8	

1 I added an empty new layer above the image layer and chose Filter \Rightarrow Render \Rightarrow Tree... This opened the Tree filter dialog, where I entered the settings shown here to create the desired tree shape.

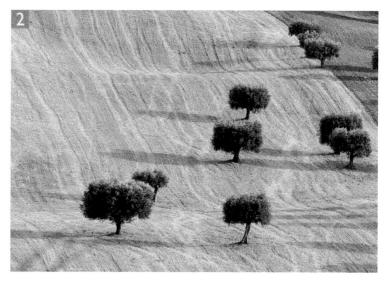

2 I also clicked on the Custom Color for Leaves and Custom Color for Branches buttons to open the color picker shown here to sample colors from the trees in this photograph so that the leaves and branch colors would match.

3 This shows the finished result, where I added the first plus a second tree and copied the shadows of the other trees to make these appear to match the rest of the scene. I also converted the rendered layer to a smart object and applied a very small amount of Gaussian Blur to soften the texture of the trees slightly so they matched the other trees.

Tree filter panel options

Figure 9.35 shows the Basic panel options. When the Default Leaves option is checked, a tree will be generated using the leaves linked to the selected base tree type. If you uncheck this you can select other leaf types in order to create your own custom hybrid tree.

Figure 9.36 shows the Advanced panel options. At the top is a Camera Tilt slider to set the viewing angle of the tree. As was shown in the previous step-by-step example, you can check the Use Custom Color for Leaves and Use Custom Color for Branches options to set custom colors for both. The Flat Shading – Leaves option and the Flat Shading – Branches option apply a flat tone fill to either the leaves or branches. The Enhance Contrast – Leaves option mostly adds more texture contrast to the leaves. Leaves are normally rotated in three dimensions. If you check the Leaves Rotation Lock option box, you can stop the leaves rotating three dimensionally. This will produce more illustration-like results. Lastly, when Randomize Shapes is unchecked, you can adjust the Arrangement slider to apply different seed values to generate different tree shapes.

Figure 9.35 The Tree filter dialog Basic panel options.

Figure 9.36 The Tree filter dialog Advanced panel options.

The Oil Paint filter

The Oil Paint filter is located in the Filter \Rightarrow Stylize submenu. The sliders in the Brush settings section can be adjusted to refine the oil paint effect, while the Lighting section can be used to adjust the angle of the lighting. The Shine slider can make a big difference to the relief texture of the oil paint effect.

Figure 9.37 shows an example of the Oil Paint filter applied to a landscape photograph and how this adds a painterly quality to the image. Figure 9.38 shows a more practical application, where I applied it to a copied layer of a beauty headshot using the settings shown here. I added a layer mask to the filtered layer (filled with black) and then painted with white on the hair areas only to reveal the effect of the Oil Paint filter. Basically, I was able to use the Oil Paint filter to create smoother-looking hair.

Graphics card requirements

If you can't access the Oil Paint filter it may be because you have a graphics card/system configuration that does not support OpenCL v1.1 or higher (most modern graphics cards should). Or, it may be because the image you are editing is not in RGB color mode.

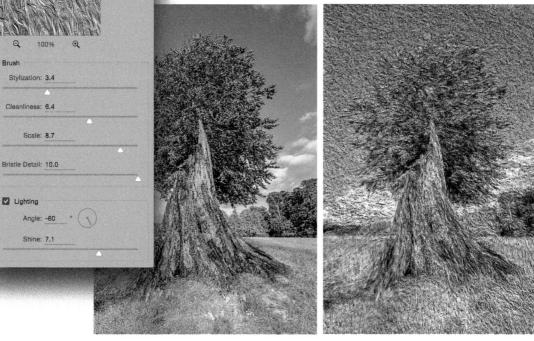

Figure 9.37 This shows an example of the Oil Paint filter in use, where I added a strong Lighting texture to the original photograph.

Oil Paint

OK

Cance

Preview

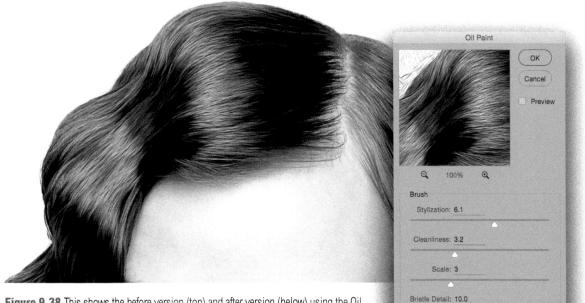

Figure 9.38 This shows the before version (top) and after version (below) using the Oil Paint filter settings shown here to smooth the hair texture.

Chapter 9: Blur, optical, and rendering filters 663

Lighting

Angle: 274

Shine: 2.3

1

To use the Filter Gallery, select an image (8-bit only), choose Filter Gallery from the Filter menu, and click on the various filter effect icons revealed in the expanded filter folders. These icons provide a visual clue as to the outcome of the filter, and as you click on these the filter effect can be previewed in the preview panel area. This gives you a nice, large preview for many of the creative Photoshop filters. As shown in Figure 9.38, you can combine more than one filter at a time and preview how these will look when applied together. To add a new filter, click on the New Effect Layer button at the bottom. As you click on the effect layers you can edit the individual filter settings. To remove a filter effect layer, click on the Delete button.

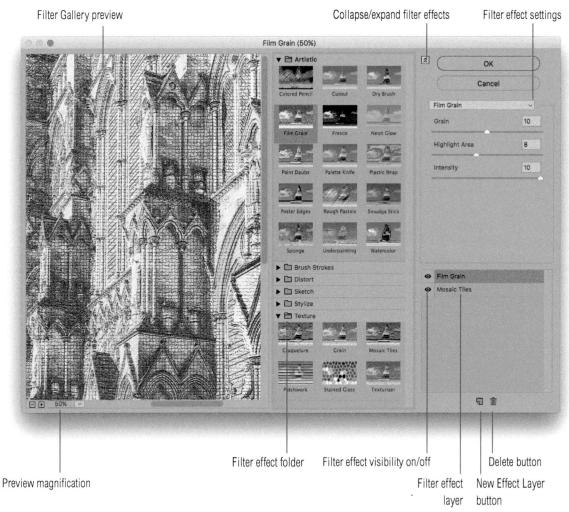

Chapter 10

Color management

The color management system in Photoshop went through many changes in the early years of the program. Bruce Fraser once said of the Photoshop's color management system 'it's push-button simple, as long as you know which of the 60 or so buttons to push and in which order!' Much have changed since then and it is fair to say that most people working today in the pre-press industry are now using ICC color profile managed workflows without having to think too much about what goes on behind the scenes, so long as it works. The aim of this chapter is to introduce the basic concepts of color management before looking at the color management interface in Photoshop and the various color management settings. An advertising agency art buyer was once invited to address a meeting of photographers. The chair, Mike Laye, suggested we could ask him anything we wanted, except 'Would you like to see my book?' And if he had already seen your book, we couldn't ask why he hadn't called it back in. And if he had called it in again we were not allowed to ask why we didn't get the job. And finally, if we did get the job we were forbidden to ask why the color in the printed ad looked nothing like the original photograph!

That in a nutshell is a problem which has bugged many of us throughout our working lives, and it is one which will be familiar to anyone who has ever experienced the difficulty of matching colors on a computer display with the original or a printed output. Figure 10.1 shows two versions of the same photograph. The picture on the left shows how you might see an image on your display in Photoshop and the one on the right represents how that same image might print if sent directly to a printer without applying any form of color management. You might think it is merely a matter of making the output color less

Client: Russell Eaton. Model: Lidia @ MOT.

Figure 10.1 The original image is shown on the left. And, on the right, how it might print if you don't use color management.

blue in order to successfully match the original. Yes, that would get the colors closer, but when trying to match color between different digital devices, the story is actually a lot more complex than that. The color management system in Photoshop can help you successfully match the colors from the scanner to the computer display and to the printer.

So why can there sometimes be such a marked difference between what is seen on the display and the actual printed result? Well, digital images are essentially nothing more than bunches of numbers. Color management is all about making sense of those numbers and translating them into meaningful colors at the various stages of the image-making process.

Color management objectives

Successful color management relies on the use of profiles to describe the color handling characteristics of each device, such as a scanner or a printer, and using a color management system to translate the profile data between each device in the chain. Consider for a moment the scale of the task at hand. We wish to capture a full color original subject, digitize it with a scanner or digital camera, examine the resulting image via a computer display, and then reproduce it in print. It is possible with today's technology to simulate the expected print output of a digitized image on a computer display with remarkable accuracy and print with confidence. But in doing so, one should not underestimate the huge difference between the mechanics of all the various bits of equipment that make this process happen. All digital devices have different characteristics, and just like musical instruments, they all possess unique color tonal properties, such that no two devices are absolutely identical or able to reproduce color exactly the same way as another device. The color data you input to the computer has to be translated into illuminated pixels on a color display, so that the image you see on the display looks recognizably the same as what you shot. Finally, at the print stage, the color data has to be converted to reproduce as tiny color ink drops on paper.

Unless you are able to quantify what the individual characteristics are for all your devices, you won't be able to communicate effectively with other devices and other computer programs in your computer setup, let alone anyone working outside your own system color loop.

Some computer displays have manual controls that allow you to adjust the brightness and contrast (and in some cases the RGB color as well) and the printer driver will also allow you to make color balance adjustments, but is this really enough? Plus, even if you are able to get your display and printer to match, will the colors you see on your display appear the same on another person's system?

Color vision trickery

They say that seeing is believing, but nothing could be further from the truth, since there are many interesting guirks and surprises in the way we humans perceive vision. There is an interesting book on this subject titled Why We See What We Do, by Dale Purves and R. Beau Lotto (Sinauer Associates, Inc). There is also a website at www.purveslab.net where you can have fun playing with the interactive visual tests, to discover how easily our eyes can be deceived. What you learn from studies like this is that color can never be properly described in absolute mathematical terms. How we perceive a color can also be greatly influenced by the other colors that surround it. This is a factor that designers use when designing a product or a page layout. You also do this every time you evaluate a photograph, often without even being aware of it.

CMYK ink values	С	1	N	Y		K
US Web Uncoated	08	2	23	29		0
Euroscale Coated	09	2	25	30	0	
Japan Pos proofing	07	2	8	33		0
RGB pixel values	R		(3		B
Adobe RGB	220	1	19	90	165	
Lambda printer	230	1	18	34		158
Epson 9000 RGB	231		17	79		123

Figure 10.2 This shows the skin tone number measurements for different CMYK and RGB color spaces.

The versatility of RGB

A major advantage of working in RGB is that you can access all the bells and whistles of Photoshop which would otherwise be hidden or grayed out in CMYK mode, and if you choose to use Adobe RGB or ProPhoto RGB, you will have a larger color gamut to work with. These days there is also no telling how a final image may end up being reproduced. A photograph may get used in a variety of ways, with multiple CMYK separations made to suit several types of publications, each requiring a slightly different CMYK conversion (because CMYK is not a 'one size fits all' color space). For example, high-end retouching for advertising usage is usually done in RGB mode and the CMYK conversions and film separations are produced working directly from the digital files to suit the various media usages.

Photographers are mainly involved in the RGB capture end of the business, which means that more images than ever before are starting out in, and staying in RGB color. This is an important factor that makes color management so necessary and also one of the reasons why I devote so much attention to the management of RGB color, here and elsewhere in the book. So, if professional photographers are more likely to supply a digital file at the end of a job, how will this fit in with existing repro press workflows that are based on the use of CMYK color? Although digital capture is now commonplace, the RGB to CMYK issue needs to be resolved. If the work you create is intended for print, the conversion from RGB to CMYK must be addressed at some point, and so for this important reason, we shall also be looking at CMYK color conversions in detail later on in this chapter.

Output-centric color management

Printers who work in the repro industry naturally tend to have an 'output-centric' view of color management. Their main concern is getting the CMYK color to look right on a CMYK press and printers can color correct a CMYK image 'by the numbers' if they wish.

While experienced repro people can make this work for themselves when managing CMYK files, these working methods don't translate to editing in RGB. Take a look at the photograph in Figure 10.2. The Caucasian flesh tones of this model should contain equal amounts of magenta and yellow ink, with maybe a slightly greater amount of yellow, while the cyan ink should be a quarter to a third of the magenta. This rule will hold true for most CMYK press conditions and the accompanying table compares the CMYK and RGB space measurements of a flesh tone color. However, you will notice there are no similar formulae that can be used to describe the RGB pixel values of a flesh tone. If you were to write down the flesh tone numbers for every RGB device color space, you could in theory build an RGB color space reference table. From this you could feasibly construct a system that would assign meaning to these RGB numbers for any given RGB space. This is basically what an ICC profile does except an ICC profile may contain several hundred color reference points. These can then be read and interpreted automatically by the Photoshop software and give meaning to the color numbers.

Profiled color management

The objective of profiled color management is to use the measured characteristics of everything involved in the image editing workflow, from capture through to print, to reliably translate the color at each stage of the process. In a normal Photoshop workflow, the color management begins with reading the profiled RGB color data from the incoming file and, if necessary, converting it to the current Photoshop RGB workspace. While an RGB image is being edited in Photoshop the workspace image data is converted on-the-fly to the profiled display space and sent to the computer display, so that the colors can be viewed correctly. When the image is finally output as a print, the RGB workspace data is converted to the profile space of the printer. Or, you might carry out an RGB to CMYK conversion to the CMYK profile of a known proof printer.

Whether you edit the image in the source profile, or convert to the workspace profile, that profile information should be embedded in an image file. When a profile is read by Photoshop and color management is switched on, Photoshop is automatically able to find out everything it needs to know in order to manage the color correctly from there on. This will also be dependent on you calibrating your display, but essentially all you have to do apart from that is to open the Photoshop Color Settings from the Edit menu and select a suitable preset such as the US Prepress Default setting. Do this and you are all set to start working in an ICC color managed workflow.

Think of a profile as being like a postcode (or ZIP code) for images. For example, the address label shown in Figure 10.3 was rather optimistically sent to me at 'Flat 14, London,' but the inclusion of the postcode made all the difference and it arrived safely! Some labs and printers have been known to argue that profiles cause color management problems. This I am afraid is like a courier company explaining that the late arrival of your package was due to you including a ZIP code in the delivery address. A profile can be read or it can be ignored. What is harmful in these circumstances is a recipient who doesn't use an ICC workflow.

Martin Evening Flat 14 LONDON London NI ITG

Figure 10.3 Even if you have never been to London before, you know it's a fairly big place and 'Flat 14, London' was not going to help the postman locate my proper address!

Translating the color data

One way to comprehend the importance of giving meaning to the numbers in a digital file is to make a comparison with what happens when language loses its meaning. There is an excellent book by Lynne Truss called Eats. Shoots & Leaves: The Zero Tolerance Approach to Punctuation. It is partly a rant against poor punctuation, but also stresses the importance of using punctuation to assign exact meaning to the words we read. Remove the punctuation and words can soon lose their true intended meaning. Another good example is the way words can have different meanings in other languages. So a word viewed out of context can be meaningless unless you know the language to which it belongs. For example, the word 'cane' in English means 'dog' in Italian.

Figure 10.4 A color management system is able to read the profile information from an incoming RGB file and behind the scenes it builds a table that correlates the source RGB information with the Profile Connecting Space values.

Color Management Modules

At the heart of any ICC system is the Color Management Module, or CMM, which carries out the profile conversion processing.

The International Color Consortium (ICC) is an industry body that represents the leading manufacturers of imaging hardware and software. The ICC grew out of the original Color Consortium that was established in 1993 and has been responsible for extending and developing the original ColorSync architecture to produce the standardized ICC format, which enables profiles created by different vendors to work together. All ICC systems are basically able to translate the color gamut of a source space via a reference space (the Profile Connection Space) and accurately convert these colors to the gamut of the destination space. Although the ICC format specification is standardized, this is one area where there are some subtle differences in the way each CMM handles the data.

In Photoshop you have a choice of three CMMs: Adobe Color Engine (ACE), Apple ColorSync, or Apple CMM. There are other brands of CMM that you can use as well, but this really need not concern most Photoshop users, as I recommend you use the default Adobe (ACE) CMM in Photoshop.

The Profile Connection Space

If the CMM is the engine that drives color management, then the Profile Connection Space (PCS) is at the hub of any color management system. The PCS is the translator that interprets the colors from a profiled space and defines them using either a CIE XYZ or CIE LAB color space. The Profile Connection Space is an interim space. It uses unambiguous numerical values to describe color values using a color model that matches the way we humans observe color (see Figure 10.4). You can think of the PCS as being like the color management equivalent of a multilingual dictionary that can translate one language into any other language.

If an ICC profile is embedded in the file, Photoshop will recognize this and know how to correctly interpret the color data. It helps to understand here that in an ICC color managed workflow in Photoshop, what you see on the display is always a color corrected preview and you are not viewing the actual file data. If color management is switched on, the RGB input profile is read and temporarily converted (as necessary) via the PCS to the RGB workspace. What you then see on the display is an RGB preview that's converted from the RGB workspace to your profiled display RGB via the PCS (see Figure 10.5). When you make a print, the image data is converted from the workspace RGB to the printer RGB via the PCS. The same thing happens when Photoshop previews CMYK data on the display. The Photoshop color management system calculates a conversion from the file CMYK space to the display space. Photoshop therefore carries out all its color calculations in a virtual color space. In a sense, it does not necessarily matter which RGB workspace you edit with. It does not have to be exactly the same as the workspace set on another user's Photoshop system. If you are both viewing the same file, and your displays are correctly calibrated and profiled, a color image should look near enough the same on both. Having said that, the RGB color space selection for the workspace can make a difference to the depth of colors (the color gamut) you have to work with. We'll be looking at the RGB workspace options towards the end of this chapter.

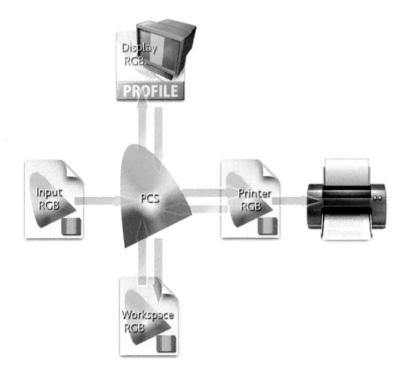

Figure 10.5 This diagram shows how the Photoshop color engine uses a Profile Connecting Space to handle the incoming RGB data and translate the data that is displayed on the screen and the data that is sent to the printer.

Figure 10.6 This shows an X-Rite Eye-One device being used to calibrate and profile a display.

Profiling the display

To get color management to work in Photoshop you have to calibrate and profile the computer display. This is by far the most important and essential first link in the color management chain. It is after all the instrument you rely upon most when you make your color editing decisions. The display itself is important of course. The cheaper displays tend to have a limited color gamut, are likely to have uneven luminance and may run too bright to calibrate successfully. If you are prepared to spend a bit more money you can get a wide gamut color display that can display more colors and near enough the entire Adobe RGB gamut. Some high-end LCD displays, such as the Eizo ColorEdge and the NEC Spectraview feature hardware level calibration.

I strongly urge you to purchase a display calibration kit that includes the necessary calibration software and use this to calibrate the monitor on a regular basis. In my office I use an X-Rite Eye One device (Figure 10.6) to calibrate and profile my displays and I use BasICColor Display software to carry out the calibration process. See the Calibration chapter on the book website for more information about the steps to follow when calibrating and profiling your display. Do remember that the performance of the display will fluctuate over time, so it is therefore important to check and calibrate the display at regular intervals.

Figure 10.7 The i1 Profiler interface.

Profiling the input

Input profiling is possible, but it's easier to do with a scanner than it is with a digital camera. To profile a scanner you'll need to scan a film or print target and use profile creation software such as X-Rite's i1 Profiler[™] program to read the data and build a custom profile based on readings taken from the scanned target (Figure 10.7). The target measurements are then used to build a profile that describes the characteristics of the scanner. It can then be incorporated into your color managed workflow to interpret the color image data coming into Photoshop. This can be done by selecting the profile in the scanner software or by assigning the profile in Photoshop as the file is opened.

Camera profiling is a lot trickier to do. This is because the camera sensor will respond differently under different lighting conditions and you would therefore need to build a new profile every time the light changed. This is not necessarily a problem if you are using a digital camera in a studio setup with a consistent strobe lighting setup. As you will recall in the Camera Raw chapter, Camera Raw has built-in 'Adobe Standard' camera profiles for all supported cameras. Where required, you can include an X-Rite ColorChecker in a setup, photograph this, and use the Adobe DNG Profile Editor app to generate a custom camera profile for that specific camera and lighting setup.

Overall, I would not stress too much about input profiles unless this is something that is critical to your workflow that you have absolute color control from start to finish. Most photographers can successfully rely on the Adobe Camera Raw Adobe Standard profile to get the colors looking correct. Once you start editing a photo it is more important to trust what you see on your monitor display and obtain good color management between the image that's previewed on the computer display and what you see in print.

Profiling the output

Successful color management also relies on having accurate profiles for each type of media paper that's used with your printer. If you buy a desktop printer it should come with a driver on a CD, or one you can download. The installation procedure should install a set of canned profiles that will work when using the proprietary inks designed to be used with the printer and for a limited range of branded papers. The canned profiles are generally good enough for professional print results. However, you can carry out custom profiling to build profiles for other types of print/paper combinations. This can be done by printing out a test target like the one shown in Figure 10.8, but without color managing it. This can be done by downloading the Adobe Color Printer Utility from the Adobe website (tinyurl. com/25onde3). Use this to print the supplied target. Once the test print has been allowed to stabilize, it can be measured the following day with a device like the X-Rite Eye-One spectrophotometer (Figure 10.9). The patch measurement results can then be used to build a color profile for the printer. The other alternative is to take advantage of Neil Barstow's remote profiling service special offer which is available to readers (see the back of the book). You can use a profiled printer to achieve good CMYK proofing, even from a modestly priced printer, which comes close to matching the quality of a recognized contract proof printer.

Figure 10.8 An X-Rite color target that can be used to build an ICC color profile.

Figure 10.9 Once a printed profile has been printed out, the color patches can be read using a spectrophotometer and the measurements used to build an ICC profile.

Figure 10.10 re-examines the problem encountered at the beginning of this chapter where the skin tones in the original image printed too blue. In this workflow no printer profile was used and the image data was sent directly to the printer with no adjustment made to the image data. Figure 10.11 shows a profile color managed workflow and what happens behind the scenes when Photoshop carries out a color profile conversion. The profile created for this particular printer is used to convert the image data to that of the printer's color space before being sent to the printer. The (normally hidden) color shifting which occurs during the profile conversion process ensures the output more closely matches the original.

Figure 10.10 This shows an example of a non-color managed workflow.

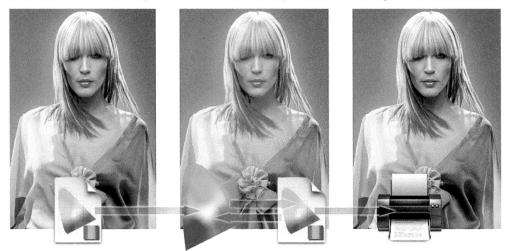

Figure 10.11 This shows an example of a Photoshop color managed workflow.

Settings: North Am	erica Prepress 2					ОК	
Working Spaces			Conve	rsion Options			
RGB:	Adobe RGB (1998)	~	Engine:	Adobe (ACE)		Cancel	
СМҮК:	U.S. Web Coated (SWOP) v2	~	Intent:	Relative Colorimetric ~		Load	
Gray:	Dot Gain 20%	~		Use Black Point Comp	ensation	Save	
Spot:	Dot Gain 20%	~		Use Dither (8-bit/chan	nel images)		
Color Management	Policies			Compensate for Scene	e-referred Profiles	Previet	
RGB:	Preserve Embedded Profiles ~		Advan	ced Controls			
СМҮК:	Preserve Embedded Profiles ~		Desa	turate Monitor Colors By:	20 %		
Gray:	Preserve Embedded Profiles ~		Blen	d RGB Colors Using Gamm	a: 1.00		
Profile Mismatches:	🛛 Ask When Opening 🛛 Ask Whe	n Pasting	🖸 Blend	d Text Colors Using Gamma	a: 1.45		
Missing Profiles:	Ask When Opening			synchronized: Your Creative not synchronized for cons			
Description							
	s 2: Preparation of content for commo	on printing co	nditions in	North America. CMYK valu	es are preserved.		
rofile warnings are en	abled.						

Figure 10.12 The Color Settings dialog.

The Color Settings

The Color Settings (Figure 10.12) are located in the Edit menu. The first item you will come across is the Settings pop-up menu. Photoshop provides a range of preset configurations for the color management system and these can be edited to meet your own specific requirements. The default setting will be a General Purpose setting and the exact naming and subsequent settings list will vary depending on the region where you live. Since this is just a default I advise changing this to one of the prepress settings. This selects Adobe RGB as your RGB workspace, and enables the Profile Mismatch and Missing Profiles alert warnings. So if you live in Europe, you would select the 'Europe Prepress' setting from the Settings options shown in Figure 10.13. The prepress' settings are an ideal starting point for any type of color managed workflow, especially if you are a photographer. This is all you need to concern yourself with initially for a nice and easy simple color management setup that is good to go. However, if you want to learn more about how color management works and what the various settings do, then read on.

Custom Other Euro prepress custom Europe General Purpose 3 Europe Prepress 3 Europe Web/Internet 2 Monitor Color North America General Purpose 2 North America Newspaper North America Web/Internet Japan Color for Newspaper Japan General Purpose 2 Japan General Purpose 3 Japan Magazine Advertisement Color Japan Prepress 2 Japan Web/Internet

Figure 10.13 The Settings menu options in Color Setting.

The first thing Photoshop does when a document is opened is check to see if an ICC profile is present. The default policy is to preserve the embedded profile information. So whether the document has originated in sRGB, Adobe RGB, or ColorMatch RGB, it will open in that RGB color space and after editing be saved as such. This means you can have several files open at once and each can be in an entirely different color space. A good tip here is to set the Status box to show 'Document profile' (on the Mac this is at the bottom left of the image window; on a PC it is at the bottom of the system screen). Or, you can configure the Info panel to display this information. This allows you to see each individual document's color space profile.

Preserve embedded profiles

The default policy of 'Preserve Embedded Profiles' allows you to use the ICC color management system straight away, without too much difficulty. So long as there is a profile tag embedded in any file you open, Photoshop gives you the option to open that file without converting it. So if you are given an sRGB file to open, the default option is to open it in sRGB and save using the same sRGB color space. This is despite the fact that your default RGB workspace might be ProPhoto RGB or some other RGB color space. The same policy rules apply to CMYK and grayscale files. Whenever 'Preserve Embedded Profiles' is selected, Photoshop reads the CMYK or Grayscale profile, preserves the numeric data and does not convert the colors, and the image remains in the tagged color space. This is always going to be the preferred option when editing incoming CMYK files because a CMYK file may already be targeted for a specific press output and you don't really want to convert and alter the numbers for those color values.

Profile mismatches and missing profiles

The default prepress color management policy setting is set to 'Ask When Opening' if there is a profile mismatch (see Figure 10.14). This means you will see the warning dialog shown in Figure 10.15 whenever the profile of a file you are opening does not match the current workspace. This offers you a chance to use the embedded profile (which is recommended). Or, you can override the policy and convert to the working space, or discard the embedded profile. Whatever you do, select one of these options and click OK, because if you click 'Cancel' you'll cancel opening the file completely. I normally select Preserve Embedded Profiles and deselect 'Ask When Opening,' so I am not constantly shown this dialog.

RGB:	Preserve Embedded Profiles ~
CMYK:	Preserve Embedded Profiles V
Gray:	Preserve Embedded Profiles v
Profile Mismatches:	Ask When Opening Ask When Pasting
Missing Profiles:	Ask When Opening

Figure 10.14 The Color Management Policies, with the Profile Mismatches and Missing Profiles checkboxes checked.

A newcomer does not necessarily have to fully understand how Photoshop color management works in order to use it successfully. When 'Preserve Embedded Profiles' is selected this makes the Photoshop color management system quite foolproof and the color management system is adaptable enough to suit the needs of all Photoshop users, regardless of their skill levels. Whichever option you select – convert or don't convert – the saved file will always be tagged with a correct ICC profile.

!	The document "_1BA1883.tif" has an embedded color profile that does not match the current RGB working space.
	Embedded: ProPhoto RGB
	Working: Adobe RGB (1998)
	What would you like to do?
	O Use the embedded profile (instead of the working space)
	Convert document's colors to the working space
	O Discard the embedded profile (don't color manage)
	Cancel OK

Figure 10.15 The Embedded Profile Mismatch dialog.

If you select the 'Convert to Working RGB' policy, Photoshop automatically converts everything to your current RGB workspace. If the incoming profile does not match the workspace and the Ask When Opening option is unchecked, the default option is to carry out a profile conversion from the embedded profile space to the current workspace (as shown in Figure 10.16). Here, you can click OK to convert to the current work space. If the 'Ask When Opening' box is checked in the Profile Mismatches section you will see the dialog shown in Figure 10.17. Here, you can make a choice on opening to use the embedded profile, convert to the working space, or override the policy and discard the embedded profile. If the incoming profile matches the current RGB workspace, there will of course no need to convert the colors.

The same applies when selecting the 'Convert to Working CMYK' policy. However, in the case of CMYK files it is inadvisable to convert to the CMYK working space because once a file has been converted to CMYK it is best not to reconvert to CMYK again.

Figure 10.16 The Embedded Profile Mismatch dialog.

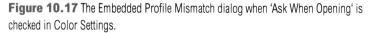

Color Management Off

When the 'Off' option is selected Photoshop appears not to color manage incoming documents and assumes the default RGB or CMYK workspace to be the source. If there is no profile embedded, the document opens 'as is.' If there is a profile mismatch between the source and the workspace, you'll see the dialog shown in Figure 10.18, which points out that if you click OK the embedded profile will be deleted. If the 'Ask When Opening' box is checked in the Profile Mismatches section, you will see the options shown on Figure 10.19.

If the source profile matches the workspace, there is no need to remove the profile. In this instance the profile tag will not be removed (even so, you can still remove the ICC profile at the save stage). Therefore, Photoshop is still able to color manage certain files and strictly speaking is not completely 'off.' Turning the color management off is not recommended for general Photoshop work. If working on an unfamiliar computer, do check the Color Settings to make sure Photoshop's color management hasn't been disabled.

When it is good to 'turn off'

Sometimes it is desirable to discard a profile. For example, you may be aware that the image you are about to open has an incorrect profile and it is therefore a good thing to discard it and assign the correct profile later in Photoshop. I still would not recommend choosing 'Off' as the default setting though. Just make sure you have the Color Management Policies set to 'Ask When Opening' and you can easily intervene and discard the profile when using the 'Preserve Embedded Profiles' or 'Convert to Working' RGB color management policies settings.

The document "_MG_4290.tif" i that does not match the current current RGB color management do not match the working space	t RGB working space. The policy is to discard profiles that
Embedded: ProPhoto RGB	
Working: Adobe RGB (1998)	
Don't show again	Cancel OK

Figure 10.18 The Embedded Profile Mismatch dialog when Color Management is set to Off.

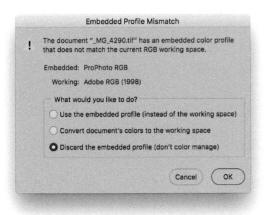

Figure 10.19 The Embedded Profile Mismatch dialog when Color Management is set to Off and 'Ask When Opening' is checked in Color Settings.

RGB to RGB conversion warning

A Convert to Profile is just like any other image mode change in Photoshop, such as converting from RGB to Grayscale mode. However, if you use Convert to Profile to produce targeted RGB outputs don't overwrite the original RGB master. As always, customized RGB files such as this may easily confuse other non-ICC savvy Photoshop users. Not everyone is using Photoshop, nor does everyone have their color management configured correctly. RGB to RGB conversions can produce RGB images that look fine on a correctly configured system, but look very odd on one that is not.

Profile conversions

As you gain more experience you will soon be able to create your own customized color settings. The minimum you need to know is "which of the listed color settings are appropriate for the work you are doing." To help in this decision making, you can read the text descriptions that appear in the Description box at the bottom of the Color Settings dialog. The following section explains how to make profile conversions once files have been opened in Photoshop, as well as how to assign different profiles where it is necessary to do so.

Convert to Profile

Even if you choose to preserve the embedded profile on opening, it can be useful to convert non-workspace files to your current workspace after opening. This is where the Convert to Profile command comes in, because you can use it to carry out a profile conversion at any time, such as at the end of a retouch session, just before saving. To do this, go to the Edit menu and choose 'Convert to Profile...' (Figure 10.20). The Source space shows the current profile space. In Basic mode, the Destination Space defaults to 'Working RGB.' Or, you can change this, as I have done here to sRGB.

Click on the Advanced button to go to the Convert to Profile Advanced dialog (Figure 10.21). Here, the Destination space options are broken down into different color mode types: Gray, RGB, Lab, and CMYK, plus other more esoteric options such as Device Link and Abstract profile modes. With the color modes segmented this way, it

	Convert to Profile	
Source	Space	
Profile:	ProPhoto RGB	ОК
Destin	ation Space	Cancel
Profile:	sRGB IEC61966-2.1	✓ ✓ Preview
Conve	rsion Options	
Engine:	Adobe (ACE)	Advanced
Intent:	Relative Colorimetric ~	
🖌 Use I	Black Point Compensation	
Use I	Dither	
Flatte	en Image to Preserve Appearance	
		Landonstrade, Officiality, Security, Science, Security, Science, Science, Science, Science, Science, Science, S

Figure 10.20 The Basic Convert to Profile dialog.

			Convert to Profile Advanced		
	Space ProPhoto	RGB		(ок
Destina	ation Spa	се		(Cancel
🔿 Gray		Profile:	Working Gray - Dot Gain 15%	-	Preview
O RGB		Profile:	sRGB IEC61966-2.1	~	
				(Basic
ОСМУ	ĸ	Profile:	Working CMYK - Coated FOGRA39 (ISO 12647-2:20	~	
Multi	channel	Profile:			
	e Link	Profile:	AnimePalette	~	
O Abst	ract	Profile:	Black & White	~	
Conve	rsion Opt	ions			
Engine:	Adobe (ACE)	▼		
Intent:	Relative	Colorime	tric 🗸		
🗸 Use I	Black Poli	nt Comper	nsation		
Use I	Dither				
Flatte	en Image	to Preserv	ve Appearance		

Figure 10.21 The Advanced Convert to Profile dialog.

makes it easier to access specific types of profiles when carrying out a conversion. Also, when you select from the RGB menu you only see RGB spaces and if you click on the CMYK menu you only see the CMYK space options (see Figure 10.22).

The Convert to Profile command is most commonly used when converting photographs to sRGB for the Web, or converting to a specific CMYK color space (which isn't the same as the default CMYK space). It is also useful whenever you wish to create an output file to send to a printer for which you have a custom-built profile but the print driver does not recognize ICC profiles. You can record the Convert to Profile as an Action step when batch processing images where you wish them to all be converted to a specific color space.

Be aware that whenever you make a profile conversion the image data will end up in a different color space and you might therefore see a slight change in the on-screen color appearance. This is because the profile space you are converting to may have a smaller gamut than the one you are converting from.

Also, whenever you open an image in Photoshop that is in a color space other than the default working space, or you convert to a different working space, Photoshop appends a warning asterisk (*) to the color mode in the title bar (Mac) or status bar (PC).

Custom CMYK Coated FOGRA27 (ISO 12647-2:2004) Coated EOGRA39 (ISO 12647-2:2004) Coated GRACoL 2006 (ISO 12647-2:2004) Japan Color 2001 Coated Japan Color 2001 Uncoated Japan Color 2002 Newspape Japan Color 2003 Web Coated Japan Web Coated (Ad) U.S. Sheetfed Coated v2 U.S. Sheetfed Uncoated v2 U.S. Web Coated (SWOP) v2 U.S. Web Uncoated v2 Uncoated FOGRA29 (ISO 12647-2:2004) US Newsprint (SNAP 2007) Web Coated FOGRA28 (ISO 12647-2:2004) Web Coated SWOP 2006 Grade 3 Paper Web Coated SWOP 2006 Grade 5 Paper Euroscale Coated v2 Euroscale Uncoated v2 Generic CMYK Profile Japan Color 2011 Coated Photoshop 4 Default CMYK Photoshop 5 Default CMYK Figure 10.22 The CMYK destination

profile menu.

Incorrect sRGB profile tags

Some digital cameras won't embed a profile in the JPEG capture files or, worse still, embed a wrong profile, yet the EXIF metadata will misleadingly say the file is in sRGB color mode. The danger here is that while you may select Adobe RGB as the RGB space for your camera, when shooting in JPEG mode the camera may inadvertently omit to alter the EXIF tag which stubbornly reads sRGB. This can be resolved by going to the Photoshop menu and choosing: Preferences ⇒ File Handling... If you check the 'Ignore EXIF Profile tag' option, Photoshop always ignores the specified camera profile in the EXIF metadata and only relies on the actual profile (where present) when determining the color space the data should be in.

Assign Profile

If an image is missing its profile or has the wrong profile embedded, the color numbers will be meaningless. In these situations the Assign Profile command (Figure 10.23) can be used to correct such mistakes and assign a correct meaning to the numbers. For example, if you know the profile of an opened file is wrong, you can use the Edit \Rightarrow Assign Profile command to rectify the problem. Or, let's say you have opened an untagged RGB file and for some reason decided not to color manage the file when opening. The colors don't look right and you have reason to believe that the file had originated from the sRGB color space. Yet, it is being edited in your current ProPhoto RGB workspace as if it were a ProPhoto RGB image. By assigning an sRGB profile, you can tell Photoshop that this is not a ProPhoto RGB image and the numbers should be interpreted as being in the sRGB color space.

In most instances, assigning sRGB will bring the colors back to life. For example, whenever I get sent an unprofiled file, in just about every case I can successfully correct the image by assuming the missing profile to be sRGB.

You can also use Assign Profile to remove a profile by clicking on the Don't Color Manage This Document button. This strips the file of its profile. You can also do this by choosing File \Rightarrow Save As... and deselecting the Embed Profile checkbox in the Save options.

Assign Pro	file:		ОК
🔵 Don't Co	lor Manage This Document		UN
O Working	RGB: ProPhoto RGB		Cancel
O Profile:	sRGB IEC61966-2.1	~	Preview

Figure 10.23 The Assign Profile dialog.

Profile mismatches when pasting

It is possible to have multiple images open in Photoshop that have different profiled color spaces. Therefore, whenever you copy and paste image data, or drag a layer from one image to another, it is possible for a profile mismatch may occur; although this will very much depend on how you have the Color Management policies configured in the Color Settings (see Figure 10.24).

If the Profile Mismatches: Ask When Pasting box is unchecked in the Color Settings and a profile mismatch occurs, you will see the dialog

RGB:	Preserve Embedded Profiles ~
CMYK:	Preserve Embedded Profiles ~
Gray:	Preserve Embedded Profiles V
Profile Mismatches:	Ask When Opening Ask When Pasting
Missing Profiles:	Ask When Opening

Figure 10.24 The Profile Mismatches settings in the Color Management section of the Color Settings dialog will influence Profile Mismatch behavior.

shown in Figure 10.25. This asks if you wish to convert the color data to preserve the color appearance when it is pasted into the new destination document. If the Profile Mismatches: Ask When Pasting box is checked in the Color Settings, then you will see the dialog box shown in Figure 10.26. This offers you the choice to convert or not convert the data. If you select 'Convert,' the appearance of the colors will be maintained when you paste the data and if you choose 'Don't Convert' the color appearance will change but the numbers will be preserved.

		s to a destination document wil current RGB working space?
Source: Adobe	RGB (1998)	
Destination: sRGB	IEC61966-2.1	
Working: ProPh	oto RGB	
Don't show again	n	Cancel OK

Figure 10.25 The Paste Profile Mismatch dialog.

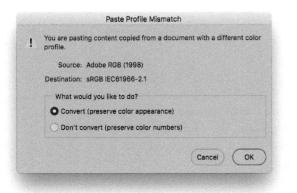

Figure 10.26 The Paste Profile Mismatch dialog when Ask When Pasting is checked in Color Setings.

Once you have configured the settings to suit a particular workflow, you can click on the Save... button in the Color Settings dialog to save these as a custom setting. The directory path will be: Username/ Library/Application Support/Adobe/Color/Settings (Mac), or Program Files/Common Files/Adobe/Color/Settings folder (PC). When you save a custom setting it must be saved to this location and will automatically be appended with the 'csf' suffix.

When you save a setting you can enter any relevant comments or notes about the setting you are saving in the text box shown in Figure 10.27. This information will then appear in the Color Settings dialog text box at the bottom. You might name a setting something like 'Client annual report settings' and write a short descriptive note to accompany it, reminding you of situations where you would need to use this particular custom setting. Color Settings files can also be shared between some Adobe applications and with other Photoshop users.

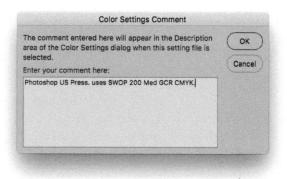

Figure 10.27 The Color Settings Comment dialog.

Reducing the opportunities for error

When you adopt an RGB space such as ProPhoto RGB as the preferred workspace for all your image editing, you must take into account how this might cause confusion when exchanging RGB files between your computer (which is operating in a color managed workflow) and that of someone who might be using Photoshop with the color management switched off. When sending image files to other Photoshop users, the presence of a profile can help them read the image data correctly, so long as they have the Photoshop color settings configured to preserve embedded profiles (or convert to the working space) and their computer display is calibrated correctly. They will then see your photographs on their system almost exactly the way you intended them to be seen. The only variables will be the accuracy of their display calibration and profile, the color gamut limitations of the display, and the environment in which it is being viewed. Configuring the Color Settings is not so difficult to do, but the recipient does have to be as conscientious as you are about ensuring their display is correctly calibrated.

It is important to be aware of these potential problems because it is all too easy for the color management to fail once an image file has left your hands and been passed on to another Photoshop user. With this in mind, here are some useful tips to help avoid misunderstandings over color. The most obvious way to communicate what the colors are supposed to look like is to supply a printed output. If you are sending a file for CMYK repro printing, it is sensible to also supply a CMYK targeted print output. Supplying a print is an unambiguous visual reference, which if done properly can form the basis of a contract between yourself, the client, and the printer.

You cannot always make too many assumptions about who you are sending image files to and it is for this reason that you should sometimes adopt a more cautious approach. I have often asked to supply RGB files as JPEGs for initial approval by the client before making a finished print. In these situations I find it safer to supply a profiled sRGB image. I do this by choosing Edit \Rightarrow Convert to Profile... and select sRGB as the destination space. If the recipient is color management savvy, then the version of Photoshop they are working with will be able to read the sRGB profile and handle the colors correctly. If not, one can be almost certain that they are using sRGB as their default RGB workspace. So in these instances, converting to sRGB means they stand a better chance of seeing the colors correctly regardless of whether they have the color management on or off.

Playing detective

Whenever you have to share files with another Photoshop user it helps to do a little detective work to ascertain the recipient's setup. For example, you might want to ask what color settings they are using. This will help you determine which RGB space they are using and whether the color management is switched on or off. You can also ask if computer display is calibrated and profiled.' This will tell you quite a bit about the other person's system, how accurate their computer display is at displaying colors, and therefore how you should supply your files. Some printing labs specify that the files you supply must be converted to a specific profile space. If so, make sure you do this rather than rely on having them convert the file for you. Other than that, sRGB is a useful 'dumbed down' space to convert to when communicating with unknown users. If you have any doubts, the safest option is always to convert to sRGB before sending. The Color Settings dialog is shown below in Figure 10.28. In the Conversion Options section you have a choice of three Color Management Modules (CMMs). I recommend you leave this set to the Adobe Color Engine (ACE), which uses 20-bit per channel bit-depth calculations to calculate its color space conversions. But you can if you like select the Apple CMM ColorSync engine.

	uro prep	ress custom				ОК
Working S	paces		Conve	rsion Options		
	RGB:	ProPhoto RGB ~	Engine:	Adobe (ACE)		Cancel
	CMYK:	Coated FOGRA39 (ISO 12647-2:2004) ~	Intent:	Relative Colorimetric Y		Load
	Gray:	Dot Gain 15% ~		Use Black Point Compensation		Save
	Spot:	Dot Gain 15% ~		Use Dither (8-bit/channel images)		
Color Man	acomont	Policies		Compensate for Scene-referred Pro	ofiles	Preview
COIOT MIATI	RGB:	Preserve Embedded Profiles	Advan	ced Controls		
	CMYK:	Preserve Embedded Profiles 🗸	Desa	aturate Monitor Colors By: 20	%	
	Gray:	Preserve Embedded Profiles ~	Blen	d RGB Colors Using Gamma: 1.00		
Profile Mism	natches:	Ask When Opening 🛛 Ask When Pasting	🗹 Blen	d Text Colors Using Gamma: 1.45		
Missing I	Profiles:	Ask When Opening	G Sy	nchronized: Your Creative Cloud applica		
				e synchronized using the same color set consistent color management.	tings	
Description						
aro prepress	oustam					

Figure 10.28 The Color Settings dialog.

Rendering intent

The rendering intent influences the way the data is translated from the source to the destination space. The rendering intent is like a rule that describes the way the conversion is calculated. Whenever you make a profile conversion, such as when converting from RGB to CMYK, not all of the colors in the original source space will have a direct equivalent in the destination space. RGB spaces are mostly bigger than CMYK,

or an RGB print space, which can result in colors in the source space being out of gamut relative to the destination space. In these situations the out of gamut colors have to be translated to their nearest equivalent color in the destination space. The way this translation is calculated is determined by the rendering intent. The Color Settings dialog lets you choose which rendering intent (Intent) you would like to use as the default method for all color mode conversions (Figure 10.29), but you can also override this setting and choose a different rendering intent whenever you use the Edit \Rightarrow Convert to Profile command (Figure 10.30), or soft proof an image using View \Rightarrow Proof Setup \Rightarrow Custom. The latter lets you preview a simulated conversion without actually converting the RGB data.

Perceptual

The Perceptual rendering is an all-round rendering method that is sometimes suitable for certain types of images. Perceptual rendering compresses the out-of-gamut colors into the gamut of the target space in a rather generalized way (so that they don't become clipped), while preserving the visual relationship between those colors. More compression occurs with the out-of-gamut colors, smoothly ramping to no compression for the in-gamut colors. Perceptual rendering provides a best-guess method for converting out-of-gamut colors where it is important to preserve tonal separation (such as in the shadow detail areas), but it is less suitable for images that happen to have fewer out-ofgamut colors.

Saturation

The Saturation rendering intent preserves the saturation of the out-ofgamut colors at the expense of hue and lightness. Saturation rendering preserves the saturation of colors making them appear as vivid as possible after the conversion. This rendering intent is best suited to the conversion of business graphic presentations where retaining bright bold colors is of prime importance.

Relative Colorimetric

Relative Colorimetric is the default rendering intent utilized in the Photoshop color settings. Relative Colorimetric rendering maps the colors that are out of gamut in the source color space (relative to the target space) to the nearest 'in-gamut' equivalent in the target space. For example, when doing an RGB to CMYK conversion, an out-ofgamut blue will be rendered the same CMYK value as a 'just-in-gamut' blue and out-of-gamut RGB colors are therefore clipped. This can be a

Engine	Perceptual Saturation	
Intent	Relative Colorimetric	
	Absolute Colorimetric	
	W Use Black Point Comp	ensation
	Use Dither (8-bit/char	nel images)
	Compensate for Scen	e-referred Profile

Figure 10.29 The Conversion Options Intent menu.

Convert to Profile	
Source Space	OK
Profile: ProPhoto RGB	UK
Destination Space	Cancel
Profile: Working CMYK - Coated FOGRA39 (ISO 12647-2:20 *	Preview
Conversion Options	
Engine: Adobe (ACE) ~	Advance
Intent: Relative Colorimetric ~	
Use Black Point Compensation	
Use Dither	
Plutino lango to Preserve Appearance	
A REAL PROPERTY AND A REAL	

Figure 10.30 The Convert to Profile dialog.

Which rendering intent is best?

If you are converting photographic images from one color space to another, then you should mostly use the Relative Colorimetric or Perceptual rendering intents. Relative Colorimetric has always been the default Photoshop rendering intent and is still the best choice for most image conversions. However, if you are converting an image where it is important to preserve the shadow colors, then Perceptual may often be better. For these reasons, I recommend you use the Soft proofing method described in the Print chapter to preview the outcome of a profile conversion. problem when attempting to convert the more extreme out-of-gamut RGB colors to CMYK color, but if you use View \Rightarrow Proof Setup \Rightarrow Custom (Figure 10.31) to call up the Customize Proof Condition dialog you can check to see if such gamut clipping will cause the loss of any important image detail when converting to CMYK with a Relative Colorimetric conversion.

Custom Proof Condition:	Custom		ОК
	Custom		UN
Proof Conditions			Cancel
Device to Simulate:	Uncoated FOGRA29 (ISO 12647-2:2004)	~	
	Preserve Numbers		Load
Rendering Intent:	Relative Colorimetric	~	Save
	Black Point Compensation		
Display Options (On	-Screen)		Preview
Simulate Paper Col	lor		
Simulate Black Ink			
Simulate Black Ink			

Absolute Colorimetric

Absolute Colorimetric maps in-gamut colors exactly from one space to another with no adjustment made to the white and black points. This rendering intent can be used when you convert specific 'signature colors' and need to preserve the exact hue, saturation, and brightness (such as the colors in a commercial logo design). This rendering intent is seemingly more relevant to the working needs of designers than photographers. However, you can use the Absolute Colorimetric rendering intent as a means of simulating a target CMYK output on a proofing device. Let's say you make a conversion from RGB to CMYK using either the Relative Colorimetric or Perceptual CMM and the target CMYK output is a newspaper color supplement printed on uncoated paper. If you use the Absolute Colorimetric rendering intent to convert these 'targeted' CMYK colors to the color space of the proofing device, the proof printer can reproduce a simulation of what the printed output on that stock will look like. For example, when you select the 'Proof' option in the Photoshop print dialog, the rendering intent menu appears grayed out. This is because an Absolute Colorimetric rendering is selected automatically (although the Print dialog doesn't actually show you this) in order to produce a simulated proof print.

Figures 10.32 to 10.34 illustrate how the rendering intent can influence the outcome of a color mode or profile conversion. Figure 10.32 shows the Adobe RGB color space (represented by a mesh shape) overlaying a US Sheetfed Coated CMYK color space (represented as a solid shape). Adobe RGB is able to contain all the colors that may be squeezed into this smaller CMYK space. The palm tree photograph is plotted as dots to represent where the RGB colors in this image fall within the Adobe RGB space gamut.

When the colors in this RGB image are converted to CMYK, the rendering intent determines how the RGB colors that are outside the gamut limits of the CMYK space are assigned a new color value. If you turn over the page you will notice the subtle differences between a relative colorimetric (Figure 10.33) and a perceptual (Figure 10.34) rendering (I have highlighted a single blue color in each to point out these differences). With a Relative Colorimetric rendering the out-of-gamut blue color is rendered to the nearest in-gamut CMYK equivalent. With a Perceptual rendering the same blue color is squeezed in further. This rendering method preserves the relationship between the out-of-gamut colors but at the expense of sometimes (but not always) producing a less vibrant separation.

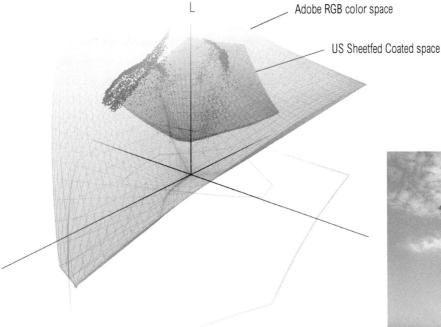

Figure 10.32 The colors in this photograph are represented here as dots within the Adobe RGB space color gamut, which is compared with the smaller CMYK output gamut.

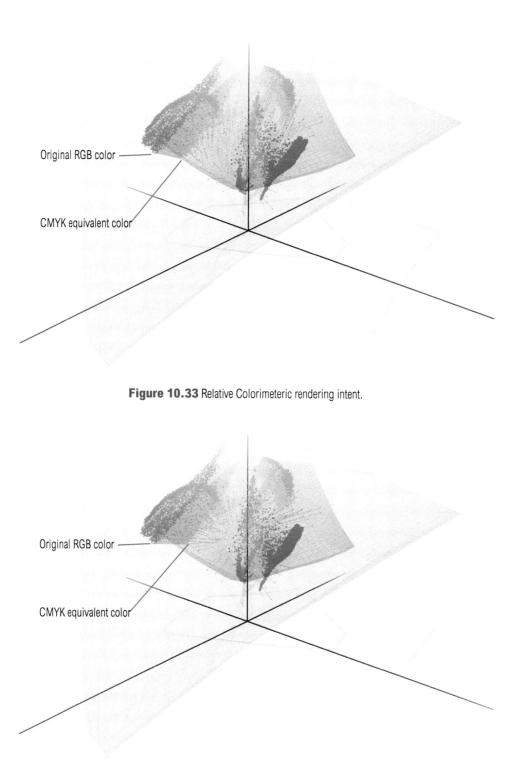

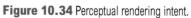

Black Point Compensation

This maps the darkest neutral color of the source RGB color space to the darkest neutrals of the destination color space. Black Point Compensation plays a vital role in translating the blacks in your images so that they reproduce as black when printed. As was explained in Chapter 2, there is no need to get hung up on setting the shadow point to anything other than zero RGB values. It is not necessary to apply any shadow compensation at the image editing stage, because the color management will automatically take care of this for you and apply a black point compensation obtained from the output profile used in the mode or profile conversion. If you disable Black Point Compensation you may obtain deep blacks, but you will get truer (compensated) blacks if you leave it switched on.

You will want to use Black Point Compensation when separating an RGB image to a press CMYK color space. However, in the case of a conversion from a CMYK proofing space to an inkjet profile space, we must preserve the (grayish) black of the press and not scale the image (because this would attempt to correct the blacks). For this reason Black Point Compensation is disabled in the Print dialog when making a proof print to simulate the black ink and how light the blackest colors will print.

Use Dither (8-bit per channel images)

Banding may occasionally occur when you separate to CMYK, particularly where there is a gentle tonal gradation in bright saturated areas. Any banding which appears on the display won't necessarily always show in print and much will depend on the coarseness of the screen that's eventually used in the printing process. However, the dither option can help reduce the risk of banding when converting between color spaces.

Scene-referred profiles

The Compensate for Scene-referred Profiles option isn't of any real significance for photographers. It is switched on by default and designed to automatically apply video contrast when converting between scene and output-referred profiles. This basically matches the default color management workflow for After Effects CS4 or later.

Advanced controls

Desaturate Monitor Colors

The 'Desaturate Monitor Colors' option can be used to visualize and make comparisons between color gamut spaces where one or more gamut space is larger than the display RGB space. For example, a color spaces such as ProPhoto RGB has a gamut that is much larger than the computer display is able to show. So turning down the monitor colors saturation can allow you to make a comparative evaluation between these two different color spaces. It is in essence a 'hurt me' button, because if you don't understand how to use this feature, you might inadvertently leave it on and end up assuming all your images are desaturated.

Blend RGB Colors using Gamma

This option lets you override the default color blending behavior. There used to be an option in Photoshop 2.5 for applying blend color gamma compensation. This allowed you to blend colors with a gamma of 1.0, which some experts argued was a purer way of doing things, because at higher gamma values than this you might see edge darkening occur between contrasting colors. Some users found the phenomenon of these edge artifacts to have a desirable trapping effect. However, many Photoshop users complained that they noticed light halos appearing around objects when blending colors at a gamma of 1.0. Consequently, gamma-compensated blending was removed at the time of the version 2.5.1 update, but has since been restored as an adjustable option. So, if you understand these implications you can enable and adjust this setting if you wish. Figure 10.35 shows a pure RGB green soft-edged

Figure 10.35 Comparing Blend RGB Colors using Gamma.

brush stroke on a layer above a pure RGB red Background layer. The version on the left shows the layer appearance using the normal default blending. The version on the right shows what happens when I checked the Blend RGB Colors using Gamma option and applied a gamma of 1.0.

The Blend Text Colors Using Gamma option is always checked by default with a setting of 1.45 to provide optimum blending for vector text layers. This value is chosen for vector shapes and text to make the anti-aliasing look better.

Custom RGB and work space gamma

If you know what you are doing and wish to create a customized RGB color space, you can do so by selecting the Custom option in the popup menu. Having done this, enter the desired White Point, Gamma, and color primaries coordinates (Figure 10.36). My advice is to leave these expert settings well alone. Avoid falling into the trap of thinking that the RGB workspace gamma should be adjusted to be the same as the monitor display gamma setting. The RGB workspace is not a display space. You do not actually 'see' the RGB workspace and the gamma setting has no effect on how the colors are displayed on the screen (so long as Photoshop ICC color management is switched on). All good reasons why the custom color space options are safely tucked away in Color Settings. The settings shown in Figure 10.36 are those needed to define 'Bruce RGB,' named after Bruce Fraser who once devised this color space as a suggested prepress RGB space for Photoshop.

RGB we	ork	space	and	gamma
--------	-----	-------	-----	-------

Adobe RGB is considered a good choice as an RGB workspace because its 2.2 gamma provides a more balanced, even distribution of tones between the shadows and highlights, while others, prefer the 1.8 gamma ProPhoto RGB space for its wide color gamut.

	Save RGB		
	Other		
	Monitor RGB - iMac-Basiccc-040117 (4887643609937).icc	Custom RGB	
Settings: Euro pre Working Spaces RGB ~ CMYK Gray	Adobe RGB (1998) Apple RGB ColorMatch RGB HDTV (Rec. 709) ProPhoto RGB SDTV NTSC SDTV PAL srGB IECE1966-2.1		OK
Spot Color Managemer	ACES Academy Color Encoding Specification SMPTE ST 2065-1 ACES CG Linear (Academy Color Encoding System AP1) ACEScog ACES Working Space AMPAS 5-2014-004 ARIL LocQS Wide Color Samut - El 1000	hann X Y ene- White: 0.3127 0.3290	
RGB	ARRI LogC3 Wide Color Gamut - El 1280 ARRI LogC3 Wide Color Gamut - El 1280 ARRI LogC3 Wide Color Gamut - El 160 ARRI LogC3 Wide Color Gamut - El 1600	Primaries: Custom	
СМҮК	ARRI LogC3 Wide Color Gamut - El 1000	x y	
Gray	ARRI LogC3 Wide Color Gamut - El 250 ARRI LogC3 Wide Color Gamut - El 320	mma: Red: 0.6400 0.3300	
Profile Mismatches	ARRI LogC3 Wide Color Gamut - El 400	Green: 0.2800 0.6500	
Missing Profiles.	ARRI LogC3 Wide Color Gamut - El 500 ARRI LogC3 Wide Color Gamut - El 640 ARRI LogC3 Wide Color Gamut - El 600 ARRI WCG Preview LUT for P3 Serview LUT for P3	ve Cl Blue: 0.1500 0.0600	

Figure 10.36 The Work space menu (left) and Custom RGB dialog (right).

Saving custom CMYK settings

Custom CMYK settings should be saved using the following locations: Library/ColorSync/Profiles/Recommended folder (Mac OS X); Windows\System32\Spool\Drivers\Color folder (PC).

CMYK conversions

Print images are nearly always reproduced in CMYK. Since the conversion from RGB to CMYK has to happen at some stage, the question is: at what point should this take place and who should be responsible for the conversion? If you have decided to take on this responsibility yourself then you need to understand more about the CMYK settings. When it comes to four-color print reproduction, it is important to know as much as possible about the intended press conditions that will be used at the printing stage and use this information to create a customized CMYK setup.

CMYK setup

If you examine the US prepress default setting, the CMYK space says 'U.S. Web Coated (SWOP) v2.' This setting is by no means a precise setting for every US prepress SWOP coated print job, because there can be many flavors of SWOP, but it does at least bring you a little closer to the type of specification a printer in the US might require for printing on coated paper with a web press setup. If you mouse down on the CMYK setup pop-up list, you will see there are also US options for Web uncoated and Sheetfed press setups. Under the European prepress default setting, there is a choice between coated and uncoated paper stocks, plus the latest ISO coated FOGRA39 setting. Then there is also Custom CMYK... where you can create and save custom CMYK profile settings.

There is not a lot you can do with the standard CMYK settings: you can essentially choose from this handful of generic CMYK profile settings or choose 'Custom CMYK...' If you check the More options box, you'll be able to select from a more comprehensive list of CMYK profile settings in the extended menu (depending on what profiles are already in your ColorSync folder).

Creating a custom CMYK setting

Figure 10.37 shows how to select the Custom CMYK option, along with the Custom CMYK dialog, where you can enter all the relevant CMYK separation information for a specific print job. Ideally you should save each purpose-built CMYK configuration as separate color settings with a description of the print job it was created for.

Once you have configured a new CMYK workspace setting, this becomes the new default CMYK workspace that is used when you convert an image to CMYK mode. (Altering the CMYK setup settings will have no effect on the on-screen appearance of an alreadyconverted CMYK file). This is because the CMYK separation setup settings must be established first before you carry out the conversion.

Custom CMYK		Settings	Custom CMYK			
Settings: Euro pre Save CMYK Working Spaces				Name: SWOP (Coated), 20%, GCR, Medium		
	Other		Ink Options			
RGB	Coated FOGRA27 (ISO 12647-2:2004)	Engine: Adobe (ACE)	Ink Colors:	SWOP (Coated)	~	Car
СМҮК -	 Coated FOGRA39 (ISO 12647-2:2004) 	Intent: Relative Colorimetric 👻	INK COIOIS.	onor (coulda)	the second se	
Gray	Coated GRACoL 2006 (ISO 12647-2:2004) Japan Color 2001 Coated	Use Black Point Compensation	Dot Gain:	Standard	× 20 %	
Spot Color Managemer	Japan Color 2001 Uncoated Japan Color 2002 Newspaper Japan Color 2003 Web Coated	Use Dither (8-bit/channel images Separation Options Compensate for Scene-refere				
RGB	Japan Web Coated (Ad) U.S. Sheetfed Coated v2 U.S. Sheetfed Uncoated v2	Advanced Controls	Separation Type:		Gray Ramp:	
СМУК	U.S. Web Coated (SWOP) v2	Desaturate Monitor Colors By:	Black Generation:	Medium ~	/	
Gray Profile Mismatches	U.S. Web Uncoated v2 Uncoated FOGRA29 (ISO 12647-2:2004) US Newsprint (SNAP 2007) Web Coated FOGRA28 (ISO 12647-2:2004)	 Blend RGB Colors Using Gamma: Blend Text Colors Using Gamma: 	Black Ink Limit:		A	
Missing Profiles	Web Coated SWOP 2006 Grade 3 Paper	Synchronized: Your Creative Cloud at	Total Ink Limit:	300 %	//	
Trunita	Web Coated SWOP 2006 Grade 5 Paper Euroscale Coated v2	are synchronized using the same coll for consistent color management.	UCA Amount:	0 %		

Figure 10.37 The Custom CMYK menu option (left) and Custom CMYK dialog (right).

Ink Colors

If you click on the Ink Colors menu, you can select one of the preset Ink Colors settings that are suggested for different types of printing. For example, European Photoshop users can choose from Eurostandard (coated), (uncoated), or (newsprint). These are just generic ink sets though. If your printer can supply you with a custom ink color setting, then select 'Custom...' from the Ink Colors menu. This opens the custom Ink Colors dialog shown in Figure 10.38.

Specialist Ink Colors options

For special print jobs such as where nonstandard ink sets are used, or the printing is being done on colored paper, you can enter the measured readings of the color patches (listed here) taken from a printed sample on the actual stock that is to be used. For example, you could measure these printed patches with a device such as the X-Rite Eye-One and use this information to create a custom Ink Colors setting for an individual CMYK press setup.

Figure 10.38 The Ink Colors dialog.

Comparing dot gain settings

You can see for yourself how the dot gain values affect the CMYK separations. Try converting an image to CMYK using two different dot gain values and then compare the appearance of the individual CMYK channels.

Dot gain

Dot gain can be due to an accumulation of factors during the repro process that make a dot printed on the page gain size and appear darker than expected. Among other things, dot gain is dependent on the type of press and the paper stock that's being used. The dot gain value entered in the CMYK setup determines how light or dark the separation needs to be. If a high dot gain is encountered, the separated CMYK films will need to be less dense so the plates produced lay down less ink on the paper and produce the correct-sized printed halftone dot for that particular type of press setup. Although the dot gain value affects the lightness of the individual channels, the composite CMYK channel image is always displayed correctly on the screen, showing how the final printed image should look.

If you select the 'Dot Gain Curves' option, you can enter custom settings for the composite or individual color plates in the Dot Gain Curves dialog (Figure 10.39). If your printer is able to provide dot gain values at certain percentages, enter these here. The dot gain curves can be the same for all channels, but since the dot gain may vary on each ink plate, you can enter dot gain values for each plate individually.

Figure 10.39 The 'Dot Gain: Curves dialog.

Gray Component Replacement (GCR)

The default Photoshop CMYK setting is GCR, Black Generation: Medium, Black Ink Limit 100%, Total Ink Limit 300%, UCA Amount 0%. If you ask your printer what separation settings they use and they quote you these figures, you'll know they are just reading the default settings from an unconfigured Photoshop setup. They either don't know or don't want to give you an answer. The black ink limit should typically be around 95% for most separation jobs, but in the region of 85–95% for newsprint. The total ink limit should roughly be in the region of 300–350% for Sheetfed coated and Web press coated jobs, 260–300% for Sheetfed uncoated and Web uncoated jobs, and 260–280% for newsprint. If you prefer, you can just stick to using the prepress CMYK setting that most closely matches the output (such as US Sheetfed/Web Coated/Uncoated, or one of the European FOGRA settings).

Black Generation

The Black Generation determines how much black ink is used to produce the black and gray tonal information. A light or medium Black Generation setting will work best for most photographic images. I would therefore advise leaving this set to 'Medium' and only change the black generation if you know what you are doing.

You may be interested to know that I specifically used a Maximum Black Generation setting to separate all the dialog boxes that appear in this book. Figure 10.40 shows a view of the Channels panel after I had separated the screen grab shown in Figure 10.38 using a Maximum Black Generation CMYK separation. With this separation method only the black plate is used to render the neutral gray colors. Consequently, this means that any color shift at the printing stage has no impact whatsoever on the neutrality of the gray content. I cheekily suggest you inspect other Photoshop books and judge if their panel and dialog box screen shots have reproduced as well as the ones shown in this book.

Undercolor Addition (UCA)

Low-key subjects and high-quality print jobs are more suited to the use of GCR (Gray Component Replacement) with a small amount of UCA (Undercolor Addition). GCR separations remove more of the cyan, magenta, and yellow ink where all three inks are used to produce a color, replacing the overlapping color with black ink. By dialing in some UCA one can add a small amount of color back into the shadows. This can be particularly useful where the shadow detail would otherwise look too flat and lifeless. The percentage of black ink used is determined by the black generation setting. When making conversions, you are usually better off sticking with the default GCR, using a light to medium black generation with 5–10% UCA. This will produce a longer black curve with improved image contrast.

Undercolor Removal (UCR)

The UCR (Undercolor Removal) separation method replaces the cyan, magenta, and yellow ink with black ink in just the neutral areas. The UCR setting is also favored as a means of keeping the total ink percentage down on high-speed presses, although it is not necessarily suited for every type of print job.

CMYK previews in Proof Setup

Once the CMYK setup has been configured, you can use View ⇒ Proof Setup ⇒ Working CMYK to see a CMYK preview of what a photograph will look like after a CMYK conversion, while you are still editing the image in RGB mode.

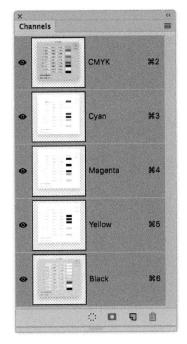

Figure 10.40 Here is a view of the Channels panel showing the four CMYK channels after I had separated the screen grab shown in Figure 10.38 using a Maximum black generation CMYK separation.

CMYK to CMYK

It is not ideal for CMYK files to be converted to RGB and then converted back to CMYK, as this is a sure-fire way to lose data fast. I always prefer to keep an RGB master of each image and convert to CMYK using a custom conversion to suit each individual print output. Converting from one CMYK space to another is not really recommended either, but in the absence of an RGB master. this will be the only option you have available: just specify the CMYK profile you wish to convert to in the Convert to Profile dialog box. Remember, the Preserve Embedded Profiles policy ensures that tagged incoming CMYK files can always be opened without converting them to your default CMYK space (because that would be a bad thing to do). This means that the color numbers in the incoming CMYK files are always preserved, while providing you with an accurate display of the colors on the computer display.

Choosing a suitable RGB workspace

The RGB space you choose to edit with can certainly influence the outcome of your CMYK conversions, which is why you should choose your RGB workspace carefully. The default sRGB color space is widely regarded as an unsuitable space for photographic work because the color gamut of sRGB is actually smaller than the color gamut of CMYK (and that of most inkjet printers). If you choose a color space like Adobe RGB or ProPhoto RGB, you'll be working with a color space that can adequately convert from RGB to CMYK without significantly clipping the CMYK colors. Adobe RGB has long been a favoured space for professional photographers and you should really notice the difference here if you are able to view the photos you are editing on a decent display like the high-end Eizo or NEC displays. These are capable of displaying something like 98% of the Adobe RGB gamut and therefore just about all the gamut of a typical CMYK space. It can make a big difference if you can use such a display to accurately preview the colors you are editing and soft proof them for print (see Chapter 12).

Whichever color workspace you select in the RGB color settings, you will have to be conscious of how your profiled Photoshop RGB files may appear on a non-ICC savvy Photoshop system. What follows is a guide to the listed RGB choices.

Apple RGB

This is the old Apple 13" monitor standard. In the early days of Photoshop Apple RGB was used as the default RGB editing space where the editing space was the same as the monitor space. If you have legacy images created in Photoshop on a Macintosh computer using a gamma of 1.8, you can assume Apple RGB to be the missing profile space.

sRGB IEC-61966-2.1

sRGB was conceived as a multipurpose color space standard that consumer digital devices could all standardize to. It is essentially a compromise color space that provides a uniform color space which all digital cameras and inkjet printers and displays are able to match (since sRGB aims to match the color gamut of a typical 2.2 gamma PC display). Therefore, if you are opening a file from a consumer digital camera or scanner and there is no profile embedded, you can assume that the missing profile should be sRGB. It is an ideal color space for Web design but unsuitable for photography or serious print work. This is mainly because the sRGB space clips the CMYK gamut quite severely and you will never achieve more than 75–85% cyan in your CMYK separations.

ColorMatch RGB

ColorMatch is an open-standard RGB display space that was once implemented by Radius, who used to make displays and graphics cards for the Macintosh computer market. ColorMatch has a gamma of 1.8 and is still favored by some Macintosh users as their preferred RGB working space. Although not much larger than the gamut of a typical display space, it is at least a known standard and more compatible with legacy 1.8 gamma Macintosh files. The problem with selecting a small gamut space like this means you end up losing tonal separation in colors that may be important, such as when carrying out an RGB to CMYK conversion.

Adobe RGB (1998)

Adobe RGB (1998) has become established as a recommended RGB editing space for RGB files that are destined to be converted to CMYK. For example, the Photoshop prepress color settings all use Adobe RGB as the default RGB working space. Adobe RGB was initially labeled as SMPTE-240M, which was a color gamut once proposed for HDTV production. As it happens, the coordinates Adobe used did not exactly match the actual SMPTE-240M specification. Nevertheless, it proved popular as an editing space for repro work and soon became known as Adobe RGB (1998). I have in the past used Adobe RGB as my preferred RGB working space, since it is well suited for RGB to CMYK color conversions.

ProPhoto RGB

This is a large gamut RGB space that has the advantage of preserving the full gamut of raw capture files when converting the raw data to RGB. It is also suited for image editing that is intended for output to photographic materials such as transparency emulsion or a photo quality inkjet printer. This is because the gamut of ProPhoto RGB extends more into the shadow areas compared with most other RGB spaces, resulting in better tonal separation in the shadow tones.

I have ProPhoto RGB configured as the RGB work space on all my computers running Photoshop and normally carry out all my editing on RGB files in 16-bit. However, I am wary of releasing files to clients in ProPhoto RGB. If I am sending a file to someone who I believe is ICC color management savvy, I'll send them a profiled Adobe RGB version. If I am sending a file by email or to someone who may not understand color management, I always play safe and send them an sRGB version.

×				44
Info				*
ä,	R : G : B :	186 186 186	C: M: Y: K:	25% 19% 20% 2%
8	l-bit		8-bit	270
+.	X: Y:	4.48 5.55	₽ ₩ H	
		M/5.16M 100%*		
Clicl		e to choos	e new backgro	bund

Figure 10.41 The gray color measurement shown here is clearly neutral in color because the RGB values are identical.

Lab color

The Lab color space does not use embedded profiles since it is assumed to be a universally understood color space. It is argued by some that converting to Lab mode is one way to surmount all the problems of mismatched RGB color spaces. You could make this work, but I don't personally advise this for a number of reasons. In fact, a few readers have taken me to task over not covering Lab mode image editing in this book, so let me clarify why I don't see editing in Lab mode as being so useful now for high-end image editing. In the early days of Photoshop I would sometimes use the Lab color mode to carry out certain tasks, such as to separately sharpen the Lightness channel. This was before the introduction of layers and blending modes, where I soon learnt you could use the Luminosity and Color blend modes to neatly target the luminosity or the color values in an image without having to convert to Lab mode and back to RGB again. Also, with Camera Raw the sharpening is applied to the luminance values only and it is possible to further filter the sharpening using the Detail and Masking sliders.

Let's just say that there are no right or wrong answers here. If you can produce good-looking prints using whatever methods work best for you, and you are happy with the results, well who is to argue with that? However, I would hope by now that having learnt about optimizing tones and colors in Camera Raw, followed by what can be achieved using Photoshop, you'll realize that these are all the tools you'll ever need to process a photograph all the way through to the finished print stage. My response to the Lab color argument is that it is simply adding complexity where none is needed. There are good reasons why in recent years the Adobe engineering teams have devoted considerable effort to enhancing the Camera Raw image editing for Photoshop and Lightroom. Their aim has been to make photographic image editing more versatile, less destructive, and, above all, simpler to work with rather than rely on cumbersome workarounds.

Measuring by the numbers

Given the deficiencies of typical computer color displays, such as their limited dynamic range and inability to reproduce certain colors like pure yellow, color professionals may sometimes rely on the numeric information to assess an image. Certainly, when it comes to getting the correct output of neutral tones, it is possible to predict with greater accuracy the neutrality of a gray tone by measuring the color values with the eyedropper tool. If you use the eyedropper tool to measure the colors in an image that's in a standard RGB space, such as sRGB, Adobe RGB or ProPhoto RGB, and the RGB numbers are all equal, it is unquestionably a gray color. Figure 10.41 shows an eyedropper measurement being taken from a white balance card. The even RGB values indicate that this light gray color is perfectly neutral in color.

Interpreting the CMYK ink values is less straightforward. This is because a neutral CMYK gray is not made up of an equal amount of cyan, yellow, and magenta. If you compare the Color readout values between the RGB and CMYK Info panel readouts, there will always be more cyan ink used in the neutral tones, compared with the yellow and magenta inks. This is because a greater proportion of cyan ink is required to balance out the magenta and yellow inks to produce a neutral gray color in print (if the CMY values were equal, you would see a muddy brown color cast). This is due to the fact that the process cyan ink is less able to absorb its complementary color – red – compared with the way magenta and yellow absorb their complementary colors. This also explains why a CMY black will tend to look reddish/brown, without the addition of the black plate to add depth and neutrality.

When retouching a portrait (such as in the Figure 10.42 example), you can use the Info panel CMYK readout numbers to help judge if the skin tones are the correct color. To do this set the panel options to display RGB and CMYK readouts. Then use the eyedropper to measure the skin tone values. Caucasian skin tones should have roughly a third or a quarter as much cyan as magenta and slightly more yellow than magenta. Black skin tones should be denser, have the same proportion of cyan to magenta, but usually a higher amount of yellow than magenta and also some black.

Color management references

If your main area of business revolves around the preparation of CMYK separations for print, then I do recommend you invest in a training course or book that deals with CMYK repro issues. I highly recommend the following books: *Real World Color Management* by Bruce Fraser, Chris Murphy and Fred Bunting; *Color Management for Photographers* by Andrew Rodney; and *Getting Colour Right: The Complete Guide to Digital Colour Correction* by Neil Barstow and Michael Walker. And lastly, an easy-to-follow ebook guide called *Accurate Color*, an interactive guide by Herb Paynter.

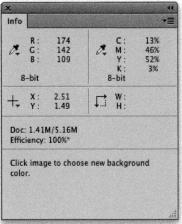

Figure 10.42 You can use the CMYK values in the Info panel to help check if the skin tones are the correct color by comparing the percentage of cyan with the magenta and yellow inks.

Keeping it simple

Congratulations on making it through to the end of this chapter. Your head may be reeling from all this information about Photoshop's color management system, but successful color management doesn't have to be complex. Firstly, you need to set the Color Settings to the prepress setting for your geographic region. This single step configures the color management system with the best defaults for photographic work. The other thing you must do of course is to calibrate and profile the display. If you want to do this right, you owe it to yourself to purchase a decent colorimeter device and ensure the computer display is profiled regularly. Do just these few things and you are well on your way to achieving a reliable color management workflow. However, color management can't always be expected to yield perfect results. The ability to match colors between capture and print is ultimately dependent on the gamut limits of the display and output device. This is a subject I will be addressing further in the following chapter on print output.

Chapter 11

Print output

This chapter is all about the print output process. To obtain the bestquality print output, it is important to have a good understanding of the Photoshop Print and system print dialog interfaces and how to configure the settings. While Photoshop printing can be as easy as loading a sheet of paper and clicking print, there are several important issues you need to address in order to get optimum prints. For example, print output sharpening is always required to achieve prints that look as sharp as what you see on the screen. You should also use soft proofing to ensure the colors you see on the display accurately reflect how an image will actually print.

Desktop printing

The most popular desktop printers these days are inkjets. The A4 models are very affordable and can be just as good as the large format, high-end inkjets. Basic models will mostly use four inks—cyan, magenta, yellow, and black—while the advanced models have multiple inks including extra colors such as red and blue, as well as various shades of gray and black inks for matte or glossy media. Then there are all the different types of paper you can print to. Not only do you get a wide range of options, but through careful choice, some paper and ink combinations can be guaranteed to last up to 100 years, or longer.

Rather than go into all the details about different print processes, I have pared this chapter down so that it concentrates on just the essentials. If you want to know more about Photoshop printing, there is a book I co-wrote with Jeff Schewe titled Adobe Photoshop CS5 for Photographers: The Ultimate Workshop. I can recommend Mastering Digital Printing, Second Edition (Digital Process and Print) by Harald Johnson, which provides an extensive overview of desktop printing, as well as The Digital Print – Preparing Images in Lightroom and Photoshop for Printing by Jeff Schewe.

Print sharpening

One of the most important things you need to do when making a print is to sharpen the image before you send it to the printer. So I am going to start by looking at print output sharpening.

Earlier in Chapter 3, I outlined how you can use the Detail panel sharpening sliders in Camera Raw to capture sharpen different types of images. This pre-sharpening step is something all images require. The goal in each case is to consider the image content, whether the photograph contains fine-edge or wide-edge details, and then apply a custom capture sharpening so it ends up in what can be considered an optimized sharpened state. The aim essentially, is to sharpen each photograph just enough to compensate for the loss of sharpness that is a natural consequence of the capture process.

Output sharpening is a completely different matter. Any time you output a photograph and prepare it for print—either to appear in a magazine, on a billboard, or when you send it to an inkjet printer—it will always require additional sharpening beforehand. Some output processes may incorporate automatic output sharpening, but most don't. It is therefore essential to always include an output sharpening step immediately before you create a print output. So, how much should you sharpen? While the capture sharpening step should be tailored to the individual characteristics of each image, the output sharpening approach is different. It is a standard process and one that is dictated by the following factors the output process (i.e., whether it is being printed on an inkjet printer or going through a halftone printing process), the paper type used (whether glossy or matte), and, finally, the output resolution.

Judge the print, not the display

It is difficult to judge just how much to sharpen for print output by looking at the image on a display. Even if you reduce the viewing size to 50% or 25%, what you see on the screen does not fully represent how the final print will look. The ideal print output sharpening can be calculated on the basis that at a normal viewing distance, the human eye resolves detail to around 1/100th of an inch. So if the image you are editing is going to be printed from a file that has a resolution of 300 pixels per inch, the edges in the image will need a 3 pixel radius if they are to register as being sharp in print. When an image is viewed on a computer display at 100%, this kind of sharpening will look far too sharp, if not downright ugly (partly because you are viewing the image much closer up than it will actually be seen in print), but the actual physical print should appear correctly sharpened once it has been printed from an 'output sharpened' version of the image. So, based on the above formula, images printed at lower resolutions require a smaller pixel radius sharpening and those printed at higher resolutions require a higher pixel radius sharpening. Now, different print processes and media types also require slight modifications to the above rule, but essentially, output sharpening can be distilled down to a set formula for each print process/resolution/media type. This was the basis for research carried out by the late Bruce Fraser and Jeff Schewe when they devised the sharpening routines used for PhotoKit Sharpener. These are elaborated upon in Real World Image Sharpening with Adobe Photoshop, Camera Raw, and Lightroom (2nd Edition) by Bruce Fraser and Jeff Schewe (ISBN: 978-0321637550).

High Pass filter edge sharpening technique

The technique described on page 706–707 shows an example of just one of the formulas used in PhotoKit Sharpener for output sharpening. In this case I have shown Bruce Fraser's formula for sharpening a typical 300 pixel per inch glossy inkjet print output. You will notice that it mainly uses the High Pass filter combined with the Unsharp Mask filter to apply the sharpening effect. If you wish to implement this sharpening method, do make sure you have resized the image beforehand to the exact print output dimensions and at a resolution of 300 pixels per inch.

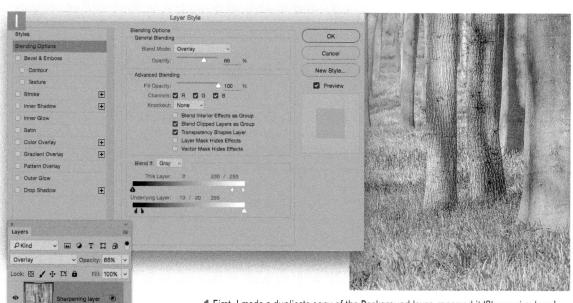

1 First, I made a duplicate copy of the Background layer, renamed it 'Sharpening layer' and set the layer opacity to 66%. I then double-clicked the duplicate layer to open the Layer Style options and adjusted the Blend If sliders as shown here.

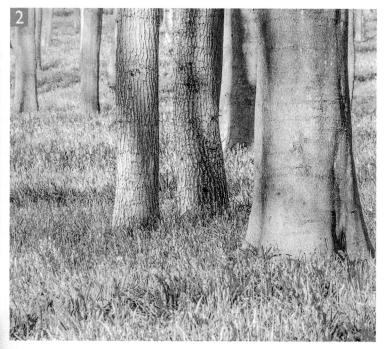

2 Next, I applied the Unsharp Mask filter to the layer using an Amount of 320, Radius of 0.6 and Threshold of 4. I then chose Edit ⇒ Fade, changed the blend mode to Luminosity and reduced the opacity to 70%.

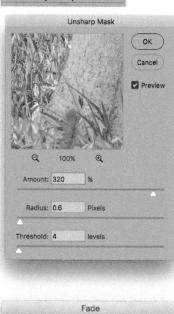

0

Background

fx 🖸 🖉 🛅 🕤 🧰

Opacity	r:	70	%	ОК
Mode:	Luminosity		~	Cancel
				Preview

•

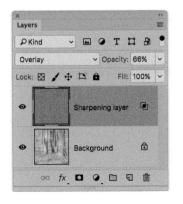

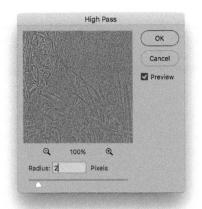

3 I changed the Layer blend mode from Normal to Overlay and went to the Filter menu, chose Other \Rightarrow High Pass filter and applied a Radius of 2 pixels. This step effectively isolated the High Pass filter sharpening effect to the sharpening layer. This is because when a layer is set to the Overlay blend mode, a neutral gray color will have no effect on the image, only those colors that are lighter or darker than neutral gray will have an effect. Here is a 1:1 close-up view of the sharpened image. You should be able to judge the effectiveness of the technique by how sharp the photograph appears here in print. The sharpening layer here can be increased or decreased in opacity or easily removed. The underlying Background layer remained unaffected by the preceding sharpening steps.

The View menu contains a Gamut Warning option that can be used to highlight colors that are out of gamut. The thing is, you never know if a highlighted color is just a little or a lot out of gamut. Gamut Warning is therefore a fairly blunt instrument to work with, which is why it is better to use the soft proofing method described here.

Soft proof before printing

Color management can do a good job of translating the colors from one space to another, but for all the precision of measured targets and profile conversions, it is still essentially a dumb process. Color management can usually get you fairly close at the printing stage, but it won't be able to interpret every single color or make aesthetic judgments about which colors are important and which are not. Plus some colors you see on the computer display simply can't be reproduced in print. This is where soft proofing can help. Using the Custom Proof Condition dialog, you can simulate on the display how a photo will look when it is printed. All you have to do is to select the correct profile for the printer/paper combination you are about to use, choose a suitable rendering intent (Perceptual or Relative Colorimetric) and make sure Black Point Compensation and Simulate Paper Color (and by default simulate black ink) are both checked. Simulate Paper Color may sometimes make the whites appear bluish, which is most likely associated with optical brightener detection in the ICC profile. It is optional that you check this when carrying out a soft proof.

Also, when the Customize Proof condition is active and applied to an image, the Photoshop Print dialog can reference the soft proofed view as the source space. This means you can use the Customize Proof Condition to select a CMYK output space and the Photoshop Print dialog configured to create a simulated print using this CMYK space.

Sustom Proof Condition:	Custom	(ОК
Proof Conditions			
Device to Simulate:	SPR2000 Epson Ultra Smooth Fine Art Paper	~	Cancel
	Preserve RGB Numbers		Load
Rendering Intent:	Relative Colorimetric	~ (Save
	Black Point Compensation		<u></u>
Display Options (On-	Screen)		Preview
Simulate Paper Co	lor		
Simulate Black Ink			

1 To begin with, I opened an image, went to the Image menu and chose Duplicate... I then re-selected the Original image, went to the View menu and chose Proof Setup ⇒ Custom... Here I selected a profile of the printer/paper combination that I wished to simulate, using (in this case) the Relative Colorimetric rendering intent and made sure Simulate Paper Color option was checked in the On-Screen Display Options.

2 In this screen shot you can already see a slight difference in tone contrast and color between the two versions. The original master image is on the left.

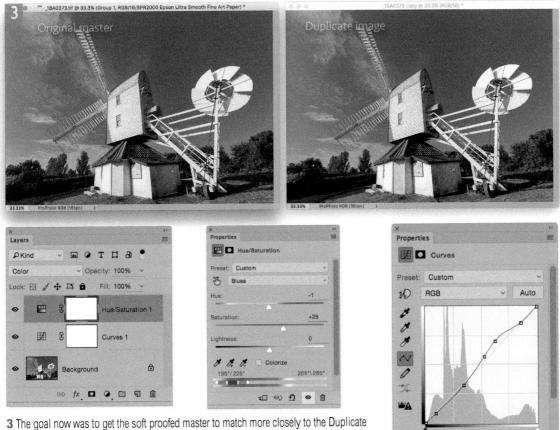

3 The goal now was to get the soft proofed master to match more closely to the Duplicate image on the right. I added a Curves adjustment layer to tweak the tones (using the Luminosity blend mode) and a Hue/Saturation adjustment to tweak the colors (using the Color blend mode).

Output: 182

•

(∞) <u>€</u>

Input: 137

*

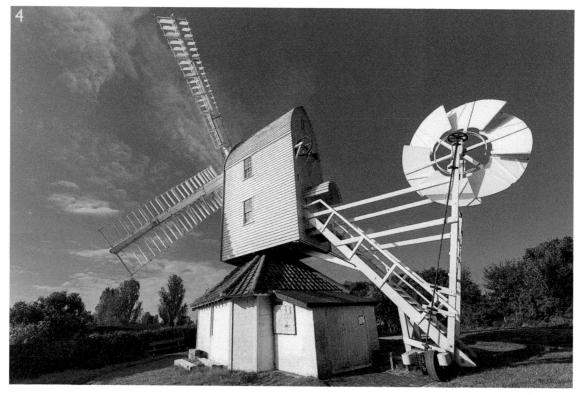

4 Here is the final version, which shows the corrected, soft proofed master image. When this corrected version was sent to the printer, I could expect the print output to match very closely to what was seen on the computer display. I recommend the correction adjustment layers be preserved by grouping them into a layer group. You will then be able to turn the visibility off before saving and only need to switch the layers back on again when you want to make further prints.

Managing print expectations

When you use soft proofing to simulate a print output your initial response can be "Eek, what happened to the contrast?" This can be especially true when you also include Simulate Paper Color in a soft proof setup. If we assume you are using a decent display and that it has been properly calibrated, the soft proof view should still represent an accurate prediction of the contrast range of an actual print compared to the high contrast range you have become accustomed to seeing on an LCD display. One solution is to look away as you apply the soft proof preview so that you don't notice the sudden shift in the on-display appearance so much.

Making a print

There are two Photoshop Print options. File \Rightarrow Print... (**HP** [Mac] **CIT**(**P** [PC]) takes you directly to the Photoshop Print dialog. Should you wish to make a print using the current configuration for a particular image, but wish to bypass the Photoshop Print dialog, you can choose File \Rightarrow Print One Copy (**H Shift P** [Mac] **CIT**(**alt** Shift **P** [PC]).

The Photoshop print workflow is designed to make the print process more consistent between operating systems, as well as more repeatable. The operating system Page Setup option is accessed solely within the Photoshop Print dialog via the Print Settings button, from where you can manage all the remaining operating system print driver settings. Because both the Mac and PC operating system print drivers are incorporated into the Photoshop Print dialog, the process of scripting and creating print actions is therefore more reliable.

Photoshop Print dialog

When you choose Print... from the File menu, this takes you to the Photoshop Print dialog shown in Figure 11.1. You can resize the dialog as big as you like to see an enlarged print preview and because of this you can now get a much clearer preview of what the print output will look like, especially when using the soft proof preview options. The Preview background color will match the canvas color set in the Photoshop Interface preferences. However, you can right-click on the outer background area to view the contextual menu and select a different background color if you like.

When the Print dialog is enlarged you can easily access all the print controls at once from the panel list on the right. Solo panel opening is possible by *mu*-clicking on a panel header. This expands the selected panel contents and keeps all the others closed. Plus you can click on a button to open the selected printer Print Utility dialog. To begin with let's take a look at the Printer Setup options.

Printer selection

If you have just the one printer connected to your computer network, this should show up in the Printer list by default (circled in Figure 11.1). If you have more than one printer connected you can use this menu to select the printer you wish to print with. Below that is the Print Settings button. Click on this to open the operating system print driver dialog for Mac or PC and configure the desired print settings,

Remembering the print settings

The settings you apply in the Photoshop Print dialog are included with the document after you click Print or Done and then save the file. So, if you open a document that you have printed before, you'll get to see the last settings that were used to print that document. If you open a document which hasn't been printed before, you get the last used print settings. If you hold the spacebar as you select File ⇒ Print, Photoshop ignores the Print Settings that may previously have been saved to that document. This allows you to specify the print settings from a fresh starting point. However, if your print settings are for a printer that is no longer available, everything gets reset to the default settings.

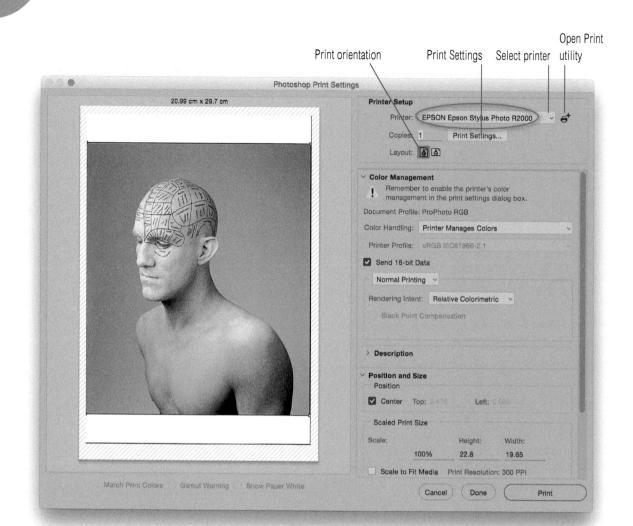

Figure 11.1 The Photoshop Print dialog, with the focus on the Printer Setup options.

specifying the paper size you intend to print with as well as the media type. In Figure 11.2, you'll see screen shots of the Mac OS Print dialog showing how to select the correct printer model and desired paper size. Figure 11.3 shows the Windows dialog, where in the Advanced panel section you can go to the paper size menu (circled) and do the same thing. Once you are done, you can click on the Save or OK button to return to the Photoshop Print dialog. Now, you do also need to use the system print dialogs to specify the media type, print quality and ICC/ ICM settings. I discuss this at the end of the chapter.

The Layout section has print orientation buttons where you can select to print in either portrait or landscape mode.

11

	arconorma	s Photo R	mm						
	ayout Pages per Sheet: Layout Direction: Border: Two-Sided:	1 None	e orientatio		Printer Presets Copies per Size	A5 A6		A4 (Sheet Feeder - Bord A4 (Sheet Feeder - Bord	
? PDF Hide Deta	116		Cancel	Save	1 Hide D	🗌 Flip h	*		erless (Auto Expand lerless (Retain Size))

Figure 11.2 The Mac OS X Printer Settings, showing also the paper size selection menu.

🛦 Main 🚯 Advances	d 🥶 Page Layout	Maintenance
Paper & Quality Options Sheet Epson Premium Glossy	Settings(0)	Color Management Color Controls PhotoEnhance © IDM
Photo RPM A4 210 x 297 mm		Off (No Color Adjustment) ICM Mode
Borders O B	orderless	~
Orientation		Input Profile
	andscape	v
Print Options		Intent
Print Uptions		V
		Printer Profile
✓ Gloss ✓ High Speed	Auto 🗸	Printer Profile Description
Grayscale		Ô
Edge Smoothing		Show all profiles.
R1900 Glossy Phote 👻	Save Setting	Show this screen first
Beset Defaults	Technical Support	
		OK Cancel Help

Figure 11.3 This shows the Windows Printer Settings, with the Paper Size section circled.

Check the print heads

If you make a print and the colors look way off from the screen image, it is most likely because one or more nozzles on the inkjet printer head have become clogged with ink. Before you start blaming the color management or profile setting, I recommend you run a nozzle check, followed if necessary by a nozzle clean.

Color Management

Figure 11.4 shows the Print dialog with the Color Management settings section expanded. In the Color Handling section you have the option to choose Printer Manages Colors or Photoshop Manages Colors (see Figure 11.5). The former can be used if you want to let the printer driver manage the color output. If this option is selected the Printer Profile menu appears grayed out, as will the Black Point Compensation box, but it will be possible to select a desired rendering intent: either Perceptual or Relative Colorimetric (although not all printers will be able to honor this setting). If you change printers in the Print dialog, the color management always defaults to select 'Printer Manages Colors.' This setting is most suitable for those who are unsure how to configure the print color management settings in Photoshop.

When the 'Photoshop Manages Colors' option is selected the Photoshop Print dialog can be used to handle the print output color

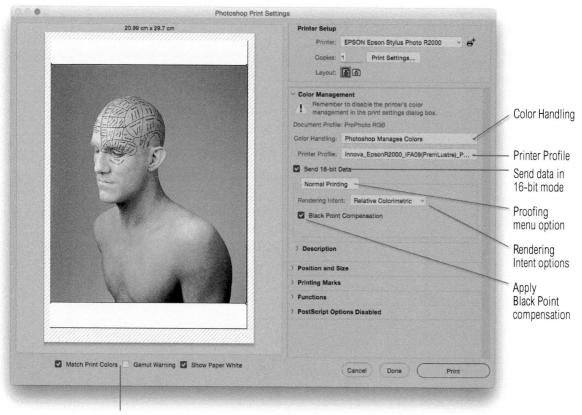

Color proofing options

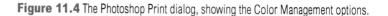

managem	nent r to enable the printer's color ent in the print settings dialog box. : SWOP 2006 #3 Med GCR		managem	ment r to disable the printer's color ent in the print settings dialog box. :: SWOP 2006 #3 Med GCR
Color Handling:	Printer Manages Colors	~	Color Handling:	Photoshop Manages Colors ~
Printer Profile:	sRGB IEC61966-2.1	· · · · · · · · · · · · · · · · · · ·	Printer Profile:	Canon PRO-1000/500 Photo Paper Pro Luster~
Send 16-bit D	ata		Send 16-bit D	lata
Normal Print	ng Y		Normal Print	ing Y
Rendering Inter	t: Relative Colorimetric Y		Rendering Inter	nt: Relative Colorimetric ~
Black Point	Compensation		Black Point	Compensation

Figure 11.5 The Color Handling options: Printer Manages Colors or Photoshop Manages Colors.

management. You will then need to go to the Printer Profile menu and select the printer profile that matches the printer/paper you are about to print with. Current printer devices are very consistent in print output. Therefore, selecting a canned profile supplied by the printer or paper manufacturer should work well enough. When you select the printer model in the Print Settings this filters the ICC profiles that are associated with the printer, so that these will appear at the top of the profile list (see Figure 11.6). A set of canned printer profiles should be installed in your System profiles folder at the same time as you install the print driver for your printer. If you can't find these, try doing a reinstall, or do a search on the manufacturer's website. Also, the printer selection and profiles are sticky per document, so once you have selected a printer and configured the associated print settings, these will be saved along with everything else in the document. It is therefore important to remember to always save a document after clicking Done, or making a print.

Adobe Color Printer Utility

You can download an Adobe Color Printer Utility from the Adobe website. This allows you to print your print target files without applying color management. Here is the link to download: tinyurl.com/25onde3. Having created a custom profile, this will need to be used with the 'Photoshop Manages Colors' option when printing.

,	Canon IJ Color Printer Profile 2015
	Canon PRO-1000/500 Canvas -P
	Canon PRO-1000/500 Extra Heavyweight Fine Art Paper -P
	Canon PRO-1000/500 Heavyweight Fine Art Paper -P
	Canon PRO-1000/500 Heavyweight Photo Paper -P
	Canon PRO-1000/500 Highest Density Fine Art Paper -P
	Canon PRO-1000/500 Japanese Paper Washi -P
	Canon PRO-1000/500 Lightweight Photo Paper -P
	Canon PRO-1000/500 Matte Photo Paper -P
	Canon PRO-1000/500 Photo Paper Plus Glossy II
	Canon PRO-1000/500 Photo Paper Plus Semi-gloss
	Canon PRO-1000/500 Photo Paper Pro Luster
	Canon PRO-1000/500 Photo Paper Pro Platinum
	Canon PRO-1000/500 Photo Paper Pro Premium Matte
	ACES Academy Color Encoding Specification SMPTE ST 2065-1
	ACES CG Linear (Academy Color Encoding System AP1)
	ACEScg ACES Working Space AMPAS S-2014-004
	ARRI LogC3 Wide Color Gamut - El 1000
	ARRI LogC3 Wide Color Gamut - El 1280
	ARRI LogC3 Wide Color Gamut - El 160
	ARRI LogC3 Wide Color Gamut - El 1600
	ARRI LogC3 Wide Color Gamut - El 200
	ARRI LogC3 Wide Color Gamut - El 250
	ARRI LogC3 Wide Color Gamut - El 320
	ARRI LogC3 Wide Color Gamut - El 400
	ARRI LogC3 Wide Color Gamut - El 500
	ARRI LogC3 Wide Color Gamut - El 640
	ARRI LogC3 Wide Color Gamut - El 800
	ARRI WCG Preview LUT for P3
	ARRI WCG Preview LUT for P3D65
	ARRI WCG Preview LUT for Rec. 709
	ARRIFLEX D-20 Daylight Log (by Adobe)
	ARRIFLEX D-20 Tungsten Log (by Adobe)
	Camera RGB Profile
	Canon PRO-1000/500 for Canson Infinity Baryta Photographique 3"
	Canon PRO-1000/500 for Canson Infinity Montval Aquarelle 310
	Canon PRO-1000/500 for Canson Infinity PhotoArt HD Canvas 400
	Canon PRO-1000/500 for Canson Infinity Platine Fibre Rag 310
	Canon PRO-1000/500 for Hahnemuhle FineArt Baryta 325
	Canon PRO-1000/500 for Hahnemuhle FineArt Pearl 285
	Canon PRO-1000/500 for Hahnemuhle German Etching 310
	Canon PRO-1000/500 for Hahnemuhle Museum Etching 350
	Canon PRO-1000/500 for Hahnemuhie Photo Rag 308
	Canon PRO-1000/500 for Hahnemuhle Photo Rag Baryta 315
	Canon PRO-1000/500 for Hahnemuhle Photo Rag Bright White 310
	Canon PRO-1000/500 for Hahnemuhie Photo Rag Ultra Smooth 30
	Canon PRO-1000/500 for Magiclee Silver Rag 300
	Canon PRO-1000/500 for Moab Entrada Rag Natural 300
	Canon PRO-1000/600 for Moab Entrada Rag Natural 300 Canon PRO-1000/500 for Moab Lasal Exhibition Luster 300
	Canon PRO-1000/500 for Pictorico Blue Label 285
	CIE RGB
	Cinema HD (2A7070WTUG0).icc
	Dalsa Origin Tungsten Lin (by Adobe)
	DCDM X'Y'Z' - White Point D55, Gamma 2.6, SMPTE ST 428-1
	DCDM X'Y'7' - White Point DR0 Gamma 2 & SMDTF ST 428-1

Figure 11.6 The printer profile list, with the printer manufacturer profiles for the selected printer placed at the top of the list.

16-bit output

Image data is normally sent to the printer in 8-bit, but a number of inkjet printers now have print drivers that are enabled for 16-bit printing (providing you are using the correct driver and the 16-Bit Data box is checked in the Color Management section). There are certain types of images that may theoretically benefit from 16-bit printing and where using 16-bit printing may avoid the possibility of banding appearing in print, but I have yet to see this demonstrated. Let's just say, if your printer is enabled for 16-bit printing, Photoshop now allows you to send the data in 16-bit form (but only if the file you are attempting to print is in 16-bit, of course).

Rendering intent selection

In 'Normal Printing' mode the rendering intent can be set to Perceptual, Saturation, Relative Colorimetric, or Absolute Colorimetric. For regular RGB printing the choice boils down to a choice of just two settings. Relative Colorimetric is best for general printing as this will preserve most of the original colors. Perceptual is a good option to choose when printing an image where it is important to preserve the detail in saturated color areas, when a photo that has a lot of deep shadows, or you are printing to a smaller gamut output space, such as a fine-art matte paper. Whichever option you choose, I advise you to leave Black Point Compensation switched on, because this maps the darkest colors from the source space to the destination print space. Black Point Compensation preserves the darkest black colors and maximizes the full tonal range of the print output.

The Photoshop Print dialog preview can be color managed by checking the 'Match Print Colors' option (see Figure 11.4). As you pick a printer profile or adjust the rendering intents you can preview onscreen what the printed colors will look like. When proofing an RGB output in this way you can also check the 'Show Paper White' option to take into account the paper color of the print media. There is even a Gamut Warning option, but this isn't as useful as using the soft proofing method described earlier to gauge how your print output will look.

Hard Proofing

If the Hard Proofing option is selected in the Color management settings (circled in Figure 11.7), you can select a custom proof output space to simulate on a desktop printer. When the Hard Proofing option is selected you'll need to select a proof setup setting from the

	ment r to disable the printer's color ent in the print settings dialog box.	
Document Profile		
Color Handling:	Photoshop Manages Colors	~
Printer Profile:	SPR2000 Epson Premium Semigloss	~
Send 16-bit [Data	
Hard Proofing		
Proof Setup:	Blurb relative re ~	
Proofing Profile	Blurb_ICC_Profile.icc	
Simulate Pa	per Color 😨 Simulate Black Ink	

Figure 11.7 The Color Management Hard Proofing options (configured here for Blurb book printing).

Proof Setup menu. This is how you configure a printer to simulate a specific CMYK output when making a print. You may already have configured a custom proof setup via the Custom Proof Condition dialog (see Figure 11.8). If not, you can go to the View menu, choose Proof Setup \Rightarrow Custom... and configure a custom setting. If a proof condition is already active for a document window (such as a standard CMYK preview or a custom proof setting) and you select the Hard Proofing option, this proof condition will be selected automatically. The Simulate Black Ink is always checked by default, but you can also choose to check Simulate Paper Color when creating a hard proofing output. When this option is selected, the whites may appear duller than expected when the print is made. This does not mean the proof is wrong, rather it is the presence of a brighter white border that leads to the viewer regarding the result as looking inferior. To get around this try adding a white border to the outside of the image you are about to print. You will need to do this in Photoshop by adding some extra white canvas. After making your print, trim away the outer 'paper white' border so that the eye does not get a chance to compare the dull whites of the print with the brighter white of the printing paper used.

Proof print or aim print?

If someone asks you to produce an RGB inkjet print that simulates the CMYK print process, the 'Hard Proofing' method can be used to create what is sometimes referred to as a 'cross-rendered aim print.' This is not quite the same thing as an official 'contract proof' print, but a commercial printer will be a lot happier to receive a print made in this way, as a guide to how you anticipate the final print image should look when printed on a commercial press, rather than one made direct from an RGB image using the full color gamut of your inkjet printer.

	Customize Proof Condition			Color Management	
Custom Proof Condition:	Fogra 39 v		ОК	Remember to disable the printer's color management in the print settings dialog box.	
Proof Conditions			Cancel	Document Profile: ProPhoto RGB	
Device to Simulate:	Coated FOGRA39 (ISO 12647-2:2004)	~	Carloor	Color Handling: Photoshop Manages Colors	~
	Preserve Numbers		Load	Printer Profile: SPR2000 Epson Premium Semigloss	~
Rendering Intent:	Relative Colorimetric	*	(Save)	Send 16-bit Data	
	Black Point Compensation		Preview	Hard Proofing ~	
Display Options (On	-Screen)		Preview	Proof Setup: Fogra 39	
Simulate Paper Co	blor			Proofing Profile: Coated FOGRA39 (ISO 12647-2:2004)	
Simulate Black Int	•			Simulate Paper Color 🔯 Simulate Black Ink	

Figure 11.8 The View \Rightarrow Proof Setup \Rightarrow Custom Proof Condition dialog for screen viewing (left) and how these Custom Proof settings are read in the Photoshop Print dialog Color Management section for print output (right).

You'll notice that the print preview is contained within a bounding box (Figure 11.9). You can position the image anywhere you like, by dragging inside the box, or scale it by dragging any of the bounding box handles. In the Position and Size section you can choose to center the photo, or precisely position it by entering measurements for the Top and Left margins. In the Scaled Print Size section, if the image overflows the currently selected page size, you can choose 'Scale to Fit Media.' This automatically resizes the pixel resolution to fit the page and the Print Resolution PPI adjusts accordingly. You can also enter a specific Scale percentage, or Height and Width for the image, but it is usually better to resize the image in Photoshop first and print using a 100% scale size.

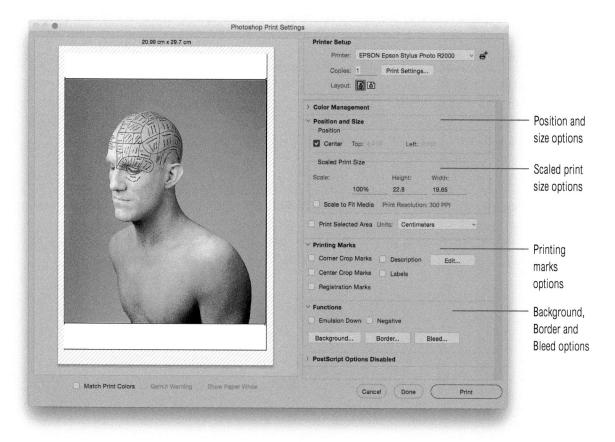

Figure 11.9 The Photoshop Print Dialog focusing on the remaining panel options.

Print selected area

With most printers the printable area is restricted in the margins and the trailing edge at the bottom that is usually wider than the side and top margin edges. You can see this in Figure 11.10, where the printable area margin is indented more at the bottom than it is at the top and sides. You can't adjust these of course, but if the Print Selected Area option is checked (circled below) you can adjust the cropped print margin sliders to apply a crop via the Print dialog within the printable area. Or, if you have applied a selection in the image first, this automatically adjusts the margin sliders to crop the image accordingly. The thing to make clear here is you are determining the area within the page that can be printed, rather than cropping the actual image itself (this can be useful for printing a small test area on a smaller sheet of paper). You can also mouse down on the print preview and click and drag the image relative to the crop using the Move tool shown here. You'll see a heads-up display showing the precise position on the print page preview. Similarly, when dragging the preview corner handles.

Adjusting the print margins

If you hold down the *all* key while dragging a margin for the print selected area, the opposite margin will move accordingly. So, if you *all* drag the left margin, the right margin will move also. Hold down the **(Mac)**, *cll* (PC) key to have all four margins move to match the drag made on one margin.

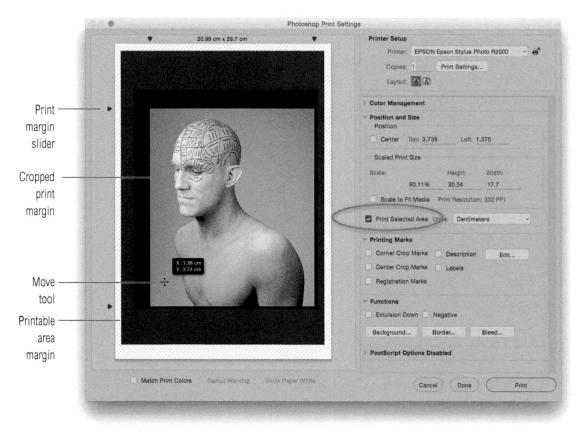

Figure 11.10 The Photoshop Print Dialog focusing on the Print Selected Area option.

Ensuring your prints are centered (Mac)

We would all love Photoshop printing to be simpler, but unfortunately there are no easy solutions and this is not necessarily Photoshop's fault. The problem is that there are a multitude of different printer devices out there and in addition to this, there are different operating systems, each of which has its own protocols as to how the system print dialogs should be organized.

Making sure a print is centered is just one of several problems that require a little user intervention. If you center a print in the Photoshop Print dialog, but it doesn't print centered, this is probably due to the default margin settings being uneven. The reason for this is some printers require a trailing edge margin that is wider than all the other margins (see page 719). However, you can overcome this on the Macintosh system by creating your own custom paper size and margin settings. In Mac OS X, click on the Print Settings... button in the Photoshop Print dialog and choose Manage Custom Sizes... from the Paper Size menu (Figure 11.11). In the Custom Page Sizes dialog check the margin width for the bottom trailing edge margin for the selected printer. If you want your prints to always be centered, all you have to do is to adjust the Top margin width so that it matches this Bottom measurement. Set a Width and Height for the new paper size and save this as a new paper size setting and add 'centered' so you can easily locate it when configuring the Page Setup or Paper Size settings (see Figure 11.11).

Printing Marks

In the Printing Marks section you can select any extra items that you wish to see printed outside the image area. The Corner and Center Crop Marks indicate where to trim the image, while adding Registration Marks can help a printer align the separate plates. Checking the Description box will print any text that has been entered in the File \Rightarrow File Info box Description field, though you can also click on the Edit... button next to this and enter description text directly via the Photoshop Print dialog. Lastly, check the Labels box if you want to have the file name printed below the picture.

Functions

Click on the Background... button if you want to select a background color other than white. For example, when sending the output to a film writer, you would choose black as the background color. Click on the Border... button to set the width for a black border (Figure 11.12), but just be aware that the border width can be unpredictable. If you set too narrow a width, the border may print unevenly on one or more sides of the image. The Bleed... button determines how much the crop marks are indented (Figure 11.13).

List :			
	Items	Current Settings	Registered Settings
	Paper Source	Sheet	
	Document Size	A4 210 x 297 mm	
	Orientation	Portrait	
	Paper Type	Epson Premium Glossy	÷
	Grayscale	Off	
	Quality	Photo RPM	÷
	High Speed	On	
Name : R1900 Glossy Photo	Mirror Image	Off	•
	Edge Smoothing	Off	
Comments (optional):	Gloss Optimizer Color Management	On(Auto) No Color Adjustment	
	×		

Figure 11.14 This shows how to save printer settings on a PC (left) and on a Mac (right).

Width: 3	Millimeters ~	ОК
		Canaal
		Cancel

Presets 🗸		fault Settings t Used Settings	
Copies	Sav	e Current Settings as Preset	
Paper Size	Sho	ow Presets	mn
	Prin	nt Settings	\$-
aareenteesteren	Ba	SIC Advanced Color Settings	
Preset N	Constanting Constanting	Advanced Color Settings R2000-PGPP)
	lame:]

1	Ξ			Default Actions			
1		-	Print actions				
1	▼ EP4800 A3 Portrait glossy						
1				 Print Print Options of current document 			
				Color Space: RGB color			
				Profile: "Pro4800 PGPP250"			
				Intent: relative colorimetric			
				With Black Point Compensation			
				Printer Name: "EPSON Stylus Pro 4800"			
				Name: "Blurb_ICC_Relative"			
				Name: "Blurb_ICC_Relative"			
				Without Caption			
				Without Calibration Bars			
				Without Registration Marks			
				Without Corner Crop Marks			
				Without Center Crop Marks			
				Without Labels			
				Without Negative			
				Without Emulsion Down			
				Background Color: RGB color			
				Red: 255			
				Green: 255			
				Blue: 255			
				Border: 0 cm			
				Bleed: 0 cm			
				With Include Vector Data			
				Page Position: user defined			
				Left: 2.61 cm			
				Top: 2.89 cm			
				Print Scale: 100%			
,				Print One Copy			

Figure 11.15 Photoshop actions can be used to record the complete print process.

Saving operating system print presets

Once you have established the operating system print dialog settings for a particular printing setup, it makes sense to save these settings as a system print preset that can easily be accessed every time you want to make a print using the same printer and paper combination. To do this, apply the required print settings and save the settings via the Printer Properties/Print dialog and give the setting an appropriate name. To save print settings on a Mac, choose 'Save Current Settings as Preset ...' via the system Print dialog Presets menu. To save the PC system print settings as a preset, click on the Save Settings button in the Printer Properties dialog and click 'Save' (see Figure 11.14).

Print output scripting

The system print settings are applied after the Photoshop Print dialog. This means it is possible to record a Photoshop action in which you select the printer model, the media size, type, and orientation plus the system Print settings, followed by the Photoshop Print dialog settings. Once recorded, you can use this action to make print outputs with the click of a button (Figure 11.15). So while it is a shame there is no current mechanism in Photoshop to create and save custom print settings, the ability to record the print output step as an action does at least provide one reliable method for saving the Photoshop print settings for future reuse. You can also convert such actions into Droplets. This allows you to bundle the printer model selection, the page setup, the media type, and Photoshop print settings all into the one droplet/action (as shown below in Figure 11.16), where you can simply drag and drop a file to a droplet to make a print. To find out more about actions and droplets check out the Automate PDF on the book website.

Print A5 Landscape glossy

Figure 11.16 When you convert an action to a droplet you can simply drag and drop files to the droplet to initiate the desired print output.

Configuring the Print Settings (Mac and PC)

The following dialogs show the Mac and PC Print Settings dialogs for the Epson R1900 inkjet printer. In both the examples shown here, I wished to produce a landscape oriented print on a Super A3 sized sheet of Epson glossy photo paper using the best-quality print settings and with Photoshop handling the color management.

Figure 11.17 shows the Mac Print Settings for the Epson R1900 printer. In the Print Settings you will need to select a media type that matches the paper you are going to print with. Go to the Media Type menu and choose the correct paper. Next, you will want to select a print quality setting that might say something like 'Super-duper Photo' or 'Max Quality.' You may also need to locate an Off switch for the printer color management. This is because you do not need to make any further color profile adjustments. With this particular driver it knows when you are choosing to print with the printer color management switched off and the 'Off (No Color Adjustment)' option is selected automatically. All you have to do now is click on the Save button at the bottom of the dialog to return to the Photoshop Print dialog from where you can click on the Print button to make a print.

Copies: 1 Paper Size: A3	 [3]	297 by	420 mm	
	nt Settings			
	Advanced Color	Setting	S	
Page Setup:	Standard			0
Media Type: Color:			2 16 bit/Channel	
Color Settings:		ient) C		
Print Quality:	Photo RPM	0		
	High Speed Mirror Image			
Gloss Optimizer:	On	3		

Figure 11.17 The Mac Print Settings for the Epson R1900 printer.

Print quality settings

In the Print settings, a higher print resolution will produce marginally betterlooking prints, but take longer to print. The High Speed option enables the print head to print in both directions. Some people prefer to disable this option when making fine quality prints, but with the latest inkjet printers, the High Speed option shouldn't necessarily give you inferior results. Figure 11.18 shows the Windows Print Settings for the Epson R1900 printer. Again, you will need to use the Media Type menu to select the correct paper to print with. For the Print Quality, select a high-quality setting, such as the Photo RPM Quality setting selected here. In the Color Management section I checked the Off (No Color Adjustment) box to disable the printer-managed color management. Lastly, I clicked the OK button to return to the Photoshop Print dialog from where I could click on the Print button to make a print.

The system print settings dialog options will vary from printer to printer. As well as having Mac and PC variations, you might have a lot of other options available to choose from and the printer driver for your printer may look quite different. However, if you are using Photoshop to manage the colors, you just need to make sure you select the correct media setting in the print settings and you have the printer color management turned off. This may mean selecting 'No Color Adjustment' in the Print Settings or Color Management sections and you should ignore any of the other options you might see such as: 'EPSON Vivid' or 'Charts and Graphs.'

Main 🔇 Advanced	🔅 Page Layout	Maintenance		
Epson Premium Glossy	Settings(0)	Color Management Color Controls PhotoEnhance ICM		
Photo RPM A3+ 329 x 483 mm	*	Off (No Color Adjustment) ICM Mode		
Borders O Bord	erless			
Orientation		Input Profile		
O Portrait 💿 Land	iscane			
O				
Print Options Reverse Order				
✓ Gloss	uto 🗸			
✔ High Speed		Printer Profile Description		
Grayscale		0		
Print Preview		Show all profiles.		
Custom Settings 🛛 👻	Save Setting	Chamble		
Reset Defaults	Technical Support	Show this screen first		
Teser Derduits	recrimeal support	1		

Figure 11.18 This shows the Windows 8 Print Settings for the Epson R1900 printer.

Creating custom print profiles

The profiles that are shipped with the latest inkjet printers can be considered reliable enough for professional print quality work (providing you are using the manufacturer's branded papers). If you want to extend the range of papers you can print with, then you will either have to rely on the profiles supplied by these paper companies or consider having a custom printer profile built for each paper type.

One option is to purchase a complete calibration kit package such as the X-Rite i1 Photo Pro 2 with i1Profiler software. The other alternative is to get an independent color management expert to build a profile for you. There are a few individuals who are able to offer these services, such as Andrew Rodney, who is based in the US (digitaldog.net). A company called colourmanagement.net are also offering a special coupon to readers that entitles you to a discount on their remote printer profiling services (see back of book and the book website for more details).

Remote profiling is a simple process. All you have to do is to follow the link to the provider's website, download a test target similar to the one shown in Figure 11.19, and follow the instructions closely when preparing a target print for output. The target file must be opened without any color conversion and sent directly to the printer without any color management and the print dimensions must remain exact (See 'Adobe Color Printer Utility' on page 715). If it is necessary to resize the PPI resolution, make sure that the Nearest Neighbor interpolation mode is selected. The system print dialog settings used to produce the target print (see page 723) should also be saved so that exactly the same print settings can be used again when you then follow the steps outlined on pages 714–715. You will then need to send the printed target to the supplied address, where the patch readings will be used to build an ICC profile that represents the characteristics of a particular paper type on your individual printer. You'll then receive back an ICC profile via email.

The important points to bear in mind are that you must not color manage the target image when printing. The idea is to produce a print in which the pixel values are sent directly to the printer without any color management being applied.

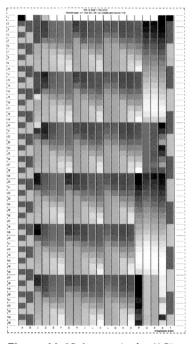

Figure 11.19 An example of an X-Rite color target that can be used to build an ICC color profile.

Replacing canned profiles

On the Mac system at least, if you are familiar with using the ColorSync Utility, you can go to the Devices section, select a canned profile, click on the Current Profile name, choose Other... and select a custom profile to replace it with. This will let you promote a custom profile to appear in the filtered profile list for that printer.

Creating contact sheets via Bridge CC

The latest version of Bridge CC has an updated contact sheet feature, which is shown below in Figure 11.20. To access, click on the Output workspace setting (circled). Initially, you will see the default 2 x 2 cells setting, where the cells will be blank. All you have to do is drag and drop photos from the Filmstrip below to fill the cells. You can do this by selecting a batch of images, or drag them individually.

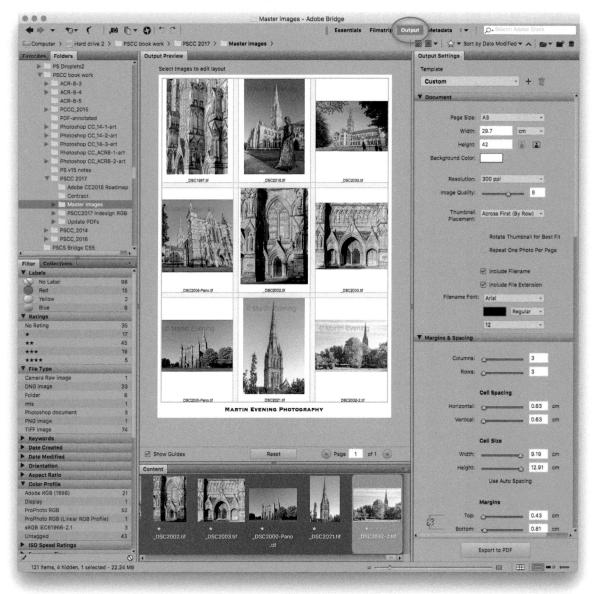

Figure 11.20 The Bridge Output work space.

You can then click on the Template menu in the Output Settings panel (Figure 11.21) to open the Presets menu shown in Figure 11.22. Use this as a quick way to load a contact sheet template, or you can configure your own custom settings and click on the + button to add to the preset list. The remaining panels on the right can be used to manually adjust the contact sheet settings. The Document panel (shown in Figure 11.21) lets you set the document size, resolution, and image quality. You can also use this panel to add filenames below each thumbnail image.

The Margins and Spacings panel can be used to adjust the number of columns and rows, along with the cell spacing, cell size, and margin widths top, bottom, left, and right.

The Header and Footer panel settings can be used to add header or footer information. In the Figure 11.20 example I added a footer, where I entered custom text and selected the desired font, font size, and color. For multiple page contact sheets you may want to include a page number as well.

In the Figure 11.20 example I also used the Watermark panel to add a text-styled watermark to the top left corner of each thumbnail. Alternatively, you can click on the Image Watermark option and choose an image file (PNG format recommended) to add as a watermark. The remaining settings can be used to refine the placement, scale and opacity.

Finally, there is the PDF Properties panel, where you can set passwords for opening, or permissions to edit the PDF, along with page transition options. Once you are done, click the Export to PDF button. This generates a PDF document that is then ready to share, or print direct via any PDF reading program, such as Adobe Reader.

Printing tips

The soft proofing and print sharpening discussed at the beginning of this chapter are crucial to successful printing. Simply opening the Print dialog and clicking Print isn't going to help much. This is especially the case if you print to fine art papers where you have a limited range of colors to work with. In these instances the soft proofing can help you pre-visualize what the printed result will look like. This can save you a lot of money on wasted ink and paper. To adjust an image while soft proofing I suggest you try using the Camera Raw filter because this provides immediate access to all the tone and color controls you need within a single user interface. The Camera Raw filter also includes the Clarity slider adjustment. This can make a tremendous difference when printing to matte papers. I nearly always add extra Clarity when making such prints as this can be used to boost the midtone contrast and add life to what would otherwise be a dull-looking matte print.

Figure 11.21 The Bridge Output work space Output Settings and Document panel.

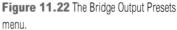

Index

Symbols

16-bit 325 color space selection 326 32-bit 410, 415 Exposure 16

A

Absolute Colorimetric rendering intent 688 Acrobat format (PDF) 80 Actions 722 Activating Photoshop 2 Adaptive Wide Angle filter See Filter menu ADC 90 Add anchor point tool 53 Adjustment layers See Image adjustments Adjustments panel 331, 388-389 auto-select targeted adjustment 338 reset adjustment 333 Adobe Color Engine 670 Adobe Color Printer Utility 673, 715 Adobe Color Themes panel 51 Adobe Lens Profile Creator 642 and Auto-Align 643 browse Adobe Lens Profile Creator online 643 interpolating lens profiles 643 Adobe Lens Profiles 166 Adobe PDF 80 Adobe Reader 80 Adobe RGB 328-329, 668, 699 Adobe Stock 7 Agarwala, Aseem 644 Agrawala, Maneesh 644 Aim prints 717 Alpha channels 492, 496, 498-500 Alternative Raw processors 94 Anti-aliasing 500 Apple RGB 698 Application frame mode 5, 11

Art History Brush 66, 69 Auto adjustments 351 Automating Photoshop *See* PDF on website Auto select layer 56 Axial chromatic aberration 173

B

Background eraser tool 54 Background saving 74 Banding use dither option 691 Barroso, Clicio 152 Barstow, Neil 701 BasICColor 672 Berkeley University 644 Bibble 94 Bicubic interpolation 317 bicubic automatic 317 bicubic sharper 317 bicubic smoother 317 Big data 380 Bilinear interpolation 317 Bird's Eye View 11, 59 Bit depth 324 32-bit floating point 410, 416 raw images 325 Black and white black and white adjustments adjustment presets 391 converting color to B&W 388-399 Lab mode conversions 388 Black Point Compensation 714 Blending modes 64, 528-532 Color 44, 342, 441, 533, 709 Color Burn 529 Color Dodge 530 Darken 529 Darker Color 529 Difference 532 Dissolve 528, 635 Divide 533 Exclusion 532

Hard Light 531 Hard Mix 532 Hue 533 Lighten 530 Lighter Color 530 Linear Burn 529 Linear Dodge (Add) 530 Linear Light 531 Luminosity 342-343, 442, 533, 709 Multiply 529 Normal 528 Overlay 308-309, 531, 707 Pin Light 532 Saturation 533 Screen 530 Soft Light 531 Subtract 532 Vivid Light 531 Blur filters See Filter menu Blur tool 43 Bokeh 610-611 Box blur filter See Filter menu Bracketed exposures for HDR 412 Bridge CC 72, 81-85, 726-727 contact sheet 726 content panel 85 custom work spaces 84 favorites panel 83 file menu open in Camera Raw 101 filter panel 81 folders panel 83 installing Bridge 83 interface 83-87 opening camera raw 96-99 output presets 727 output settings 727 document panel 727 header and footer panel 727 margins and spacings panel 727

PDF properties 727 watermark panel 727 slideshow view 85-86 tools menu Photoshop 430 preferences file type associations 72 Brushes bristle shape brushes 43, 50 bristle preview panel 50 brush picker 44 brush preset menu 44 dual brush control 47 jitter control 47 on-the-fly brush changes 44 pressure sensitive control 47 shape dynamics 47 smoothing options 50-51 adjust for zoom 51 catch-up on stroke end 50 pulled string mode 50 stroke catch-up 50 texture dynamics 47 Brushes panel 46, 48 Brush preset picker 43, 48 hardness slider 43 size slider 43 Brush Settings panel 46-49 bristle qualities options 50 color dynamics 47 flow iitter 47 scattering controls 47 Brush stroke smoothing 50-51 Brush tool 43 brush tool presets 48 Brush tool presets 48 Bunting, Fred 701 Burn tool 43, 362 Byte order 78

С

Camera exposure 92, 321 Camera histograms 115 Camera JPEG previews 92 Camera Raw 86–88, 96–136, 320 ACR preferences 98 adjusting hue and saturation 164 Adjustment Brush 218 add new brush effect 220 adjustment strength 220 Auto Mask 225, 234, 297 brush settings 219 color mode 233 color swatch 234 defringe slider 176-178 density 219 duplication 221 edit brush 223 erase 223 extending the sharpening limits 279 feather 219 flow 219 how to apply localized sharpening 280 moiré reduction 296-297 negative sharpening 279, 282 noise reduction 294-295 pin markers 220 previewing brush strokes 223 sharpening 279 size 219 altering background color 114 alternative raw processors 94 as a JPEG editor 93 as a Photoshop filter 202-203 auto corrections apply auto grayscale 121 apply auto tone 121 Basic panel 128-129 auto tone corrections 147 basic adjustment procedure 144 blacks 137, 146, 423 auto adjustments 147 auto-calculated blacks range 138 clarity 150-153 clipping points 138 contrast 135, 145 exposure 135, 139, 154 hiding shadow noise 140 highlights 136, 145, 423 saturation 156-157, 233 shadows 136, 145, 232, 423

vibrance 156-157 white balance 128-133 whites 137, 146, 423 auto adjustments 147 Bird's Eye View 118 bit depth 106 black and white conversions 388. 398-399 cache size 121 Calibration panel 200-201 camera profile menu 200 camera profiles 200 legacy profiles 200 process versions 200 Camera Calibration panel 134 black and white conversions 400 process versions 134 camera profile calibrations 201 camera profiles 200 Camera Raw advantages 90 Camera Raw database 248 Camera Raw defaults 249 Camera Raw filter 424 Camera Raw presets 250 Camera Raw settings 240, 247 folder location 278 Camera Raw support 95 Camera Raw tools 98 Camera Raw workflow 90 camera specific default settings 149 capture sharpening 704-705 color sampler tool 98 copying settings 251-252 correcting high contrast 154 cropping 98, 125 custom crop ratio 127 defringe slider 177 Detail panel 265-295 amount 267, 293 color detail slider 286, 289 color slider 286, 288 color smoothness slider 290-291 default sharpening settings 277 detail slider 269-270, 276 grayscale preview 271 luminance contrast slider 289 luminance detail slider 285

luminance slider 285, 289 masking slider 272-273, 276 noise reduction 284-287 radius preview 271 radius slider 264, 276, 278 save sharpen settings 277 sharpening a landscape 275 sharpening a portrait 274 sharpening defaults 266 sharpening effect sliders 266 sharpening examples 274 sharpening fine-detail 276 Smart Object sharpening layers 279 DNG DNG file handling 122 update embedded JPEG previews 248 does the order matter? 91 Effects panel 190 dehaze slider 196-197 grain slider 196-197, 292-293 post crop vignetting 190 amount slider 191 color priority 193, 194, 195 highlight priority 193-194 highlights slider 194 midpoint slider 190 paint overlay 192 roundness slider 191 style options 192 emulating Hue/Saturation 164 export settings to XMP 248 filmstrip menu 427, 539 full screen mode 99, 116 graduated filter 235 angled gradient 235 brush editing a mask 243 negative sharpening 279 pin markers 235 selective sharpening 279 sharpness negative sharpness 283 hand tool 98 HDR processing 424-431 Photo Merge HDR DNGs 425 HDR TIFF processing 424 hiding shadow noise 140 high dynamic range adjustments 422

histogram 98, 115 clipping indicator 137 histogram and RGB space 115 interactive histogram controls 115 how Camera Raw calculates 143 HSL/Grayscale panel 162, 399 auto grayscale 398 color sliders 398 convert to grayscale 398-399 gravscale conversions 398, 402 saturation 164 image browsing via Camera Raw 116 Lens Corrections panel 166-167 chromatic aberrations 169 color tab 171 custom lens profiles 168 defringe section 171 eyedropper tool mode 172 enable lens profile corrections 166 enable profile corrections 167 lens calibration charts 168 lens settings 164 lens vianettina 189 profile tab distortion 166 vignetting 166 remove chromatic aberration 170 Lightroom-linked smart objects 110 load settings 248 localized adjustements dehaze slider 198-199 localized adjustments 218 adjustment strength 220 defringe slider 176 maintaining ACR compatibility 260 MakerNote data 257 modal tool adjustments 118 multiple file opening 101-102 navigation controls 116 open as a Smart Object 110 opening multiple files 101-102 opening photos from Bridge 86 opening TIFFs 122 open object 111, 419 photo merge HDR 425-428 align images 428

auto tone 427 deghost 425 HDR merge preview 428 panorama 538-541 and adaptive wide-angle filter 542 auto crop 540 boundary warp 542-543 panorama merge preview 538, 540 projection options 539 PNG support 95 Preferences 120-121 accelerated graphics 123-124 automatically open JPEGs/TIFFs 122 default image settings 121 disable JPEG/TIFF support 122 general preferences 120 ignore sidecar 'xmp' files 122 performance 123 sharpening 120 use graphics processor 123-124 preserve cropped pixels 108 Presets panel 249 legacy presets 252 preview draw image frame 114 preview controls 102-105 checkpoints 103 preview preferences 103 process versions 134-139 process version mismatch 252 synchronizing settings 252 radial filter 98, 240-244 brush editing a mask 243 correcting edge sharpness 245 fill to document bounds 243 range masking 86, 227-230 color mode 227-229 eyedropper tool 227 luminance mode 227, 229-230 recovering out of gamut colors 163 Red Eye removal tool 98, 216-217 pet eye mode 217 add catchlight 217 rotate rotate clockwise 98 rotate counterclockwise 98

save new Camera Raw defaults 149 save options 107 saving 125 resolving naming conflicts 108 save options 107 save settings 125, 248 saving a JPEG as DNG 108 selecting rated images only 116 sidecar files 120 single file opening 98 smart objects 418 Snapshots panel 254 snapshots 254-255 Lightroom snapshots 254 softening skin tones 152 Split Toning panel 405-408 saturation shortcut 405 spot removal tool 98, 206-207 brush spots 212-215 circle spots 207-208 deleting spots 213 synchronized spotting 208 visualize spots 210-211 star rating edits 116 straighten tool 98, 125-126 suggested workflows 90 synchronized spotting 208 synchronized view 116 synchronize settings 251 synchronizing process versions 252 target adjustment tool 98, 159 thumbnails filmstrip 101 Tone Curve panel 158-163 parametric curve 159 point curve editor mode 160-161 RGB Curves 160 Transform panel 178-187 manual transform sliders 180 upright adjustments auto 179 full 179 guided upright adjustments 184 level 179 synchronizing upright settings 184 vertical 179 transparency support 86 update DNG previews 248

white balance tool 98, 128-132 localized white balance 130-131 workflow options 98, 106-110 workflow presets 106 zoom tool 98 scrubby zoom 124 Canon Canon DPP 257 Canvas canvas size 375 relative canvas size 375 Capture One 94 Capture sharpening 704-705 Carroll, Robert 644 Casio 256 CCD sensors 90, 287 CC Files 6 CGI effects 410 Chan, Eric 264 Channel Mixer 602 Channels 492-494 Chromatic aberration 169 CIE LAB 670 CIE XYZ 670 Clipping masks 551-553 Clipping the highlights 139 Clipping the shadows 140 Clone Source panel 448-449, 472-473 angled cloning 472 show overlay 445, 448 Clone Stamp tool 54, 444-445, 448 alignment mode 448 ignore adjustment layers 450-451. 454 sample all layers 450 tool settings 444 Cloning 444-446 CMOS 90 CMOS sensors 287 CMYK 668, 694-697 black generation 697 CMYK conversions 139 CMYK numbers 668 CMYK setup 694-695 CMYK skin tones 701 CMYK to CMYK conversions 698 custom CMYK settings 694

dot gain 696 GCR separations 696 ink colors 695 proofing 691 separation setup 695 SWOP print settings 694 UCA separations 697 UCR separations 697 Color blend mode 533 Color Burn blend mode 529 Color Dodge blend mode 530 Color Management hue/saturation 356 aim prints 685 assign profile 682 black point compensation 716 camera profiling 672 CMMs 670 color management modules 670-671 Color Settings 669, 675, 702 blend RGB Colors using gamma 692 CMYK setup 694 color management off 679 color management policies 679 color policies 676 color settings files 684 conversion options 686 convert to profile 680-681, 685, 698 convert to workspace 678, 684 customizing RGB color 693 desaturate monitor colors 692 prepress settings 702 preserve embedded profiles 676-678, 684, 698 profile conversions 680 profile mismatches 676 ask when pasting 683 when pasting 682 Save custom CMYK settings 694 saving color settings 684 use dither 691 display profiling 672-673 document profiles 676 hard proofing 716 ICC profiles 669-672 incorrect profiles 679

incorrect sRGB EXIF data 682 input profiling 672 missing profiles 676 objectives 667 output-centric workflows 668 output profiling 673 print color management 708, 714 profile connection space 670-671 profiled color management 669-671 reducing errors 684-686 rendering intent 686-691 absolute colorimetric 688 black point compensation 691 perceptual 687 relative colorimetric 687 saturation (graphics) 687 which is best 688 RGB to RGB conversions 680 saving a color setting 683 scene-referred profiles 691 setting the endpoints 141 working in RGB 668 ColorMatch RGB 699 Color Range See Select menu Color replacement tool 54 Color sampler tool 60 Color Settings 686 See Color management ColorSync 686 ColorSync Utility 725 Color temperature 360 Color Themes panel 51 Color toning 392 Color vision trickery 667 Colourmanagement.net 725 Content-aware filling See Edit menu Content-aware move tool 463, 468-469 adaptation menu 464-465 color control 468-469 extend mode 465 face detection 463 move mode 463 sample all layers 463 Structure control 469 with transformations 470-471

Content-aware scaling 382-385 amount slider 382 protect facial features 384 Contextual menus 41 Convert point tool 53 Convert to Smart Object 587 Count tool 62 Creating a new document 9 Creative Cloud creative cloud libraries 564-567 adding and linking assets 565 collaborate 566 sharing libraries 566 Cropping 368-379 crop tool 368 content-aware crop 377-379 crop guide overlay 371 crop preview 368 crop ratio modes 369 crop tool options 372 crop tool presets 370 delete cropped pixels 368 disable edge snapping 372 front image cropping 372 measurement units 370 options bar 370 delete cropped pixels 380 straighten tool 386 selection-based cropping 374 perspective crop tool 381 Crop tool 34, 54 Current Tool status 16 Curvature pen tool 53 Curves See Image adjustments Customize Toolbar 33 Custom keyboard shortcuts 26-27 Custom shape tool 52

D

Darken blend mode 529 Darker Color blend mode 529 Dead pixels 287 Debevec, Paul 410 Delete anchor point tool 53 Depth of field blending 546–547

Depth of field brush 308 Depth of field effects 608 Detect faces 40 Difference blend mode 532 Digital dog 725 Digital exposure 142 Direct selection tool 53, 595-598 Displays calibration 710 dual display setup 28-29 Dissolve blend mode 528 Distribute layers 57 Distribute linked layers 575 DNG Converter 260 Document profile 16 Document windows 15 floating windows 12-15 Dodge tool 43, 362 Dots per inch 314 Dreamweaver, Adobe 77 Droplets 722 Duplicate an image state 70 Dx0 Labs DxO Mark sensor evaluation 411 Dx0 Optics Pro 94, 245 Dynamic range 142, 409

E

Editing JPEGs & TIFFs in Camera Raw 93 Edit menu auto-align layers 546, 643 auto-blend layers 546-547 seamless tones and colors 547 color settings 328, 669 content-aware fill 468-469 convert to profile 141 fill 460 content-aware fill 460-461 keyboard shortcuts 558-559 menu options 25-26 paste special paste in place 36 perspective warp layout mode 578 warp mode 578, 580

puppet warp adding pins 581 distort mode 581 expansion setting 582 multiple pin selection 583 normal mode 581 pin depth 583 pin rotation 582 rigid mode 581, 584 show mesh 581 using Smart Objects 583 transform 571-580 aligning layers 575 distribute layers 575 free transform 574, 587 interpolation options 573 numeric transforms 573-574 perspective 573 rotate 572 show transform controls 574 skew 573 transforming paths 574 transform menu 571 warp transforms 588-589 Edit Toolbar 33 Efficiency 16 Electronic publishing 80 Elliptical marguee tool 495 Elliptical shape tool 52 EnableAllPluginsforSmartFilters 586, 608 Epson Epson printers Epson R1900 dialog 723 Eraser tool 54 Exclusion blend mode 532 EXIF metadata 416 Export options 562-563 color space 564 exporting a layer 564 export preview 562-563 metadata 564 quick export 562-563 Exposure value (EV) 412, 413 Evedropper tool 60 eyedropper wheel display 60 Eve-One 672, 673

F

Fade command 607 File formats 76-82 **BIGTIFF 78** DNG 122, 248, 256-258 compatibility 95 DNG adoption 256 DNG compatibility 95, 257 DNG Converter 260 embed custom profiles 201 lossy DNG 258-259 MakerNote data 257 use lossy compression 258-259 for iPhone 79 HEIF 79 JPEG 79 JPEG compression 79 JPEG saving 73 saving 16-bit as 8-bit 79 OpenEXR 416-417 PDF 80-83 Photoshop PSD 74, 76 maximize compatibility 76 smart PSD files 77 PNG 80, 95, 304 PSB 74, 416 PSDX 77 Radiance 416 TIFF 78, 416 compression options 79 flattened TIFFs 79 pixel order save image pyramid 78 File menu Automate 430 lens correction 643 Merge to HDR Pro 410 complete toning in ACR 424 detail slider 433 exposure slider 433 gamma slider 433 HDR toning 431, 436 highlight slider 433 how to fool Merge to HDR 416 radius slider 433 removing ghosts 434

response curve 430-431 saturation slider 433 script 430 shadow slider 433 smooth edges 436 smoothing HDR images 440 strength slider 433 tone in ACR 424 toning curve and histogram 433 vibrance slider 433 Photomerge 534 Close close all 74 new document 9 legacy new document 10 pixel aspect ratio 9 preset details 9 presets 10 Open in Camera Raw 96 Print One Copy 711 Save 73 Save As 75 save for web export options 562-563 quick export 562-563 scripts 501 layer comps to PDF 554 Files that won't open 72 Fill dialog 462 Film grain retouching 444 Filter menu Adaptive Wide Angle 536, 633-637, 644-653 applying constraints 647 calibration 652 constraints 651 constraint line colors 649 constraint tool 647 editing panorama images 653-655 how the filter works 646 loupe view 647 missing lens profiles search online 646 panorama correction 654 panorama mode 653 polygon constraint tool 655

preferences 649 rotating a constraint 648 saving constraints 649 Blur 604-608 Average Blur 604 Box blur 607 Lens blur 608-611 depth of field effect 608 Radial blur 605 zoom mode 605 Shape blur 607 Surface Blur 607 Blur Gallery 610-629 adding grain 614-615 blur gallery options 612 blur ring 611, 616, 618 bokeh color 611 Field blur 618 Iris blur 610 ellipse field controls 611 radius roundness 611, 613 light bokeh 610 light range controls 611 multiple blur effects 616 noise panel 614-615 Path blur 623-627 blur direction arrows 623 centered blur 624 end point speed 627 motion blur effects 625 rear sync flash 623, 625 speed slider 623 strobe flashes 627 taper slider 623 save mask to channels 612 selection bleed slider 612 smart objects and selections 628 smart object support 628-630 Spin blur 620-622 symmetric distortion 617 Tilt-Shift blur 616 distortion slider 616-617 no-blur zone 616 transition zone 616 video layers 629-630 convert to smart filters 583 Fade filter 607

Filter Gallery 664 new effect layer 664 Lens Correction 638-643 Adobe Lens Profile Creator See Adobe Lens Profile Creator auto correction 638, 641 auto-scale Images 638-639 batch processing 643 chromatic aberration 638-639, 642 custom lens corrections 639 geometric distortion 638-639, 642 grid overlay 640 lens profiles 638, 642-643 move grid tool 640 remove distortion 639 rotation 639 scanned image limitations 639 search criteria 639, 642 selecting appropriate profiles 642 transform section 639 video files 639 vignette section 639 vignette removal 638 Liquify 480-488, 576 bloat tool 480-481 face-aware liquify 485-487 face tool 480 forward warp tool 480-481, 490 freeze mask tool 480-481, 483, 490 liquify performance 488 liquify tool controls 480 liquify tools 480 mask options 483 mesh grid 484 on-screen cursor adjustments 482 pin edges 482 pucker tool 480-481 reconstruct tool 480-482 restore all 485 revert reconstruction 484 saving the mesh 483-485 show backdrop 484, 490 smart object support 488 smooth tool 480, 485 thaw mask tool 480-481 twirl clockwise tool 480-481 view options 489-490

Noise Add Noise 604 Reduce Noise filter See PDF on book website Other High Pass 310, 704-705, 707 Render flame 656-658 flame filter controls 658 tree 659-661 shake reduction filter smart object support 304 Sharpen Shake Reduction 302-307 Smart Sharpen 298-301 lens blur mode 299 motion blur 301 save settings 300 Unsharp mask 310, 705-706 Smart filters 603, 618 enable all plugins 608 Stylize oil paint 662-663 Vanishing Point 474 stamp tool 474 Filters third-party plug-ins 632 Fisheye lens 167, 534, 644 Fit to screen view 15 Flick panning 60 Flip a laver 571 Focus area 522-523 See Select menu Fraser, Bruce XXI, 308, 310, 693, 701, 705 Freeform lasso tool 36 Freeform pen tool 53

G

Garner, Claire XXIV Gaussian Blur filter *See* Filter menu: Blur Geary, Valerie XXIV Generator 568–571 extended tagging 562–563 generator syntax 562, 580 Gorman, Greg XXIV Gradient tool 52 Graphics card compatibility 124 Graphics display performance 11 Graphics Processor support Camera Raw 123 Grayscale mode grayscale conversions 388 Grid 18–19 Guided Upright adjustments Lens Corrections panel upright corrections 178–187 Guides adding new guides 18

Η

Hand tool 59 Hard Light blend mode 531 Hard Mix blend mode 532 Hard Proofing 716 Hasselblad 256 HDR avoiding the 'HDR look' 434 bracketed exposures 412, 414 capturing HDR 414 exposure bracket range 415 HDR essentials 410 HDR file formats 415 Large Document format (PSB) 416 OpenEXR 416 Radiance 416 **TIFF 416** HDR shooting tips 414 HDR Toning 432 limits of human vision 413 Photomatix program 413 tone mapping HDR images 432 equalize histogram 432 exposure and gamma 432 highlight compression 432 local adaptation 432 Healing Brush 54, 446-447, 451 alignment mode 448 better healing edges 451 diffusion slider 456-457 elliptical brush setting 451

healing blend modes 453 replace blend mode 453 sample options 450 **HEIF** format 79 Hide Extras 36 HighDPI 3 High dynamic range imaging See HDR High Efficiency Image File format 79 High Pass sharpening 705-707 Histogram 320-322 camera LCD 143 Histogram panel 141, 322-325, 334 History 56, 66-70 History Brush 66 history panel 66 create new snapshot 70 new snapshot dialog 70 non-linear history 66 history settings and memory usage 67 history versus undo 69 make layer visibility changes undoable 67 purge history 68 Holbert, Mac XXI HSL/Grayscale panel 162 HUD color picker 45 Hue blend mode 533 Hue/Saturation 356-357

L

Image adjustments adjustment layers 330–333, 361–362, 502 adjustment layer masks 362 cumulative adjustments 361 Auto Auto Color 351–352 Auto Contrast 351–352 Auto Levels 334, 351 Auto Tone 351–352 enhance brightness and contrast 351, 352 Black & White 331, 388–391, 394 adjustment presets 391 auto 389

Brightness/Contrast 331 Channel Mixer 331 Color Balance 331, 392 preserve luminosity 393 Color Lookup 331 Curves 331, 336 auto 336 black and white toning 394 channel selection 336 channel selection shortcuts 354 color corrections 354 curves histogram 337 draw curve mode 337 dual contrast curve 345 Locking down curve points 344 negative number support 336 on-image editing 338 point curve editor mode 337 removing curve points 338 target adjustment tool 338-339 using Curves in place of Levels 340 data loss 322 direct image adjustments 330 Exposure 331 Gradient Map 331 black and white toning 396-397 photographic toning presets 396 HDR Toning 347, 416-417 detail slider 438-439 edge glow radius 441 edge glow strength 441 exposure slider 438 gamma slider 438-439 highlight 438 local adaptation 437 radius slider 438 save preset 439 strength slider 439 toning curve 439-440 Hue/Saturation 331, 356-357, 709 saturation 356 Invert 331 Levels 141, 331 basic Levels editing 323 gamma slider 322 output levels 340

Match Color 352 multiple adjustment layers 361 Photo Filter 331, 360, 637 Posterize 331 save preset 391 Selective Color 331 Shadows/Highlights 325, 346-349 amount 346 color correction 349 midtone contrast 349 radius 346, 349 tonal width 346 Threshold 331 using smart filters 366-367 Vibrance 331, 359 Image editing tools 54-55 Image interpolation 316-319 Bicubic 317 Bicubic Automatic 317 **Bicubic Sharper 317 Bicubic Smoother 317** Bilinear 317 Nearest Neighbor 317 Preserve Details 318-319 Image menu Canvas size 375 Duplicate 708 image rotate menu 571 reveal all 108 ImagePrint 77 Imagesetters 314 Image size 315-319 altering image size 315 In-app searches 7 InDesign, Adobe 77-78 Information tools 58 Installing Photoshop 2 Interface customizing the interface 4 International Color Consortium 670 iPhone 412 ISO settings 92

J

Johnson, Harald 704 JPEG capture 93

К

Keyboard shortcuts 25–26 Kost, Julieanne 366

L

Lab color Lab color conversions 700-701 Large Document format 77 Lasso tool 36, 496 Laye, Mike 666 Layer Comps panel 554-555 Layers 64, 501-523 adding a layer mask 505 adding an empty layer mask 506 add vector mask current path 593, 600 adjustment layers 502 align linked layers 575 align shortcuts See Shortcuts PDF on website arrange layer menu 575 arrange shortcuts See Shortcuts PDF on website auto-select shortcut 557, 562-563, 580-581 clipping mask 553 color coding layers 548 copy layer 501 distribute linked layers 575 image layers 501 layer basics 501 layer filtering 568-570 isolation mode filtering 570 layer groups 548-550 group linked 551 layer group management 548 lock all layers 549 masking group layers 552 moving layers in a group 549 layer linking 556-559 layer locking 561 lock all 561 lock image pixels 561 lock layer position 561 lock transparent pixels 561 layer masks 499, 505-506

adding a layer mask 505 copying a layer mask 506 disable a layer mask 506 linking layer masks 560 removing a layer mask 506 layers panel controls 503-504 laver visibility 503 managing layers 501 merged copy layer 479 merging layers layer naming 568 multiple layer opacity adjustments 556 multiple layers 548 new layer 501 selecting all layers 556 text layers 502 thumbnail contextual menu 507 clip to document bounds 507 thumbnail preview clipping 506 vector masks 365, 498-500, 505 combine shapes 600 isolating an object 601 subtract front shape 600-601 Layers panel export as 562 quick export 562 Layer Styles/Effects 503, 505 See also Book website layer style dialog blend if layer options 395 blend if sliders 309 layer style options 309, 394-395 layer style options 706 Learning center 7 Learn panel 88 Leica 95, 256 Lens Baby blur effect 616 Lens profiles 166, 646 Levels 334-344 Lighten blend mode 530 Lighter Color blend mode 530 Lighting Effects filter See Filter menu Lightroom 94 black and white conversion 400 Lightroom CC 6

add photos to 8 auto tone 147 Lightroom Classic CC 6 Lightroom Photos 6 Linear Burn blend mode 529 Linear Dodge blend mode 530 Linear Light blend mode 531 Lines per inch 313 Line tool 52 Liquify filter 480-488 See also Filter menu Load Files Into Photoshop Layers 546 Lock image pixels 561 Lossy DNG 258-259 Lotto, R. Beau 667 Luminosity blend mode 533 LZW compression 79

М

Magic eraser tool 54 Magic wand tool 36, 496 Magnetic lasso tool 36 Marquee selection tool 36, 496 Masks 499 clipping masks 551-553 Maximize backward compatibility 76 Measurement scale 16-19 Menus customizing menu options 25 Mercury Graphics processing 611 Merge to HDR Pro See also File menu: Automate Microsoft Dial support 45 Migrate settings 2 Mirror shake 415 Mixer brush tool 30, 43, 48-49 clean brush 48 flow rate 49 mix ratio 49 paint wetness 49 Moiré removal 296 Motion blur how to remove 301 Motion blur filter See Filter menu: Blur Move tool 54, 56-57

auto-select layers 556 layer selection 56, 556 options bar 575 auto-select 56 show transform controls 56 MPEG group 79 Multiple undos 66 Multiply blend mode 529 Murphy, Chris 701

Ν

Nearest Neighbor interpolation 317 Neutral gray tones 701 Nikon D800E camera 296 Noise reduction See PDF on book website Non-linear history 70 Normal blend mode 528 Notes panel 62 Notes tool 62 Numeric transform 56, 573 N-up window options 14–15

ο

Online help guide instructions XXIII On-screen brush adjustments 45 Onyx PosterShop 77 OpenCL 21–22, 45, 611 Open command 72 Open Documents as Tabs 11 Options bar 4 Outlying pixels 287 Output sharpening 704–707 Overlay blend mode 531

Ρ

Page Setup manage custom sizes 720 Paint bucket tool 52 Painting tools 43–47 Panels 22–23 collapsing panels 22–23 compact panels 4, 23–24 docked layout 22–24

organizing panels 22-23 panel arrangements and docking 23-24 panel positions in workspaces 24 revealing hidden panels 23-24 Panoramas (with Photomerge) 534-535 Parser plug-in 81 Patch tool 54, 458-461 adaptation methods 460 color control 464 content-aware mode 461 diffusion slider 456-457 sample all layers 461 structure control 461-462, 464 transparent mode 459 Paths 498-499, 499-500, 593-596 convert path to a selection 595 curved seaments 595 make path 593 rubber band mode 596 Path selection tool 53, 598-599 laver selection 558-559 Paths panel 593 add mask 593 create new path 593 fill path button 593 load path as a selection 593 Stroking a path 454 Pattern stamp tool 54 PDF file format 80-83 Pencil tool 43 Pentax 256 Pen tool 53, 601, corner points 594 curved segment 595 paths mode 594 shape layers mode 594 Perceptual rendering 687 Perceptual rendering intent 687 Perspective crop tool 54, 381 options bar front image 381 show grid 381 Perspective retouching 474 Perspective Warp 578-582 Phase One 94 Photo Filter 359

PhotoKit 263 PhotoKit Sharpener 705 Photomatix Pro 410, 413, 438 Photomerge 534-537 and adaptive wide angle 653-655 auto 534 blending options 537 collage 534 content-aware fill transparent areas 535 cylindrical 534-535 geometric distortion correction 537 perspective 534 reposition 534 spherical 534 vignette removal 537 Photoshop activation 2 Photoshop license 2 Photoshop preferences See also PDF on website Cursors 45 Export preferences export location 562-563 quick export default 562-563 File Handling Camera Raw to convert 32-bit 424 General history log 74 Interface 12-15 open documents as tabs 11 show tool tips 31, 331 Performance 578 Technology Previews preserve details upscale 318 Photoshop print dialog 711-716 background color 721 bleed option 721 border 713-715, 721 color management 16-bit output 716 black point compensation 714, 716-717 Photoshop manages colors 714 printer manages colors 714 description box 721 functions 721 gamut warning 716 match print colors 716

Photoshop manages colors 714 position and size 718 preview background color 711 printer manages colors 714 printer profile menu 715 printer selection 711 printer setup 711 printing marks 721 print margins adjusting 719 print orientation 711 print output scripting actions 722 print preview 718 print selected area 719 print settings 711-712 filtered ICC profiles 715 proof settings 716 registration marks 721 rendering Intents 716 scaled print size 718 scale to fit media 718 show paper white 716 simulate black Ink 717 Photoshop Touch 77 Photosites exposure limits 410 Pin Light blend mode 532 Pixel aspect ratio 9 Pixel Genius 263 photoKit sharpener 263 Pixel grid view 21-22 Pixels per inch 313 Polygon shape tool 52 PostScript PostScript RIP 314 Preferences See Photoshop preferences Preset manager 63-64 saving presets as sets 65 Printing See Photoshop print dialog centering prints 720 color management 714 color management off 724 profiles custom print profiles 725

making a print 711-720 printing resolution 314 printing tips 727 print quality settings 723 print sharpening 704-707 saving print presets 722 Print output scripting 722 Print settings Mac 723-724 PC 723-724 Print (system) dialogs color management 724 media type 723 print resolution 723 print settings 722 Process versions 134-139, 200, 264-267 Camera Raw legacy presets 252-253 process version mismatch 252 Version 1/Version 2 See PDF on website Version 3/Version 4 synchronizing settings 252-253 tone controls 135 ProfileMaker 672-673 Profile Mismatch 676 Profiling profiling the display 672-673 remote profiling 725 Prohibit sign 31 Proof printing 717, 718 Proof Setup 697 Properties panel 332-333 adjustment controls 336 masks controls 330, 362-367, 508 color range 363 density 362, 365 feather 363-364, 500 invert 508 masks mode options 508 masks panel editing 364 selection lab 363 ProPhoto RGB 326-329, 668, 699 PSB format 77 PSD format 76 PSDX format 77

Puppet Warp 581 See Edit menu density setting 581 semi-transparent edges 582 Purves, Dale 667

Q

QuarkXPress 78 Quick mask 494–96, 498, 499, 507, 509 Quick selection tool 37, 509–511 add to a selection 509 auto-enhance edge 510 blocking strokes 509 brush settings 509 double Q trick 509 subtract from a selection 509

R

Radial blur filter See Filter menu: Blur Raw capture 92 Recent files (accessing) 5 Rectangular marguee tool 37-38, 497 Rectangular shape tool 52 Red Eve tool 54 Reducing noise through HDR merging 412 Refine Edge 462 Relative colorimetric 687 Reloading selections 493 Removing objects 385 Rendering intents absolute colorimetric 716 perceptual 716 relative colorimetric 708-709, 716 saturation (graphics) 716 Resnick, Seth XXI Resolution terminology 313 Retina support 3 Retouching beauty shots 478 Reveal All 380 RGB RGB color space selection 326 RGB to CMYK conversions 668 RGB workspaces 693

ideal RGB working space 698 Rich tool tips 34 Ricoh 256 Rodney, Andrew XXI, 701, 725 Rotate a layer 571 Rotate image 386 Rotate view tool 61 Rotating images 386 Rounded rectangle shape tool 52 Rubylith mode 506 Rulers 18 Ruler tool 61, 386 options bar straighten layer 386

S

Samsung 256 Saturation and curve adjustments 342 Saturation blend mode 533 Saturation rendering 687 Saturation rendering intent 687 Save Progress status bar indicator 16 Saving 73 background saving 74 Save As 75 Schewe, Jeff XXI, 443, 704-705 Scratch disks scratch disk sizes 16 Screen blend mode 530 Select and Mask 511-519, 527 auto-enhance 509 brush tool 513 cache setting 515 contrast slider 509, 521 decontaminate colors 515-516 edge detection radius 514 smart radius 514, 520-521 alobal refinements contrast 514-515, 520-521 feather 514-515, 520-521, 527 shift edge 515, 520-521 smooth 509, 514 lasso tool 513

mask creation 513 output settings 515 quick selection tool 513, 516 radius 509, 521 refine edge brush tool 514, 517, 521 show edge 513-514 show original 513-514 smart radius 514 truer edge algorithm 513 view modes show edge 513 show original 513 Selections 491-498 adding to a selection 497 anti-aliasing 500 creating a selection 495 feathering 500 load selections 493 marching ants mode 493 modifying 496 recalling last used selection 494 reloading selections 493 save selections 492 selection shortcuts 493 Selection tools 35-38, 36 elliptical selection tool 36 magnetic lasso tool 36 marquee selection tool 36 quick selection tool 37 single row selection tool 36 Select menu Color Range 38-39, 524 adjustable tone ranges 40-42 detect faces 40 fuzziness slider 38 localized color clusters 38, 525 preview options 525 range slider 38, 525 skin tones selection 40 deselect 494 Focus Area 522-523 modify expand 462 reselect 494 transforming selections 574 Shadows/Highlights 346-349

Shake Reduction filter 302-307 Shape tools 52 Share feature 6, 8 Sharpening and JPEG captures 263 and raw mode capture 263 capture sharpening 262 depth of field brushes 308 edge sharpening technique 705 for scanned images 263 high pass edge sharpening 704 Lab mode sharpening 263 localized sharpening 262 PhotoKit Sharpener 263 print sharpening 262, 704-707 Real World Image sharpening 264 sample image 265 Smart Sharpen filter See Filter menu When to sharpen 262 Sharpen tool 43 protect detail 298 Show all menu items 25 Single column marquee tool 36 Skin tones CMYK numbers 701 Smart filters 586-593 See also Smart Objects enable all plugins 608 enabling the Lens Blur filter 608 Smart guides 18-19 Smart Objects 111-113, 299, 418-419, 586-593, 632-638 blending options 299 Camera Raw 202 enable all plugins 586 image adjustments 366-367 layers panel searches 592 linked smart objects 589-592 nested smart objects 366 Smart Object sharpening layers 279 smart object status 16 status bar 590 transform adjustments 586 Smart PSD format 77

SMPTE-240M 699 Smudge tool 43 Snapshots 69-70 Snap to edge 372 Soft Light blend mode 531 Soft proofing 708-710 Sonv RX-100 camera 245 Spectrophotometer 673 Spirit of St Louis 367 Splash screen 88 Sponge tool 43 Spot Healing Brush 54, 452-453 content-aware mode 453-454 normal blend mode 454 replace blend mode 454 create texture mode 453 diffusion slider 456-457 proximity match mode 452 replace blend 453 stroking a path 454 sRGB 329, 676, 698 incorrect tags 682 Start workspace 5 recent files 5 Status information box 16 Subtract blend mode 532 Surface Blur filter See Filter menu: Blur Swatches panel 51 Synchronized scroll and zoom 14-17

T

Tabbed document windows move to a new window 11 Task-based workspaces 27 Third-party plug-ins 632 Threshold mode preview 340 Timing 16 Title bar proxy icons 16 Tonal compression techniques 418 Toolbar presets 32–33 Tool preset picker Tool preset picker Tool presets panel 35 current tool only 35 Tools panel 31–32 Tool switching behavior 31 Tool tips 34 rich tool tips 34 Tool tips info 31 Touch bar (Mac) 4 Trackpad gestures 58 Transform command *See* Edit menu

U

Unsharp mask filter See PDF on book website User interface settings 11

V

Vanishing Point filter 474 Vector layers 502 Vector masks See Lavers Vector programs 313 View menu gamut warning 708 arid 18 quides 18 new guides from shape 20 proof setup CMYK previews 697 custom proof condition 708-709 snap to 372 view extras 18 Vignetting 189 Vivid Light blend mode 531

W

Wacom 44, 444, 446, 480 Walker, Michael 701 Welcome screen 5 WhiBal cards 129 White Lion 88 Window documents 13 floating windows 13 image tiling info 16 N-up windows 14 Window menu arrange 14 match location 14 match zoom 14 cascade windows 13 tile windows 13 workspace new workspace 27 panel locations 28 reset workspace 28 workspace settings 23, 27–28 workspace shortcuts 26 Windows 7 multi touch support 60 Woolfitt, Adam 256 Workspace See Window menu start workspace 5 Wynne-Powell, Rod XXI

Х

XMP metadata 122 XMP sidecar files 120 X-Rite ColorChecker 673 ColorChecker chart 129 i1 Photo 673 i1 Pro 2 725 i1 Profiler 672 i1 Profiler software 725 ProfileMaker Pro 672–673 X-Rite ColorChecker 201

Z

ZIP compression 79 Zoom blur filter 605 Zooming scrubby zoom 15 zoom percentage info 15 Zoom tool 58 zoom tool shortcuts 58

colourmanagement.net

Remote profiling for RGB printers

You have just been reading one of the best digital imaging books in the marketplace. Now you'll probably want to be sure your colour is as good as it can be. Lots of print testing to achieve expected colour really does use up the ink and paper, but, more importantly it uses up the creative spirit. We'd like to offer you a deal on a printer profile. Have look at the inkjet profiling page here: www.colourmanagement. net/services/inkjet-printer-profiling. We send a detailed manual and color charts. You post printed charts to us. We will measure using a professional auto scanning spectrophotometer. This result is then used within high-end profiling software to produce a 'printer characterisation' or ICC profile which you will use when printing. Comprehensive instructions for use are included. You can read a few comments from some of our clients at: www.colourmanagement.net/clients/

Remote RGB profiles cost £95 plus VAT. For readers of 'Adobe Photoshop CC for Photographers', we are offering a special price of £50 plus VAT. If our price has changed when you visit the site, then we will give you 30 percent off. We also resell the colour management gear that you need: profiling equipment, LCD displays, print viewers, RIPs, printers and consumables etc. www.colourmanagement.net/profilegear.htm

Is your color right? Do you need to be sure? Read about our Verification Kit www.colourmanagement.net/products/icc-profile-verification-kit. Normally £80 + VAT with UK postage. This offer gives a 50% discount. Overseas delivery by arrangement. We also resell the colour management gear that you need: profiling equipment, LCD displays, print viewers, RIPs, printers and consumables etc. www.colourmanagement.net/profilegear.html

We also resell the color management gear that you need: profiling equipment, LCD displays, print viewers, RIPs, printers and consumables etc. www.colourmanagement.net/profilegear.html.

Consultancy services

Neil Barstow, colour management and imaging specialist, of www.colourmanagement.net, offers readers of this fine book a discount of 15% on a whole or half day booking for consultancy (subject to availability and normal conditions).

Coupon code: MEPSCS7-10

The above coupons will expire upon next revision of Adobe Photoshop for Photographers. E&OE.

Rod Wynne-Powell

Rod, a fellow Adobe Prerelease Tester, continues to provide technical help and suggestions when tech-editing for this series of books. When he is not helping me, he finds time to train others in Lightroom and Photoshop workflow, and one of his 'students' was asked by her colleagues what was it he had, to which her reply was "Gravitas and Patience"—seemingly they thought he had an App called 'Gravitas'!

He keeps abreast of the technologies that impinge upon photography, the Mac and Photoshop, which can prove invaluable. The lessening amount of both retouching and consultancy work has resulted in a return to his roots—the taking of photographs, with a growing interest in windsurfing and wildlife photography in particular, due to being close to Brogborough Lake and the Forest Centre.

For over thirty years Rod Wynne-Powell has provided consultancy and training—retouching to graphic designers; progress photography to construction companies; guidance to photographers in relation to Macs and their operating system. Much of the training is tailored for one-to-one involvement as this generally proves to be the most effective way to learn. Several photographers have availed themselves of his time for extended periods of up to six days as far afield as Tuscany, Provence, Paris, and Aberdeen, with follow-up sessions remotely using programs such as Messages and Skype.

Photograph and retouching: Rod Wynne-Powell

Email: rod@solphoto.co.uk Blog: http://rod-wynne-powell.blogspot.com Skype: rodders63 Messages: rodboffin M: +44(0)7836-248126

DATE DUE			
APR (8 2019		
MAR	3		
0CT 2	3		
JAN	2 5 2021		
×			PRINTED IN U.S.A.